# CORPUS OF ANGLO-SAXON STONE SCULPTURE

## Volume IV

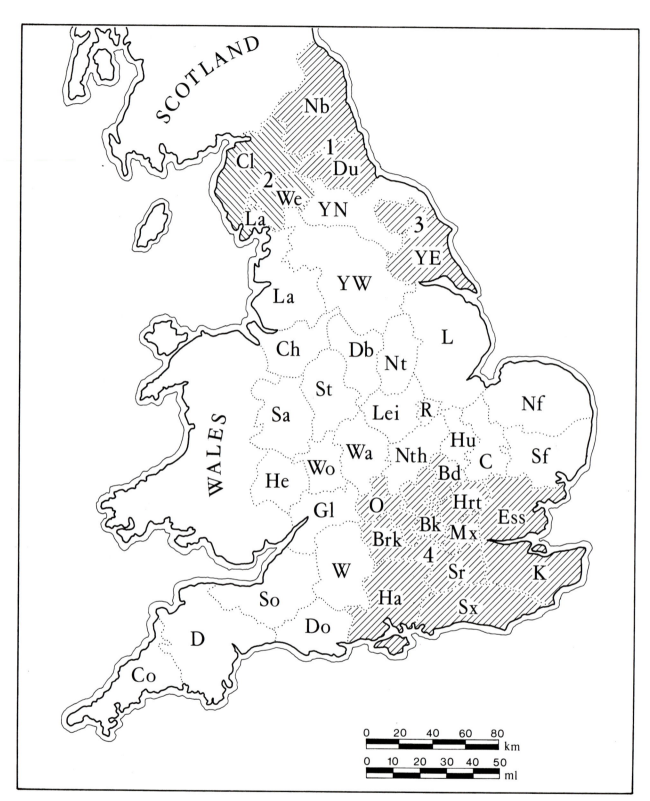

FRONTISPIECE

Map of England showing position of areas covered by Volumes I–IV of Corpus of Anglo-Saxon Stone Sculpture

# CORPUS OF ANGLO-SAXON STONE SCULPTURE
## Volume IV

# SOUTH-EAST ENGLAND

BY

DOMINIC TWEDDLE,
MARTIN BIDDLE, BIRTHE KJØLBYE-BIDDLE

WITH CONTRIBUTIONS BY

Michael P. Barnes, John Higgitt, Henry R. Loyn,
David Parsons, and Bernard C. Worssam

Published for THE BRITISH ACADEMY
by OXFORD UNIVERSITY PRESS

*Oxford University Press, Walton Street, Oxford OX2 6DP*

*Oxford New York*
*Athens Auckland Bangkok Bombay*
*Calcutta Cape Town Dar es Salaam Delhi*
*Florence Hong Kong Istanbul Karachi*
*Kuala Lumpur Madras Madrid Melbourne*
*Mexico City Nairobi Paris Singapore*
*Taipei Tokyo Toronto*

*and associated companies in*
*Berlin Ibadan*

*British Library Cataloguing in Publication Data*
*Data available*

*ISBN 0–19–726129–9*

*Produced by Alan Sutton Publishing, Stroud*
*Printed in Great Britain*
*on acid-free paper by*
*WBC Limited*
*Bridgend*

# FOREWORD

This splendid series describes and defines a most important part of Britain's cultural heritage, and a part that is less well known and less well documented than it deserves to be. It is particularly pleasing to see that many scholars are contributing to the series, and the University of Durham is delighted to be associated with it.

Professor EVELYN A. V. EBSWORTH, F.R.S.E.
*Vice-Chancellor and Warden*

The publication of this volume has been generously assisted by a grant from the Henry Moore Foundation.

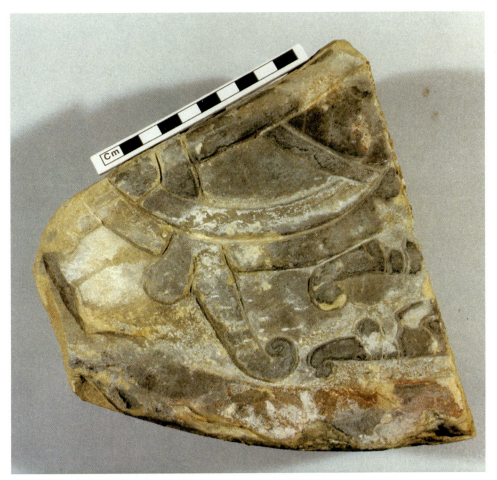

**Plate 1** Rochester 3A, showing the surviving paint deposits, nts (see p. 166)
(*copyright Mrs L. A. Arnold, photographer M. Parry*)

# CONTENTS

# LIST OF FIGURES

The frontispiece and Figures 1–3, 6–7, 26, 29, 33–4, 39–41, 43 were drawn by Yvonne Beadnell. Figures 4–5 were drawn by Karen Atkinson. Helen Humphreys drew Figures 8–20, 21–5, 28, 30–2, 35–8, and 42, and Birthe Kjølbye-Biddle Figure 27.

# LIST OF TABLES

# PREFACE

The fourth volume of the British Academy's Corpus of Anglo-Saxon Stone Sculpture ventures for the first time into the south of England. The material catalogued differs greatly from the previous volumes, including as it does sculptural—mainly architectural—fragments from one of the main ecclesiastical centres of Wessex, Winchester. These include pieces excavated by Martin Biddle and Birthe Kjølbye-Biddle from the site of the Old and New Minsters, and the Corpus Committee is particularly grateful to them for allowing these important objects to be included in the Corpus and for writing them up so promptly. The controversial fragments from Reculver, now in the crypt of Canterbury cathedral, are here re-published and re-examined despite great technical difficulties, and the surviving sculptures from one of the major early centres of English Christianity, St Augustine's, Canterbury, have now received proper treatment.

The Corpus Committee is grateful to Dominic Tweddle for his hard work in producing the volume despite the distractions of a busy life with the York Archaeological Trust. It could not have been brought to fruition, however, without the hard work of Eric Cambridge, who has seen the whole volume into the press. In thanking him in the warmest possible terms we would also thank Rosemary Cramp, the founder of the project, and many others who have helped in the production of this volume; in particular we are grateful to Henry Loyn for generously contributing at short notice a chapter on the historical background of the region. The generosity of the University of Durham in continuing to give support to the Corpus project is once again gratefully acknowledged, as is the financial and administrative support of the British Academy in difficult times.

DAVID M. WILSON
*Chairman, Committee for the Corpus
of Anglo-Saxon Stone Sculpture, 1994*

# ACKNOWLEDGEMENTS

This volume has been written in two distinct sections by authors who have prepared, in a different format, a large section of the material. Dr Tweddle's Ph.D. thesis was concerned with the whole region (Tweddle 1986b), while the stones from the Winchester excavations have been prepared for publication as part of a volume in the Winchester Studies series (Biddle and Kjølbye-Biddle forthcoming a). The format of the acknowledgements takes this into account.

The editors are grateful to all the specialists, each of whom has made a substantial contribution to this book. Bernard Worssam has significantly advanced our knowledge of the geological picture of the region in the pre-Conquest period. We would also like to thank the epigraphers, John Higgitt, Michael Barnes, and David Parsons, and also Henry Loyn, for their scholarly contributions. Richard Gem has provided helpful advice in relation to Romanesque architectural sculpture, as did Richard Bailey on editorial matters, while Leslie Webster helped with locating photographic illustrations of several of the key monuments.

Yvonne Beadnell has continued to give skilful support to the series by providing most of the line drawings for the volume, ably assisted by Helen Humphries and Karen Atkinson. Although there is a wider range of photographic sources for this volume than previously, (specific sources of photographs, and copyright holders, being acknowledged on p. 382), we are particularly grateful for the substantial contributions of Simon I. Hill and John Crook. Computing expertise was provided by Francis Pritchard and the University of Durham Computing Service. The Index and the Form and Motif Table were compiled by Derek Craig, who also saw the volume through press.

The authors' specific acknowledgements are listed below.

*University of Durham*                                                    ROSEMARY CRAMP
                                                                                    ERIC CAMBRIDGE

For the research in the field, the production of my Ph.D. thesis, and finally of this book, I have drawn very heavily on the generosity of many individuals. It is a great pleasure to be able to thank those who gave so freely of their time and expertise.

My first and warm thanks must go to Sir David Wilson who suggested this topic to me and who supervised it and also to James Graham-Campbell for his academic support and administrative help. Both have saved me from many errors and misconceptions; any that remain I claim as my own.

I am grateful to the incumbents and churchwardens in whose care most of the sculptures remain. I owe a particular debt of gratitude to the Reverend Dennis Lane for helping me to track down the sculptures from Titsey, and to the late Major R. Leveson-Gower, their then

owner, for his generous hospitality and assistance. Lieutenant-Colonel E. P. Ball and Canon P. Welsby smoothed my path at Rochester Cathedral and I am grateful to the late Canon F. Busby of Winchester Cathedral, R. E. Steel of Canterbury Cathedral, and to W. R. J. Pullen, Receiver General of Westminster Abbey, for arranging access to material in their care and answering my numerous enquiries. Similarly, museum curators and staff have been endlessly patient and helpful, particularly J. Clark of the Museum of London, the late E. R. Coveney of Dover Museum, J. Dool of Winchester City Museums, L. Millard of Kent County Museums Service, C. C. Paine of the Oxfordshire Museums Service, L. M. Pole of Saffron Walden Museum, and M. G. Welch then of the Ashmolean Museum, Oxford. I am particularly grateful to Mrs L. E. Webster of the Department of Medieval and Later Antiquities at the British Museum for allowing free access to the Department's index of pre-Conquest stone sculpture, discovering the cast of the runic inscription from St Augustine's Abbey, Canterbury, and giving generously of her profound knowledge of Anglo-Saxon art. Dr M. Budny has given freely of her unrivalled knowledge of southern English manuscript art and helped in a number of other ways. The York Archaeological Trust generously granted me a sabbatical in order to complete the thesis and provided word processing facilities; I am most grateful to the Council and Director of the Trust for this assistance.

Other friends and colleagues have assisted with a multitude of specific enquiries or problems, and in numerous other ways: P. V. Addyman; F. Aldsworth; R. N. Bailey; V. E. Black; A. Bott; M. Brown; J. Butler; J. Cherry; H. Clarke; E. Coatsworth; R. J. Cramp; I. R. Dake; P. Everson; D. Freke; K. S. Gordon; C. Haith; R. A. Hall; A. C. Harrison; I. Henderson; M. Hughes; M. J. Hughes; J. T. Lang; J. Maytom; E. Okasha; R. I. Page; the late S. E. Rigold; J. P. Sedgeley; D. A. Stocker; and S. Werberg-Moller.

This work could not have been completed without the help of the staff of the major libraries and archives consulted: the British Library; Canterbury Cathedral Library; the Courtauld Institute Library, Durham University Library; the Library of the Society of Antiquaries of London; the library of University College, London; the University of London Library; York University Library; and the National Monuments Record.

Finally, I wish to thank my parents for their encouragement and support at every stage of the undertaking; without them this work would never have been contemplated, much less completed.

*York Archaeological Trust*                                                              DOMINIC TWEDDLE

For the help we have received in writing the sections in this volume dealing with the carved stones from the Winchester excavations of 1961–71, excavated by us on behalf of the Winchester Excavations Committee, and in describing the Anglo-Saxon capitals, shafts, and bases reused in the Norman transepts of St Albans Abbey, we wish to thank: the Dean and Chapter of Winchester Cathedral, and especially the late Oswyn Gibbs-Smith, in whose time as dean the excavation of the Old and New Minsters took place; the staffs of the Winchester Excavations Committee, especially Katherine Barclay, and of the Winchester Museums Service, especially Elizabeth Lewis and Geoffrey Denford; the then Dean, Dr Peter Moore, and the Council of the Cathedral and Abbey Church of St Alban, and the vergers, especially

Frank Lane; Frances Rankine, Nicholas Griffiths, and Geoffrey Wallis, who drew the Winchester stones for publication in Winchester Studies (Biddle and Kjølbye-Biddle forthcoming a); John Crook, who photographed all the pieces we have described; and Bernard Worssam for his meticulous geological inspection and comments. We are particularly grateful to Dr Tom Blagg for examining the St Albans capitals, bases, and shafts, in relation to Romano-British elements of the same general type, and for his report included here.

*Oxford*                                                 BIRTHE KJØLBYE-BIDDLE
                                                          MARTIN BIDDLE

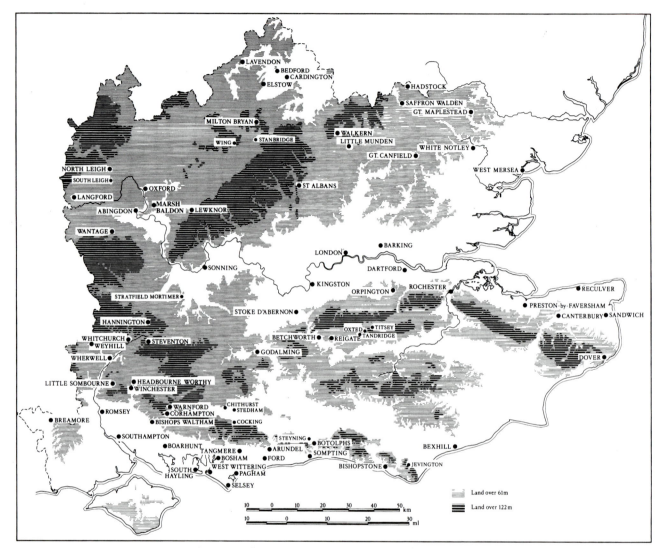

FIGURE 1
Sites with sculpture in South-East England

# CHAPTER I

# EARLIER RESEARCH

## by D. Tweddle

At the time of his death in 1932, G. Baldwin Brown had compiled raw statistics on the numbers of pre-Conquest sculptures then known in each of the English counties; these statistics were finally published in 1937 in the last, posthumous, volume of his *The Arts in Early England* (Brown 1937, fig. 13). In them south-east England presented a sorry spectacle, with only 44 sculptures from eleven counties, compared with 450 for Yorkshire alone and 200 for Durham and Northumberland combined. In large part this imbalance reflected genuine differences in the scale of sculptural production between north and south, but equally southern England had produced no scholars of sculpture of comparable standing to those working on the Northumbrian material, such as W. S. Calverley, Romilly Allen, and W. G. Collingwood. Instead innumerable local topographers, antiquaries, architects, and archaeologists, had gathered information piecemeal and, if it was published at all, consigned it to the too-seldom consulted pages of obscure local journals or ephemeral guide books. Lacking even a mediocre synthesis or publicist this data had reached rapid oblivion, for by 1930 not 44 but 145 pre-Conquest sculptures had actually been recognised in south-east England; even excluding the numerous, but mostly fragmentary, excavated stones from Winchester (see Chap. VIII), the total now stands in excess of 200.

In common with many other areas of the country, the study of pre-Conquest sculpture in south-east England began, albeit accidentally, towards the end of the eighteenth century with the rising tide of antiquarianism. As the educated and leisured classes of the period began to value the ancient buildings around them, so they began to record them, either by themselves sketching or painting, by employing professionals to do so, or by buying the prints produced in increasing numbers by amateur and professional artists alike. The work of the gentleman antiquary is exemplified by William Cole. A friend of

the architect James Essex and of Horace Walpole, Cole was Rector of Hadstock, Essex. His main interests were genealogy, heraldry, and the history of Cambridge, but in 1775 he sketched the decorated north nave doorway of that church, and his sketches are the only record of a similar doorway in the north chancel wall, now lost (BL Add. MS 5836, fol. 18v; Rodwell 1976, 65). The decoration of the surviving doorway had also been drawn by Essex (BL Add. MSS 6768, p. 90; 6744, fol. 3r). Another important amateur antiquarian topographer was the Rev. James Skinner. Although principally interested in excavations on the Isle of Wight (BL Add. MS 33650, fols. 62r–66r, 87r–89r, 125r–134r), in 1817, on his annual holiday, he recorded the larger of the two Crucifixions at Romsey, Hampshire (no. 1) (ibid., fol. 210r). This piece had also attracted the attention of the professional topographer John Carter; his print of the figure was published between 1780 and 1794, probably the first piece of pre-Conquest sculpture in the region to be published (Carter 1780–94, pl. II). In the same period the Swiss watercolourist S. H. Grimm recorded in watercolour the figure of an ecclesiastic at Sompting, Sussex, for Sir William Burrell (BL Add. MS 5673, fol. 53r), and John Buckler recorded the architectural sculptures at Sompting (BL Add. MSS 36432, item 1252, 27765C, fol. 83r) and at Langford, Oxfordshire (BL Add. MS 36356, item 200).

By far the most important work of the period, however, was that done in 1805 at Reculver, Kent, during the demolition of its seventh-century church. A. R. Gandy drew a measured plan and elevation of the triple arcade separating the nave and chancel, as well as various details including one of the decorated column bases (Society of Antiquaries MS, Red Portfolios, Kent, L–R, fol. 26r; BL Add. MS 32370, fol. 105r). These drawings, together with an important general view of the demolition by I. Baynes (ibid., fol.

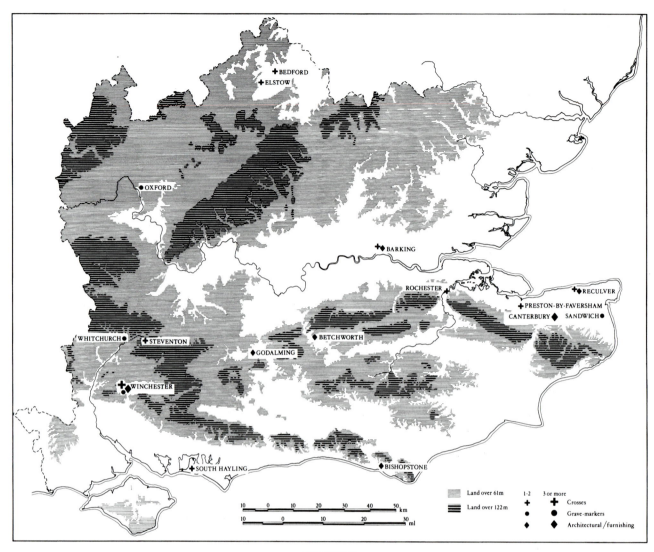

FIGURE 2
Sculpture earlier than *c.* 950

106r), were published by Roach Smith in 1850 (Smith 1850, 198). They not only provide an invaluable record of a lost monument of the first importance, but in 1859 enabled Sheppard to recognise the Reculver columns (no. 4) in an orchard near Canterbury and rescue them from oblivion (Talbot 1860, 135–6, pl. facing 136). These drawings were, however, atypical; most never reached publication. Where the drawings were published, the Anglo-Saxon sculptures were not recognised for what they were; they were merely mysterious or picturesque curiosities.

The early and middle years of the nineteenth century were dominated by the struggle to establish reasoned chronologies, not just for sculpture, but for all classes of monument and archaeological materials. One of the most significant figures in this work was Thomas Rickman who, between 1817 and 1848, set out the criteria for periodizing English medieval architecture (Rickman 1817; idem 1848). An important side effect of this work was the recognition of criteria which would identify pre-Conquest fabrics (Rickman 1836); where such buildings employed architectural sculpture, then it too must be of pre-Conquest date. Sculptures at Sompting, Sussex (Rickman 1848, figs. pp. xxvii–viii); and from the Hampshire sites of Headbourne Worthy (Carter 1845; Haigh 1846, 414), Corhampton (ibid., 408, 410), Warnford (loc. cit.), Winchester (loc. cit.), Boarhunt

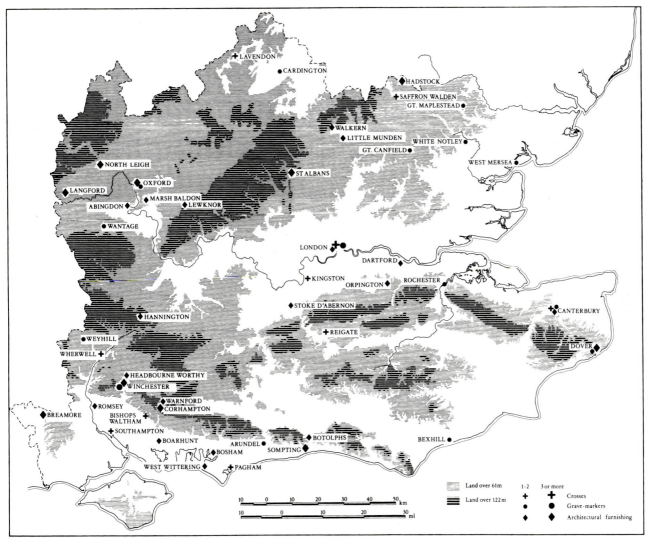

FIGURE 3
Sculpture later than *c.* 950

(Irvine 1877b) and Breamore (Hill 1897a; idem 1898), could at last be recognised for what they were. Equally sculptures reused as building materials, either in pre-Conquest or very early post-Conquest buildings, could be dated, although usually with less certainty, as at St Mary in Castro, Dover (Puckle 1864, 54–5, 71–2), and Stedham, Sussex (Butler 1851).

Evidence derived from architectural analysis was supplemented by linguistic evidence. Following the decisive work of J. M. Kemble, runic inscriptions in either Old Norse or Old English could now be read, although with varying degrees of accuracy and acrimony. By this means the stones from Sandwich (Wright 1845, 12; Haigh 1861, 52) and the grave-cover from Dover St Peter (Kemble 1840, 346), were recognised for what they were. Inscriptions in Old English in Latin characters had always been recognisable as of pre-Conquest date, as had the Old English names in the Latin inscriptions at Whitchurch (Smith 1871) and Stratfield Mortimer (Westwood 1885–7), allowing them also to be dated.

Where clues from architectural analysis or from inscriptions were missing, however, oblivion or, worse, destruction, was still a common fate for newly-discovered sculptures. Here the work of Romilly Allen, Calverley, and Collingwood was decisive. As they painstakingly analysed the range of forms and decorative motifs and the variations which might be

encountered among pre-Conquest sculpture, so more material could be identified by enterprising local scholars and protected. Allen's work was of particular importance in this respect since he identified and published a number of southern pieces including the grave-cover from Bexhill, Sussex (Allen 1885a, 274–7, fig. facing 274) and the cross-shafts from Wantage, Berkshire, (idem 1893–4b, 58, fig. 12) and Steventon, Hampshire (Page 1908a, 238–9). Allen's manuscript notes preserved in the British Library reveal that his knowledge of the sculpture of south-east England was both extensive and up-to-date, although relatively little of his data found its way into print (BL Add. MSS 37539–628).

With the means to identify and date pre-Conquest sculptures, no matter how crudely, local scholars were able to hunt them with zeal and enthusiasm. Outstanding was the work of the architect P. M. Johnston. He had an extensive practice, largely in Sussex and Surrey, and specialised in the restoration of churches ((——) 1937). During his work at Stoke D'Abernon church he noticed and published the pre-Conquest sundial there (Johnston 1900b, 77–8, fig. 21). At Ford, Sussex, he discovered the fragment of interlace built into the vestry doorway (Johnston 1900a, 118–20, fig. 5), and during the underpinning of the tower at Cocking church, Sussex, he noticed and published the grave-cover which had been discovered there in 1896 during earlier restorations (Johnston 1921, 182, fig. 1). Stimulated by these discoveries Johnston went on to publish the grave-covers at Chithurst (Johnston 1912, 106, pl. 6), to re-publish the grave-covers from Bexhill (Johnston 1905) and Steyning (idem 1915, 149–50, 161, fig. p. 150) in Sussex, and to publish the first photographs of the cross-shaft from Kingston upon Thames, Surrey (Johnston 1926, 232, pl. 1). He is the only source of information for the lost gable cross from Walberton, Sussex (Johnston 1921, 178, n.), and in 1904 discovered a grave-cover (Arundel 1) built into the wall of a builder's yard at Walberton, and established that it had originally been brought from Arundel castle (Johnston 1904).

Of equal importance was the work of H. L. Jessep. In his work on the pre-Conquest architecture of Hampshire and Surrey, published in 1913, he discussed the sculptures at Breamore (Jessep 1913, 1, 19, fig. 1), Corhampton (ibid., 17, fig. 1), Headbourne Worthy (ibid., 19), Warnford (ibid., 17), and St Michael's, Winchester (loc. cit.), all in Hampshire, and at Godalming in Surrey (ibid., 28–9). His work on the pre-Conquest architecture of Sussex, published in the following year, was rather more wide-ranging, including material which was strictly non-architectural, and for that reason was of greater importance. In it Jessep published the Cocking grave-cover for the first time (Jessep 1914, 61), as well as the little-known sculptures from Chithurst (loc. cit.) and Ford (ibid., 31–2), and also discussed some of the better known sculptures, such as those at Jevington (ibid., 32, 61), Bishopstone (ibid., 26–7), and Sompting (ibid., 37–9).

The work of these local scholars is reflected in the large number of guide books which mention pre-Conquest sculptures. In the early twentieth century, for example, the guides of the Homeland Association spasmodically introduced notices of pre-Conquest sculpture. The guide book for Bexhill-on-Sea with Battle abbey, published in 1914, records the grave-cover at Bexhill, Sussex (Anderson 1914, 30–1), the guide for Seaford and Newhaven, published in 1904, notes the sundial at Bishopstone, Sussex (Day 1904, 26), and the guide for Oxted, Limpsfield, and Edenbridge, published in the same year, mentions the grave-covers at Oxted, Surrey (Home 1904, 17). Methuen's *Little Guides*, largely written by J. C. Cox, began publication in the same period as those of the Homeland Association, the revised editions of the thirties and forties receiving extensive additions on pre-Conquest sculpture. In 1935 P. M. Johnston revised the guides to Surrey and Kent, mentioning in the Surrey guide the sculptures at Godalming (Cox and Johnston 1935, 109), Stoke D'Abernon (ibid., 165, 193), Tandridge (ibid., 168) and Titsey (ibid., 172), and in the Kent guide the cross-shaft at Preston by Faversham (Cox and Johnston 1935, 247–8), unnoticed since its meagre publication by Scott Robertson in 1895 (Robertson 1895, 126). After Johnston's death in 1936 Jowitt took over the revision of the series. The 1938 edition of the Essex guide records the sculpture at Great Maplestead (Cox *et al.* 1938, 206).

What was still lacking for south-east England, however, was a scholarly analytical corpus for the region as a whole, the nearest approach being Frank Cottrill's MA thesis of 1931, *A Study of Anglo-Saxon Sculpture in Central and Southern England*, a work which, apart from one portion (Cottrill 1935), remains unpublished. Most individual counties also lacked the sort of survey undertaken in the north of England, as in Collingwood's detailed catalogues of the sculptures from Yorkshire. In south-eastern England only Hampshire received such attention when in 1951 A. R. and P. M. Green published their

*Saxon Architecture and Sculpture in Hampshire.* The work of the Greens was aided by the fact that when they wrote a Victoria History for the county was already complete. Romilly Allen had contributed a chapter on the Early Christian monuments for the county to the introductory volume (Doubleday and Page 1903, 233–49); entries for individual sculptures in the five volumes are evidently based on his notes. Apart from Hampshire, the material from Essex and Hertfordshire, both minor counties in sculptural terms, has been covered in the volumes of the Royal Commission on Historical Monuments for those counties. The only catalogue yet compiled of a single class of sculptures for the area, sundials, was also the work of A. R. Green (Green 1928). Other classes of architectural sculpture have also received attention, notably by Baldwin Brown (Brown 1937), A. W. Clapham (Clapham 1930), and H. M. and J. Taylor (Taylor and Taylor 1966), but none of these works claims to be complete.

Work in south-east England was not, however, confined to local scholars. A. W. Clapham, in particular, played an important role in recognising and publishing pre-Conquest material from the region, including the cross-shaft from Barking, Essex (no. 1), and the lengths of frieze and foliate-decorated arcade from Sompting, Sussex (nos. 1–11). It was from the period spanned by Johnston and Clapham, from the late nineteenth into the earlier twentieth century, that the first sculptures in the region began to come from controlled archaeological excavation. The first pieces to come to light in this way were a capital and possibly also a grave-cover or decorative panel from the excavations of Peers and St John Hope at St Augustine's abbey, Canterbury (nos. 3 and 9). They were followed by the fragments from Reculver in 1927, and in more recent years, from the excavations at Rochester cathedral, Pagham church, Sussex, Barking abbey, Essex (no. 2), and pre-eminently, those at the Old and New Minsters at Winchester and at other sites in the city (see Chap. VIII).

Despite all of this work, spanning almost two hundred years, material from south-east England is still viewed as a meagre footnote to the sculptural riches of Northumbria; the major monuments of the region, such as the Reculver fragments, are treated as exotic and alien, divorced from their local sculptural context. It must be admitted that the quantity of sculpture from south-east England is small when set against that from Northumbria, but the range of forms and decoration is wide, and the quality often high; the material makes a significant contribution to our understanding of south-east England in the Anglo-Saxon period.

# CHAPTER II
# HISTORICAL BACKGROUND TO THE SCULPTURE
## by H. R. Loyn

The area dealt with in this volume consists predominantly of lands vitally affected by influence coming from the Thames estuary and the south coast. Much of the debate over cultural developments in art, learning, and sculpture revolves around the impact of ideas and techniques imported from the continent through the three centres of Canterbury, London, and Winchester. Such debate is, however, far from the whole story, and can be positively distorting. For long periods political, and also cultural, pressure came from the north-west along Watling Street, especially during the period of growth of Greater Mercia in the late seventh and eighth centuries. Scandinavian influence also, both from the Danelaw and directly during the reigns of Cnut and his sons (1016–42), proved far from negligible.

## THE ROMAN HERITAGE AND THE PAGAN ANGLO-SAXON PERIOD

The degree of survival of the Romano-British population from Roman Britain to Anglo-Saxon England remains an open question. Plague, pestilence and war took their toll. Linguistic evidence suggests an overwhelming preponderance of migrant Germanic-speaking settlers in the south-east. Place-name forms are more ambiguous. Conspicuous geographical features, hills, such as the Chilterns and great rivers, such as the Thames, tended to retain their names. London and Kent are outstanding among names that may indicate an element of survival of the native population. Throughout the area there is nevertheless consistent dominance of Anglo-Saxon elements in places denoting settlement and in the names of small rivers and streams, all suggestive of intense colonization by Germanic-speaking cultivators of the soil (Loyn 1991, 6–15). Systematic wholesale extermination of the native population may have been rare (or possibly unnecessary) although something

approaching ethnic cleansing is not impossible, with some Romano-British peoples surviving in enclaves or as slaves, effectively culturally negative. Even so, physical survivals from Rome were great, and we become increasingly aware of them as excavations disclose the shape of early Anglo-Saxon towns and townships. In Canterbury, for example, the ruins of the massive Roman theatre, which is reckoned to have housed 7000 people, must have dominated the early medieval town; and the ruined church on the site of Christ Church and St Martins were not unique in remaining as identifiable buildings in 597 when the Augustinian mission arrived (Brooks 1984, 24–5). London is more complicated, but there is reason to believe that many Roman buildings were still recognizable by the late seventh century even if significant Anglo-Saxon settlement took place on the Strand to the west of historic *Londinium*.[1] Roman road systems remained in use. At Winchester the line of the Roman wall was followed by all subsequent defences (Biddle 1976, 272–7, 451). Enough Roman masonry persisted at *Verulamium* so that eleventh-century abbots of St Albans could stockpile material to build their massive new Norman abbey nearby. Even if we accept that major economic and social dislocation took place in the fifth and sixth centuries, we should always remember the continuing reminder of Roman presence that was to be found in the stone and brick buildings which they left behind them, ruinous and in decay as most of them must have become.

During this period, *c.* 450–600, the Anglo-Saxon settlers, some of whom were initially invited in as federates, slowly formed themselves into the historic kingdoms of Sussex, Wessex, Essex, and Kent. By the end of the period Kent under king Aethelberht

1. Vince takes the view that present archaeological evidence suggests that London itself may have eventually become deserted with a rebirth in the late sixth or seventh century (Vince 1990, 150–1).

6

(d. 616) became dominant not only in the south-east but over all Germanic settlers south of the Humber. The kingdoms were artificial creations, and evidence of earlier, smaller groupings is everywhere to be found. The kingdom of Kent at some stage was divided territorially into east Kent and west Kent; and the historic divisions into lathes represent very early administrative regions which may even link with the Roman past. Hastings preserved a separate identity within Sussex deep into Anglo-Saxon times. The subdivisions of Surrey disclosed in later estate structures suggest early consolidated groupings around, for example, the men of Woking or Godalming. In Berkshire the names Reading and Sonning, and in Essex the Rodings, give traces of identifiable peoples before the kingdoms were formed. There are still deep problems awaiting solution on the origins and date of Middlesex and the fate of London. Along the Hampshire coast and in the Isle of Wight the presence of people known as Jutes is incontestable. The building-blocks of which our historical kingdoms were shaped are better known thanks to the intense study of topography in recent years.[2] The implications of such study for the cultural history of the pagan period are great, and in part negative. Establishment of viable arable districts by men accustomed to working in wood rather than stone leaves little tangible trace: but pagan sites such as Tuesley or Harrow may yet yield dividends to later archaeologists.

## THE CONVERSION TO CHRISTIANITY: THE SOUTH-EAST TO THE ACCESSION OF ALFRED (871)

In 597 a new phase was opened in the history of the south-east. Pope Gregory the Great (590–604) did not succeed in converting all the pagan English, but the mission of St Augustine and his immediate successors brought the south-east firmly within the Christian fold with an archbishopric at Canterbury and bishoprics at London and Rochester. Later generations completed the task of conversion. A bishopric was set up at Dorchester on Thames in 634, an indication of the importance of the settlements on the Middle Thames as the centre of the growing authority of the

West Saxon kingdom, and then in 662 at Winchester. By the end of the seventh century all of England was nominally Christian, thanks to the efforts of missionaries drawn both from the continent and from the Celtic West. The last of the organized peoples to receive the new faith were, curiously enough, within our region, and it was not until the 680s that St Wilfrid from York brought Christianity to Sussex and opened the way to the conversion of the pagans in the Isle of Wight (Stenton 1971, 138).

Culturally the conversion was an event of maximum importance. Arts ancillary to the faith, literacy, book-production, painting, sculpture, the use of stone where available for church-building, received massive impetus from the adoption of Christianity, opening wide contact with Rome and the world of Mediterranean civilization on the one hand and the Celtic Christians of Ireland, Wales and the West on the other.

The political background of the process was complex. For much of the seventh century, certainly after the death of the pagan Penda of Mercia in 654, the Northumbrians were the dominant power. Ravaged by internal dissension and threatened on hostile borders they could not establish permanent overlordship of the English peoples but the so-called Northumbrian Renaissance, coinciding roughly with the life of the greatest scholar of the age, the Venerable Bede (672–735), spread cultural light throughout all regions, including the south-east. In the eighth century dominance passed into Mercian hands under Aethelbald (716–57) and then supremely under king Offa (757–96). Offa's impact on the south-east was great. Mercian control of London was confirmed and the subordination of southern kings and princelings in Wessex, Sussex, Surrey, Kent, and Essex, emphasized (Stenton 1971, 206–12; Dornier 1977). Mid-Saxon London (*Lundenwic*) flourished to the west of Roman *Londinium*, along the Strand around Aldwych, a companion urban settlement of similar name-type to Ipswich and to *Hamwic* (Southampton). Late in his reign, in 793, the establishment of the abbey of St Albans (in part atonement for the political murder of king Aethelberht of East Anglia), provided a permanent social and cultural focal point on Watling Street, just one day's journey north-west from London. During the period of Mercian supremacy refinement of the taxation system, the creation of a reformed silver penny as a staple coinage and involvement in large-scale enterprise, civil and military (Offa's Dyke is the outstanding example) helped to consolidate the English people south of the Humber into a more coherent community, though there was

---

2. Bassett 1989 includes essays by Nicholas Brooks on Kent, Martin Welch on Sussex, Barbara Yorke on the Jutes and the origins of Wessex, John Blair on Surrey, Keith Bailey on the Middle Saxons, and David Dumville on Essex, Middle Anglia, and the expansion of Mercia in the south-east midlands. Hawkes 1986 is also very valuable for the upper Thames region, notably Dorchester-on-Thames.

also reaction, notably in the south-east. The violence and military activity alienated the men of Kent and East Anglia. The abortive attempt to set up an archbishopric at Lichfield (*c.* 787–803) roused intense hostility at Canterbury. In the 820s political mastery passed from Mercia to West Saxon hands under king Egbert (802–38) with general support from our region. Scandinavian raiding became a sporadic menace from the later eighth century to the ominous campaign of the winter of 851 when the Danes first stayed over winter in the Isle of Thanet. In 865 the Danes began their full-scale effort to conquer the country, an effort which brought yet a new dimension to the development of English society.

## ALFRED THE GREAT AND THE LATER ANGLO-SAXON PERIOD

The reign of king Alfred (871–99), Egbert's youngest grandson, proved a momentous period in Anglo-Saxon history. By a mixture of military and diplomatic skill he stabilized a political frontier with the Danes that left the Scandinavian invaders and settlers in control of most of England north and east of Watling Street and the river Lea, and his own West Saxons in command of the south and west, including western Mercia and, after 886, London. His issue of a coinage with the London monogram symbolizes the reoccupation of the city which still had many Roman buildings standing, even if in ruins (Hobley 1986, 20). Alfred's kingship was deeply Christian, and his encouragement of learning had consequent effects on buildings and sculpture. Asser records Alfred's concern with the building and rebuilding of cities and towns, the treasures (*aedificia*) incomparably fashioned in gold and silver, the royal halls and chambers marvellously constructed of wood and stone, and the royal stone residences, moved from their old sites and splendidly rebuilt at more appropriate places by royal command (Asser 1959, 59 (chap. 76), 77 (chap. 91); Keynes and Lapidge 1983, 91, 101). His successors, Edward the Elder, Aethelstan, Edmund, and especially Edgar (959–75), followed his tradition, defeating and absorbing the Danish communities until Edgar, crowned at Bath in 973, could truly be styled king of the English. Scandinavian influence was reinforced by Danish conquest under Cnut and his sons between 1016 and 1042. The reestablishment of the old dynasty in the person of Edward the Confessor (1042–66) did not conceal its presence and it is no surprise to find, deep in English England, fine

examples of stonework in Scandinavian style, such as the Ringerike-style stones from the churchyard of St Paul's cathedral in London (Ills. 350–2) and Rochester (Ills. 147–50), or reflecting a Scandinavian mythological background, such as the splendid example from Winchester (Ill. 646). The Danish kings were converts to Christianity and the church continued to play a dominant role in social life. Alfred's Christian kingship proved a permanent example to his successors in the legal field, notably to Edgar, and then to Cnut. Ecclesiastical influence was reinforced in the second half of the tenth century by the monastic revival led and inspired by St Dunstan, abbot of Glastonbury and then archbishop of Canterbury (960–88). The vigorous Benedictine activity of the last century of Anglo-Saxon England fostered an active interest in all manner of cultural life at houses such as Abingdon and St Albans as well as at the major centres of Canterbury, London, and Winchester. Meanwhile modifications were taking place in the structure of society. Secular lordship became increasingly dependent on the possession of compact estates of calculated hidage as obligation to tax. Ecclesiastical organization retained some minsters serving a wide-spread area but also developed an increasing number of recognizable compact parishes (Blair 1988). All this was matter of moment for the future of artistic patronage and use of local craftsmen and artists, preparing the ground for the formulation of the full feudal order under the Norman conquerors.

## THE NORMAN CONQUEST

The Norman settlement of England which followed William the Conqueror's victory at Hastings in October 1066 brought innovation, but there were also strong strands of continuity with the institutions and manners of the Anglo-Saxon past. In the new Anglo-Norman world developments took place that owed as much, if not more, to Anglo-Saxon roots as to continental: indeed, even before 1066 Anglo-Saxon influence in painting and manuscript illumination was powerful within the Norman duchy (Wormald 1944, 127–45). The conqueror's dynamism is unquestioned, but in the south-east it is well to remember work already done at Westminster and Waltham to place side by side with the intense activity of the new Norman lords, lay and ecclesiastical, at Canterbury, Rochester, Winchester, or St Albans. Odo, bishop of Bayeux, half-brother of king William, became earl of Kent, an office he held until his imprisonment in

1082; and he was famous for his patronage of builders and craftsmen on both sides of the channel (Bates 1975). Men of the stamp of Lanfranc, archbishop of Canterbury, Gundulf, bishop of Rochester, or Paul of Caen (Lanfranc's nephew and abbot of St Albans), were not slow to use their newly acquired wealth. The result was the evolution of a new style in the Romanesque mould in which coherence between architecture and sculpture became a characteristic element (Zarnecki 1966, 96). To adorn constructions rather than to construct adornments may be taken as one of the principal ideals in the art of sculpture. Lesser churches multiplied, giving great opportunity to local craftsmen, and muddying scholarly attempts to distinguish late Anglo-Saxon from Anglo-Norman; there was deep overlap up to about 1120. Nowhere is this more obvious than in the south-east where the Conquest opened the way to continuous movement from Normandy and the north French coast. The student of Anglo-Saxon achievement is hard put to it if he attempts too zealously to draw the line and cry halt at 1066.

# CHAPTER III
# REGIONAL GEOLOGY
## by Bernard C. Worssam

The geology of south-east England is indicated in outline in Fig. 4. The outcrop of the Chalk, corresponding to Upper Cretaceous in Table 1, gives rise to tracts of high ground that constitute the physiographical backbone of south-east England. In the north-west are the Berkshire Downs and the Chiltern Hills, west and north-east respectively of the River Thames. Beyond the Chiltern scarp, south-easterly dipping Upper Jurassic beds form the Vale of Aylesbury and the Oxford Clay vale; farther north-

west, Middle Jurassic limestones give rise to high ground, the northerly continuation of the Cotswold Hills.

The Chiltern dip-slope declines south-eastwards into the London Basin, a downfold with Tertiary clays and sands occupying its centre. The Chalk reappears south of the London Basin as the North Downs, between which and the South Downs lies the Weald, an east-west anticlinal, or upfolded area. The Weald contains a thick development of Lower Cretaceous

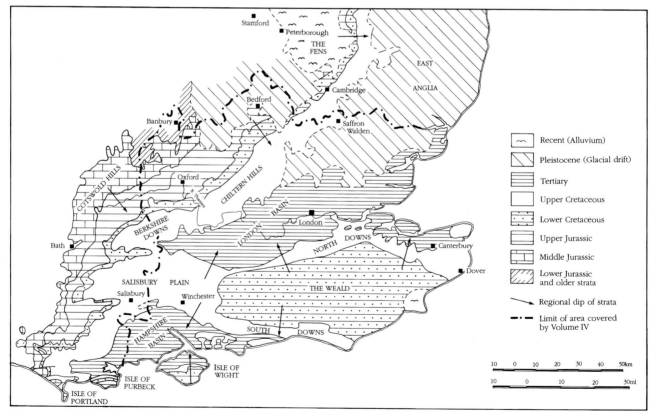

FIGURE 4
Geology

sandstones and clays, which are largely missing beneath the Chalk of the Chilterns, where the only Lower Cretaceous formation with a continuous outcrop is the Gault clay, the youngest in the sequence. The folds of the Weald continue westwards, less strongly marked, into the wide Chalk outcrop of the Salisbury Plain. To the south lies the Hampshire Basin, like the London Basin a syncline with Tertiary beds at its centre. Its southern limit is the narrow Chalk ridge, breached by marine erosion, running through the 'Isle' of Purbeck and the Isle of Wight.

In northern parts of Oxfordshire and Bedfordshire, and in northern Essex, Jurassic to Tertiary strata are covered by extensive glacial deposits, mainly Boulder Clay, laid down towards the southern limit of ice sheets that at one time or another in the Quaternary era covered much of the Midlands and East Anglia.

Table 1 shows the relation between chrono-stratigraphical divisions (as in Fig. 4), based on geological age, and lithostratigraphical divisions of Group and Formation status represented in south-east England.

## STONE TYPES USED FOR THE SCULPTURES

The various types of stone used for sculptures are described in stratigraphical order. Geological formations may, of course, contain other beds than those of building (or sculptural) stone quality: not all the Taynton Stone (or Taynton Limestone) Formation, for instance, is made up of Taynton stone (with a small 's'). The nature of the formation none the less determines the characteristics of the type of stone, both in this case and in those of other formations that contain stone types with local names (for instance Reigate stone, Quarr stone) acquired long before the advent of geological classification.

Both sandstones and limestones were brought into use, and most in each category were arenites, i.e. having sand-sized particles. Arenites lie within the total size-range 0.06–2 mm diameter. Fine-grained arenites have particles up to 0.2 mm diameter, medium-grained 0.2–0.6 mm, and coarse-grained from 0.6–2 mm. For identification, the stone of each sculpture was examined by hand lens with a built-in measuring grid, allowing the diameter of grains above 0.1 mm to be measured with confidence.

Much of the stone, at least for the earlier Anglo-Saxon sculptures in south-east England, probably came from Roman ruins. The distribution of stone types (Fig. 5) may therefore owe much to Roman building activity. The two main types of stone, both of them oolitic limestones, came from outside the area, one, Barnack stone, from the Inferior Oolite of Northamptonshire and Lincolnshire, the other, Bath stone, from the Great Oolite of the vicinity of Bath. In addition, some fifteen types of stone from localities in south-east England were used. Three varieties came from northern France: Caen stone, Marquise oolite, and Calcaire Grossier limestone. A few carvings are of stone of uncertain provenance.

## INFERIOR OOLITE GROUP, LINCOLNSHIRE LIMESTONE FORMATION (BARNACK STONE)

A number of sculptures in northern parts of Essex, Hertfordshire, and Bedfordshire, and some in and around London, are of a shelly oolitic limestone from the upper part of the Lincolnshire Limestone, i.e. from the Sleaford Member or Clipsham Member as defined by Ashton (Ashton 1980), together equivalent to the Upper Lincolnshire Limestone of current Geological Survey usage (1:50,000 Geological Map, Grantham Sheet 127). The Lincolnshire Limestone contains various types of building stone. Two of them, Ketton stone and Ancaster Freestone, are composed of compacted ooliths with little interstitial matrix; another, Ancaster Rag, is a very shelly oolite with conspicuous calcite cement. The texture of the Lincolnshire Limestone of Anglo-Saxon sculptures in the south-east lies between these two extremes. Stone of this type in Roman and Anglo-Saxon contexts is generally called Barnack stone, after the village of Barnack near Stamford, where quarries were active in Roman times and from the later part of the Anglo-Saxon period up to the fourteenth century, when the stone became worked out. The stones here described have enough features in common to suggest that they came from one sedimentary unit, and such geological evidence as exists is consonant with this having been of limited geographical extent, and sited at Barnack.

The stone of the sculptures has a rather drab, pale yellowish grey to brownish grey colour, with ooliths around 0.4 mm diameter (ranging from 0.3–0.6 mm) and worn shell detritus of 5–10 mm diameter in a crystalline calcite matrix. Among the shell debris, ostreid fragments and (at Cardington and Hadstock) fragments of spired gastropods were noted. Planar bedding is common; some stones show low-angle cross-bedding. White Notley consists of alternate planar layers of oolite (0.3 mm ooliths) and coarser shelly oolite (0.5–0.6 mm ooliths). Many of the blocks

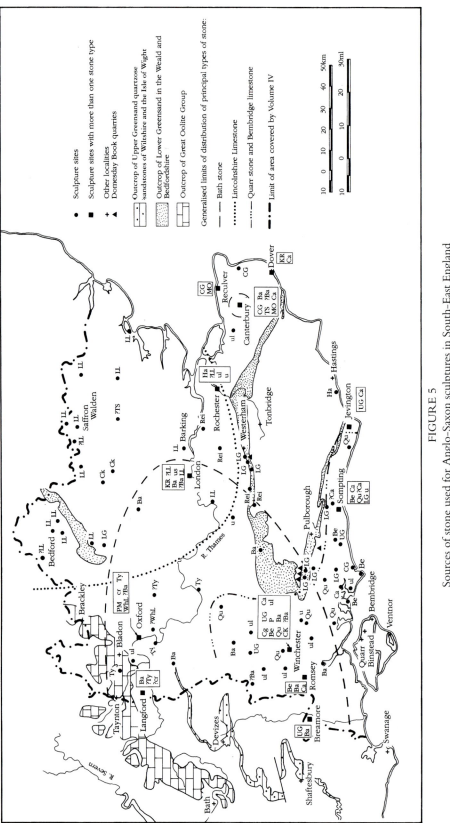

FIGURE 5

Sources of stone used for Anglo-Saxon sculptures in South-East England

Abbreviations for stone types, in alphabetical order:

| | | | | |
|---|---|---|---|---|
| Ba | Bath stone | LG | Lower Greensand other than Kentish Rag | TY | Taynton stone |
| Be | Bembridge limestone | LL | Lincolnshire Limestone | UG | Upper Greensand other than Reigate stone |
| Ca | Caen stone | MO | Marquise oolite | WhL | White Limestone |
| CG | Calcaire Grossier | P | Portland stone | ul | unidentified limestone |
| Ck | Chalk | PM | Purbeck Marble | us | unidentified sandstone |
| Cr | Corallian limestone | Qu | Quarr stone | u | unidentifiable – stone inaccessible, |
| Ha | Hastings Beds sandstone | Rei | Reigate stone (Upper Greensand) | | whitewashed, or missing |
| KR | Kentish Rag (Lower Greensand) | TS | Thanet Beds sandstone | | |

are large (89 cm in length at Cardington and 180 cm at Milton Bryan), without being more than 30 cm in thickness. Calcite veinlets, a regular feature of Bath stone, are absent.

## GREAT OOLITE GROUP, GREAT OOLITE FORMATION (BATH STONE)

Bath stone was the most commonly used stone for Anglo-Saxon sculptures in the area considered in this volume, principally at Winchester, but occurring as far east as Godalming, Surrey, and London (All Hallows by the Tower nos. 1 and 3), with isolated examples at Canterbury (St Augustine's Abbey nos. 1 and 9).

Bath stone is, like Barnack stone, a shelly oolitic limestone. It is, however, geologically younger, and accumulated in a different basin of deposition. It has generally a greyish yellow to yellow-brown colour (10YR 8/2–3), warmer than the drab yellowish grey of Barnack stone; this could result from different proportions of pyrite or other iron minerals in the matrix. Bath stone commonly has a notable content of larger ooliths (0.7 mm) than has Barnack stone, and includes conspicuous ovoid pellets up to 0.9 mm in length. In Bath as in Barnack stone, the ooliths are set in a crystalline calcite matrix. A common feature of Bath stone in particular is that weathered surfaces have a honeycomb-like appearance, being pitted by vacant hollows that once held ooliths. One of the few Bath stone sculptures with well-developed planar bedding is the large Crucifixion figure at Langford, Oxfordshire (no. 2). The main distinguishing feature of Bath stone is the presence of calcite veinlets 1–2 mm in width, cutting across the bedding, and spaced from 150–600 mm or more apart. They are known to quarrymen as 'watermarks' or 'snailcreep'.

Green and Donovan showed that the Great Oolite Formation of the Bath area includes three distinct bodies of workable Bath stone, from below upwards the Combe Down Oolite, the Bath Oolite and (in the Upper Rags division) the Ancliff Oolite (Green and Donovan 1969). The stone used for Anglo-Saxon sculpture seems to have been largely Combe Down Oolite.

The Combe Down Oolite is up to 17 metres thick at Bath and near Box, 9 km north-east of the city (Fig. 6, based on Penn and Wyatt 1979, fig. 11). The worked freestones, with commercial names Odd Down Stone, Combe Down Stone, Box Ground Stone and St Aldhelm's Stone, occur in the upper half of the Combe Down Oolite in the area where it is thickest. The Bath Oolite, which includes such

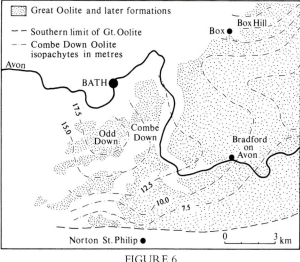

FIGURE 6
Isopachytes of the Combe Down Oolite

varieties as Bathampton, Farleigh Down, Stoke Ground, Westwood Ground and Winsley Ground stones, is less shelly, has ooliths of a smaller size-range, and is less weather-resistant than typical Combe Down Oolite. The Ancliff Oolite (Bethel Stone, Bradford Ground Stone), invariably contains layers of shell debris and of worn polyzoan fragments (Green and Donovan 1969, 19, 21); the sundial at Hannington, Hampshire, is of this character.

## GREAT OOLITE GROUP, TAYNTON STONE (OR TAYNTON LIMESTONE) FORMATION (TAYNTON STONE)

The Taynton Stone Formation is composed largely of shelly oolitic limestones, quarried in the valley of the river Windrush, a tributary of the upper Thames (Worssam and Bisson 1961). Slightly different varieties of the building stone, such as Burford stone and Windrush stone, were named after the particular locality where quarried, but all have the same geological character. Sellwood and McKerrow have described the formation as made up of underwater-dune deposits of a shallow open-shelf sea (Sellwood and McKerrow 1974).

Quarries at Taynton are mentioned in Domesday Book. If the exterior stonework of Taynton church (fourteenth century) can be taken as typical of Taynton stone, then this is a yellowish cross-bedded oolite, with shell fragments tending to be concentrated in calcite-cemented streaks that stand out on weathered surfaces as ribs or 'bars' (Arkell 1947, 77).

The grain size for the most part is variable, with ooliths from 0.2 up to 0.6 mm. 'Watermarks' are rare: about one per cent of the stones on the church exterior show them.

Sculptures from Abingdon and Sonning in Berkshire, and from Oxfordshire at Langford (no. 1), Oxford (St Michael 2), and Lewknor, as well as baluster shafts in the church towers at North Leigh and St Michael in Oxford (no. 1), are of Taynton stone; they are in or near the Thames valley at locations reasonably accessible from the Taynton quarries.

GREAT OOLITE GROUP, WHITE LIMESTONE FORMATION

In Oxford, St Aldates 1 is of oolitic limestone with light yellowish ooliths of 0.3–0.4 mm diameter, close-set in a pale grey fine-grained matrix. Many of the ooliths project on a fractured surface of the stone, giving the rock a 'millet-seed' appearance. Fossils comprise an ostreid fragment and a number of small fragments of fossil wood. Though unusual in oolitic limestones, fossil wood does occur in oolites in the Forest Marble and White Limestone formations north of Oxford, deposited close to contemporary shorelines. The carving could well be of Bladon stone, a White Limestone oolite (Sumbler 1984), used for Oxford buildings since at least the fourteenth century (Arkell 1947).

The sundial from Marsh Baldon, Oxfordshire, is also of oolite of 'millet-seed' type, which may be from Bladon or elsewhere on the White Limestone outcrop near Oxford.

BATHONIAN, CALCAIRE DE CAEN FORMATION (CAEN STONE)

The Calcaire de Caen is of the same age (Bathonian) as the Combe Down Oolite, Taynton Stone and White Limestone, but is of different facies from any of them. Caen stone, familiar from its large-scale usage in Norman buildings, is a fine-grained, soft, yellowish (2.5Y 8/2) and more rarely whitish limestone. It is not oolitic, and its particles are barely resolvable under the hand lens. Its fineness of grain and poorly developed bedding indicate sheltered, perhaps lagoonal, conditions of deposition. Weathered surfaces of the stone may be pitted by small hollows of 10–20 mm diameter. Cavernous weathering of this type is commonly attributed to the activity of burrowing organisms in the sediment before lithification. According to Rioult, the Calcaire de Caen in the Caen vicinity has a thickness around 35 m, of which the lower 12 metres or so is marly and is not exposed in the quarries (Rioult 1962).

Mr R. W. Sanderson, of the Natural History Museum, described a thin section, seen under a microscope, of a small cored sample from a frieze or blind-arcade fragment in Sompting church (no. 9), as follows (*in litt.*, November 1989):

The stone is a fine-grained pelletal limestone. Small foraminifera are relatively abundant. Micritic fecal pellets, ovoid in shape and between 0.06–0.15 mm in length, are embedded in a patchy micritic paste of less dense appearance, together with abundant small shell fragments. Some irregular sparry grains of calcite enclose echinoid fragments in optical continuity. The stone compares well with that in a sequence of thin sections taken at 25 cm intervals through the La Maladrerie Quarry section, Caen, though bedding is more distinct in the Sompting stone than in that of the Caen quarry.

Caen stone was used for one architectural feature at Winchester (an undecorated circular window (WS 198) not included in the present volume), and for a small Crucifixion panel at Romsey (no. 2). It is elsewhere represented along the south coast at Bosham, Sompting (where it is much in evidence), Botolphs, Jevington, and Dover (St Mary in Castro 1).

BATHONIAN, OOLITHE DE MARQUISE FORMATION (MARQUISE STONE)

The importation of Marquise stone, from near Boulogne, into east Kent both by the Romans and in the early Norman period has only recently come to light (Worssam and Tatton-Brown 1990; Tatton-Brown 1990). Anglo-Saxon sculptures in this stone are the Reculver columns (no. 4), Canterbury St Martin 1, and baluster shafts from St Augustine's abbey, Canterbury (nos. 6 and 7).

The Reculver columns consist of a pale grey oolite of 'millet-seed' type, formed of close-packed grains (which may be pseudo-ooliths) of 0.2–0.5 mm diameter. Two varieties of the stone are seen in the columns: one is characterised by scattered, very coarse oncoliths (i.e. aggregates of ooliths enclosed in a thin outer coating), 2 mm in diameter; the other is a more even-grained oolite, without oncoliths. The St Martin's church inscription is on stone of the latter type.

The main outcrop of the Oolithe de Marquise measures only 10 km or so along the strike (Fig. 7). The formation has lithological points of resemblance

FIGURE 7

Sources of stone in east Kent and northern France used for Anglo-Saxon sculptures

to the White Limestone which, in the writer's opinion, could well pass laterally into it.

### ANCHOLME GROUP, CORALLIAN BEDS

In the neighbourhood of Oxford the Corallian Formation includes the hard Coral Rag, used for rubble walling, and the Wheatley and Headington freestones, both of which are reef-apron deposits, composed of irregularly-sized sub-rounded detritus rather than of ooliths. Wheatley stone is recorded as having been used in Oxford from 1290 onwards, while Headington stone was brought in only after the end of the fourteenth century (Arkell 1947).

The tower of St Michael's church, Oxford, has Coral Rag walling, but some of its quoin stones are of a fine-grained limestone with conspicuous oyster-like shells, and are perhaps Wheatley stone with *Exogyra nana*, as recorded by Arkell in the front quadrangle of New College (Arkell 1947). One of the tower windows, that on its east side at the second stage, has a baluster shaft of similar shelly limestone.

There seems no warrant for Jope's identifications of carved stones in London (at All Hallows and Stepney)

as Wheatley stone (Jope 1965, 109), for both are of oolitic limestone.

## PORTLAND GROUP, PORTLAND LIMESTONE FORMATION (PORTLAND STONE)

Portland stone, a near-white (5Y 8/1) oolite, quarried principally on the Isle of Portland, and the most widely used building stone of southern England from the seventeenth century onwards, is represented by only four small pieces of Anglo-Saxon carving. These, Winchester Old Minster nos. 38, 41, 42 and 74, are even-grained, with ooliths of 0.3–0.4 mm diameter, closely packed but with numerous interstitial voids—a texture quite different from that of Bath stone. Shell fragments are sparse.

## PURBECK GROUP, DURLSTON FORMATION (PURBECK MARBLE)

The Purbeck Group comprises the Lulworth Formation, below, and the Durlston Formation, above. The Jurassic–Cretaceous boundary is at or near the boundary between the two formations. Purbeck Marble occurs near the top of the Durlston Formation, in the Isle of Purbeck (Melville and Freshney 1982, 62).

The 'marble', so much a feature of thirteenth-century English churches, was used for only two extant Anglo-Saxon sculptures in south-east England. One, a large grave-cover from the cathedral in Oxford, is of typical lithology, composed of small gastropod shells of the genus *Viviparus*, closely packed in a fine-grained matrix. The stone is 'blue-hearted', with pale greyish-brown top and bottom surfaces, these being more weathered. The other sculpture, a small fragment of carved drapery from Winchester Old Minster (no. 85), is of a rather unusual Purbeck Marble lithology, being composed of broken shell fragments, apparently mostly of bivalves.

## WEALDEN GROUP, HASTINGS BEDS DIVISION

The Wealden Group is a thick sequence of fresh- to brackish-water clays and sands. Its lower part, the Hastings Beds, occupies the central part of the Weald, and comprises three formations, from below upwards the Ashdown Beds, the Wadhurst Clay and the Tunbridge Wells Sand. Fine-grained yellow-brown Hastings Beds sandstone was used for sculptures at Bexhill, Sussex, and Rochester, Kent.

The Bexhill stone is composed of quartz grains of 0.1–0.2 mm diameter, in 1–2 mm laminae that show small-scale trough cross-bedding. The cross-cutting relationships of the bedding incidentally show that the stone, as carved, is geologically right-way up. Stone of this type could be matched in the Ashdown Beds or the Cliff End Sandstone (Wadhurst Clay Formation). Both crop out in the Hastings vicinity, and large blocks of sandstone litter the foreshore below sea cliffs in which the beds are exposed.

The grave-marker Rochester 3 is of very evenly graded fine-grained sandstone, with the rather friable 'sandrock' texture typical of Hastings Beds sandstones. The nearest outcrops of stone of this type are in the Medway valley upstream from Tonbridge. Alternatively the stone could have been shipped from Hastings.

## LOWER GREENSAND GROUP, HYTHE BEDS FORMATION (KENTISH RAG)

Both Lower Greensand and Upper Greensand are characterised by the occurrence of grains of the green mineral glauconite; it indicates marine conditions of deposition. Kentish Rag, a sandy limestone occurring in the Hythe Beds in Kent, was used for the grave-cover from Dover St Peter, Kent, and for the cross-head from St John Walbrook, London.

The Dover cover is of dark grey glauconitic sandy limestone, with some well-rounded quartz grains of 2 mm diameter and glauconite grains up to 1 mm across. The back surface of the stone is not dressed, and shows a nautiloid cast 80 mm in diameter and a number of 10 mm-wide infilled burrows. Limestones of this type occur in the upper part of the Hythe Beds between Sellindge and Hythe (Fig. 7; Smart *et al.* 1966).

The St John Walbrook, London, cross-head is of a much finer-grained stone. Some dark grey inclusions of about 10 mm diameter suggest the phosphatic nodules that occur in some ragstone beds of the Maidstone area, whence ragstone was shipped into London in large quantities in Roman and medieval times.

## LOWER GREENSAND GROUP, HYTHE BEDS SANDSTONES OF SURREY AND SUSSEX

Westward of Westerham, the Kentish Rag facies of the Hythe Beds is replaced by one of sands with beds of non-calcareous sandstone. The sandstone has been worked for building stone between Westerham and Limpsfield, and on the south side of the Weald

between Petersfield and Pulborough. Four of the seven quarry localities in England recorded in the Domesday Book were on this sandstone. They were Limpsfield (two quarries), and, on the south side of the Weald, Grittenham, Iping, and Stedham (Darby 1977).

Grave-covers at Titsey, Oxted and Tandridge, in Surrey, are of a pale olive (5Y 6/3) to greenish brown sandstone, with quartz grains of 0.3 mm diameter, very fine (0.1 mm) glauconite grains, and some moulds of sponge spicules. The large size of these covers is noteworthy. Stone with a texture closely matching this was mined in the nineteenth century at Hosey Common, south of Westerham (Dines *et al.* 1969, 68).

Hythe Beds sandstone in west Sussex has been given various local names, of which Pulborough stone is one. It is, however, uncertain whether the stone differs markedly from one locality to another, and no particular local name seems appropriate for the stones described here. Grave-covers at Chithurst, Stedham, and Cocking in Sussex, are of pale yellow (5Y 8/2 to 2.5Y 8/4) stone of a similar grain size to that in Surrey. A cored sample from the Cocking cover includes moulds of sponge spicules. Some of the Chithurst and Stedham covers display round cavities of 10–20 mm diameter with a 2 mm-thick, hard limonitic lining. So does sandstone used for the nineteenth-century south porch of Stedham church, which points to a common source.

The capitals of mid-wall shafts of the two north belfry windows of Sompting church, Sussex (nos. 20–1) are of similar stone to that of these grave-covers. They have been in part repaired with a closely matching sandstone, identified by Dr Martyn Owen (in Aldsworth and Harris 1988, 117) as Pulborough stone.

The two grave-covers at Steyning, Sussex, are of a slightly finer-grained sandstone (0.2–0.3 mm quartz grains). A cored specimen of no. 2 is pale yellow (2.5Y 8/2) speckled dark green, shows sponge-spicule moulds, and is quite similar to stone marketed (in 1988) as Midhurst stone, from James's Quarry (Thurrell *et al.* 1968, p.77), about 3 km north of Midhurst. The carved window-head at Tangmere, Sussex, is of stone with a similar texture but an overall olive-grey colour.

## LOWER GREENSAND GROUP, WOBURN SANDS FORMATION

North of London the Lower Greensand is represented by the Woburn Sands, loose yellow sands with impersistent layers of ferruginous sandstone,

known locally as carstone. The cross-shaft in Stanbridge churchyard, Bedfordshire, is of hard, dark reddish brown sandstone with sub-angular to well-rounded quartz grains of 0.5–0.9 mm diameter and sub-angular 0.3–0.4 mm opaque grains, close-packed in a dark brown limonitic cement. In all probability it came from this formation. Similar (though finer-grained) sandstone was used in the fifteenth century for the tower and clerestory of the church.

## GAULT GROUP, UPPER GREENSAND FORMATION (REIGATE STONE)

The Upper Greensand of the Reigate vicinity provided great quantities of building stone for London and its surrounding area from the eleventh century onwards. Anglo-Saxon sculptures of this stone are found at Betchworth and Reigate in Surrey, and at Orpington and Dartford in Kent. The stone is a fine-grained sandstone, pale grey with a slight greenish tinge (5Y 7.5/1), and is composed of 0.1–0.2 mm granules which seem to be of authigenic (i.e. grown in-situ) silica rather than of detrital quartz. It is dusted with very fine (0.1 mm) glauconite, and commonly contains scattered mica flakes. All the more important workings for building stone seem to have been along a fifteen-kilometre stretch of the outcrop between Brockham, 5 km west of Reigate, and Godstone, to the east (Sowan 1976). Names such as Gatton stone and Merstham stone, ostensibly reflecting the source of the stone, have been used, but the stone from all localities is geologically indistinguishable, and the single name Reigate stone is now generally favoured.

## GAULT GROUP, UPPER GREENSAND OTHER THAN REIGATE STONE

A decorative fragment at Ford, Sussex, is of stone which, though closely similar to that described as from Reigate, could be 'malm rock' (Jukes-Browne 1900, 116) from the Sussex outcrop of the Upper Greensand. The Domesday Book recorded a quarry (for millstones) at Bignor, on the Upper Greensand not far from Ford (Darby 1977).

At outcrop on the coast at Eastbourne the Upper Greensand formation, some 10 metres thick, consists of sandstone that differs from Reigate stone in being composed of distinct quartz grains (0.2 mm diameter) and in containing more glauconite, giving it a greenish-grey colour. The baluster shafts of the belfry windows of Jevington church tower (no. 2) were fashioned from this stone, and some large blocks of it

are included in the mainly flint-rubble walling of the tower.

Reid stated that the stone 'was formerly taken from the reefs between tide-marks, and used for building-purposes' (Reid 1898, 14). Indeed, much if not all of the Eastbourne stone used for building, from Roman times (for Pevensey Castle) onwards until the nineteenth century, must have come from the foreshore, for the outcrop extends only for 2 km or so inland from the coast, concealed throughout beneath Drift deposits.

A similar type of Upper Greensand to that at Jevington is represented in Hampshire at Whitchurch and Winchester (Prior's Barton 1). An inlier at Kingsclere is perhaps a possible source for the stone at Whitchurch. At Breamore, the inscribed voussoirs of the south porticus arch (no. 2c) are, according to Tim Tatton-Brown (pers. comm., 1994), of Hurdcot stone, a sandstone from an Upper Greensand outcrop at the east end of the Vale of Wardour, about 20 km north-west of Breamore, which was in use as a building stone before Chilmark stone began to be exploited for that purpose.

## CHALK GROUP

At Winchester a carved block (Old Minster 64) of fine-grained grey limestone, of less than 0.1 mm grain size, apparently slightly silty and not glauconitic, may well be of Lower Chalk. There is a small inlier of Lower Chalk on the east side of the Itchen valley at Chilcombe, just east of Winchester. Other outcrops of it lie 20 km or more from the city.

At Walkern, Hertfordshire, a Crucifixion figure (no. 1) on the wall above the south nave arcade, though mounted too high for close examination, appears to be of white chalk. It may have been whitewashed. Walkern is on the Chalk outcrop, and the source of the chalk used for the sculpture need not have been distant. A limewashed or emulsion-painted impost at Walkern (no. 2) may also be of chalk, like that at Little Munden in Hertfordshire.

## THANET BEDS FORMATION

From Roman times onwards much use was made of a fine-grained, light grey (5Y 7/1) calcareous sandstone from the Thanet Beds for rubble walling in east Kent. At St Augustine's abbey, Canterbury (in early Norman walls), many blocks of it have holes bored by, and containing the shells of, Recent bivalve molluscs (Tatton-Brown 1991, 86). These blocks

must therefore have been collected from the foreshore below one of the two cliff sections where the sandstone crops out: between Herne Bay and Reculver; and at Pegwell Bay on the south side of the Isle of Thanet. The stone is poorly exposed inland, and in all likelihood most if not all of that used in building came from one or other of its foreshore localities.

Two sculptures in this stone are from Canterbury St Augustine's abbey. They are a grave-cover (no. 2) and a small carved stone (no. 10). The grave-cover, 102 cm long, 43 cm wide and 15 cm thick, is of pale greyish-brown sandstone composed of well-rounded 0.1–0.2 mm quartz grains, with numerous black glauconite grains of 0.1 mm diameter. The carved stone has slightly coarser quartz grains (0.2 mm, with some up to 0.3 mm); it shows traces of sponge spicules and a fine-grained, bluish-grey inclusion which may be of chert.

A third sculpture which may be of Thanet Beds sandstone is the grave-cover at Great Canfield church, Essex, reused as the south impost of the chancel arch. Its dimensions are close to those of the St Augustine's abbey cover. It contains quartz in well-rounded 0.2–0.3 mm grains and glauconite in grains mostly of 0.2 mm but some 0.1 mm in diameter. The edge of the cover shows glauconite grains concentrated along planes of small-scale cross-bedding. They also surround burrows, oval in cross-section owing probably to compaction of the sediment, 14–18 mm in width, and infilled with clear quartz grains. Similar-sized burrow casts are displayed by some sandstone blocks on the foreshore west of Reculver.

## CALCAIRE GROSSIER FORMATION

The clays and sands of the Bracklesham Group in England are represented in the Paris Basin by a thick near-white (10YR 8/2) foraminiferal limestone, the Calcaire Grossier, quarried and mined for building stone since Roman times. Calcaire Grossier was identified by Dr L. R. Cox (in Peers 1927b) as the stone of the lost cross-head from Reculver (no. 3). It was next identified as a sculptural stone in this country by Mr Dennis Curry, who reported as follows on the Anglo-Saxon cross-head fragment in Pagham church, Sussex:

The rock is a soft biocalcarenite, with a small proportion, (possibly 10%) of fine angular quartz sand. It has suffered notable diagenesis: it was originally rich in organic fragments, especially foraminiferids, most of which are now unidentifiable. The matrix was examined for nannoplankton

but without success, owing no doubt to the diagenesis. The rock contains numerous tubes of the unattached Serpulid worm *Ditrupa*, no doubt *strangulata* (Deshayes). Aragonitic fossils have lost their shells, but the following can be identified from moulds: *Venericardia*, *Pitar* or *Callista*, *Mesalia*, and a cerithiid. Amongst the foraminifera are; *Orbitolites* (no doubt *complanatus* Lamarck), miliolids (*Miliola saxorum* d'Orbigny?), and species of *Cibicides*, *Hanzawaia*, *Reussella*, *Bulimina,* and *Rotalia*? In north-west Europe *Orbitolites* only occurs in the Lutetian, including Paris Basin zones III and IV of Abrard (Middle Lutetian of Pomerol) and Hampshire Basin, Upper Bracklesham Beds . . . White or buff limestones occur in the Eocene of the Paris Basin, where they are known as Calcaire Grossier. They are also present near Arthon and Valognes, and sporadically in Belgium. Only those of the Paris Basin are regularly worked for building stone. *Ditrupa* occurs at levels throughout the north-west European Eocene, but very sporadically. I only know of one limestone level where it is both common and widespread. This is Zone III of Abrard: 'La Zone III est le plus souvent très riche en *Ditrupa strangulata* (Deshayes), ce qui lui a fait donner le nom de "calcaire à Ditrupes" (Abrard 1925, 370)'. All the fossils here recorded are consistent with an ascription to the Middle Lutetian of Pomerol, and the lithology also matches well (Pomerol 1973). I therefore think the limestone must be 'mid-Lutetian', and that it came from the northern part of the Paris Basin, very probably from somewhere between Creil and Laon. None of the other areas here mentioned give a good lithological match, nor is *Ditrupa* conspicuous in any of them.' (Dennis Curry, *in litt.*, January 1988).

The shaft fragments from Reculver, Kent (no. 1) are also of *Ditrupa* limestone, and these too have proved to be of Calcaire Grossier, of a bed known to quarrymen in the Oise valley as the Banc de St Leu (Worssam and Tatton-Brown 1990). Other east Kent sculptures in the same limestone are two grave-markers from Sandwich, one with a runic inscription, three composite capitals from St Augustine's abbey, Canterbury (nos. 3–5), and a column (Blagg 1981) in the church of St Pancras, Canterbury.

The stone for the Pagham cross-head may have come from the ruins of the first-century Fishbourne palace (Worssam and Tatton-Brown 1990), as also, possibly, did blocks of *Ditrupa* limestone built into the late Anglo-Saxon tower of Bosham church, Sussex (Aldsworth 1990).

Two Winchester column fragments are of Calcaire Grossier. One of them, Old Minster 12, is a *Ditrupa* limestone of Banc de St Leu type, with *Orbitolites*. The other, Old Minster 19, has small cavities that are the external moulds of cerithiid gastropods. *Cerithium*, adapted to flourish in conditions of variable salinity, is characteristic of the upper part of the Calcaire Grossier

formation (Blondeau *et al.* 1980). Limestone of this type could have come from the upper levels of a quarry working the *Ditrupa* limestone.

## SOLENT AND BEMBRIDGE FORMATIONS (HEADON HILL LIMESTONE, BEMBRIDGE LIMESTONE AND QUARR STONE)

The Bembridge Formation (Melville and Freshney 1982, 108) is restricted to the Isle of Wight, and comprises the Bembridge Limestone, below, and the Bembridge Marls, above. The Bembridge Limestone, 5.5 metres thick in the west of the island and 8 metres thick in the east, contains massive beds of fine-grained limestone that include freshwater gastropods and moulds of nucules of the water plant *Chara*. The latter are calcite-lined hollow spheres of about 1–2 mm diameter; under the hand-lens their walls show a spiral ornament.

Quarr stone represents a local facies of the Bembridge Limestone, formed from closely packed gastropod shell fragments. Anderson and Quirk suggested that the stone originated as a roughly elliptical bank of shell detritus at an early stage in deposition of the Bembridge Formation (Anderson and Quirk 1964). The stone was quarried at Quarr, in the north-east of the island, from Roman times until becoming virtually exhausted by the beginning of the fourteenth century. Quarr stone is easy to recognise. It is pale grey (10YR 7/1) to yellowish (2.5Y 8/2). Initially a felted mass of small arcuate shell fragments, around 3–5 mm long and 0.2 mm thick, these have been dissolved out to leave arcuate voids in a matrix of crystalline calcite. A lithology transitional to the fine-grained type of Bembridge limestone can occur, in which the shell fragments, distributed in clusters, themselves occur as crystalline calcite. The sundial from Bishopstone, Sussex is considered to be an example of this.

Anderson and Quirk proposed the names Binstead Stone and Quarr Stone for the normal and detrital-shelly parts of the Bembridge Limestone respectively (Anderson and Quirk 1964). Neither term has been taken up by subsequent geological authors. The name Bembridge limestone (with a small 'l') is used here to indicate fine-grained limestone from the Bembridge Formation, irrespective of where on the outcrop it may have been quarried.

Bembridge limestone, so defined, was used for a grave-cover from the excavations at Winchester Old Minster (no. 6) and its associated foot-stone (no. 2). The most easterly Anglo-Saxon occurrence of the

limestone is a grave-marker from Arundel, Sussex. It is almost completely lichen-covered, but has closely-spaced 1 mm-diameter perforations, which are taken to be *Chara* nucule moulds. Some Bembridge limestone blocks, for instance the cross-base from South Hayling, Hampshire, show irregular small solution-cavities, which may have been initiated at the hollow moulds of gastropod shells.

Two fragments from Selsey (nos. 2 and 3), are of typical Bembridge limestone appearance, containing *Chara* nucules and moulds of smooth-shelled gastropods; nos. 1 and 4 from that site are of fine- to medium-grained pelletal limestone with fine shell detritus. Mr D. Curry, on examining the Selsey fragments, mentioned the possibility (personal communication, 1988) that these (and, presumably, others among the carvings classed as Bembridge limestone) could be from the Headon Hill Limestone in the western part of the Isle of Wight, a 4.3 metre bed at a lower horizon (Solent Formation) than the Bembridge Formation, but which also includes *Chara* nucules.

STONES OF UNCERTAIN PROVENANCE

In Hampshire, three limestone sculptures, those at Steventon, Wherwell, and Bishop's Waltham, are planar-bedded shell-detrital oolites, with ooliths around 0.3 mm in diameter. Though from 70–100 cm long, none of the blocks show the calcite veinlets that normally serve to indicate Bath stone. The carvings from Winchester Upper Brook Street and High Street are coarser-grained, with 0.4–0.5 mm ooliths.

A carving from the Old Minster at Winchester (no. 5) is of greyish-yellow oolitic limestone with fine-grained (0.2 mm) ooliths in a calcite matrix which also includes unevenly scattered larger ooliths or ovoid pellets, mostly of 0.5–0.8 mm diameter. There are occasional whole fossil shells, notably a hollow bivalve or brachiopod cast with calcite lining. The stone is probably from the Great Oolite Group of the Bath-Cotswolds region.

At Langford, Oxfordshire, the sundial high up on the south face of the church tower (no. 3) appears to be of limestone, with signs of cavernous weathering and of shells that may be ostreids. If they are, this might possibly be a Corallian limestone from near Oxford; a Cotswold Inferior Oolite source is perhaps less likely.

At West Wittering, Sussex, a small triangular stone with inscribed crosses appears to be of 'millet-seed' oolite, but is far from any Jurassic outcrop and has no obvious source.

A fragment from Rochester, Kent (no. 1) is of pale brownish yellow, slightly shelly oolitic limestone, unevenly graded, with a few 1 mm pale orange limonitic grains and some sub-rounded 1 to 2 mm pellets or oncoliths. It resembles to some extent the stone of a slab from St Augustine's abbey, Canterbury (no. 9), which also includes limonitic pellets and may be an 'ironshot' variety of Bath stone.

Carved fragments at Little Somborne, Hampshire, are of a porous limestone, of which little can be seen beneath their limewash coating. The stone, if not Bembridge limestone, may possibly be a geologically Recent calcareous tufa, extensive deposits of which occur in the flood plain of the River Test near Stockbridge, only 3 km north-west of Little Somborne (White 1912).

Two carvings from London, a cross-head fragment (All Hallows 2), and a grave-cover (City 1), are of pale grey to brownish, even-grained, fine, porous sandstone of 0.1–0.2 mm quartz grains, with a few dark grains which may or may not be of glauconite. The grain size is that of Hastings Beds sandstones, and it is difficult to suggest any other source of such large blocks reasonably close to London.

TABLE 1. Stratigraphical divisions in southern England and northern France

NOTE: Broken lines indicate gaps in the geological record; asterisks mark lithostratigraphical units that yielded stone for Anglo-Saxon sculptures.

| ERA | PERIOD | LITHOSTRATIGRAPHICAL UNITS IN SOUTH-EAST ENGLAND | SOME FORMATIONS IN NORTH FRANCE |
|---|---|---|---|
| QUATERNARY | RECENT | 'Drift' deposits (★?) | |
| | PLEISTOCENE | 'Drift' deposits | |
| | | ------------- | |
| TERTIARY | PALAEOGENE | Hamstead Formation | |
| | | Bembridge Formation★ | |
| | | Solent Formation(★?) | |
| | | Barton Formation | |
| | | Bracklesham Group | Calcaire Grossier★ |
| | | London Clay | |
| | | Reading Beds | |
| | | Thanet Beds★ | |
| | | ----------- | |
| MESOZOIC | UPPER CRETACEOUS | Chalk Group★ | |
| | LOWER CRETACEOUS | Gault Group | |
| | |     Upper Greensand★ | |
| | |     Gault | |
| | | Lower Greensand Group★ | |
| | | Wealden Group★ | |
| | | Purbeck Group | |
| | |     Durlston Formation★ | |
| | UPPER JURASSIC |     Lulworth Formation | |
| | | Portland Group★ | |
| | | Ancholme Group | |
| | |     Kimmeridge Clay | |
| | |     Corallian Beds★ | |
| | |     Oxford Clay | |
| | |     Kellaways Beds | |
| | MIDDLE JURASSIC | Great Oolite Group★ | Oolithe de Marquise★ |
| | | | Calcaire de Caen★ |
| | | Inferior Oolite Group★ | |
| | LOWER JURASSIC | Lias Group | |

# CHAPTER IV

# CLASSIFICATION OF FORMS

## by D. Tweddle

As an aid to the discussion below, and as a summary of information in the Catalogue, a Form and Motif Table can be found on pp. 345ff.

### GRAVE-MARKERS AND GRAVE-COVERS
(Cramp 1991, pp. xiv, xxi, and figs. 4–7)

The earliest memorial sculptures from the region are probably the two stones from Sandwich, Kent (Ills. 151–7). Each is of square section with a flat upper end, and tapering towards the lower end. It is evident that the roughly dressed tapering bases were inserted into the ground and the upper ends left exposed; one is panelled on two faces and the other has a runic inscription. This division between a roughly dressed base and a decorated upper portion is precisely the pattern encountered among the later, tenth- and eleventh-century, grave-markers discussed below. In addition the runic inscription has been read as a personal name, again suggesting a memorial function, although the alternative reading proposed below, pp. 169–70, completely revises this interpretation. Both the absence of Christian symbolism and the archaic features exhibited by the runic inscription suggest an early, perhaps seventh-century, date for these pieces; they are certainly of a form without close parallels.

Accepting an early date for the Sandwich pieces there is a long gap before grave-markers occur again and grave-covers appear for the first time. Chronologically, the next grave-marker is that from Whitchurch, Hampshire (Ills. 481–9), for which a ninth-century date can be argued. This represents a new type in southern England, having parallel sides and a semicircular head (Cramp 1991, fig. 4bii). In this case the thickness of the stone suggests that it was not sunk into the ground, but stood on the ground surface. The Whitchurch grave-marker is the sole ninth-century example of this type from south-east England,

but in the tenth, and more particularly the eleventh, centuries the semicircular-headed type persisted in use; examples occur at Stedham, Sussex, where there were three (nos. 7 (Ills. 243–4), 10 (Ill. 246), and 11 (Ill. 248)), Rochester 3, Kent (Ills. 147–50), and perhaps also at White Notley, Essex (Ill. 375), though the shape of the latter may not be original. The markers from Stedham, Rochester, and White Notley are all much thinner and more slab-like than the Whitchurch example, and their lower ends must have been inserted into the ground. Decoration is also usually much simpler, consisting of a low relief or incised cross on one or both broad faces. This is in contrast to the elaborate figure sculpture on face A of Whitchurch, combined with plant-scroll on face C and an inscription on the edge. Among the late semicircular-headed grave-markers only Rochester 3 has similar elaborate decoration, with part of a cross on face C, animal ornament on face A, and an inscription on the edge, as at Whitchurch.

In addition to the semicircular-headed markers at Stedham, Sussex, there was apparently a single parallel-sided, square-headed example (no. 9; Ill. 247; Cramp 1991, fig. 4biii). This was decorated with a plain relief cross on face A. Of the same general type, if much more elaborately decorated, is the Ringerike-style stone from St Paul's, London (Ills. 351–2). This has often been described as the end of a box tomb or sarcophagus, but contemporary accounts of the discovery suggest that it was discovered *in situ* at the head of a grave with no other associated sculpture. In addition there was a lower, undecorated, part of the stone which was subsequently cut away and discarded. In all respects, therefore, the piece when discovered resembled other grave-markers except only in the quality and elaboration of the decoration.

A third form of marker, in the form of a small circular cross-head with square-ended, splayed arms (type E8), is represented at Winchester Old Minster

95 (Ills. 717–18). The similar heads from South Leigh, Oxfordshire (Ill. 406), Pagham, Sussex (Ills. 98–100), and St John Walbrook, London (Ills. 347–9) may have come from comparable grave-markers but equally could have come from small standing crosses and are, therefore, discussed with the other cross-heads (below, p. 24).

The pieces from Rochester, Kent (no. 2), Great Canfield, Essex, and London (All Hallows 3) are also probably parts of grave-markers but are too fragmentary to be classified.

Excavations at a number of sites, notably the Old Minster, Winchester (see below, Chap. VIII; Biddle 1966a, 325, pl. LXI), Raunds, Northamptonshire, and Wharram Percy, Yorks (Beresford and Hurst 1976, 133–4, pl. II.13), have demonstrated the use of grave-markers in association with grave-covers. However, in south-east England there are more than three times as many covers than markers. Either this is an accident of survival or covers were also used separately from markers.

The grave-covers from south-east England are all of tenth- or eleventh-century date, and fall into four basic shapes. The overwhelming majority have squared ends and taper towards the foot: Arundel, Chithurst, Cocking, Stedham 2, 4–6, and Steyning 2 in Sussex; Canterbury St Augustine's 2 and Dover St Mary in Castro 1, Kent; London, St Benet Fink; Cardington and Milton Bryan, Bedfordshire; Oxford, cathedral; Titsey 1–3 and 5, Surrey; Weyhill, Hampshire; and probably Great Maplestead, Essex. At Oxted, Surrey (Ills. 235–6) and probably at Stedham, Sussex (no. 9; Ill. 247), there are covers with square ends and no taper (Cramp 1991, fig. 4a) and at Steyning an example with squared ends which tapers towards both the head and foot (no. 1; Ill. 249). From Dover (St Peter) in Kent is a cover with rounded ends which also tapers towards the foot (Ill. 77).

A few covers have more three-dimensional forms. The covers from Tandridge, Surrey (Ill. 231) and Headbourne Worthy, Hampshire (no. 2; Ills. 684–5) are coped (Cramp 1991, fig. 4g), as is an example from Winchester (Old Minster 6; Ills. 509–10, 521). That from Bexhill, Sussex, takes the form of a truncated pyramid on a rectangular base (Ill. 10). One of the Steyning covers (no. 2) is almost square in section and a fragment from St Maurice, Winchester (no. 1; Fig. 42) must also have been nearly square in section, but longitudinally convex on the upper face, not flat as at Steyning. A grave-cover from London (City 1) has a transversely convex upper face.

One very specialised form of cover is represented by the coffin lid from Westminster abbey (Ills. 355–7). This was made to fit a reused Roman coffin, but both the decoration on the upper face and contemporary drawings of its excavation suggest that the lid was left exposed. When in use, therefore, there would have been no apparent distinction between this coffin lid, and the other covers which simply lay on the ground surface over the grave.

## FREE-STANDING CROSSES (Cramp 1991, p. xiv, and figs. 1–3)

### CROSS-SHAFTS

There are 25 standing cross-shaft fragments from south-east England falling into two main types, angular shafts (those of square or rectangular section), and round shafts (those of circular section).

Fifteen of the cross-shaft fragments are of the angular type, one which was introduced to the south-east of England in the mid eighth century and which, apparently, always remained the predominant type. It occurs at Barking 1 and Saffron Walden, Essex, Bedford and Elstow, Bedfordshire, Kingston upon Thames, Surrey, London (All Hallows 1), Preston by Faversham and Rochester 1, Kent, Reigate, Surrey, and Bishop's Waltham, Southampton, Steventon, Wherwell, and Winchester (Upper Brook Street), all in Hampshire. The remains of a slight step at the upper end of the Elstow shaft (Ills. 268–9) may suggest that it belongs to the stepped sub-type (Cramp 1991, fig. 1c), but there is no evidence that any of the others originally derived from the stepped, shouldered, or collared sub-types encountered in other areas (ibid., fig. 1c–e).

Ten fragments derive from round shafts. The earliest monument of this type is probably the shaft from Reculver, Kent, which accounts for seven of the ten known fragments. This can be assigned to the late eighth or, more plausibly, the early ninth century (see Chap. VI). The other examples are from Wantage, Berkshire, and High Street 1 and Priors Barton 1 in Winchester. The Wantage and Priors Barton shafts are probably of tenth-century date, while the fragment from High Street is ninth century. From these few examples it seems that the type may have fallen out of use by the beginning of the eleventh century although there is little enough evidence on which to base any solid conclusion. Of these shafts only at Reculver is there enough surviving for it to be fairly certain that it was columnar (Cramp 1991, fig. 1f). The other round shafts could have come from either columnar types or

round-shaft derivatives (Cramp 1991, fig. 1g–h). In addition there is one clear fragment of a round-shaft derivative, that from St Augustine's, Canterbury (no. 1). This exhibits the usual upper part of square section, with the faces ending in semicircular swags, and with a group of roll mouldings below marking the transition of the shaft to a circular section (Ills. 20–3).

### CROSS-HEADS

There are only five surviving cross-heads from south-east England. As noted above (p. 23), it is not clear if all of these derive from free-standing crosses rather than small grave-markers. Nevertheless these five cross-heads represent five different types. The earliest is undoubtedly the lost fragment from Reculver (no. 3), for which an eighth- or early ninth-century date can be suggested. This was apparently a fragment of a free-armed head of the general type A9 or 10. Surviving photographs reveal no evidence for a ring and supporting evidence for the head having been free-armed is provided by the concave disc on face A, with a moulding of square section running away from it along the vertical axis of the arm (Ill. 121). These features suggest that the piece was part of a free-armed head of the 'lorgnette' or 'spine and boss' type, where face A was decorated with five discs or bosses linked by straight plain mouldings (Collingwood 1927, 94–8). The remaining four heads are all of tenth- or eleventh-century date. Those from Pagham, Sussex, and South Leigh, Oxfordshire, are ring-heads. The Pagham example is of the general form E11 with a type b ring (Ills. 98–100) and the South Leigh example of the form B6 with a type a ring (Ill. 406). Related to this form is the circle-head encountered at All Hallows by the Tower, London (no. 2), of the type E8 (Ills. 343–4). The remaining cross-head, from St John Walbrook in London, is a disk-head with very narrow arms of type E1 (Ills. 347–9).

### CROSS-BASES

The only possible cross-base from south-east England is from South Hayling, Hampshire (Ills. 465–9). The piece, currently used as a font, is in the form of an inverted, truncated pyramid, decorated on all four faces, and hollowed. There is a drain hole in face B (Ill. 466), and there appears to have been a prominent moulding of square section around what is now the rim of the bowl. This is now very heavily weathered. The piece resembles no known pre-Conquest font in southern England. The examples from Potterne, Wiltshire (Okasha 1983, 96–7, pl. IXa), Deerhurst, Gloucestershire (Rice 1952, pl. 30a), Wells, Somerset (Rodwell 1990, 162–3, pls. 2–4), and Melbury Bubb, Dorset (Cramp 1975, 198, pl. XXI), are all circular in section. This appears also to have been the norm elsewhere. It is possible, therefore, that the piece has been reused. Certainly the drain hole is secondary as it cuts through the decoration, and by inference the hollowing may also be secondary.

If it was not originally a font, then the South Hayling piece is best inverted and viewed as a cross-base (as in Ills. 465–9). The truncated pyramidal form is relatively common particularly in early contexts (Bailey and Cramp 1988, 13), and the ornament of the South Hayling piece certainly suggests an early date, perhaps in the late eighth or early ninth century. Only two possible cross-bases are known from southern or eastern England, the cuboid bases from Haddenham (Okasha 1971, 74–5, n. 43, pl. 43) and Balsham (Tweddle 1978) in Cambridgeshire, and cross-bases occur only rarely elsewhere. However, the surviving examples can be divided into three main types: cuboid bases, as at Beckermet St Bridget (nos. 1–2) and Brigham (no. 9) in Cumberland (Bailey and Cramp 1988, ills. 41, 168–71), and Hexham, Northumberland (Cramp 1984, I, 181, II, pl. 176 (928–32)); stepped bases, as at Addingham and Gosforth, Cumberland (Bailey and Cramp 1988, ills 1–4, 292–5); and truncated pyramids, as at Raistrick and Walton, Yorkshire (Collingwood 1915, 231–3). The latter pair are taller in proportion to their width and depth than is the case at South Hayling, but the overall concept is the same. Cross-bases much more closely comparable in form to the South Hayling example can be found among the early Christian monuments of Wales, as at Penmon (Nash-Williams 1950, 65–7, pl. XXXII), and of Ireland, as at Kells (Henry 1964, pls. 26 and 28), Clonmacnoise (ibid., pl. 46) and Durrow (ibid., pl. 52). These particular examples have no direct parallels with the decoration of the base at South Hayling, but they serve to demonstrate that this type of base was known in Insular sculpture in the eighth and ninth centuries. The suggested reuse of part of a cross as a font can certainly be paralleled both in southern England and elsewhere. At Melbury Bubb, Dorset (Cramp 1975, 198, pl. XXI) and Wilne, Derbyshire (Routh 1937, 42–4, pl. XXI), for example, the fonts are made from reused sections of circular cross-shafts.

## ARCHITECTURAL FEATURES AND FURNISHINGS (Cramp 1991, p. xxi)

Almost half of the pre-Conquest carvings from south-east England are architectural. The material can be divided into nine categories in accordance with standard architectural terminology: baluster shafts; capitals; imposts; bases; hoodmoulds and arch heads; mid-wall slabs; string-courses; friezes; sundials; figural groups; and church furnishings.[3] In addition, there are several pieces which, although probably architectural, cannot be further classified.

### BALUSTER SHAFTS

These may be divided into two main types: those which are lathe-turned with grooved decoration; and those which are moulded. The first type is rare in south-east England, occurring at Canterbury St Augustine's 8 (Ill. 50) and perhaps also at Winchester Old Minster, though there the remains are extremely fragmentary (e.g. nos. 17–18; Ills. 515–16; see Chap. VIII). These may have been architectural in function or formed parts of church furnishings. The second type may have been exclusively architectural in function, though many of the examples are *ex situ* so it is difficult to be certain of this. Major collections of the latter occur at Dover (St Mary in Castro), St Albans, and Winchester Old Minster, while there are *in situ* examples at Oxford St Michael and North Leigh, Oxfordshire.

### CAPITALS

There are 35 decorated capitals from south-east England, from seven sites. In Sussex, Botolphs has two and Sompting nine. There are six at Hadstock in Essex (nos. 1–2) and twelve at Langford; all are *in situ*. The pair of capitals from Reculver (no. 4), the three from St Augustine's, Canterbury (nos. 3–5), both in Kent, and the single capital from Betchworth in Surrey, are all *ex situ*. The Reculver and Canterbury capitals belonged to free-standing columns. Two of the Sompting capitals (nos. 20–1) derive from mid-wall shafts. The remaining examples are attached shaft capitals. On the basis of their form and decoration

they can be divided into five types: composite capitals, upright leaf capitals, volute capitals, faceted capitals, corbelled capitals and moulded capitals.

### Composite Capitals

This type is represented only by the three capitals from St Augustine's abbey, Canterbury (nos. 3–5). The standard elements of this type, a double row of upright leaves on the base separated by a recessed zone of egg-and-dart from the volute-decorated upper portion, are greatly simplified but still recognisable. The double row of leaves has been reduced to one and the egg-and-dart transformed into a recessed zone of interlocking triangles (e.g. no. 5; Ill. 39).

### Upright Leaf Capitals

This type of capital is decorated with one or more horizontal zones of upright leaves, although the leaf form varies. There are seventeen capitals of this type from south-east England: three at Sompting and two at Botolphs in Sussex, and twelve at Langford in Oxfordshire (no. 4).

The best examples of the type are the capitals of the half-columnar soffit shafts of the tower arch at Sompting (no. 14; Ills. 183–91), together with the closely-related example on the half-round shaft on the north face of the tower (no. 18; Ills. 200–1). Each of these capitals is decorated with overlapping horizontal zones of out-turned upright leaves with clubbed ends. At Botolphs, Sussex, the soffit roll of the chancel arch is also carried by capitals of this general type. On the south side the leaves are reduced to three horizontal rows of pointed-ovoid incisions, a simplification of the Sompting type (Ill. 4), but on the north side there is a single row of narrow, pointed, vertical leaves on short thick stems (Ill. 5). At Langford (no. 4) the form is different again (Ills. 297–312). The capitals are reduced to narrow strips delineated by plain mouldings of square section. The ornament consists of a row of acanthus leaves developing from the lower moulding. In the centre of each window above the capital, a band of acanthus also decorates the springing of the archivolt roll moulding.

Despite the variety of leaf forms, all of these capitals may be thought of as greatly simplified Corinthian or Composite capitals, with the volutes suppressed and the zone of upright leaves greatly enlarged. This phenomenon can be observed on the continent, for example, on the capitals of the westwork in Corvey, Germany, where the volutes are vestigial; from there it was only a short step to their complete suppression.

3. Besides these groups, two other architectural fragments survive: the gable cross from West Wittering and the apotropaic figure from Oxford (St Michael 2). Both are unique in the region and neither of them finds ready parallels from elsewhere. In addition the roundel fragment from Abingdon, Berkshire, may also be architectural, but how it was originally used is unclear.

*Volute Capitals*

In the same manner as the upright leaf capitals, these are derivatives from Corinthian or Composite types, but with the zone of upright leaves suppressed and the volutes enlarged. The three capitals of this form from south-east England are all from Sompting, on the south, east, and west half-round pilasters of the tower (nos. 16–17 and 19; Ills. 196–7, 202–4).

The tower arch capitals at Sompting (no. 14), with their flanking strips, perfectly exemplify this process of disintegration of the Classical prototypes into separate volute and upright leaf forms. The capitals of the half-columns themselves, as noted above (p. 25), represent the upright leaf zone of the Corinthian or Composite type. The flanking volutes on the dosseret or jamb behind each half-column equally represent, no matter how whimsically, the upper voluted zone of such a capital displaced to form flanking strips, as at Langford (Ills. 183–91).

*Facetted Capitals*

This form is similar to the Romanesque cushion capital, but instead of having a lunette on each face, the curve of the lunette is replaced by an angle. In the same way, on what is normally the conical section, the capital is trimmed to produce flat planes meeting at an angle. There are six capitals of this form in south-east England, all from Hadstock in Essex. Two are on the angle shafts of the north door (no. 1; Ills. 279, 284) and four on the angle shafts of the south porticus arch (no. 2; Ills. 288–91). In every case they are decorated all over with palmette ornament.

*Corbelled Capitals*

This form again resembles the cushion capital, except that two parallel faces are extended to the full thickness of the wall, with the consequent loss of the lunettes. Only two decorated examples are known from south-east England, both from Sompting (nos. 20–1) where the mid-wall shafts of the north belfry windows are of this form; the long faces are decorated with two pairs of volutes, one above the other, linked at the base (Ills. 205–12).

*Moulded Capitals*

The moulded capital is decorated with a series of plain mouldings parallel to the upper end of the capital and of diminishing size towards the lower end. There are three capitals of this form from south-east England, two from Reculver (no. 4) and one from Betchworth. All are decorated with superimposed fasciae; those at Reculver narrow from top to bottom (Ills. 126, 128),

but it is unclear which way up the Betchworth example (Ill. 2) would have been set originally.

*Unclassified*

In addition to these capitals there is one other which is unclassified, also from Sompting (no. 23). This is inside, on the shaft between the two triangular-headed windows in the north side of the tower, and takes the form of a face mask carved onto the body of the shaft (Ills. 214–15).

IMPOSTS

There are twelve decorated imposts from south-east England, at six sites: Breamore and Corhampton 4a–b in Hampshire, Dartford in Kent, Hadstock in Essex (nos. 1–2), and Little Munden and Walkern 2 in Hertfordshire. They can be divided into two main types, square imposts and moulded imposts, following the classification proposed by Taylor (Taylor and Taylor 1965–78, III, 1051–5). The only modification here is to place the sculptured imposts, grouped separately by Taylor, with the undecorated impost type which they most closely resemble. Except that from Dartford, all of the imposts are still *in situ*.

*Square Imposts*

These are of square plan and section and are the commonest type of pre-Conquest impost. There are six decorated examples from south-east England, two from Breamore, Hampshire (no. 2a–b) and four from Hadstock, Essex (nos. 1–2). At Breamore the south porticus arch imposts are enriched with cable mouldings on the angles, except on the north face where the imposts have been cut back flush with the wall (Ills. 429, 434–7). At Hadstock the imposts of the north door (no. 1) are also fundamentally square in section, but each has a prominent roll moulding on the lower angle which returns across the outer end of the north face (Ills. 277–84). On the south porticus arch (no. 2) this feature is so enlarged that the imposts have acquired a stepped profile (Ills. 285–91). Both sets of imposts are decorated with palmette ornament.

*Moulded Imposts*

Essentially these are a variant of the square or chamfered impost in that they have one or other of these basic shapes, enriched all over with horizontal mouldings and lacking any other decoration. There are six imposts of this type from south-east England, a pair each from Corhampton, Hampshire (no. 4a–b) and Little Munden, Hertfordshire, and one each from

Walkern, Hertfordshire (no. 2), and Dartford, Kent. At Walkern 2 (Ills. 398–9) and Little Munden (Ills. 318–19) the imposts are chamfered, but each enriched with cable mouldings, the cables twisted alternately in opposite directions. The Dartford impost is square with its single surviving decorated face treated in a similar manner (Ill. 61). The Corhampton imposts are also square (Ills. 442–3, 445), but with plain rather than cabled mouldings.

### Decorated Imposts

Attention has been drawn to the strips flanking the archivolt roll capitals of the belfry windows at Langford, Oxfordshire (no. 4; Ills. 297–312) and to the similar strips on the tower arch at Sompting (no. 14; Ills. 183–91). These rather curious forms are difficult to classify, but most resemble a form of decorated impost block.

### BASES

Two sites in south-east England have surviving decorated bases: Reculver, where there are two (no. 4), and Corhampton, Hampshire (nos. 2–3, 4c–d) where there are four. With so few extant examples no classification is possible.

At Reculver the bases are those of two free-standing columns which originally supported the triple arcade between the nave and chancel of the church. Both bases are of the same form and are elaborately decorated with cable mouldings and fret ornament (Ills. 133, 138). At Corhampton, by contrast, the bases belong to external pilasters of square section; two are decorated with a pair of out-turned volutes flanking a median bulbous feature (nos. 1–2; Ills. 439–40). These are unparalleled elsewhere in the corpus of pre-Conquest architectural sculpture.

In addition there is a base from St Pancras's, Canterbury, decorated only with mouldings.

### HOODMOULDS AND ARCH HEADS

On the basis of their section hoodmoulds are normally split into three categories, those of square section, chamfered section, and half-round section. Decorated hoodmoulds are rare. The single example from south-east England, from Hadstock, Essex (no. 1) is of square form decorated with palmette ornament confined between shallow roll mouldings along the edges (Ill. 278).

In addition to this hoodmould there are two decorated arch heads from south-east England, though one of these, at Tangmere, Sussex, is the result of post-Conquest reuse. At Breamore, Hampshire, the north face of the south porticus arch has voussoirs ornamented with an incised inscription (no. 2c; Ills. 429, 430, 433). Two other fragments from similar inscriptions survive *ex situ* (nos. 3–4; Ills. 431–2). They are very damaged and incorporated into the fabric so it is difficult to ascertain if they were originally voussoirs from a similar arch or arches, perhaps into the north porticus or chancel, or whether they belonged to another type of architectural feature. The size of the letters, however, is broadly similar to those on the south porticus arch.

### MID-WALL SLABS

Mid-walls slabs, whether in wood or stone, provided a framework for glazing or shuttering a window. The specimen from Boarhunt, Hampshire (Ill. 420), is the only example in stone, decorated or undecorated, from south-east England, although there are undecorated wooden examples from Hadstock, Essex (Taylor and Taylor 1965–78, I, 275). The Boarhunt slab is decorated on both sides with two bands of cable moulding outlining the opening (Ills. 423–4).

### STRING-COURSES

External string-courses survive on fourteen sites in south-east England (Taylor and Taylor 1965–78, III, 902–14) but only at Sompting is there any decoration. At Sompting the string-course (no. 15) divides the ground floor of the tower from the upper floors (Ill. 192). It is of fundamentally square section enriched with a chequer pattern; both the raised and recessed fields are vertically facetted (Ills. 193–5).

No pre-Conquest fabric in south-east England retains an internal string-course *in situ*, but it is possible that the fragments of acanthus-decorated frieze at Sompting originally served this purpose (nos. 1–8). The pieces probably all derive from the same feature as they share several closely-related acanthus forms (Ills. 162–71), and their dimensions are closely comparable; all the pieces are 10–12 cm thick. The total length of the fragments is *c.* 372 cm and the original feature from which they derive must have been longer as none of the surviving stones is complete. The large-scale nature of this feature is sufficient to suggest it was architectural and the form of the fragments would be compatible with their use as a string-course; all are of rectangular section with

the carving confined to one of the narrow edges. An internal use is implied by the fine preservation of the carving, which can never have been exposed to weathering.

## FRIEZES

The only recognizable remains of a decorated frieze are from Sompting (nos. 9–11), together with a lost stone from Dover (St Mary in Castro 4; Ill. 70) p. 30. At Sompting there are three rectangular fragments, each decorated with the remains of one or more reeded arch heads; plant ornament fills the tympanum and spandrels of each (Ills. 172–80). The similarity of their decoration suggests that the pieces are from the same feature. Five arch heads survive, giving a minimum original length of *c.* 500 cm and potentially very much more. Close examination reveals that the junctions of the arch heads were originally carried down to form piers. However, in each case, the careful confinement of the ornament to the tympanum suggests that it did not extend down between the piers. Instead these must have flanked niches or a separate sculptured panels. This would allow the reconstruction of the fragments as a frieze or blind arcade. Alternatively the pieces may have formed part of a free-standing screen. This is, however, less likely as on one of the fragments the arch is carved on the lower half of a larger stone, the upper part of which is roughly dressed. If this were a frieze fragment then the upper part would originally have been set in the wall and plastered, but if the fragment formed part of a screen it is difficult to see how this roughened area could have been disguised, particularly as the other fragments lack this feature.

## SUNDIALS

There are ten surviving sundials from south-east England. These can be divided into three groups: circular dials; square dials; and semicircular-headed dials. Circular dials have the dials cut on the face of a circular stone, as at Orpington, Kent (Ills. 105–7), and Hannington (Ill. 441) and Winchester St Maurice (no. 2; Ill. 672), Hampshire. Square dials employ a circular dial on a square stone, as at Stoke d'Abernon, Surrey (Ill. 216), and Corhampton (no. 1; Ill. 438), Warnford (Ill. 478), and Winchester St Michael (Ill. 671) in Hampshire. Semicircular-headed dials have the upper half of the circular dial fitting into the semicircular head of a parallel-sided slab, as at Bishopstone, Sussex (Ills. 6–7) and Marsh Baldon, Oxfordshire (Ill. 358).

Related to this type is the dial from Langford, Oxfordshire (no. 3; Ill. 296). This also has the dial forming the upper part of a rectangular slab, but here the dial is semicircular and its upper edge co-terminus with the upper edge of the slab.

Decoration is usually minimal. At Orpington and Marsh Baldon there are cabled edge mouldings; the Orpington dial also has a marginal inscription. At Bishopstone there is a simple fret encircling the dial and an inscription on its face (Ill. 7). The Langford dial is held aloft by two figures (no. 3; Ill. 296). The Hampshire dials, apart from the example from Hannington, all have simple foliate decoration. The dial from Stoke d'Abernon is undecorated.

The number of calibrations is of little help in classification. Calibration is usually confined to the lower half of the dial; only at Orpington is the whole dial calibrated (Ills. 105–7). The principal, mid-tide, lines at 9 am, 12 noon, 3 pm and 6 pm, are usually crossed near their ends. Between each pair of principal lines there are either two minor lines marking the hours, or alternatively, a single line marking the hour and a half. Only two dials lack this standardised calibration. Both at Marsh Baldon and St Maurice's, Winchester, the gnomon hole is placed towards the upper edge of the dial, and at Marsh Baldon the 6 am and 6 pm lines are missing (Ill. 358). This was apparently also the case at St Maurice's although the lines of calibration are now almost weathered away (Ill. 672).

## FIGURAL GROUPS

In south-east England there are six large-scale pre-Conquest crucifixion groups. The examples at Headbourne Worthy, Hampshire (no. 1) and Walkern 1, Hertfordshire, are *in situ*; those at Breamore 1 and Romsey (no. 1) in Hampshire, and the two at Langford in Oxfordshire (nos. 1–2) are reset. In addition there are two crucifixion panels, at London (Stepney) and Romsey 2, Hampshire, and two other figural panels, at Jevington 1 and Sompting 13, both in Sussex.

The large-scale crucifixion groups can be classified iconographically, or according to their position in the church, but in either case the *ex situ* examples remain problematical as their original position is lost and any subsidiary figures may have been destroyed in their removal. In addition the examples at Breamore 1 and Headbourne Worthy 1 have been mutilated.

Iconographically the material can be split into three groups: those with Christ depicted as in agony; those with Christ depicted as in repose; and those where

Christ is robed. At Breamore 1 (Ill. 428) and Langford 1 (Ill. 293) the figure of Christ is depicted as in agony with limbs contorted. At Headbourne Worthy 1 and Romsey 1 (Ills. 451–2) Christ's body appears in repose; at Romsey the drilled pupils of the eyes indicate that they are open and that the figure of Christ was intended to be living (Ill. 456). This feature is not paralleled at Headbourne Worthy, but the head of Christ there has been destroyed. At Headbourne Worthy (Ill. 448), Breamore, and Langford 1 (Ill. 293), the crucified Christ is accompanied by the figures of the Virgin and St John. The sun and moon are also personified at Breamore (Ills. 425–8).

These figures do not occur with the robed Christ at Walkern 1 where, if they had existed, they might be expected to survive. They are also absent at Romsey 1 and Langford 2, but both figures are *ex situ* and accompanying figures may have been lost. At Headbourne Worthy 1 an area of chiselling beneath the feet of the crucified Christ suggests that something has been cut away (Ill. 448), perhaps a serpent, as at Bitton, Gloucestershire (Taylor and Taylor 1966, 6–8, fig. 2).

This classification is a slight modification of Coatsworth's (Coatsworth 1988, n. 29). The crucifixions with Christ in agony correspond to her type 3, and those with Christ in repose and placed frontally to her type 1. The only disagreement is over the crucifixion at Headbourne Worthy 1 which she assigns to her type 2, a type in which the trunk sags to one side so that one hip is lower than the other. This may be the case at Headbourne Worthy, but the extent of the damage makes it uncertain (Ill. 448). Robed crucifixions, excluded from consideration by Coatsworth, are included here.

Little can be made of the position in the church of these groups. Headbourne Worthy 1 is over the west door, while Walkern 1 is over the original south door. Nothing is known of the original position of the groups at Langford 1, Breamore 1, nor of the great rood figure Romsey 1, although it is interesting (if not necessarily significant) that on all these sites the crucifixions have been reused in association with south doorways. The crucifixion panel from Stepney in London was reused in a similar manner.

The two crucifixion panels from London (Stepney) and Romsey 2, Hampshire, have a close relationship with the large-scale crucifixion groups. At Stepney (Ill. 354) the figure of Christ is depicted as in agony, but at Romsey (Ills. 453, 455) he is in repose. In both cases the crucified Christ is accompanied by the Virgin and St John, although at Romsey there are the additional figures of Stephaton and Longinus and an angel above each of the arms. At Stepney personifications of the sun and moon occupy these positions. Although their iconographic relationship with the major crucifixion is clear, these much smaller slabs need not have been used in the same way. Perhaps they were used in conjunction with altars as part of the church furnishings (Taylor and Taylor 1965–78, III, 1056; Taylor 1975, 167–8).

Similar rectangular slabs, but decorated with figural groups other than the crucifixion, are known from Sompting (no. 13) and Jevington (no. 1). At Sompting the slab is decorated with a single figure within an arch (Ill. 181). The figure is tonsured and has to the left a crozier and to the right a reading desk. It must, therefore, represent a monk who was also a bishop and possibly an author. There is no comparable figure in stone, ivory or metalwork from southern England, but comparisons with the manuscripts suggest that the figure could be either St Gregory or St Benedict. At Jevington (Ill. 232) the scene is more easily recognisable as Christ trampling on the beasts, as related in *Psalms* 91, 13: 'Thou shalt tread upon the lion and adder: the young lion and the dragon shalt thou trample under foot'. This satisfactorily explains the careful differentiation between the forms of the animals at the feet of Christ, a feature paralleled in a number of late Anglo-Saxon manuscripts (Temple 1976, nos. 56 and 79, ills. 168, 259). Again the precise functions of these panels is not known, but they may represent part of the church furnishings.

## CHURCH FURNISHINGS

In addition to the slabs discussed above, there are three other pieces of church furnishing from south-eastern England, possible screen fragments from Sonning, Berkshire, and Dover, Kent (St Mary in Castro 4; Ill. 70), and a stoup fragment from Godalming, Surrey (no. 1).

When reconstructed (Fig. 37) the Sonning fragment is *c.* 60 cm square and decorated with a free-armed cross with a circular interlace in each of the re-entrant angles. As the piece is built into a wall (Ill. 454) it is not possible to see whether there is decoration on the other side, or to gauge its thickness, so the panel may not originally have been free-standing. It is, however, in the same size range as the Hexham panel which is regarded as a closure screen (Cramp 1974, 175, n. 23, pl. viia). Alternatively, the Sonning piece may have formed part of another feature employing decorative slabs, such as the frontal of a box altar (Thomas 1971, 183–90) or part of a shrine.

The lost slab from St Mary in Castro, Dover (no. 4), may also have been a closure slab. It was decorated on both faces and may, therefore, have been free-standing. It was originally *c.* 70 × 55 cm, the same size range as the possible closure slabs from Hexham and Sonning described above. However, the decoration on face A, a Latin cross with interlace in the re-entrant angles, fits the field precisely (Ill. 69). In contrast, the decoration on the opposite face (C), the junction of two reeded arch heads with plant ornament in the spandrel, was clearly intended to continue onto other slabs (Ill. 70). This may simply reflect differing decorative schemes on each side of the original screen; it may, however, suggest that the slab has been reused, in which case, any discussion of its function is much more problematical. Perhaps the arch heads originally related to a frieze or blind arcade, such as that postulated at Sompting. The piece may have been reused to form a small grave-cover or -marker. There is a very similar grave-cover from Little Shelford, Cambridgeshire, for example (Fox 1920–1, no. 21, pl. V).

The function of the sculptured ring from Godalming, Surrey (Ills. 81–91) is equally difficult to establish, not least because there is no comparable piece from Anglo-Saxon England. The ring is of fundamentally square section with a chamfer on the inside of the upper edge and a rebate on the inside lower edge (Ills. 81, 83). On this basis the piece may have formed the separate rim of a cylindrical stone vessel lined with metal. If the metal were folded over the lip of the lower element it could be neatly accommodated by the rebate. The piece is too small for use as a font, but its association with a smaller vessel such as a stoup is possible.

## UNCLASSIFIED FRAGMENTS

This study of the uses and form of sculpture from south-east England has taken no account of fifteen other fragments for which neither function nor even original form is readily identifiable. These are the pieces from: St Martin's Canterbury and Rochester 4 in Kent; Godalming 2, Surrey; Ford, Selsey, and Sompting 12 in Sussex; Stanbridge, Bedfordshire; Lavendon, Buckinghamshire; and Lewknor and Oxford (St Aldate's), Oxfordshire.

# CHAPTER V

# THE DEVELOPMENT OF SCULPTURE TO *c.* 950

## by D. Tweddle

### THE SEVENTH CENTURY

There are seventeen pieces of sculpture from south-east England which may belong to the seventh century or earlier, excluding some excavated fragments from Winchester which may be as early as this (see Chap. VIII): two memorial stones from Sandwich, Kent, two columns from Reculver, Kent (no. 4), a column base from St Pancras's, Canterbury; nine baluster-decorated fragments from the excavations at the Old Minster, Winchester; a similarly-decorated fragment from Barking abbey, Essex (no. 2); a baluster fragment from St Augustine's, Canterbury (no. 8); and an inscription from St Martin's, Canterbury.[4]

Possibly the earliest of these five sculptures are the two tapering memorial stones of square section found between Sandwich and Richborough in Kent (Ills. 151–7). On no. 2, at the upper end, two faces are decorated with framed rectangular fields (Ills. 152, 154). On no. 1, at the upper end, two adjacent faces have their common long edge paralleled by pairs of incised lines (Ills. 156–7). On one of these faces (Ill. 156) is a runic inscription, commonly supposed to be a personal name, though the analysis proposed below by Parsons casts some doubt on this (pp. 169–70). The linguistic forms allegedly recorded in the inscription have previously been considered crucial for the dating of the pieces (Elliott 1959, 81; Evison 1960, 244). The revised reading by Parsons has cast doubt on some of these features, but an early date still seems probable on other grounds. If, as is still possible, the inscription can be read as a personal name, then it is likely that both this stone and the closely related piece found with it performed a memorial function. In that case the absence of any Christian symbol or allusion is remarkable and unparalleled in any other complete memorial inscription from south-east England. It is possible that a cross at the beginning of the inscription has been obliterated by the weathering which also makes the first character difficult to read, but if not then this absence of Christian symbolism or allusion may suggest a date for the piece before the introduction of Christianity to Kent in 597, or shortly thereafter.

The form of the two Sandwich stones also provides support for this early dating. Memorial sculpture in the ninth, tenth, and eleventh centuries in south-east England falls into clearly defined categories: coffin lids, grave-covers, grave-markers, and small memorial crosses, discussed in detail in Chap. VII. The Sandwich stones bear little resemblance in form to any of these, although they were clearly used partially sunken into the ground in the same way as the grave-markers (Ills. 151–7). It is, therefore, probable that they belong to the period before the emergence of these well-defined groups, i.e., to the eighth century or earlier. Certainly the stones appear to copy wooden prototypes, a fact demonstrated by the tapering of their bases, a feature which can have had no functional purpose. The stones could not have been driven into the ground without shattering, and the tapering of the bases would not have eased the sinking of the stones into the ground; the labour saved in digging the holes would have been more than offset by the labour involved in shaping the stones. This tapering can best be explained if the prototype for these monuments was a squared wooden post with a sharpened end which was driven into the ground. A number of pagan Anglo-Saxon cemeteries in Kent do have graves with either a single post hole in association, as at Finglesham (Hogarth 1973, 113) or post holes in association with another structural feature, as at St Peter's, Broadstairs (ibid.). Some of these post holes may have accommodated the wooden prototypes of the Sandwich stones.

---

4. A seventh-century date has also been argued for the cross-shaft fragments from Reculver, Kent (no. 1); the problem of their date is discussed separately in Chap. VI.

With the coming of Christianity and the consequent re-introduction of the tradition of stone building into south-east England, it might be expected that stone sculpture would also be re-introduced and widely used. This, apparently, was not the case. A large number of early Christian sites in south-east England is known from historical sources: Dorchester, Berkshire (Mayr-Harting 1972, 100, 117); Barking abbey and Bradwell-juxta-mare, Essex (Taylor and Taylor 1965–78, I, 91–3); the Old Minster, Winchester, Hampshire (Biddle 1970, 317–21); St Augustine's (Taylor and Taylor 1965–78, I, 134–143) and St Martin's (ibid., I, 143–5), Canterbury, Lyminge (ibid., I, 408–9), Reculver (ibid., II, 503–9) and Rochester (ibid., II, 518–19), all in Kent; and St Paul's, London (ibid., I, 265–6). Several of these have been explored, but only six have produced sculpture of an early date, and possibly contemporary with the foundation of the churches. These are: Reculver, Kent (no. 4); St Martin's, St Pancras's and St Augustine's Canterbury (no. 8); the Old Minster, Winchester (nos. 36–40, 42, 44, 47–9); and Barking abbey (no. 2).

At Reculver (no. 4) the surviving sculptures consist of a pair of columns with decorated bases and capitals (Ills. 123, 126, 128–38), originally supporting the triple arcade separating the nave from the chancel of the church (Ills. 124–5, 127). Although the church stands in the centre of a Roman fortress it is unlikely that the columns are directly reused Roman material as the form of both the capitals and the bases is difficult to parallel in the Classical world. The capitals are decorated with inclined fasciae above a necking with a projecting half-round moulding. This form is unparalleled among the surviving Romano-British capitals, and appears to be a version of the impost block placed above the capital proper (Blagg 1981, 52–3). This was an east Mediterranean innovation, first occurring in the fifth century, for example, in Ravenna at St Giovanni Evangelista of 423–34 and St Apollinare Nuovo of 490, and in Salonika at St Demetrios of *c.* 470 (ibid., 53). In Anglo-Saxon England there are similar capitals or bases from Ripon in Yorkshire, possibly from the seventh-century church built by St Wilfrid (Taylor and Taylor 1965–78, II, 518), and there are examples from St Mary, Castlegate in York (Lang 1991, no. 10, ills. 413–15). These were incorporated as building material into the foundations of the chancel arch of a two-celled late pre-Conquest church (Wenham *et al.* 1987, 154–5, fig. 37, pl. XXVIII). A pre-Conquest capital from Betchworth, Surrey, is of similar form, but much smaller and decorated with eight narrow fasciae (Ill. 2).

It is incorporated into the fabric of the Victorian chancel and, therefore, cannot be closely dated (Malden 1905, 447).

The use of ornamented column bases is much more readily paralleled in the Roman world, and some Roman bases even have cabled mouldings as at Reculver, particularly on the lower torus. There are bases of this type in the Capitoline Museum and in the Palazzo dei Conservatori in Rome (Blagg 1981, 52–3). Few such bases survive in Britain and none of them closely resembles the Reculver bases (ibid., 53). Their profile, with collars and a square-cut torus, can, however, be paralleled on bases at St Apollinare in Classe, Ravenna of 532/6–549 (loc. cit.). As with the capitals, this suggests an east Mediterranean and post-Roman prototype for the Reculver columns (Blagg 1981, 53).

If the Reculver columns are not reused Roman material, then their use in a late seventh-century building might be assumed to provide a *terminus ante quem* for them. Unfortunately, the demolition of Reculver church in 1805 involved the complete destruction of the fabric virtually without record. It is thus now impossible to be certain that the columns were not a secondary insertion, something which has been suggested for the similar triple arcade carried on columns at St Pancras, Canterbury (Jenkins 1975–6, 4). Controlled excavation in the area of the chancel arch might have elucidated this problem, but the area was heavily disturbed in 1878 in excavations by Dowker (Dowker 1878, 259) and little, if any, of the stratigraphy can now remain intact.

In default of a stone-by-stone survey of the fabric, or of archaeological evidence, it is necessary to use the few drawings and sketches made during the demolition of the church to assess whether the triple arcade was a primary feature or an insertion. A drawing by Gandy (Society of Antiquaries MS, Red Portfolios, Kent, L–R, fol. 23r (Ill. 125)) shows that the columns supported arches turned in Roman tile or brick, and that the outer ends of the outer arches rested on walls made of coursed, small, rectangular stone blocks. Each of these had three bonding courses of Roman tile or brick, on the topmost of which rested the arch heads. The accompanying annotated ground plan notes that these walls returned to the east to form the north and south walls of the chancel. There is no indication of the materials used for the gable-end supported by the triple arcade. A drawing by Baynes (BL Add. MS 32370, fol. 106r (Ill. 127)) confirms that the north and south walls of the chancel were of the same build as the wall supporting the

outer ends of the triple arcade, since the tile bonding courses run through both walls at the same level. However, in the chancel there was a fourth tile bonding course above the others and just below the eaves. If it could be demonstrated that this returned across the wall supported by the triple arcade and immediately above the arch heads, it would prove that there was no disturbance in the walling and hence that the triple arcade was a primary feature. Unfortunately, in the Baynes drawing this area is largely obscured by plaster and all that can be seen through the gaps in it are the same small, rectangular dressed stones seen elsewhere in the earliest walling, and at a level below the possible position of the tile bonding course. This suggests, but cannot prove, that the triple arcade was a primary feature as it is unlikely that it could have been inserted without leaving some trace. Combined with the other evidence noted above (p. 32), this would date the decorated columns to the late seventh century.

The single surviving column base from the original four columns supporting the triple arcade at St Pancras's, Canterbury (Ills. 59–60), can also be assigned to the seventh century. As Blagg has pointed out, although this base is decorated only with mouldings, their handling does not correspond with that observed on Romano-British column bases; it is, therefore, very unlikely that they are reused Roman material (Blagg 1981, 50). The best parallels for column bases with low torus mouldings placed on tall plinths, the form employed at St Pancras's, are to be found in the east Mediterranean, where the type developed in the fifth and sixth centuries, as at St Demetrios, Salonika of *c.* 470, St Apollinare in Classe, Ravenna of 532/6–549, and Grado cathedral of 571–9 (loc. cit.). Excavation at St Pancras's suggests that the triple arcade was a secondary insertion, probably of seventh-century date (Jenkins 1975–6, 4). It seems likely that the columns were made specifically for this purpose at that time, imitating late Roman and early Byzantine prototypes from the east Mediterranean.

Other architectural sculptures of possible seventh-century date from south-east England derive from the excavations at Barking abbey, the Old Minster, Winchester, and St Augustine's abbey, Canterbury. From Barking abbey comes a corner fragment, probably from an impost, decorated on both surviving faces with plain balusters of rounded section (no. 2; Ills. 260–2). The material from Winchester Old Minster (nos. 36–40, 42, 44, 47–9) is similar, consisting of architectural fragments decorated with baluster friezes. The balusters (e.g. no. 37; Ill. 561) are plain, of semicircular section, and are widely spaced; in some cases (e.g. no. 47; Ill. 576) a pair of such friezes flanks a broad zone decorated with two undulating guilloche strands. All of these pieces derive from the demolition levels of the Old Minster, and are probably (though not certainly) as early as the seventh century in date. They have, moreover, been compared by the Biddles with the baluster-decorated friezes and fragments from Hexham, Northumberland and Jarrow, co. Durham, an analogy which tends to support an early date (and which would also apply to the Barking fragment). The comparison certainly appears sound, for a date in the late seventh or early eighth century has been suggested for these Northumbrian baluster-decorated friezes on the grounds that some of the balusters form parts of decorative schemes on readily datable monuments. In particular, the cross-head from Jarrow with a baluster-decorated edge (no. 9) has been dated by Cramp on the basis of its form and decoration to the first half of the eighth century (Cramp 1984, I, 109, II, pl. 93, 498), although the decoration is only a simple zig-zag, while the fragmentary monumental slabs from Jarrow with baluster decoration on the edges (nos. 13–14) are dated on the basis of their form and epigraphy to the late seventh or early eighth century (ibid., I, 110–12, II, pls. 94, 513; 95, 515). This early dating is supported by the comparisons which can be drawn between these depictions of lathe-turned balusters and the actual stone balusters which occur in large numbers both at Jarrow and Monkwearmouth. The twenty-five balusters from Jarrow (no. 30) are all *ex situ* (ibid., I, 120–1), as are another thirty-five from Monkwearmouth (no. 14; ibid., I, 128–9). However, four balusters at Monkwearmouth remain *in situ* incorporated into the west doorway of the tower (no. 8; ibid., I, 125–6). The lower part of this tower is generally agreed to have been a two-storey porch added very early in its history to the first church on the site, founded in 674 (Taylor and Taylor 1965–78, I, 433, 437–9, fig. 204).

This type of large, stone, lathe-turned baluster appears to have been derived from Gaul where there is a surviving fifth-century example from Nouaillé (Cramp 1965, 4, pl. 3). This accords well with the historical evidence for the building of the churches at Monkwearmouth and Jarrow recorded in the anonymous *Life of Ceolfrith* ((——) 1896, 390), and in Bede's *Lives of the Holy Abbots* (Bede 1896, 368), which confirm that Benedict Biscop imported masons from Gaul to oversee the works. There are no small-scale baluster-decorated friezes surviving from Gaul

earlier than the ninth-century impost from Germigny-des-Prés (Cramp 1965, 4; Hubert *et al.* 1970, pl. 251), but there are small-scale balusters in wood, for example, on the seventh-century reading desk of St Radegund (Hubert *et al.* 1969, pl. 23) and on the bed and chair from the Frankish prince's grave under Cologne cathedral (Werner 1964, 206, figs. 6–7).

The dating of the Northumbrian baluster-decorated fragments suggests a comparable late seventh-century or early eighth-century date for the Winchester examples, and in this context it may be significant that there was a large measure of Frankish influence on the West Saxon church in the seventh century. Agilbert, the second bishop of the West Saxons (650–60 or 664) was a Frank (Stenton 1971, 122), and Wine, his successor, had been consecrated in Gaul (loc. cit.). Less is known about the origins of Birinus, the first bishop of the West Saxons (634–650), but it is likely that he was of continental stock as he was consecrated by bishop Asterius of Milan (Mayr-Harting 1972, 100) and there is a surviving letter to him from pope Honorius I urging him to preach in Britain (Stenton 1971, 117). This would make little sense if he were a native Anglo-Saxon.

To judge from the surviving fragments from Winchester Old Minster, large lathe-turned balusters of the Monkwearmouth-Jarrow type did not form part of its early decorative scheme, but at St Augustine's abbey, Canterbury, there is a single fragment of a similar baluster (no. 8; Ill. 50). This was discovered during the demolition of the nineteenth-century wall overlying the south side of the abbey church (Wood, pers. comm.), and can thus only be dated typologically. It is without taper and decorated with a roll moulding, now largely broken away, flanked by pairs of narrow grooves. This use of narrow grooving and the lack of taper are not features typical of later Anglo-Saxon balusters from the region. Those from this site (nos. 6–7; Ills. 41–9) and from St Mary in Castro, Dover (nos. 2–3; Ills. 64–7, 71–5), for example, all lack them. These features are, however, found consistently on balusters of the Monkwearmouth-Jarrow type. It seems reasonable, therefore, to assign the St Augustine's piece to the same date as the Northumbrian balusters, that is, to the late seventh or early eighth century.

Of possible early date is the dedication inscription from St Martin's church, Canterbury (Ill. 57), which is discussed below by Higgitt (pp. 136–7). This is incorporated into a pre-Conquest doorway in the south wall of the chancel, a doorway which Taylor and Taylor have suggested is contemporary with the nave of the church, dated by them to the period 600–50 (Taylor and Taylor 1965–78, I, 143). This would provide a *terminus ante quem* for the making of the sculpture. Taylor and Taylor adduce no evidence for their dating, and it is possible that the doorway, which they admit to be an insertion, is of a later pre-Conquest date. Even if the dating of this doorway to the seventh century is sound, it is possible that the inscription was inserted as part of a later patching. This is supported by the material from which the sculpture is made (limestone, whereas the rest of the doorway and walling is of Roman brick) and by the fact that the stone is only 10 cm deep. This means that it is merely applied to the face of the wall and is not structural. Indeed it seems unlikely that a Christian inscription, possibly the dedication stone of a church, would be set up and then destroyed for reuse within only fifty years of the conversion. The evidence derived from the inscription itself may also suggest a later date (see below, p. 137).

The pattern of use of sculpture in south-east England in the seventh century, therefore, seems relatively clear. The bulk of the material was clearly architectural. It draws on both eastern Mediterranean traditions, as with the column bases from Reculver and St Pancras, Canterbury, and on Frankish traditions in the case of the baluster friezes from Winchester Old Minster and the baluster from St Augustine's Canterbury. In addition there are the two memorial sculptures from Sandwich. This mix of architectural and memorial sculpture is one which is exactly paralleled in early Northumbria (Cramp 1984, I, 23–8). There is a very heavy concentration of material in eastern Kent, at Canterbury and Reculver. In part, this must be an accident of survival and discovery, but equally it is probably no coincidence that sculpture is most abundant in the cradle of early Christianity in south-eastern England. This is the area where the church early acquired wealth and power, and one which remained little affected by the pagan revival of the seventh century (Brooks 1984, 63–107). In contrast, in the eighth century, little sculpture appears to have been made or used within this heartland of early Christianity.

## THE EIGHTH CENTURY

Apart from the baluster friezes from the Old Minster and the lathe-turned baluster from St Augustine's abbey, which may all belong equally to the late seventh or early eighth century, there is only a small

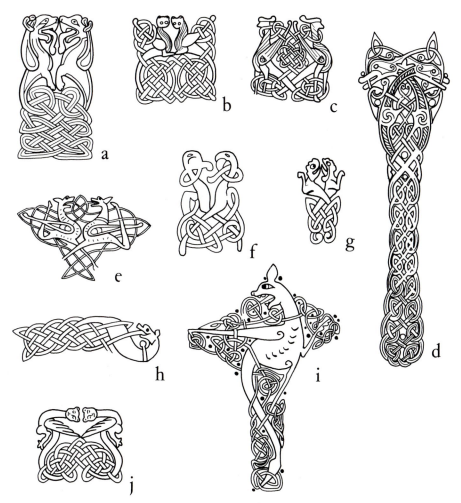

FIGURE 8

Animal types, nts (KEY: a, Elstow 1A; b–c, Gandersheim casket; d, York, Coppergate helmet; e, Witham pins; f, Maaseik, embroideries; g, BL MS Royal I.E.VI, fol 4r; h, Pentney brooch; i, Leningrad Gospels, fol. 16r; j, Peterborough, 'Hedda' stone)

quantity of eighth-century sculpture from south-east England. The only possible candidates are: the cross-shafts from Bedford St Peter and Elstow, Bedfordshire; the shaft from Steventon, the fragments from Little Somborne, and the base from South Hayling, all in Hampshire; and in Winchester itself, some possible examples from the Old Minster (e.g. no. 75), and Upper Brook Street. Even with these pieces it is uncertain whether they belong to the late eighth or the early ninth century.[5]

The use of bipeds on faces A, B, and D of the Elstow shaft (Ills. 269–71) suggests a date for the piece

after the middle of the eighth century, when this animal became the standard type. It is not employed in works of the seventh or first half of the eighth century, such as the Lindisfarne Gospels (Alexander 1978, no. 9, ills. 28–46) or the Vespasian Psalter (ibid., no. 29, ills. 143–6). In these works the animals are quadrupeds or birds, often conventionalised and contorted, but still recognisable. Bipeds predominate in the works of the mid to late eighth century, however, as in the Leningrad Gospels (ibid., no. 39, ills. 188–95) and the Barberini Gospels (ibid., no. 36, ills. 169–78), and this remained the case into the early ninth century. BL MS Royal I. E. VI, for example, makes extensive use of bipeds (ibid., no. 32, ills. 160–4; see Fig. 8).

The late eighth- or early ninth-century date suggested for the Elstow shaft by the use of bipeds is

5. The dating of the fragments from Reculver, Kent (no. 1), for which an eighth-century date has been proposed (Wilson 1984, 72) is discussed separately in Chap. VI.

supported by the fact that on faces A and D the hindquarters of the animals develop into interlace (Ills. 269, 271). This feature appears to have been a mid eighth-century development, first observed in the Stockholm Codex Aureus, as, for example, on fol. 11r (Alexander 1978, no. 30, ill. 152), and one which became very popular in the late eighth and early ninth centuries in works in almost every medium: in manuscripts, as on fol. 16r of the late eighth-century Leningrad Gospels; in ivory, as on the rear of the Gandersheim casket (Beckwith 1972, 18, no. 2, pls. 10–13); and in metal, as on the Witham pins (Wilson 1964, no. 19. pl. XVIII) and on the nasal of the Coppergate helmet (Tweddle 1983a, 110–11, fig. 2; 1984, pls. on 14). Bipeds developing into interlace also occur in the repertoire of the late eighth or early ninth century Maaseik embroideries (Budny and Tweddle 1984, pl. Vb). In all of these examples the animals not only develop into interlace, but are enmeshed in it. The reduction and disciplining of the interlace, seen on the Elstow shaft, was apparently a development of the early ninth century. For example, in the early ninth-century Bible fragment BL MS Royal I. E. VI, on fol. 4r, the fields above the capitals of piers two and four of the Canon Table arcade are filled with paired bipeds very similar in form to those at Elstow, and also developing into interlace; the animal's bodies are interlocked, but they are rigidly separated from the interlace which, as at Elstow, fills the lower part of the field (Alexander 1978, no. 32, ill. 162). This more highly-disciplined disposition of the interlace persisted throughout the ninth century, as, for example, on works decorated in the Trewhiddle style. On them paired bipeds occur relatively infrequently, but single animals with their hindquarters developing into interlace are common. Again the separation of the animal from the interlace is usual, as, for example, on the largest of the brooches from Pentney, Norfolk, where the outer border of the brooch is decorated with eight fields each containing ornament of this nature (Wilson 1984, pl. 120).

This disciplining of the interlace suggests an early ninth-century date for the Elstow shaft, but is contradicted by the occurrence of spiraliform elements within the interlace itself. These argue for an earlier, eighth-century, date. Spiral ornament was popular throughout the eighth century in works in all materials, as, for example on fol. 30v of the Vespasian Psalter (Wilson 1984, no. 29, pl. 146), on fol. 150v of the Stockholm Codex Aureus (ibid., no. 30, pl. 147), on the rear of the Gandersheim casket (Beckwith 1972, no. 2, pl. 13), and on a fragmentary copper-alloy disc from Ixworth, Suffolk (Hinton 1974, no. 18,

pl. VIII.18). It had, however, fallen out of fashion by the early ninth century (Budny and Graham-Campbell 1981, 11); spiral ornament is absent, for example, from both BL MS Royal I. E. VI and from almost the entire corpus of Trewhiddle-style metalwork. The only exception is the pommel from Fetter Lane in London, but this arguably belongs just before or at the very beginning of the Trewhiddle style, around 800 (Wilson 1964, no. 41, pl. XXIII). Certainly the best parallel to the spiraliform interlace on face D at Elstow (Ill. 271) is provided on fols. 78r and 119r of the mid to late eighth-century Leningrad Gospels (Alexander 1978, no. 39, ills. 193–4).

The general repertoire of the decoration of the Elstow shaft therefore, consisting of animal ornament and interlace, without plant ornament, suggests a date in the late eighth century, at a time before plant ornament, with the possible exception of vine- or plant-scroll, became popular in Anglo-Saxon art (Budny and Graham-Campbell 1981, 11). This suggestion is supported both by the form of the animals and by the use of spiraliform elements, as spirals seem to have dropped out of use in Anglo-Saxon art by the early years of the ninth century. Only the rigid separation of the interlace from the animal bodies on faces A and B argues in favour of an early ninth-century date, and this feature alone is not distinctive enough for much weight to be placed upon it.

Closely related to the decoration of the Elstow shaft is that on the shaft from Bedford (Ills. 265–7). Only two of the faces are now visible. One of them is decorated with interlace, but the other is ornamented with a pair of confronted winged bipeds with their hindquarters developing into interlace. This decoration is of the same type as that used on face A of the Elstow shaft (Ill. 269), although the animals are simplified and lacking in detail, and the workmanship is of much poorer quality. As with the animals on the Elstow shaft the interlace is highly disciplined, occupying only the lower third of the field; the animals themselves are not enmeshed or embedded in it. As argued above, all these features are indicative of a late eighth-century date, with only the highly disciplined nature of the interlace perhaps arguing for a slightly later date.

In addition to the cross-shafts from Elstow and St Peter's, Bedford, there are other possible eighth-century cross-shaft fragments from the region, all from Hampshire: one from Steventon, and one from Winchester (Upper Brook Street). In addition, the closely-related fragments from Little Somborne probably derive from a cross-shaft.

FIGURE 9
Steventon 1, Animal types, nts (KEY: a, face B, upper; b, face A;
c, face B, lower)

All of these sculptures share the same basic
decorative repertoire; they are ornamented with paired
or single ribbon-like animals with their contoured and
hatched or pelleted bodies developing into, and
embedded in, interlace. There are differences in detail.
On the Steventon shaft (Fig. 9; Ills. 471–2) the animals
on face A are confronted, with their necks and
undulating bodies crossing symmetrically. The limbs
are suppressed and the interlace develops from the
animals' tongues. On face B each field is filled with a
single animal body, which lacks both head and limbs
and is enmeshed in interlace. The shaft from Upper
Brook Street, Winchester, is heavily weathered (Ill.
683), but the single visible face is apparently decorated
with two looped animal bodies, one developing from
each end (Fig. 10a), and enmeshed in interlace. The
fragments from Little Somborne are too fragmentary
for the form or disposition of the animals to be
established (Ill. 447), but their presence is clear, as is
their relationship with the other Hampshire pieces
noted above.

These pieces form part of a well-defined group of
sculpture, first recognised by F. Cottrill (Cottrill
1935), whose distribution is firmly south-western.
The principal examples are from Ramsbury and
Colerne, Wiltshire; Shaftesbury, Dorset; Rowberrrow
and West Camel, Somerset; Dolton, Devon; and
Tenbury, Worcestershire (Figs. 10 and 11). These
additional pieces greatly extend the repertoire of
ornament employed on the Hampshire examples. At
Colerne there are confronted animals with spiral hips
(ibid., pl. XV); at Dolton there are addorsed winged
bipeds (Reed 1935, 286–7, pl. XXVI, fig. 2); and at
Dolton (loc. cit.) and West Camel (Cottrill 1935, pl.
XVIII) there are paired animals viewed from above

with their bodies crossing symmetrically. Animals
viewed from above appear again at Tenbury (ibid, pl.
XIV), and there is a leafless tree-scroll with a
segmented stem at West Camel (ibid., pl. XVIII).

Wilson has suggested that the animals on the
sculptures from Ramsbury, West Camel, and Colerne,
with their ribbon-like, contoured, and textured
bodies, are related to those of the Viking Jellinge style

FIGURE 10
Animal types, nts (KEY: a, Winchester Upper Brook Street 1A; b,
Ramsbury; c–e, Tenbury; f–g, Colerne)

FIGURE 11
Animal types, nts (KEY: a–b, West Camel; c–d, Dolton; e,
Gloucester; f, Ramsbury)

southern England. As noted above (pp. 35–6), the use of animals embedded in interlace was particularly popular in the eighth century, with the use of animals with their hindquarters actually developing into interlace, as at Steventon, Ramsbury, and Tenbury, being an innovation of the mid eighth century, employed for the first time in the Stockholm Codex Aureus. In contrast, by the early ninth century the animal and interlace were often rigorously separated, the interlace reduced, and the emphasis was placed upon the animal. The late eighth-century date which can be suggested for the group on these grounds is confirmed by the use of spirals on the joints and on the neck of the animals at Colerne. As noted above (p. 36), the spiral was popular in the seventh and eighth centuries, but had virtually dropped out of use in Anglo-Saxon art by the early ninth century (Budny and Graham-Campbell 1981, 11). Equally suggestive is the appearance of plant ornament at West Camel, as this was an innovation of the mid to late eighth century (loc. cit.).

The late eighth-century dating for this group suggested by the over-all type and disposition of the ornament can be confirmed by specific comparisons with works in other materials, particularly with the mid to late eighth-century Leningrad Gospels (Alexander 1978, no. 39, ills. 188–95, frontispiece). This uses the same general repertoire of ornament as the south-western group of sculptures: a small amount of plant decoration, as on fols. 12r, 12v and 13v (ibid., no. 39, frontispiece, ill. 188), and a mixture of single or paired winged bipeds or ribbon-like animals developing into, and embedded in, interlace. As at Dolton and Tenbury some of these animals are viewed from above, for example on fols. 12v, 16v and 16r (Fig. 12; ibid., no. 39, ills. 188 and 190). Almost all of the animals in the Leningrad Gospels have contoured bodies, but the effect is achieved by the use of colour and not line. Hatching of the bodies is rarer, but does occur, as on the bodies of the animals forming the arch heads and pier bases of the Canon Table on fol. 16r (ibid., no. 39, pl. 190), and on the body of the quadruped enclosed by the letters L and I of the *Liber Generationis* page, fol. 18r. As with the Colerne shaft, a number of the animals have spiral joints, either to the wing or legs, as on fols. 12r and 18r (Wilson 1984, pl. 110). In their disposition some of the animals on the Leningrad Gospels provide very close parallels to those employed on the south-western group of sculptures. For example, the paired winged bipeds on fols. 12r and 16r are relatively close in form to those on the Dolton fragments (Alexander 1978, no. 39,

(Wilson 1984, 106). This view divorces these pieces from the closely-related examples discussed by Cottrill without argument, and fails to provide an historical context for the introduction of the Jellinge style into the heartland of Wessex. In fact, all of the features of the decoration of these shafts, and of the rest of the group defined by Cottrill, can be paralleled within the native Anglo-Saxon artistic tradition current in

FIGURE 12
Animal types, Leningrad Gospels (after Schröde 1974, nts) (KEY: a, fol. 16r; b, fol. 16v; c, fol. 12r; d, fol. 16v; e, fol. 12v; f, fol. 12r)

frontispiece, ill. 190), whilst the looping of the paired animal bodies from either end of a narrow field on fols. 12r and 12v (ibid., no. 39, frontispiece, ill. 188) provides a good parallel for the ornament on face B of the Steventon shaft (Ill. 472), and for the decoration on the Upper Brook Street shaft from Winchester (Ill. 683). In one field on fol. 12r the loop of the animal's body is clasped in interlace of almost identical form to that deployed in similar situations on the Steventon shaft. The Leningrad Gospels also make extensive use of paired animals whose bodies undulate regularly,

crossing and recrossing, as on fols. 12v, 17r, and 17v (ibid., ills. 188, 191), a feature paralleled at Steventon, West Camel, and Dolton. All these comparisons suggest a broad contemporaneity between the Leningrad Gospels and the south-western group of sculptures.

By contrast, it is difficult to find an adequate parallel either in metal or ivory for the decorative schemes deployed on the south-western group of sculptures. They are clearly generically similar to those on a number of eighth-century works, such as the

Gandersheim casket (Beckwith 1972, 118, no. 2, pls. 10–13), the Larling plaque (Wilson 1984, pl. 97), and the Witham pins (Wilson 1964, no. 19, pl. XXIII), but the animals on the sculptures are usually ribbon-like, rather than the bipeds which are the norm on all of these works, although one of the Witham pins does employ a ribbon-like animal viewed from above, as on the Dolton and Tenbury shafts. The only close parallel to the sculptures in either metal or ivory is provided by the decoration on the nasal of the late eighth-century Coppergate helmet (Tweddle 1983a, 110–11, fig. 2; 1984, pls. 14). This consists of a pair of confronted bipeds with undulating ribbon-like bodies regularly crossing and recrossing before developing into interlace, a form employed at Steventon, Colerne, West Camel, and Dolton. In addition the Coppergate animals have a spiral on the neck, a feature paralleled at Glastonbury, Somerset, and Colerne. The bodies of the Coppergate animals are contoured and hatched, a treatment which is difficult to parallel on other Anglo-Saxon metalwork, but which, as noted above (p. 37), consistently occurs in works of the south-western group of sculptures. The only major difference between the decoration employed on the nasal and that of the sculpture lies in the tight disciplining of the helmet's decoration, something normally lacking on the sculptures. Unfortunately, this comparison does little to refine or support the late eighth to early ninth-century date advanced for this group of sculptures on the basis of the manuscript parallels, as the helmet itself is dated primarily by art-historical methods.

Another possible eighth-century piece from Hampshire is the cross-base from South Hayling, Hampshire (Ills. 465–9). Unfortunately, it has been savagely damaged by weathering and the decoration is difficult to decipher (see pp. 265–6, Fig. 38). Given the condition of the piece, detailed comparative study and hence close dating is impossible; however, the ornament permits dating to within broad limits. In particular, the combination of spiral-based ornament and plant ornament suggests a late eighth- or early ninth-century date, a period, as noted above (p. 36), when spiral ornament was dropping out of use (Budny and Graham-Campbell 1981, 11) and when plant ornament was making its first consistent appearance in Anglo-Saxon art (loc. cit.). This dating is reinforced by a consideration of the decoration on face C (Ill. 467). If this can be interpreted as a double-spiral animal then the form is both distinctive and unusual. It occurs in the Canon Table arch heads on fol. 16r of the Leningrad Gospels (Alexander 1978, no. 39, ill. 190), and in the late eighth-century Hereford Cathedral Library MS P. I. 2

on fol. 102r, (ibid., no. 38, ill. 199). Here the motif appears twice on the monogram INP, but in each case the elements of the double spiral are separated by the downstrokes of the letters. Nevertheless, the comparison with the South Hayling example is reasonably close.

## THE NINTH AND EARLY TENTH CENTURIES

In the ninth to early tenth centuries, there was a modest increase in sculptural production, with nearly three times as many pieces attributable to this period compared with the eighth century.[6] Moreover, whereas the eighth-century pieces from south-east England appear to belong to the periphery of sculptural traditions centred outside the region, in the ninth century there seems to be a resurgence of sculptural innovation and production centred in the region. Four of the sculptures probably from this period are from Hampshire, the round shafts from Priors Barton and High Street, Winchester, a grave-marker from Whitchurch, and a crucifixion panel from Romsey (no. 2). There are also twelve pieces from Kent: seven fragments of a round shaft from Reculver (no. 1) discussed in detail in Chap. VI, fragments of cross-shafts of square section from Preston by Faversham and Rochester 1, and three fragmentary capitals from St Augustine's abbey, Canterbury (nos. 3–5). In addition there is a stoup rim from Godalming, Surrey (no. 1), a grave-cover from Oxford (New Examination Schools 1) and a sundial from Bishopstone, Sussex.

Amongst the Hampshire sculptures the most varied in its decoration is the grave-marker from Whitchurch, Hampshire. This has a semicircular head which on face C is filled with an incised leafless tree-scroll with only a single pair of branches and confined within a semicircular border (Ill. 484). On face A is a recessed field containing a high-relief, half-length figure identified by its cruciform nimbus as Christ (Ill. 483). On the edge, running over the semicircular head of the stone is a framed memorial inscription (Ills. 482, 485–9). Originally the sculpture must have been accomplished, but it is now heavily weathered. With such a restricted repertoire of ornament, combined with extensive damage, dating is difficult, but, as noted above (p. 36), the use of plant ornament suggests a late eighth-century date at the earliest; plant ornament was not used consistently in Anglo-Saxon art until that date, becoming common only in the

6. This figure excludes the grave-marker, Old Minster 1, and several minor fragments from Old Minster (nos. 31, 59–61, 63, 65, and 75) which are probably also of ninth-century date.

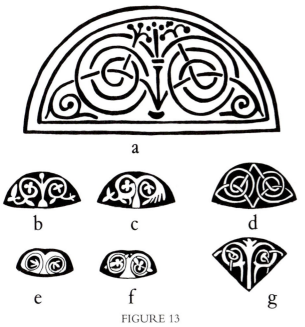

FIGURE 13

Tree scrolls in semicircular fields, nts (KEY: a, Whitchurch 1C; b–c, Lilleby mount; d, Hedeby disc; e–f, Komnes disc; g, Tessem mount

ninth century (Budny and Graham-Campbell 1981, 11). The precise form of plant ornament used here (Ill. 484) occurs in manuscript art only in one of the Canon Table column bases on fol. 12v of the mid to late eighth-century Leningrad gospels (Alexander 1978, no. 39, ill. 188), although there is something similar within the upper element of the initial B on fol. 3v of the Leningrad Bede, dated to *c.* 746 (ibid., no. 19, ill. 83). However, neither of these provides a particularly close parallel to the Whitchurch scroll. To find something much more closely comparable it is necessary to turn to metalwork (Fig. 13). A firm ninth-century date for the Whitchurch piece is supported by a ninth-century *pressblech* disc from Hedeby (Fig. 13d; Capelle 1968, no. 72, taf. 25.1). This disc is decorated with a free-armed Anglian cross having in each of the re-entrant angles a semicircular field filled with interlace. The interlace is, however, almost identical in form with the scroll at Whitchurch and must originally have been derived from a similar leafless tree-scroll.[7]

The motif of the leafless tree-scroll used on the Whitchurch piece occurs again on a fragment of a round shaft from Winchester, High Street (Ills.

7. The ninth-century date argued for the Whitchurch piece on art-historical grounds is supported by a study of its epigraphy. As Higgitt points out (p. 272), the letter forms of the inscription suggest a date not much later than the end of the ninth century.

679–82). Here the plant has a stepped base and a single pair of median-incised branches, and as the shaft has been broken away above there must originally have been several more pairs of branches. This type of continuous tree-scroll has a very wide date range, from the late eighth or early ninth century, as in the Barberini Gospels (Alexander 1978, no. 36, ill. 170) or on the Alstad mount (Bakka 1963, 37–40, figs. 32–3), to the late ninth or early tenth century as on the shaft from East Stour, Dorset (Backhouse *et al.* 1984, no. 23, pl. II). After this date the form persisted but was reclothed in acanthus foliage, as in the borders of the Presentation Scene of the New Minster foundation charter, for example (Temple 1976, no. 16, ill. 84). Leafless tree-scrolls are, however, relatively uncommon in southern England and, apart from the specialised version employed on the Whitchurch piece, the closest parallel to the scroll on Winchester High Street 1 is on the late eighth- or early ninth-century shaft from West Camel, Somerset (Cottrill 1935, pl. XVIII.2). Here the scroll is similarly without leaves and has a segmented stem. If the decoration of the shaft from High Street is ambiguous in terms of dating, then its round-shaft form is suggestive, for that appears to have been a ninth-century introduction (Cramp 1978, 9); it does not, for example, occur among the eighth-century pieces discussed above.

From Priors Barton on the outskirts of Winchester comes another fragmentary round shaft, in this case decorated with four vertical fields separated by plain relief mouldings on stepped bases, possibly originally supporting arch heads (Ills. 686–90). The use of acanthus foliage (Ill. 688) is significant and would, at first sight, suggest a tenth-century date for the shaft, since acanthus foliage does not appear in manuscript art until that date. However, the combination of animal, plant, and interlace ornament, with the different types of ornament alternating with each other, is more reminiscent of late eighth- and early ninth-century art. The embroideries of this date from the church of St Catherine at Maaseik, Belgium, for example, have a series of arches filled alternately with plant and animal ornament. The arch heads are decorated with alternating interlace and plant ornament, while the columns supporting the arch heads and the spandrels are filled with animal, plant, or interlace ornament varying in complex rhythm. These embroideries were probably made in southern England (Budny and Tweddle 1984). Similarly, the arcades framing the Canon Tables in the early ninth-century manuscript BL MS Royal I. E. VI are decorated with rectangular fields filled alternately with

different types of ornament (Alexander 1978, no. 32, ills. 162–4). As on the Priors Barton shaft the plant ornament develops animal heads, although this feature is not confined to the ninth century, and is seen on the eighth-century Bjørke mount, for example (Bakka 1963, 12–15, fig. 8). This rhythmical alternation of different types of ornament occurs also in metal as, for example, in the borders of one of the pairs of early ninth-century disc brooches from Pentney, Norfolk. Here animal and plant ornament alternate as does the technique of the decoration. The plant ornament is in openwork and the animal ornament has the background inlaid with niello (Wilson 1984, pl. 120).

Disregarding the leaf form, the organisation of the partially defaced plant on the Priors Barton shaft, with the branches ending in a leaf and berry bunch, is also best paralleled in ninth-century art; in particular on the Mosnaes brooch, a Scandinavian type of trefoil brooch with the ornament based on Anglo-Saxon exemplar (Graham-Campbell 1980b, 438), although a tenth-century date is arguable for this piece (Wilson, pers. comm.). There is no precise equivalent to this arrangement which can be securely dated to the tenth century, although there is something similar on the cross-shaft from Littleton Drew, Wiltshire (Kendrick 1938, pl. LXXXIV 2–3). However, the combination of bush scrolls with berry bunches seen at Priors Barton can equally be paralleled in the tenth century, for example, in the margins of the presentation scene of the *Vita Cuthberti*, made in Winchester *c.* 935–9. Here as at Priors Barton the scrolls also have acanthus leaves (Temple 1976, no. 6, ill. 29). It is also at this period that acanthus appears elsewhere on sculpture. A grave-cover from St Oswald's Priory, Gloucester, is decorated with a bush scroll with acanthus foliage very similar to that on the Priors Barton shaft (West 1983) and this piece has been dated to the first half of the tenth century, possibly to the 930s (ibid., 50) as has a similar cover, decorated with an acanthus tree-scroll, from Wells, Somerset (Rodwell 1980, pl. 7). It is, therefore, possible that the Priors Barton shaft is not a ninth-century piece, as the types of ornament and their combination suggests, but represents the survival into the tenth century of these earlier decorative traditions which were then combined with newer elements such as acanthus foliage.

Related to the ornament on the Priors Barton shaft is the decoration of a grave-cover from the New Examination Schools, Oxford (Ill. 363). This has a median ridge on either side of which is an inhabited simple scroll with a segmented stem, large ragged acanthus leaves, and berry bunches each with three

a                                                   b

FIGURE 14

Inhabited Acanthus scrolls, nts (KEY: a, Oxford New Examination Schools 1A; b, Cambridge, Corpus Christi College MS 183, fol. 1v)

fruit, the same general type of ornament as on the Priors Barton shaft. The details of the cover are obscured by heavy weathering, but the ornament appears to be closely paralleled in the borders of the presentation scene in the *Vita Cuthberti* where the same simple scroll with a segmented stem is also employed (Fig. 14). As on the Oxford piece, the scroll is inhabited by birds and has acanthus foliage and berry bunches with three fruit. This close parallel may suggest a date in the first half of the tenth century for the Oxford cover, a date supported by comparison with the similar inhabited simple scroll with acanthus foliage on a shaft from Colyton, Devon. This shares with the Oxford carving the use of the simple scroll with large, flat, rather shapeless acanthus leaves inhabited by birds. Again there are berry bunches composed of three fruit (Kendrick 1949, pl. XXXIV). A later date for the Oxford piece is, perhaps, unlikely; although inhabited acanthus scrolls do occur in the late tenth and eleventh centuries, as on the bronze openwork strap-end from Winchester (Roesdahl *et al.*

1981, J6, pl. p. 168; Biddle 1990a, no. 1057), or the ivory pen case from London (Kendrick 1949, pl. XXXVI.1), they are usually bush scrolls. Moreover, the later examples employ full-blown Winchester-style acanthus ornament, absent both from the *Vita Cuthberti* and the Oxford cover.

Also linking closely to the manuscript art are the acanthus sprays on the crucifixion panel from Romsey (no. 2). This depicts the crucified Christ accompanied by the Virgin and St John, the figures of Stephaton and Longinus, and an angel on either side of the cross-head. Acanthus sprays develop from the lower limb of the cross and the lower edge of the panel (Ills. 453, 455). Two of these sprays consist of a stem from which emerges a pair of down-turned leaves, a form which echoes the tree scroll used at Whitchurch (Ill. 484). Acanthus of very similar form is used to decorate the lower corners of the border of the second Christ in Majesty page of the Aethelstan Psalter (Temple 1976, no. 5, ill. 33) and to decorate the borders containing single figures in the calendrical material prefacing the Psalter, as on fol. 9v (ibid., ill. 15). Similar acanthus sprays are used as scene separators on the St Cuthbert stole (Battiscombe 1956, pl. XXXIV). The stole is dated by inscription to *c.* 909–16, and there is little reason to doubt the traditional association of the Psalter with king Aethelstan (924–39). These parallels for the foliate ornament would, therefore, place the Romsey panel in the first half of the tenth century, although the possibility of an earlier date should not be discounted, particularly since Cramp has pointed out the strong stylistic links between the piece and west midland styles of the ninth century (Cramp 1972, 146). These links are particularly noticeable in the round staring eyes and the flat treatment of the drapery with the details picked out by shallow incised lines.

In summary, dealing with the group of Hampshire material, with its outlier in Oxfordshire, it is possible to indicate some stylistic links, including the preference for tree or bush scrolls, sometimes within a semicircular border, and sometimes with acanthus foliage. Other traits include the preference for small-scale figure sculpture and the use of round shafts. These links are clearly far too weak and the sculptures too few to suggest the existence of a single school of sculpture, but, combined with both the restricted geographical distribution and date range of the pieces, they are enough to suggest that the sculptures belong within a single evolving tradition. The distribution of the pieces suggests that this tradition was based on Winchester, a conclusion supported by the close links

between the sculptures and works in other materials which were probably produced there, such as the *Vita Cuthberti*, the Anglo-Saxon additions to the Aethelstan Psalter, and the St Cuthbert stole and maniple.

As well as the Hampshire material, there is also important ninth- and early tenth-century sculpture from Kent. Of the thirteen fragments from the county dating to this period, by far the most important are the carvings from Reculver (nos. 1–3). So multifarious and complex are the problems which these highly classicising pieces raise that they are discussed in detail in Chap. VI, where it is argued that they should be dated to the early part of the ninth century and set alongside BL MS Royal I. E. VI. This is another such highly classicising work, which was probably made at St Augustine's abbey, Canterbury, in the period *c.* 820–40. Both this luxurious manuscript and the Reculver fragments seem to derive from, and closely reflect, contemporary developments in Carolingian art.

The presence in Kent of these two strongly classicising works, reflecting Carolingian artistic trends, may provide a context for the three classicising capitals from St Augustine's abbey, Canterbury (nos. 3–5). These were discovered built into the foundations of the screen of the Romanesque abbey church during excavations in 1915–16, and consequently have no good archaeological context. They have, therefore, proved difficult to date. The capitals are of a debased composite form with a zone of upright leaves at the base separated from the corner volutes by a narrow recessed zone of interlocking triangles. In the centre of each face in the upper zone of the most intact example is a rosette (Ills. 29–40). There are no closely comparable pieces from Anglo-Saxon England, but debased composite capitals were produced in France at least from the seventh century right up to the eleventh century (Fossard 1947). The problem with the Canterbury capitals has been to find a context into which the introduction of this type of capital into England would fit. A seventh-century date, contemporary with the Merovingian examples, is possible and has been argued by Gem (pers. comm.) and West (pers. comm.). More often the capitals have been connected with the building of the octagon at St Augustine's abbey by Abbot Wulfric (1047–59), since the design of the building is known to have been influenced by William de Volpiano's St Benigné at Dijon, begun in the year 1001 (Peers 1927a, 215; Conant 1974, 149–53). There, debased Corinthian capitals survive, although none closely resembles the Canterbury capitals, but there are no surviving

composite capitals. H. M. and J. Taylor have, however, pointed out the very close resemblance between the Canterbury capitals and a Corinthian capital in the crypt of St Germain, Auxerre, which can be dated to the period 841–65 (Taylor and Taylor 1966, 47–9, fig. 20). Here the lower zone of upright leaves is similar to those on the Canterbury capitals (though less stylized), but the zone with the volutes is very similar in form and, as at Canterbury, has a rosette in the centre of each face. There are related capitals in the ninth-century crypt at Flavigny (loc. cit.), where the upright leaves more closely resemble those at Canterbury, but the volutes on the upper zone are suppressed and the rosettes greatly enlarged. No ninth-century building campaign is documented at St Augustine's abbey, but the production there in the mid ninth century of BL MS Royal I. E. VI argues for very strong Carolingian connections, and provides circumstantial evidence for the dating of the capitals proposed by Taylor. Supporting evidence for this proposed ninth-century date derives from the analysis of the blue paint used on one of the capitals (see p. 131). This proves to be Egyptian blue, a colourant current in the late Roman period, but which then fell out of use until the period of the Carolingian renaissance. Given the lack of knowledge of colourants used on stone in the Anglo-Saxon period, too much weight should not be given to this evidence, but it is nonetheless suggestive.

The Reculver fragments (nos. 1–3) and the Canterbury capitals (nos. 3–5) belong to a highly classicising tradition which can be paralleled in part in the decoration of BL MS Royal I. E. VI. The native Anglo-Saxon element in the decoration of this manuscript is less in evidence on stone sculpture from Kent, but is paralleled on a piece of sculpture from Godalming, Surrey (no. 1). This consists of a stone ring, the outer face of which is divided by four equally-spaced animal masks into rectangular fields, each with a broad, plain border. Two of the fields (Ills. 85, 91) are filled with median-incised interlace, one (Ill. 84) with a biped whose tail develops into interlace, and the fourth (Ill. 86) with a simple scroll with elongated triangular leaves. The layout of the ornament on Godalming 1 very closely resembles that of the Canon Table frames of Royal I. E. VI, which also have the decoration split into a series of rectangular panels within broad, plain borders (Alexander 1978, no. 32, ills. 162–4). This panelling of the decoration within broad borders developed in the eighth century, as in the Canon Table arcades of the Leningrad Gospels (ibid., no. 39, frontispiece, ills. 188–91) and Maaseik Gospels (ibid., no. 23, ills.

96–107) and in the initials of the Barberini Gospels (ibid., no. 36, ills. 169–72), but persisted into the ninth century, as in BL MS Royal I. E. VI (ibid., no. 32, ills. 162–4) and Cotton Tiberius C. II (ibid., no. 33, ill. 165). In the eighth-century examples the fields are filled almost exclusively with animals enmeshed in interlace, but, as noted above (p. 36), in the late eighth and early ninth century the alternation of animal, interlace, and plant ornament used at Godalming 1 became the norm. In Royal I. E. VI, for example, the fields are filled with interlace, animal or plant ornament. The animals are bipeds, as at Godalming 1, and develop at their extremities into different forms of decoration. This is usually plant ornament in Royal I. E. VI, but on Godalming 1 it is interlace. The Royal manuscript also employs the simple scroll with triangular leaves tucked under the stems, as on the Godalming piece, and the fields of ornament in the manuscript are often separated from each other by small square or circular fields; these serve the same purpose as the animal masks at Godalming (Ills. 82, 87–90). Animal masks are used as separators in the Royal manuscript, as on fol. 4r, but there they divide the ornament within a single field (ibid., no. 32, ill. 162). These parallels are enough to suggest an early ninth-century date for the Godalming piece, close to that of Royal I. E. VI.

A similar or earlier date can be suggested for a second, fret-decorated, fragment from Godalming (no. 2), as the fret (Ills. 92–3), although popular in the seventh to early ninth centuries (see, respectively, fols. 17v and 94v of the Lindisfarne Gospels (Backhouse 1981, pls. 22 and 28), fol. 30v of the Vespasian Psalter (Alexander 1978, no. 29, ill. 146), and fol. 43r of BL MS Royal I. E. VI (ibid., no. 32, ill. 161)), fell out of common use, at least in manuscript art, thereafter. Simple frets continued to be used in other materials in the tenth and eleventh centuries, as on the shanks of bone and metal dress pins from York, but none approaches in complexity the fret on the Godalming piece.

There remain two fragments of sculpture in Kent which possibly date to before c. 950; the interlace-decorated fragmentary cross-shafts from Rochester (no. 1) and Preston by Faversham. The Rochester piece was discovered during a controlled excavation, but was residual in a later level and, therefore, not closely datable archaeologically. The interlace on the single surviving decorated face (Ill. 141) has been reconstructed by Swanton as an encircled pattern with bifurcating strands (Harrison and Williams 1979, 34–5, fig. 7), but the pattern can be reconstructed

more convincingly without them. Whatever its precise reconstruction, the fine strand of the interlace can be compared with that on Reculver 1e (Ills. 119–20), and the piece may, therefore, be tentatively placed in the ninth century. Similarly, the fragmentary cross-shaft of square section from Preston by Faversham (Ills. 101–4) is decorated exclusively with interlace, including half patterns A and C. The use of half patterns is unusual in south-east England, being paralleled on Reculver 1e, where half pattern D is used. The interlace of the Preston shaft has a thicker strand than that used at Reculver, but the design is well worked out and executed, and may, on analogy with the Reculver fragment, be assigned to the ninth century.

Despite the diversity of the Kentish sculpture there are links between some of the pieces, and in particular, between the Reculver fragments (nos. 1–3), the Canterbury capitals (nos. 3–5), and the carvings from Godalming; the Rochester 1 and Preston by Faversham fragments are more distantly related. As with the Hampshire material these relationships are not strong enough to suggest that the pieces belong to a single school, but they do appear to belong to the same artistic milieu. As in Hampshire, the sculpture of the region is focused on a major ecclesiastical centre, in this case Canterbury, with the manuscript art of which the sculpture has close relationships. Again the material has a classicising element, apparently derived from Carolingian art, although that element is very much stronger in Kent than in Hampshire. The parallels and links between the two regions are significant, but many more discoveries will need to be made before these conclusions can be either substantiated or disproved.

One piece which is geographically isolated from both these groups of ninth century sculpture is the sundial from Bishopstone, Sussex (Ills. 6–7). This is apparently *in situ* in a fabric which the Taylors place before 950 (Taylor and Taylor 1965–78, I, 71–2). There is little internal evidence either to support or disprove this suggestion. The inscription on the face is short, but Okasha places it in the eleventh or twelfth century (Okasha 1971, no. 12). On epigraphical grounds Higgitt prefers a date in the ninth or tenth centuries (p. 125). Apart from the inscription the only decorative feature is the fret around the head of the dial. This may support an early date, as frets are rare in late pre-Conquest art, at least in southern England, although fairly commonplace in the ninth century and earlier; but this is a slender basis on which to determine the date of the carving.

# CHAPTER VI

# THE DATE AND STYLISTIC CONTEXT OF THE RECULVER FRAGMENTS

## by D. Tweddle

The central problem faced by any student of the fragments from Reculver, Kent, lies in deciding, firstly, whether or not all of the pieces for which a claim to have originated at Reculver (Reculver 1–3 and Canterbury Old Dover Road 1) has been advanced are in fact from that site; secondly, if such a claim can be substantiated, whether or not they derive from a single monument; and lastly, how that monument may be reconstructed. In reaching any conclusions about these difficult issues a number of factors must be considered: the style of the decoration of the fragments; the technique of carving; the comparative size and stone types of the various drums; and the documentary evidence for a cross at Reculver provided by the account of the early sixteenth-century antiquary John Leland, and by the late thirteenth-century register of archbishop Winchelsea. The detailed analyses of these problems are presented in the discussion of the various pieces in the catalogue, where it is argued that, despite their differing find-spots, the sections of shaft Reculver 1a–e, Canterbury Old Dover Road 1, and probably also the lost fragment Reculver 2, all derive from the same monument, whereas the relationship between that monument and the one described by Leland (and perhaps also referred to in Winchelsea's register) remains an open question. It is further proposed that the lost cross-head from the site, Reculver 3, probably derives from a different monument to the one probably represented by nos. 1–2. Any conclusion on these issues remains to an uncomfortable degree subjective; nevertheless, the broader questions of the stylistic context and date of the fragments which form the subject of the present chapter, will proceed on the basis of the conclusions outlined above.

The fragments from Reculver have excited much interest among twentieth-century art historians who, from the time of Peers onwards, tended to consider them to be of an early date (Peers 1927b), and such a view has also been advocated in a recent major study (Kozodoy 1976; idem 1986). There seems little doubt that the lack of publication both of Anglo-Saxon sculpture and of works in other materials from south-east England handicapped Kozodoy in her study. This apparent lack of comparative material led her to dismiss the suggestion that there could be any local context for the Reculver fragments. Instead she compared the iconography, figural and drapery styles of the fragments first with Late Antique and early Byzantine models. These comparisons are often sound, and on occasions compelling, but Kozodoy failed to confront the fact that much of Anglo-Saxon art both in content and style is based on Late Antique exemplars, either directly, or through intermediaries. An alternative view of the date and stylistic context of the stones is presented here.

The Reculver fragments are normally regarded as of late seventh-century date (Peers 1927b, 255; Brown 1903–37, VI(2), 172; Clapham 1930, 68; Kendrick 1938, 116–8; Beckwith 1968, 18; Kozodoy 1976; Kozodoy 1986, 90), although the validity of this dating has been challenged (Stone 1955, 19; Taylor 1968, 295; Rice 1952, 97–8; Tweddle 1983b, 30–5; Wilson 1984, 71–2). A seventh-century attribution rests principally on the archaeological evidence from Peers's excavations of 1926. In these excavations Peers uncovered an *opus signinum* floor in the nave of the church, which he believed was contemporary with the first, late seventh-century, phase of building at Reculver. This floor stopped against a rectangular base in front of the triple arcade separating the nave and chancel, and, therefore, Peers argued that this base must also have belonged to the first phase of building. Peers equated the base with that on which the cross

seen by Leland stood, and as he identified the surviving sculptured fragments as part of that cross, he assigned them also to the seventh century (Peers 1927b, 247).

Peers's argument is open to several objections. Firstly, the *opus signinum* floor need not be primary as he supposed. Excavations at Reculver by B. J. Philp have revealed that an identical flooring is present in one of the added eighth-century porticus (Wilson and Hurst 1969, 161), and work at St Pancras's Church, Canterbury, has revealed a very similar floor to that at Reculver datable no earlier than the mid eighth century (Rigold 1977, 163). The base may still have been primary even if the floor were laid round it later, however. Secondly and more seriously, the function of this feature as the base of a cross has been challenged, Taylor having reinterpreted it as the base of an altar (Taylor 1973, 52–8). Finally, even if the base in front of the triple arcade could be unequivocally accepted as a cross-base, there is no acceptable way of proving that the surviving fragments of sculpture formed part of the cross which originally stood on it (see Reculver 1a–e, Discussion). And even if it could be proved that Leland's cross and the surviving fragments are one and the same, there is no reason to assume that it is of the same date as the surviving base. It could equally have been a later monument placed on an earlier base.

It is evident that the line of reasoning used by Peers to establish a late seventh-century date for the Reculver fragments is unsound. This being so it is necessary to examine the whole problem of dating the fragments afresh. This is a course which presents grave difficulties. Only Reculver 1e exhibits a range of decorative motifs, with its use of a plant-scroll inhabited by human busts combined with interlace (Ills. 119–20). The rest of the fragments are decorated purely with figural ornament (Ills. 108–18). The figures are technically highly accomplished, and in a classicising style, but a classicising element, represented by the use of figural scenes, is present in English art throughout the pre-Conquest period. Initially it derived from late Classical works introduced into England with the Augustinian mission, but these works, and late Classical works imported subsequently, were copied throughout the pre-Conquest period by Anglo-Saxon artists, as were earlier native works drawing in part on Classical sources, and imported continental works of art which drew on similar sources. For this reason the topic of figure decoration in pre-Conquest art, and, in consequence, the position of the Reculver fragments, is extremely difficult to approach. There are, however, several discrete groups

of works (almost exclusively manuscripts) in southern England which exhibit classicising impulses with which the Reculver fragments might be compared. First, there are imported late Classical works, including manuscripts and panel paintings, reaching England in the seventh century in the wake of the Augustinian mission. Of these only the St Augustine's Gospels is a possible survivor. Second, there is a group of eighth-century manuscripts produced in Kent, of which the Vespasian Psalter, the Codex Aureus, and the Codex Bigotianus survive. The Barberini Gospels may also have been produced in Kent (Wilson 1984, 91), or at least in southern England in the late eighth or early ninth century (Budny and Graham-Campbell 1981, 16), although Brown prefers a provenance in Mercia or Northumbria (Brown 1991, 13; Webster and Backhouse 1991, no. 160). Third, classicizing tendencies are also observable in Canterbury works of the early ninth century represented by the luxurious manuscript BL MS Royal I. E. VI. Fourth, there are pre-Winchester style works of the late ninth and early tenth centuries, notably the St Cuthbert stole and maniple, the Aethelstan Psalter, and the fragment of wall painting from the New Minster excavations at Winchester. All of these are Winchester products. Last, there are Winchester style products of the late tenth and eleventh centuries. Such manuscripts and works in other materials were produced in numerous southern English centres including Canterbury, and Winchester itself. Both pre-Winchester style works of the late ninth and early tenth centuries and Winchester style work proper were themselves heavily influenced by Carolingian art, and this might have formed another or additional source influencing the Reculver fragments. Precise comparisons between the Reculver sculptures and all of these works are, however, hampered by the poor condition of many of the Reculver pieces. This has rendered the decorative programme of the monument or monuments indecipherable, and has obliterated many of the stylistic details.

## IMPORTED WORKS OF THE SEVENTH CENTURY

Classicising art was re-introduced into England with the advent of the Augustinian mission. Bede, for example, records that St Augustine brought with him from Rome a panel painting depicting the figure of Christ (Bede 1969, 75 (I, 25)), and it is possible that the *Biblia Gregoriana*, a lavishly-decorated Ravennate

bible, was brought to Canterbury as a gift from St Gregory to the Augustinian mission; it was certainly at St Augustine's abbey, Canterbury by the late eighth or early ninth century (Budny 1984, 799). Other panel paintings decorated with figures including scenes from the Old and New Testaments and the Mother of God, were brought to England from Italy by Benedict Biscop (Meyvaert 1979). Shortly after the arrival of St Augustine Bede also records that a second party of missionaries, including Justus and Mellitus, arrived from Rome, bringing with them numerous manuscripts (Bede 1969, 105 (III, 29)). Like the *Biblia Gregoriana* some of these must have been decorated with figural scenes as was the *Life* of St Paul known to have been brought to England from Rome at this date by Cuthwine, bishop of Dunwich (Whitelock 1972, 9). Of these imported works there are no certain survivors, although the late Classical Gospel fragment known as the St Augustine's Gospels is traditionally associated with the saint (Weitzmann 1977, pls. 41–2; Webster and Backhouse 1991, no. 1). The association, however, cannot be proven and the first evidence for the presence of the manuscript in England is provided by its eighth-century Anglo-Saxon marginalia, and it is possible that the manuscript only arrived here at that date (Budny, pers. comm.).

From this Italian Gospel fragment, in which only two decorated folios remain, 125r and 129v, it is difficult to form any accurate picture of art in Kent in the seventh century, even if the manuscript was in England at that time. The manuscript does, however, at least provide one of the possible models available in Kent. In broad terms the manuscript does have points of comparison with some of the Reculver fragments. The seated figure of St Luke on fol. 129v is within an architectural frame, consisting of columns with Corinthian capitals supporting a flat entablature, a feature seen also on Reculver 1d (Ills. 111–12) and Canterbury Old Dover Road 1 (Ills. 108, 110), although the sculptured figures are standing and not seated. Moreover they form part of a range of figures, not a single, isolated portrait as in the St Augustine's Gospels. Like Reculver 1b–c the St Augustine's Gospels employs a series of narrative scenes, twelve filling fol. 125r, and a further six flanking the seated figure of St Luke on fol. 129v. As on Reculver 1a (Ills. 113–15) the scenes are divided by plain borders, although those at Reculver probably appeared very different when their metal fittings were in place. There, however, the comparison breaks down, for the iconography of the St Augustine's Gospels is not reflected in the Reculver fragments, although only

two figure-decorated pages from the manuscript survive.

In style also the St Augustine's Gospels and Reculver 1a–d and the Canterbury fragment are far apart. In the St Augustine's Gospels the figures are small and dumpy, and only sketchily drawn, with the emphasis on the action of the scene. The garments, although rendered naturalistically, are not fully worked up, depending on line, not modelling, to define the folds in the cloth. The figures on the Reculver stones, in contrast, are more carefully and skilfully drawn, with the folds of the draperies defined not only by line, but also by careful modelling. This is a particularly remarkable feature given the intractability of stone as a medium compared with colour on parchment. If there are tenuous points of comparison between the illustrations of the St Augustine's Gospels and those on Reculver 1a–d and the Canterbury fragment, there are none with 1e (Ills. 119–20). This employs frames filled with interlace, and interlace is not used in the St Augustine's Gospels, or in any other late Classical manuscript. The plant-scroll inhabited by human busts on stone 1e from Reculver is a Hellenistic form in origin, later incorporated into Roman art (Toynbee and Ward-Perkins 1950, 1–43), but again is not paralleled in the St Augustine's Gospels. Where plants do occur in the Gospels they are semi-naturalistic, as are the plants developing from the flat entablature on either side of the arch head over the seated figure of St Luke. Again the figure style of the manuscript differs from that of the sculpture. At Reculver the bust in the roundel has naturalistically-treated draperies which are well modelled, while the hand raised in blessing across the body is unnaturally enlarged and extended to emphasise the gesture. In the St Augustine's Gospels the figure of Christ blessing the bread in the Last Supper scene on fol. 125r has exactly the same pose as the bust on stone 1e. Here, however, the draperies have their features indicated by dark lines, and are not fully modelled; moreover, the hand raised in blessing is normally proportioned.

There is, then, a marked divergence in iconography and style between the Reculver fragments and the St Augustine's Gospels, but it is possible that there existed in Kent works such as the Vienna Genesis (Wellesz 1960) or Cotton Genesis (Weitzmann 1977, pls. 21–2), both of which are more fluent and classicising in style than the St Augustine's Gospels. Indeed it has been argued that Aelfric's Pentateuch, a Canterbury manuscript made in the eleventh century, depends in part on such a model (Temple 1976, no. 86, ills. 265–272, fig. 34; Brown 1991, 52). If this was

the case, and they inspired sculpture of such outstanding quality as the Reculver fragments, then it might be expected, given the durability of the material, that other sculptures of similar inspiration and quality would survive. In fact, there is no sculptural context for the Reculver fragments in the seventh century. As noted above (see Chap. V), the only early sculptures in south-east England are in Kent, namely, the Reculver columns (Reculver 4a–b), the inscription from St Martin's Canterbury, and the Sandwich stones (nos. 1–2), but all of these sculptures are simple in form and employ an incised technique which is not comparable with the sophisticated relief techniques used at Reculver. Equally there is no southern English work of the seventh century in any medium which can compare in complexity of design, or subtlety and skill of execution, with the Reculver fragments.

Since there are no surviving southern English works with which the Reculver sculptures can be compared, it is necessary to look further afield for comparative material; specifically to Northumbria where two seventh-century figure-decorated manuscripts survive, namely, the Codex Amiatinus and the Lindisfarne Gospels. In addition, some information may be gleaned from the silver plate on the front of the portable altar of St Cuthbert (Battiscombe 1956, 326–35).

The Codex Amiatinus was made to the order of Ceolfrith, Abbot of Monkwearmouth-Jarrow 689–716 (Bruce-Mitford 1969, 2–7), and is possibly a copy of the *Codex Grandior*, a fifth-century Italian manuscript made at Cassiodorus's monastery of Vivarium (ibid., 8–9). There are three pages with figure decoration. On fol. Vr is a miniature of Ezra (ibid., pl. 2), fol. 796v is filled with a Christ in Majesty (ibid., pl. XIII), and on fol. VIr is a roundel containing the bust of God the Father (ibid., pl. XI.1). There are disparities in style between the Ezra figures and the other figural scenes, but all the figures are treated in a naturalistic, classicising manner, with the draperies carefully delineated, and on all of them there is some attempt at modelling. This naturalistic treatment, however, is not carried through wholly successfully. With all the figures, despite the modelling, the folds of the draperies are delineated by hard, dark lines. For the most part these draperies reflect the shape of the body beneath, but on the figure of the seated Christ on fol. 796v the folds over the legs have been reduced to a pattern which has lost touch with the shape of the body beneath. This occurs again with the seated figure of Ezra on fol. Vr,

although here it is not only the folds which are stylized, but the form and colour of the garment. On the upper part of the body the outer garment is coloured red, and the under-garment green. On the lower part of the body these colours are arbitrarily reversed. The draperies on the Reculver fragments, in contrast, are well modelled without the dependence on line betrayed by the Codex Amiatinus, and they consistently reflect the shape and movement of the body beneath. Unlike the figures in the Codex Amiatinus, which are short and wooden, those on the Reculver fragments are well-proportioned and fluently drawn, whether in repose or in movement. Any relationship must, therefore, be dismissed.

The tendency of the Codex Amiatinus to depend on line to depict the draperies is accentuated in the Lindisfarne Gospels, made at Lindisfarne *c.* 698 (Alexander 1978, no. 9, 35–40, ills. 28–46), and like the Codex Amiatinus copying a south Italian model, at least in part (ibid., 36–7). In each of the Evangelist portraits the draperies of the figures are not modelled. Instead hard, thick, dark lines are used to delimit the folds. Moreover, the draperies no longer reflect the shape of the body beneath, instead the folds are arranged to form surface patterns. This tendency to reduce the draperies to pattern finds its ultimate expression in the St Luke portrait on fol. 218r of the Lichfield Gospels, where the shape of the body is wholly replaced by a symmetrical patterning (ibid., no. 21, 48–50, ill. 82). As with the Codex Amiatinus, the approach to figure drawing used in the Lindisfarne Gospels has little to do with the concepts underlying the figure drawing of the Reculver fragments. The Lindisfarne Gospels does use interlace of the quality found on stone 1e, but it does not use the plant ornament combined with it at Reculver. The Codex Amiatinus lacks both interlace and plant ornament. Any relationship with the Reculver fragments can, therefore, be rejected.

In addition to the figure-decorated manuscripts, a seventh-century date has been argued for the silver plate on the front of the portable altar from the grave of St Cuthbert (Battiscombe 1956, 334). The sheet is decorated with the seated figure of St Peter (ibid., fig. 330, pl. XIX), identified by semi-vertical inscriptions, perhaps paralleling the putative arrangements of metal strips which may have borne inscriptions on stone 1a from Reculver (see Reculver 1a–e, Discussion). Unfortunately, only fragments of the sheet survive, but the drapery style is highly naturalistic, unlike that in the manuscripts, and much closer in spirit to Reculver 1a–d. There must, however, be doubts about the date

of the silver sheet on the altar, and an eighth-century date has been proposed by Webster, with further additions later in the century (Webster and Backhouse 1991, no. 99). Okasha certainly places the silver sheet much later than the core on the grounds of their differing scripts (Okasha 1971, no. 35, pl. 35).

If there is doubt over the date of the silver sheet on the St Cuthbert altar, and little comparison between the Reculver fragments and the Codex Amiatinus and Lindisfarne Gospels, there is equally no early sculpture in northern England with which the Reculver fragments can be compared. As Cramp has pointed out, the only seventh-century sculpture in Northumbria seems to be architectural, such as the turned balusters from Monkwearmouth and Jarrow (Cramp 1984, I, 24–5, figs. 7–8), and the baluster friezes from Jarrow and Hexham (ibid., 25–6). There are also some grave-markers simply decorated with incised inscriptions or crosses, such as the examples from Whitby and Hartlepool (ibid., 7). It was not until the mid eighth-century that the large figure-decorated standing crosses, such as those at Ruthwell and Bewcastle, were made (ibid., 27–8). As with the seventh-century material from southern England, that from Northumbria is technically simple, using either incised or low-relief techniques which do not bear comparison with the range of sophisticated techniques employed at Reculver.

If there are no manuscripts or sculptures in England in the seventh century with which the Reculver fragments can adequately be compared, it remains a possibility that they are themselves exotic in a southern English context: not imports, but the products of imported workmen, such as those which Benedict Biscop brought from Gaul to build the monasteries at Monkwearmouth and Jarrow. If so, then the sources of the Reculver sculptures would have to be sought on the continent, either in Italy or in Gaul. Lively contacts between Kent and Gaul in the sixth and seventh centuries are attested by the grave-goods from the many rich pagan Anglo-Saxon cemeteries in the county, as well as by the marriage of king Aethelberht of Kent to the Frankish princess Bertha recorded by Bede (Bede 1969, 73–5 (I, 25)). That these links continued after the Augustinian mission is documented by Bede, who, for example, records the careful demarcation of responsibilities between the bishop of Arles and St Augustine, the underlying assumption being that St Augustine would travel frequently to France (ibid., 103 (I, 27)). In the later seventh century Anglo-Saxon contacts with Gaul continued. Wilfrid spent much time at Lyons en route

to Rome (Webb 1965, 136–7, 138–9), while the Frank Agilbert became bishop of Winchester, and later returned to Gaul to become bishop of Paris (Stenton 1971, 122). Although there is no historical reference to Gallic workmen being brought to Kent, it is improbable that the seventh century churches in the county were exclusively of local inspiration and craftsmanship. At St Augustine's Canterbury (no. 8; Ill. 50), recent excavations have produced a single turned baluster with the deep grooves employed on similar balusters from Monkwearmouth and Jarrow, a type which Cramp has suggested may be of Gallic inspiration. There is, for example, a similar baluster from Nouaillé (Cramp 1965, 4, pl. 3).

In this period Gaul had a number of flourishing regional sculptural traditions, represented by the accomplished sarcophagi of south-western Gaul (James 1977, I, 29–67, II, nos. 1–47), and the classicising capitals employed in buildings as widely separated as the crypts at Jouarre and the Baptistery of St Jean at Poitiers (Fossard 1947). However, figure sculpture seems to have been very little used in Gaul, although it does occur on 47 of the south-western sarcophagi (James 1977, II, nos. 1–47), and occasionally elsewhere, as on the sarcophagus of Agilbert at Jouarre (Hubert et al. 1969, 72–7, pls. 84–9), and in the Hypogée des Dunes, Poitiers (ibid., 60–2, pls. 74, 76). The result, however, is very direct, lacking the technical and stylistic sophistication evident at Reculver, even where complex iconography is deployed. The few seventh-century manuscripts which survive from Gaul, such as St Gregory's commentary on Ezekiel made at Luxeuil, also eschew figural decoration in favour of plant and animal ornament (ibid., pl. 178).

Is Italy a possible source of inspiration for the Reculver fragments? Again there were clearly close links between southern England and Italy in the very late sixth and seventh centuries, beginning with the Augustinian mission. These links were renewed with the despatch from Rome of further missionaries to England including Justus and Mellitus (Bede 1969, 105 (I, 29)), and later of Theodore of Tarsus and abbot Hadrian (ibid., 330–3). Notable English visitors to Rome included some of the archbishops of Canterbury, who made the journey in order to receive the pallium from the hands of the pope. Wigheard, for example, died in Rome before he could return to England, but must have had a retinue of followers who did return (ibid., 319). Prominent lay people also made the pilgrimage to Rome. Caedwalla, king of Wessex, abdicated and travelled to Rome for baptism (ibid., 468–73), and his successor Ine also retired to

Rome (ibid., 473). Neither of these two men returned, but others, such as Benedict Biscop, did, bringing numerous works of art with them (Meyvaert 1979).

Sixth- and seventh-century Italian art is diverse, drawing on late Classical traditions, on Ostrogothic and Lombard sources, and on Byzantine art. Within these traditions there is accomplished Classical figural art of the type used at Reculver, as in the *Maria Regina* scene in the presbytery at Sta Maria Antiqua in Rome (Hubert *et al.* 1969, 107, pl. 122). Such accomplished figural art, however, is not translated into stone, and among the many surviving sarcophagi, church fittings, and architectural sculptures produced in Italy, figural scenes are rare. Instead simple plant and animal ornament was used, and invariably worked in a flat, low-relief technique. This has little relationship to the elaborate, high relief, almost three-dimensional styles which are employed at Reculver (ibid., 250–7, pls. 277–81). It remains possible, however, that portable pictures in the style of the Sta Maria Antiqua frescoes were brought to England to provide a source for the Reculver figural scenes.

In conclusion, the Reculver fragments do not fit easily in terms of style, iconography, or technique into the pattern of seventh-century art either in England or on the continent. It is evident, therefore, that the traditional seventh-century date for the fragments must be rejected.

## SOUTHERN ENGLISH ART OF THE EIGHTH CENTURY

If a seventh-century date for the Reculver fragments can be rejected, the next recognisable phase of southern English art in which Classical sources were of major importance is in the eighth century. Fortunately, three decorated manuscripts from Kent survive from this period; the Vespasian Psalter (Alexander 1978, no. 29, 55–6, ills. 143–6; Webster and Backhouse 1991, no. 153), the Stockholm Codex Aureus (Alexander 1978, no. 30, 56–7, ills. 147–59; Webster and Backhouse 1991, no. 154) and the Codex Bigotianus (Alexander 1978, no. 34, 60, ills. 166–8; Webster and Backhouse 1991, no. 155). In addition the Barberini Gospels may have been made in southern England (see above, p. 47). The manuscripts were probably made in that order, the Vespasian Psalter in the second quarter of the eighth century, the Codex Aureus in the mid eighth century, the Codex Bigotianus in the second half of the eighth century,

and the Barberini Gospels in the late eighth century. All betray the use of Classical sources for at least part of their ornament. In the Vespasian Psalter, the Codex Aureus and the Barberini Gospels this is suggested by the use of accomplished figural decoration. A Greek Psalter of the early sixth century was a major source for the illustrations of the Vespasian Psalter (Webster and Backhouse 1991, no. 153), while Alexander has proposed the derivation of the decoration of the Codex Aureus from the St Augustine's Gospels, discussed above (Alexander 1978, 56). The Codex Bigotianus lacks figural decoration, but on fol. 137r the initial Q incorporates a naturalistically drawn dolphin (ibid., ill. 166), a characteristic Classical motif. There is, for example, a closely comparable dolphin with the same three-element tail in the Jewish Catacomb, Villa Torlonia in the Via Nomentana, Rome, dated to the third century (Du Bourguet 1972, pl. p. 17).

The use of figure decoration in the Vespasian Psalter, the Codex Aureus and the Barberini Gospels allows comparisons of iconography and style with the Reculver fragments which, with the exception of stone 1e, are exclusively figure-decorated. The Vespasian Psalter contains an introductory miniature, now displaced on fol. 30v, of king David playing the harp with musicians, dancers and secretaries in attendance (Alexander 1978, no. 29, ill. 146). Two other miniatures are placed within the large initials introducing Psalms 26 and 52 on fols. 31r and 53r (ibid., ills. 143–4). These depict David and Jonathan, and David rescuing a lamb from a lion. A third miniature, now lost, depicting Samuel, probably introduced Psalm 1 (ibid., 55). In broad terms these scenes can be described as narrative, and thus compare with the narrative scenes on stones 1b–c from Reculver (Ills. 116–18), one of which is also drawn from the Old Testament. There, however, the comparison ends, for the subject-matter of the Vespasian Psalter miniatures is not repeated at Reculver. Equally, the standing ranges of figures (probably Apostles) employed at Reculver have no place in the decoration of the Psalter. Figures of the Apostles do occur in the Codex Aureus in the two surviving author portraits prefacing the Gospels of St Matthew and St John on fols. 9v and 150v (ibid., ills. 147, 153) and, as at Reculver, each Apostle is viewed in isolation within an architectural frame. This feature has, however, no evidential value, as the convention originated in late Classical manuscripts and persisted throughout the Anglo-Saxon period.

There is also little resemblance in style between the

Vespasian Psalter and Codex Aureus on the one hand and the Reculver fragments on the other. In the Vespasian Psalter the garments of the figures are less naturalistically rendered than on the Reculver fragments. On the frontispiece of the Psalter, for example (Alexander 1978, no. 29, ill. 146), the hems of the garments are treated as hard straight lines. Folds in the garments are rendered by thick, dark lines, and there is a marked tendency to reduce the folds to symmetrical patterns which only inadequately reflect the shape of the body beneath; a feature particularly noticeable in the figure of king David. Where there are edges of drapery which fall vertically in a series of folds, then the folds are treated with absolute regularity. These stylistic traits in the figure drawing recur in the Codex Aureus. In the miniature of St Matthew, for example (ibid., no. 30, ill. 153), the saint wears an overgarment which has been reduced to a series of hard dark lines, highlighted in white, which make a formalised pattern having little relationship with the saint's body beneath. This same patterning is seen in the garments of St John (ibid., ill. 147) which are arranged almost symmetrically, and where the vertical folds of drapery, as in the Vespasian Psalter, are rendered with absolute regularity. In addition, in both the Vespasian Psalter and the Codex Aureus, there is only the most rudimentary attempt at modelling, which leaves the figures flat and two-dimensional. The figure style of the Vespasian Psalter and Codex Aureus thus bears little relationship to that of the Reculver fragments, although on stone 1a (Ills. 113–15) one of the figures does have the edge of his garment falling in a series of regular folds, as in the St John portrait of the Codex Aureus (Alexander 1978, no. 30, ill. 147). However, this is only an isolated point of comparison, and the Reculver figures are imbued with an entirely different spirit. The figures are wholly naturalistically treated. They are fully modelled, and sometimes almost fully free-standing and three-dimensional. Their garments fall naturalistically in a way which reflects the shape, posture and action of the body. Hems are gently folded, not like the hard straight lines of the manuscripts.

Stone 1e from Reculver stands apart from the other fragments in the complexity of its ornament (see Reculver 1e, Discussion), which embraces a figural subject in combination with interlace and plant ornament (Ills. 119–20). In this variety of ornament it is broadly comparable to the decoration of the Vespasian Psalter. There, however, the plants are a minor element in the decoration, occurring only on fol. 30v (Alexander 1978, no. 29, ill. 146) and do not

resemble the simple plant-scroll used on Reculver 1e, but rather are bush scrolls with thick, fleshy leaves. The only point of comparison between them and the Reculver plant-scroll is in the use of groups of rounded-ended appendages developing from the underside of the branches, although this feature also occurs widely on later plant ornament. Unlike the Vespasian Psalter the Codex Aureus lacks plant ornament, except for the short sprays on either side of the seated figure of St Matthew on fol. 9v (ibid., ill. 143), and the plant spray flanking the figure in the roundel on top of the left-hand column of the same folio. It does, however, make lavish use of interlace, and the interlace decoration on the chair of St Matthew is closely comparable in form to the interlace framing on Reculver 1e.

The Codex Aureus also employs roundels containing human busts, a feature broadly comparable to the busts in the plant-scroll on stone 1e from Reculver (Ills. 119–20). Such busts occur in the Codex Aureus on the tops of the columns flanking the seated figure of St Matthew on 9v, and they also occur in similar positions in the Canon Tables, as on fol. 6v, where the outer piers of the Canon Table arcades have busts within roundels at their head and foot. This feature appears in manuscript art in Canon Tables deriving wholly or in part from the Apostolic type, and elsewhere in manuscripts which draw on such sources. They occur over a very restricted date range in Anglo-Saxon or Anglo-Saxon-influenced art from the mid eighth century to the mid ninth, in the Maaseik and Trier Gospels, the Codex Aureus, BL MS Royal I. E. VI, and the Book of Cerne (Budny 1984, 462–4; Webster and Backhouse 1991, no. 165). The busts in the Codex Aureus share the same flat drawing style without modelling, and with a tendency to show the folds of the garments as symmetrical patterns with hard dark lines. This contrasts with the handling of the busts on Reculver 1e, which are treated naturalistically with the garments falling in a manner which reflects the shape of the body beneath.

The late eighth- or early ninth-century Barberini Gospels also employs figural ornament, in the Evangelist portraits on fols. 11v, 50v, 79v, and 124v, and in the tympana of the Canon Table arcade on fol. 1r, where each column is headed with the zoo-anthropomorphic symbol of an Evangelist. The style of the figure drawing is rather different from that employed in the Vespasian Psalter and the Codex Aureus: more naturalistic and much closer in spirit to that employed at Reculver. In the Evangelist portraits in every case the figure is naturalistically posed with

the feet properly positioned and correctly fore-shortened as at Reculver. The garments reflect the shape of the body beneath and fall naturalistically with the folds being indicated both by line and modelling, the hems are gently folded and, as on fol. 11v, often paralleled by a coloured line. There is, however, a residual tendency to surface patterning, as on the overgarment of St Matthew on fol. 11v. Despite this the figure and drapery style lies very close to that at Reculver stones 1a–d and the Canterbury fragment. There are fewer parallels which can be drawn with stone 1e. Busts within plant-scroll do not occur in the Barberini Gospels, and where plant ornament is used, as on fols. 18r and 79v, it employs multi-lobed leaves and delicate flowers, not the pointed leaves used at Reculver. The Barberini Gospels does, however, use interlace-filled frames, as, for example, on the frames of the Evangelist portraits on fol. 11v, and in the Canon Table arcade on fol. 1r. In the arch heads half patterns are used, as on Reculver 1e.

In summary there is a wide divergence in both content and style between the Vespasian Psalter and the Codex Aureus on the one hand, and on the other the Reculver fragments, including stone 1e. There are, however, much closer links between the figure style of the Barberini Gospels and Reculver 1a–d and the Canterbury fragment, although Reculver 1e seems to have little relationship with the decorative content of the Barberini Gospels.

As with the seventh century, so in the eighth, it is impossible to find a sculptural context in southern England into which the Reculver fragments would fit. There are no stone sculptures from Kent which can be dated to the eighth century, and the only non-architectural sculptures in south-east England which may be eighth-century works are the shafts from Elstow, Bedfordshire, and Bedford St Peter, and the works of the south-western type at Winchester (e.g. Prior's Barton 1), Steventon, and South Hayling, all in Hampshire. These are on the periphery of the region and their decoration, with animals developing into, or enmeshed in, interlace, are very different in conception and spirit from the classicising Reculver fragments (see Chap. V).

In the eighth century, the closest group of figural sculpture to Reculver geographically is to be found in east Mercia, where figural panels occur at Peterborough (Cramp 1977, fig. 58b), Fletton (ibid., figs. 56a–b), and Castor (ibid., fig. 57b) in Northamptonshire, and Breedon, Leicestershire (ibid., figs. 55, 57a, 58a and c, 59 a–c). Ranges of figures also occur on the sides of the Hedda stone at Peterborough

cathedral (ibid., fig. 57c). At Fletton (Kendrick 1938, pl. LXXIV) and Breedon (Cramp 1977, figs. 50–3) these figural panels occur in conjunction with narrow friezes decorated with plant, animal, interlace, pelta ornament, and (at Breedon) frets. There is also a fragment of a similar frieze at Ely, Cambridgeshire (St John's Farm, unpublished). There are generalized parallels between some of these sculptures and the fragments from Reculver. The Hedda stone, for example, employs on each of the long sides ranges of standing figures beneath arches supported by columns, a disposition which echoes that on the Canterbury fragment and Reculver 1d, although there the columns carry a flat entablature (Ills. 108, 110–12). Similar ranges of standing figures occur also at Breedon (Cramp 1977, figs. 59 a–c), Castor (ibid., fig. 57b), and Peterborough (ibid., fig. 58b). Apart from the fact that they are on panels, not on a cross-shaft as at Reculver, these figure sculptures are also on a larger scale, and lack the narrative scenes employed on stones 1b–c from Reculver. Stylistically there are two broad divisions within the figure sculptures of east Mercia. At Fletton (ibid., figs. 56 a and b), Breedon (ibid., figs. 57a, 58a) and Castor (ibid., fig. 57b) the figures are treated naturalistically, as are their draperies which have the main folds of the garments falling naturally in a way that reflects the shape of the body, and gently folded hems. However, the surface of the draperies is covered with fine parallel grooving varying in direction within each subdivision of the garment. This is an effect which is not employed in southern English manuscript art and which is absent also from the Reculver fragments. Where fine grooving does occur at Reculver it is used to point up the details of the folds of the garments, not as a mere surface enrichment as on the east Mercian examples.

At Breedon the second figure style is represented by the panel with the angel (Cramp 1977, fig. 58c). Here again the figure is represented naturalistically, but the draperies are reduced to a series of parallel folds and loops forming a surface pattern. Between the folds are deep and wide U-shaped channels which have the effect of hard dark lines, particularly when the sculptures are side lit. The treatment of the draperies provides a good parallel in stone for the style employed in the southern manuscripts, particularly in the Vespasian Psalter and the Codex Aureus, and which occurs also in the early ninth century Book of Cerne, as on the symbol of St Matthew on fol. 2v and the *imagines clipeatae* on the heads of the arches on fols. 2v, 12v, 21v, and 31v (Alexander 1978, no. 66, 84–5, ills. 310–15). Indeed, Cramp has suggested that the

Breedon angel and the stylistically related sarcophagus fragments (Cramp 1977, figs. 59 a–c) are of ninth-century date (ibid., 211–18). As noted above, this figure style is in many ways the antithesis of that employed on the Reculver fragments. As with the first east Mercian figure style this material provides no adequate context against which the Reculver fragments might be viewed. The only stylistic link lies in the turning up of the edges of the hem so as almost to form a volute, as on the Canterbury fragment (Ill. 109), on the Breedon angel, and to a lesser degree on fol. 2v of the Book of Cerne (Alexander 1978, no. 66, ill. 312).

This conclusion applies also to the unusually-decorated stone 1e from Reculver where the figure sculpture follows the small-scale, naturalistic style employed on the rest of the fragments. The plant-scroll and interlace employed in conjunction with the figure sculpture on stone 1e (Ills. 119–20) can in general terms be paralleled in east Mercia, particularly on the friezes from Breedon (Cramp 1977, figs. 50, 51, 52 a–c; Jewel 1986, pls. XLII, XLIII, XLV, XLVII-LIII), but detailed analysis reveals that the structure and leaf type of the Reculver scroll differs markedly from that at Breedon. There the stems of the scroll are narrow and wiry with the diverging stems developing from trumpet bindings. Where leaves are used they are trefoils or ovoids, and they are used in conjunction with berry bunches. These are absent from stone 1e where the leaves are single-lobed, pointed, and hatched to simulate veins. A distinctive motif is the leaf bent back under its own stem. All these features are absent at Breedon. Trumpet bindings do occur at Reculver, but they are treated less as three-dimensional cones, as at Breedon, and more as organic parts of the plant. Some of the scrolls at Breedon are inhabited by birds, animals, or centaurs, but none has *protamoi*, as at Reculver.

## ART IN KENT IN THE EARLY NINTH CENTURY

Only two manuscripts which were probably made in Kent in the early part of the ninth century survive, BL MS Cotton Tiberius C. II (Alexander 1978, no. 33, 59–60, ills. 134, 165; Webster and Backhouse 1991, no. 170) and BL MS Royal I. E. VI (Alexander 1978, no. 32, 58–9, ills. 160–4; Budny 1984; Webster and Backhouse 1991, no. 171). Tiberius C. II is a copy of Bede's *Historia Ecclesiastica*. The decoration is confined to the initial letters and continuation lettering at the

opening of each of the five books, on fols. 5v, 34v, 60v, 94r and 126r. The first of these, the initial B, is the most elaborate. The letter is panelled, each panel containing plant, interlace, animal, or fret decoration. The centre of the letter is divided into four fields, each filled with a single animal (Wilson 1984, pl. 111). The decoration of this initial is clearly of the same type and in the same style as the decoration of the Canon Tables of Royal I. E. VI, where the panelled decoration is almost identical in layout and decorative content.

BL MS Royal I. E. VI is a fragment of a luxurious Bible of which only the Gospels partially survive. Of the original decorated pages only the Canon Tables, fols. 4r–6r, and the *incipit* page of St Luke's Gospel on fol. 43r survive, together with small decorated initials on fols. 42r and 68r. The openings of the gospels of St John, St Matthew, and St Mark are lost, but an offset indicates that the opening of St John's Gospel closely resembled that of St Luke (Budny 1984, 442–5, fig. 10). At least three full-page miniatures are also lost. The former presence of these is indicated by their facing pages which are purple stained and carry inscriptions in gold and silver display lettering. These inscriptions serve to identify the lost scenes as the Lamb of God surrounded by the symbols of the four Evangelists opposite fol. 1v; the Baptism of Christ prefacing the Gospel of St Mark opposite fol. 30r; and the Annunciation to Zachariah prefacing the Gospel of St Luke opposite fol. 44r. The presence of numerous other illustrations can be inferred (ibid., 688–727, fig. 13). The manuscript bears the late thirteenth-century press mark of St Augustine's abbey, Canterbury, although the folio which has this mark is not original to the manuscript (ibid., 199–213). Despite this there seems little doubt that the manuscript was made at St Augustine's (loc. cit.) probably in the period 815–845 (ibid., 756).

Comparison between the Reculver fragments and these manuscripts presents an almost insuperable problem. As noted above (p. 47), all but stones 1e and 2 from Reculver are decorated solely with figural ornament, but BL MS Cotton Tiberius C. II lacks figure decoration, and while BL MS Royal I. E. VI once possessed an extensive programme, only a bust within a roundel on the *incipit* page of St Luke's Gospel survives. Unfortunately on this page the normal portrait of the Evangelist beneath the arch, employed for example in the Codex Aureus (Alexander 1978, no. 30, ills. 147, 153), has been replaced by the opening of the text. Despite this severe handicap there is an evident comparison between the

handling of the bust in Royal I. E. VI and the figure sculptures at Reculver. The manuscript bust is naturalistically drawn. The figure is well proportioned apart from the hand raised in blessing, where the two raised fingers are unnaturally extended. The figure's garments are also naturalistically drawn, reflecting the shape of the body. Both the figure and its draperies are carefully modelled, without the reliance on line evident in the earlier manuscript art of Kent.

This naturalistic treatment is carried through onto the Evangelist symbol, a half-length bull, in the tympanum of the arch beneath the bust. Again the animal is naturalistically drawn and well proportioned with a combination of thin, delicate line to pick out the detail and skilful modelling to yield a three-dimensional effect. The revolutionary change which overtook figural drawing in Kent between the mid eighth century and the early years of the ninth is underlined by a comparison between this Evangelist symbol and those of the Codex Aureus. The St Luke portrait is lost, but the St John portrait survives (ibid., pl. 147). As in all the drawing of the Codex Aureus the symbol of St John, the eagle, is depicted as two-dimensional, and the drawing of the feathers has turned them into a regular surface pattern picked out by hard, thick, dark lines. The outspread wings of the eagle can be compared directly with those of the bull in Royal I. E. VI. In the Codex Aureus the feathers are formalised and regular with the usual hard, dark outlines and thick white highlights. In Royal I. E. VI the feathers are outlined with thin lines, and the white highlighting has yielded to more subtle modelling using accomplished gradations of shading. The effect is to make the wing life-like. In the Codex Aureus the eagle symbol is set against a uniform plain coloured ground. In Royal I. E. VI the ground is treated impressionistically to give a feeling of depth and space.

The handling of the figure and animal drawing in Royal I. E. VI is clearly comparable to the manner of handling the figure sculpture on the Reculver fragments, even if direct comparisons are difficult to draw. The figures on the Reculver fragments are portrayed wholly naturalistically; they are well proportioned and naturalistically posed with the folds of their garments reflecting the shape of the bodies beneath. The folds of the draperies are carefully delineated without the tendency to surface patterning seen in eighth-century works such as the Codex Aureus. As in BL MS Royal I. E. VI, the Reculver figures are fully modelled and, on the Canterbury fragment, heavily undercut (Ills. 108–10) to give the three-dimensional effect to which Royal I. E. VI also aspires.

Stone 1e from Reculver has more concrete links with Royal I. E. VI. Like that manuscript it employs busts within roundels, although here within a plant-scroll (Ills. 119–20). The busts on 1e are stylistically close to that in the manuscript. Like it they are naturalistically drawn and fully modelled with the draperies of the garments fully reflecting the shape of the body beneath. Completely absent are the hard, formalised patterns of eighth-century manuscript and sculptural draperies, seen, for example, in the busts within roundels in the Codex Aureus (ibid., pls. 153, 155).

Stone 1e also has links with BL MS Royal I. E. VI in that, like the manuscript, it employs a mixture of motifs: figural, plant, and interlace; a mixture which, as noted above (p. 40), is typical of Anglo-Saxon art of the late eighth and early ninth centuries. There are no specific comparisons between the interlace employed on 1e and that of the manuscript, but there are exact parallels in the plant ornament. In particular the fan-shaped groups of rounded-ended extensions developing from the upper tendril of the stem on 1e can be paralleled in the Canon Tables of Royal I. E. VI, as, for example, on fol. 4r. The use of the pointed leaf turning back under its own stem, seen both on stone 1e and the lost stone (Reculver 2), is also paralleled on fol. 4r. Indeed, so close is the comparison that Budny has concluded that the same 'model or type of model' must lie behind both works (Budny 1984, 630–1). These are both features which occur also in ninth-century Anglo-Saxon metalwork. The leaf turning under its own stem, employed on Reculver 1e (Ills. 119–20) and in BL MS Royal I. E. VI, is used, for example, on the Fuller brooch (Fig. 15a; Wilson 1964, no. 153, 211–5, pl. XLIV; Backhouse et al. 1984, no. 11) and one pair of the brooches from Pentney, Norfolk (Fig. 15b; Wilson 1984, pl. 120, top), as well as on a strap-end from the Cuerdale hoard (Wilson 1964, no. 13, 128–9, pl. XVIII). The use of groups of foliate elements which expand towards rounded ends is paralleled on the sword-pommel from the River Seine, Paris (Fig. 24c; ibid., no. 66, 166–7, pl. XXIX), and on the Fuller brooch, where similar elements emerge from the cornucopias held by the figure of Sight in its centre (Fig. 24f; ibid., pl. XLIV).

There are, then, very close and specific comparisons between the decoration of BL MS Royal I. E. VI and stone 1e from Reculver, and striking, if generalised, comparisons between the handling of the figure decoration in the manuscript and that on stones 1a–d from Reculver and the Canterbury fragment. Certainly if the Reculver fragments can be regarded as

a

b

FIGURE 15
Foliate ornament, nts (KEY: a, Fuller brooch; b, Pentney brooch)

of ninth-century date there is a sculptural context in south-east England at this period into which they will fit. For example, the mixture of animal, plant and interlace ornament seen on Reculver 1e is mirrored on the stone ring from Godalming, Surrey (no. 1; Ills. 81–91), on which the plant-decorated field employs the same pointed leaf turned under its own stem (Ill. 86). The Godalming piece must be of early ninth-century date as it compares directly with Royal I. E. VI which, in the Canon Table arcades, has the same type of panelled ornament (Alexander 1978, no. 32, ills. 162–4). As at Godalming the panels are filled with animal, plant or interlace ornament, often alternating with each other; very similar decoration is employed also in BL MS Cotton Tiberius C. II (ibid., ill. 165; Wilson 1984, pl. 111) (see above, pp. 44, 54).

There are also other sculptures which employ small-scale classicising sculpture, discussed more fully above (pp. 40–3). Frustratingly, there is nothing of this type from Kent itself, but there are pieces from the Winchester area. A small-scale figure, only 25 cm high, occurs on the grave-marker from Whitchurch, Hampshire (Ill. 483). Unfortunately this is heavily weathered but appears to be in the same naturalistic, classicising style as the figure sculptures from Reculver. At Romsey, Hampshire, is another small-scale figure sculpture, this time a panel decorated with a crucifixion scene (no. 2). The figures are, however, treated in a very different manner from those at Reculver and Whitchurch, in a flat, unmodelled style with the draperies picked out by incised lines and

having little relationship with the bodies beneath (Ills. 453, 455). This is very much in the tradition of the late eighth-century east Mercian material discussed above (p. 53), but the use of acanthus ornament closely comparable to that on the St Cuthbert stole and maniple places the piece firmly in the late ninth or early tenth century. Perhaps this piece represents the continuity of older figural styles into the tenth century, or perhaps it is simply the work of a less accomplished sculptor who strove for the effects seen at Whitchurch or Reculver but lacked the technical competence to achieve them.

If, as argued above, the classicising figure sculpture at Reculver and Whitchurch belongs to the same artistic milieu as the classicising figure drawing of BL MS Royal I. E. VI, then the manuscript seems to pinpoint the sources of this new impulse in ninth-century art, sources which appear to lie both in late Classical and Carolingian art (Budny 1984, 795–800). The importance of Carolingian sources in the art of the ninth century is something which has been argued for other areas of Anglo-Saxon England, particularly Northumbria. There are, unfortunately, no identifiable surviving Northumbrian manuscripts made after the mid eighth century, but there are a number of sculptures which can be distinguished by their use of small-scale, classicising figure decoration combined with technical excellence. These include the Otley, Easby, and Rothbury shafts, the cross-head at Hoddom, and the slab at Hovingham. At Otley the so-called 'Angel Cross' employs on one of the main faces a series of three vertically-placed panels each of which presumably originally contained a human bust within a single element of a medallion plant-scroll; only one now survives (Cramp 1970, taf. 41, A, 42, 1; Collingwood 1927, fig. 52). This provides the closest parallel in Anglo-Saxon art to the plant-scroll with busts used on stone 1e from Reculver (Ills. 119–20), and is a feature unparalleled outside these two sites. Other busts within roundels occur in Northumbrian art of the ninth century, most notably at Hoddom, Dumfriesshire, where the cross-head has a central roundel containing a human bust holding a book. The bust is rendered in a technically highly accomplished manner (Collingwood 1927, fig. 51). The figure is naturalistically rendered with carefully delineated robes reflecting the shape of the body beneath, a treatment which closely resembles that at Reculver, and the bust in BL MS Royal I. E. VI. A very similar bust in the centre of a cross is known also from Little Ouseburn, Yorkshire.

Other features of the Reculver sculptures are also

reflected in Northumbrian art of the ninth century. At Masham, Yorkshire, for example, there is a round shaft decorated with superimposed ranges of decoration, some of which consist of rows of figures beneath arches (Collingwood 1927, fig. 13), a layout which closely reflects that of Reculver 1a–d and the Canterbury fragment and a similar range of figures is employed on the rectangular panel from Hovingham (Lang 1991, ills. 494–9). Here, as at Reculver, the figures are small-scale and highly classicising, but more detailed analysis is rendered impossible by their poor state of preservation. That there was any direct link between these Northumbrian sculptures and the art of south-east England is, perhaps, unlikely, but what can be suggested is that Northumbria was subject to the same artistic impulses which affected south-east England, and that these impulses lead to the creation of similar works in two geographically widely separated areas.

## THE ART OF WINCHESTER IN THE EARLY TENTH CENTURY

The fragments of large-scale figure sculpture found in excavation at Winchester (nos. 75–85) cannot now be related to the type of elaborate sculptural scheme described as adorning the tenth-century tower of New Minster (Quirk 1961), and (with the exception of no. 75) is probably all later than the early tenth century. Moreover, between the middle of the ninth century and the late tenth century no figure-decorated work of art in any medium survives from Kent. The nature of southern English art is indicated by the three major representatives of the figural art of early tenth-century Winchester which do survive: the St Cuthbert stole and maniple (Battiscombe 1956, 375–432, pls. XXIV-IX, XXXII-IV), the Aethelstan Psalter (BL MS Cotton Galba A. XVIII (Temple 1976, no. 5, ills. 15–17, 30–3)), and the Corpus Christi *Vita Cuthberti* (Corpus Christi College Cambridge MS 183 (ibid., no. 6, ills. 18–19, 29; Wilson 1984, pl. 203)). The evidence of these is supplemented by a fragment of wall painting from the New Minster excavations at Winchester (Biddle 1967b; Biddle and Kjølbye-Biddle 1990b; Wilson 1984, 155–6, pl. 204). These artifacts are of special relevance to any evaluation of Reculver.

Of the major works the earliest in date are the St Cuthbert stole and maniple. The stole bears the names of Queen Aelflaed of Wessex and Frithestan, bishop of Winchester. It must, therefore, have been made between the consecration of Frithestan in 909

and the death of Aelflaed in 916 (Freyhan 1956, 409). The name of Frithestan also appears on the maniple (loc. cit.), which given its similarity in style and technique with the stole must have been made at the same date and probably by the same hands. The stole is decorated with a series of standing figures, identified by inscriptions as the Old Testament prophets. The figures are placed vertically (a layout dictated by the shape of the object) and are separated by sprays of acanthus ornament. In broad terms this use of a series of compartmentalised figures corresponds with the decoration on stones 1a and 1d from Reculver and the Canterbury fragment.

In the poses of the figures there are also close comparisons between the figures on the stole and some of those on the Reculver fragments. Each of the figures on the stole stands on a rocky ground and is half-turned to one side or the other in regular alternation. The figures are bearded with the hair falling down behind. The figure's left hand holds either a palm leaf, as is the case with Hosea, Isaiah, Daniel, Amos, and Jonah, or holds a book as do Joel, Nahum, and Zachariah. In each case the figure's right hand is raised in blessing. Each figure is clad in a long undergarment with an overgarment bound at the waist and falling diagonally across the body. On the Reculver fragments the left-hand figure on stone 1d (Ills. 111–12) closely resembles the prophets on the stole. Like them the figure is half-turned to one side and, as on the stole, the range of figures may have alternated (the right-hand figure on stone 1d is half-turned to the other side) but with only two figures surviving this may be mere chance; it does not occur on stones 1a and the Canterbury fragment which also have ranges of figures. The figure on stone 1d, like the figures on the stole, is also bearded with his right hand raised in blessing, but the left hand holds a scroll rather than a book. Again the figure is clad in an undergarment, with an overgarment bound at the waist and falling diagonally across the body. The other figures from Reculver are less easy to parallel on the stole. The figures on the Canterbury fragment (Ills. 108–10) are too badly damaged for meaningful comparisons to be drawn. On stone 1a the figures are frontally placed (Ills. 113–15), but if the metal fittings on the borders between them carried identifying inscriptions, as suggested elsewhere (see Reculver 1a–e, Discussion), then they would have been comparable to the vertically-placed inscriptions on the stole. The rocky ground employed on the stole can also be paralleled at Reculver where a similar ground is used on stone 1b (Ill. 116).

The comparison of style between the stole and the Reculver fragments presents more difficulties than comparisons of iconography, difficulties which arise out of both the poor state of preservation of the Reculver fragments, and from differences in medium. The figures on the stole are treated in a naturalistic, classicising manner. The figures are naturalistically posed with the left leg slightly flexed as if to take the weight of the body. The feet are also carefully drawn with the right foot foreshortened and the left foot in profile. Like the figures the garments are naturalistically rendered, reflecting faithfully the shape and movement of the body beneath. With the figure of Daniel, for example, where the left arm is raised to hold the palm leaf the loose sleeve of the garment is shown as having fallen back to the elbow, leaving the forearm bare. There is no working up of the figure using shading and highlighting to give solidity to the bodies, but this is a painter's technique which is inappropriate in embroidery, where instead there must be a dependency on line.

As noted elsewhere (see Reculver 1a–e, Discussion) the Reculver stones exhibit an almost identical naturalistic style, although with sculpture the solidity of a body can be faithfully reproduced and there is, therefore, less dependence on line. One particular stylistic trick is common to the stole and to the Canterbury fragment, the turning up of the hemline to each side in an unnaturalistic manner. This occurs with the figures Amos, Jonah, Joel, and an incomplete, unnamed prophet, and on the left-hand figure on the Canterbury fragment. Here the hem is turned up (particularly to the left) and curled back (Ill. 109), and is not as elaborately folded as is usually the case on the stole, but the centre of the hem is an elaborate double fold which precisely parallels that on the figure of Amos on the stole (Ills. 108, 110). There can be little doubt that this use of the billowing hem on the stole is a forerunner of the elaborate treatment accorded to the hem in works of the Winchester style, and the occurrence of this feature at Reculver may be of significance in dating. Unfortunately, it is only an isolated occurrence. The hems of the figures on stones 1a and 1d do not survive, and the feature is absent from 1b–c.

There are, then, some links both in iconography and style between the St Cuthbert stole and elements of the decoration on the Reculver fragments. Similar links can also be identified with the Aethelstan Psalter (BL MS Cotton Galba A. XVIII). This is a ninth-century Carolingian Psalter probably made in the region of Liège (Temple 1976, no. 5, 36). To it have been added in England a metrical calendar (fols. 3r–14v), *compotus* matter (fols. 15r–19r) and a Greek litany (fols. 178r and 200r) (loc. cit.). Four miniatures have also been added, including two Majesty scenes (fols. 2v and 21r; ibid., ills. 32–3), the Ascension (fol. 120v; ibid., ill 31), and the Nativity originally prefacing Psalm 1.[8] The additions were probably made in Winchester in the reign of king Aethelstan (924–39) (ibid., 37).

Iconographically, the closest link with the Reculver stones is provided by the first Majesty scene (Temple 1976, ill. 32). This has Christ seated in a mandorla adored by choirs of the angels and prophets. The figures are divided into four ranges separated by plain coloured bands, a disposition which echoes the superimposed ranges of figures which originally decorated the Reculver cross. Unlike the Reculver figures, those in the Psalter are not compartmentalised, but instead are partially overlapping. Compartmentalised figures do, however, occur in the calendrical material added to the Aethelstan Psalter where, in the bottom left-hand corner of some folios, there is a single standing figure within a plain rectangular border (ibid., ill. 15). Some of these figures compare closely with those on the St Cuthbert stole and maniple. The use of plain borders to contain figures can be paralleled on stone 1a from Reculver (Ills. 113–15), although elsewhere architectural frames are employed. In the Aethelstan Psalter the dividing frames of the Majesty scene are used to carry inscriptions (ibid., ill. 32), something which may have occurred at Reculver. The Aethelstan Psalter even has curved inscriptions on the mandorla of the second Christ in Majesty scene (ibid., ill. 33), something which may be postulated on stone 1b from Reculver (Ill. 116) where the lost curved metal fitting may have carried an inscription.

There are also some specific iconographical links between the Reculver stones and the Aethelstan Psalter. For example, the figures on the lower range of the first Christ in Majesty scene are all partially turned to one side. The right hand of each figure is raised in blessing and the left hand holds a book. Each figure is clad in a long undergarment with an overgarment bound at the waist and falling diagonally across the body. Some of the figures are bearded with their hair falling down behind. These figures are closely comparable to those of the prophets on the St Cuthbert stole, and also to the left-hand figure on stone 1d from Reculver (Ills. 111–12).

---

8. The latter leaf is now detached and in Oxford, Bodleian Library, MS Rawlinson B. 484, fol. 85r; ibid., ill. 30.

Stylistically, there are also parallels between the Aethelstan Psalter and the Reculver stones. The Aethelstan Psalter uses a naturalistic, classicising style of figure drawing, although one hand in the figure drawing is more accomplished than the other. In every case the figures are naturalistically posed with the draperies also rendered naturalistically and faithfully reflecting the shape of the body beneath. In each case the emphasis is not on line but on modelling to portray the figures in a three-dimensional manner. Stylistically, this precisely reflects the aims of both the Reculver fragments, discussed at length above (pp. 48ff.), and the figures of the St Cuthbert stole and maniple.

The fragment of wall painting from the New Minster excavations at Winchester, is small, but again is figure-decorated, although little survives apart from several superimposed busts (Wilson 1984, pl. 204). Wormald has suggested that these can be compared directly with the superimposed ranges of busts flanking the second Christ in Majesty scene in the Aethelstan Psalter (Temple 1976, no. 5, ill. 33), a scene which he had argued, before the discovery of this fragment, was probably derived from a wall painting. There are no specific comparisons which can be made between this fragment and the Reculver stones, but it is useful in providing corroborative evidence for the dating and Winchester provenance of the manuscript.

The last of the major Winchester works of the early part of the tenth century is the Corpus Christi *Vita Cuthberti*. This was probably made in Winchester in the reign of king Aethelstan (Temple 1976, no. 6, 38) and incorporates on fol. 1v a framed frontispiece showing king Aethelstan presenting the book to St Cuthbert (Wilson 1984, pl. 203). The manuscript can probably be identified as the book given by king Aethelstan to the community of St Cuthbert at Chester-le-Street in 937 (Temple 1976, 38). Unfortunately this work has no iconographic parallels with the Reculver fragments, although the presentation scene is probably based on a late Classical exemplar transmitted through Carolingian intermediaries (loc. cit.). Similarly the framing relies on Carolingian antecedents and is possibly derived from manuscripts of the Court School (loc. cit.). Stylistically also the *Vita Cuthberti* has little in common with the Reculver fragments except that the figures are rendered naturalistically, although their poses are wooden and the folds of the garments tend to be formalised. This handling reflects that of the Reculver fragments although no specific comparisons can be made.

In summary there are both general and specific points of comparison in both iconography and style between the Aethelstan Psalter and St Cuthbert stole on the one hand, and some of the Reculver fragments on the other. There are no specific comparisons which can be made with the *Vita Cuthberti*, or the New Minster wall painting fragment, although these clearly belong to the same artistic milieu as the St Cuthbert stole and maniple and the Aethelstan Psalter. It seems likely, however, that all these works draw on ninth-century sources and represent the end of ninth-century traditions, before the Winchester style was developed and overtook them. Certainly the fragmentary wall painting from the New Minster excavations was discovered in foundations which can be dated to *c.* 903, placing the painting firmly in the ninth century (Biddle and Kjølbye-Biddle 1990a). These Winchester products may, therefore, represent the end of a tradition which began with works such as BL MS Royal I. E. VI. That these works are later in date than the Reculver fragments is confirmed by their use of acanthus foliage. This is found on the corners of the frame enclosing the second Christ in Majesty scene in the Aethelstan Psalter (Temple 1976, ill. 33), and similar acanthus is used to separate the scenes on the St Cuthbert stole and maniple (Battiscombe 1956, pl. XXXIV). Acanthus is absent from the New Minster wall painting, but occurs in the frame of the presentation scene in the *Vita Cuthberti*, although incorporating features of vine-scroll, such as berry bunches, and birds and animals inhabiting the foliage (Wilson 1984, pl. 203). On stones 1e and 2 from Reculver, in contrast, the plant form is the earlier form of vine- or plant-scroll (Ills. 119–20, 122).

## THE WINCHESTER STYLE

In the tenth century a new phase of classicising art developed in southern England, the so-called 'Winchester style' (Kendrick 1949, 1–54; Temple 1976, 12–17). This was primarily a manuscript style, but is found on works in other materials, especially in ivory, but also in metal. Here the emphasis of the decoration is on the figural scenes, often contained in lush acanthus-filled frames. Interlace and animal ornament, hitherto such important components of Anglo-Saxon decoration, were relegated to a relatively minor role, occurring most commonly in initials. The style was not, however, uniform and monolithic, and different styles of drawing can be discerned (ibid., 12–22). One, drawing on various Carolingian sources

(ibid., 17), is exemplified by an outline drawing of St Dunstan at the feet of Christ (Oxford, Bodleian Library MS Auct. F. 4. 32, fol. 1r, made at Glastonbury c. 950 (ibid., no. 11, 41, ill. 41)). Here the figures are calm, monumental, and solid, although clad in light fluttering draperies (ibid., 17). The second style probably derives from Carolingian manuscripts of the Rheims school (ibid., 17), and in it figures are lively and excited, the focus being on the action of the scene. Gestures are exaggerated and draperies flutter around the figures with their edges folded in masses of small zig-zags (ibid., 18–22). The earliest example of the style may be in the Presentation Scene of the New Minster Foundation Charter (ibid., no. 16, ill. 84). This is often dated to c. 966 (ibid., 18), but is probably a later work. These two styles, the calm and monumental, and the dramatic, clearly interacted and towards the mid eleventh century fused to form a new style characterised by an impressionistic manner allied with fuller modelling (ibid., 22–4), as in the Judith of Flanders Gospels (ibid., nos. 93–4, ills. 285–6, 289).

The Winchester style clearly developed in manuscripts, and nearly a hundred such manuscripts survive, but it did translate easily into ivory, as with the figures of the Virgin and St John from Saint-Omer (Beckwith 1972, no. 25, pls. 57–8) and a plaque from Winchester (ibid., no. 16, pl. 39). Works in the Winchester style in other materials are less common. In metal there is the engraved decoration around the altar in the Musée de Cluny (Backhouse et al. 1984, no. 76, pl. 76), on the reverse of the Brussels cross (ibid., no. 75, pl. 75), on the Heribert crosier (Beckwith 1972, no. 30, pls. 80–1), and a cast figure from Colliergate, York (Backhouse et al. 1984, no. 267, pl. 267). Only the major figural styles which have a specific relevance to sculpture are discussed with special reference to Reculver.

In stone sculpture the rich decoration which once adorned the Old Minster after its extensive alterations in the late tenth and early eleventh centuries now survives only in fragments, though scraps of acanthus ornament (no. 71; Ill. 615) hint at a relationship to manuscript styles, and the remains of large-scale figural decoration hints at the elaboration of what has been lost (nos. 75–85; Ills. 618–22, 625–38, 641). The more complete works which do survive should probably be seen as provincial reflections of the lost major works in the capital itself. Two angels from Bradford on Avon, Wiltshire (Rice 1952, pl. 7) compare closely in style with the manuscripts and ivories, while the crucified figure of Christ from

Romsey, Hampshire (no. 1), closely relates to similar scenes in the manuscripts, such as BL MS Harley 2904 (Temple 1976, no. 40, ills. 140–2). The lush acanthus employed in the manuscripts is virtually absent from stone sculpture, but there are fragments of fully-developed Winchester-style acanthus from Avebury, Wiltshire (Cramp 1975, 189), and Peterborough cathedral (Backhouse et al. 1984, no. 137, pl. 137).

Against this background the Reculver fragments sit rather uneasily, although Talbot Rice has suggested a tenth-century date for them (Rice 1952, 97–8). The plant-scroll employed on stone 1e cannot be paralleled in the late tenth and eleventh centuries, when acanthus was the predominant form of foliage. The interlace borders which contain the plant-scroll on stone 1e are equally difficult to parallel among works of the Winchester style. Reculver 1e (Ills. 119–20) and the closely allied no. 2 (Ill. 122) cannot belong to this period.

Turning to the figure-decorated drums, the figures at Reculver are still and composed, particularly on 1a and d (Ills. 111–15), and the fragment from Canterbury (Ills. 108, 110). Even on stones 1b–c, which are narrative, there is a stillness which is quite at variance at least with the second of the Winchester styles, as a comparison between the Ascension scene on stone 1b and the Benedictional of St Aethelwold (Temple 1976, no. 23) demonstrates. On stone 1b, although Christ is climbing a hill, the scene is static, without any upward movement (Ill. 116). In the Benedictional, in contrast, the figure of Christ leaps into the air in a swirl of draperies reaching forwards towards the Hand of God; the entire scene is filled with movement and life. It is possible that the Reculver figures belong to the more monumental figure style, but even here the draperies are handled very differently, with fluttering ends flying away from the body, and elaborate zig-zag folds with a distinctive broken profile. All this is very far from the naturalistic, but calm and still effect conveyed at Reculver. It seems clear, then, that the Reculver fragments must belong to the period before the Winchester style became so all-embracing, before say c. 950.

## CONCLUSION

In order successfully to place the Reculver fragments it is necessary to find a period in which certain criteria can be met: when round shafts were made and used; when the combination of interlace, plant-scroll and naturalistic figures employed on stone 1e was popular;

and when a naturalistic, classicising figure style was current.

The form of the shaft, of circular section and drum-built, may serve to suggest a *terminus post quem* for the making of the Reculver monument. As noted elsewhere (see Reculver 1a–e, Discussion) round shafts only seem to have been introduced in the ninth century, and were used, if infrequently, in southern England thereafter, although the making of specifically columnar monuments is rare enough to urge caution in pressing this argument too far. This possible *terminus post quem* is supported by the decoration of stone 1e, which mixes naturalistic figure sculpture, plant-scroll and interlace. This mixture of motifs is typical of the art of the late eighth and ninth centuries (Budny and Tweddle 1984, 78). It is seen, for example, in manuscript art in BL MSS Cotton Tiberius C. II (Alexander 1978, no. 33, ills. 134, 165) and Royal I. E. VI (ibid., no. 32, ills. 161–4), although both works also employ frets and animal ornament. In other materials the use of figural ornament in conjunction with interlace and plant-scroll is unparalleled, but the mixture of different motifs is common. The Maaseik embroideries, for example, combine plant, animal, and interlace ornament (Budny and Tweddle 1984, 78–84, ills. I–VI), and a similar mixture is often encountered in metalwork, for example, on the brooches from Pentney, Norfolk (Wilson 1984, pl. 120). Foliate decoration was itself an introduction into southern English art only in the late eighth century (Budny and Graham-Campbell 1981, 11), but the precise form of the foliage on stone 1e from Reculver can only be paralleled in the ninth century, particularly in Royal I. E. VI, and in some pieces of metalwork decorated in the Trewhiddle style.

The absence of comparative material means that the figure style of fragments 1a–d and the Canterbury fragment is more difficult to parallel, but specific comparisons can be drawn, especially with BL MS Royal I. E. VI, and the Barberini Gospels. Moreover, it is in this period, the early ninth century, that small-scale classicising sculpture was introduced elsewhere in southern England, most notably in Hampshire. The *terminus ante quem* must lie at the latest in the mid tenth century. The ornament of the fragments has no affinities with works decorated in the Winchester style. The figure style is very different and much less agitated than that employed in the Winchester style. The foliage is plant-scroll, not the acanthus used universally in the Winchester style. The only parallels which can be drawn between the Reculver fragments and tenth-century works are with products of the early part of the century, before the Winchester style had fully formed and become so universal. In particular, parallels can be drawn with the St Cuthbert stole and maniple (Freyhan 1956, 409–32, pls. XXIV–XXV, XXXIII–XXXIV), and with the Aethelstan Psalter (Temple 1976, no. 5, ills. 30–3). Both works employ a very similar figural style to that employed at Reculver.

The date of the Reculver fragments probably therefore lies between the early ninth and early tenth centuries. This presents a problem, as the early tenth-century works noted above are usually regarded as innovative, representing a new phase in Anglo-Saxon art, the precursors to the Winchester style (Backhouse *et al.* 1984, 19). Given the lack of late ninth-century works from southern England it is, however, possible that these works constitute a continuation of ninth-century traditions, before the Winchester style developed and overtook them. The discovery of the fragmentary wall painting from the foundations of the New Minster in an archaeological context dated to *c.* 903 (Biddle 1967b; Wilson 1984, 155, pl. 204; Biddle and Kjølbye-Biddle 1990a–b), places it at least in the ninth century and may confirm that the closely-related Aethelstan Psalter represents late ninth-century artistic traditions. If this conclusion can be accepted, it reconciles some of the difficulties in dating the Reculver sculptures, and places them firmly in the ninth century, perhaps, given the close links with BL MS Royal I. E. VI, in the earlier part of that century.

# CHAPTER VII

# THE DEVELOPMENT OF SCULPTURE *c.* 950-1100

## by D. Tweddle

The last century of Anglo-Saxon England witnessed an extraordinary increase in the survival and, therefore, probably in the production of stone sculpture in the south-east. Even excluding the material from the excavations at Winchester (see Chap. VIII), nearly two hundred sculptures survive which can be dated to this period, as opposed to about three dozen surviving from the period between *c.* 600 and 950. This contrast must reflect more than differential rates of survival. In addition there appears to have been a radical change in the types of sculpture produced. In the earlier period almost half the pieces were from cross-shafts or cross-heads, about one-third were architectural sculptures, and only five were monumental sculptures. In the late tenth and eleventh centuries there seems to have been almost a complete reversal. Free-standing crosses account for less than one tenth of the surviving examples, whereas monumental sculptures account for about a quarter. More than half, however, are architectural. The remaining pieces are unclassified. The period also seems to have witnessed the growth of a number of local workshops, apparently divorced from contemporary shifts in fashion, such as those producing the grave-covers of Surrey and Sussex, discussed in more detail below. The bulk and diversity of the material has prompted a sub-division by function. Within each group the dating of the individual pieces is then tackled.

## IN SITU ARCHITECTURAL SCULPTURE

Apart from the Winchester fragments (Chap. VIII), the crucifixion panels and figural scenes, and the sundials, which are all discussed separately below, more than 50 of the late Anglo-Saxon architectural sculptures from south-east England are *in situ* and another three dozen or so are *ex situ*. In dating the *in*

*situ* sculptures, one approach is to attempt to date the fabric of which the sculpture forms a part, that is to use primary dating evidence. Apart from the problems of identifying reused pieces, and pieces which are later embellishments to a fabric, discussed in Chap. IV, the fundamental difficulty in employing this approach is that none of the fabrics is dated by inscription or has any surviving contemporary documentation, and the close stylistic dating of pre-Conquest fabrics still presents almost insuperable difficulties. The best that can yet be achieved is to separate those fabrics which are of early, middle, and late Anglo-Saxon date (Taylor and Taylor 1965–78, III, 1068–70). This is of help in at least identifying some of the sculptures which might be assigned to the late tenth or eleventh centuries.

Taylor and Taylor have isolated several criteria which serve to distinguish late Anglo-Saxon fabrics. These include the use of double-splayed windows, long and short work quoins used in conjunction with pilaster strips, hoodmoulds and stripwork, and belfry towers. Using these criteria the following churches from south-east England which employ architectural sculpture can be identified. Hadstock, Essex; Breamore, Boarhunt, and Corhampton, all in Hampshire; North Leigh, St Michael in Oxford and Langford, Oxfordshire; and Sompting, Sussex. The church at Headbourne Worthy, Hampshire, also exhibits some of these features, but the only sculpture is the crucifixion group, discussed in detail below (p. 76). Less survives of the church of Botolphs, Sussex, but its chancel arch shares a number of features with the fabrics at Sompting, Langford, and Hadstock. A late pre-Conquest date can also be advanced for parts of the fabric at Walkern and Little Munden, Hertfordshire, but on different grounds from those proposed by Taylor and Taylor.

In considering these eleven late Anglo-Saxon churches three architectural groups can be identified. The first group, comprising the Hampshire churches

of Boarhunt, Breamore, and Corhampton, employs almost all of the features noted by Taylor, but belfry towers do not occur. At Boarhunt there are external pilaster strips, stripwork, and a hoodmould around the chancel arch, and there is a double-splayed window (Taylor and Taylor 1965–78, I, 76–8, fig. 34, II, pl. 394). At Breamore there are long-and-short work quoins, external pilaster strips, and double-splayed windows (ibid., I, 94–6, fig. 42, II, pls. 405–6). At Corhampton, in addition to these features, there is stripwork and a hoodmould outlining the north door (Ills. 442–3) and the west face of the chancel arch (ibid., I, 176–9, figs. 74–5, II, pl. 440). The second group consists of the church at North Leigh and Oxford (St Michael). At both places only the plain, unbuttressed, west tower survives, with baluster shafts employed for the belfry windows. There are long-and-short work quoins on the north side at St Michael's, but the southern quoins are of rubble (ibid., I, 481); at North Leigh the quoins are side alternate (ibid., I, 464), there are also single-splay windows at first floor level (ibid., I, 464, fig. 222). The third group of buildings includes the fabrics at Botolphs and Sompting, Sussex, Hadstock, Essex, and Langford, Oxfordshire. These employ some of the features noted by Taylor and Taylor, long-and-short work quoins and double-splayed windows at Sompting (ibid., II, 558–62, figs. 271–3), Langford (ibid., I, 367–72, figs. 164–8, II, pls. 511–3), and Hadstock (ibid., I, 272–5, fig. 120, II, pls. 479–80), and pilasters and belfry towers at Sompting and Langford. More distinctively, all the churches in the third group employ features characteristic of Romanesque architecture, in particular, engaged angle shafts at Hadstock and Langford, and soffit shafts and rolls at Botolphs, Langford (Ill. 297), and Sompting (Ills. 183, 186). In addition there is an angle roll on the arch head of the north door at Hadstock (Ill. 277).

Churches in the first group and second groups are difficult to date more closely than simply to the late Anglo-Saxon period, although attempts have been made to do so. Taylor and Taylor, for example, place Breamore, Hampshire (Taylor and Taylor 1965–78, I, 94), and North Leigh, Oxfordshire (ibid., I, 464), in the period c. 950–1000, and Corhampton, Hampshire (ibid., I, 176), and Oxford (St Michael) (ibid., I, 481) in the period 1050–1100, but they are unable to refine the dating of the church at Boarhunt, Hampshire. However, the evidence on which these assertions are based is not always adequately argued. In contrast, the dating of the third group of buildings can be narrowed considerably as the Romanesque features which they

embody only appeared on the continent in the course of the eleventh century, providing a *terminus post quem* for the English examples. Half-round pilasters like those at Sompting (Ill. 192) first appear at St Maria im Kapitol, Cologne, where the Holy Cross altar was dedicated in 1049 followed by another dedication in 1065 (Gem 1973, II, 494; Conant 1974, ill. 337); at St Remi, Rheims dedicated in 1049 (Gem 1973, II, 494); and in the mid eleventh-century Abbot's chapel at Vendôme (loc. cit.). Soffit shafts used at Botolphs, Langford (no. 4), and Sompting (Ill. 183) occur first on the continent from the second quarter of the eleventh-century onwards, as at Speyer in Germany of c. 1030–61 (ibid.; Conant 1974, ill. 90), and at Bernay, under construction between 1017–55 (Gem 1973, II, 494; Gem 1983, 126; Musset 1974, pls. 1–4), at Le Mont St Michel in work of 1034–64 (Gem 1973, II, 494), and at Jumièges, 1037–66 (ibid.; Conant 1974, ills. 357–8), all in Normandy. Soffit rolls, used in conjunction with the shafts, are an equally late feature occurring first in the crypts of Auxerre and Nevers cathedrals, dated to c. 1030 and 1029 respectively (Bony 1967, 75; Conant 1974, 244, ill. 112) and at St Martin, Tours, dated to c. 1050 (Bony 1967, 75; Conant 1974, 162, ill. 115). Angle shafts and rolls, used at Hadstock, make their earliest appearance on the continent in the mid eleventh century, for example, at Le Mont St Michel in work dated to 1048–58 (Bony 1967, 76).

The late dating of the continental analogues for the Romanesque features, which appear in churches of the third group, must place them in the middle of the eleventh century or later. This in turn has fired a debate over whether the churches of this group are of pre- or post-Conquest date. Anglo-Saxonists such as H. M. and J. Taylor, naturally, regard them as of pre-Conquest date, and scholars of the Romanesque treat them as of post-Conquest date (Bony 1967; Gem 1983, 128). In defence of the protagonists of a pre-Conquest date it is clear that Romanesque buildings were constructed in England before the Conquest, most notably at Westminster abbey which was begun c. 1050 (Gem 1980, 34). Also a single well-dated pre-Conquest building of Romanesque style survives, at Kirkdale, Yorkshire. Here the two-celled building has a west door and chancel arch with angle shafts, but is dated by inscription to 1055–65 (Taylor and Taylor 1965–78, I, 357–61, figs. 158–60, II, pls. 504–6). It is arguable that the inscription, on a sundial over the south door, has been reused from an earlier building, but there is no evidence to support such a suggestion. Moreover, the form of the bases to the angle shafts is

not one encountered elsewhere in demonstrably post-Conquest Romanesque architecture (D.A. Stocker, pers. comm.). The evidence, then, suggests that some of the churches of the third group may be of pre-Conquest date, although the elaborate forms of some of them, most notably at Langford, must place them firmly after the Conquest. Precise dating, however, is relatively unimportant in terms of the sculptures which adorn them. These are rather different in type and approach from those which decorate the earliest incontrovertibly Romanesque buildings in south-east England, such as the capitals in Canterbury cathedral crypt of *c.* 1075 (Zarnecki 1951b, 26, pl. 11). The sculptures adorning the third group of churches are thus arguably of pre-Conquest style or tradition, if not necessarily of pre-Conquest date.

Turning from the buildings to the sculptures which adorn them, it is noticeable that architectural sculpture is used more sparingly on churches of the first and second groups than on buildings of the third group. At Boarhunt, Hampshire, decoration is confined to the cabled ornament on the mid-wall slab of the north window of the chancel (Ills. 423–4). Cabled ornament is used in south-east England exclusively on sculptures of the late pre-Conquest period, as on the cross-shaft from London All Hallows by the Tower (no. 1), a fact which apparently confirms the primary dating evidence. However, the motif is so simple that dating by this feature alone is unsafe. At Breamore, Hampshire, the decoration is slightly more elaborate. Apart from the crucifixion (no. 1), discussed below, which is *ex situ*, again there is cabled ornament, this time on the impost blocks of the opening into the south porticus (nos. 2a–b). On the arch head is an inscription (no. 2c) and there are two other fragmentary inscriptions (nos. 3–4); unfortunately, these are difficult to date precisely (see below, pp. 112, 253–6).

At Corhampton, Hampshire, the decoration is equally elaborate. Apart from the sundial discussed below, four of the pilasters probably once had foliage-decorated bases. Only one of the bases (no. 2) survives more or less intact, and this is decorated with a broad bulbous leaf, flanked by a pair of out-turned volutes (Ill. 440). This is an arrangement which occurs frequently in tenth- and eleventh-century art, particularly in manuscripts (Fig. 16a–i). It is employed in initials as on the initial D on fol. 118r of the Junius Psalter, a work of the second quarter of the tenth century (Temple 1976, no. 7, ill. 26), and on the initial B on fol. 4r of BL MS Harley 2904, a work dated to the last quarter of the tenth century (ibid., no. 41, ill. 141). The motif occurs

FIGURE 16

Foliate ornament, nts (KEY: a, York, Coppergate disc brooch; b, New York, Pierpont Morgan Library MS 709, fol. 2v; c, Athelstan Psalter, fol. 21r; d, Lincoln, ivory seal matrix; e, Winchester New Minster foundation charter, fol. 2v; f, Cambridge, Pembroke College MS 301, fol. 10v; g, London, Cheapside hoard disc brooch; h, Junius Psalter, fol. 118r; i, BL MS Harley 2904, fol. 4r; j, Corhampton 2)

also on the corners of frames to figural scenes, as on fol. 21r of the Aethelstan Psalter, dated to 924–39 (ibid., no. 5, ill. 33), or fol. 10r of Cambridge, Pembroke College MS 301, dated to *c.* 1020 (ibid., no. 73, ill. 233). In some cases the majority of the lush acanthus work making up the frame is composed of this motif endlessly repeated to form a simple bush scroll, as in the case of fol. 2v of the New Minster Foundation Charter, dated to after 966 (ibid., no. 16, ill. 84), and on fol. 2v of New York, Pierpont Morgan MS 709, dated to the second quarter of the eleventh century (ibid., no. 93, ill. 285). This three-leaved motif occurs also in ivory, as on an eleventh-century seal matrix from Lincoln, and in metal, for example on the lead-alloy disc brooches from the Cheapside hoard (Clark 1980, 14, pl. on 13), and on two disc brooches from 16–22 Coppergate, York (Tweddle 1982, 26–9, fig. p. 26; Hall 1984, ill. 60). On each of these brooches the design in the central field is made up from interlinked three-leaved motifs of the form used at Corhampton. The two Coppergate brooches derive from tenth-century contexts (Hall 1984, 60), but the Cheapside hoard can probably be dated to the eleventh century (Clark 1980, 14). These parallels for the Corhampton pilaster bases serve to underline the tenth- or eleventh-century date suggested by the primary evidence, but do little to refine it further.

On churches of the second group, sculpture is confined to the use of baluster shafts. At North Leigh these are plain with undecorated capitals and bases (Ills. 400–3). At Oxford (St Michael 1) there is a simple roll moulding encircling each baluster at the mid-point (Ills. 364–70). As Wright pointed out in his seminal article on Anglo-Saxon architecture (Wright 1844), such turned balusters are depicted in late Anglo-Saxon manuscripts, as in Aelfric's Pentateuch, on fols. 37v and 74r. This is a work of the second quarter of the eleventh century, probably made at St Augustine's abbey, Canterbury (Brown 1991, 52), a site which has yielded two *ex situ* balusters (Ills. 41–9) of very similar form to those depicted in the manuscript, discussed more fully below, p. 72. An eleventh-century date would, therefore, be plausible for examples from North Leigh and Oxford.

Sculpture is more abundant on fabrics of the third group of churches, those with Romanesque architectural features, with 32 out of the 52 *in situ* architectural sculptures occurring in churches of this group. Of these 32 there are two sculptures at Botolphs, Sussex; five at Hadstock, Essex (no. 1), thirteen at Langford, Oxfordshire (no. 4); and twelve at Sompting, Sussex (nos. 14–23). In addition, the six sculptures on the south porticus arch at Hadstock (no. 2) clearly derive from the same building as the *in situ* doorway, although there is some argument over whether they have been re-arranged (Rodwell 1976, 62–3; Fernie 1983a). As noted above (pp. 63–4), the primary, architectural, evidence suggests that all of these sculptures should be dated to the middle or later part of the eleventh century, and limited support for this dating can be derived from the form and style of the individual sculptures.

At Sompting, Sussex, the sculpture consists of an external string-course (no. 15), capitals and flanking impost-like strips on the internal tower arch (no. 14), capitals on the half-round pilaster strips (nos. 16–19), two leaf-decorated belfry capitals (nos. 20–1) and two voluted bases (no. 22). The string-course is of complex and unparalleled form and cannot be independently dated, and the voluted bases are so simple that comparative dating is impossible. However, some additional dating evidence may be gleaned from the remaining sculptures. On the tower arch the layout of the decoration, with soffit shaft capitals flanked by impost-like strips (Ills. 183–91), is unusual and is paralleled in England only at Langford, Oxfordshire (no. 4; Ills. 297–312), and on the continent at Bernay in Normandy, where similar strips are found flanking a number of capitals in the south transept in work dated

to 1017–55 (Gem 1973, II, 495, 522; idem 1983, 126). As noted above (p. 25), the capitals of the tower arch and of the pilaster strips are of debased composite or Corinthian form in which either the zone of upright leaves is suppressed leaving only the volutes, or the volutes are suppressed leaving only the zone of upright leaves. This particular type of debasement is paralleled elsewhere in England only in Lincolnshire where, at Bracebridge and Glentworth, there are volute capitals with the zone of upright leaves suppressed (Brown 1925, fig. 192, VII, XVI), and at Great Hale there are upright leaf capitals with the volutes suppressed (ibid., fig. 192, XII, XIV). At all three sites the capitals adorn belfry towers of the Lincolnshire type, for which a firm early post-Conquest date is increasingly being argued. A number of the towers, for example, use standard Romanesque capital forms, such as the cushion capital, while at Branston the tower has a Romanesque blind arcade around the base (Taylor and Taylor 1965–78, I, 93–4, II, pl. 404). This is clearly primary despite the Taylor's valiant attempt to argue that it is secondary (ibid.; D. A. Stocker, pers. comm.).

The belfry capitals at Sompting (nos. 20–1) are of the corbelled form, and have each of the main faces decorated with two pairs of volutes, one above the other, linked at the base. The volutes take the form of long, narrow tendrils with clubbed or lobed ends (Ills. 205–12). This attenuated leaf type occurs elsewhere in Anglo-Saxon art in the latest phase of the Winchester style (Kendrick 1949, 102–3), for example in Rheims, Bibl. Mun. MS 9. fol. 23, dated to *c.* 1062 (Temple 1976, no. 105, ill. 299). Here on fol. 88r the corner rosettes of the frame have the acanthus drawn out to form long, attenuated strands with the tips curled over (ibid., ill. 299) and a similar treatment is evident in the upper right-hand corner rosette on fol. 1v of Oxford, Bodleian Library MS Tanner 3, dated to the second quarter of the eleventh century (ibid., no. 89, ill. 298). Similar attenuated tapering leaves with lobed ends are employed also in the Ringerike style, as, for example, on the grave-marker from St Paul's, London (Ill. 351). The Ringerike style was current in England from the late tenth century to the middle of the eleventh century (Wilson and Klindt-Jensen 1966, 145–6). Whether the Sompting capitals draw on one or both of these artistic strands, the parallels for the form of the leaves suggest a date towards the middle of the eleventh century, a date for the tower which, in broad terms, is also suggested by the form of the other capitals, and by the disposition of the decoration on the tower arch.

At Botolphs, Sussex, the only architectural sculptures are the capitals of the chancel arch (Ills. 4–5). They are upright leaf types related to those on the tower arch at Sompting (Ills. 186, 190). Again, they appear to be debased versions of the composite or Corinthian form, and a similar date can be argued for them.

At Langford, Oxfordshire, the sculptured decoration consists of nine capitals to the archivolt and soffit roll shafts of the belfry windows of the central tower (no. 4), and a sundial on the south face of the tower (no. 3). The narrow capitals are continued by flanking impost-like strips (Ills. 297–312), a feature which, as noted above, is paralleled elsewhere only at Sompting, Sussex, and Bernay in Normandy. The decoration of both capitals and friezes consists of sprays of acanthus developing from the lower edge moulding; each spray is contained within a semicircular field. This type of decoration is widely paralleled in late pre-Conquest art as, for example, in a highly conventionalised form on fol. 4v of the Sherborne Pontifical, dated to the last quarter of the tenth century (Temple 1976, no. 35, ill. 13); in the upper border of the scene of the miracle of the tribute money in the Gospel Lectionary fragment formerly in the Musée van Maerlant, Damme, Belgium, dated to *c.* 1000 (ibid., no. 53, ill. 176); on the lower border of the scene on fol. 171r of the Winchcombe Psalter, dated to *c.* 1030–50 (ibid., no. 80, ill. 253); and in the borders of fol. 2r of Aelfric's

FIGURE 17

Foliate ornament, nts (KEY: a, Damme, gospel lectionary; b, Aelfric's Pentateuch, fol. 2r; c, Canterbury, censer cover; d, Cambridge, University Library MS Ff.1.23, fol. 171r)

Pentateuch, a work of the second quarter of the eleventh century (ibid., no. 86, ill. 265). In metalwork a similar composition is employed on the inlaid silver plates around the base of the Canterbury censer cover, dated to the mid tenth century (Fig. 17c; Wilson 1964, no. 9, pls. XII-XIV; Backhouse *et al.* 1984, no. 73, pl. XXII). These parallels confirm the late pre-Conquest or early post-Conquest date suggested for the sculpture by the primary, architectural, evidence, but do nothing to advance the dating further.

The sundial at Langford (no. 3) is equally of little help in further refining the dating. The dial is set very high up and is not easy to read and it is possible that it has been reused from an earlier building. Even if the dial is contemporary with the tower, the decoration, which consists of two secular figures, half twisted and holding aloft the semicircular dial (Ill. 293), is not closely datable. Secular figures clad in knee-length garments and wearing cloaks are commonplace in manuscript art in both the tenth and eleventh centuries. They occur, for example, in the late tenth-century illustrations to Prudentius's *Psychomachia* in Cambridge, Corpus Christi College MS 23, as on fols. 2r and 37v (Temple 1976, no. 48, ills. 155–6), and in the Presentation scene in the Foundation Charter of the New Minster, Winchester, dated to after 966 (ibid., no. 16, ill. 84). In the eleventh century similar figures occur in the illustrations of the labours of the months in BL MS Cotton Tiberius B. V, dated to the second quarter of the eleventh century (ibid., no. 87, ills. 273–4). The best parallel for the posture of the figures at Langford, half-turned and looking upwards with their arms raised, is provided by the figure of king Edgar in the Presentation scene on fol. 2v of the Foundation Charter of the New Minster. However, the solid naturalistic style of the draperies at Langford is closer in style to eleventh-century works, such as BL MS Cotton Tiberius B. V, than to the fluttering, agitated draperies of the New Minster Foundation Charter.

The church at Hadstock, Essex, has two sculptured capitals, two impost blocks, and a hoodmould to the north doorway (no. 1; Ills. 277–84), as well as four sculptured capitals and two impost blocks on the arch into the south porticus (no. 2; Ills. 285–91), although, as noted above, the present south porticus arch may be a re-arrangement of older material (see above, p. 65). In every case the decoration consists of palmette-like leaf ornament made up of interlocking, sub-triangular groups of radiating wedge-shaped leaves. This type of decoration is extremely difficult to parallel elsewhere, but something similar occurs in the upper right-hand

border of the crucifixion scene in the Winchcombe Psalter, a work of *c.* 1030–50 (Temple 1976, no. 80). There is also comparable decoration on the mid twelfth-century eastern impost of the south doorway of Great Canfield church, Essex. Here the motif has developed into a series of rigidly interlocking triangles of palmette ornament, but the form and grouping of the leaves is close to that at Hadstock (Cobbett 1937, 45–6, pl. I). On the continent similar ornament occurs in conjunction with early Romanesque features on a capital in the crypt of Nevers cathedral, dated to *c.* 1030 (Bony 1967, 75). Presumably the Hadstock ornament lies in date somewhere between these various works, between *c.* 1030–50 and *c.* 1150, a date which fits comfortably with that provided by the primary evidence.

Apart from these two groups of churches which can be recognised as late Anglo-Saxon by reference to the criteria advanced by the Taylors, it is clear that parts of the fabrics at Walkern and Little Munden, Hertfordshire, must also be of pre-Conquest date. At Walkern the south arcade of the nave is of early twelfth-century date (Page 1912c, 224). This cuts through an earlier wall, reusing one jamb and an impost from an earlier south doorway (no. 2) and also leaving *in situ* a sculptured crucifixion (no. 1) which was positioned over the doorway (Taylor and Taylor 1965–78, II, 628–30, figs. 318–9). The date of the Romanesque arcade suggests that the earlier wall with its south doorway and crucifixion might be of pre-Conquest date. The more exact placing of this fabric within the pre-Conquest period is more difficult, but the iconography and style of the crucifixion group, discussed below, argues for a tenth-, or more probably an eleventh-century date, and this can be used to date the cable-decorated impost surviving from the original south doorway. The impost at Walkern (no. 2; Ills. 398–9) is made up of four bands of cabling, each projecting beyond the one below. The twists of the rope are modelled, and along the middle of each strand is a V-shaped notch. This distinctive type of cabled decoration occurs on three other impost blocks from south-east England, two at Little Munden, and one at Dartford, Kent. At Little Munden, about five miles from Walkern, the western bay of the north nave arcade has jambs of square section which carry imposts of precisely the same form as those at Walkern (Ills. 318–19). It seems likely that they also are of eleventh-century date. At Dartford an impost on the north side of the late eleventh-century tower arch (Ill. 61) has identical cabling to that employed at

Walkern and Little Munden, but the bands of cabling do not project. It is clear that this block must have been reused from an earlier fabric, as only the western face is decorated; the south face has been cut back flush with the jamb of the arch. Moreover, the block does not extend through the full thickness of the wall. Like the imposts from Walkern and Little Munden this appears to be a late pre-Conquest piece, probably of eleventh-century date.

## *EX SITU* ARCHITECTURAL SCULPTURE

In addition to the *in situ* architectural sculptures discussed above there is also a number of late pre-Conquest architectural sculptures which are now *ex situ*. These originally served a variety of purposes. At Sompting, Sussex, there are eight pieces from an internal string-course (nos. 1–8) and three frieze or blind arcade fragments (nos. 9–11). There are single fragments of screens from Sonning, Berkshire, and St Mary in Castro at Dover in Kent (no. 4); a gable cross from West Wittering, Sussex, and possibly another from Walberton, Sussex; and balusters or baluster fragments from St Augustine's, Canterbury, where there are two, St Mary in Castro, Dover, where there are five, and Jevington, Sussex, (no. 2) where there are two, and St Albans, Hertfordshire, where there are sixteen. The fragment from St Aldate's, Oxford, may also originally have been architectural. In addition, the fragmentary roundel from Abingdon, Berkshire, appears to have served an architectural function. The two fragmentary *ex situ* inscriptions from Breamore, Hampshire (nos. 3–4) and the *ex situ* impost block from Dartford, Kent, are discussed above (pp. 64, 67). There are also sundials from Warnford and Hannington, Hampshire; St Maurice's and St Michael's, Winchester; Orpington, Kent; Marsh Baldon, Oxfordshire and Stoke D'Abernon, Surrey, discussed below (pp. 72–3).

The most elaborately decorated of these *ex situ* fragments are the lengths of string-course from Sompting (Fig. 18a–e). Six of these (nos. 1–5 and 7; Ills. 162–3, 167–8, 170–1) are decorated with foliage, each element of which consists of a long stem ending in a pair of out-turned leaves, with an axial bud or third leaf. The stalk is longitudinally grooved and the leaves are hollowed. The stems are angled and interlace where they cross. On two other fragments (nos. 6 and 8; Ills. 166, 164) the stems rise vertically from the border and do not interlace; some stems

FIGURE 18

Foliate ornament, nts (KEY: a, Sompting 7; b, Sompting 8; c, Sompting 6; d, Sompting 5; e, Sompting 4; f, Arenberg Gospels, fol. 17v; g, Oxford, Bodleian Library MS Tanner 3, fol. 1v; h, BL MS Cotton Vitellius C.III, fol. 11v; i, Rome, Vatican Library MS Reg. Lat. 12, fol. 62r)

develop into five or six leaves. On both of these fragments the curved leaves from pairs of adjacent stems interlock to form semicircular fields, each containing a small semicircular-ended grooved leaf rising from the border.

These types of foliage can be closely paralleled in the acanthus-decorated borders of manuscripts in the Winchester style. The main leaf type with its long grooved stems and three-element tip can be paralleled in a number of manuscripts, most notably in the Arenberg Gospels of c. 990–1000, as on fols. 17v and 126v, where some of the leaves have precisely the same form as those at Sompting (Temple 1976, no. 56, ill. 169; Backhouse *et al.* 1984, no. 47, pl. XI). Similar leaves occur in the borders of the St Mark portrait added c. 1000 to BL MS Royal I. E. VI (Temple 1976, no. 55, ill. 172), and in the corner rosettes on fol. 1v of Oxford, Bodleian Library MS Tanner 3, dated to the second quarter of the eleventh century (ibid., no. 89, ill. 298). Here the stalks are attenuated and angled so that they cross over each other, a feature characteristic of the plant ornament at Sompting. The combination of this leaf type with interlacing stems occurs also in the Arenberg Gospels (ibid., no. 56, ill. 169; Backhouse *et al.* 1984, pl. XI), and angled,

interlocking stems with different forms of acanthus foliage are also abundant in manuscript art as, for example, on fol. 53r of BL MS Arundel 155, dated to 1012–23 (Temple 1976, no. 66, ill. 217); on fol. 11v of BL MS Cotton Vitellius C. III, dated to the early eleventh century (ibid., no. 63, ill. 187); and on fol. 62r of Rome, Vatican Biblioteca Apostolica MS Reg. lat. 12, dating to the second quarter of the eleventh century (ibid., no. 84, pl. 262).

Both the leaf type at Sompting, with its three-element tip, and the interlocking of the stems can also be paralleled in works in other materials in late Anglo-Saxon art. In metalwork three-element leaves are commonly encountered, as in the centres of the disc brooches from the Cheapside hoard, London (Clark 1980, 14, pl. p. 13) and from 16–22 Coppergate, York (Tweddle 1982, fig. p. 26; Hall 1984, ill. 60). The use of interlocking stems is more unusual, but is paralleled in ivory on the early eleventh-century Tau-shaped crosier from Alcester, Warwickshire (Beckwith 1972, no. 29, pls. 65–6). Here some of the acanthus sprays have long grooved stems and three-element tips, but the length of the stem varies greatly and the acanthus is inhabited. Apart from these differences the parallel with the Sompting frieze is close.

The parallels which can be drawn between the main leaf type at Sompting and these Anglo-Saxon works, principally of eleventh-century date, might suggest a similar date for the majority of the Sompting frieze fragments. However, both this leaf type and the use of interlocking stems persisted into the post-Conquest period and were assimilated into Romanesque art. At Canterbury one of the crypt capitals, dated to *c.* 1120, employs leaves very similar in form to those at Sompting, although the organisation of the leaves, to fill the faces of a cushion capital, is very different (Zarnecki 1955, 215, pl. 161). At Steyning on a capital in the south aisle, also dated to *c.* 1120, the foliate stems have voluted, not tripartite, ends, but interlock and interlace in a manner evocative of the arrangement of the stems at Sompting (ibid., 212, pl. 156). The foliate decoration at Sompting must lie in date between the pre-Conquest works of the first half of the eleventh century and these Romanesque capitals of the early twelfth century. The parallels with the Anglo-Saxon works are more numerous and more convincing than with the Romanesque, and it is probable that the Sompting pieces lie closest in date to them, perhaps towards the middle of the eleventh century.

The remaining two fragments of string-course from Sompting (nos. 6 and 8) have leaf decoration which is of the same general character as that on the other six pieces, if coarser and more formalised (Ills. 166, 164). From their dimensions and material it is clear that they originally formed part of the same architectural feature as the other five fragments, and must, therefore, be of the same date. Independent confirmation of this derives from the form of the leaf decoration, as the leaves form semicircular fields each containing a short vertical stem with a semicircular tip. This very closely parallels the decoration of the belfry windows at Langford, Oxfordshire (no. 4; Ills. 297–312), for which a mid eleventh-century date is argued above on primary evidence. As noted above (p. 66), this form of decoration is employed on a number of late tenth- and eleventh-century manuscripts, and in metalwork on the mid tenth-century censer cover from Canterbury.

The three frieze or blind arcade fragments from Sompting (nos. 9–11) are decorated with reeded arch heads whose tympana and spandrels are filled with plant ornament (Ills. 172–80). Some of the plant stems are held together with collars. The leaves are lozenge shaped, or take the form of short tight volutes and in addition there are small trefoil leaves or berry bunches. One of the plant stems ends in an animal head with a domed forehead, open mouth with short jaws, and a reversed lentoid eye. In the reconstruction of the frieze proposed above (Fig. 19a–c) the arches are viewed as the heads of niches or decorated panels, or as a blind arcade, a layout which is reflected most closely in manuscript Canon Tables, which often employ series of arch heads supported by piers or columns. Surviving pre-Conquest Canon Tables range in date from the eighth to the eleventh century, but only one set, in the Trinity Gospels, dated to the second quarter of the eleventh century (Temple 1976, no. 65), offers a number of close parallels to the features of the Sompting arch heads (Fig. 19d). Like them it employs plant ornament filling the tympana or spandrels. The foliage is usually Winchester-style acanthus, but on occasions it is simplified to single volutes or pairs of tight volutes, as at Sompting. In addition there are cinquefoil berry bunches. The most precise parallel to the layout and treatment of the ornament on the Sompting fragments occurs on fol. 11r, where the spandrels are filled with pairs of out-turned plant sprays whose stems cross beneath the arch heads from the adjacent pairs of tympana and are held together by collars. The sprays are of acanthus, but the edges of the leaves are voluted to produce an effect very similar to that employed at Sompting (Fuglesang 1980, pl. 85A). Outside the pages of the Trinity Gospels, the only close parallel to the decoration on the Sompting friezes is provided by Warsaw, Bibl. Narodowa MS I. 3311 (Fig. 20a), a manuscript dating to *c.* 1000 (Temple 1976, no. 92, figs. 51–5, 59, ills. 281–4). On fol. 69r (ibid., ill. 282) the initial A is decorated with plant ornament having a number of features in common with the Sompting friezes, including the use of tightly voluted and trefoil leaves, the use of stems which are leafless for most of their length, and the use of stems ending in animal heads. As at Sompting the animal heads are small, barely wider than the stem of which they form a part. They have domed foreheads, open jaws and lentoid eyes, although not reversed as at Sompting.

Neither of these two manuscripts provides an exact parallel for the decoration of Sompting 9–11, although some of the individual features compare closely, but together they suggest a date in the eleventh century for the sculptures. This is reinforced by one distinctive individual feature, the use of the reversed lentoid eye on the single animal head (Ill. 179). This form of eye is widely used in Viking art, particularly in the Ringerike and Urnes styles. The Ringerike style was current in England from the late tenth century to the mid eleventh century (Wilson and Klindt-Jensen

FIGURE 19
Sompting 9–11, reconstructions, nts (KEY: a, 11A; b, 10A; c, 9A; d, Cambridge, Trinity Gospels, fol. 11r)

1966, 145–6). The Urnes style was probably introduced after the Conquest, and persisted until the end of the eleventh century, and conceivably even later (ibid., 160).

There are two possible late pre-Conquest screen fragments from south-east England, from St Mary in Castro, Dover, Kent (no. 4), and Sonning, Berkshire. The fragment from Dover is decorated on face C with the junction of two reeded arch heads, with in the spandrel a series of stems held together by a collar; one of the stems ends in a tight volute (Ill. 70). The decoration very closely resembles that on the frieze fragments from Sompting, and must be given a similar, eleventh-century, date. This is reinforced by a consideration of the decoration on face A, which consists of a cross with parallel-sided arms and simple

FIGURE 20

Foliate ornament, nts (KEY: a, Warsaw, Biblioteka Narodowa MS I.3311, fol. 15r; b and i, Eadui Codex, fol. 10r; c, BL MS Arundel
155, fol. 133r; d–g, Monte Cassino MS BB.437, 439, pp. 126–7; h, Bury Gospels, fol. 8v; j, Sompting 13)

interlace in the re-entrant angles (Ill. 69). This type of
decoration is very similar to that employed on a
number of late tenth- and eleventh-century grave-
covers, such as those from Cambridge castle (Fox
1920–1, 20–1, pls. III–IV, VII), and Cardington,
Bedfordshire (Ill. 264), and suggests a similar date for
the Dover fragment.

The layout of the decoration on face A of the
Dover slab (Ill. 69) is echoed on the Sonning
fragment, which is also decorated with a cross having
interlace in each of the re-entrant angles (Fig. 37). In
this case the cross is of Anglian form and the interlace
is more complex, consisting of ring-knots each of

which incorporates two closed loops (Ill. 454). The
use of closed circuit loops suggests a late date for the
piece as this feature does not normally occur before
the tenth century (Collingwood 1927, 65, 68). This
late date may be confirmed by the uneven laying-out
of the decoration, a feature which is again more
characteristic of late Anglo-Saxon interlaces than of
earlier material; the interlaces from Reculver 1e (Ills.
119–20), Preston by Faversham (Ills. 101–4), and
Rochester (no. 1; Ill. 141) in Kent, for example, are all
well worked out, and an early date can be suggested
for all of them. Such evidence can, however, only be
regarded as tenuous and unreliable.

Also of architectural function are the *ex situ* balusters and baluster fragments from St Albans (Ills. 376–96), St Augustine's, Canterbury (nos. 6–7; Ills. 41–9), St Mary in Castro, Dover (nos. 2–3; Ills. 64–7, 71–5), and Jevington (no. 2; Ills. 229–30). These balusters are of the type decorated with groups of projecting mouldings, and associated with belfry openings. *In situ* examples are encountered within the region at Oxford (St Michael 1) and North Leigh, Oxfordshire (Ills. 400–3). Such openings appear to be a late Anglo-Saxon phenomenon; Taylor and Taylor place the tower at North Leigh in the late tenth or eleventh century (Taylor and Taylor 1965–78, II, 464–5), and that of St Michael at Oxford in the late eleventh century (ibid., 481–2).

At Abingdon, Berkshire, is a fragmentary roundel which may have served an architectural function (Ill. 413). The decoration can be reconstructed as a Greek cross with slightly pointed ends to the arms and an interlace triquetra in each of the re-entrant angles (Fig. 36). The decoration has obvious affinities with that on face A of the slab from St Mary in Castro, Dover (no. 4; Ill. 69) and on the fragment from Sonning, Berkshire (Ill. 454), and these parallels suggest a late pre-Conquest date, as does the use of rather thick median-incised strands; as noted elsewhere (p. 92), there is no example of a median-incised interlace from south-east England dating to before the tenth century. This late dating is confirmed by the form of the piece; the disc decorated with a cross has obvious affinities with the plate-headed crosses for which a tenth- and eleventh-century date is argued below (p. 93). The form of the cross at Abingdon, with its pointed ends, is paralleled elsewhere in south-eastern England only on the grave-marker or -cover from Arundel, Sussex (Ill. 1; Fig. 28), for which a tenth- or eleventh-century date is argued below (p. 84), and in ivory on a pectoral cross in the Victoria and Albert Museum, for which a mid eleventh-century date has been argued (Beckwith 1972, no. 45, pls. 99–102; Backhouse *et al.* 1984, no. 125, pl. 125). The only parallel to the interlace decoration on the Abingdon roundel is provided on fol. 2v of Cambridge, Pembroke College MS 301, dated to *c.* 1020 (Temple 1976, no. 73, ill. 233). Here, on the top of pier three of the Canon Table is a roundel containing four interlace triquetras arranged in the same formation employed at Abingdon, but without the cross. All these parallels argue for a tenth or eleventh-century date for the Abingdon fragment, but none is compelling.

The gable cross at West Wittering, Sussex (Ills. 217–18), is decorated on both faces with a simple incised Greek cross within a circle, a form related to that used at Abingdon (Fig. 36), and to the ring-, circle-, and plate-heads discussed in more detail below (p. 93). On this basis a tenth- or eleventh-century date for the piece can be argued.

## SUNDIALS

Apart from the crucifixion scenes and figural panels discussed below, the only other architectural sculptures from south-east England are sundials. There are nine of them (see Ch. III). The dial from Langford, Oxfordshire, is discussed separately above (p. 66). All, with the exception of the dials from Corhampton and Hannington in Hampshire (and perhaps also that from Langford in Oxfordshire), are *ex situ*.

The dials from Warnford, Hampshire, and St Michael's, Winchester, must be grouped with the *in situ* example from Corhampton, Hampshire, as they share the same form, a circular dial sculpted on a square stone; the same calibration; and very similar decoration, consisting of a stem ending in three leaves in each corner of the slab on which the dial is carved. On primary evidence the dial from Corhampton can be placed in the eleventh century, and a late pre-Conquest date is confirmed by the form of the leaf ornament (Ill. 438) which, as noted above (p. 64), occurs widely in manuscripts, ivory and metalwork of the tenth and eleventh centuries. This dating can be extended to the other dials of the group. Of similar date must be the dial from Hannington. Although apparently sculpted on a circular stone (Ill. 441), the calibration matches that of the other Hampshire dials. Architecturally, what remains of the Anglo-Saxon church at Hannington suggests a late tenth- or eleventh-century date for the fabric (Taylor and Taylor 1965–78, III, 282–3), and, by extension, for the dial.

At Orpington, Kent, the dial is carved from a single circular stone (Ills. 105–7) and can be identified as of pre-Conquest date because of the Old English inscription around the edge, and the runic characters on the face of the dial. Unfortunately the epigraphy of the inscription is of little help in dating (see below, pp. 148–9), and the only decorative feature on which dating can be based is the cabled moulding encircling the dial. This has the cable modelled with an incised median line along each strand. The form is paralleled elsewhere in south-east England at Dartford, Kent, Walkern 2 and Little Munden, Hertfordshire, and All Hallows by the Tower, London, all probably works of the eleventh century. A similar date can be suggested for the Orpington dial.

The dial at Marsh Baldon, Oxfordshire (Ill. 358), like those from Corhampton, Hampshire (no. 1), Warnford, and St Michael's, Winchester, is sculpted on a square stone, and, like Orpington, has a cabled edge moulding, but without the incised median line of the latter. The gnomon hole is displaced towards the upper edge of the dial, but the calibration is of pre-Conquest type with the crossed lines representing the mid tides at 9 am, 12 noon, and 3 pm. Dating of the dial is difficult, but the use of a cabled moulding may suggest a late pre-Conquest date as there is no occurrence of this type of moulding in south-east England before the tenth century.

The sundials at Stoke D'Abernon, Surrey, and Winchester St Maurice 2, are even more difficult to date as they lack any form of decoration. The Stoke D'Abernon dial (Ill. 216) was carved on a square block, and that from St Maurice's (Ill. 672) on a circular stone, both types encountered among the demonstrably pre-Conquest dials. Both are calibrated in the Anglo-Saxon manner, again indicating a pre-Conquest date. Given the paucity of early pre-Conquest dials from south-east England (there is only one, from Bishopstone, Sussex) it may seem more likely that the St Maurice's and Stoke D'Abernon dials are of late pre-Conquest date, but the suggestion is not susceptible of proof.

## CRUCIFIXION GROUPS

Of all the architectural sculptures from south-east England the most splendid and imposing are the large-scale crucifixion groups. Six of these survive. Three are from sites in Hampshire, at Breamore (no. 1; Ills. 425–8), Headbourne Worthy (no. 1; Ills. 448–50), and Romsey (no. 1; Ills. 451–2); the others are at Walkern (no. 1) in Hertfordshire, and the two from Langford, Oxfordshire (nos. 1–2). All except the examples from Headbourne Worthy and Walkern are *ex situ*. A pre-Conquest date has also been suggested for the two smaller-scale crucifixions built into the west tower at New Alresford, Hampshire (Green and Green 1951, 40–1, pl. XII), but these have been excluded from consideration here as the disturbed walling around them suggests that they are later insertions into the fabric of the twelfth-century tower. This conclusion is supported by the small-scale, plastic, three-dimensional nature of the sculpture which is more appropriate to the thirteenth or fourteenth centuries, and by the chamfers visible along the edges of the cross-arms. This is a feature not encountered on the pre-Conquest

examples, but which is typical of later medieval crosses, such as that in the churchyard at Terwick, Sussex. Given their relatively small size, it is probable that both crosses are reused later medieval gable crosses.

Despite the doubts raised over the pre-Conquest dating of the examples from Langford and Romsey by Clapham (Clapham 1951), there is clear primary evidence for the use of such large-scale crucifixion scenes in the pre-Conquest period. The scene at Headbourne Worthy, Hampshire (no. 1), is *in situ* above the west doorway of the pre-Conquest church. The Hand of God above the cross (Ill. 448) forms an integral part of the string-course spanning the west gable, and the foot of the cross forms one of the voussoirs of the pre-Conquest west doorway (Taylor and Taylor 1965–78, I, 290, fig. 128). The crucifixion at Walkern 1, Hertfordshire, is also *in situ*, over the original south doorway of the pre-Conquest church (see above, p. 67). Outside the area of the present study parts of other similar scenes also remain *in situ*. At Bitton the feet of a crucifixion are *in situ* over the chancel arch, although the rest of the scene has vanished (Taylor and Taylor 1966, 6–8, fig. 2), and two angels at Bradford on Avon, discovered *in situ* over the chancel arch may also represent a lost crucifixion scene in this position (ibid., 29), although other scenes than the crucifixion are possible. The Anglo-Saxon wall painting at Nether Wallop, Hampshire, is also positioned over the chancel arch, but depicts the Ascension with Christ's mandorla supported by very similar angels (Gem and Tudor-Craig 1981). This accumulation of primary evidence for the use of large-scale crucifixion scenes in the pre-Conquest period suggests that the similar *ex situ* scenes at Romsey 1 and Langford 2 may also be regarded as of pre-Conquest date. In contrast, from the greater volume of architectural sculpture surviving from after the Conquest only a single scene of this type is known, from Barking abbey, Essex, a piece which can be dated to the twelfth century (Kendrick 1949, 53–4). The Barking crucifixion scene differs in style from the crucifixions for which a pre-Conquest date can be advanced based upon primary evidence, and it also differs radically in constructional technique. It is composed of nine fairly small, coursed stones on which the sculpture has been carved. In contrast, at Headbourne Worthy 1 the figure of Christ is composed of three massive stones, one forming the vertical limb of the cross and the other two the arms. The figures of the Virgin and St John are also each carved from a single massive block of stone (Ills.

448–50). A similar constructional technique is used at Walkern 1, although here any accompanying figures have been lost. The *ex situ* crucifixions all share the constructional technique of the Headbourne Worthy and Walkern pieces, although on the larger of the two crucifixions at Langford (no. 2; Ills. 294–5) the vertical limb of the cross is composed of two separate stones. Each of the arms is made from a single massive stone and tenons on their inner ends fit into a gap between the two stones making up the vertical limb. The use of tenoned ends to the arms of the cross can only be paralleled in the scene of the crucifixion of St Peter over the north-west portal of the twelfth-century church at Aulnay, France (Porter 1923, 7, 983). But here, as at Barking, the rest of the scene is composed of small, rectangular, coursed stone blocks, in contrast to the monolithic construction used at Langford.

One distinctive iconographic feature also suggests a pre-Conquest date for the crucifixions. Four of the six, at Walkern 1, Romsey 1, Headbourne Worthy 1, and Breamore 1, employ the Hand of God developing from a cloud above the head of Christ (Ills. 397, 451–2, 448, 427). The use of this feature is a strong indicator of a pre-Conquest date as it was commonly used in pre-Conquest crucifixion scenes, but only comparatively rarely after the Conquest. Of the fourteen pre-Conquest ivory crucifixion scenes catalogued by Beckwith, eleven employ this feature (Beckwith 1972, nos. 17, 17a, 30–8). Similarly, of the eleven Anglo-Saxon manuscript crucifixion scenes listed by Ohlgren, seven employ the Hand of God (Ohlgren 1983, nos. 140, 161, 182, 185, 187, 189, 198); it is difficult to find a single Romanesque manuscript illustration of the crucifixion which employs this feature, and of the seven Romanesque ivory crucifixions catalogued by Beckwith, only two employ the Hand of God (Beckwith 1972, nos. 78, 108). The number of surviving works is too small for compelling conclusions to be drawn, but it appears that the use of the Hand of God is a possible indicator of pre-Conquest date. The primary evidence, that of the constructional technique, and the use of the Hand of God, all suggest that the *ex situ* roods at Breamore 1, Romsey 1 and Langford 1–2 are of pre-Conquest date. This conclusion can be supported by comparisons in iconography and style between the stone sculptures and crucifixion scenes in other materials.

The iconographical study of the crucifixions is rendered difficult by the poor condition of most of the sculptures. Those at Breamore 1 and Headbourne Worthy 1 have been hacked back flush with the walls into which they are built. The crucifixions at Romsey and the larger of the two examples from Langford (no. 2) are *ex situ*, and it is likely that subsidiary figures have been lost. Only the smaller crucifixion at Langford (no. 1) appears to be intact. Despite these difficulties, as noted above (p. 28), three iconographical groups can be identified, coinciding (with one minor variation) with Coatsworth's classification (Coatsworth 1988, n. 29). The crucifixions from Walkern (no. 1; Ill. 397) and the larger of the two from Langford (no. 2; Ills. 294–5) depict Christ as clad in a sleeved, ankle-length robe. The smaller of the two Langford crucifixions (no. 1; Ill. 293) and that from Breamore 1 (Ill. 428) depict the dead Christ with his arms and legs contorted. The examples from Romsey 1 (Ills. 451–2) and Headbourne Worthy 1 (Ill. 448) depict Christ as in repose, with the legs and arms straight or only slightly bent, and his head facing straight ahead or only slightly bent to the left.

To the robed crucifixions at Walkern 1 and Langford 2 can be added the example from Bitton, Gloucestershire, outside the area of the present study. This shares with the Langford crucifixion the use of transverse bars behind the hands of the crucified Christ, but in addition has a serpent below his feet. Such a feature may have existed at Langford as this area has been cut away. Although there is clear primary evidence for a late tenth- or eleventh-century date for the Walkern and Bitton crucifixions, closer dating is hampered by the fact that only two other Anglo-Saxon robed crucifixions survive in any medium (both of them much earlier than the fabrics at Walkern and Bitton), in Durham Cathedral Library MS A. II. 17, dated to the late seventh or early eighth century (Alexander 1978, no. 10, ills. 47, 202) and on the putative eighth-century ivory diptych now in the Musée de Cluny, Paris (Beckwith 1972, no. 6, pl. 19).

Because of this paucity of surviving Anglo-Saxon robed crucifixions, undue emphasis has been placed on the *Liber Albus* of Bury St Edmunds which records the presence there of a robed crucifixion, a copy of the *Volto Santo* of Lucca, ordered by Abbot Leofstan on his return from Rome in 1049/50 (Clapham 1951; Raw 1990, 92; Dodwell 1982, 318). The present *Volto Santo* (probably a thirteenth-century copy of the original which Leofstan saw) depicts a robed Christ. Hence it has been argued that the introduction of the robed crucifixion into English sculpture must be dated to after 1050. In fact there need be no connection between the Bury St Edmunds crucifixion and those at Langford 2, Walkern 1, and Bitton, and this

reference to the *Volto Santo* is of importance only in that it demonstrates that examples of robed crucifixions were being made in England in the eleventh century, copying continental exemplars.

During the late tenth and eleventh centuries the use of the robed crucifixion, predominant from the sixth to the ninth century, but not common thereafter (Coatsworth 1979, I, 108), enjoyed a modest revival, at least on the continent. The type occurs, for example, in manuscript art in the Egbert Codex, a work of *c.* 980 (Holländer 1974, pl. 104), in Paris, Bibl. Nat. MS lat. 9453, a work of the second half of the tenth century (Hubert *et al.* 1970, pl. 144), and in the Uta Gospels of 1000–1025 (Dodwell 1971, pl. 84). Robed crucifixions occur also in ivory, as on a late tenth-century plaque in the Rheinisches Landesmuseum, Bonn (Goldschmidt 1914–23, II, no. 37, pl. 37), and on an eleventh-century book cover in the Musée des Arts Decoratifs, Brussels (ibid., no. 55, pl. 55). Similar, readily portable objects may have been copied in England in the late tenth or eleventh centuries. A continental derivation for the robed rood is supported by the occurrence of a serpent below the feet of Christ at Bitton, Gloucestershire. This feature occurs elsewhere only twice in Anglo-Saxon art, in Cambridge, Corpus Christi College MS 421, p. 1, a manuscript made in the west country in the second quarter of the eleventh century (Temple 1976, no. 82, ill. 254), and on fol. 35r of the Bury Psalter, made at the same time at Christ Church, Canterbury (ibid., no. 84, fig. 26, ills. 262–4). However, the serpent beneath the feet of Christ occurs frequently in Carolingian art as, for example, on the ivory on the front cover of the Psalter of Charles the Bald of *c.* 850–60 (Lasko 1972, pl. 30), on an ivory panel of *c.* 870 in the Victoria and Albert Museum (ibid., pl. 61), and on a crystal from the abbey of St Denis made *c.* 867 (ibid., pl. 56). It occurs also in Carolingian manuscript art, as on fol. 6v of a sacramentary from Metz (Mütherich and Gaehde 1977, pl. 34).

To the second group of crucifixions, those depicting the dead Christ, belong the examples at Breamore 1 (Ill. 428) and Langford 1 (Ill. 293). Like the robed crucifixions this group is well defined, the weight of Christ's sagging body being carried on the arms which slope down to the shoulders. The legs are bent and the head bowed. As noted above (pp. 73–4), there is no primary evidence for the dating of either of these crucifixions, but the use of the Hand of God at Breamore suggests a pre-Conquest date. At both Breamore 1 (Ill. 425) and Langford 1 (Ill. 293) the crucified Christ is accompanied by the figures of the

Virgin and St John, as is the case in nine out of the eleven pre-Conquest manuscript crucifixions catalogued by Ohlgren (Ohlgren 1983, nos. 140, 146, 161, 177, 182, 185, 187, 198, 208), but in only four out of the fourteen ivory crucifixions catalogued by Beckwith (Beckwith 1972, nos. 17, 17a, 30, 38). At Breamore, disks over the heads of the Virgin and St John, at the ends of the arms of the cross (Ill. 425), probably represent the sun and moon, symbols often associated with the crowned Christ (Raw 1990, 129). These occur on five out of the ten manuscript crucifixions, always in association with the figures of the Virgin and St John (Ohlgren 1983, nos. 177, 182, 185, 198, 208), but on only three of the ivory crucifixions, in two cases with the Virgin and St John (Beckwith 1972, nos. 30, 34, 38). It is possible that the disks at Breamore have been moved from their original positions over the cross-arms, as there is sound evidence for the whole scene having been brought from elsewhere and inserted over the south door (Rodwell and Rouse 1984, 309–12). In all the manuscript scenes and on most of the ivories the sun and moon occupy positions over the cross-arms, but on one, the Heribert crosier (ibid., no. 30, pl. 80), the figures are at the ends of the cross-arms, an unusual arrangement paralleled otherwise only at Breamore 1. If it could be proved that at Breamore the sun and moon have not been misplaced then this feature might place the sculpture at about the same date as the crosier, in the early eleventh century.

The type of Christ used at both Breamore 1 (Ill. 428) and Langford 1 (Ill. 293) has both the arms and legs bent. This feature occurs only three times in pre-Conquest manuscript art: in the Arenberg Gospels, dated to *c.* 990–1000 (Temple 1976, no. 56, ill. 171); in the Judith of Flanders Gospels, dated to *c.* 1025–50 (ibid., no. 93, ill. 298); and in BL MS Cotton Tiberius C. VI, dated to *c.* 1050 (ibid., no. 98, ill. 311). This type is also found in an addition of *c.* 1080 to BL MS Arundel 60 (Kendrick 1949, pl. XXI.2). The Arenberg Gospels and the Judith of Flanders Gospels also employ the Virgin and St John, but only in the Judith of Flanders Gospels do the figures of the sun and moon appear as at Breamore. In BL MS Cotton Tiberius C. VI the Virgin and St John are replaced by Stephaton and Longinus, and there is a *titulus*. In BL MS Arundel 60 only two bushes flank the figure of Christ. Iconographically, the Breamore crucifixion, therefore, most closely corresponds to the scene in the Judith of Flanders Gospels. The Langford 1 crucifixion, lacking any other accompanying figures than the Virgin and St John, finds only one close

parallel in the manuscripts, in BL MS Harley 2904, dating to *c.* 975–1000, where Christ is also accompanied only by the figures of the Virgin and St John, but there is also a *titulus*, absent at Langford (Temple 1976, no. 41, ill. 142). In BL MS Harley 2904, however, although Christ is clearly depicted as dead with the head bowed and arms bent, the legs are straight.

These manuscript parallels for the iconography at Breamore 1 and Langford 1 serve to place the crucifixions in the late tenth or eleventh centuries. A consideration of the ivories of the period does little to clarify this dating. Only two, a crucifixion plaque in the Victoria and Albert Museum dated to the late tenth or early eleventh century (Beckwith 1972, no. 32, pl. 68), and the Tau-shaped crosier from Alcester, dated to the early eleventh century (ibid., no. 29, pl. 66), use a figure of Christ with the legs bent. On the Alcester crosier there are no accompanying figures. The Victoria and Albert Museum plaque has roundels containing the symbols of the Evangelists in the re-entrant angles of the cross.

To the third iconographical group of crucifixions, those having Christ's legs and arms straight and his head slightly bowed to the left, belong the examples at Headbourne Worthy 1 (Ill. 448) and Romsey 1 (Ills. 451–2), Hampshire. As noted above (p. 62), primary dating evidence places the Headbourne Worthy crucifixion in the late tenth or eleventh centuries, and a pre-Conquest date may be confirmed by the use of the Hand of God, employed also at Romsey. At Headbourne Worthy the figure of Christ is accompanied by the Virgin and St John. As noted above (p. 75), this feature occurs in nine out of the eleven pre-Conquest manuscript crucifixion scenes catalogued by Ohlgren, and on four of the fourteen ivories of this date catalogued by Beckwith. An area of chiselling below the feet of Christ suggests that something has been cut away, probably either a chalice or a serpent, the only two symbols which occupy this position in pre-Conquest art. Of the two the serpent, symbolising Christ's triumph over evil (Raw 1990, 147), occurs in sculpture at Bitton, and in manuscript art in Cambridge, Corpus Christi College MS 421, dated to *c.* 1025–50 (Temple 1976, no. 82, ill. 254), and the Bury St Edmunds Psalter which is of similar date (ibid., no. 84). In Corpus Christi MS 421, as at Headbourne Worthy, the figures of the Virgin and St John accompany the crucified Christ. The chalice at the foot of the cross, a eucharistic symbol (Raw 1990, 147), occurs in combination with the serpent in the Bury St Edmunds Psalter (ibid., no. 84), and by itself

in the Sherborne Pontifical of *c.* 975–1000 (ibid., no. 35, ill. 134), and in the Arenberg Gospels of *c.* 990–1000 (ibid., no. 56, ill. 171), in the two latter cases in combination with the Virgin and St John; however, both scenes have angels above the cross-arms and these are absent at Headbourne Worthy. These iconographical parallels suggest an eleventh-century date for the Headbourne Worthy crucifixion scene, but none is exact.

Little is added to the discussion by a consideration of the form of the figure of Christ. As noted above (p. 74), both the legs are straight, a feature which occurs in at least four out of the eleven manuscript crucifixion scenes catalogued by Ohlgren (Ohlgren 1983, nos. 140, 177, 182, 187). It occurs also in ivory in nine out of the fourteen crucifixion scenes catalogued by Beckwith (Beckwith 1972, nos. 6, 17, 17a, 20, 31, 33, 35, 37–8). The vicious damage sustained by the Headbourne Worthy crucifixion renders closer comparisons impossible.

At Romsey 1, in contrast, all that survives is the figure of Christ, any accompanying figures having been lost when the figure was incorporated into the twelfth-century fabric of Romsey abbey (Ills. 451–2). Here, as at Headbourne Worthy 1 (Ill. 448), Christ's legs are straight and his arms are outstretched. His head is slightly bowed to the left, but his eyes are open. As noted above, this pose occurs in at least four pre-Conquest manuscript crucifixion scenes, but only in two, BL MS Cotton Titus D. XXVII (Temple 1976, no. 77, ill. 246) and the Sacramentary of Robert of Jumièges (ibid., no. 72; Rice 1952, pl. 53b), are Christ's eyes open. The Sacramentary of Robert of Jumièges dates to *c.* 1020 (ibid., 89–90) and Cotton Titus D. XXVII to *c.* 1025–35 (ibid., 94–5). The open-eyed Christ of this form is more commonly found in ivory, and at least five out of the fourteen ivory crucifixions catalogued by Beckwith exhibit this feature, all of them of late tenth- or eleventh-century date (Beckwith 1972, nos. 17, 17a, 31, 33, 35).

One peculiar feature of the Romsey crucifixion is the flattening of the top of the head and the suppression of the vertical limb of the cross of Christ's cruciform nimbus (Ill. 456). This is not accidental damage and suggests that something, probably in another material, was originally placed on top of Christ's head; something tall enough to obscure the vertical limb of the cruciform nimbus, rendering its carving superfluous. This feature can only have been a fairly tall crown, probably of metal, and emphasising Christ's kingship (Raw 1990, 129–46). This

iconographic feature is only paralleled in Anglo-Saxon art on fol. 12v of BL MS Arundel 60, dating to *c.* 1060 (Temple 1976, no. 103, ill. 312), on fol. 13r of BL MS Cotton Tiberius C. VI, dating to *c.* 1050 (ibid., no. 98, ill. 311), and on p. 1 of Cambridge, Corpus Christi College MS 421, dating to the second quarter of the eleventh century (ibid., no. 82, ill. 254). It also occurs, if infrequently, in works produced on the continent, as in the Uta Gospels of the first quarter of the eleventh century and in a Psalter executed at St Germain des Prés, Paris, in the middle of the eleventh century. The Christ in the Uta Gospels is robed but open-eyed (Dodwell 1971, pl. 84); the Christ in the St Germain des Prés manuscript, as at Romsey and in the English manuscripts, is clad in a loin-cloth, has the legs and arms straight out, and is open-eyed. The figure is, however, accompanied by the Virgin and St John and the sun and moon, with a serpent at the base of the cross. The scene is surrounded by the symbols of the four Evangelists (Beckwith 1969, pl. 172).

That similar crucifixion scenes with a crowned Christ existed in other materials in Anglo-Saxon England, at least in the eleventh century, is confirmed by documentary sources. At Waltham abbey, Essex, a stone crucifixion was given a gold and jewelled crown by Glitha, wife of Earl Tovi the Proud (d. soon after 1042) (Dodwell 1982, 119, n. 145), and at Winchester king Cnut (1016–35) donated his own crown to the Old Minster; it was placed on or above the head of the crucified Christ (Dodwell 1982, 212, n. 227). The *Anglo-Saxon Chronicle* (version E) records that in 1070 'Hereward and his band' looted the monastery at Peterborough, even taking the gold diadem from the head of the crucified Christ (ibid., 212–13; Garmonsway 1967, 205), an incident which is also reported in the *Peterborough Chronicle* of Hugh Candidus (Dodwell 1982, n. 238).

The written sources and continental manuscript parallels may suggest an eleventh-century date for the Romsey crucifixion; it is possible, however, that the flattening of the top of the head of Christ is a twelfth-century re-working, done at the time when the crucifixion was reused in its present position, *c.* 1150–90. Numerous twelfth-century crucifixions survive which employ the crowned Christ, as, for example, on the Monmouth crucifix of *c.* 1170–80 (Zarnecki *et al.* 1984, no. 241, pl. 241) and two cast crucifix figures in the University Museum of Archaeology and Ethnology, Cambridge, both dating to the second quarter of the twelfth century (ibid., nos. 236–7, pls. 236–7).

Comparatively little is added to a discussion of the dating of most of these crucifixion scenes by a discussion of their style, particularly since the Headbourne Worthy 1 and Breamore 1 crucifixions are virtually destroyed, and the remaining examples, except that at Walkern 1, are heavily weathered. However, some observations can be made.

Of the two robed crucifixions that at Langford (no. 2) has a calm, massive presence. The robes are stiff and formalised without the elaborate folds and fluttering draperies characteristic of figure drawing in the Winchester style; the only folds in the robe are vertical and the hem of the garment is straight (Ills. 294–5). This formality has little in common with much of late pre-Conquest art, but in spirit lies closest to the rounded, solid figure style employed in some very late pre-Conquest works, notably in BL MS Cotton Tiberius B. V, a work of the second quarter of the eleventh century (Temple 1976, no. 87, ills. 273–6). Here, in a calendar, in illustrations accompanying Cicero's *Aratea*, and in the Marvels of the East, are figural illustrations probably executed by the same artist. The figures are solid and well-rounded with much of the weighty presence of the Langford Christ. The draperies are usually restrained and naturalistic, with only some of the hems betraying the fluttering folds of the Winchester style, features displayed at their best in scenes accompanying May and August in the calendar (ibid., ills. 273–4). There is really no equivalent to this style in the ivories, where the small scale of the crucifixions makes the figures rather delicate or even emaciated. Draperies are generally calmer and more naturalistic than in the manuscripts, but this may owe more to the nature of the material than to the intention of the artist. If these manuscript parallels can be accepted then it suggests a date for the Langford 2 crucifixion in the middle of the eleventh century, a date which is not at variance with the iconographic parallels.

At Walkern 1 (Ill. 397) the calm, expressionless face of Christ creates the same stillness and serenity as at Langford 2 and, although different in technique, the folds of the garment are linear and without the fluttering folds of the Winchester style. The effect which is sought appears to be the same as that at Langford. It is clear, however, that the flat robed body was intended to be painted and if the paint had survived the effect might have been quite different from that presented now. As for Langford, an eleventh-century date seems most appropriate and does not conflict with the architectural or iconographic evidence.

The other Langford crucifixion (no. 1) shares the solidity of these two robed crucifixions. The figures are naturalistic, without the agitated gestures characteristic of so much of Winchester-style art. As on Langford 2, the draperies lack the fluttering folds of the Winchester style; instead the folds fall vertically. Only on the figure of Christ is the hem of his loin-cloth folded in a manner typical of the Winchester style, if rather subdued (Ill. 293). Heavy parallel lines indicate the upper edge of the loin-cloth, probably a conventionalised version of the folds at the waist often employed in manuscript crucifixion scenes, for example, in the Judith of Flanders Gospels (Temple 1976, no. 93, ill. 289) or the Sherborne Pontifical (ibid., no. 56, ill. 171). A similar pair of hard horizontal lines indicates the hem of the garment of the figure of St John. Again this appears to be a conventionalisation of the folded hems employed in manuscript crucifixion scenes, as for example on the figures of the Virgin in the Arenberg Gospels (ibid., no. 56, ill. 171) and in the Sherborne Pontifical (ibid., no. 35, ill. 134). The heavy, solid form of the figures and the restrained nature of the draperies may suggest a date close to the robed Langford crucifixion, in the mid eleventh century.

In terms of stylistic analysis the Breamore 1 crucifixion presents a formidable problem since it is almost completely defaced (Ills. 425–6, 428); only the cloud from which issues the Hand of God survives (Ill. 427). This takes the form of three undulating, parallel mouldings from which emerge the Hand of God. Two further pairs of undulating mouldings link the outer ends of the cloud with the Hand of God to form a rough triangle. The use of a series of parallel, undulating lines to indicate the cloud occurs in a number of manuscript crucifixion scenes, most notably in the Arenberg Gospels (Temple 1976, no. 56, ill. 171). It occurs also in non-crucifixion scenes, as in the Evangelist portraits in the York Gospels of the late tenth or early eleventh centuries (ibid., no. 61, ills. 183–4). The triangular form of the cloud cannot be paralleled in crucifixion scenes, but in the translation of Enoch in the Caedmon Genesis of *c.* 1000, Enoch disappears into a triangular cloud which is composed of three, roughly parallel, undulating lines, as at Breamore (ibid., no. 58, ill. 189). This parallel may suggest an eleventh-century date for the Breamore crucifixion, but it is slender evidence.

Like the Breamore example the crucifixion at Headbourne Worthy is also destroyed leaving only the Hand of God, which is of similar form (Ills. 427, 448). At Romsey 1 the cloud from which the hand issues is

composed of a number of tightly-packed volutes or curls (Ills. 451–2), a form unparalleled elsewhere, but which is presumably merely an elaboration of the single volute used on the cloud on fol. 22v of the York Gospels (Temple 1976, no. 61, ill. 181). The figure of Christ is calm and monumental, and the musculature is carved in detail. The loin-cloth is folded at the waist, and falls between the legs in an 'apron' fold paralleled only in BL MS Harley 2904, a work dated to *c.* 975–1000 (ibid., no. 41, ill. 142), and in BL MS Arundel 60, dated to *c.* 1060 (ibid., no. 103, ill. 312). However, on the Romsey crucifixion the cloth is pulled tight over the thighs, something not seen in BL MS Arundel 60, but which does occur in BL MS Harley 2904. The Romsey draperies exhibit few of the agitated folds employed in BL MS Harley 2904, but the manuscript figure in its calm monumentality, with all the musculature well drawn, is otherwise close in feel to the Romsey figure, for which on this evidence a similar late tenth-century date can be proposed, although this is slightly at variance with the iconographic evidence discussed above.

The primary, iconographical and stylistic evidence suggest a date in the late tenth or eleventh century for these large-scale crucifixion scenes, with the accent perhaps on the eleventh century. This is confirmed by the historical sources. These contain numerous mentions of crosses, but both Old English and Latin use the same word, *rōd* and *crux* respectively, to describe both a cross and a crucifix, so that crucifixion scenes can only be recognised where figures are mentioned (Dodwell 1982, 211). In addition to the crucifixions at Waltham, Essex, Winchester, Peterborough, and Bury St Edmunds, noted above, examples are recorded at Evesham, Winchester, Bury St Edmunds, Suffolk, Durham, and Ely. At Evesham, Leofric, earl of Mercia (d. 1057) and his wife Godiva gave a crucifixion accompanied by the figures of the Virgin and St John (ibid., 212, 318, n. 224). At Durham, where the donors were also distinguished secular figures (Judith and her husband Tostig, earl of Northumbria (1055–65)), again the crucifixion was accompanied by the figures of the Virgin and St John (ibid., 119, 281, n. 147). Stigand, bishop of Elmham (1043–47), Winchester (1047–1066), and archbishop of Canterbury (1052–70), was a particularly active benefactor of Ely (ibid., 211, 318, n. 221), Bury St Edmunds (ibid., 213, 319, n. 241) and, in 1057, of Winchester (ibid., 212, 319, no. 231).

All these crucifixions were large, probably life-sized (Dodwell 1982, 212) and made of precious metals,

presumably over wooden cores, with the exception of the stone crucifixion at Waltham and perhaps also the one from Durham (ibid., 119, 213). All of the crucifixions, with the possible exceptions of the examples from Waltham and Peterborough, were of eleventh-century date. This may reflect an imbalance in the historical record; for example the great cross of gold given by archbishop Albert of York to York Minster in the eighth century may have been a crucifix (ibid., 210, 317 n. 211), but it is also possible that the fashion for near life-sized figure groups was confined to the very late Anglo-Saxon period. This view may be supported by the fact that other life-sized figures are recorded in the late tenth and eleventh centuries, such as the four gold and silver statues of virgins given by abbot Brihtnoth to Ely in the late tenth century (ibid., 214–5, 319 n. 244), and the Madonna and Child made for Abbot Aelfsige of Ely (981–c. 1019) (ibid., 215, 319, n. 246).

## FIGURAL PANELS

Besides the large-sale crucifixions there are five other, smaller, figure-decorated panels from south-east England: at Stepney in London; Oxford (St Michael 2); and in Sussex at Jevington 1, Sompting 13, and Tangmere.

Of these the crucifixion panel at Stepney is clearly related to the large-scale crucifixions, belonging iconographically to the second group discussed above in which Christ is depicted as dead with his arms and legs bent (Ill. 354), and for which a late tenth or eleventh-century date has been proposed. The crucified Christ at Stepney is accompanied by the figures of the Virgin and St John. Over the horizontal arms of the cross are roundels containing busts personifying the sun and moon, symbols often associated with Christ as King (Raw 1990, 129). This feature can be paralleled in pre-Conquest manuscript art only in the eleventh century, in the Sacramentary of Robert of Jumièges dated to c. 1000 (Temple 1976, no. 72; Rice 1952, pl. 33b), BL MS Cotton Titus D. XXVII, dated to c. 1023–35 (Temple 1976, no. 77, ill. 246), The Winchcombe Psalter of c. 1030–50 (ibid., no. 80), the Judith of Flanders Gospels of 1025–50 (ibid., no. 93, ill. 289), and the psalter BL MS Arundel 60, dating to c. 1060 (ibid., no. 103, ill. 312). Of these, only the Winchcombe and Arundel Psalters have personifications of the sun and moon of precisely the same form used at Stepney, that is, with the face and hands of the half-length figures veiled. In ivory

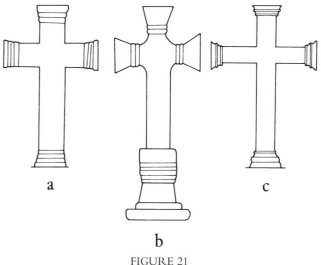

FIGURE 21

Cross forms, nts (KEY: a, London Stepney 1; b, Weyhill 1A; c, Arenberg Gospels, fol. 9v)

only two crucifixions have personifications of the sun and moon, a pectoral cross of the tenth or eleventh century in the Victoria and Albert Museum (Beckwith 1972, no. 34, pl. 71) and the Heribert crosier dated to the early eleventh century (ibid., no. 30, pl. 80). In neither case do the half figures have their hands and faces veiled as on the Stepney slab. The iconographic evidence, therefore, confirms a very late tenth- or eleventh-century date for the slab, with the accent on the eleventh century. This dating is also supported by the form of the cross. This has elaborately moulded ends to the arms; the head and foot are also moulded, but the mouldings differ from each other and from those at the ends of the arms. This arrangement is paralleled elsewhere only in the crucifixion scene in the Arenberg Gospels (Fig. 21c), dated to c. 990–1000 (Temple 1976, no. 78, ill. 244). The cross in the presentation scene of the *Liber Vitae* of the New Minster, dated to 1031, also has elaborately moulded ends to the arms, but all the mouldings are identical (loc. cit.) and, as noted below, there is a similar cross on the grave-cover from Weyhill, Hampshire (Ill. 473).

The crucifixion scene is contained within a broad frame which is decorated with encircled lobed leaves separated by pairs of transverse bars. This is clearly a variant of the acanthus ornament used widely in both Carolingian and Ottonian art, and in Anglo-Saxon England, for framing narrative scenes in both manuscripts and ivory. This relationship is demonstrated in the borders of fol. 23r of Rheims, Bibl. Mun. MS 9, dated to c. 1062 (Temple 1976, no.

105, ill. 299). Here the vertical borders are enriched with acanthus ornament of the normal Winchester type; the horizontal borders are, however, filled with a conventionalised version in which encircled, fleshy trefoil leaves develop alternately from each side. The Stepney panel merely takes this conventionalisation one step further in a manner which is common in Romanesque art, as in the borders of the Chichester panels (Zarnecki 1951b, pl. 80) (Fig. 22), and those of the tree of Jesse illustration in the Winchester Psalter (BL MS Cotton Nero C. IV, fol. 9r.), dating to *c*. 1140–60 (Turner 1971, pl. 1). This form of leaf decoration appears, then, to have been a late pre-Conquest development and would support a date for the Stepney panel in the eleventh century, and probably towards the middle of the century.

The panel at Sompting, Sussex (no. 13; Ill. 181), is decorated with a single figure of an ecclesiastic, probably St Benedict or St Gregory, beneath an arch. To the left is a crosier, to the right a reading desk. The panel has been dated as late as the twelfth century presumably on the basis of resemblances between the handling of the robes and the 'damp fold' style of twelfth-century art (Clapham 1935a, 408–9), although, more commonly, a late Anglo-Saxon date has been preferred (Rice 1952, 107, pl. 15b; Nairn and Pevsner 1965, 331). Any connection with the damp fold style must be rejected. In that style the standing figures normally have the weight of the body thrown on to one leg, usually the figure's right leg, while the body itself is curved back in that direction. The garment is pulled tight over the right leg, but narrow transverse swags sub-divide the tensed garment. The left leg is not normally emphasised in this way. The garment is also pulled tight over the torso of the figure with folds outlining an area of tightness over the stomach, and over the chest. The overgarment may fall in a fold between the legs, and the undergarment stops at ankle level. Figures of this type from a southern English atelier are perhaps best seen in the work of the 'master of the leaping figures' in the Winchester Bible (Oakeshott 1945, pls. VI, XXV). Few of these features are paralleled at Sompting. The weight of the figure is carried on both legs and there is no curve to the body. The robes are drawn equally tightly over both legs and are without the subdivisions normal in the damp fold style. There is no tightening of the garment over the stomach, and it is pulled tight over the shoulders rather than the chest. The clothing falls down in a fold between the legs, as in the damp fold style, but it also falls to each side of the figure and completely obscures the feet. It

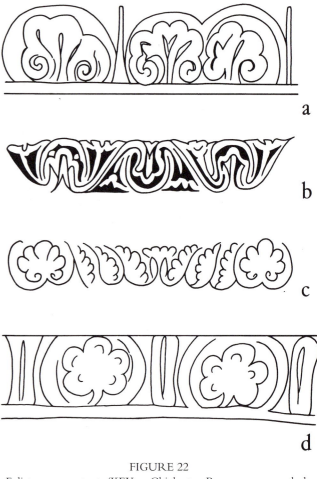

FIGURE 22
Foliate ornament, nts (KEY: a, Chichester, Romanesque panels; b, Rheims, Bibliothèque Municipale MS 9, fol. 23r; c, Winchester Psalter, fol. 9r; d, London Stepney 1)

is conceivable that all these aberrant features might be accounted for if the piece were the product of a local workshop, but nothing else remotely like this figure is known from among the substantial corpus of Romanesque sculpture in south-east England.

Elements resembling both the damp fold style and the Sompting figure can be traced in pre-Conquest manuscript art. For example, in the illustrations to Prudentius's *Psychomachia*, BL MS Cotton Cleopatra C. VIII, dated to the late tenth century (Temple 1976, no. 49, ills. 159–62), a number of scenes have figures with their draperies pulled tightly over both legs, as on fols. 10v (ibid., ill. 159), 11r (ibid., ill. 160), and 17r (ibid., ill. 163). As on the Sompting figure the robes often fall in a fold between the legs, as on fol. 17r, and sometimes also to one or both sides, as on fol. 11r. Here the figure of Patience also has her draperies gathered in a swirling mass at the hem, but at ankle

level, and not obscuring the feet, as at Sompting. A number of figures also have swirls or spirals on the shoulders, as on fols. 17v and 29r, a feature paralleled also at Sompting. The Prudentius scenes are drawings, but these features can be paralleled on fully painted figures. The pulling tight of the garment over the leg, for example, is encountered on fol. 88r of the Rheims, Bibl. Mun. MS 9, dated to *c.* 1062 (ibid., no. 105, ill. 299); there is also a swirl on the shoulder, a feature paralleled also on fol. 15r of Warsaw, Bibl. Narodowa MS I. 3311 (ibid., no. 92, ill. 283). In no case is the emphasis on the tightening of the garments as pronounced as it is at Sompting, but nevertheless the Sompting figure could be plausibly interpreted as a local variant of this pre-Conquest type.

Support for the pre-Conquest dating of Sompting 13 derives also from the form of the arch enclosing the figure (Ill. 181). Such arches commonly occur both in Romanesque and in pre-Conquest art. In Romanesque works, however, such arches are usually solid and architectural, as in the Albani Psalter of 1119–46 (Rickert 1954, pl. 61), or Boethius's *De Consolatione Philosophiae* of the second quarter of the twelfth century (ibid., pl. 68A). In both cases the arch is supported on piers as at Sompting, but the arch head is much more substantial than the flimsy structure employed at Sompting. Above it, filling the spandrels, are depictions of roofs and towers in place of the palmettes used at Sompting. Similar arches can be found in pre-Conquest art, as on fols. 21v and 30v of the St Margaret Gospels (Temple 1976, no. 91, ills. 279–80), but in tenth- and eleventh-century manuscripts the spandrels of the arches are more often filled with small foliate motifs (Fig. 20a, d–g), as at Sompting. Such plant motifs also occur in the spandrels of the arches of Canon Table frames, as on fols. 9v, and 10r of the Kestner Museum, Hanover, MS WM XXIa, 36 (ibid., no. 67, ills. 224–5). This feature is not easily paralleled in post-Conquest manuscript art, and must suggest a pre-Conquest date for the Sompting panel.

A late pre-Conquest date, therefore, seems most plausible for Sompting 13, but it must be assigned to the very end of the period as the upright leaf capitals of the arch are paralleled elsewhere only on the chancel arch at Botolphs, Sussex (Ill. 5), for which a mid eleventh-century date is argued above (p. 66), and to a lesser degree on the tower arch at Sompting itself (Ill. 183), for which a similar date might be suggested (but see pp. 68–9). Such a date would be consonant both with the rather solid, static style of the figure, without the agitated gestures and elaborate fluttering

draperies of the Winchester style, and with the stone type. The fine-grained limestone of which the figure is made has the same slight polish as the lengths of acanthus decorated frieze at Sompting (nos. 1–8); this may suggest that the pieces derive from the same feature or decorative scheme and are of similar date. A mid eleventh-century date is argued for the frieze fragments above (p. 69).

Much more readily datable is the figure-decorated panel at Jevington, Sussex, depicting Christ trampling on the beasts (Ill. 232). The animal to the right of the figure (Ill. 234) is in the Urnes style, which developed in Scandinavia *c.* 1025–50 (Wilson and Klindt-Jensen 1966, 160). The style is characterised by the use of ribbon-like animals which form a pattern of loops and curves, and interlace with narrow, filiform elements. The loops are often arranged in figure-of-eight or multi-loop schemes and frequently the animals are engaged in combat (Fuglesang 1978, 207–8; Wilson and Klindt-Jensen 1966, 147). The animal's eye is usually of lentoid shape. At Jevington the animal is ribbon-like and is engaged in combat with another, smaller, ribbon-like animal. Its body is arranged in loops and there are narrower, looping elements, but coarser than the usual filiform elements of Scandinavian Urnes-style works. The eyes are lentoid. The second animal, to the left of Christ's feet (Ill. 233), is a semi-naturalistic quadruped, but it employs the same lentoid eye and has the hind legs developing into loops which resemble those of the Urnes-style animal.

There is little comparative material from south-east England where, apart from the Jevington panel, only four other Urnes-style pieces survive: a silver mount from London (Kendrick 1949, 118–9, fig. 20b); a manuscript sketch in BL MS Royal I. E. VI, probably made at St Augustine's abbey, Canterbury (Budny 1984, 255, 257–63); a mount from Colchester, Essex (Wilson 1981, 78, fig. 66), and a stirrup iron from Mottisfont, Hampshire (Seaby and Woodfield 1980, 108, no. 9, fig. 4). Of these, the London mount is decorated in the classic Urnes style and is probably an import from Scandinavia, but (like the Jevington sculpture) the remaining pieces are Urnes-style objects made in England rather than English Urnes-style pieces in the classification proposed by Owen (Owen 1979). In any event, a date after the Conquest must be proposed for all of them, since it seems unlikely that the Urnes style can have reached England before that date (Wilson and Klindt-Jensen 1966, 153).

Although there is no other sculpture from south-east England exhibiting Urnes-style features with

which the Jevington piece can be compared, it has
been suggested that the sculptures from Southwell
(Kendrick 1949, 121–2, pl. LXXXVI) and
Hoveringham (ibid., 122; Clapham 1930, pl. 59b) in
Nottinghamshire, West Marton (Kendrick 1949,
123–4, pl. LXXXVIII) and Kirkburn (ibid., 120, pl.
LXXXIV), Yorkshire, Norwich, Norfolk (Zarnecki
1951b, 38, pl. 76; Zarnecki et al. 1984, no. 126, pl.
126) and York (Solloway 1910, 56, pl. facing;
Moulden and Tweddle 1986, no. 40, pl. 1b) are all
decorated in the Urnes style. This argument is difficult
to sustain. The West Marton cross-shaft has nothing in
common with the features of the style outlined above.
The York sculpture has an animal head with a lentoid
eye and lappets, but too little of the body survives to
be sure that this was in the Urnes style. At Kirkburn
the capitals do have looped, ribbon-like animal bodies
interlacing with filiform elements, but they are not in
other respects related to the Urnes style. At Southwell
and Hoveringham there are dragons with looped ends
to their bodies interlacing with filiform elements, but
in other respects the sculptures are of purely
Romanesque style. At Norwich there is merely an
echo of this arrangement; the filiform elements have
become attenuated plant sprays and the animal's bodies
are beaded. In no case can an Urnes-style ancestry be
convincingly argued, but if these twelfth-century
pieces retain only echoes or resonances of the Urnes
style, then the Jevington piece, with its recognisably
Urnes-style animals, must be placed earlier in date,
probably in the late eleventh century.

This dating is supported by the handling of the
sculpture of the figure itself, with its heavily-rounded
limbs, a degree of undercutting, and an attempt to
show the musculature of the body. This is related in
style, if not in accomplishment, to the large-scale
crucifixion scenes, and in particular to that at Romsey
1, Hampshire. Here there is the same use of
undercutting and again an attempt to show the
musculature of the body (Ills. 451–2). This same solid
treatment, but in lower relief, occurs on the eleventh-
century figural panel from the Old Minster,
Winchester (no. 88; Ill. 646), and is reflected also in
mid eleventh-century manuscript art. For example,
the figures in the Canterbury manuscript BL MS
Cotton Tiberius B. V, of c. 1025–50 (Temple 1976,
no. 87, ills. 273–6), share none of the exaggerated
gestures and fluttering draperies of the Winchester
style; instead the figures are given a solid, monumental
form, as in Aelfric's Pentateuch, a Canterbury
manuscript of broadly similar date (ibid., no. 86, ills.
265–72, fig. 34). The Jevington sculpture, then, on

the evidence of both the figural and animal style,
should be placed in the second half of the eleventh
century, continuing pre-Conquest sculptural traditions
into the post-Conquest period in a geographically
remote region.

The figure sculptures from Oxford (St Michael 2)
and Tangmere, Sussex are completely divorced from
contemporary trends in the ornament of sculpture,
manuscripts, and metalwork, and belong firmly to the
tradition of folk art. The apotropaic figure at St
Michael's was discovered built into the belfry stage of
the eleventh-century tower, and must, therefore, be of
a similar or earlier date. The Tangmere panel (Ill. 219)
has been reused as the head of a late eleventh- or early
twelfth-century window and is presumably of pre-
Conquest date. In both cases the simplicity of the
work and the lack of comparative material renders
closer dating impossible.

## GRAVE-MARKERS AND GRAVE-COVERS

There are 53 funerary sculptures from south-east
England of late pre-Conquest date, of these 41 are
grave-covers, one is a coffin lid, ten are grave-markers,
and one is possibly the end or side of a box
sarcophagus.

Among the grave-covers, three geographical groups
can be discerned. At Cardington and Milton Bryan,
Bedfordshire, Great Maplestead, Essex, and St Benet
Fink, London, there are grave-covers of a type
common in the east midlands. There are eight covers
at Oxted (two), Tandridge (one), and Titsey (five), all
within a three-mile radius on the Greensand belt of
Surrey, and on a ten-mile stretch of the Greensand
belt in Sussex the churches at Chithurst, Cocking,
Stedham, and Steyning, have between them produced
nineteen covers; the one at Headbourne Worthy,
Hampshire (no. 2; Ill. 685), is related to some of the
Sussex examples. The grave-covers from Stratfield
Mortimer, Berkshire (Ills. 695–709); Weyhill and
Winchester (Old Minster 6 and St Maurice 1),
Hampshire; St Augustine's Canterbury 2 and Dover St
Peter, Kent; London (City 1); Oxford (cathedral); and
Arundel and Bexhill in Sussex, are unrelated to these
groups or to each other.

Grave-covers of the east midlands type were first
described and classified by Fox (Fox 1920–1) who
defined two groups and six types. In group A the
sculpture is all in relief and all types have a median
ridge. Covers of type 1 have the ridge crossed by short

bars, but the cross-bars and ridge are filled with interlace and there are panels of interlace flanking the ridge (ibid., 25, pl. III). In type 2 there is a central cross-bar and the ridge has U- or V-shaped ends; interlace is confined to four panels flanking the median ridge (loc. cit.). Type 3 has a median ridge and cross-bars of half-round section instead of the more usual flat relief, and again there are flanking panels of interlace (ibid., 25, pls. II, IV). In group B the median ridges are incised although the flanking interlace is still in relief (ibid., 25, pls. IV, VII). Type 4 employs a cross at either end of the median ridge. Type 5 has a median ridge with U- or V-shaped ends (ibid., 25, pl. V), and type 6 employs a ringed cross at the ends of the median ridge, but no cross-bars (loc. cit.). The cover from Milton Bryan, Bedfordshire (Ill. 361), belongs to type 2 and the one from St Benet Fink, London (Ills. 345–6) to type 5. Of the grave-cover at Cardington, Bedfordshire (Ill. 264), only the central cross-bar and parts of the flanking interlace panel survive, but the median ridge is incised and the interlace panels have a broad borders around them, both features of type 4. The piece from Great Maplestead is fragmentary, but has a median ridge flanked by interlace (Ill. 274) and may, therefore, be part of a cover of the east midlands type.

Fox dated grave-covers of this general type to the late tenth and eleventh centuries on the basis of the archaeological evidence from two sites, Peterborough cathedral and Cambridge castle. At Peterborough during restoration work in 1888 two covers were found *in situ* immediately outside the walls of the pre-Conquest church which was assigned to the refoundation of the monastery by St Aethelwold in 970 (Fox 1920–1, 23–4, 31–2). At Cambridge castle in 1810 part of a cemetery employing eight such grave-covers was found *in situ* under the rampart which was constructed in 1068 (ibid., 20–1). Fox argued that these two sites served to fix the dates between which the grave-covers were used. Unfortunately, Fox's assumption that no burials can have taken place at Peterborough during the period between the destruction of the monastery in 867 and its refoundation in 970 cannot be relied upon. So deficient is the documentation that a church may well have continued to function on the site throughout this period. Even if there was no church presumably burials continued in the churchyard. Similarly, covers of this type may have continued to be used for some time after 1068; nevertheless, the archaeological evidence does point towards a late Anglo-Saxon date for the majority of them.

The grave-covers from Oxted, Titsey, and Tandridge, all in Surrey, form a more homogeneous group, all but one being decorated with a simple Latin cross in relief. The exception, Titsey 4 (Ill. 255), has a median ridge in relief with a cross-bar and part of a V-shaped terminal, a form closely related to type 2 of the east midlands group, although it is without the interlace. This single weak link may suggest a late pre-Conquest date for the whole group. Unfortunately, there is no confirmatory evidence from the circumstances of discovery.

Grave-covers similar to those encountered in Surrey occur also in Sussex. Here four general types can be identified: those decorated with a Latin cross (type 1); those decorated with a median ridge having a cross-bar near each end (type 2); those having a median ridge with V-shaped ends (type 3), and those decorated with a Greek or Latin cross near each end (type 4). Examples of types 1 and 2 occur at Chithurst, for example, no. 6 (type 1), no. 2 (type 2) and Stedham, for example, nos. 7–11 (type 1) and 4 (type 2), while covers of type 3 are found at Cocking, Stedham (no. 6), and Steyning (no. 2), and examples of type 4 occur at Stedham (no. 2) and Steyning (no. 1). A single cover from Chithurst (no. 1, Ill. 220) is a type 2/3 hybrid. The dating of most of the Sussex grave-covers is based on architectural evidence. The one from Cocking was discovered built into the foundations of the chancel, dated to the late eleventh century (Johnston 1921, 182, fig. 1), while one of the covers from Steyning (no. 1) was found incorporated into the foundations of a part of the nave dated to *c.* 1170–80 (Bloxham 1864, 238; Nairn and Pevsner 1973, 538). The grave-covers and -markers from Stedham were reused as building material in the base of the nave walls, dated to the twelfth century, a dating confirmed by the surviving twelfth-century window in the nave (Page 1907, 365). This data suggests that covers of the Sussex type had fallen out of use by the early twelfth century, although it is hardly decisive evidence. Certainly the *in situ* slabs of twelfth-century date from other southern English sites, such as Old Sarum (Shortt 1976, pl. p. 33), and Trowbridge, Wiltshire (Goddard 1904), are very different in their decoration. For example, at Trowbridge one of the covers has a Latin cross, but of far more elaborate form than those employed in Surrey and Sussex and without the stem extended to form a median ridge (ibid., pl. on 6). A second cover has a median ridge, but has a border of star pattern, and semicircles of star pattern and triple-reeded mouldings project from the border to touch the median ridge (loc. cit.).

Of the same general date must be the grave-cover

from Headbourne Worthy, Hampshire (no. 2). It is coped, like the example from Tandridge (Ill. 231), and has a median ridge with, at the surviving end, subsidiary ridges developing from it and running into the corners: a variant of the bifurcating median ridge type (Ill. 685). This type of decoration, combined with interlace, is also employed among the East Anglian covers, as at Milton Bryan, Bedfordshire (Ill. 361).

Among the remaining grave-covers, three, from Dover (St Peter), Kent (no. 1; Ill. 77), Weyhill, Hampshire (Ill. 473), and Arundel, Sussex (Ill. 1), are decorated with Latin crosses, but the crosses are very different in form from each other and from the crosses employed on the Surrey and Sussex slabs. Unusually, the example from Dover St Peter has a rounded head and foot and is decorated with a relief Latin cross which has an exaggerated fan-shaped head. On the cross-head is a runic inscription; unfortunately, this is of little help in dating the carving (see Parsons, p. 143). Dating therefore depends on the form of the relief cross (Ill. 77). There are no parallels for this form in southern or midland England, but in Northumbria the type appears to have been current in the tenth and eleventh centuries, as, for example, on the standing crosses from Kirkby Wharfe (Collingwood 1927, 88, fig. 107) and Collingham, Yorkshire (ibid., 88). The closest parallel to the form of the cross on the Dover cover is provided by a grave-cover from Spennithorne, Yorkshire, which is decorated with a closely comparable cross (ibid., 90, fig. 101). The Spennithorne cover is also decorated with bifurcating interlace typical of Anglo-Scandinavian sculpture in the north, and can, therefore, be dated to the tenth or eleventh century. A similar date can be suggested for the Dover monument, but such a geographically remote parallel is, however, an unsatisfactory basis for reliable dating.

At Weyhill, Hampshire (Ill. 473), the face of the grave-cover is edged and divided into two roughly equal faces by pairs of crude roll mouldings. The upper field is undecorated, although areas of rough chiselling suggest that sculpture may have been cut away in the manner of the crucifixions from Headbourne Worthy 1 and Breamore 1, Hampshire. The lower field is decorated with a Latin cross with the arms having concave edges and standing on an elaborately-moulded base. Pairs of transverse mouldings separate the arms of the cross from the centre which is decorated with a rosette. There is no close parallel for the shape of the cross, but the cross at Stepney, London, has a similar elaborately-moulded

base (Ill. 354) and there are similar bases in the crucifixion scene on fol. 9v of the Arenberg Gospels, dated to c. 990–1000 (Temple 1976, no. 56, ill. 171) (Fig. 21), and in the presentation scene on fol. 6r of the *Liber Vitae* of the New Minster, dated to c. 1031 (ibid., no. 78, ill. 244). In each case, however, the ends of the arms of the cross are also elaborately moulded. There is no obvious parallel for the transverse mouldings on the cross-head and -arms, although something similar is seen on a tenth- or eleventh-century Anglo-Saxon or Danish ivory crucifixion now in the National Museum, Copenhagen (Beckwith 1972, no. 36, ill. 73). These parallels suggest a tenth- or eleventh-century date for the cover, but do not allow the dating to be further refined.

The Latin cross decorating the stone from Arundel, Sussex, is also of a distinctive, but different, form, having the lower limb of the cross expanding before ending in a point. In addition the cross is portrayed as if suspended from a triangular loop. The only adequate parallel for the shape of the cross is provided by an ivory pectoral cross of c. 1050 in the Victoria and Albert Museum (Beckwith 1972, no. 45, pls. 99–102: Backhouse *et al.* 1984, no. 125, pl. 125). This has a circular field in the centre, but otherwise compares closely in shape with the Arundel cross. Like the latter, the pectoral has a triangular suspension loop, but with the apex pointing upwards, not downwards as at Arundel. This parallel suggests a late pre-Conquest or early post-Conquest date for the Arundel piece.

The decoration of the remaining grave-covers from south-east England, from Stratfield Mortimer, Berkshire, Canterbury St Augustine's 2 and Dover St Mary in Castro 1, Kent, Oxford cathedral, and Bexhill, Sussex, is more diverse. At Stratfield Mortimer (Ills. 695–709) the decoration consists of an inscription around the edges of the upper surface of the stone. This records that it covered the grave of one Aethelweard son of Kyppingus. The name Aethelweard is so common in the surviving documentary sources that it is impossible to identify the person commemorated. The name Kyppingus is much less common and it is possible that he was related to, or can even be identified with, the Cheping who is recorded as holding the church of Stratfield Mortimer in the time of the Edward the Confessor (Cameron 1901–2, 73; but see p. 337). This would place the cover around the time of the Conquest.

The grave-cover from St Augustine's Canterbury, Kent (no. 2), is also decorated with an inscription, this time arranged in eleven horizontal lines (Ills. 24–8).

On the basis of the letter forms and the late form of the names, Higgitt dates the slab to the mid to late eleventh centuries (see p. 130). The animal ornament, comprising an incised quadruped and bird between lines two and three, may suggest a rather earlier date, however. The quadruped has a triangular body and rear legs; the offside front leg is raised and the animal looks upwards. Similar animals occur fairly widely in the manuscripts, perhaps the best parallel being provided by Durham Cathedral Library MS A. IV. 19. On fol. 57r, again fitted into the text, is a closely-comparable animal, although here backward looking. This manuscript dates to the early tenth century (Temple 1976, no. 3, ill. 8), but similar quadrupeds occur in later works as, for example, in the borders of the presentation scene, fol. 1v, in the *Vita Cuthberti*, dated to *c.* 937 (ibid., no. 6, ill. 29). Later versions, however, usually have the animal's tail brought up between the legs and across the body as, for example, on p. 127 of Monte Cassino, Archivio della Badia MS BB. 437, 439, dated to *c.* 1050 (ibid., no. 95, ill. 288). This feature occurs also in metalwork, as on the cast bronze censer cover from Canterbury, dated to the tenth century (Wilson 1964, no. 9, pl. XII). The bird on the Canterbury grave-cover also finds its best parallels in the tenth century. It has a plump, rounded body, a parallel-sided tail with a square end, and large curved feet. The head is outstretched and looks slightly upwards. Birds of this type are found in numerous tenth-century manuscripts as, for example, on fol. 115v of Oxford, Bodleian Library MS Tanner 10, dating to the first half of the tenth century (Temple 1976, no. 9, ill. 37). Here the birds have precisely the same form as on the Canterbury example, although they form part of an initial. Similar birds are also encountered in metalwork, as on the Canterbury censer cover (Wilson 1964, no. 9, pl. XII) and on the small unprovenanced gilt-bronze jug in the British Museum (ibid., no. 147, pl. XLIII), both works of the tenth century. Good eleventh-century parallels are not so easy to find, but the type recurs on the Bayeux Tapestry, usually with the wings extended, but occasionally they are folded, as on the present carving. The birds on the tapestry are bigger and more elongated, however, and the wing and tail merge into each other (e.g. Wilson 1985, pls. 69–73).

The best parallels for the animal ornament on the Canterbury grave-cover are, therefore, tenth-century ones, whereas the inscription is unlikely to be earlier than the mid eleventh century (see below, p. 113). This apparent discrepancy might support Okasha's suggestion that the inscription is secondary (Okasha 1983, no. 161). Art-historical, epigraphical and linguistic dating methods are crude tools for such fine dating, however, and this apparent conflict in the dates derived from different methods may do no more than demonstrate that fact.

At Dover the grave-cover from St Mary in Castro (no. 1) is decorated with crude incised foliate decoration within cable or foliate-decorated borders (Ills. 62–3, 68). Its reuse as paving, probably in the late twelfth century (see p. 139), suggests a date in the early part of the twelfth century at the latest, and, allowing for a reasonable period of primary use, probably in the eleventh century. The decoration itself is so crude that it is of little help in dating. Equally difficult to date is the grave-cover from Oxford cathedral (Ill. 362). This was recovered from the core of twelfth-century walling in the chancel (BL Add. MS 27765G, fol. 32r), perhaps suggesting a date in the eleventh century or earlier if a reasonable period of primary use is allowed. The decoration consists of a series of groups of concentric semicircles developing from the long edges. This arrangement is paralleled on the cross-shaft fragments from Saffron Walden (Ills. 371–3). A number of grave-covers in the east midlands, possibly produced at Barnack (Butler 1956, 90), also employ nested geometrical shapes, usually triangles (as at Waterbeach, Cambridgeshire (ibid., 90, fig. 1.1) and Oxford, where they develop from the long edges of the cover), or lozenges (as at Waterbeach and Wood Walton, Cambridgeshire (ibid., 90, figs. 1.1, 1.2)). These nested geometrical shapes are more widely spaced than at Oxford and are normally used with a central rib and cross patée, features also lacking at Oxford. Butler has suggested an eleventh-century date for the east midland covers (ibid., 90); if this is acceptable then the Oxford example, with its rather different decoration, may be regarded as a regional variant of similar date, or it may represent a late pre-Conquest prototype out of which covers of the east midlands type developed.

The grave-cover from Bexhill, Sussex, is unique in south-east England, and takes the form of a truncated pyramid on a rectangular base (Ills. 10–19). The faces are panelled, and the fields are decorated with interlace, animal, plant, and geometrical ornament. As noted above (p. 41), this combination of different motifs is characteristic of the late eighth and ninth centuries, but the individual motifs employed at Bexhill cannot be paralleled in works of that period. Of the four major panels of interlace at Bexhill, three (Ills. 12–14) are filled with flaccid, disorganised

patterns which lack any logical structure, in stark contrast to the carefully considered and rigidly organised interlace employed, for example, at Elstow, Bedfordshire (Ill. 272), or Rochester, Kent (no. 1; Ill. 141). Such incoherent interlaces are not paralleled on stone sculpture or metalwork, or in manuscripts in the late pre-Conquest period, but do occur on leather sheaths. A scramasax sheath from Gloucester, dated to the eleventh century, employs a closely comparable interlace, although with zoomorphic elements, and there is an almost identical sheath from Parliament Street, York, probably also datable to the eleventh century (Tweddle 1986a, 237–8, fig. 107, pl. XI).

The animal ornament on the Bexhill cover consists not of the winged or wingless bipeds characteristic of the late eighth and ninth centuries, as at Elstow, Bedfordshire (Ills. 269–71), or Godalming 1, Surrey (Ill. 84), but instead of ribbon-like animals with narrow, shapeless heads and fan-shaped tails (Ills. 18–19). The animals' bodies undulate, and in the fields created by the undulations are triquetras linked to each other across the bodies. This type of animal is difficult to parallel on southern English stone sculpture except, perhaps, on the tenth-century shaft from Bishops Waltham, Hampshire, where there are similar ribbon-like animals, but tightly spiralled and without the interlace (Ill. 421). Looking further afield, however, an almost exact parallel is provided by a cross-shaft from St Mary Bishophill Senior, York (no. 1; Lang 1991, Ill. 249). Here face D is decorated with a similar ribbon-like animal, although the head and tail are missing, enmeshed in identical interlace. This shaft was found incorporated into eleventh- or early twelfth-century walling and probably dates to the tenth or eleventh century. There is no evidence for an earlier ecclesiastical occupation of the site despite thorough excavation (Ramm 1976). A closely comparable animal also occurs on face A of Aycliffe 2, a work of the second half of the tenth century (Cramp 1984, I, 43–4, pl. 9 (30)), and there is a fragment of a similar design at Chester-le-Street (no. 8), which is dated to the tenth century (ibid., I, 57, II, pl. 24 (126)). The tenth- or eleventh-century date suggested by the nature of the interlace and animal ornament is further reinforced by the form of the cross in the lower of the two cross-decorated panels. This has expanding arms with convex ends and concave sides; the arms are linked together by short, slightly-curved bars. This cross is clearly related to the ring-head, a type which, as noted below (p. 93), first appears in Anglo-Saxon sculpture in the tenth century and which was probably introduced by Scandinavian settlers.

The derivation of the ornament of the Bexhill cover, which combines late pre-Conquest motifs in a manner characteristic of earlier pre-Conquest art, is puzzling and presents a combination not paralleled elsewhere in the pre-Conquest art of south-east England. One clue as to its origins is, perhaps, provided by the interlace in the central panel (Ill. 15). This pattern, with its interlacing pairs of diagonals linked at the ends and interlacing with plain and looped circles, is difficult to parallel in southern Anglo-Saxon art. The closest approach occurs in Cambridge, Corpus Christi College MS 411, where on fol. 40r the corners of a rectangular frame enclosing the initial Q prefacing psalm 51 have interlaces of similar form, combining free rings or nearly closed circles with diagonals or diagonal loops (Temple 1976, no. 40, ill. 128). This manuscript, dating to the last quarter of the tenth century, draws upon a Franco-Saxon exemplar (ibid., 63), and it is to Franco-Saxon manuscripts that it is necessary to turn to find a close parallel to the central interlace on the Bexhill cover. The Leofric Missal incorporates part of a ninth-century Sacramentary made in the region of Arras and Cambrai, and was in England by the second quarter of the tenth century (ibid., no. 17; Deshman 1977, 145–8). On fol. 61v the frame of the initial T has enlarged square corners, as in Cambridge, Corpus Christi College MS 411 (Deshman 1977, pl. 1a). One of the corner squares is filled with pairs of interlacing diagonals linked together at the ends, as on Bexhill. Another square employs a looped circle, as at Bexhill. It appears, therefore, that the central motif at Bexhill must be derived from an imported Franco-Saxon exemplar, such as the Sacramentary incorporated into the Leofric Missal. This would explain the anachronistic nature of the decoration on Bexhill 1 as Franco-Saxon works, drawing upon earlier Insular exemplars, employ the same range of motifs. For example, on fol. 127r of the Gospels produced at St Vaast in the late ninth century are panels of interlace, animal ornament, and plant ornament (Mütherich and Gaehde 1977, pl. 41). The plant ornament is of a type which is conventionalised, but recognisable, at Bexhill, and the animals are ribbon-like and enmeshed in interlace, although they have spindly legs. All that the sculptor at Bexhill has done is to copy and conventionalise some motifs and to substitute for others types with which he was more familiar.

Despite this great diversity of form and decoration, other types of grave-cover were probably used in south-east England. For example, the Old Minster, Winchester, has produced a coped cover (no. 6) with

hipped ends and an axial inscription, dated to the early eleventh century (Ills. 509–13, 521), and the runic inscription from Winchester St Maurice 1, appears to have derived from a parallel-sided monument with a convex upper surface (Fig. 42; Ills. 667–70). The use of Old Norse runes probably serves to place it in the period of Scandinavian supremacy in southern England, c. 1016–42.

Closely related to some of the pre-Conquest grave-covers is the single surviving pre-Conquest coffin lid from south-east England, from Westminster abbey. The lid is decorated with a Latin cross having an expanding head and arms (type B6), but with a parallel-sided stem and foliated foot (Ills. 355, 357). There is no archaeological evidence for the dating of the lid, but the decoration resembles that of some of the covers from Surrey and Sussex, for which an eleventh-century date has been suggested above (p. 85). The foliated foot employs a central leaf flanked by narrow, out-turned leaves, a form closely paralleled by the pilaster bases from Corhampton, Hampshire (no. 2; Ill. 440), for which a tenth- or eleventh-century date has been argued above; a similar date can be proposed for the coffin lid, although the evidence is clearly tenuous. Unfortunately, the building of Westminster abbey, begun c. 1050, does not provide a *terminus post quem* for the stone, as it is clear that there was some sort of monastic community here at an earlier date (Hunting 1981, 14–19).

Apart from the grave-covers and coffin lid, there are eleven probable grave-markers from south-east England, five from Winchester (Old Minster 2, 4–5, New Minster 2, and St Pancras 1), five from Stedham, Sussex (nos. 7–11; Ills. 240, 243–4, 246–8), and one from White Notley, Essex. Most of the examples from Stedham were recovered from the same twelfth-century footings as the grave-covers, and like them were moss-covered when found so may have been of considerable age when buried (Butler 1851, 20–1, fig. 2). An eleventh-century date, therefore, seems most probable; certainly they are similar to some of the small head-stones from Winchester, dated to the late tenth or early eleventh century, although with rather more elaborate decoration (e.g. New Minster 2; Ill. 661). The fragment from White Notley, Essex, is reused as the frame of a single-splay window (Ill. 375). The single-splay window is an eleventh- and twelfth-century type, and this suggests that the grave-marker belongs either to the tenth or eleventh century according to the date of the window. This is confirmed by the form of the cross decorating it. This was probably a disk-head, a tenth- and eleventh-

century type which, as noted below (p. 93), is related to the ring-head. Confirmation of this date also derives from the fact that there is a grave-marker of identical form from the graveyard at Cambridge castle, sealed by the defences built in 1068 (Fox 1920–1, pl. VII).

Among the grave-markers and -covers one group stands out, as the pieces are decorated with an accomplished version of the Ringerike style. This group comprises three carvings from London (City 1, St Paul's 1, and All Hallows 3), two examples from Rochester, Kent (nos. 2–3), and the grave-marker or box sarcophagus fragment from Great Canfield, Essex. On the grave-cover from the City and the Great Canfield fragment the decoration consists purely of plant ornament (Ill. 353; Fig. 32). On the grave-markers from St Paul's and All Hallows the design consists of a single large animal (Fig. 23; Ills. 351–2, 341). At Rochester the design on one of the pieces (no. 2) is too fragmentary for it to be reconstructed, but there is a runic inscription on one edge (Ill. 144) as there is on the piece from St Paul's (Ill. 350). On the other Rochester fragment (no. 3), the decoration consists of tendrils in Ringerike style on face A, a cross on face C, and a Latin inscription on the narrow edge of the rounded head (Ills. 147–50). In every case the sculpture is executed in low, flat relief against a flat background. Details of the design are picked out with incised lines having a V-shaped profile and often stopping at drilled holes. The similarities of sculptural technique as well as the repetitive designs, allied to the geographically restricted distribution of the group,

FIGURE 23
Animal ornament, nts (KEY: a, London All Hallows 3A (partially reconstructed); b, London St Paul's 1A, detail)

suggests that they are the products of a single workshop, and possibly even of a single hand.

The nature of the decoration makes dating comparatively straightforward. The Ringerike style was current in Scandinavia from the late tenth century to the third quarter of the eleventh century (Wilson and Klindt-Jensen 1966, 145–6), and this provides the chronological limits for the English pieces, although it is possible that these can be more closely dated. Ringerike-style elements occur in four pre-Conquest manuscripts: in Aelfric's Pentateuch, dated to the second quarter of the eleventh century (Temple 1976, no. 86; Fuglesang 1980, no. 108, pls. 68–9); the Winchcombe Psalter, dated to *c.* 1030–50 (Temple 1976, no. 80; Fuglesang 1980, no. 109, pl. 70); the Caedmon Genesis, dated to *c.* 1000 (Temple 1976, no. 58; Fuglesang 1980, no. 110, pl. 71); and in the Bury St Edmunds Psalter, dated to the second quarter of the eleventh century (Temple 1976, no. 84; Fuglesang 1980, no. 108, pls. 68–9). This suggests that in England at least the high point of the style was in the first half of the eleventh century. Confirmation of this suggestion derives from the distribution of objects decorated in the Ringerike style which is firmly south-eastern, centred on the political heart of the kingdom, on the axis from Winchester to London. This suggests that the Ringerike style in England was a court style and, as such, probably relates to the period of Danish supremacy under king Cnut and his immediate successors, from 1016–1042. As Wilson has pointed out, it is unlikely that the style would have found favour with the Francophile court of Edward the Confessor (Wilson and Klindt-Jensen 1966, 145).

CROSS-SHAFTS

Most of the cross-shafts from south-east England of tenth- and eleventh-century date are of square or rectangular section, with the exceptions of those from Canterbury, Kent (St Augustine's abbey no. 1) and Wantage, Berkshire, which are round.

The most elaborate of the square-sectioned shafts is that from All Hallows by the Tower, London (no. 1; Ills. 320–40). This is decorated with a mixture of figural ornament, interlace, animal, and plant decoration. Figures occur on three of the four faces, but extensive damage has made the iconography difficult to interpret. On faces A and C are single, large standing figures. On face A only the shoulders and the lower part of the robes and legs survive (Ills. 323–4). On face C more of the figure survives, but it is so eroded that the features are difficult to decipher.

Radford has referred to animals at the figure's feet and has thus identified the scene as Christ trampling on the beasts (Kendrick and Radford 1943, 15), but this appears to be a misreading of the figure's legs which emerge from its tube-like robe (Ill. 339). The figures on face D are more complete and in much better condition. Two standing or sitting figures are placed side by side (Ills. 336–8). The left-hand figure holds a key and can be identified as St Peter. The right-hand figure also holds something vertically; Radford has identified it as a sword and the figure, therefore, as St Paul (ibid., 15–16). This is unlikely as a sword is only depicted once in Anglo-Saxon art in association with St Paul, on fol. 95v of the Benedictional of St Aethelwold (Temple 1976, no. 23). Here it occurs in the scene of the execution of St Paul and is carried by the executioner, not by the saint. Elsewhere, as on fol. 31r of the Hereford Troper (ibid., no. 97; Rice 1952, pl. 67b) and on fol. 29v of the Benedictional of Robert of Jumièges (Temple 1976, no. 24, frontispiece), the saint is depicted as bearded and he holds a book. It is equally possible that the feature held by the figure on the All Hallows shaft is a sceptre or scroll, not a sword.

The robes of the left-hand figure are arranged in a pronounced V-fold between the legs, and the robe appears to be gathered up from left to right (Ill. 338). This disposition of the robes is more characteristic of seated than standing figures, as are the figure's out-turned feet. It is, therefore, possible that this pair of figures derives from a model in which two figures were seated side by side. Such scenes are uncommon in Anglo-Saxon art, but ranges of seated figures do occur in some eleventh-century manuscripts, as, for example, on fol. 2v of BL MS Cotton Tiberius A. III, a work of *c.* 1050 (Temple 1976, no. 100, ill. 313), and on fol. 56v of Durham Cathedral Library MS B. III. 32, a work of similar date copied from it (ibid., no. 101, ill. 315). In the latter, the three figures in Tiberius A. III (king Edgar and saints Dunstan and Aethelwold) have, with the omission of the king, been reduced to two, as on the All Hallows shaft. In both manuscripts the figures' garments fall in V-folds between the legs and in most cases the feet are out-turned. One unusual detail which links the scene in the Durham manuscript with that on the All Hallows shaft is the use of horizontally-ribbed hose with Classical garb, worn by both of the figures on the shaft, and by the figure to the left in the manuscript. King Edgar in Tiberius A. III has his legs clad in similar hose, as is often the case with figures wearing secular dress in tenth- and eleventh-century art.

Something similar is seen, for example, on fol. 17v of BL MS Cotton Tiberius C. VI, dated to *c.* 1050 (ibid., no. 98, ill. 306), and in BL MS Stowe 944, a work of *c.* 1031 (ibid., no. 78, ill. 244), where the figure of king Cnut on fol. 6r wears comparable hose.

The manuscript parallels for the iconography of the scene on face D suggest a date for the shaft in the eleventh century and supporting evidence derives from the style of the figures and their draperies. The figures on face D are unnaturally elongated, as apparently are the figures on faces A and C, although the extent of the damage to these faces makes it difficult to judge. Such thin and elongated figures are paralleled in late pre-Conquest art, most notably in the manuscripts, as in the Judith of Flanders Gospels, a work of the second quarter of the eleventh century (Temple 1976, no. 93, ills. 285, 289), in Oxford, Bodleian Library MS Douce 296, a work of similar date (ibid., no. 79, ill. 259), and in Monte Casino, Archivio della Badia MS BB. 437, 439, made in *c.* 1050 (ibid., no. 95, ill. 287). The figures in these three works are all characterised by their very narrow shoulders, long torsos in proportion to the overall length of the body, and by the lack of a waist; indeed so similar are they that it has been suggested that these manuscripts derive from the same workshop (ibid., 112). All these features are paralleled on the All Hallows shaft, particularly on face D.

The handling of the robes on face D also points to an eleventh-century date for the shaft. The robes have the folds indicated by narrow, closely-spaced grooves, often arranged as a series of nested U-shapes, as over the legs of the figures, or in apron-like folds as at the waist of the left-hand figure (Ills. 226–8). The effect is rigid and non-naturalistic, concentrating on surface patterning not on the shape of the body beneath. In manuscript art this treatment finds its closest parallel in Aelfric's Pentateuch, a product of St Augustine's abbey, Canterbury and dated to the second quarter of the eleventh century (Temple 1976, no. 86, ills. 265–72). Here also the folds of the robes are indicated by closely-spaced lines which are rigid and formalised and have begun to loose contact with the shape of the body beneath. Frequently the lines are grouped in nested U-shapes, as on the cloaks of the figures on fol. 139v (ibid., ill. 266). Certainly this effect of surface patterning with line is as closely comparable to the effect on the All Hallows shaft as the difference in medium will permit. A sculptural example of the same phenomenon occurs on the eleventh-century cross-shaft from Shelford, Nottinghamshire (Kendrick 1949, 78–9, pl. LI). Here the figures of the Virgin and Child

on face A and a seraph on face C have the folds of the garments indicated by narrow, closely-spaced grooves as on the All Hallows shaft. The grooves are placed in groups at angles to each other, but paralleling different edges of the garments, a patterning which is more formalised than that of the All Hallows shaft. The emphasis on the knees and the patterning of the lower parts of the garments at Shelford suggests that, as at All Hallows, the standing figures were derived from a model where the figures were seated.

The figure of the Virgin at Shelford has the overgarment indicated by narrow closely-spaced grooves, and the undergarment, visible below the knees, indicated by widely spaced vertical grooves. This difference in treatment provides a crucial clue for the understanding of the treatment of the robes of the figure on face A of the All Hallows shaft. Here the upper part of the robe, above knee level, has narrow vertical grooving; the lower part splays out and is formed from a mass of folded vertical edges. The two elements are separated by a pair of transverse bars (Ills. 323–4). This appears to be a further conventionalisation of the arrangement of the overgarment and undergarment seen at Shelford. A similar conventionalisation, albeit geographically distant, occurs on an eleventh-century cross-shaft from Aycliffe, co. Durham, where on face D the crucified figure of St Peter has the overgarment and undergarment arranged in precisely this manner. The Aycliffe shaft can be dated to the last quarter of the tenth century or first quarter of the eleventh century (Cramp 1984, I, 41–3, II, pl. 8, 28).

An analysis of the iconography and figure style of the All Hallows shaft suggests a date for the piece in the eleventh century, and possibly in the middle years of the century. Little is added to such a conclusion by a consideration of the interlace, animal and plant ornament on the shaft. The simple forms of the interlace on face B exhibit no feature which would permit close dating. The paired animals on face A find no adequate parallel in south-east England in late pre-Conquest art, but the reversed lentoid eye and the elongated ears and lips with clubbed ends may be derived from Scandinavian art, as on the grave-marker from St Paul's, London (Ill. 351). The body of the animal, however, is very different. It is almost parallel sided and the legs are exceptionally long; a pair of transverse incised lines separates the hindquarters from the rest of its body. These are not usual features in late pre-Conquest art where the animal bodies usually have a triangular shape, as on Canterbury St Augustine's 2. The transverse lines across the

hindquarters may, however, be derived from the tail brought up across the hindquarters, a feature found widely in late pre-Conquest art, as, for example, in Monte Cassino, Archivio della Badia MS BB. 437, 439 on p. 127, or in metal on the censer cover from Canterbury (Wilson 1964, no. 9, pl. XII).

The plant ornament on face D is, however, slightly more informative. The spindly, ridged stalks set at angles to each other and interlacing where they cross (Ill. 336) seem to derive from the acanthus borders of Winchester-style manuscripts. As Kendrick has noted (Kendrick 1949, 103, fig. 15), in several of these the acanthus leaves cross and intertwine in precisely the fashion seen here, notably on fol. 11v of BL MS Cotton Vitellius C. III (Temple 1976, no. 63, ill. 187), on fol. 10v of Cambridge, Pembroke College MS 301 (ibid., no. 73, ill. 234), and on fol. 62r of Rome, Biblioteca Apostolica MS Reg. lat. 12 (ibid., no. 84, ill. 262), all manuscripts of the first half of the eleventh century. On the All Hallows shaft the fleshy acanthus leaves with their lobed ends employed in the manuscripts have been reduced to rigid stalks, but their ancestry is not in doubt. In sculpture the closest parallel is provided by the acanthus string-courses or friezes from Sompting, Sussex (nos. 1–3, 5, and 7), which employ similar interlacing ridged stems (Ills. 162–3, 167–9, 170– 1). The Sompting friezes can be dated to the mid eleventh century, a date which on all the available evidence would suit the All Hallows shaft.

Such a mid eleventh-century date conflicts with the dating of the inscription based on its letter forms; Higgitt suggests below that this is best placed in the ninth century (pp. 220–1). This is a difficult problem to resolve. As Higgitt points out, the use of early letter forms on a late monument cannot be paralleled elsewhere, although it is possible. Equally, the decoration on the shaft is very difficult to parallel among the surviving material before the eleventh century. There is nothing similar in the eighth or ninth centuries in south-east England (where early sculptures are in any event rare) or, indeed, from elsewhere in the country.

Like the All Hallows shaft the larger of the two cross-shaft fragments from Southampton, Hampshire (Ills. 459–64), employs figural ornament, but its fragmentary nature makes both iconographical and stylistic analysis, and therefore dating, difficult. A pre-Conquest date is suggested by the type of monument; standing crosses are rare in south-east England after the Conquest, although examples do exist as at Castle Hedingham, Essex (Brown 1903–37, VI (2), 147–8, pl.

XL.2). Such a date is supported also by the layout and nature of the ornament.

Face A of the Southampton shaft (Ill. 459) is divided into two fields, the upper larger than the lower, by a horizontal bar which at each end protrudes into a pier with a stepped base flanking the edge moulding. This type of layout is paralleled in a number of late tenth- and eleventh-century manuscripts, for example, in the Nativity scene on fol. 85r of the Aethelstan Psalter, dated to the second quarter of the tenth century (Temple 1976, no. 5, ill. 30); on fol. 2v of BL MS Cotton Tiberius A. III, a manuscript dating to c. 1050 (ibid., no. 100, ill. 313); and in the illustration prefacing Aelfric's Grammar on fol. 56v of Durham Cathedral Library MS B. III. 32, a Canterbury manuscript of c. 1050 (ibid., no. 101, ill. 315). The closest parallel is, however, provided by the St Luke Evangelist portrait on fol. 21v of St Margaret's Gospels (Oxford, Bodleian Library MS lat. lit. F. 5 (ibid., no. 91, ill. 279)). Here the figure of the Evangelist is contained within an arch whose supporting piers abut the frame and have stepped bases. These rest on a cross-bar dividing the page into two unequal parts. If the piers were extended to stand on the lower border then this layout would provide a precise parallel for that on the Southampton shaft. The area beneath the Evangelist is filled with a representation of the ground, but figures related to the scenes in the upper fields are found in analogous positions in other manuscripts, as possibly on the Southampton shaft. In both BL MS Cotton Tiberius A. III (ibid., no. 100, ill. 313) and Durham Cathedral Library MS B. III. 32 (ibid., no. 101, ill. 315) there is a monk with a scroll, and in the Aethelstan Psalter the scene in the lower field represents the midwives washing the infant Christ (ibid., no. 5, ill. 30).

The identification of the scene or scenes on the Southampton shaft (Ill. 459) remains entirely speculative. In the upper field only the feet of a figure survive, projecting from a robe and standing on a T-shaped support. A drapery fold falls to the left. This might be interpreted as a robed crucifixion with Christ's feet standing on a *suppedaneum*; as an Evangelist portrait with an unusually-shaped footstool; or as the standing figure of a saint. For example, the figures of the Virgin and St John flanking a cross on a fragment from Halton, Lancashire, stand on chalice-like features which may be related to the support on the Southampton shaft (Collingwood 1927, 159–60, fig. 191). No surviving example of any of these three scenes depicts animals below the feet of the figure, however. The animals on face A of fragment a can be

identified as a sheep and a predator of some kind, probably a lion. On fragment b, face A depicts an eagle holding a book (Ill. 458), the symbol of St John the Evangelist, with on face B an unidentified animal lying down (Ill. 457).

The iconographical evidence, therefore, advances little the dating of the Southampton shaft, and the stylistic evidence is almost equally uninformative. The falling fold of drapery to the left of the figure on face A of fragment a suggests a relationship with works of the Winchester style which often employ similar narrow folds of drapery developing extravagantly and non-naturalistically from the robes of the figures, as for example, on fol. 1r of the St Dunstan Classbook (Oxford, Bodleian Library MS Auct. F. 4. 32), dating to the mid tenth century (Temple 1976, no. 11, ill. 41), and on fol. 16r of BL MS Cotton Tiberius C. VI, dated to c. 1050 (ibid., no. 98, ill. 10). The folds on the Southampton shaft lack the characteristic broken profile of folds of the Winchester style and are harder and more mechanical (Ill. 459). This may reflect a difference in style dictated by the change in medium, or, alternatively, that the Southampton shaft belongs in the latest period of pre-Conquest art when in the manuscripts also draperies tend to be more subdued and regular without the exaggeration characteristic of earlier works as, for example, in Aelfric's Pentateuch (ibid., no. 86, ills. 269–72) and BL MS Cotton Tiberius B. V (ibid., no. 87, ills. 273–6), both works of the second quarter of the eleventh century. Both of these manuscripts also contain depictions of naturalistic sheep closely comparable with that on face A of fragment a at Southampton, for example, in the scene of the disembarkation of Noah on fol. 15v of the Aelfric Pentateuch (ibid., ill. 269) and on fol. 5r of Tiberius B. V (ibid., ill. 273). In both scenes the sheep have the same head shape and curved horns depicted on the Southampton shaft.

A late pre-Conquest date for the Southampton shaft is supported by the form of the leaf decoration on face D of fragment a (Ill. 464) and face A of fragment b (Ill. 458). In both cases this consists of a series of closely-spaced, expanding, rounded-ended leaves forming a palmette. A leaf form incorporating this feature is encountered in manuscript art only in the eighth-century Vespasian Psalter, where on fol. 30v the bush scrolls in the spandrels of the arch head have similar leaves developing from their undersides (Alexander 1978, no. 29, ill. 146). Something similar is encountered on Reculver 1e, Kent (Ills. 119–20), dated above to the early ninth century. Apart from this the motif occurs most commonly in metalwork of the

Trewhiddle style (Fig. 24), for example, on the ninth- or tenth-century sword-pommel from the River Seine, Paris (Wilson 1964, no. 66, pl. XXIX); on an early tenth-century disc brooch found in Stockholm (Backhouse et al. 1984, no. 17, pl. 17); on the hilt of the late ninth or early tenth-century Abingdon sword (Hinton 1974, no. 1, figs. pp. 2–3, pls. I–III); and on the ninth-century Fuller brooch where the sprays held by the personification of Sight have a similar form (Wilson 1964, no. 110, pl. XLIV). A cruder version of this ornament occurs on a disc brooch from Winchester which copies a penny of Edward the Elder, 899–924 (Okasha 1971, no. 141, pl. 141). All that has occurred on the Southampton shaft is that the stem of the palmette has been assimilated into the border.

The iconographic and stylistic parallels for the Southampton fragments, therefore, suggest a date in the late pre-Conquest period. The style of the draperies and the handling of the animals points to an eleventh-century date, but the form of leaf decoration to the late ninth or tenth century. So little of the decoration survives, however, that no convincing conclusion can be drawn.

Of the eight remaining shafts of square section, from Bishops Waltham and Wherwell, Hampshire; Barking (no. 1) and Saffron Walden, Essex; Kingston upon Thames and Reigate, Surrey; Lavendon (no. 1), Buckinghamshire; and Stanbridge, Bedfordshire, only that from Bishops Waltham is relatively intact, the piece forming one complete section of a shaft constructed from separate pieces. The decoration consists predominantly of panels of interlace. The patterns are well worked out and elegantly drawn, but lack the fine strand and mechanical perfection of

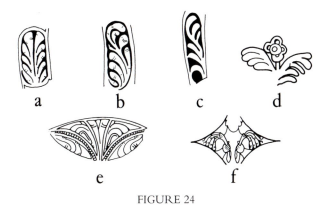

FIGURE 24

Foliate ornament, nts (KEY: a–b, Abingdon sword; c, sword from river Seine, Paris; d, Winchester, disc brooch; e, Stockholm, disc brooch; f, Fuller brooch)

eighth- and ninth-century sculptured interlace from south-east England. This, together with the use of a median incision which does not occur on the earlier material from south-east England, may suggest a late date for the shaft, but such flimsy evidence is not a sound basis for dating. Of much more importance in dating is the animal ornament on face C of the shaft (Ill. 421). This consists of a pair of tightly coiled, confronted, ribbon-like animals, one placed upside-down with respect to the other and with their appendages forming interlacing diagonals. There is no parallel for this arrangement among the sculptures of south-east England, but a tenth-century shaft from Gloucester has in one panel a single ribbon-like animal with the body in tight coils (Fig. 25b). Its appendages form interlacing diagonals and end in feet having a fan-like shape, with the toes clearly differentiated; a treatment which compares closely with that of the tails of the animals on the Bishops Waltham shaft, but at Bishops Waltham the single animal at Gloucester has been split into two (Ill. 421). An analogous arrangement of two tightly curled animals with one placed upside-down can be traced in manuscript art where in a number of manuscripts the decorated initial S is formed in this way. The closest parallel to the Bishops Waltham shaft is provided by the initial on fol. 2r of Cambridge, Corpus Christi College MS 23, a work of the late tenth century, probably made at Christ Church, Canterbury (Temple 1976, no. 48, ill. 50). A similar arrangement occurs on fol. 80v of Lambeth Palace Library MS 200, a work of the late tenth century, produced at St Augustine's abbey, Canterbury (ibid., no. 39, ill. 131). In both cases the detail is very different from that on the Bishops Waltham shaft, but the overall arrangement of the design is strikingly similar.

The tenth-century date suggested for the Bishops Waltham shaft by these manuscript parallels and by comparison with the Gloucester shaft is reinforced by comparison with the animals on the shaft and those on the cover from Bexhill, Sussex, for which a tenth-century date is argued above. The animals on Bexhill (Ills. 18–19) are not coiled, but they have the same ribbon-like bodies as the animals on the Bishops Waltham shaft (Ill. 421) and divided, fan-like tails allied with a similar head shape, with a domed forehead and open, elongated, narrow jaws.

The proposed tenth-century date of the Bishops Waltham shaft is of assistance in dating the shafts from Wherwell, Hampshire, and Barking 1, Essex, both of which, although damaged, are decorated only with interlace. At Wherwell (Ills. 479–81) the patterns are

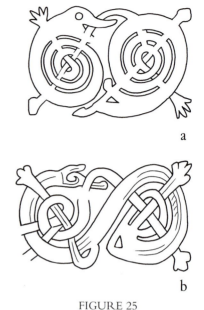

FIGURE 25
Animal ornament, nts (KEY: a, Bishops Waltham 1C; b, Gloucester)

well drawn, but the strands are thick and, in one case, median-incised. At Barking (Ills. 256–9) the strands are finer, although the designs are not well worked out and often become incoherent. The thickness of the strand at Wherwell and the incoherence of the pattern at Barking may indicate a late date. These features are not sufficient in themselves for secure dating, but comparison with the Bishops Waltham shaft at least confirms that interlace-decorated shafts of square section were being made in the tenth century and using the same types of interlaces as at Wherwell and Barking (no. 1).

The shaft from Kingston upon Thames, Surrey, may also have been decorated purely with interlace, but, as only a small part of the shaft survives, with decoration on only two faces, it is impossible to be certain. On face D there are at least two elements of an encircled pattern C apparently incorporating free rings (Ill. 95). The pattern on face B was apparently similar (Ill. 96). The use of free rings in the interlace suggests a date in the tenth or eleventh century, when this feature appears to have originated (Collingwood 1927, 65, 68), and such a late date is supported by the flaccid and disorganised laying-out of the pattern.

Of the shaft from Reigate, Surrey, only a small fragment from one corner of a face survives, decorated with part of what was probably a plain plait with broad, low-relief strands (Ill. 140). Interlace of this type is not encountered among Anglo-Saxon sculptures of the seventh to ninth centuries, but does

occur in the tenth and eleventh centuries, especially in northern England, for example, at Sockburn, co. Durham (Cramp 1984, I, 138–9, II, pl. 136 (734–6)), Aycliffe, co. Durham (ibid., I, 46–7, II, pl. 14 (58, 60)), and Middleton by Pickering, Yorkshire (Lang 1991, ills. 676, 678). On this (admittedly slender) evidence a tenth- to eleventh-century date can be suggested for the Reigate fragment.

The fragment from Lavendon, Buckinghamshire (no. 1), can be identified as part of a cross-shaft because of its taper. The decoration on the only visible face consists of a pair of interlaced closed-circuit loops. The strands are median-incised (Ill. 313). The simplicity of the decoration and the use of closed circuit elements suggest a late pre-Conquest date. The second fragment from Lavendon (no. 2) may have been part of the same or a different shaft, but too little survives for its function to be firmly established. Like Lavendon 1, it is decorated with a closed circuit pattern (Ill. 314), which may suggest a late date. The two shaft fragments from Saffron Walden, Essex, may well have formed part of the same monument. They are simply decorated, but this time with geometrical ornament consisting of concentric semicircles along each of the long edges and touching along the vertical axis of the face (Ills. 371–3). This type of decoration very closely resembles that on the grave-cover from Oxford cathedral (Ill. 362) and a similar mid to late eleventh-century date can be suggested. The decoration on the shaft from Stanbridge, Bedfordshire, is even simpler, consisting of an incised Greek cross (Ill. 409). In view of its great size and of the paucity of post-Conquest standing crosses in south-east England, a pre-Conquest date can be suggested, but there is no decisive evidence.

The two remaining cross-shafts from south-east England, from Wantage, Berkshire, and Canterbury, St Augustine's abbey 1, Kent, are different varieties of round shafts. The shaft from Wantage (Ills. 474–7) is of circular section, a form which, as noted above (p. 41), appears to have been a ninth-century innovation. Like the shafts from Bishops Waltham and Wherwell in Hampshire, and Barking 1 in Essex, it is decorated purely with interlace; as at Barking and Kingston upon Thames, Surrey, an encircled pattern is employed. The strands are thick and median-incised, a form encountered at Bishops Waltham and Wherwell. The parallels which can be drawn between the Wantage shaft and the similarly-decorated shafts of square section serve to suggest a similar tenth- or eleventh-century date. The shaft from St Augustine's abbey, Canterbury, is of the type where the upper part of the shaft is of square section and the lower part of circular

section (Ills. 20–3). As noted by Kendrick, this type is most common in north-west Mercia, although outliers of the group are known from Cumbria, Denbighshire, Yorkshire, and Dorset (Kendrick 1949, 68). Kendrick has proposed a late Anglo-Saxon date for the whole series, deriving the type from ninth-century monuments, such as the shaft from Dewsbury, Yorkshire, which also appears to have had an upper part of square section and a lower part of circular section (ibid., 72–3). His late dating of the group is underlined by the distinctive decoration of the Gosforth cross, Cumberland, the most important and imposing surviving monument of this type. This employs, among other motifs, scenes from Norse pagan myths and a Borre-style ring-chain. Taken together these would suggest a tenth-century date for the shaft and this provides a cross-check for the dating proposed by Kendrick for the group as a whole (Bailey 1980, 125–31, fig. 23; Wilson 1976, 502). A tenth/eleventh-century date would be equally acceptable for the St Augustine's shaft which, like other shafts of this date from south-east England, is purely interlace decorated, although the patterns are too fragmentary for reconstructions to be attempted.

## CROSS-HEADS

Four cross-heads of late Anglo-Saxon date survive from south-east England, at All Hallows by the Tower 2 and St John Walbrook in London; South Leigh, Oxfordshire; and Pagham, Sussex. Of these the heads from Pagham and South Leigh are ring-heads. That from All Hallows 2 is a circle-head, and the head from St John's, Walbrook, is a plate-head (Cramp 1991, p. xiv, fig. 3). As noted above (p. 72), both the plate- and circle-heads are types closely related to the ring-head. Based upon the distribution of the ring-heads which is predominantly northern and eastern, Collingwood has suggested that the type was introduced by Scandinavian settlers in the early tenth century and has pointed to the Isle of Man or Ireland as a source (Collingwood 1927, 137–9, fig. 153). As Bailey has observed, the dating of ring-heads depends not only on their distribution, but also on the fact that no cross-head of this type in England occurs with ornament of pre-Viking type, and that examples do occur which employ animal, figural, or interlace ornament deriving from Scandinavian or Scandinavian-derived motifs (Bailey 1978, 178–9). All these strands of evidence serve to place the four south-eastern cross-heads in the tenth or eleventh centuries.

Confirmation of the dating for the South Leigh cross-head derives from the archaeological evidence for the dating of an almost identical cross-head from Glastonbury Tor, Somerset. This came from a context which contained pottery of a type current in Somerset from *c.* 1000 to *c.* 1200 (Rahtz 1971, 31, 48, fig. 21). This evidence accords well with the angular form of the heads from both Glastonbury and South Leigh (Ill. 406), a feature which Collingwood has suggested is an indicator of a late date. He has, for example, suggested a post-Conquest date for the cross from St Crux, York, which is of similar angular form (Collingwood 1927, 93–4, fig. 115). This is confirmed by the occurrence of crosses of comparable angular form carved in relief on some of the head- and foot-stones of late twelfth-century date from the Canon's cemetery at Old Sarum, Wiltshire.

Little is contributed to a dating of these four cross-heads by a discussion of their decoration. The head from South Leigh is undecorated (Ill. 406), while that from Pagham (Ills. 98–100) is ornamented only with flaccid and disorganised interlace. This may confirm a tenth/eleventh-century date for the cross-head, but does not refine the dating further. The All Hallows head has a memorial inscription around the edge of face A (Ills. 343–4), but the majority of the decoration was painted and cannot now be reconstructed from the surviving colour. The cross-head from St John Walbrook has a simple mixture of pellets and roll mouldings which is not distinctive enough for reliable comparisons to be drawn (Ills. 347–8).

## UNCLASSIFIED FRAGMENTS

There are eleven fragments which are so small or incomplete as to defy even tentative classification. Four from Selsey, Sussex; two from Lewknor, Oxfordshire; one from Oxford (St Aldate's); two from St Augustine's abbey, Canterbury (nos. 9 and 11); one from Ford, Sussex, and one from Rochester, Kent (no. 4).

One of the Selsey fragments (no. 3) is decorated with incoherent, disorganised interlace for which a late date might reasonably be suggested (Ill. 159). A second (no. 4) is decorated with a six-strand median-incised plain plait (Ill. 158). The strands are fairly rounded and the closest parallel is provided by the interlace on the chancel arch from Selham, Sussex, for which a twelfth-century date might be suggested. However, the parallel is not exact, as the strands at Selham are finer and even more rounded, so an earlier

date for this fragment is possible. The third fragment (no. 1) is decorated with interlace based on a closed circuit pattern with some affinities to the Borre-style ring-chain (Ill. 161). Again a tenth- or eleventh-century date seems plausible. The last fragment (no. 2) is decorated with incoherent interlace which develops into a three-element leaf (Ill. 160). The latter is best paralleled in the tenth century; similar leaves occur, for example, on the shaft from East Stour, Dorset (Cramp 1975, fig. 19j). However, the Selsey piece is too weathered for detailed comparisons to be drawn.

The two fragments from Lewknor, Oxfordshire, are both decorated with figure-of-eight interlaces (simple pattern F) (Ills. 316–17). This decoration suggests, but does not prove, that they derive from a grave-cover of a type common in Lincolnshire, where the upper surface is covered in similar interlace. Examples of this type in Lincolnshire are known from Cammeringham (Davies 1926, 9, pl. VII), Northorpe (ibid., 17–18, fig. 3) and Stow (ibid., 19–20, fig. 4), where they are dated to the late pre-Conquest period.

A slab from St Augustine's abbey, Canterbury (no. 9), has interlace decoration, apparently consisting of surrounded pattern D (Ill. 53). The piece has no taper and a convex upper face, but it may have formed part of a grave-cover. The thick strand of the interlace may suggest a late date, but this is tenuous evidence indeed for dating. The runic inscription from St Augustine's (no. 11; Ill. 58) may have formed part of a monumental sculpture. Enough of the runes survive to demonstrate that they are of Old Norse character and the piece can probably be dated to the period of the Scandinavian supremacy in southern England, *c.* 1016–42.

The fragment from Ford, Sussex, is decorated with two groups of nested ovoids at right angles to each other and interlacing where they cross (Ill. 78). The pattern resembles that used at Dover, Kent (St Mary in Castro no. 4; Ill. 69) and Lavendon 1, Buckinghamshire (Ill. 313), for which tenth- or eleventh-century dates have been suggested, and a similar date would be appropriate for this piece. The piece from Rochester, Kent (no. 4) is also extremely difficult to date. It is decorated with an animal flanked by interlace, but very little of the animal survives, only part of the hindquarters and body. The body is thin with bulbous, exaggerated thighs, and the tail is looped around the body (Ill. 146). In southern English art, perhaps closely comparable animals are on fol. 11r of the mid eighth-century Stockholm Codex Aureus. These have similar, exaggerated thighs and thin bodies, although they are enmeshed in interlace, a feature not

found on the Rochester piece (Alexander 1978, no. 30, ill. 152). Similar animals are, however, encountered in late Anglo-Saxon art, as, for example, on fol. 1v of the *Vita Cuthberti*, dated to *c.* 937 (Temple 1976, no. 6, ill. 29) and on fol. 57r of Durham Cathedral Library MS A. IV. 19, dated to the early eleventh century (ibid., no. 3, ill. 8). It is true that these later animals tend to have more triangular bodies, with the tail brought up between the legs, but these are not consistent features, and it must be frankly admitted that not enough evidence remains for the Rochester carving to be accurately placed.

# CHAPTER VIII

# THE EXCAVATED SCULPTURES FROM WINCHESTER
## by Martin Biddle and Birthe Kjølbye-Biddle

One hundred and eight stones recovered from excavations in Winchester between 1961 and 1971 are considered here. They derive from two sites, the Cathedral Green (CG), and Lower Brook Street (BS). The former comprises: 70 pieces certainly associated with Old Minster and its cemetery and a further 29 which are probably so associated; and four pieces certainly or probably associated with the church of New Minster (New Minster 5–6 are certain, 2–3 probable), together with a further three (New Minster 1, 4, and 7) associated with Building E, one of the monastic buildings of New Minster. Two pieces were found in the excavations at Lower Brook Street, one (St Pancras 1) from the church of St Pancras, and a second (Lower Brook Street 1) which may originally have been from there or the church of St Mary.

It is impossible in some cases to be sure whether the stones from the Cathedral Green site came from Old Minster or New Minster (Fig. 26). Of the twenty-nine mentioned above as probably to be associated with Old Minster, four (Old Minster 1, 61, and 64–5) were found in burial earth below the south aisle or south porticus of New Minster. They may have been derived from New Minster church, but are more likely to have come from Old Minster or a building belonging to it. Three (Old Minster 37, 41, and 52) come from demolition debris deriving from either the baptistery, north facade, or facade chapels of Old Minster, or from the south wall of New Minster; these are more likely to have come from Old Minster than New Minster. Twenty-two come either from deposits later than *c.* 1200 overlying Old Minster (Old Minster 3, 11, 13, 20, 35, 43, 49, 55, 71, 78–9, 81, 91–6), or are unstratified (Old Minster 18, 48, 50, 66); they are probably but not certainly from Old Minster. The two stones probably from the New Minster church come from robber-trenches in areas where these cut through Old Minster demolition rubble; New Minster 2 and 3 might therefore derive from Old Minster. A single stone presumably derived from the New Minster cemetery (New Minster 1) was found in an early sixteenth-century deposit over the robbed New Minster domestic buildings (Building E).

In addition to the 106 stones included here there are 67 other Anglo-Saxon carved stones from the Old and New Minsters. These have only small, incomplete, or indistinct areas of moulding, already represented on the better preserved stones, or totally incomprehensible areas of carved surface. They add nothing to knowledge of Anglo-Saxon sculpture generally, but they do add, especially in their distribution, to an understanding of the minsters and their decoration, and will therefore be drawn into the discussion and catalogue entries as necessary, identified by their Winchester worked stone (WS) numbers. Uncarved stones with painted decoration are not included here (see Biddle and Kjølbye-Biddle 1990a; idem 1990b; Oddy 1990; and below p. 104).

Many of the stones published here are badly broken, being merely the debris left behind from the dressing of the Anglo-Saxon stones for reuse in the construction of the Norman cathedral. In the circumstances it is often not possible to be sure which way up a stone should be seen. The growing corpus of comparative material will doubtless resolve some of these uncertainties, but in the meantime it must be recognized that the alignments adopted here for some of the more fragmentary pieces, however complex, can be no more than proposals.

Under the heading 'Evidence for Discovery' the phasing of the context in which each stone was found is given in the standard Winchester Studies format, followed by the date assigned to the final phase.[9] In many cases this date bears no relation whatsoever to the date of the carving: it represents only the date of the deposit in which the stone came finally to rest,

---

9. For this phasing and the concepts involved, see Biddle 1990a, 14–23.

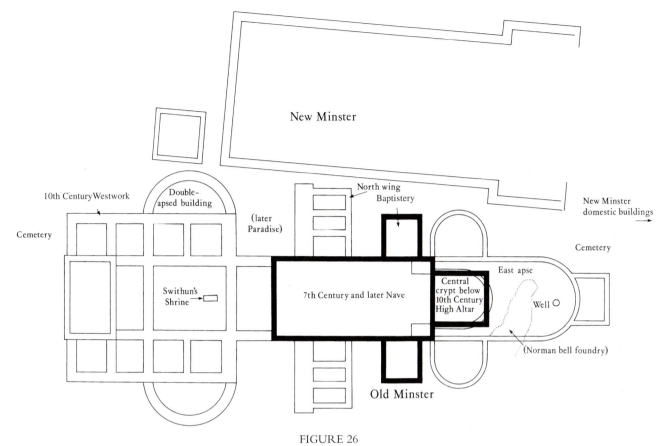

FIGURE 26

Winchester Old Minster, parts of church mentioned in text (post-demolition features in brackets)

perhaps after many moves, and in which it was found in the course of excavation. As will be seen, these find-spots may even so be of considerable importance in elucidating the decoration of the destroyed buildings from which the stones originally came.

## OLD MINSTER[10]

Known from the early tenth century as 'Old Minster' to distinguish it from New Minster (a separate foundation established immediately to the north in 901–3), the first church was built by Cenwalh (king of Wessex 643–74), possibly in 648 if the late authority

of the F-version of the *Anglo-Saxon Chronicle* is to be accepted, and dedicated to St Peter and St Paul. Initially apparently intended to serve as the chapel of a postulated adjacent royal residence, the church became a cathedral with the consecration of Wine as first bishop of Winchester in 660 (Earle and Plummer 1892–9, I, 28, II, 22; Bede 1969, 232–5 (III, 7); Wallace-Hadrill 1988, 97–100). Although several times rebuilt and moved to an adjacent and partly overlapping site on the dedication of the eastern parts of the new Norman cathedral on 8 April 1093, the church has remained the cathedral church of the bishops of Winchester ever since.

The Anglo-Saxon foundation was the principal church of Wessex and afterwards of the late Anglo-Saxon state. Among the kings buried there were Cynegils (d. 643, translated from Dorchester on Thames?), Cenwalh (d. 674), Cynewulf (d. 786), Egbert (d. 839), Aethelwulf (d. 858, translated from Steyning), Alfred (d. 899, later translated to New Minster), Eadred (d. 955), Edmund Ironside (d. 1016,

10. Quirk 1957; Biddle 1964; idem 1965; idem 1966a; idem 1967a; idem 1968; idem 1969; idem 1970; Biddle and Kjølbye-Biddle 1972; idem 1973; Biddle 1975; Kjølbye-Biddle 1975; Biddle and Keene 1976, 306–13; Sheerin 1978; Biddle 1986, 18–25; Kjølbye-Biddle 1986; Biddle 1990a, 1181–91; Biddle and Kjølbye-Biddle 1990a; Kjølbye-Biddle 1992; Biddle and Kjølbye-Biddle forthcoming a; Lapidge forthcoming; Rumble forthcoming.

translated from Glastonbury?), Cnut (d. 1035), and Harthacnut (d. 1042). Egbert may have been consecrated in the church in 828; Edward the Confessor was crowned there on Easter Day 1043. Every Easter they were in England from 1068 until its demolition in 1093 (and afterwards in the new Norman church) William the Conqueror and William II seem to have worn their crown in Old Minster. Following the translation in 971 of the body of St Swithun (bishop 852–62) from his original burial place outside the west door of the first church, Old Minster became a place of pilgrimage, 'the old church all hung from one end to the other on each wall with the crutches and stools of cripples who had been healed there' (Ælfric 1966, 79, lines 359–61).

The community, in origin probably a group of priests and clerks, later of secular canons, living under a rule and forming the *familia* of the bishop, was reformed as a regular Benedictine house by Aethelwold (bishop 963–84) on the eve of the first Sunday in Lent, 964. Thereafter Old Minster played a leading role in the movement of monastic reform. It was probably the scene *c.* 971 of the promulgation of *Regularis Concordia*, the rule under which the monks and nuns of England were henceforth to live, and its monks were sent out to rule several of the refounded or newly founded houses. During the latter part of the tenth century Old Minster became one of the principal centres of English intellectual, literary, and artistic achievement.

The site of Old Minster was identified in 1962–3 and completely excavated in 1964–9, apart from those parts which lay close to or beneath the nave of its successor, the present cathedral. The first church was built on top of a street running along the south side of the forum of Roman *Venta Belgarum*. It was a cruciform building with rectangular north and south porticus and a square east end. From the later seventh century burials were made around the church and in the early to mid eighth century St Martin's tower was built to the west, a detached axial structure probably designed to serve as a gatehouse to the cemetery and cathedral complex. The east porticus was remodelled shortly afterwards to provide an enlarged triumphal arch and a lengthened apsidal termination.

New Minster was built close to the north side of Old Minster at the beginning of the tenth century. Old Minster responded early in the century with the addition of a massive western facade, to the rear of which chapels were soon added. Following the translation of St Swithun in 971 a double-apsed building was erected around the site of his original

tomb between the west end of the seventh-century church and St Martin's tower. For some reason this vast structure had a short life. Within a few years the church was almost entirely reconstructed on a monumental scale by bishops Aethelwold (d. 984) and Aelfheah (translated to Canterbury 1006). The original seventh-century nave was heightened and the double-apsed *martyrium* was rebuilt as a rectangular westwork of ultimately Carolingian inspiration (cf. Corvey on the Weser) and dedicated in 980. The east end was then greatly extended to provide a new eastern apse with an *aussenkrypta*. The high altar was raised over a second crypt and flanked to north (and presumably to south) by lateral apses. These works were dedicated in *c.* 993–4, but were destined to last for only a century.

By the year 1000 Old Minster was a vast and richly decorated church. Over 76 metres (*c.* 250 feet) in length and (as reconstruction studies suggest) reaching in its westwork a height of between 50 and 60 metres (164 and 197 feet), the church was crowned by bells (Biddle 1990a, 100–24) and decorated with wall paintings (Biddle and Kjølbye-Biddle 1990a), with coloured and probably painted window glass (Biddle 1990a, 350–92), with relief-decorated polychrome floor-tiles,[11] and with the moulded stonework and architectural sculpture which is the subject of the present work.

Following the dedication of the eastern arms of the Norman cathedral in 1093, Old Minster was abandoned and demolished to make way for the new nave. Its buildings provided stone for the new cathedral and the eastern part of its site was used as a works yard for dressing stone and casting bells. The area of the former westwork was surfaced in pink brick-filled plaster to provide a memorial court around a free-standing monument erected over the site of St Swithun's original tomb. This court lay between the new Norman cathedral to the south and the nave of New Minster to the north. To the east it seems to have been closed by the ruins of the seventh-century west front of Old Minster and by the facade wing added to the north in the early tenth century, both left standing to provide a screen between the works area to the east and the memorial court to the west. A number of stone coffins which had originally stood within the westwork were preserved *in situ* in this court, and deep below it were reinterred more than 1100 bodies disturbed in the construction of the new cathedral.

---

11. Backhouse *et al.* 1984, nos. 142–3. For the definition of 'Style 1a' and 'Style 1b', to which the tiles belong, see Biddle and Kjølbye-Biddle 1988, 261–2.

## NEW MINSTER[12]

The *novum monasterium*, New Minster, was founded in 901–3 by Edward the Elder (king of Wessex 899–924) alongside the cathedral, henceforth Old Minster. New Minster was built in the form of an aisled building with shallow transeptal porticus and was probably intended to be the *burh* church of the newly refounded town, but it served also from the start as the burial church of Edward's family, the body of his father Alfred (d. 899) being translated from Old Minster on the completion of New Minster in 903.

The building history of New Minster is relatively simple by comparison with Old Minster. The foundation and construction of the church and monastery was followed by a dedication in 903 to the Holy Trinity, St Mary, and St Peter. A work begun by Edmund (king of Wessex 939–46) in memory of his family, possibly an eastern burial chapel dedicated to the Saviour, seems to have been completed only after Edmund's death. The reformation of the house by Aethelwold in 964 was followed by the enlargement of the precinct and the remodelling of the conventual buildings on regular lines. Finally in *c.* 980–8 an elaborately decorated tower was built by Aethelred (king of England 978/9–1016), its exterior apparently embellished by carvings which may have reflected the dedication of the six storeys(?) (*segmenta*).[13]

The conventual buildings of New Minster were destroyed by fire in 1065 and the western part of its precinct was appropriated after the Conquest for the extension of the royal palace. Faced with unhygienic conditions on a now impossibly cramped site, the foundation was moved *c.* 1110 to a new location at Hyde outside the north gate of the city.

Very limited excavations on the site of the New Minster church were undertaken in 1963–8 (Biddle 1964, 210–11; idem 1965, 257–8; idem 1966a, 325–6; idem 1967a, 272; idem 1968, 280; idem 1969, 316–7). A single line of trenches was cut from south to north across the nave in 1963 and in 1964–8 the south-west angle and much of the south wall of the nave and south porticus were examined over a length of 42 metres (138 feet). These foundations delineate what, in the context of the early tenth century, 'seems to be the largest Anglo-Saxon church so far known to scholarship'.[14] In

1970 a structure further east (Building E) was examined and shown to be part of the New Minster's domestic buildings, another part of which, at the northern limit of the precinct, had already been investigated in 1961 (Biddle and Quirk 1962; Biddle 1964, 206–7; idem 1972, 111–25). A small part of what might be the east end of the New Minster church, possibly an eastern extension, was encountered as part of the 1970 excavation of Building E (Biddle 1972, 122 (Trench XLI), figs. 7–8).

## THE ROBBING OF OLD MINSTER

By the time of its demolition in *c.* 1093–4 Old Minster was a large and complex church of many periods. Although some of these building periods are both historically documented and archaeologically identified, others, even such major works as the construction of the western facade with its attendant chapels or the double-apsed *martyrium* around the tomb of Swithun, are without any known surviving documentary evidence. It is unlikely that all such alterations and additions were identified in excavation, for above-ground changes would have left no trace in the excavated foundations (although they may have left traces among the loose finds such as the carved stonework dealt with here), while additions requiring only shallow foundations, or set upon existing floors and foundations, would have been obliterated in the thorough robbing of virtually every piece of reusable stonework. Architectural fashions and art styles covering the whole period from the mid seventh to the late eleventh century may thus have been reflected in the building from which 99 of the 108 stones presented here were recovered. None of these was found *in situ*.

The excavation of a robbed structure presents its own particular problems, but the sequence in which the walls were robbed as well as the sequence in which they were originally built can be worked out, even where the foundations themselves have been removed for reuse of their materials.[15] When foundations have been completely removed, only robber-trenches remain, and these are usually back-filled with rubbish left over from the demolition: mortar; plaster; stone chips; and originally no doubt large quantities of wood and other organic materials now decayed away. The fill of robber-trenches usually falls into three

---

12. For the building history of New Minster, see Biddle and Kjølbye-Biddle 1990b, with further references.
13. Analysed in detail in Quirk 1961.
14. Gem 1991, 809. Foundations discovered below the nave of Canterbury cathedral early in 1993 appear to belong to a nave similar in plan and proportions to the nave of New Minster, but perhaps still larger.

15. Biddle and Kjølbye-Biddle 1969 was written in the light of experience gained in the excavation of the robbed remains of Old Minster.

parts. The bottom, primary, fill, is often the result of the workmen throwing behind them what was not wanted, sometimes covering stubs of wall and stone fragments missed in the general muddle. Before this stage was reached the standing walls had been demolished to floor level, leaving heaps of rubble on the floors. This rubble had to be cut through to get at the foundations and thus often flowed over the edge into the robber-trenches. In the third, final, phase, what remained would in any case later be cast into the robber-trenches while tidying up the site, or to get at the floor paving, if this had not been removed at an earlier stage.

The primary and secondary fills of robber trenches can often not be distinguished; they are in fact part of the same process. The final filling is, however, sometimes quite different. This was clearly seen in the distinction between the upper fills of the robber-trenches to east and west of the ruins left standing after the demolition campaign of c. 1093–4. To the west, under the pink plaster surface of the memorial court, the upper fills were much darker and less rubbly, and the thick layers of masons' chippings found extensively east of the standing remains were absent. It seems clear that this area was being prepared for the display of the new monument over St Swithun's tomb and the surrounding stone coffins.

To the east, hidden by the standing ruins of the former west front and facade of Old Minster, a works area was created. Here there were massive layers of oolite stone chips where the Norman masons had knocked off the unwanted projections of the Anglo-Saxon mouldings and carved surfaces to give a flat face on at least three sides of a block. Sometimes large areas of Anglo-Saxon carving survived, as Old Minster 49 shows. Hundreds of such blocks must still remain within the fabric of the present cathedral, some perhaps reused on several subsequent occasions, and

some probably to be discovered from time to time in the course of works. Further east still, beyond the layers of chippings there were two bell foundries. Their pits were cut down through the filled robber-trenches of the tenth-century east end, and the walls of the furnaces were built of reused Anglo-Saxon stones, some of them carved (for example, Old Minster 47).

During the reconstruction of Old Minster in the late tenth century, parts of the building were pulled down and their foundations removed, leaving behind only robber-trenches filled with loose rubble. A century later these robber-trenches were themselves cut into by the primary robbing of 1093–4. The rubble fills of these first Norman robber-trenches were cut into again about a year later as further parts of the building were removed, or foundations previously left in position were grubbed out. New Minster was demolished c. 1110. The still standing ruins of Old Minster, comprising the west end of the seventh-century nave flanked by the northern facade added in the early tenth century, were not finally demolished and robbed out until the middle or later part of the twelfth century. The demolition and robbing of Old Minster had thus taken at least half a century to complete.

## THE DISTRIBUTION OF FINDS IN THE ROBBER-TRENCHES

The archaeological contexts of the 106 stones from the Old and New Minsters catalogued here are summarized in Table 2, which shows that nearly 90 per cent of the stones were found in demolition deposits or in later layers. Of the twelve stones from Anglo-Saxon contexts, two (Old Minster 31 and 63, the latter with pelleted interlace) come from contexts

TABLE 2. Carved stones from Old and New Minsters: summary of archaeological contexts

| CONTEXT | NUMBER OF STONES | PERCENTAGE |
| --- | --- | --- |
| Anglo-Saxon layers (see Table 7) | 12 | 11.3 |
| Demolition of 1093–4 | 27 | 25.5 |
| Final infill of 1093–4 | 30 | 28.3 |
| Robbing of New Minster | 5 | 4.7 |
| Final robbing of Old Minster | 9 | 8.5 |
| Later layers | 20 | 18.9 |
| Building E | 3 | 2.8 |

earlier than *c.* 903, and the remainder from contexts later then *c.* 903 but earlier than *c.* 1093 (Old Minster 16, 61, 64–5, 75–6, and 85, plus the grave-markers and -covers, Old Minster 1–2 and 6). In the latter group there are another two fragments with pelleted interlace (Old Minster 61 and 64), as well as two other stones (Old Minster 1 and 65), which come from layers in the south aisle and porticus of New Minster and which in origin may pre-date the construction of that church in *c.* 903.

With nearly 90 per cent of the stones coming from demolition deposits or from later layers, it becomes vital to ask whether those found in any one robber-trench are related to the particular part of the building which stood there. When the distribution of the various other types of building material is looked at, it is clear that there was no great redistribution of rubble around the site. For example, the pink plaster known as 'somp' is characteristic of the western part of the site and is hardly to be found at the east end (Biddle and Kjølbye-Biddle 1990a). The 350 fragments of glazed floor tiles show a different but equally striking distribution with 50 per cent from the area of the westwork, 47 per cent from the area of the nave and high altar, but only three per cent from the east end, and none from elsewhere in the building.

This does not, of course, mean that none of the larger stones was taken from the westwork into the works area to the east of the standing ruins for redressing. Although only five of the stones are from Norman levels over the westwork (Old Minster 7, 39,

46, 53, and 84), two of the most important fragments from Anglo-Saxon contexts come from this area (Old Minster 75 and 85), as well as the spectacular pieces from the post-Norman layers (e.g. Old Minster 3, 66, 71, 91–4). Whatever happened to the major carved stones from the Anglo-Saxon westwork in the Norman period, they are not likely to have reached the eastern works area (if that is where they went) before the robber-trenches in that area were filled. The layers of masons' chippings covering this area never dip into or merge with the fills of the robber-trenches; instead they fill only the upper depressions and seal the robber-trenches.

The distribution pattern of the carved stone fragments (Fig. 27) shows that there is a remarkable concentration, especially of elaborate string-courses, in the robbing deposits of the baptistery (Old Minster 36–7, 40–1, 54, 74, 82–3, and 86–7). Figure 27 also shows that carvings with large floral elements in the Winchester style (Old Minster 67–70 and 72) occur almost exclusively in the eastern apse, the single exception (Old Minster 71) being found reused in a thirteenth-century boundary wall at the west end of the site. The distribution of grave-markers and grave-covers also suggests that there had been little movement of rubble about the site, for, with the exception of those from New Minster (New Minster 1–2) and an Old Minster grave-marker from beneath New Minster (Old Minster 1), they were all found either at the east end of Old Minster, where they came from the eastern cemetery and perhaps from

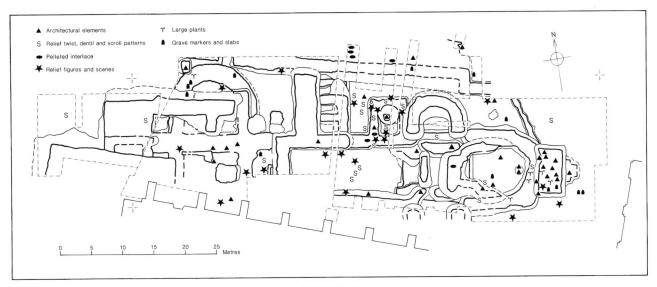

FIGURE 27
Winchester Old Minster, trench-plan showing find-spots and ornament type of carved fragments

graves in the crypt itself (Old Minster 2, 4–6, and 95), or at the west end, where they presumably came from the western cemetery (Old Minster 3, 92–4).

It seems clear that the standing walls of Old Minster were demolished with care and the major stones set aside for reuse. Some, however, were missed or lost in the general confusion of the robber-trenches. These, and the much larger number of small fragments removed and abandoned in the course of dressing the stones for reuse, and their distribution across the site of the demolished Old Minster (Fig. 27), allow the following hypotheses to be advanced.

1. The baptistery of Old Minster was richly decorated, apparently with elaborate string-courses, including dentils and twisted columns and cables, as well as with figured sculpture which may have included the head of a dove (Old Minster 74). The surviving fragments suggest that sculpture from the earliest, seventh-century, stage of the church had survived here throughout its history.

2. Figure sculpture was a feature of the decoration of several phases of Old Minster. Large-scale sculpture of this kind was probably present in the nave before—perhaps long before—the mid ninth century (Old Minster 75); it also occurred in the tenth-century rebuilding of the nave (Old Minster 76–7, 80, and 86) and in other later tenth-century contexts, in the double-apsed building constructed around St Swithun's grave (Old Minster 85), the westwork (Old Minster 84 and perhaps also 91), and the east end (Old Minster 81 and 88).

3. When the New Minster was built, carving with pelleted interlace, either from Old Minster or one of its associated buildings, or from some funerary structure, was already present on the site (Old Minster 61, 63–4).

4. Winchester-style acanthus carving was a feature of the eastern apse of Old Minster constructed between 980 and c. 993–4 (Old Minster 67–70 and 72).

5. The cemetery east of Old Minster was characterized by elaborate stone grave settings (Old Minster 2 and 6 (found *in situ* together), 4–5, and 95).

6. The cemetery west of Old Minster was characterized by grave-markers with stylized crosses (Old Minster 92–4), but contained at least one more elaborate marker (Old Minster 3).

## THE TYPES OF STONE

Tables 3 and 4 show the types of stone represented among the 108 carved pieces found in excavation and catalogued here.[16] Combe Down Oolite provides over four-fifths of the whole material: 86.2 per cent of the architectural mouldings and sculpture from Old Minster, all those from New Minster, and 55.3 per cent of the grave-markers. The other stone types represented among the Old Minster fragments are numerically insignificant, even if individually interesting. The grave-markers by contrast drew substantially on at least one and possibly two stone types other than Combe Down Oolite: Quarr accounts for 26.7 per cent of all grave-markers compared with 2.7 per cent of all architectural stones, and Binstead is used only for markers. The relative variety of stone types appearing in the grave-markers is reflected another way: 44.7 per cent of the grave-markers are not Combe Down Oolite compared with only 13 per cent of the architectural stones.

Both the stratigraphic and the stylistic dating of the architectural pieces shows that the Combe Down Oolite quarries near Bath provided the bulk of the stone used for architectural mouldings and decorative carving in the Old and New Minsters through the entire building period from the seventh to the tenth centuries, while the grave-markers suggest that the use of Combe Down Oolite remained significant throughout the eleventh century (Table 5). Among the architectural pieces, the use of Portland Stone seems to belong to the seventh century, and of Quarr to the later tenth or eleventh century; the other stone types are too rare to reveal any pattern (Table 6). The dating of the use of Quarr and Portland to the later and earlier limits of the period emphasises the overall dominance of Combe Down Oolite.

The appearance of Quarr at the end of the Anglo-Saxon period suggests the opening of quarries on the Isle of Wight towards the end of the tenth century. The Winchester evidence indicates that Quarr was perhaps used at first particularly for the manufacture of grave-markers, but it was soon providing stone for architectural features, as the Late Saxon and Saxo-Norman churches of Hampshire and Sussex amply demonstrate (Jope 1964, 101–2, fig. 26). The use of Binstead Stone for grave-markers at just this period (Old Minster 2 and 6) is probably related to the

16. The Winchester stones had previously been identified by the late Dr F. W. Anderson, formerly of the Geological Survey of Great Britain (Anderson 1990; cf. Biddle 1990b). The 108 stones catalogued here were mostly re-examined by Bernard Worssam specially for the Corpus, to ensure comparability with entries elsewhere in the volume. The discussion which follows is based on these 108 identifications, but the inclusion of the generality of the Winchester stones would not change the balance of the evidence presented in Tables 3 and 4.

opening of the Quarr Stone quarries, for the two stone types are found in very close proximity (Anderson and Quirk 1964).

Other less frequent stone types among the architectural pieces are probably the result of the reuse of materials first quarried in the Roman period: Portland Stone (apparently used here only in the seventh century), Calcaire Grossier (possibly also used early: Worssam and Tatton-Brown 1990), and perhaps Bembridge Limestone (used here in the late ninth century or earlier). The same may be the case with the remainder, the Great Oolite Group, the Lower Chalk, and the Purbeck marble, but these could all be Anglo-Saxon introductions, the Oolite as part of the Combe Down complex and the Lower Chalk from local quarrying. The single fragment of Purbeck marble is enigmatic (Old Minster 85). The abrasion required to polish the surfaces of this piece of figure sculpture demonstrates a knowledge of the techniques required to work Purbeck marble and where that knowledge existed there would have been no need to rely on recycled stone. If Old Minster 85 is correctly assigned to the late tenth century, as both stratigraphy and style suggest, it indicates the working of Purbeck marble in the Late Saxon period, on however small a scale.

The striking extent to which the Combe Down Oolite quarries near Bath provided the bulk of the stone used for architectural mouldings and decorative carving in the Old and New Minsters requires further examination. There are at least three good reasons why the quantity of Combe Down Oolite implied by the figures in Table 3 could not have been derived from the reuse of stone from the buildings of Roman Winchester. First, the stone types used in Winchester in the Romano-British period were varied, and included a good deal of sandstone and various limestones as well as oolitic limestone (Worssam forthcoming): any collection derived from this base would have shown much larger proportions of stone types other than Combe Down Oolite. Second, very few if any of the Roman stones seen in excavation begin even to approach the size of the blocks of Combe Down Oolite used in Old Minster, whether for the carved stones catalogued here (Old Minster 62 and 88; see no. 88, Discussion), the flagstones forming the floor of the east porticus of the seventh-century church (Biddle 1970, 315, pls. XLVII, XLVIIIa), or the Late Saxon stone coffins (Biddle and Kjølbye-Biddle forthcoming a). Third, Combe Down Oolite was the principal dressed stone used in building the original Old Minster in the seventh century, as the stone dust and masons' chippings in the construction debris showed (ibid.). It was also the principal stone used for the architectural elements and carved work of the late tenth-century rebuilding, as the pieces catalogued here fully demonstrate. It seems quite unlikely that large reserves of Combe Down Oolite, unmixed with other stone types, were available for recovery from Roman buildings and reuse in the seventh century, for the building of New Minster in c. 901–3, and again for the reconstruction of Old Minster between 971 and 993–4. Availability and block size both suggest that the Combe Down Oolite used in the Old and New Minsters was obtained fresh from the quarries 80 miles away in the seventh century as in the tenth.

This conclusion concerns the fine freestone used for architectural details and sculpture (Old English *wercstan*). It confirms and extends the pattern of quarrying and long-distance transport of building stone in the Anglo-Saxon period first established in a pioneer study thirty years ago (Jope 1964), while serving perhaps as a partial corrective to the more recent view that quarrying is essentially a Late Saxon industry (Parsons 1990a, 3–9). There is no doubt that the majority of the building material used for the foundations, footings, and walls of the Old and New Minsters (Old English *walstan*) was of local origin. In the original construction of Old Minster in the mid seventh century this was predominantly reused tile, brick, concrete, flints, and green sandstone blocks recovered from Roman buildings. In the tenth century large quantities of freshly quarried chalk and flint were used, and at all periods available materials were reused from structures of any earlier date, as the vivid example of the ninth-century wall painting recovered from the foundations of the early tenth-century New Minster shows (Biddle and Kjølbye-Biddle 1990b). But the evidence of the pieces catalogued here seems clearly to show that at all periods freestone for carved details, whether architectural or decorative, was normally obtained fresh from the quarry.

## LEWIS-HOLES

What seems to be a lewis-hole exists in Face A of Old Minster 88 where it has been filled with pink plaster (see pp. 315, 317). Although not seen on any of the other pieces in this catalogue, lewis-holes appear on at least one of the undecorated Combe Down Oolite blocks from the seventh-century Old Minster. The presence of lewis-holes is normally taken as a sure sign that a stone was quarried in the Roman period (e.g.

Parsons 1990a, 6; Stocker with Everson 1990, 86, 88). The arguments which suggest that Combe Down Oolite was reaching Winchester freshly quarried throughout the Anglo-Saxon period would indicate, however, that the lewis may have been used in the Early Middle Ages. This might be explained by the presence of Gallic masons (as must probably be assumed for the construction of the seventh-century Old Minster), since so simple a device is unlikely to have fallen out of use in Merovingian Gaul. It is not clear whether its use continued, however, since Old Minster 88 may be a reused stone and could have formed part of the seventh-century church before being reused and carved in the early eleventh century.

## PAINTING

One of the most remarkable finds from the excavation of the Old and New Minsters in 1962–70 was a painted stone which had been reused as rubble in the foundations of New Minster (Wormald 1967; Biddle 1967b; Biddle and Kjølbye-Biddle 1990b; Oddy 1990). The painting was done in earth colours directly onto the stone without preparation of the ground. The stone had a raised border 28 mm high down its right edge, but was not otherwise shaped other than as a rectangular ashlar, and is not therefore included in this Corpus. Eleven other pieces of ashlar with paint either directly applied or on a white ground were also found, but being plain are also not included here.

Twenty-one of the sculptured stones catalogued here do, however, show traces of whitewash (Old Minster 7, 34, 36–8, 41–3, 52, 54, 60, 73–4, 76–7, 79–81, 83, 96, and NM 4), but in only one case does the whitewash carry paint (NM 4). In one other case red paint may have been applied directly onto the stone (Old Minster 43). A few stones show traces of plaster render, either on its own or additional to whitewash (Old Minster 26, 34, 43, 50, 54, 56, 70,

and 73), in some cases clearly or probably secondary (Old Minster 26, 43, and 54). Close examination by the writers and others (e.g. Wilson 1985, 208) has revealed no other traces of paint, even in the deepest nooks and crannies of the carvings where it seems certain that paint would sometimes have survived had it ever been used at all extensively. In many cases the stones will have been buried from the moment of demolition, or lain around for only short periods before becoming incorporated in the fills of the robber-trenches and thus protected from exposure and weathering. Since there is clear evidence that painted surfaces have survived well in the buried environment of the site, the conclusion that paint was little used on the mouldings and carvings of Old Minster seems difficult to avoid.

The one stone with paint on whitewash (NM 4) comes from New Minster. So little of that church has been excavated that it is impossible to say whether this one piece suggests that New Minster was different to Old Minster in this respect. The painted stone, discussed above, discovered in the foundations of New Minster ante-dates that building and must therefore derive from the Old Minster or one of its associated structures, unless it comes from the short-lived *monasteriolum* of Grimbald which occupied part of the New Minster site before the foundation and construction of the church in *c.* 901–3. Only one stone from Old Minster may show paint similarly laid direct onto the unprepared surface of the stone (Old Minster 43).

Study of the wall-plaster from the Old and New Minsters has similarly suggested a restrained use of paint in the decoration of these buildings (Biddle and Kjølbye-Biddle 1990a). Since window glass and polychrome-glazed floor tiles show that colour was not eschewed (see above, p. 98), colour may have been brought to the walls by the use of hangings and curtains. This does not explain why the stonework seems to have been left essentially unpainted, or at most whitewashed.

TABLE 3. Carved stones from the Old and New Minsters and other Winchester sites excavated in 1961–71: buildings and stone types

NOTE: Column percentages are given in brackets immediately after the number of stones which they represent.

| STONE TYPE | STONES | OLD MINSTER | NEW MINSTER | GRAVE-MARKERS |
|---|---|---|---|---|
| Combe Down Oolite | 88 | 75 (86.2%) | 5 (100%) | 8 (55.3%) |
| Quarr | 6 | 2 (2.3%) | – | 4 (26.7%) |
| Portland | 4 | 4 (4.6%) | – | – |
| Calcaire Grossier | 2 | 2 (2.3%) | – | – |
| Binstead | 2 | – | – | 2 (13.3%) |
| Great Oolite Group | 2 | 1 (1.1%) | – | 1 (6.7%) |
| Bembridge Limestone | 1 | 1 (1.1%) | – | – |
| Lower Chalk | 1 | 1 (1.1%) | – | – |
| Purbeck Marble | 1 | 1 (1.1%) | – | – |
| TOTALS | 107 | 87 | 5 | 15 |

TABLE 4. Grave-markers from the Winchester excavations of 1961–71: sources and stone types

| STONE TYPE | OLD MINSTER | NEW MINSTER | LOWER BROOK STREET | ST PANCRAS |
|---|---|---|---|---|
| Coombe Down Oolite | 7 | – | 1 | – |
| Quarr | 1 | 2 | – | 1 |
| Binstead | 2 | – | – | – |
| Great Oolite Group | 1 | – | – | – |
| TOTALS | 11 | 2 | 1 | 1 |

TABLE 5.  Winchester grave-markers: chronology and stone type

| ASSIGNED DATE | STONE NO. | STONE TYPE |
|---|---|---|
| pre 901–3 | OM 1 | Combe Down Oolite |
| late 10th century | OM 3 | Combe Down Oolite |
| late 10th to early 11th century | NM 1 | Quarr |
|  | NM 2 | Quarr |
|  | SP1 | Quarr |
|  | OM 5 | Great Oolite Group |
| early 11th century | OM 2 | Binstead |
|  | OM 6 | Binstead |
| early to mid 11th century | OM 4 | Combe Down Oolite |
| mid to late 11th century | OM 92 | Quarr |
|  | OM 93 | Combe Down Oolite |
|  | OM 94A | Combe Down Oolite |
|  | OM 94B | Combe Down Oolite |
|  | OM 95 | Combe Down Oolite |
| 11th century | LBS 1 | Combe Down Oolite |

TABLE 6.  Architectural and decorative carved stones from Old Minster: chronology and stone types other than Combe Down Oolite

| ASSIGNED DATE | STONE NO. | STONE TYPE |
|---|---|---|
| 7th century? | OM 38 | Portland |
|  | OM 41 | Portland |
|  | OM 42 | Portland |
|  | OM 74 | Portland |
| late 9th century or earlier | OM 63 | Bembridge Limestone |
| 9th to 10th century | OM 64 | Lower Chalk |
| 10th century or earlier | OM 12 | Calcaire Grossier |
|  | OM 19 | Calcaire Grossier |
|  | OM 32 | Quarr |
|  | OM 91 | Great Oolite Group |
| late 10th century | OM 85 | Purbeck marble |
| mid to late 11th century | OM 96 | Quarr |

TABLE 7. Carved stones from Anglo-Saxon contexts in Old and New Minsters

| PHASE DATE | STONE NO. | STONE TYPE |
| --- | --- | --- |
| late 8th to later 9th century | OM 31 | Combe Down Oolite |
| late 9th century | OM 63 | Bembridge Limestone |
| early to mid 10th century | OM 1 | Combe Down Oolite |
|  | OM 61 | Combe Down Oolite |
|  | OM 65 | Combe Down Oolite |
| mid 10th century | OM 75 | Combe Down Oolite |
| late 10th century | OM 16 | Combe Down Oolite |
|  | OM 85 | Purbeck marble |
| late 10th to mid 11th century | OM 64 | Lower Chalk |
| late 10th to late 11th century | OM 76 | Combe Down Oolite |
| early 11th century | OM 2 | Binstead |
|  | OM 6 | Binstead |
| late 11th century | NM 7 | Combe Down Oolite |

# CHAPTER IX

# THE INSCRIPTIONS IN LATIN LETTERING
## by John Higgitt[17]

Fifteen of the stone monuments described in this volume carry inscriptions in Latin lettering. A further six have texts in runes and one of those with Latin lettering (at Orpington, Kent) also carries three probably runic characters of uncertain meaning (see p. 148). The numbers of inscriptions in the south-eastern counties is low in comparison with the north of England (Okasha 1971, map I; Page 1973, fig. 7). This is probably due to the greater intensity of later development in the south.

Most of the surviving inscriptions in the south-east date from the last century or so of the Anglo-Saxon period. The early church has left little or no epigraphic trace. This is in marked contrast with Northumbria where important groups of inscriptions remain from several documented ecclesiastical centres, such as Lindisfarne, Jarrow, Monkwearmouth, Hartlepool, Whitby and York (Okasha 1971; Higgitt 1979). This strongly monastic phase of the early church is unrepresented among the surviving inscriptions of the south-east. Even Canterbury, whose early inscriptions might tell us much about the cultural contacts of the early church there, remains a blank apart from a fragmentary inscription of uncertain date from St Martin's and a very late grave-cover from St Augustine's (no. 2). The recorded texts of verse epitaphs of three early archbishops, however, suggest that inscriptions were taken very seriously in early Canterbury (see below).

Although there are three inscriptions in Latin lettering from pre-Conquest Winchester and two each from London and Canterbury, each of the inscriptions is *sui generis* and no epigraphic centre with definable

characteristics comparable with the Northumbrian centres mentioned above emerges in the south-east.

Where their origin is clear the inscribed stones are architectural features, stone crosses, or grave-markers. There are four architectural inscriptions. Two of these are sundials (Bishopstone and Orpington (Ills. 6–7, 105–7)), which may be compared with the group of late Anglo-Saxon inscribed sundials in Yorkshire (Higgitt in Lang 1991, 123–4, 133–5, 163–6, 195, ills. 418, 451–3, 568–73, 729–31). A fragment of a dedication inscription, which is probably re-set in its present position on a door jamb of the early chancel at St Martin's in Canterbury (Ill. 57), can be compared with a number of other Anglo-Saxon inscriptions of various forms that record details of the dedication of churches (Higgitt 1979, 346–7, 368–9). The prominent inscription on the extrados of the arch that opens from the crossing to the transept of the later tenth- to early eleventh-century church at Breamore is unusual both in the size of its lettering and in its bold and disciplined architectural setting (no. 2c; Ills. 429–30, 433–7). The letters, which are in the region of 15 cm high, and the three letters from another inscription re-set over the chancel arch, which seem to be even larger (Ill. 431), are very probably the largest to survive from Anglo-Saxon England. The setting of carved lettering on the extrados of an arch is without parallel in Anglo-Saxon England and seems to be very unusual elsewhere in the early Middle Ages. The idea was perhaps suggested by lettering in mosaics in Rome, where inscriptions can still be seen on the extrados of the triumphal arches in San Paolo fuori le mura and San Lorenzo fuori le mura and of the arch around the apse in the triclinium of Leo III (Oakeshott 1967, pls. 77, 112, 183, 185). Certainly such monumental and architectural treatment of lettering is very unusual in the earlier Middle Ages (Petrucci 1980, 5–9; Mitchell 1990, 205–16).

The two inscriptions from All Hallows by the

---

17. I would like to thank my daughter, Catherine Higgitt, for help during the field-work undertaken in preparing the non-runic epigraphic descriptions in this volume. I am also very grateful to David Parsons for his helpful comments on my discussions of Old English texts and names and also for his contribution to the discussion of the probable runes at Orpington.

Tower in London are on fragments of stone crosses (Ills. 320, 324, 327, 343–4). One (no. 2) is inscribed around a head (Ills. 343–4) and the other (no. 1) within the sculptural field on the shaft (Ills. 320, 324, 327). Inscribed stone crosses of the Anglo-Saxon period are quite common in the north of England but only three remain in the south (Higgitt 1986, 147–8).

Five of the other inscriptions (from St Augustine's Canterbury (no. 2), Rochester 3, Stratfield Mortimer, Whitchurch, and the Old Minster cemetery in Winchester) are on grave-covers and head- or foot-stones (Ills. 24–8, 147–50, 695–709, 482, 485–9, 509–13, 521). The two other Winchester fragments with Latin lettering may also have come from funerary monuments but the original form of these monuments is uncertain (Ills. 490–3, 676–8). The monuments with runic inscriptions from Dover (St Peter), London (St Paul's cathedral) and Winchester (St Maurice 1) were also grave-markers or -covers and those from Rochester (no. 2) and Sandwich (no. 1) in Kent are also likely to have been so.

The texts seem to have served a variety of different purposes and to have spoken on behalf of different sorts of patrons. Most had as one of their functions the commemoration of individuals (the dead, patrons and makers). The language may tell us something about the intended audience, or at least about the patrons. Probably seven of the extant monuments have texts in Latin (Canterbury (St Augustine's 2 and St Martin's 1), Orpington, Stratfield Mortimer, Whitchurch, and Winchester (Old Minster 1 and Lower Brook Street 1)), and at least four, probably five, have Old English texts (Breamore 2, London All Hallows 1–2, Orpington, and Winchester Old Minster 6). Two of the runic texts are also demonstrably in the vernacular, in their cases Old Norse (London St Paul's cathedral and Winchester St Maurice 1).

The four architectural inscriptions have little in common with each other. The Bishopstone sundial displays a name, presumably that of a patron or benefactor, without further comment. The Old English and Latin texts on the Orpington sundial probably refer to the function of the sundial, as do texts on sundials at Kirkdale and Great Edstone in Yorkshire (Higgitt in Lang 1991, 133–5, 164–6). The Orpington texts seem to betray some pride in the possession of a sundial and in the computistical knowledge needed to read the dial; and the obscure runes also hint at pleasure in special knowledge. The inscription on St Martin's in Canterbury (Ill. 57) seems to have been in Latin and to have recorded (in accordance with church law) details of the dedication,

apparently with the common formula *in honore(m) NN* (Higgitt 1979, 346–7, 368–70). The Old English text of the Breamore inscription is uniquely prominent in its display but unfortunately its purpose is not clear. The language is reminiscent of some Old English charters but as the text could be incomplete at either end it is difficult to know whether the covenant or agreement it refers to is a covenant with God or a record of an earthly transaction, although a good case for the former has recently been argued (Gameson and Gameson 1993). This (now) uniquely prominent display of a text within an Anglo-Saxon church perhaps makes a religious meaning more likely (Ill. 429). To record a major benefaction or privilege in this way would be without parallel among Anglo-Saxon inscriptions but charter-like notes of donations of land are displayed in inscriptions on stone elsewhere, for example on crosses of the tenth or eleventh centuries at Merthyr Mawr and Ogmore in Glamorgan and in a probably ninth-century inscription at Santa Maria Maggiore in Rome, which was carved and displayed 'pro cautela et firmitate temporum futurorum' (R.C.A.H.M.W. 1976, 55–6, 57; Gray 1948, 100–1).

The head of the one of the two crosses from London (All Hallows 2) carries a memorial inscription in Old English. Memorial texts are the most frequent type of text to be found on Anglo-Saxon crosses (Higgitt 1986, 133–4). As often in the earlier Middle Ages, the inscription apparently recorded both the name of the deceased and that of the person who had the monument raised (Gauthier 1975, 43–8; Higgitt 1986, 133, 139; Moltke 1985, 189–91, 224–41, 289–327 *passim*). The approximately contemporary runic inscription on the grave-marker from St Paul's in London (Ill. 350) similarly records, in Old Norse, the names of those who raised the monument (see pp. 225–6). The other London cross (All Hallows 1) has an incomplete text of uncertain meaning but probably also in Old English, cut in the spaces by the legs of a carved figure. The position of the text suggests that it may have referred to the sculpture. When Leland saw the Reculver cross in the sixteenth century, it too was inscribed (Leland 1964, IV, 59–60; Kozodoy 1986, 68). The texts were spoken by Christ and four of the Apostles and the two texts he records were scriptural quotations (*Revelation* 1, 8; *Matthew* 16, 16). There are texts which relate to Christian figure carving on some nine Anglo-Saxon crosses (Higgitt 1986, 136–7).

Three of the grave-markers are inscribed in Latin and three further fragmentary inscriptions, two in Latin and one probably so, probably also come from

grave-markers. The complete texts at Canterbury (St Augustine's 2), Stratfield Mortimer, and Whitchurch, use known Early Christian and medieval memorial formulae or variants of them. All three identify the burial. The two late, probably eleventh-century, grave-covers (Canterbury St Augustine's 2 and Stratfield Mortimer) further identify the deceased by naming his father. The former notes the date (but not the year) of death, which would have aided annual commemoration in the same way as entries of obits into an obituary or calendar. The date noted at Stratfield Mortimer, on the other hand (that of the burial and not the death), is of less obvious use (cf. Gauthier 1975, 49). These two inscriptions also include requests for prayers for the soul of the deceased but use quite different formulae to do so. The Canterbury request contains an early use of the *requiescat in pace* formula, which, Rieckenberg has argued, originated in the liturgy of Mainz in the tenth century (Rieckenberg 1966). This may have encouraged the usage but there seem to have been some earlier epigraphic examples (Jörg 1984, 113). Finally these two late grave-covers have a further point in common. Both conclude with a maker formula of the common 'speaking object' type: *me fecit* in Canterbury and *me scripsit* at Stratfield Mortimer. The verb *scripsit* implies literacy and probably refers to the drawing up of the text or to the design of the lettering (see below). The commemoration of the craftsman and/or designer in this way can be compared with similar formulae on more or less contemporary sundials in Yorkshire (in Old English at Great Edstone and Kirkdale and probably in Latin at Old Byland) (Higgitt in Lang 1991, 46, 134–5, 164–6, 195).

The two fragments from Winchester (Old Minster 1 and Lower Brook Street 1) have what are probably parts of Latin memorial formulae (*hic* and *vivat in evum*). All that is legible on the Rochester 3 inscription is *amen*, in all probability the conclusion of a memorial prayer. The language of the prayer is, however, uncertain.

The grave-cover from the cemetery of the Old Minster in Winchester (no. 6) is in Old English. Its *her līð* formula corresponds to the common Early Christian and early medieval *hic requiescit* which was used in England at Monkwearmouth, co. Durham, and on Whitchurch 1, and was recorded by Bede in epitaphs at Canterbury and Ripon (Bede 1969, 144–5 (II, 3), 522–9 (V, 19)). The name, Gunni, is Scandinavian in origin and the burial has been attributed to the time of Cnut (Kjølbye-Biddle and Page 1975, 390–2; see pp. 278–80). The monument

was in a Christian cemetery but there is nothing specifically Christian about the brief text except the introductory cross.

There are some non-palaeographical indications of date of various sorts for some of the inscriptions. The St Martin's Canterbury inscription is built into the fabric of the early (perhaps seventh-century) chancel, but it seems not to be an original feature (see above, p. 34). One of the fragments excavated in Winchester (Old Minster 1) can be dated on archaeological grounds to before *c.* 901–3. The head-stone at Whitchurch has been attributed on stylistic grounds to the ninth century (see pp. 41, 272). The archaeological contexts of two other inscriptions from Winchester also provide dating evidence for them: the early eleventh century for the tombstone of Gunni and some time before about the middle of the eleventh century for the HIC fragment. The church at Breamore, which is agreed to belong to some time between the middle of the tenth and the early eleventh century, provides a terminus post quem for its inscription.

Scandinavian influences provide another class of dating evidence. The ornament in the Ringerike style on Rochester 3A (Ill. 147) is very close to that on the rune-inscribed grave-marker from St Paul's in London (Ill. 351); an early eleventh-century date is likely for both (see pp. 167, 227). The tombstone of Gunni in Winchester (Old Minster 6) has been dated to late in the pre-Conquest period, and probably to the Danish period, because of the Scandinavian name and the use of *feolaga*, which is in origin an Old Norse loan-word, and perhaps also that of *eorl* as a title (Kjølbye-Biddle and Page 1975, 391–2; Page 1971, 180; below, pp. 278–80). The Old English memorial formula on the cross-head from London (All Hallows 2) appears to have been influenced by wording sometimes found in Norse inscriptions (Okasha 1967; Page 1971, 178). One of the reasons for seeing the tombstone at Stratfield Mortimer as late is the Old Norse origin of the name of the craftsman, author, or designer of the text.

What determined the choice between Latin lettering and runes for inscriptions in this area? Although the runic inscription from Sandwich (no. 1; Ill. 156) has been dated to as early as the seventh century, its meaning and date are uncertain (see pp. 169–70). The earliest reasonably certain dating for any of the inscriptions in Latin lettering is to some time before *c.* 901–3 for one of the inscribed fragments from Winchester (Old Minster 1). There is no useful evidence for answering the question for the

earlier part of the period. The introductory cross and name inscribed in Anglo-Saxon runes on the tombstone from Dover St Peter (Ill. 76) are well cut and lightly seriffed in a manner that implies that the letter-cutter had experience of cutting inscriptions in Latin lettering (cf. Page 1973, 104, fig. 25). There may have been some knowledge of both Anglo-Saxon and Scandinavian runes at Orpington, although the significance of the three runes, if that is what they are, is obscure, and they may be secondary to the texts in Latin lettering. Two inscriptions in Old Norse and inscribed in Danish runes on what were probably funerary monuments (London St Paul's and Winchester St Maurice 1) have been attributed to the early eleventh-century period of Danish control (Kjølbye-Biddle and Page 1975; Page 1971, 175). The patrons seem to have been members of the Danish élite. Gunni probably belonged to the same social group, but was commemorated instead in Scandinavian-influenced Old English in Latin lettering, a sign, presumably, of greater integration with the indigenous culture. The Ringerike stone from Rochester (no. 3), which is also inscribed in Latin lettering, may show the same thing, if it is not a case of the Anglo-Saxon adoption of Scandinavian styles.

The lettering of the non-runic inscriptions is, with one exception, in capitals which take the forms of Roman capitals or of common variants of them (see *Note on Capitals*, p. 113). The exception is the fragmentary inscription on the cross-shaft from London (All Hallows 1) (Ills. 323–4, 327). Only two of the five different letters of the Latin alphabet approximate to their Roman capital form. The other three forms are uncial D, probably half uncial H, and oblong O. This eclectic mixture of forms is reminiscent of the 'decorative capitals' found in the display script of many Insular manuscripts of the seventh to ninth centuries and in a number of contemporary inscriptions on stone, especially in Northumbria (Higgitt 1982, 310–15; idem 1994). This resemblance is reinforced by the use of wedge-like serifs, which were characteristic of early Insular lettering, on the London cross-shaft. This inscription is the only evidence that lettering reminiscent of Insular decorative capitals was used on stone in the south-east of England. The late character of the decoration on this cross means that this inscription must be a late reflection of Insular decorative capitals. Such lettering would, however, be surprising much after the end of the ninth century. Certainly the decorative capitals that appear in the display script of

one or two English manuscripts of around 900 are only dimly reminiscent of earlier Insular capitals (Temple 1976, ills. 3 and 9) and Roman capitals are the normal display script in English manuscripts of the tenth and eleventh centuries.

As was seen above, very little is known from surviving material about the inscriptions of the first two to three centuries of the Anglo-Saxon period after the conversion to Christianity. Three of the inscriptions might be datable to before *c.* 900: one of the Winchester fragments (on archaeological grounds to before *c.* 901–3); the inscription at St Martin's in Canterbury (uncertainly associated with the early Anglo-Saxon fabric of the church); Whitchurch (attributed on art historical grounds to the ninth century). All three use Roman capitals and variants of them (Ills. 57, 485–9, 490). None of the forms are sufficiently characteristic to help in dating. The wedge-like seriffing on the Whitchurch inscription is an embellishment that would be unlikely to be used much after the ninth century (Ills. 485–9). These three inscriptions suggest that Roman capitals had been in use for inscriptions in the south-east for some time before *c.* 900. It is quite possible that they were the normal epigraphic script from the time of St Augustine. They had been one of the epigraphic scripts in Northumbria from the later seventh century on (Higgitt 1979). It is, however, not unlikely that there was also some use of Insular decorative capitals. These might have resembled those in the display scripts of manuscripts of the eighth and ninth centuries which were probably written at Canterbury, where the 'decorative' forms appear alongside a high proportion of Roman capital forms (Alexander 1978, ills. 144, 145, 152, 160).

The other source for the early Anglo-Saxon epigraphy of the south-east is in the recorded texts of the long Latin verse inscriptions that served as epitaphs for archbishops of Canterbury in the late seventh and earlier eighth centuries. They were composed in imitation of the ambitious verse inscriptions of the continental and especially the Roman church. The texts of such inscriptions were known through manuscript collections and some of the epigraphic verses from England were in their turn copied into books (Lapidge 1975). Bede quoted the first four and last four verses of the thirty-four verse epitaph marking the burial of archbishop Theodore ('Hic sacer in tumba pausat cum corpore praesul . . .') in the church of Saints Peter and Paul in Canterbury (Bede 1969, 474–5 (V, 8)). (Theodore died in 690.) Bede described these lines as the 'epitaphium . . .

monumenti ipsius', which implies that they were inscribed on or near his tomb, probably on stone. The epitaph recorded the day of the month of the archbishop's death.

In the sixteenth century Leland transcribed a number of such verse texts from an eighth-century manuscript collection from England and these included the epitaphs of two later archbishops of Canterbury, Berhtwald, who died in 731, and Tatwine, who died in 734 (texts in Lapidge 1975, 810–2). The epitaphs of all three archbishops were in elegiac couplets, as also were the tomb-inscriptions in Rome of pope Gregory I (d. 604) and Caedwalla (d. 689), which were known to, and recorded by, Bede (Bede 1969, 132–3 (II, 1), 470–3 (V, 7)). As we have them, Berhtwald's epitaph consisted of twenty-two verses and Tatwine's of fourteen. Berhtwald's inscription contains the interesting information that Berhtwald had his monument made ('artificum manibus fecerat ipse sibi') while he was still living, although the inscription itself was composed and executed after his death. The monument must therefore have been something more than a simple tomb. The author of the epitaph asks for the prayers of the archbishop. Tatwine's epitaph (Lapidge 1975, 811) again probably marked the grave to which it refers: 'Hoc tegitur corpus venerandi praesulis antro'.

The same collection includes eight lines of rhythmic and rhymed octosyllables commemorating a dedication of a church or an altar to St Paul by bishop Haedde of Winchester (676–705) (Lapidge 1975, 817). The verses open with the *in honorem* formula. It is not clear whether these lines were taken from an inscription or whether they were simply a manuscript exercise in the genre but in either case these lines, along with the Canterbury epitaphs, show that the early church in the south-east was familiar with the tradition of Latin verse inscriptions.

The other inscriptions included in this volume all probably belong to the period after *c.* 900 and all use Roman capitals, although there are some variations in style. The inscriptions at Breamore (no. 2) and Orpington are well preserved examples of neat and well executed lettering and seem to be characteristic of one late Anglo-Saxon style (Ills. 105–7, 429–33). The letter strokes are of even breadth with no contrast of thick and thin and they have no noticeable seriffing. The letters tend to be tall in their proportions. The forms of the capitals are Roman but one or two angular variants occur (C, G and S) and, as often, slight differences are introduced in the treatment of the cross-bars and tops of A. The Breamore

inscription is probably contemporary with the arch, which was probably built within a decade or two of the year 1000. The Orpington lettering is likely to be of approximately the same sort of age. The inscription on Gunni's tombstone in Winchester (Old Minster 6 (Ills. 511–13)) is generally similar in execution and forms (angular G). The two or three letters left on Rochester 3 may also have belonged to an inscription in the same style (Ills. 149–50).

The rather worn lettering on the inscription on the tombstone at Stratfield Mortimer is a little squatter and is not so even (Ills. 698–709). Again the strokes are of even breadth but they finish in serifs. The capital forms are Roman with the exception of angular C and G, uncial Q and variations on A. The lettering cannot be closely dated but it would fit well with the eleventh-century date suggested by the contents of the inscription.

The neat capitals of the Breamore/Orpington style were probably contemporary with the capitals used in the display script of many southern English manuscripts in the period following the tenth-century Benedictine Reform (see Temple 1976, *passim*, for numerous illustrations; Heslop 1990, 163–6). They have the same regularity and their angular variants can be found in some of the manuscripts (Temple 1976, ills. 114, 115, 126, 133, etc.). The even and unseriffed lines of the inscriptions seem, however, to be an epigraphic development and are quite unlike the contrasting thicks and thins and the serifs of the manuscript capitals.

The other four inscriptions are distinctive in various ways. The inscription on the cross-head from London All Hallows (no. 2) is more roughly designed than the others (Ills. 343–4). Again the underlying forms are Roman capitals but the rune-like angular R and the extension of the verticals of E and L below the bottom horizontal and perhaps (in the case of E) above the top horizontal look like barbarisms in comparison with the regular, almost Classical forms of Breamore and Orpington (Ills. 105–7, 429–33). The probable Scandinavian influence on the Old English text accords with such lettering and it also suggests a date around the last century before the Conquest. This lettering is also exceptional in the use of dot serifs. These were also used to embellish at least some of the letters of the Bishopstone inscription (Ills. 6–7). Here the capitals are more regular in their forms and execution but are not closely datable.

The fragment from Winchester with the letters HIC (Lower Brook Street 1) does not offer much scope for palaeographical dating (Ill. 678). It is of

interest because of its broad letter strokes which flare out towards the ends and because of the cross-section of the trenches which would only make sense if they were intended for some kind of inlay. The idea may have been suggested by lead-filled lettering such as that of the Carolingian epitaph of Adalberga in Tours (Gray 1986, ill. 69).

The lettering of the grave-cover from Canterbury (St Augustine's 2) is made up of slender, even strokes which terminate in small serifs (Ills. 25–8). The capitals are Roman. No angular forms are used; on the other hand a rounded (uncial) E is used alongside the normal capital form. Tall I is a little surprising; it is a feature that could have been imitated from Roman inscriptions. The lettering is likely to be later than the Breamore/Orpington phase and similarities to that on the Bayeux Tapestry suggest that it could date from shortly after the Conquest.

This region provides an impressive amount of evidence for the use of colour in conjunction with pre-Conquest inscriptions on stone (both in Latin lettering and in runes). There are records or surviving traces of colour on more than a third of the inscribed stones discussed in this volume: at Breamore 2, London All Hallows 2, London St Paul's, Reculver 1, Rochester 2 and 3, Stratfield Mortimer, and Winchester St Maurice 1 (Tweddle 1990, 150–1). In the case of Rochester 3, the visible colour is not in or around the letters, but elsewhere on the stone (Pl. 1; Ills. 147–50). As Tweddle points out, the colour may in some cases be secondary (Tweddle 1990, 150). The amount of evidence for colour found in this sample of inscriptions confirms the view (cf. Higgitt 1986, 131–2, 138–9, 143) that it was usual to pick out carved letters in colour.

There are cracks in the normally anonymous facade of inscriptions in one or two of this group of inscriptions. The maker formulae at Stratfield Mortimer (*me scripsit*) and St Augustine's in Canterbury (*me fecit*) could refer to all, some or just one of the various aspects of the production of the inscriptions: the drafting of the text; the designing of the inscription, not necessarily on the stone itself; the laying-out of text on the stone; the cutting of the lettering; and the painting of the inscription. Some craftsmen no doubt needed the assistance of a literate person with the wording and the letter forms (Higgitt 1990, 151–2). Others were perhaps literate enough to design and carve a text. The development of an epigraphic style of lettering like that at Breamore and

Orpington shows that the cutting of inscriptions could be a routine and professional matter. The correction of a wrong letter in the Whitchurch inscription (Ill. 487) and the probable additions in the St Augustine's Canterbury (Ill. 25) inscription would be explained either by a literate letter-cutter thinking about the text while working on it or else by close supervision from a literate person. The Canterbury inscription stitches together epigraphic phrases, in one case apparently without fully understanding the syntax of the model. Was this composed by a professional stone-cutter with a stock of formulae or by an amateur monastic collector of epitaphs?

## NOTE ON CAPITALS

The capitals used in Anglo-Saxon inscriptions vary considerably and it is not possible to isolate a single distinctive Anglo-Saxon type of capital (Okasha 1968; Okasha 1971). For the purpose of description and analysis it is helpful to compare examples with the forms of 'Roman capitals'. Roman capitals were made known throughout the Roman Empire through their use in inscriptions. Early Christian and early medieval book and epigraphic scripts developed away from this capital script but Roman capitals continued to exert an influence, especially in Italy. At certain periods and in certain places there seem to have been attempts to reproduce comparatively 'pure' Roman capitals in inscriptions and manuscript display scripts, most famously during the Carolingian period (Gray 1986; Bischoff 1990, 55–61).

When reference is made in discussion of letter forms to 'Roman capital' forms, this is not meant to imply a conscious imitation of Roman forms, although it is possible that 'purer' or 'more Classical' Roman forms were sometimes deliberately adopted because they were thought to look more 'Roman'. I have argued that this was the case at Monkwearmouth and Jarrow, co. Durham, in their early years (Higgitt 1979).

To avoid ambiguity the 'Roman' or 'Latin' alphabet is here referred to as the 'Latin alphabet', in order to distinguish it, regardless of letter forms, from other alphabets such as runes.[18]

---

18. Following standard international practice, the typographical convention of transcribing Scandinavian runes in lower case bold without inverted commas has been adopted throughout this volume (Eds).

# NOTE ON THE CATALOGUE

This is the first volume in the series *The Corpus of Anglo-Saxon Stone Sculpture* to comprise a large region embracing more than two counties, and this has produced some formal problems in the layout. The number of monuments catalogued is comparable with earlier volumes, but they are more thinly distributed, and most of the counties (including the ancient kingdom of Kent) have too few sites to justify splitting them into county units. They have therefore been grouped into larger blocks. Most of the sculptures derive from the western sector of greater Wessex, but there is a group around London and counties north of the Thames which were located in the debatable land between Wessex and Mercia. These have been included partly because of their stylistic links with the rest but also because they were catalogued in the thesis (Tweddle 1986b) on which much of the volume is based.

In order to help the user of this volume all sites are listed here in the order of the entries, a table of sites by county is also provided (see p. 343), and in the Form and Motif Table and the General Index the sites are listed alphabetically.

The pre-1974 county of each site is indicated by the following abbreviations placed after its name: Bd., Bedfordshire; Brk., Berkshire; Bk., Buckinghamshire; Ess., Essex; Ha., Hampshire; Hrt., Hertfordshire; K., Kent; O., Oxfordshire; Sr., Surrey; Sx., Sussex.

With the exception of the geological identifications (all by Bernard Worssam), the initials of the author or contributor have been placed at the end of each entry or part of entry written by them. They are: M.B., Martin Biddle; M.P.B., Michael Barnes; J.H., John Higgitt; B.K.-B., Birthe Kjølbye-Biddle; D.P., David Parsons; D.T., Dominic Tweddle. Editorial notes are indicated by the abbreviation Eds.

# LIST OF ALL SITES IN CATALOGUE ORDER

# CATALOGUE

# KENT, SURREY, AND SUSSEX

# ARUNDEL, Sx.

## TQ 019073

### 1. Grave-marker or -cover     (Fig. 28; Ill. 1)

PRESENT LOCATION Built into outer wall of former yard of A. Booker and Sons Ltd., builders, Walberton, Sussex (SU 969059)

EVIDENCE FOR DISCOVERY Removed from base of wall of Arundel castle during repairs by Messrs. Booker's, probably in late nineteenth century

H.   69 cm (27.2 in)   W.   49 cm (19.3 in)
D.   Built in

STONE TYPE Pale yellowish-brown, fine-grained limestone, with numerous 0.5–1.5 mm diameter perforations, some of which are calcite-lined and presumed to be *Chara* nucules; Bembridge limestone, Bembridge Formation, Palaeogene, Tertiary; Isle of Wight

PRESENT CONDITION Bruised and very heavily weathered

DESCRIPTION It is rectangular. The upper right-hand corner is broken away, and the lower part is lost. The break is dressed roughly horizontally.

*A (top):* Along each of the surviving edges is a plain relief border with a median-incised line. This encloses a splayed-armed Latin cross, type A1/B6, outlined by plain raised mouldings of indeterminate section and portrayed as if pendant from a suspension loop in the form of an inverted isosceles triangle. The ends of the upper and horizontal limbs of the cross are square, but the foot is either rounded or slightly pointed. One of a pair of diverging mouldings touches each side of the lower end of the cross and runs off the broken edge of the stone.

FIGURE 28
Arundel 1A, nts

DISCUSSION Johnston has suggested that the stone is from a pre-Conquest predecessor to the chapel of St Martin in the keep of Arundel castle. There is no evidence for the existence of such a building, however, and the carving could equally have come to the site as building material at almost any time in the history of the structure. There is no record of the date of the wall from which the piece came. The lost foot was probably originally squared. There is no close parallel in stone sculpture for the form of the cross used to decorate it.

DATE Tenth to eleventh century

REFERENCES Johnston 1904, 148–50, pl. on 49; Page 1907, 362; Jessep 1914, 61; Tweddle 1986b, I, 90, 223–4, II, 347–8, III, fig. 34, pl. 17a

D.T.

# BETCHWORTH, Sr. (St Michael and All Angels)

## TQ 211498

**1. Capital**           (Ill. 2)

PRESENT LOCATION Built into ground floor of tower, inside, reused as capital of western shaft of south window

EVIDENCE FOR DISCOVERY First mentioned in Page 1905

H.  17 cm (6.7 in)  W.  20 cm (7.9 in)
D.  Built in

STONE TYPE Pale greenish-grey (5Y 8/2), fine-grained, very finely glauconitic sandstone; Reigate stone, Upper Greensand, Gault Group, Lower Cretaceous

PRESENT CONDITION Angles bruised; lightly weathered

DESCRIPTION In plan the capital is square at one end and circular at the other. It is composed of eight superimposed fasciae of diminishing size.

DISCUSSION Capitals composed of superimposed fasciae are encountered elsewhere in south-east England only at Reculver (no. 4), where the capitals of the triple arcade which divided the nave and chancel of the seventh-century church were of this form (Ills. 126, 128). The form is equally rare outside the region. There is an example at Ripon cathedral, Yorkshire, which may have come from St Wilfrid's late seventh-century church (Taylor and Taylor 1965–78, II, 517; Wenham *et al.* 1987, pl. XXIX) and two others at St Mary Castlegate in York, (ibid., 153–5, fig. 47, pl. XXVIII) found reused in the foundations of a pre-Conquest church probably of eleventh-century date (ibid., 152). All these examples are of much larger size than the Betchworth example, however. This comparative evidence allows a date as early as the seventh century for the Betchworth piece, but a later (though still pre-Conquest) date is also possible.

DATE Seventh century?

REFERENCE Page 1905, 447, fig. on 448

                                             D.T.

# BEXHILL, Sx. (St Peter)[1]

## TQ 746081

**1. Grave-cover**       (Fig. 29; Ills. 10–19)

PRESENT LOCATION Fixed internally to south tower wall

EVIDENCE FOR DISCOVERY Found during restoration of church in 1878, *c.* 15 cm (6 in) below the modern floor, near westernmost pillar of south nave arcade

H.  79 cm (31 in)  W.  36 cm (14.2 in)
D.  *c.* 10 cm (4 in)

STONE TYPE Pale greyish-brown, fine-grained sandstone, laminated and with small-scale trough cross-bedding; a Hastings Beds sandstone, Wealden Group, Lower Cretaceous; probably from the Hastings vicinity

PRESENT CONDITION Good

DESCRIPTION Grave-cover taking the form of an irregular truncated pyramid on a rectangular base. Only the upper face is carved.

*A (top):* Enclosing the flat central field is a plain relief frame carried down the angles into the corners, and separating the cabled mouldings along its edges. Each of the five fields thus delimited is further sub-divided

---

1. The following are unpublished manuscript references to no. 1: BL Add. MS 37552 no. XIV, items 378–387; BL Add. MS 47695 fol. 177v; BL Add. MS 47709, fol. 212v.

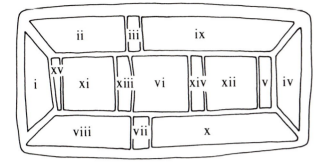

FIGURE 29
Bexhill 1A, labelling of panels, nts

into panels (see Fig. 29). Each is decorated in low relief and has a plain raised border. They are designated i–xv as on Fig. 29. Panels i–viii are decorated with interlace. In panels i–iii and viii the interlace is flaccid and disorganized, but in panel viii it conforms to Adcock's basic pattern A. In panel iv two pairs of diagonals interlace where they cross. The point of intersection is encircled by a plain strand which interlaces with the diagonals. In the corners of the panel the end of each diagonal is turned sharply out and back to link with that of its neighbour. A second circular band interlaces with the loops thus formed, and is itself looped between them. In panel v is a tight three-strand plain plait. Field ix is animal decorated. The animal has a ribbon-like, undulating body, with a fan-shaped tail split into three elements. The head has an open mouth, protruding tongue, and an incised eye. In each of the fields created by the undulation of the body is an outward-facing Stafford knot, linked with its neighbours across the animal's body. The loose end of the strand crosses the animal's muzzle and terminates in a loop. In panel x is a similar animal facing in the opposite direction,

with its tail split into four, and lacking the strand crossing the muzzle. In panel xi is a Greek cross with expanding, rounded-ended arms drawn out to form an almost complete circle. Between the cross and the corners of the field are U-shaped devices with out-turned ends, their open sides facing the cross. Panel xii is similarly decorated except that straight bars link the cross-arms. Panel xiii contains an angular plant with a triangular leaf in each of the fields created by the regular undulations of the stem. In panel xiv is a plain band with alternate broad and narrow undulations. Panel xv is cable decorated.

DISCUSSION It is unclear whether the stone was *in situ* when discovered; it is unlikely that the possibility of an associated burial was considered at that time.

The form of the monument is unparalleled in south-east England, although it should clearly be grouped with the more three-dimensional forms, such as the coped covers at Headbourne Worthy, Hampshire (no. 2; Ill. 685), Tandridge, Surrey (Ill. 231), and, more loosely, with Winchester, Hampshire (Old Minster 6; Ill. 509).

DATE Tenth to eleventh century

REFERENCES Lewis 1880, 445–6; (——) 1884; Allen 1885a, 267, 274–77, fig. facing 274; Allen 1885b, 357; (———) 1887; Langdon and Allen 1888, 314; Allen 1889, 230; Allen 1895, 148; Brown 1900b, 336, pl. IV; Langdon and Allen 1902, 256; Johnston 1904, 150; Johnston 1905, 153–5, pl. 14; Page 1907, 362; Ray 1910, 62–3; Anderson 1914, 30–1; Jessep 1914, 47, 61; Collingwood 1927, 183; Clapham 1930, 141, pl. 64; Cottrill 1931, appendix; Mee 1937, 37; Salzman 1937, 121; Kendrick 1949, 86, pl. LVI; Rice 1952, 121, 143; Fisher 1959, 86; Nairn and Pevsner 1965, 3, 416; Earwaker 1969, 15, 25–6; Fisher 1970, 33–4; Tweddle 1986b, I, 90, 227–30, II, 350–2, III, fig. 48, pl. 21a

D.T.

# BISHOPSTONE, Sx. (St Andrew)[1]

TQ 472010

## 1. Sundial                 (Ills. 6–7)

PRESENT LOCATION Built in over south door, outside

EVIDENCE FOR DISCOVERY First recorded in Horsefield 1835

H. (visible)[2] *c.* 55 cm (21.5 in)   W. *c.* 38 cm (15 in) D. Built in

STONE TYPE Pale yellow and grey mottled, fine-grained limestone, packed with fine arcuate shell fragments preserved in calcite; Quarr stone transitional to Bembridge limestone, Bembridge Formation, Palaeogene, Tertiary; Isle of Wight

PRESENT CONDITION Weathered and partly obscured by mortar

DESCRIPTION The dial has a semicircular head and straight sides which diverge towards the base; the latter is overlapped by the apex of the concrete revetment to the south door (Ill. 6). Three incised lines parallel the edge of the stone, and a pair of incised lines delimits the lower edge of the circular dial, the upper edge of which is formed by the head of the stone. In the centre of the dial is a large, irregular gnomon hole. (A new gnomon has been cemented into this hole recently (Ill. 7).) The lower half of the dial is calibrated using incised lines. The lateral lines, just above the horizontal, the vertical line, and the pair of lines at 45 degrees, all have crossed ends. The ends of the cross-arms and the principal lines are drilled. Between each pair of principal lines are two equally-spaced shorter lines also with drilled ends. The upper half of the dial is uncalibrated. Immediately inside the triple-incised edging there is an incised marginal fret.

<div align="right">D.T.</div>

*Inscription* The inscription (Okasha 1971, 54; eadem 1992b, 342, 344) is incised into the semicircular area at the top of the stone above the dial. It is arranged asymmetrically in two horizontal lines. The inscription is much more deeply cut than the surrounding

decoration. This suggests that the inscription could have been recut at some date. Any recutting cannot, however, have been very recent, to judge from the weathering. A possible time for such work would have been during the restoration of 1848 (Figg 1849, 276, 279; idem 1854, 61). The inscription opens with an introductory cross and two widish points mark the end of the text. The letters are 4 cm (1.6 in) in height and are capitals. They can be transcribed as follows:

<div align="center">

+ E A D

R I [C]

</div>

The text must be the common Old English personal name Eadric (Searle 1897, 186–8; Feilitzen 1937, 233–6).

The letters are neatly executed but their spacing is a little irregular: cramped in the first line and spacious in the second. The layout suggests an inexperienced designer. A has a bar across the top that meets the diagonals shortly before the point at which they would converge. The last letter looks more like a Roman G than a C; the short vertical rising from the bottom right-hand end of the letter is quite distinct. G for palatalized *k* would, however, be a remarkable spelling.[3] The short vertical could be due to an error or could be the result of the possible recutting suggested above. Whether the letter intended was C or G, it is the standard Roman form. The E and the A (and perhaps also the D) have dot serifs (Okasha 1968, 332) that look as if they have been produced with a drill or by revolving a mason's point. Similar dot-like sinkings decorate the terminals of the introductory cross and the plain cross terminals of the dial lines.

<div align="right">J.H.</div>

DISCUSSION The dial belongs to a group of sundials having the circular dial fitting into the semicircular head of a basically rectangular slab, a form adopted also at Marsh Baldon in Oxfordshire (Ill. 358). The calibration falls into the standard pre-Conquest pattern, with only the lower half of the dial calibrated, and the principal, mid-tide, lines crossed near their ends.

The dating of the piece derives principally from the fact that it is *in situ* in a fabric which the Taylors place

---

1. The following are unpublished manuscript references to no. 1: BL Add. MS 37580, items 389, 563, 719, 722–7; BL Add. MS 37581, items 29–30; BL Add. MS 47693, fol. 30r.

2. The bottom of the stone is hidden behind mortar. The actual height appears to be at least 65 cm (25.5 in).

3. I am grateful to David Parsons for his advice on the form of this name.

before *c.* 950 (Taylor and Taylor 1965–78, I, 71–2). Fernie, however, is less precise, allowing a pre- or post-Viking date (Fernie 1983b, 178). An early date is supported by the use of fret decoration; frets are rare in late Anglo-Saxon art in southern England, but commonplace in the ninth century and earlier.

<div align="right">D.T.</div>

*Inscription* If the last letter is a G, it is in a Classical and Carolingian form which is fairly unusual in Anglo-Saxon inscriptions but can be found on the dedication inscription of 1056 at Deerhurst, Gloucestershire, and apparently on the probably tenth-century brooch from Cuxton, Kent (Gray 1986, figs. 11, 18, 24, 67, 68, 70, etc.; Okasha 1971, pls. 27–8; Wilson 1964, 129–30). The form of the serifs is unusual, dot serifs being rare in Anglo-Saxon inscriptions. (For a full discussion and references, see London, All Hallows by the Tower 1.) The serifs of R and I seem to have been of a more usual chisel-cut type. This difference may simply have been due to the craftsman's desire for decorative variation. Alternatively, these serifs might have been introduced at the stage of the hypothetical recutting of the stone.

Eadric could be either the craftsman or, more probably, the patron of the dial (or of the church in general), to judge from names recorded in fuller texts on sundials in Yorkshire at Great Edstone (maker formula) and Kirkdale (patronage and maker formulae) (Okasha 1971, 73, 87–8; Higgitt in Lang 1991, 134–5, 164–6). The name is too common to make attempts at identification worthwhile.

There are other sundials with inscriptions across the top of a semicircular dial, at Great Edstone, Kirkdale, and Old Byland, Yorkshire (Okasha 1971, pls. 41, 64, 98; Lang 1991, ills. 451, 453, 568, 570, 729–30), and possibly formerly at Leake, Yorkshire (Okasha 1971, pl. 72).

<div align="right">J.H.</div>

DATE Probably ninth century

REFERENCES Horsefield 1835, I, 271; Lower 1840, 496, fig.; Figg 1849, 279; Hussey 1852, 199–200; Figg 1854, 60–1, fig. on 60; Figg 1856, 322, fig.; Haigh 1857, 179, fig.; Way 1868, 208–9; Lower 1870, I, 55; Gatty 1872, xix, 144; Cuming 1873, 282, fig. 2, pl. II; St Croix 1875, 274–5; Hübner 1876, no. 168, 61, fig.; Haigh 1879, 135, 196, fig. on 197; Allen 1889, 201, fig. 12; Gatty 1889, 407, 423–4, fig. on 423; Searle 1897, 186; Brown 1900b, 336; Gatty 1900, 66, fig. on 67; Johnston 1900b, 75–6; Legge 1903, 177–8, fig. 2, figs. on 174–5; Day 1904, 26, fig. facing 26; Johnston 1907, 17; Page 1907, 362; Tavenor-Perry 1909, 62; Leeny 1911, 373, pl. on 373; Jessep 1914, 26–7; Whitley 1919, 127; Brown 1903–37, V, 174; Brown 1925, 193, 194 n., 444; Cabrol and Leclercq 1907–53, II, col. 1543, fig. 1825; Green 1928, 508–10, fig. 19; Mee 1937, 41, pl. facing 401; Zinner 1939, 10, taf. 5, abb. 6; Cole 1945–7, 77, pl. XXI; Clapham 1948, 7; Godfrey 1948, 167–8; Crowley 1956, 176; Godfrey 1957, 3–4, pl. facing 8; Zinner 1964, III, 46; Nairn and Pevsner 1965, 72; Taylor and Taylor 1965–78, I, 418, II, 747; Taylor and Taylor 1966, 19, 49; Bowen and Page 1967, 288; Stoll 1967, 283, pl. 37; Okasha 1969, 26–7, fig. 1; Fisher 1970, 44–5, pl. on 18; Okasha 1971, no. 12, pl. 12; Kirby 1978, 164; Service 1982, 148; Tweddle 1986b, I, 84, 162–3, II, 352–3, III, pl. 21b

# BOSHAM, Sx. (Holy Trinity)

## SU 804038

### 1. Fragment                                                    (Ill. 3)

PRESENT LOCATION Built in to west end of north wall of north aisle, inside

EVIDENCE FOR DISCOVERY First recorded by author in 1991

H.   30 cm (11.8 in)   W.   35 cm (13.8 in)
D.   Built in

STONE TYPE Pale yellowish-grey (10YR 8/3–4), finely granular limestone; Caen stone, Calcaire de Caen formation, Bathonian, Middle Jurassic; Caen, Normandy

PRESENT CONDITION Angles and face bruised, but unweathered

DESCRIPTION Irregularly broken below and to either side, but with an original upper horizontal edge. Along this edge is a broad plain border, supported to the right by a stepped capital carried by a reeded

pilaster, partially broken away. To the extreme left may be the remains of another stepped capital, but the degree of damage renders this uncertain. The remains of the intervening field are decorated with a three-element palmette or foliate spray developing from the lower edge. Each element is reeded.

DISCUSSION The small size of the fragment makes its original function difficult to establish. The lack of weathering may suggest that it was originally located inside a building, and the use of plant sprays between reeded pilasters is reminiscent of the decorative friezes at Sompting 9–11 (Ills. 172–80) and Dover, St Mary in Castro no. 4 (Ill. 70). The dating of the piece is equally problematic, but the use of reeded, formalized foliage, perhaps derived from acanthus, is paralleled on the string-course fragments from Sompting (nos. 1–8; Ills. 162–71), and a similar mid eleventh-century date is possible for this fragment.

DATE Eleventh century

Unpublished

                                                                      D.T.

# BOTOLPHS, Sx. (St Botolph)

## TQ 094193

### 1a–b. Corbels                                    (Ills. 4–5, 8–9)

PRESENT LOCATION *in situ* supporting soffit roll of chancel arch

EVIDENCE FOR DISCOVERY First recorded in Bloxham 1882

north: H.   34 cm (13.4 in)   W.   28 cm (11 in)
       D.   17 cm (6.7 in)
south: H.   32 cm (12.6 in)   W.   28 cm (11 in)
       D.   16 cm (6.3 in)

STONE TYPE Unidentifiable due to a thick coat of whitewash. Possibly Caen stone, which seems to be in evidence on other parts of the chancel arch where plaster and whitewash have flaked off

PRESENT CONDITION Unknown

DESCRIPTION The chancel arch is of fundamentally square section with a half-round soffit roll supported by corbels. Each corbel takes the form of an inverted, halved, convex-sided cone. On the north corbel, from the undecorated base develops a row of long half-round stems, each carrying a narrow convex-sided leaf. Each leaf touches its neighbours and has a deep, narrow median hollow. The tips of the leaves are cut off by a broad raised band around the upper edge of the corbel. This is decorated with a median band of deep triangular nicks, with their apices pointing downwards. The decoration is heavily damaged where the corbel abuts the wall. On the south side there is a slight roll moulding around the upper edge of the corbel. Below this is a band of deep triangular nicks with their bases on the moulding and their apices pointing down. The lower edge of this band is delimited by an irregular incised line. Below this are three interlocking zones of narrow, convex-sided nicks, each zone in slightly higher relief than the one above. The decoration is obliterated where the corbel abuts the wall.

DISCUSSION The nature of the damage to the jambs of the arch, and the disposition of the ornament on the corbels, away from the lower half, suggests that there were originally soffit shafts and that the corbels were originally capitals.

DATE Eleventh century

REFERENCES Bloxham 1882, I, 63; Allen 1889, 198; Jessep 1914, 48–9; Godfrey 1930–1, 218; Nairn and Pevsner 1965, 113; Taylor and Taylor 1965–78, I, 85; Taylor and Taylor 1966, 49; Fisher 1970, 66; Gem 1973, II, 496; Tweddle 1986b, I, 59–61, 174–5, II, 356–7, III, pl. 25

                                                                      D.T.

# CANTERBURY, K. (St Augustine's Abbey)

TR 155578

**1. Part of cross-shaft** (Ills. 20–3)

PRESENT LOCATION Historic Buildings and Monuments Commission stores, Dover castle

EVIDENCE FOR DISCOVERY First recorded in Cottrill 1931

H. 34 cm (13.4 in)    W. 19.7 cm (7.8 in)

STONE TYPE Greyish-yellow, medium-grained, oolitic limestone, slightly shelly, with calcite veinlets; Combe Down Oolite, Great Oolite Formation of the Bath area, Great Oolite Group, Middle Jurassic

PRESENT CONDITION Broken and worn

DESCRIPTION It is of square section above and circular section below. The fragment is roughly broken above, below, and to the rear, so that parts of only two adjacent faces of the upper portion of the shaft survive. The lower ends of these faces are semicircular, project, and are slightly concave. They are delimited by prominent roll mouldings which merge where the faces abut.

Faces A and B are decorated with interlace, but the decoration is too fragmentary for the patterns to be identified. In each case the strands are median-incised. Below these faces where the shaft assumes a circular section less than a quarter of the circumference survives, enriched with three roll mouldings. The median moulding is recessed and has an incised median line.

DISCUSSION Like no. 3, it may have been one of the 'smaller fragments' of pre-Conquest sculpture discovered by Hope built into the base of the Romanesque screen overlying Wulfric's rotunda. It is not specifically mentioned by him, however.

For many years this piece was interpreted and displayed as part of a turned baluster shaft with an elaborate base, but comparison with the surviving balusters from Kent throws considerable doubt on this identification. Two of the three turned balusters from St Augustine's abbey have surviving bases (nos. 6 and 7) and both of these are undecorated, square in plan, and rectangular in section (Ills. 41–3, 46–8); outside Kent there is similarly no evidence for the use of elaborately shaped and decorated baluster bases. In

addition, the triple roll moulding on the putative St Augustine's baluster fragment cannot be paralleled elsewhere, either on other balusters from the same site, or on any of the closely-related group from St Mary in Castro, Dover (nos. 2–3; Ills. 64–7, 71–5). On all of these, where groups of three mouldings do occur, it is the median moulding which is the most prominent, and the pair of mouldings flanking it are recessed and much slighter. In addition, none of the mouldings on the Kent balusters has an incised median line.

Also inconsistent with the use of this piece as a baluster base is the decoration of the two surviving facets. Close examination confirms that neither facet has any surviving vestige of a lower edge moulding, meaning that the fields are incomplete. Their original size is difficult to estimate, but the interlaces filling them are best regarded as the ends of longer patterns. It is possible to construct more compact patterns by simply joining the loose ends of the interlaces, but they are unconvincing and unparalleled elsewhere. If, however, the interlaces are viewed as the ends of longer patterns then the design on face A falls into place as the end of a pattern based on a four-strand plait. The interlace on face B could equally be interpreted as the end of a six-strand plait.

The most elegant solution to these difficulties is simply to invert the fragment, when it can be viewed as part of a round-shaft derivative of the type common in the west midlands, where the upper part of the shaft is of square section and the lower part of circular section. The facets then fall into place as the semicircular swags at the lower ends of two of the faces of the upper part of the shaft, permitting the reconstruction of the interlaces in the most convincing fashion, as the ends of longer patterns. The triple roll moulding can, similarly, be interpreted as the zone of triple roll mouldings normally found encircling such a shaft immediately below the zone of transition between its upper and lower elements. Although the concentration of shafts of this type in the north-west midlands suggests that it is a regional type (Kendrick 1949, 68–76), there are outliers in other regions. These include the example from Gilling West, Yorkshire (Lang, pers. comm.), and a small group, including the Gosforth cross, in Cumbria (Bailey and Cramp 1988, ills. 288–308). A single example,

Eiliseg's Pillar, Denbighshire, is known from Wales (Nash-Williams 1950, 123–5, pls. XXXV–VI). Most importantly for the present piece, there is another example from southern England, at Yetminster, Dorset (Kendrick 1949, 72–3). Other round shafts from south-east England may originally have formed part of the base of such a cross, but there is now no way of establishing this.

DATE Tenth to eleventh century

REFERENCES Cottrill 1931, appendix; Tweddle 1986b, I, 95–8, 249, II, 364–5, III, fig. 10, pl. 30b

D.T.

## 2. Grave-cover                                (Ills. 24–8)

PRESENT LOCATION Historic Buildings and Monuments Commission stores, Dover castle

EVIDENCE FOR DISCOVERY Discovered during controlled excavations *c.* 1965, covering post-medieval well or cess pit towards north end of refectory

L.  *c.* 102 cm (40.2 in)   W.  *c.* 43 > 39 cm (17 > 15.4 in)
D.  *c.* 15 cm (5.9 in)

STONE TYPE Pale greyish-brown, finely glauconitic, fine-grained sandstone; Thanet Beds, Palaeogene, Tertiary; from Reculver or Pegwell Bay, Kent

PRESENT CONDITION Worn and pitted

DESCRIPTION Grave-cover, tapering towards the foot. The upper left-hand corner has been carefully cut away, and the lower left-hand corner is roughly broken.

*A (top):* On the upper face is an inscription. There is a large space between the words GER[R]ALD and [:]FILIVS EDVVARDI (lines three and four respectively (Ill. 26)). This is partially filled by two incised sketches. Close to the D of GER[R]ALD is a vertically-placed bird facing the head of the stone. The folded wings are carefully delineated and it has a heavy beak. Above the AR of EDVVARDI is a vertically placed leonine quadruped facing the foot of the stone. Its offside leg is raised.

D.T.

*Inscription* The inscription (Okasha 1983, 88–9) is cut into the roughly smoothed surface of the uneven face of this stone. There are several areas of pitting and the letter-cutter has taken care in laying-out the lettering to avoid the worst of the potholes. This would explain some of the oddities in the layout. The incised drawing of the lion and the bird are space-fillers in an area below

the second line where the pitting was too bad for uninterrupted lines of lettering. The fifth line starts some way in from the left-hand edge to avoid a crack (Ill. 26). Similarly the last three lines are squeezed up into the left side of the stone because of damage down its centre at this point (Ill. 28). The two ligatures occur at the ends of lines (M/E in the seventh line and H/E in the ninth) and again look like devices for avoiding craters (Ills. 27–8). That the pitting is earlier than the lettering can be demonstrated where, in the fifth line, the cutting of the lower parts of both letter Is of OBIIT continues down into the large depression below the line (Ill. 26). In two places letters have been damaged after (or perhaps while) being cut (the second R of GER[R]ALD in the third line and the Q of QVI in the fifth (Ill. 26)).

The lettering is arranged in surprisingly neat lines considering the condition of the stone. There is some variation in letter height within each line. The average height of letters in the first, second, and fourth to eighth lines is about 3 cm (1.2 in) with some letters reaching about 3.5 cm (1.4 in). The third line is about half-size with letters of around 1.5 cm (0.6 in). The last three lines, the ninth and especially the tenth (*c.* 2.2–2.7 cm (0.8–1.2 in)) and eleventh (*c.* 1.9 cm (0.75 in)) decrease in height again.

It is likely that the half-size D in the second line (1.5 cm (0.6 in)) and the whole of the awkwardly-arranged third line are after-thoughts (Ill. 25). The shallowly carved and serif-less QVI at the end of the second line is probably another addition. (On these see further below.)

The lettering is quite well preserved and there is no indication of any loss to the text at either top or bottom. The inscription, which is in capitals, can be transcribed:

[C]ONDITVS HIC
EST E<D>ZI[EQVI]
GER[R]ALD
[:]FILIVSEDVVARDI
[Q]VIOBIIT[:]INXPO
I[N]XIIIKL IVNII
SEP DICITOANIM/E
REQVIESCATIN
[P]ACE[:]H/E
RIVV[A]LD
ME [FE]CIT

The language is Latin and the text can be edited as follows:

CONDITVS HIC EST EDZIE QVI GERRALD [:] FILIVS EDVVARDI QVI OBIIT [:] IN CHR(IST)O

IN XIII K(A)L(ENDAS [or -ARVM?]) IVNII
SE(M)P(ER) DICITO ANIME REQVIESCAT IN
PACE [:] HERIVVALD ME FECIT
(Translation: 'Here was buried Edzie, who [ . . . ]
Gerrald, son of Edward, who died in Christ on 20th
May. Always say for his soul: "May he rest in peace." [or,
taking ANIME as a mistake for ANIMA, 'Always say:
"May his soul rest in peace."'] Heriwald made me.')

Okasha suggests that there is a letter missing
between the two Rs of GERRALD. A gap was left
between these two letters because of the condition of
the stone, but there is no sign of there ever having
been a letter in this gap (Ill. 25). There seems to be a
break in the sense after the first QVI. There is some
uncertainty about the expansion of the abbreviated
date formula.

The lettering consists of quite confidently designed,
slightly uneven, capitals. The letter strokes are even
and slender, and show little or no modelling. Strokes
are normally finished with small, neatish serifs. The
letters nearly all follow Roman capital forms. The
following should be noted. With one exception (in
the third line) A has a horizontal cross-bar. It appears
both with and without a very short cross-bar over the
top. E is generally the Roman capital, but there is one
example of the uncial letter (Ill. 28). A tall form of the
letter I seems to be used deliberately in some cases: IN
(line six); DICITO (line seven); REQVIESCAT (line
eight). M has (more or less) vertical sides and a short
central V. O is circular and the first O (in the first line)
has a dot near the centre (Ill. 25). Because the stone is
extensively pitted, it is impossible to be sure whether
this is a deliberate and original feature. Capital P is
used for Greek *rho*. Q is the capital with simple
rightward-curving lines as tails in lines two and five; in
line eight the tail consists of two curving lines that
converge to form a horn-like form (Ill. 27). X is plain
in the numeral in line six. In line five, where it
represents the Greek *chi*, the rightward-leaning stroke
curves over at the top. VV is used for W in English
names. Z makes a very rare appearance in the name in
the second line, although it is conceivable that the
letter is an accidentally reversed angular S.

Word-division is inconsistently indicated:
sometimes with a gap; sometimes not at all; and
sometimes apparently with a mid-line point (although,
given the pock-marked surface of the stone, it is
possible that these are accidental marks). Bars over
words or through letters are correctly used to mark
abbreviations. The normal *nomen sacrum* abbreviation
is used for *Christo*.

J.H.

DISCUSSION Okasha suggests that the inscription fits
around the carving and that it may be secondary but,
as suggested above, it seems more likely that the
carvings are space-fillers in areas too pitted for
lettering. She also suggests that the lower end is
incomplete, and that some of the inscription may have
been lost. There is, however, no evidence that either
the stone or the inscription is incomplete.

D.T.

*Inscription* The lettering is remarkable for the lack of
angular alternatives to round letters (with the possible
exception of angular S) and of round alternatives to
angular letters (with one exception, the uncial E in
the last line). A without a cross-bar is rare, but can be
found in a number of Anglo-Saxon inscriptions of the
ninth century and later (Okasha 1968; eadem 1971,
pls. 1, 19a, 33, 66, 94, 107a, 117, 135, and 158;
Wilson 1984, pls. 205–7; see also Rochester 3). Tall I
was used in Classical Roman inscriptions originally to
indicate a metrically long I, and the idea may have
been suggested by looking at Roman inscriptions,
perhaps in Canterbury itself. Here it seems to be used
for variety as an alternative to the letter of standard
height. O with a dot in the centre can be seen on the
tenth-century censer cover from Pershore,
Worcestershire, and perhaps too in stone inscriptions
from Lancaster, Lancashire, and Thornton-le-Moors
in Cheshire (Okasha 1968, 325, 327; Okasha 1971,
pls. 68b, 100; Higgitt 1983, 27; Deschamps 1929, 15).

The general aspect and the proportions of the
lettering, with its thin, even strokes, and
predominantly Roman forms, is not unlike that of the
Bayeux Tapestry (Wormald 1957, 177, pls.). If one
makes allowances for the different media, the seriffing
is also similar. The Bayeux Tapestry uses a few round
letters (E, H, and, on two occasions each, D and M)
but no angular variants: a similar picture on a much
larger scale to that on this monument. The spelling of
EDVVARD with a double V appears, for example, in
the first word on the Tapestry. These similarities
suggest that the stone and the textile are approximately
contemporary, although they do not, of course, prove
it. The Tapestry has been attributed to Canterbury by
some scholars (Wormald 1957, 34).

The main part of the text on this grave-marker
consists of memorial formulae. The first section
identifies the deceased, giving his name and that of his
father. The opening phrase, CONDITVS HIC EST,
echoes, perhaps consciously, an Early Christian
formula; compare *hic est conditus* in Rome or *hic
conditus* in Trier (Diehl 1925–67, no. 3056; Gauthier

1975, 515–16; Krämer 1974, 39). The day and month of his death are recorded, which is necessary for annual commemoration, but not the year. The date is introduced by the phrase OBIIT IN CHRISTO, a formula which is again characteristic of early inscriptions. It is fairly common around the sixth century in the Viennoise (Descombes 1985, 125; cf. Le Blant 1856–65, II, nos. 393–4, 407, 466a, 693). The reader of the epitaph is then addressed, as in many medieval epitaphs, and asked to pray for the repose of the soul of the deceased (Favreau *et al.* 1974, 65, 73; idem 1977, 63; idem 1978, 143; *idem 1979* 1979, 24, 31; idem 1982, 24, 137–8). The use of the *requiescat in pace* formula may be an argument for dating the inscription to no earlier than the eleventh century. Rieckenberg's study of the origins of the formula concludes that it originated in the Mainz Romano-German Pontifical, and the earliest inscription that he cites as using it is the epitaph of archbishop Erkenbold of Mainz, who died in 1021 (Rieckenberg 1966). There is, however, a number of earlier examples, although the formula seems to have been taken up much more widely following its use in the Romano-German Pontifical in the tenth century (Jörg 1984, 113). The text finishes with a maker formula of the common 'speaking object' type: HERIWALD ME FECIT. Which aspect or aspects of the production, or possibly patronage, Heriwald was responsible for is not specified (see further Introduction, p. 113, and Stratfield Mortimer, Discussion).

The significance of the dative case of ANIME in line seven is not immediately clear. One possibility is that it is a dative of advantage, like that in an early twelfth-century epitaph in Poitiers '—*defuncto dicito psalmos atque pater noster quod sibi sit requies*': (Favreau and Michaud 1974, 73)). Alternatively, the author of the text has misunderstood his source. Verse epitaphs of two of the tenth-century archbishops of Mainz included lines calling on the reader to pray to Christ for the soul of the departed (Strecker 1939, 320). The lines in question are: '*Dic "anime requiem da cuius, Christe, perennem . . ."*' ('Say: "Christ, grant eternal peace to his soul . . ."'); and '"*Cuius*" dic "*animae miserere, piissime Christe . . ."*' ('Say: "Most gracious Christ, have mercy on his soul . . ."'). Here we have the same conjunction of the imperative of *dicere* and the dative of *anima*, which could be confusing if read without modern punctuation. If some such epitaph is the source, ANIME has been copied without full understanding, but is perhaps taken as the subject of REQUIESCAT.

There are four personal names (Okasha 1983, 88–9). EDZIE (apparently modified from an original EZIE) is explicable as a late form of the Old English masculine name Eadsige, and the spelling is comparable to Domesday Book's *Edzi* (Okasha 1983, 89). If EZIE was the original spelling, that in its turn would correspond to Domesday Book's *Ezi* (Feilitzen 1937, 236–7). GERRALD is presumably a form of the Old German name Gerald. It was known in England at the end of the Anglo-Saxon period (occurring in Domesday Book) and was common in France (Feilitzen 1937, 27–9, 260; Morlet 1968, 100; Dauzat 1984, *s. v. Géraud*). EDWARDI (genitive) and HERIWALD are Old English masculine personal names (Okasha 1983, 89). As on the Bayeux tapestry, vernacular names are not latinized in the nominative.

As noted above, the small D in the second line and the whole of the third line with the name GERRALD look like additions. These letters are similar to those of the main inscriptions but smaller and awkwardly fitted in. The D may have been added because it had been omitted in error, or in order to clarify the pronunciation. GERRALD was probably Eadsige's (Norman-French?) alias. These additions need not have been much later; in fact they could have been added while work was in progress. The status of the QVI at the end of the second line is puzzling, since it has no dependent verb. The letters appear to be more shallowly carved than the rest of the inscription, and they show no trace of serifs. Either they had been lightly incised prior to cutting and were never fully cut, perhaps because a change in wording made them redundant, or they were an attempt to link the probably added name with the first name.

This epitaph could date to some time in the late pre-Conquest period but similarities to the Bayeux Tapestry and the combination of three Old English names (one of which is in a late form shared with the Domesday Book) and a probably Norman-French name (whether original or added) perhaps make a date shortly after the Conquest more likely for the inscription. St Augustine's seems to have kept a distinct English character at least until the repression of the revolts against the Norman Abbot Wido in the late 1080s (Knowles 1963, 115–16; Dodwell 1954, 24–5). The use of a piece of stone in such poor condition could imply a period of comparative poverty or disorganization, and the change of name, if that is what it is, might illustrate a process of Normanization.

J.H.

DATE Eleventh century

REFERENCES Okasha 1983, no. 161, pl. II; Tweddle 1986b, I, 89, 224–6, II, 365–6, III, pl. 31a

## 3. Part of capital, in two joining pieces

(Ills. 29–32)

PRESENT LOCATION Historic Buildings and Monuments Commission stores, Dover castle (reg. no. 78203098)

EVIDENCE FOR DISCOVERY Found in 'recent excavations' when first recorded in 1917 (Hope 1917, 24)

H.   30 cm (11.8 in)   W.   43 cm (17 in)
D.   34 cm (13.4 in)

STONE TYPE Greyish-yellow, finely granular limestone, with some 1-mm perforations; *Ditrupa* limestone, Calcaire Grossier Formation, Palaeogene, Tertiary; Paris Basin

PRESENT CONDITION Heavily damaged below; otherwise crisp

DESCRIPTION The decoration is divided into three zones of which the lower is the principal. This is of square plan above and circular plan below, each of the angles being rounded and decorated with a narrow, parallel-sided, upright leaf having a rounded, out-turned end and carved as if composed of a number of receding layers. On the vertical axis of each face is a similar shorter leaf separated from those at the angles by a pair of similar, but recessed leaves with their tips truncated. The leaves at the angles support a narrow block of square plan, in the lower corners of each face of which is a tight volute. The volutes on each face are linked by a band carved as if it were composed of several overlapping layers, which curves down in a swag to pass below a rosette on the vertical axis of the face. The upper and lower elements of the capital, linked by the leaves at the angles, are elsewhere separated by a narrow recessed zone decorated with narrow relief bands forming a zig-zag pattern. Each of the triangular fields thus created has two vertical facets.[1]

---

1. Traces of pigment were found on this capital during conservation by the Ancient Monuments Laboratory, and subsequent examination by the Paint Research Laboratory of English Heritage. These suggest that 'the scrolls between the volutes were decorated in bands of red, yellow and blue pigments. Minute quantities of gold have been found on the yellow zone, suggesting that it was gilded. The acanthus leaves bear traces of blue pigment'. This has been identified as Egyptian blue, and is the only example in post-Roman painting in Britain. See Webster and Backhouse 1991, 34–5, and D. Braine and P. Welford forthcoming (Eds).

DISCUSSION This capital is decorated on all four faces and must derive from a free-standing column. Such columns are unusual in the pre-Conquest architecture of south-east England; they occur elsewhere only at Reculver (no. 4; Ills. 123–38) and St Pancras, Canterbury (Ills. 59–60). Unlike other pre-Conquest sculptures from the site, it seems that this capital came from somewhere other than the foundation of the Romanesque screen which overlay the western part of Abbot Wulfric's rotunda. Hope's description of the discovery of the sculpture is, however, remarkably vague and ambiguous, 'The remarkable capital shewn in Fig. 13 and another like it, may have been part of Wulfric's work: the smaller fragments, which are also pre-Conquest, were embedded in the destroyed screen foundations' (Hope 1917, 24).

DATE Ninth century

REFERENCES Hope 1917, 24, fig. 13; Peers 1927a, 215, pl. XXVIII; Clapham 1930, 126; Cottrill 1931, appendix; Rice 1952, 145; Taylor and Taylor 1966, 48–9, fig. 20; Gem 1973, II, 439, 455; Tweddle 1983b, 35–6, pl. Xa; Tweddle 1986b, I, 58–9, 157–9, II, 362–3, III, pl. 29a; Webster and Backhouse 1991, 34–5, no. 18

D.T.

## 4. Part of capital

(Ills. 33–7)

PRESENT LOCATION Historic Buildings and Monuments Commission stores, Dover castle (reg. no. 78203093)

EVIDENCE FOR DISCOVERY See no. 3.

H.   27 cm (10.6 in)   W.   28 cm (11 in)
D.   27 cm (10.6 in)

STONE TYPE Pale yellowish-grey, finely granular limestone, with numerous Serpulid worm tubes; *Ditrupa* limestone, Calcaire Grossier Formation, Palaeogene, Tertiary; Paris Basin

PRESENT CONDITION Broken and worn

DESCRIPTION Corner fragment of a capital similar to no. 3, except that the surviving angle leaf is broader and decorated with pairs of incised lines rising obliquely, one on each side of its vertical axis.

DISCUSSION Although only fragmentary, the close comparison in form between this example and no. 3 suggests that it too derived from a free-standing column. Like no. 3, it seems that this fragment came from a location on the site other than the Romanesque screen base, which yielded much of the rest of the pre-Conquest sculpture from the site.

DATE Ninth century

REFERENCES Peers 1927a, 215, pl. XXVIII; Clapham 1930, 126; Cottrill 1931, 49, appendix; Rice 1952, 145; Taylor and Taylor 1965–78, I, 48–9; Tweddle 1983b, 35–6; Tweddle 1986b, I, 58–9, 157–9, II, 363–4, III, pl. 29b

D.T.

### 5. Part of capital                    (Ills. 38–40)

PRESENT LOCATION Historic Buildings and Monuments Commission stores, Dover castle (reg. no. LM 102)

EVIDENCE FOR DISCOVERY First recorded in Clapham 1927 (in museum of St Augustine's College); not mentioned in Hope 1917

H. 30 cm (11.8 in)   W. 35 cm (13.8 in)
D. 20 cm (8 in)

STONE TYPE Greyish-yellow, finely granular limestone, with some 1-mm perforations; *Ditrupa* limestone, Calcaire Grossier Formation, Palaeogene, Tertiary; Paris Basin

PRESENT CONDITION Extensively bruised, but apparently unweathered

DESCRIPTION Roughly broken behind and below, so that about half of the capital is lost; the ends of the volutes are also broken away. Otherwise, similar to no. 3, though rather taller and narrower.

DISCUSSION Probably part of the same architectural scheme as nos. 3–4, and of the same date.

DATE Ninth century

REFERENCES Peers 1927a, 215; Cottrill 1931, 49, appendix

D.T.

### 6. Baluster, in two joining pieces    (Ills. 41–5)

PRESENT LOCATION Historic Buildings and Monuments Commission stores, Dover castle (reg. no. 7820 3095)

EVIDENCE FOR DISCOVERY None; possibly one of 'smaller' pre-Conquest fragments found built into the Romanesque screen foundations overlying west end of abbot Wulfric's rotunda (begun *c.* 1049, demolished *c.* 1073) recorded in Hope 1917

H. 57.7 cm (22.6 in)   W. (max.) 31 cm (12.25 in)
D. (max.) 28.8 cm (11.3 in)
Diameter of shaft (max.) 19.6 cm (7.75 in)

STONE TYPE Greyish-yellow (10YR 8/2–3), medium-grained oolitic limestone, with ooliths 0.3–0.5 mm in diameter, close-packed in a finely oolitic or pellety matrix of 0.1–0.2 mm particles; Marquise stone, Oolithe de Marquise Formation, Bathonian, Middle Jurassic; Boulonnais, France

PRESENT CONDITION Broken into two pieces, with some loss around the join, damage to the angles of the base, and light bruising all over; unweathered

DESCRIPTION The base is rectangular in plan and of rectangular section. The front right corner is broken away, and the upper corners to the rear left and right broken. The lower end of the shaft consists of a square fillet above which is a narrow roll moulding, then a deep hollow. Above this is a feature consisting of a wide roll moulding flanked by two narrower roll mouldings. The shaft then expands towards another similar feature at the mid-point of the shaft, before tapering again. At the upper end of the shaft is another wide roll moulding flanked by two narrower mouldings. Above this the baluster expands again with three hollows flanked by three narrow roll mouldings. At the upper end is a plain square fillet. At the front of the shaft is a deep nick of triangular section in the tapering plain section just below the upper end (Ill. 42). There is a similar deep nick at the rear in the equivalent position at the lower end (Ill. 43). In the centre of the upper and lower ends are shallow, square hollows.

DISCUSSION The placing of deep nicks on opposite sides and opposite ends of the shaft is suggestive not of accidental damage, but rather of a deliberate attempt to break up the baluster; indeed, the lower nick caused the baluster to break into two. The hollows on the ends (Ills. 44–5) were designed to accommodate the mandrels of the lathe on which the baluster was turned.

This piece is similar, but not identical, to the baluster from St Mary in Castro, Dover (nos. 2–3; Ills. 64–7, 71–5). The Dover fragments may be contemporary with the surviving late Anglo-Saxon fabric of the church; it is possible that there was originally a belfry stage to the central tower, which was remodelled in the thirteenth century. One of the balusters at Dover (no. 3b; Ill. 80) is recut to form a section of early Gothic moulding, probably a vault rib. Certainly where turned balusters of this general type occur in south-east England, as at Oxford (St Michael 1; Ills. 364–70), they are probably of late Anglo-Saxon date.

DATE Tenth or eleventh century

REFERENCES Hope 1917, 24; Brown 1925, 266; Taylor and Taylor 1966, 48

D.T.

### 7. Part of baluster                              (Ills. 46–9)

PRESENT LOCATION Historic Buildings and Monuments Commission stores, Dover castle (no. 7820 3096)

EVIDENCE FOR DISCOVERY See no. 6.

H.   29 cm (11.4 in)   W.   (base) 27 cm (10.6 in)
D.   (base) 24 cm (9.5 in)
Diameter of shaft 17.4 cm (7 in)

STONE TYPE Pale yellowish-grey (10YR 8/2–3), medium-grained oolitic limestone of 'millet-seed' type, with a few 2 mm oncoliths; Marquise stone, Oolithe de Marquise Formation, Bathonian, Middle Jurassic; Boulonnais, France

PRESENT CONDITION Incomplete, the angles and surfaces heavily bruised; unweathered

DESCRIPTION The base is of square plan and rectangular section. The front left-hand corner is broken away, and the base is roughly broken to the right and rear. The base of the shaft consists of a roll moulding above which is a hollow flanked by deep grooves. Above this is a tapering roll moulding topped by a roll moulding flanked by two similar, but narrower, recessed rolls. Above the moulded base, the shaft expands before being roughly broken away above. In the centre of the base is a deep, square, tapering hole with a flat bottom (Ill. 49).

DISCUSSION This base is very similar to that of the intact baluster shaft from this site (no. 6), although the precise detailing of the mouldings varies a little. It is also of a very similar size, and may have come from the same architectural scheme. A late Anglo-Saxon date can be suggested on similar grounds.

DATE Tenth or eleventh century

REFERENCES Hope 1917, 24; Brown 1925, 266; Taylor and Taylor 1966, 48

D.T.

### 8. Part of baluster                              (Ill. 50)

PRESENT LOCATION Historic Buildings and Monuments Commission stores, Dover castle (not currently available)

EVIDENCE FOR DISCOVERY Removed from nineteenth-century boundary wall of old County Hospital, overlying south side of St Augustine's abbey church, in front of old mortuary

H.   24 cm (9.5 in)
Diameter 20 cm (8 in)

STONE TYPE Not obtained

PRESENT CONDITION Extensively damaged; unweathered

DESCRIPTION Roughly broken above and below. There is a broad median roll moulding, largely broken or dressed away. To each side it is flanked by two narrow roll mouldings separated by deep grooves.

DISCUSSION The lack of taper and the use of narrow grooving are features not encountered among the late Anglo-Saxon balusters of the region. These features are, however, found consistently on early lathe-turned balusters in Northumbria, as at Jarrow, co. Durham, where there are twenty-five, and Monkwearmouth, where there are thirty (Cramp 1984, I, 120–1, 128–9). A late seventh-century date can plausibly be argued for this series, since four of the Monkwearmouth examples are *in situ* in the west porch (Cramp 1984, II, pls. 112–15), which is generally agreed to have been a very early addition to the first church on the site, founded in 674 (Taylor and Taylor 1965–78, I, 433, 437–9, fig. 204). A similar date may be argued by analogy for the present example.

DATE Seventh century

REFERENCE Tweddle 1986b, I, 133

D.T.

### 9. Grave-cover or panel                          (Ills. 51–3)

PRESENT LOCATION Historic Buildings and Monuments Commission stores, Dover castle

EVIDENCE FOR DISCOVERY First recorded in Peers 1927a

L.   15 cm (5.9 in)   W.   31.5 cm (12.4 in)
D.   9 cm (3.5 in)

STONE TYPE Greyish-yellow, orange-flecked, oolitic and pellety limestone with shell fragments; of uncertain provenance, possibly an ironshot limestone from the Great Oolite Formation of the Bath area, Great Oolite Group, Middle Jurassic

PRESENT CONDITION Broken and heavily weathered

DESCRIPTION It is sub-rectangular, with a broad, plain, low relief border to the left and right, and a similar, narrower border at the upper end. The lower end is roughly broken. Only one face is carved.

*A:* This face is slightly convex and is decorated with a neatly laid out but worn interlace, surrounded pattern D.

*B and C:* The two surviving edges of the stone are smoothly dressed.

DISCUSSION This may be one of the 'smaller fragments' of sculpture discovered during Hope's excavations built into the base of the Romanesque screen overlying the western part of Wulfric's rotunda. There is no direct mention of it in his account of his work, however. See also no. 3, above.

The simplest way to reconstruct this piece is as one end of a rectangular slab. The damage to the sides makes it difficult to decide whether the long edges were originally parallel, or whether the stone tapered.

The stone could originally have served any one of a number of functions, for example, as a decorative architectural panel or closure slab, but the convexity of face A is more reminiscent of the treatment of grave-covers. A number of relatively narrow covers are known from south-east England, for example, several of those from Chithurst, Sussex. The depth of the St Augustine's slab is also typical of grave-covers from the region, which tend to be around 10 cm deep.

The dating of the stone is based on the type of interlace pattern employed, and the thickness of the strand; these features are of a type normally associated with late Anglo-Saxon sculpture.

DATE Tenth to eleventh century

REFERENCES Peers 1927a, pl. XXVIII; Cottrill 1931, appendix; Tweddle 1986b, I, 90, 252–3, II, 364, III, pl. 30a
                                                                                    D.T.

## 10. Trial piece?                                    (Ills. 54–6)

PRESENT LOCATION British Museum, Department of Medieval and Later Antiquities, no accession number

EVIDENCE FOR DISCOVERY Found on spoil heap following excavations at St Augustine's abbey

H.   9 cm (3.5 in)   W.   4.8 cm (1.9 in)
D.   2.4 cm (0.9 in)

STONE TYPE Pale grey, finely glauconitic, fine-grained sandstone; probably a Thanet Beds sandstone from Reculver or Pegwell Bay, Kent; Palaeogene; Tertiary

PRESENT CONDITION Good; lightly weathered

DESCRIPTION It is sub-triangular with the upper edge convex. The lower and left-hand edges are roughly broken. It is of sub-triangular section, tapering towards the lower edge.

*A (broad):* Along the upper edge is a row of pellets. Below this is a row of three rosettes, each with hollowed petals and encircled by a plain moulding. The central encircled rosette is set under an arch composed of a median-incised moulding. Similar half arches to the left and right enclose the flanking rosettes, which are separated by the common piers. To the left and right the arch head develops into a row of pellets encircling the underside of the rosette. A similar row of pellets, but here confined between the plain mouldings, links the bases of the piers curving below the central rosette.

*C (broad):* There is a row of pellets on the upper edge separated by a plain zone by a sub-rectangular field. This is filled with median-incised interlocking spiraliform elements, one pelleted. To the left is a quadrilobate element, with the lobes hollowed. A row of beading edges this end of the decorative field. Another row of pellets develops from the left to flank the lower edge of the field for a short distance.

DISCUSSION The function of this piece is very uncertain, but the fact that the carving partially overlies some of the broken edges suggests that it is not part of a larger object. Cramp has suggested that the may be either a mould or a trial piece (Cramp 1975, 191). It is, however, extremely unlikely that it could have been used as a mould. The design is too shallow to trap any molten metal, if it were used as a one-piece mould. Nor, if it were part of a two-piece mould, is there any method for engaging the two halves. There is also none of the characteristic discolouration which might be expected from heating. The shallowness of the carving also rules out the use of the piece as a matrix.

It seems much more likely that the piece is a trial or motif-piece. The small scale of the fragment, the lack of detailed finishing of the piece, and the unintegrated nature of the decoration, are all characteristic of such pieces, which can be regarded as sketches for works in other materials, or training exercises (O'Meadhra 1987, 169–70). Trial pieces are not common in England, but have been encountered in a variety of materials in major urban excavations, most notably in London (for example, Wheeler 1935, pl. XXI), and York (for example, Hall 1984, figs. 56–7); the majority date from the ninth to tenth centuries.

It is, however, possible that the piece was used directly to emboss leather. It is shaped like the tip of a scramasax sheath, and has the correct cross-section. It could have been inserted into the tip of a pre-formed sheath through the open seam. The wet leather would then have been pressed over the pattern, embossing it into the leather. Pre-Conquest leather sheaths are relatively uncommon but all were designed to house the blade and handle of the knife, with the decoration on the sheath reflecting this division (Tweddle 1986a, 237–41, fig. 107, pls. XI-XIII). This piece would yield the pattern covering the area housing the blade.

The use of rosettes, of a hybrid ornament combining seed pods, foliate elements, and spirals, and of pelleting, all point to an early ninth-century date.

DATE Ninth century

REFERENCE Cramp 1975, 191, pl. XXa

<div align="right">D.T.</div>

## 11. Inscription (cast)                                    (Ill. 58)

PRESENT LOCATION British Museum, no accession number

EVIDENCE FOR DISCOVERY None; first recognized by Mrs. L. E. Webster, British Museum

H.   6.5 cm (2.6 in)   W.   12 cm (4.7 in)
D.   2.2 cm (0.9 in)

STONE TYPE Not identifiable from the cast

PRESENT CONDITION Unobtainable

DESCRIPTION *Inscription* The cast shows four runic characters that appear to be Scandinavian. Irrespective of whether ᛦ and ᚾ are left-facing—as the presence of retrograde **u** suggests they may be—the occurrence of both forms makes it unlikely that the runes are Anglo-Saxon. The fact that **u** is retrograde poses problems for the reading of the inscription: what is the direction of writing, and which of ᛦ ᚾ is **a** and which **n**? There are four possible readings.

(right to left): (i) **anu**[.] or (ii) **nau**[.]
(left to right): (iii) [.]**uan** or (iv) [.]**una**

Of these (i), in which we have a straightforward right-to-left inscription, is the most plausible, followed by (iii), where it is assumed that the second rune is retrograde but that the third and fourth face the same way as the direction of writing. The other two readings are considerably less probable.

<div align="right">M.P.B.</div>

DISCUSSION A note on the back of the cast in R. A. Smith's handwriting reads 'St. Augustine's Canterbury (Rev. F. J. Badcock).' A second cast in the British Museum is marked 'St. Augustine's College.' Badcock was a member of the College in the early part of this century. The phraseology leaves it unclear whether the original of this fragment came from St Augustine's, or whether he had taken a cast of something that he had seen elsewhere. However, nothing resembling this cast is now known.

<div align="right">D.T.</div>

*Inscription* The problems involved in reading the inscription, together with its seemingly fragmentary state, make interpretation well-nigh impossible. **anu** does not give a known word, but if we assume the sequence to contain the remnants of more than one word, —*a nú* or —*ann u*— are two of the more likely among several possibilities. **uan** might be the first or third person past singular of *vinna* ('work', 'achieve', 'overcome'). In the absence of further clues, however, such speculation is fruitless.

<div align="right">M.P.B.</div>

DATE Eleventh century?

REFERENCE Tweddle 1986b, I, 253, II, 366–7, III, pl. 31b

# CANTERBURY, K. (St Martin)

TR 159578

## 1. Inscribed stone                                    (Ill. 57)

PRESENT LOCATION Incorporated into western jamb of blocked south chancel doorway, outside

EVIDENCE FOR DISCOVERY First recorded in Brock 1883

H.   10 cm (4 in)   W.   23 cm (9 in)
D.   *c.* 5 cm (2 in)

STONE TYPE Pale yellow, medium- to coarse-grained, granular or pellety limestone; Marquise stone of a yellowish, even-grained facies, Oolithe de Marquise Formation, Bathonian, Middle Jurassic; Boulonnais, France

PRESENT CONDITION Broken and worn

DESCRIPTION *Inscription* The fragment (Okasha 1971, 60–1) is almost certainly reset in its present position. The stone is finely dressed and the lettering neatly incised. The lettering is set horizontally and the right way up for reading, but none of the original edges of the inscribed face now seems to survive. Parts of two lines of worn lettering remain. In the upper line the upper parts of the letters have broken away. The lower line was probably the bottom line of the text, since the space beneath is much larger than that between the two existing lines. It is not certain how many, if any, are lost above the two that remain; nor is it clear how much of the stone and of the text is lost on the left and right sides. The letters are comparatively small: about 1.8 cm (0.7 in) high. The inscription is in capitals and reads:

—[.*ORE SCE*]—
—[.] OMNIV̄ SC̄ORV̄

The language is Latin and the expansion of the last two words is certain: OMNIV(M) S(AN)C(T)ORV(M), which can be translated as 'of all the saints' or 'of All Saints'. What remains of the letters in the line above is compatible with the letters —ORE SCE. In the context and with a following genitive, the first partially surviving word, which probably ended in —ORE, should probably be reconstructed as [*HON*]*ORE*. We would then have the common dedicatory formula: *in honore(m)* with the genitive (Higgitt 1979, 368–70). The next three

letters, if correctly read as SCE, are probably another abbreviation of *sanctus*, in this case the genitive of the feminine singular: S(AN)C(T)E. The text could then be plausibly reconstructed as: . . . *in honore* (or *honorem*) *sancte . . . et omnium sanctorum* '. . . in honour of Saint (or 'the holy') . . . and of all the saints').

The letters have suffered in their exposed position, though it can still be seen that they were carefully executed. They appear to have been of even breadth. Slight traces of light serifs seem to survive at the ends of one or two strokes. The letters are capitals. The forms are standard Roman ones, with the following exceptions: square C; M with vertical outer strokes and a short central V. Only eight different letters are represented, and they are given forms that can be found in both early and late Anglo-Saxon inscriptions (Okasha 1968). The letter forms do not, therefore, help in dating this inscription.

Words are separated by gaps, but there is now no trace of points being used as word-dividers. Bars are used to mark abbreviations in the correct manner. The abbreviations consist of the suspension of final M and the regular contraction of *sanctus*. (The bar noted by Okasha over the first O of OMNIV is probably an accidental mark (Okasha 1971, 61).)

J.H.

DISCUSSION The piece is dated by its incorporation into the jamb of a doorway which has been dated to 600–50 (Taylor and Taylor 1965–78, I, 143). However, a later dating for this doorway is possible, and even if the doorway dates from the seventh century, it is possible that the piece is a later insertion; the rest of the jambs and archway are largely made from reused Roman brick.

D.T.

*Inscription* It is probable that this inscription originally recorded the dedication of a church or an altar. As has already been seen, the present location is probably secondary, and so it is not certain to which church or altar it would have originally referred. The use of the *in honore(m)* formula does not help to date the text; it is found in both early and late dedication inscriptions (Higgitt 1979, 368–70). While Anglo-Saxon dedication inscriptions could contain several elements, it is possible that this inscription consisted originally of

no more than the formula *in honore(m)* with the names of the dedicatees in the genitive (see the analysis of dedication inscriptions in Higgitt 1979, 367–70). The list of dedicatees probably opens with the feminine singular *sancte*. This could introduce the name of a female saint or another feminine noun such as *trinitatis* for the Holy Trinity. The list probably ends with All Saints as does that on the late Anglo-Saxon dedication inscription in St Mary Castlegate in York (Higgitt in Lang 1991, 100). If St Martin's (or any other saint's) name was originally included in the list, it would then have had to appear between the feminine dedicatee and All Saints, which would necessitate relatively long lines. The dedication to All Saints is perhaps an argument against a very early date. It seems not to be recorded as a church dedication in seventh- or eighth-century England, although the feast of All Saints was known in Northumbria after the middle of the eighth century (Levison 1946, 160, 259–65; Binns, Norton and Palliser 1990, 138).

J.H.

DATE Pre *c.* 900?

REFERENCES Brock 1883, 52–3; Routledge 1897, 9; Routledge 1898, 56–9; Peers 1901, 414; Clapham 1929c, 280; Fisher 1962, 356, pl. 193; Okasha 1969, 29; Okasha 1971, 60–1, pl. 22; Higgitt 1979, 347, 368; Tweddle 1983b, 30; Tweddle 1986b, I, 112, 129–30, II, 367–8, III, pl. 32a

# CANTERBURY, K. (St Pancras)

## TR 156578

### 1. Column-base    (Ills. 59–60)

PRESENT LOCATION *in situ* at south end of triple arcade formerly separating nave and chancel

EVIDENCE FOR DISCOVERY Excavated and recorded by Hope (Hope 1902)

H.   42 cm (16.5 in)
Diameter 59 cm (23.2 in)

STONE TYPE Yellowish-grey, finely granular limestone, with *Ditrupa*; *Ditrupa* limestone, Calcaire Grossier Formation, Palaeogene, Tertiary; Paris Basin

PRESENT CONDITION Incomplete; base cracked and patched with mortar; heavily weathered

DESCRIPTION The lower drum of the column survives, broken away to one side at the upper end. The base is moulded and sits on an integral square plinth. The mouldings consist of a pair of rolls separated by a hollow.

DISCUSSION Although this piece has usually been regarded as reused Roman material (Hope 1902, 228; Taylor and Taylor 1965–78, I, 146), Blagg has pointed out that it has several highly unusual features which make this highly improbable. For example, the combination of tall plinths with low roll mouldings is much more typical of fifth- and sixth-century column bases from the eastern Mediterranean, than it is of Romano-British bases. Moreover, these eastern Mediterranean bases also lack a cyma or cavetto moulding above the upper roll, as here (Ill. 59).

More recent excavations at St Pancras's have suggested that the columns supporting the triple arcade were secondary insertions, probably of the late seventh or eighth century, and that the church originally had only a single arch separating the nave from the chancel (Jenkins 1975–6, 4–5). If so, then the columns may have been made at that time, specifically for this location.

DATE Late seventh or eighth century

REFERENCES Hope 1902, 228; Taylor and Taylor 1965–78, I, 146; Jenkins 1975–6, 4; Blagg 1981, 51–2, fig. 7a; Worssam and Tatton-Brown 1990, 59

D.T.

# CANTERBURY, K. (Old Dover Road)

## TR 155570

**1. Part of cross-shaft** (Ills. 108–10)

PRESENT LOCATION Canterbury cathedral crypt

EVIDENCE FOR DISCOVERY Discovered in 1931 by Canon G. M. Livett in rockery at 150, Old Dover Road, Canterbury, and presented by him to Canterbury cathedral in 1950; connected with Reculver by tradition in owner's family

H. 35 cm (13.8 in)
Diameter (reconstructed) *c.* 46 cm (18 in)

STONE TYPE Medium light grey, finely granular limestone, with numerous Serpulid worm tubes; *Ditrupa* limestone, Calcaire Grossier Formation, Palaeogene, Tertiary; Paris Basin

PRESENT CONDITION Broken and worn

DESCRIPTION Part of a drum of a shaft of circular section, dressed flat above, below, and to each side. Only two faces are carved.

*A (side):* The surviving portion of the circumference is divided into two equal fields by a three-quarter round column with a damaged base. The damaged capital, separated from the column by a narrow roll moulding, has a pair of outward-facing S-shaped scrolls flanking an upright leaf, from above which springs a pair of scooped volutes linked at the base. Between them is a small, round ended, scooped leaf. Along the left-hand edge of the drum are the mutilated remains of a second similar column. These support a heavily damaged flat entablature, originally of square section, along the upper edge of the drum. In the left-hand field is a heavily damaged, full-length, frontally-placed figure, with its arms held across the body at waist level, and with the feet apart standing on a roughly-indicated ground surface. The figure wears a full-length robe with a folded hem, and an overgarment

gathered up from left to right and thrown over the figure's left arm. A similar but more heavily damaged figure occupies the right-hand field.

*E (bottom):* A two-strand twist runs round the edge (Kozodoy 1976, 90, fig. 31; idem 1986, 76, pl. XXXVIc).

DISCUSSION Both figures are clad in Classical dress (the *tunica* and *pallium*) and can probably therefore be identified as two of the Apostle or Prophets. It is unusual for a selection of the Apostles, apart from the Evangelists, to be depicted, but a selection of the prophets would be possible, though there is too little evidence for more than speculation.

The most interesting feature of this fragment is the two-strand guilloche on the underside. For this to have been visible, the stone must have been set fairly high up in its original context, and must have projected by nearly 3 cm.

For the probability that this stone originally formed part of the same monument as Reculver 1a–e, and its possible relationship to the other surviving pieces, see Reculver 1a–e, Discussion (p. 152–61).

DATE Ninth century

REFERENCES Livett 1932, 8, cols. 3–4, pl. col. 3; Jessup 1936, 185, pl. III; Brown 1903–37, VI(2), 173–4; Clapham 1951, 195, n.; Taylor 1968, 291–2, n. 5; Newman 1976, 195; Tweddle 1983b, 31–2; Kozodoy 1986, 69, 76, 82, pl. XXXVIb, c; Tweddle 1986b, I, 95, 255–330, II, 368–9, III, pl. 32b; Tweddle 1990, 147–8; Worssam and Tatton-Brown 1990, 54–5

D.T.

CHITHURST, **1–8.** See Appendix A, p. 188.

COCKING, **1.** See Appendix A, p. 190.

# DARTFORD, K. (Holy Trinity)

## TQ 544741

**1. Impost** (Ill. 61)

PRESENT LOCATION Reused on north side of blocked arch in east wall of tower

EVIDENCE FOR DISCOVERY Date of discovery and partial unblocking of the arch unknown, but perhaps during major restorations in 1862 and 1882, or alterations to north aisle in 1877

H. *c.* 20 cm (7.9 in)   W.   *c.* 57 cm (22.4 in)
D.   Built in

STONE TYPE Pale grey, fine-grained, finely glauconitic sandstone; Reigate stone, Upper Greensand, Gault Group, Lower Cretaceous

PRESENT CONDITION Damaged but unworn

DESCRIPTION The west face is rectangular and flush with the wall. It is decorated with a pair of cable mouldings twisted in opposite directions, flanked by a pair of mouldings of square section, one running along each of the upper and lower edges of the face. The south face is cut back flush with the jamb.

DISCUSSION The north tower of Dartford church is of Norman date, and in its present location the piece is clearly reused. The south face of the impost block has been cut away, and the block set flush with the soffit of the arch.

The form of the cabled mouldings, with the twisting strands modelled and each with a median incision of V-shaped profile, appears to be a distinctive late pre-Conquest type in south-east England. It is found, for example, on the imposts from Walkern 2 and Little Munden, Hertfordshire, and on the corners of the cross-shaft from All Hallows-by-the-Tower, London.

DATE Eleventh century

REFERENCES Bowen and Page 1967, 289; Porteus 1974, 6, 15; Tweddle 1986b, I, 66, 68, 178–9, II, 378, III, pl. 41a

D.T.

# DOVER, K. (St Mary in Castro)

## TR 327418

**1. Grave-cover** (Ills. 62–3, 68)

PRESENT LOCATION Built into the western-most arch of the sedilia at the south-east end of the nave

EVIDENCE FOR DISCOVERY Discovered during restoration by Scott in 1860–2, reused as paving of central opening of footing of probably late twelfth-century screen (Newman 1974, 287) spanning western tower arch (Puckle 1864, 54)

L.   110 cm (43.3 in)   W.   37 > 27 cm (14.6 > 10.6 in)
D.   10 cm (3.9 in)

STONE TYPE Pale yellow, fine-grained limestone; Caen stone, Calcaire de Caen Formation, Bathonian, Middle Jurassic; from Caen, Normandy

PRESENT CONDITION Broken and worn

DESCRIPTION A tapering cover with a square head and foot; each of the edges is slightly convex. It is broken into three approximately equal parts, the breaks rising from right to left. The decoration is largely defaced except at the head end and in a small area to the lower left. Close to, and paralleling the head of the stone is an incised line stopping short of the edges to the left and right. Inside it is a second line paralleling the head. From the outer edge of this emerges a series of short, oblique incised lines leaning to the left with their ends pecked. The base line is returned to parallel the edges to the left and right. To the left, inside and close to this line, is a second similar incised line from the inner edge of which emerge a series of oblique lines leaning towards the head of the stone, a decorative zone bounded on its inner side by a

third incised line. To the right the arrangement is similar except that the oblique lines emerge from the outer edge of the inner line. The incised decoration of the main face is heavily damaged, but appears to consist of incoherent foliate ornament. In the area of decoration surviving to the lower left two incised lines parallel the left-hand edge, and from the inner of these emerge three incised, curved, upward-leaning lines.

DISCUSSION After discovery, it was reburied below the new tiled floor protected by a second slab, and was probably recovered during the restoration of the church by Butterfield in 1888.

DATE Eleventh century

REFERENCES Puckle 1864, 54–5, fig. facing 54; Clapham 1929a, 255; Cottrill 1931, appendix; Tweddle 1986b, I, 89, 226, II, 380–1, III, pl. 42a–b

<div align="right">D.T.</div>

## 2. Baluster                                (Ills. 64–7)

PRESENT LOCATION In eastern-most arch of sedilia at south-west end of nave

EVIDENCE FOR DISCOVERY Discovered during clearance of church prior to restoration of 1860–2 by G. G. Scott; deposited with other fragments in south-west angle of tower

H.    33 cm (13 in)
Diameter c. 20 cm (8 in)

STONE TYPE Pale yellow (10YR 8/2), finely granular limestone; Caen stone, Calcaire de Caen Formation, Bathonian, Middle Jurassic; from Caen, Normandy

PRESENT CONDITION Face, angles, and mouldings very heavily bruised

DESCRIPTION Only the middle portion of the shaft survives. It is longitudinally split, with only a third of the original circumference surviving. Encircling the middle of the shaft is a group of three prominent roll mouldings, heavily damaged and partially broken away. To either side of this the shaft narrows in a deep curve with a shallow roll moulding beyond. To each side the shaft then tapers and is undecorated. It is dressed roughly flat at either end.

DISCUSSION Puckle records the discovery of 'perhaps a score' of baluster fragments deposited in the south-west angle of the tower. This one is not among the three which he illustrates (Puckle 1864, 68–71, figs. facing 70 and 72), nor is it one of the four illustrated by Baldwin Brown (Ills. 71–4). A selection of the

balusters (not including the present example) were transferred to Dover Museum at some time, where they were destroyed by bombing during the Second World War (see no. 3).

Much of the surviving fabric of St Mary in Castro is late Anglo-Saxon in date, and it is possible that this and others of the surviving or recorded baluster fragments derive from lost belfry openings to the central tower. Several of the fragments had been reused as early Gothic vault ribs, and it is possible that the belfry stage of the tower was modified when the stone vault was added to the tower and chancel c. 1190 (Newman 1976, 287). Certainly the majority of late Anglo-Saxon balusters which remain in situ are in belfry windows. Scott, however, reconstructed pairs of round-headed openings in each face when he restored the belfry stage of the tower, based upon the evidence then surviving.

DATE Tenth or eleventh century

REFERENCES Scott 1862–3, 5–6, pl. II; Puckle 1864, 68–71; Brown 1925, 265, fig. 111

<div align="right">D.T.</div>

## 3a–d. Parts of four balusters       (Ills. 71–5, 79–80)

PRESENT LOCATION Destroyed

EVIDENCE FOR DISCOVERY Unobtainable

STONE TYPE 'Caen stone' (Scott 1862–3, 6)

PRESENT CONDITION Unknown

DESCRIPTION The problem of determining which of the fragments drawn by Puckle (Ills. 75, 79–81) are to be identified with those drawn by Baldwin Brown (Ills. 71–4) is discussed stone by stone; the descriptions, however, have been based on Baldwin Brown's drawings, as these seem likelier to be the more accurate.

a: Brown's drawing of fragment a (Ill. 71) is probably to be identified with Puckle's shaft 1 (Ill. 79), as the differences between the mouldings in the two drawings are very slight.

On a square base of rectangular section stood the lower half of a turned baluster, broken off roughly above and to the rear. Above the base was a square fillet surmounted by a pair of rolls, the upper of which tapers. This, in turn, was surmounted by a prominent roll, with another, slighter, roll above it. The plain shaft then swelled gently before tapering again towards a roll with a prominent angular roll above it. The rest of the shaft had been lost.

b: The drawing of fragment b in Brown (Ill. 73) is probably to be identified with Puckle's shaft 2 (Ill. 80). There are small differences between the two, notably the absence of the median groove in Puckle's sketch, and the smaller size of the top roll, but these are relatively minor. If they are the same, then to the rear the piece was redressed to form a length of vault-rib of simple sub-circular section, with a deep hollow to either side. About half of the original circumference survived.

Dressed flat above and below. At the upper end was a prominent roll moulding, below which was a second, narrower, and recessed roll. The plain shaft then expanded towards a central feature consisting of a narrow roll followed by an expanding moulding of S-shaped profile, a deep groove, a tapering moulding of reversed S-shaped profile, and finally a narrow roll. The plain shaft then tapered again before being broken away.

c: Fragment c as drawn by Baldwin Brown (Ill. 72) may be the same as Puckle's shaft 3 (Ill. 75); there are, however, substantial differences in the mouldings at the upper end of the shaft between the two drawings, and it is possible that they represent different shafts.

This lathe-turned shaft survived to its full length, but had been split in two longitudinally so that only half of the circumference survived. On a circular base and separated from it by an incised groove stood a vertical fillet, above which was a roll tapering upwards towards a pair of rolls of which the lower projected further and was the wider. Above these the plain shaft expanded towards a median feature composed of a pair of rolls flanking an angular roll which tapered to each side. The upper part of the shaft was plain and tapered towards the mouldings of the top of the shaft. These consisted of a pair of equal rolls, a recessed narrower roll, an expanding angular roll, and then two rolls of equal weight crowned by a vertical fillet.

d: Fragment d (Ill. 74) was not recorded by Puckle. This was the middle portion of a lathe-turned baluster shaft, roughly broken above, below, and to the rear, so that about half of the circumference survived. The plain lower shaft tapered towards a median feature composed of a prominent roll, flanked by two smaller, recessed, rolls. Above this the plain upper portion of the shaft expanded.

DISCUSSION See no. 2.

DATE Tenth or eleventh century

REFERENCES Scott 1862–3, 5–6, pl. II; Puckle 1864, 68–71, pl. facing 70; Brown 1925, 265–6, fig. 111

D.T.

## 4. Decorative panel                    (Fig. 30; Ills. 69–70)

PRESENT LOCATION Unknown; presumed destroyed in air-raid on Dover Museum in Second World War

EVIDENCE FOR DISCOVERY Found during Scott's restoration of the church in 1860–2, close to group of Anglo-Saxon balusters discovered in south-west angle of central tower

H. *c.* 61 cm (24 in)   W. *c.* 51 cm (20 in)
D. Unobtainable

STONE TYPE Unobtainable

PRESENT CONDITION Unknown

DESCRIPTION It is sub-rectangular. The upper edge is dressed flat. To the right the edge is roughly broken, protruding unevenly, and to the left the upper part of the edge is vertically trimmed and the lower part obliquely broken.

*A (broad):* This face is decorated with a relief cross, only the upper limb of which is intact. Each of the arms, save that to the left, has an incised central line stopping short of the point of junction of the arms. In the angle between the arms to the upper left is a motif composed of two ovoids set at 90 degrees to each other, and interlacing where they cross. In the corresponding positions to the upper and lower right are the remains of similar motifs. The field to the lower left is destroyed.

*C (broad):* On this face two curving quadruple roll mouldings converge, and meet towards the lower edge. Between them is a bundle of narrow half-round stems held at the base by a pelleted collar. The stems fan out, and the outer stem to the right is tightly scrolled. At the base one of the stems is carried beneath the moulding to the left and right before looping back again.

DISCUSSION The original function of this carving is problematical. As it is decorated on both faces it may have been a closure slab and may, therefore, have been free-standing. It must originally have measured *c.* 70 × 55 cm, the same size range as the possible closure slabs from Hexham, Northumberland, and Sonning, Berkshire, described above (p. 72). However, the decoration on face A, a Latin cross with interlace in the re-entrant angles, fits the field precisely. In contrast the decoration on face C, the junction of two reeded arch heads with plant ornament in the spandrel, was clearly intended to continue onto other slabs. This may simply reflect differing decorative schemes on each side of the original screen; it may, however, suggest that the slab has been reused, in which case

a

c

FIGURE 30
Dover St Mary in Castro 4, reconstruction, nts (KEY: Letters as Faces in Description)

interpretation of the function of the stone is more open. Perhaps the arch heads originally related to a frieze or blind arcade such as that postulated at Sompting (nos. 9–11; Ills. 172–80). The piece may then have been reused to form a small grave-cover or -marker. There is a very similar grave-cover from Little Shelford, Cambridgeshire, for example (Fox 1920–1, no. 21, pl. v).

DATE Eleventh century

REFERENCES Puckle 1864, 71–2, fig. facing 72; Irvine 1877a, 219; Knocker 1932, 44, pl. on 44; Cottrill 1931, appendix; Tweddle 1986b, I, 81–2, 179, 185, II, 381–2, III, fig. 4

D.T.

# DOVER, K. (St Peter)[1]

## TR 3141

### 1. Grave-cover, in two joining pieces  (Ills. 76–7)

PRESENT LOCATION Dover Museum. No accession number

EVIDENCE FOR DISCOVERY Found in 1810 during excavations for cellar at Antwerp Hotel (on north side of Market Square) on site of St Peter's church; stone broken in two and reused as pier base. Acquired by Sir Thomas Mantell and presented to Dover Museum

L.   184 cm (72.4 in)   W.   67 cm (26.4 in)
D.   18 cm (7 in)

STONE TYPE Dark greenish-grey, glauconitic, sandy limestone, bioturbated and with an 80 mm-diameter Nautiloid cast on the rear surface; Kentish Ragstone, Hythe Beds, Lower Greensand Group, Lower Cretaceous; from the Sellindge to Hythe outcrop

PRESENT CONDITION Complete apart from slight chipping; slightly worn

DESCRIPTION Tapering cover with a semicircular head and foot. It is broken into two unequal parts, the break rising from left to right just below the horizontal arms of the low relief Latin cross decorating the convex top.

*A (top):* The head of the cross (lateral arms type B10, upper arm type E9) is close to and parallels the edge of the stone, and the sides of the arms are concave, the curves being continuous with those of the upper edges of the square-ended horizontal arms. The curves of the concavities of the lower edges of these arms return slightly before the edges of the broad lower limb of the cross are carried down the stone in parallel. The limb is splayed close to the foot. Its end is convex and parallels the foot of the stone. Across the horizontal arms of the cross is incised a runic text.

D.T.

*Inscription* The inscription, in Anglo-Saxon runes, is set along the arms of the cross, upside-down with respect to its head. Lines are punched out, and most of the terminals bear wedge-shaped serifs. The first rune is worn and partly broken away, but enough remains

for identification to be certain. The earliest published drawing suggests it may have been clear and undamaged when the stone was found ((——) 1834, 604). The three wedge-shaped points which follow the runes are deeply cut and clearly intentional. The inscription reads:

+(*j*)ᴣslheard⸭

This is a form of the attested Old English masculine personal name *Gislheard*.[2]

D.P.

DISCUSSION This stone is not closely paralleled in its regional context. The form of the cross suggests a date in the tenth or eleventh centuries.

D.T.

*Inscription* Two choices made by the rune-master are noteworthy. The representation of palatal *g* by 'j' finds a parallel in England on an inscribed stone from Thornhill, Yorkshire (Page 1973, 145). There is, however, insufficient evidence to determine whether the use, in both cases, of this particular form of 'j' reflects an epigraphical tradition at variance with the runic lore recorded in manuscripts, as Page has argued (Page 1973, 46). The choice of 'ᴣ' where 'i' seems equally possible is a potentially early feature, for the rune may originally have denoted a high front vowel, eventually falling together with the sounds given by 'i'. Its use elsewhere for a velar consonant seems to be a later stage of development, derived from the final sound of the rune-name *ih*; however, at any period the general principle of choosing a rune by the initial sound of its name might have suggested 'ᴣ' as a straight alternative to 'i'. Elliott dates the inscription to the ninth or early tenth century on the grounds that 'there are no early features either in the runes or in the name itself' (Elliott 1989, 108–9), but this is unfounded. There are simply no linguistic or runic features which exclude any date after the conversion of the Anglo-Saxons to Christianity.

D.P.

---

1. The following are unpublished manuscript references to no. 1: BL Add. MS 32361, fol. 118r; BL Add. MS 37550 no. XII, item 559; BL Add. MS 37580, items 379, 39488.

2. Both elements of the name are common but there seem to be just four other instances of the combination: three (probably one man) in mid ninth-century charter witness lists (Sawyer 1968, nos. 319, 344, and 1439), and one in the (now lost) name of an estate, *Gisleardesland* (Robertson 1956, no. 52). Curiously enough all four documents relate to Kent, but drawing a connection with the inscribed name must be highly speculative. (D.P.)

DATE Tenth or eleventh century

REFERENCES (——) 1834; Kemble 1840, 346, fig. 13, pl. XVI; Cutts 1849, 76, pl. XXV; (——) 1854; Haigh 1855–7, 106; Haigh 1857, 182; Haigh 1861, fig. 18, pl. III; Haigh 1870, 191; Haigh 1872, 164, 173–4, 265, fig. on 174; Haigh 1877, 431; Taylor 1879, 137; Bloxham 1882, III, 326–7; Palmer 1883, 15, fig. following 14; Stephens 1866–1901, I, xxvi, 465–6, fig. on 465, II, 356–6, 927, III, 200; Stephens 1884, 140–1, fig. on 141; Allen 1885b, 357; Sweet 1885, 129; Allen 1889, 208, 211, 222; Bugge and Olsen 1891–1924, I, 119; Chadwick 1894–9, 171–2; Stephens 1894, 10; Browne 1899–1901, 169; Grienberger 1900, 295; Page 1908c, 340, 384; Paues 1911, 451; Collingwood 1915, 279; Collingwood 1927, 90; R.C.A.H.M.C.S. 1920, 273; Clapham 1929a, 257; Amos and Wheeler 1929, 49, 57; Dickins 1932, 19; Knocker 1932, 44; Dickins 1938, 83; Arntz and Zeiss 1939, 385, 85; Derolez 1954, xxi, xxii, 60; Blair 1956, 309; Elliott 1959, 36, 44, 82–3, 88–9, fig. 31; Page 1959, 398; Marquardt 1961, 41–2; Wilson 1964, 71; Bowen and Page 1967, 291; Page 1973, 29, 48, 88–9, 135–6, fig. 25; Tweddle 1986b, I, 90, 222, II, 378–80, III, pl. 41b; Elliott 1989, 108–9

# FORD, Sx. (St Andrew)[1]

## TQ 002037

### 1. Fragment　　　　　　　　　　　(Ill. 78)

PRESENT LOCATION Incorporated in the north face of the nave wall, into the head of the door into the vestry

EVIDENCE FOR DISCOVERY First recorded in Johnston 1900

H.　24 cm (9.5 in)　W.　14.5 cm (5.7 in)
D.　Built in

STONE TYPE Pale grey, fine-grained sandstone, apparently finely glauconitic; Upper Greensand, Gault Group, Lower Cretaceous; possibly from the vicinity of Bignor, Sussex

PRESENT CONDITION Broken and worn

1. The following is an unpublished manuscript reference to no. 1: BL Add. MS 37552, no. XIV items 388–9.

DESCRIPTION The fragment is sub-rectangular and is decorated with an incomplete quatrefoil composed of two groups of four concentric ovals crossing at right angles, and interlacing where they cross.

DISCUSSION It has probably been in its present location since c. 1420 when the doorway into which it is incorporated was inserted into the eleventh-century nave wall. No original edge of the fragment survives, making it impossible to ascertain its original function.

DATE Tenth to eleventh century

REFERENCES Johnston 1900a, 118–20, fig. 5; Johnston 1905, 155; Page 1907, 364; Jessep 1914, 31–2; Mee 1937, 164; Nairn and Pevsner 1965, 226; Fisher 1970, 33, 113, 115; Tweddle 1986b, I, 112, 253, II, 385, III, pl. 45a

D.T.

# GODALMING, Sr. (Sts Peter and Paul)

## SU 968440

### 1. Stoup rim　　　　　　　　　(Ills. 81–91)

PRESENT LOCATION On table tomb in chapel at east end of south aisle

EVIDENCE FOR DISCOVERY Found built into east wall of chancel above east window in 1859

H.　17 cm (6.7 in)　W.　8 cm (3.2 in)
Diameter 49 cm (19.3 in)

STONE TYPE Pale yellowish-grey, medium-grained, shelly, oolitic limestone, with a prominent calcite veinlet; Combe Down Oolite, Great Oolite

Formation of the Bath area, Great Oolite Group, Middle Jurassic

PRESENT CONDITION Chipped and slightly worn

DESCRIPTION It takes the form of a ring of fundamentally rectangular section. On the inside the upper edge is chamfered, and the lower edge rebated. The outer face is divided into approximately equal fields by four prominent, heavily weathered, high-relief, downward-facing animal heads. Each has a broad muzzle and drilled eyes, and terminates in a pair of pointed ears above, but is cut off flush with the lower edge of the ring below. Between each pair of heads is a decorated panel, designated anti-clockwise i–iv. Field i has a plain raised border above and below, and is decorated with a four-strand plain plait. Field ii has borders like field i and is decorated with an animal looking to the right, with its head in the upper left-hand corner of the field. The animal's muzzle is square ended, and its mouth is open. There is a small, blunt. backward-pointing ear. The tapering body curves down to touch the lower border and is carried across the panel to touch the upper border before terminating in interlace, the loose end of which enters the animal's mouth. From the lower edge of the body as it curves towards the upper border develops a leg, bent double and squashed against the lower border. Field iii has borders like field i and decorated with a simple scroll with three tight scrolls, from the junctions of which develop short, rounded-ended axial growths. Each scroll ends in a long tapering leaf crossing diagonally over or under its own stem. Field iv has a broad plain border on all sides and is decorated with median-incised interlace consisting of two simple pattern E loops arranged back to back.

DISCUSSION There is no piece of pre-Conquest sculpture of comparable form to the present piece. The simplest way to interpret it is as the separate rim to a cylindrical vessel lined with metal. The rebate would then fit neatly over the folded edge of the vessel lining. This use of a separate decorated vessel rim would be analogous to the use of a metal rim on a drinking horn, such as those from the Trewhiddle hoard (Wilson 1964, nos. 94–6, pl. XXXVII). Similar decorated rims are applied to the wooden cups from Sutton Hoo, Suffolk (Bruce-Mitford 1972, 33–5, fig. 11, pls. H, 21b–d), and their usage into the later Anglo-Saxon period is suggested by the lost rim from Brougham, Westmorland. Bailey

views this as a ninth-century Pictish work (Bailey 1977), but it seems reasonable to suggest that similar objects were known in England at the same period. The use of downward-facing animal heads on the rim of the present piece may support such a link, since similar heads in metal were added to the rim of the Ormside bowl (also from Westmorland) in the ninth century. However, these parallels cannot be pressed too far given the differences in scale, material, and place of discovery.

If the Godalming piece is indeed a vessel rim, the question remains as to the type of vessel to which it belonged. The piece seems very small for use with a font, although very little is known about fonts of this early period. An alternative vessel type is the stoup, but no other pre-Conquest example is known.

DATE Ninth century

REFERENCES Heales 1869, 202; Nevill 1880, 282; Malden 1905, 447; Johnston 1913, 33, fig. on 32; Johnston 1926, 232; Cox and Johnston 1935, 109; Mee 1938, 138; Kendrick 1949, 86; Nairn and Pevsner 1971, 256; Bott 1978, 3, 13–14, pl. 22; Tweddle 1983b, 35–6, fig. 7, pl. Xb; Tweddle 1986b, I, 80–3, 159–60, II, 385–7, III, figs. 6, 21, pls. 45b–48a; Webster and Backhouse 1991, 246, no. 211

D.T.

## 2. Fragment                                                      (Ills. 92–4)

PRESENT LOCATION See no. 1.

EVIDENCE FOR DISCOVERY Found (with two other fragments since lost) during rebuilding of pre-Conquest west tower arch in 1879

H.   14 cm (5.5 in)    W.   38 cm (15 in)

STONE TYPE Yellowish-grey, medium- to coarse-grained, shelly, oolitic limestone; Combe Down Oolite, Great Oolite Formation of the Bath area, Great Oolite Group, Middle Jurassic

PRESENT CONDITION Damaged and worn

DESCRIPTION Fragment of a slightly tapering drum, dressed flat below, but roughly broken above and to each side. Along the upper and lower edges of the surviving portion of the face is a narrow, plain, raised border. Inside it is a heavily-weathered geometrical fret pattern.

DISCUSSION The piece is too fragmentary for its function to be determined; however, it matches no. 1 very closely in reconstructed diameter, is made of the

same material, and (to judge from its decoration) must belong to the same period. It is, therefore, possible that this piece formed part of the base of no. 1.

DATE Ninth century

REFERENCES Nevill 1880, 282; Malden 1905, 447; Jessep 1913, 28–9; Johnston 1913, 33; Mee 1938, 138; Kendrick 1949, 86; Nairn and Pevsner 1971, 256; Bott 1978, 3, 14, pl. 22; Tweddle 1983b, 36; Tweddle 1986b, I, 112, 161, II, 387, III, fig. 50, pl. 48b

D.T.

JEVINGTON, **1–2.** See Appendix A, p. 191.

# KINGSTON UPON THAMES, Sr. (All Saints)

TQ 179693

**1. Fragment of cross-shaft** (Ills. 95–7)

PRESENT LOCATION On ledge of east window of Vicar's chapel

EVIDENCE FOR DISCOVERY First mentioned in Finny 1926

H. 24 cm (9.5 in) W. 44 cm (17.3 in)
D. 25 cm (9.8 in)

STONE TYPE Pale yellowish-grey, medium-grained, shelly, oolitic limestone; probably Barnack stone, Lincolnshire Limestone Formation, Inferior Oolite Group, Middle Jurassic

PRESENT CONDITION Broken and slightly worn

DESCRIPTION The shaft is of rectangular section and tapers slightly towards the upper end. It is broken roughly horizontally above, and roughly broken below and to the rear, so that face C and approximately half the width of faces B and D are lost.

*A (broad):* Dressed flat.

*B (narrow):* There is a pair of broad, plain, low-relief mouldings to the left; the face is decorated with an encircled pattern C interlace, apparently incorporating free rings.

*C (broad):* Broken away.

*D (narrow):* Decorated with interlace which probably resembled that on face B, with the border along its right-hand edge.

DISCUSSION This is part of a square cross-shaft, but too little survives for it to be clear whether it was originally monolithic, or built in sections, as were other southern English square shafts, such as that from Elstow, Bedfordshire (Ill. 268). It is impossible to tell whether the piece was originally only decorated with interlace, or whether there was a mixture of motifs as at Bishops Waltham, Hampshire (Ill. 421).

The probable use of free rings in the interlace suggests a date in the late tenth or eleventh century, when this feature appears to have originated (Collingwood 1927, 65, 68). The flaccid and disorganised manner of laying-out the decoration supports such a late date.

DATE Tenth to eleventh century

REFERENCES Finny 1926, 212, pl. I; Johnston 1926, 232, pl. I; Finny 1943, 3; Kendrick 1949, 86; Rice 1952, 137; Nairn and Pevsner 1971, 331; Tweddle 1986b, I, 95, 234, 247, II, 395–6, III, pls. 54b-55a

D.T.

# ORPINGTON, K. (All Saints)

TQ 466664

## 1. Sundial                                                      (Ills. 105–7)

PRESENT LOCATION Built into south wall of old church, inside (upside-down as reset)

EVIDENCE FOR DISCOVERY Discovered in 1958, reused in springing of fourteenth-century window-arch, by Mr. A. Eldridge; reset approximately where found

H.   45 cm (17.7 in) Diameter 64 cm (25.2 in)
D.   Built in

STONE TYPE Pale grey, fine-grained sandstone, with scattered 0.1-mm glauconite grains and mica flakes; Reigate stone, Upper Greensand, Gault Group, Lower Cretaceous

PRESENT CONDITION Broken and damaged in places; otherwise crisp

DESCRIPTION The stone is described and illustrated as originally intended to be seen, and not as reset. Only one face is visible.

The dial is circular and the surround is carved on a sub-rectangular panel, the upper third of which has been broken away. The break is horizontal. The frame of the dial consists of a pair of cable mouldings twisted in opposite directions; the strands are well modelled and median-incised. These mouldings are separated from a broad, flat, slightly recessed zone by a pair of narrow roll mouldings. The recessed face of the dial has a central drilled gnomon hole. The area around it is damaged and linked to the upper edge of the stone by a (presumably secondary) vertical U-shaped channel, the edges of which have been roughly chamfered. Thirteen equally-spaced lines calibrate the whole of the surviving portion of the face, each terminating on the frame. The horizontals, the surviving vertical, and the lines equidistant between the horizontals and the verticals are crossed by short incised lines close to their outer ends.

D.T.

*Inscriptions* The dial bears four incised texts. Three of these (*a–c*) are in Latin lettering and are fragmentary (Okasha 1971, 105). The fourth (*d*) is in runes and is incomprehensible (Page 1964, 70; Page 1967, 289–91). Two of the texts in Latin lettering (a and b) run around the sunken flat annular field set between mouldings that frame the dial, both originally starting at or near the top of the dial. These letters occupy the full available height, that is to say, between 5 and 5.3 cm (2 and 2.1 in). The beginnings of both of these texts were lost with the top of the dial. The feet of the letters in text *a* face towards the centre of the dial and ran round its right side; those of *b* face away from the centre and were on the left. The two texts end neatly at the bottom of the stone and are separated by an incised cross placed on what was presumably the vertical axis of the stone. The third text, *c*, is set in the upper half of the face of the dial. The upper half of the circle seems, like the lower half, to have been divided into eight sectors by lines radiating from the centre. One letter is set in each of the surviving sectors. Six letters remain wholly or in part; probably two more are missing at the top from the middle of the text. The first two letters of this text are 4.2 cm (1.7 in) and the last two are 4 cm (1.6 in) in height. The feet of the letters face towards the centre. Text *d* consists of three characters, probably all runes, in the lower half of the face of the dial. They occupy the three of the eight sectors into which the lower half is divided that are furthest to the left. The runes are about 4 cm (1.6 in) high. The feet of the runes face away from the centre of the dial.

Texts *a* and *b* are in capitals and the language is Old English. They can be transcribed as follows:

(a) —[Æ]CÐÐANÐESECAN[C]AN/HV+
(b) —[.E]LTE[*LL*]AN7H/EA]LDAN
These can be edited as follows:
(a) —[Æ]CÐ ÐAN ÐE SECAN CAN HV +
(b) —EL TE[*LL*]AN 7 HEALDAN

The texts have been translated as follows. (*a*) 'to (or 'for') him who knows how to seek out how' (Page 1967, 290–1) or 'for him who knows how to seek (it)' (Okasha 1971, 105). —[Æ]CÐ can perhaps be restored as *tæcð* 'shows' or 'teaches'. The meaning might then be '. . . shows him who knows how to seek'. (*b*) '. . . to count (or 'to tell') and to hold' (Page 1967, 290). All that remains of the fragmentary letter at the start of this section of text is part of a horizontal at the top. In the context angular S is perhaps the most likely reconstruction, because the first surviving word could then be read as *sēl* (the adverb 'better'). These

texts presumably relate to the function of the sundial and were perhaps to be read together as a single text. A possible interpretation of the two lines taken together might then be: '[This dial shows] to him who knows how to seek, how [better] to reckon and keep [the time].' Given the layout, it would be more natural to start with text (*a*), which reads downwards clockwise from the top.[1]

Text (*c*) is in capitals and the following is the most conservative transcription:

OR[.—.]VM

All that remains of the third letter is the bottom of a rightward sloping diagonal. This is most likely to have been the bottom of the left leg of a capital A. Two letters are probably missing from the top two sectors. The fragment of a letter before VM is almost certainly the lower right-hand section of an angular G. The ending suggests that this is a Latin neuter singular. As Page proposes, this is presumably a form of the Latin (*h*)*orologium*, 'clock' or, in this case, 'sundial' (Page 1967, 291). He suggests that the spelling on the stone was probably ORALOGIVM and that the sixth sector contained both the letters G and I, side by side or with the I within the G. The latter is the more likely. The inscription is likely therefore to have read either OR[ALOGI]VM or OR[ALOG]VM. Although it does involve placing two letters in one sector, the spelling *oralogium* looks more probable. Furthermore, it seems to have been used in the tenth-century addition to the Leofric Missal (Warren 1883, 58).

J.H.

Text (*d*) consists of three characters. The first, reading left to right, could be the Anglo-Saxon rune 'æ', although in that case the stave is irregularly extended above the junction with the upper diagonal. It is in fact closer in appearance to the Scandinavian rune **o**. Page compared the second character to the variant of the Anglo-Saxon 'œ' rune found on the Thames scramasax (Page 1967, 290) and in some manuscripts. It is not, however, identical to the Thames rune, being rounded and not angular in form. It is closer in form to a Danish **m**, which appears commonly with rounded bows but is generally rather narrower in proportions than this character. The third character is a neat and well-formed Anglo-Saxon 'o' rune. This last character is sharp and neat, but the other two are less so. Indeed, the first is rather small and poorly executed. No obvious reading of this 'text' suggests

itself and it is quite possible that they were not all cut by the same hand. The asymmetrical placing of text (*d*) contrasts with the balanced layout of texts (*a–c*) and may indicate that all three characters were secondary.

J.H.; D.P.

The lettering of inscriptions (*a–c*) is well executed. The strokes of the letters are of even breadth. The letters either lack serifs altogether or are only very slightly seriffed. The lettering is somewhat elongated, especially in the densely packed texts of (*a*) and (*b*). Space is also saved in (*a*) and (*b*) by the use of ligatures (once in each). The forms of the capitals are Roman with the following exceptions: A with an angular cross-bar (as well as Roman A); angular C; M with vertical sides and a very shallow central 'V'; N with the diagonal meeting the verticals short of the ends (as well as the Roman form); and angular S. In addition, angular G was probably used in inscription (*c*). Old English *eth* appears both in the usual form as Roman D with a horizontal bar through the vertical, and as Roman D with a horizontal bar through the bow.

There is no word-division nor any use of points. A cross is used to mark the ends of (and to separate) texts (*a*) and (*b*). The texts are unabbreviated apart from the use of the Tironian symbol for *and* or *ond* in text (*b*).

J.H.

DISCUSSION Apart from the possible implications of the inscriptions, only the cabled moulding encircling the dial provides any hint as to the possible date of the stone. This has modelled strands, each with a median moulding of V-shaped section, precisely the form used on Little Munden, and on Walkern 2, both in Hertfordshire, Dartford 1 in Kent, and All Hallows by the Tower 1 in London, for most of which a late tenth- to mid eleventh-century date can be argued.

D.T.

*Inscriptions* The lettering (Ills 105–7) is similar to that at Breamore, Hampshire (Ills. 430–3), in the even line, the lack of serifs, the tall proportions, and the use of Roman forms with one or two angular variants. It is perhaps roughly contemporary with the lettering of Breamore, which was carved on an arch of the later tenth or earlier eleventh century.

There are several other inscribed stone sundials from pre-Conquest England, one at Bishopstone in Sussex (Ills. 6–7) and the rest in Yorkshire. Most (perhaps all) of these date from late in the Anglo-Saxon period. The majority of the dials are semicircular. The best formal parallels are provided by

---

1. The restorations *tǣcð* and *sēl*, and the interpretation which takes texts *a* and *b* together, were suggested by David Parsons.

the (probably eleventh-century) circular sundial at Aldbrough, Yorkshire, and the fragmentary dial of the later eleventh or early twelfth century at Stow, Lincolnshire. These dials have texts set in an annular framing field. At Aldbrough the text goes right round the dial, which was probably also formerly the case at Stow, and at both the feet of the letters point towards the centre (Higgitt in Lang 1991, 123, ill. 418; Okasha 1992a, 54, pl. VId). The dial at Leake, Yorkshire, also has an annular framing field part of which shows traces of what may have been lettering (Okasha 1971, 92, pl. 72).

The three partially comprehensible texts on this sundial are probably related to its function. The Latin texts can be compared to the one which runs across the top of the semicircular dial at Great Edstone, Yorkshire. This probably read '+ ORLOGIV[M V]IATORVM' (Higgitt in Lang 1991, 134–5, Ill. 453). In their incomplete state, the Old English texts (*a*) and (*b*) are more cryptic, but references to special knowledge and perhaps to computation (*tellan*) might have been thought appropriate on the new sundial. Both Great Edstone and Kirkdale, also in Yorkshire (Higgitt in Lang 1991, 164–6, Ills. 570–1) have texts that comment on the function of the sundials. The use of texts in both Latin and Old English is also found on the Great Edstone dial.

J.H.

DATE Tenth to eleventh century

REFERENCES (——) 1958, 1; Parsons 1958, 211; Wilson 1964, 70; Taylor and Taylor 1965–78, I, 476–8, fig. 231; Taylor and Taylor 1966, 23–5, fig. 11; Bowen and Page 1967, 287–91, pl. II; Hawkes and Page 1967, 2–3, 25; Page 1967; Okasha 1969, 28–9; Page 1969, 46; Okasha 1971, 105, pl. 99; Page 1971, 180; Page 1973, 15, 29, 134–5, 140; Tweddle 1986b, I, 84–5, 180, 187–8, II, 425–6, III, pl. 68a

OXTED, **1–2.** See Appendix A, p. 192.

# PAGHAM, Sx. (St Thomas-à-Becket)

## SZ 884975

### 1. Cross-arm                                        (Ills. 98–100)

PRESENT LOCATION On display in the church

EVIDENCE FOR DISCOVERY Found reused in fill of later medieval grave during controlled excavations in 1976

H.   12 cm (4.7 in)   W.   23.5 cm (9.3 in)
D.   10 cm (3.9 in)

STONE TYPE Pale greyish-brown, soft and porous limestone, with *Ditrupa*, bivalves, and foraminifera including *Orbitolites*; *Ditrupa* limestone, Calcaire Grossier Formation, Palaeogene, Tertiary; Paris Basin

PRESENT CONDITION Damaged and worn

DESCRIPTION Part of the arm and the ring of a ring-headed cross. The inner end of the arm is roughly broken, the break rising from right to left. The outer end is convex, the curve being continuous with that of the outer edges of the short surviving portions of the ring, each of which terminates in a rough break. The sides of the arms are concave, the curves being continuous with those of the inner edges of the ring.

*A (broad):* Bordered by narrow, plain, raised mouldings of indeterminate section, the face is decorated in relief with a flaccid, disorganised interlace.

*C (broad):* The decoration is largely defaced, but seems to have been similar to face A.

*E:* Narrow, plain borders carved in relief define a panel of what was probably four-strand plain plait, separated by narrow, undecorated zones from further, fragmentary, interlace.

DISCUSSION The fact that this piece is a ring-head serves to place it in the late pre-Conquest period. This type was introduced by Scandinavian settlers into England, from a source in the Celtic west or north-west (Collingwood 1927, 137–9, fig. 153; Bailey 1978, 178–9). The flaccid and disorganised nature of the interlace decoration may support this dating. Few cross-heads of this type occur in the south-east, but there is an example from

South Leigh, Oxfordshire (Ill. 406), and closely related types from London (St John Walbrook (Ills. 347–8) and All Hallows by the Tower 2 (Ills. 343–4)).

DATE Tenth to eleventh century

REFERENCES Freke 1981, 252–4, pl. II; Tweddle 1986b, I, 99, 250–1, II, 431–2, III, pl. 71–2a; Worssam and Tatton-Brown 1990, 56–7

D.T.

# PRESTON BY FAVERSHAM, K. (St Catherine)[1]

## TR 017607

### 1. Fragment of cross-shaft                    (Ills. 101–4)

PRESENT LOCATION Formerly on the sill of west window of south porch, not now locatable

EVIDENCE FOR DISCOVERY First recorded in 1895 (Robertson 1895)

H.   19 cm (7.5 in)   W.   12.5 cm (5 in)
D.   13.5 cm (5.3 in)

STONE TYPE Brownish-yellow (10YR 8/4), even-grained oolitic limestone, with ooliths mostly of 0.4–0.5 mm diameter, closely set in a hard calcite matrix, and with a few small shell fragments; Great Oolite Group, Middle Jurassic, of uncertain provenance (possibly Bath stone)

PRESENT CONDITION Heavily broken, but surviving carving only slightly worn

DESCRIPTION The shaft is square in section, tapers, and is roughly broken above and below.

*A:* There is a broad, plain, raised border along the upper, left-hand, and right-hand edges. The face is decorated with one unit and part of a second of half pattern C interlace. Two of the thick strands terminate in the upper corners of the face.

*B:* The borders resemble those on face A. Within is a panel containing half pattern A interlace.

*C:* There is a border to left and right, enclosing an interlace too worn to be identified.

*D:* There is a border to left and right enclosing the remains of an interlace, apparently half pattern C.

*E (top):* There is a deep drilled dowel hole in the centre of the upper end.

DISCUSSION The fragment formed part of a square cross-shaft built in sections. Presumably the dowel hole in the upper end facilitated the joining of the pieces. The very small size of this section suggests that it came from a position towards the top of a large shaft, or derived from a smaller cross, perhaps of memorial function. The restricted repertoire of decoration makes dating difficult, but the use of half patterns in the interlace is rare, being paralleled elsewhere in the region only at Reculver 1e (Ills. 119–20), which can be dated to the early ninth century. The well worked-out nature of the interlace patterns also point to an early date for the piece.

DATE Ninth century

REFERENCES Robertson 1895, 126, fig. facing; Cox and Johnston 1935, 247–8; Tweddle 1983b, 36–7, pl. XI; Tweddle 1986b, I, 95, 161–2, II, 432–3, III, pl. 72b-73

D.T.

---

1. The following is an unpublished manuscript reference to no. 1: BL Add. MS 37550, items 566–8.

# RECULVER, K. (St Mary)[1]

TR 228694

## 1a–e. Cross-shaft, in five pieces         (Ills. 111–20)

PRESENT LOCATION Canterbury cathedral crypt

EVIDENCE FOR DISCOVERY Probably found in 1876 when Hillborough church (TR 212680), built from materials of demolished Reculver church, was itself rebuilt; removed to Canterbury cathedral in 1949 ((——) 1949)

Fragment a: H.   38 cm (15 in)   W.   44 cm (17.3 in)
    Diameter (reconstructed) *c.* 53 cm (18 in)
Fragment b: H.   32 cm (12.6 in)   W.   25 cm (9.8 in)
    Diameter (reconstructed) *c.* 46 cm (18 in)
Fragment c: H.   29.5 cm (11.6 in)   W.   23 in (9 cm)
    Diameter (reconstructed) *c.* 46 cm (18 in)
Fragment d: H.   30 cm (11.8 in)   W.   28 cm (11 in)
    Diameter (reconstructed) *c.* 46 cm (18 in)
Fragment e: H.   29 cm (11.4 in)   W.   26 cm (10.25 in)
    Diameter (reconstructed) 38 cm (15 in)

STONE TYPE Greyish-white, finely granular limestone; some stones include moulds of gastropods and bivalves, and all except fragment c include Serpulid worm tubes; *Ditrupa* limestone, Calcaire Grossier Formation, Palaeogene, Tertiary; Paris Basin

PRESENT CONDITION Surfaces damaged and worn

DESCRIPTION Each fragment forms part of the drum of a cylindrical shaft. All except fragment d retain traces of paint.

Fragment a: Dressed flat below, but broken above and to the rear. The decorated face is divided into four fields (numbered (i)–(iv) from left to right) by three damaged, vertical mouldings originally of square section. These are rebated to take narrow, rectangular, metal fittings. The median moulding also has two pairs of pin holes. Only a marginal undecorated fragment of field (i) survives. In field (ii) is a frontally placed robed figure, surviving from waist level to just below the knee. The left leg is bent at the knee, the right leg is straight. The figure's left hand is held at waist level, and it wears a long robe, over which is a shorter garment falling in a series of folds from left to right, with a portion of it falling in a series of vertical folds

beside each frame. In field (iii) the figure is similarly posed, and survives from mid-torso to just below the ankle. The figure is robed like that in field b, but the full-length robe stops just above the ankles which are bare. The shorter overgarment is gathered up across the body and the end flung over the left arm of the figure to fall vertically beside the frame. The folds of the garment across the body are suggested by incised lines, and where the robe falls over the arm its edge is paralleled by a pair of incised lines. The left hand of the figure is held at waist level and holds a partially open scroll. The fragmentary field (iv) contains part of a similar frontally-placed robed figure, with portions of its robe falling in vertical folds beside the frame. Traces of paint survive, often applied on a thin plaster ground. Red is used for the background with a dark blue on the robes of the figures. In some cases vertical folds are alternately red and blue.

Fragment b: Dressed flat above and below, and broken to each side so that it roughly tapers. A curved moulding of square section runs along the right-hand edge of the drum before running off towards the mid-point of the lower edge. To its left are three small rounded hillocks diminishing in size from right to left, on which stands a robed, barefoot figure, cut off at shoulder level and incomplete to the left. The figure is half-turned to the right, with its left leg bent at the knee, and the foot, in profile, placed on the largest of the hillocks. The right leg is straight, and the foot placed frontally on the smallest of the hillocks. The heavily-damaged right arm of the figure is raised, and the left arm is held out straight, with a hole drilled through the palm of the hand. The figure wears a long robe reaching down to mid-calf level, and with a folded hem. Over this is a shorter robe reaching to the knee and having a straight hem. There is a sash at the waist, and a fold of the garment is draped over the left arm. A second fragmentary, robed, barefoot figure stands on the ground to the right, and leans to the left, behind and beyond the frame. The figure wears an ankle-length robe which has a folded hem. In the ankle is a drilled hole. Traces of paint survive, often applied on a thin plaster ground. Red is used for the background, blue for the robes.

Fragment c: Dressed flat above and below, and roughly broken to each side. It is decorated with a barefoot,

---

1. The following are unpublished manuscript references to no. 1: BL Add. MS 47695, fol. 72v; Canterbury cathedral Library MS U3/99/28/1.

robed figure, in profile, cut off at chest level, and leaning to the right with its left foot flat on the ground and its right foot half raised. The figure wears a long robe terminating at mid-calf level in an undulating hem which is paralleled by an incised line. Over this is a second robe of similar length gathered across the body to the right, incised lines suggesting the folds. The figure is winged. In front of the figure is a plain rectangular block on top of which is a swirling device, possibly a flame. A hand, palm outwards, develops from the lower right in front of the block. To the left of the figure is the garment edge and part of the wing of a second figure. Between the two figures, at thigh level, is a disc-shaped object. Traces of paint survive, often applied on a thin plaster ground. Red is used for the background, blue for the robes.

Fragment d: Dressed flat above, below, and to the right, but roughly broken to the left. The face is divided into two unequal fields by a three-quarter round column, the damaged capital of which is decorated with a large, upright, veined, serrated leaf. Incised lines suggest the veins. From behind this a volute emerges to the right. The capital is damaged to the left. In the smaller field to the left is an incomplete, bearded, robed figure, with its long hair falling onto the right shoulder. The figure is cut off at mid-calf level, and is damaged to the left. It looks and is half-turned to the right, with the left leg bent at the knee. The left arm rests on the waist, and the damaged right arm, bent at the elbow, is raised across the right side of the body. The figure wears a full-length robe, over which is a knee-length garment. The folds over the body are suggested by incised lines. Part of the robe is flung over the left shoulder of the figure and falls beside the flanking column to mid-thigh level. In the field to the right only the head of the figure survives, placed frontally and turned slightly to the left. Over the head is a cloth. The eyes are drilled.

Fragment e: Dressed flat above and below, but roughly broken to the left and right. The face is divided into two unequal and incomplete fields by a wide, vertical interlace border of half pattern D, flanked by mouldings of square section. This unites with a horizontal interlace border along the upper edge of the drum. The plain mouldings are returned to parallel the upper edge of the drum. In the fragmentary field to the left only a wing survives, curving round in the upper corner of the panel and carried down beside the plain moulding to the right to terminate in a point near the lower edge of the stone. There is a rectangular figure at waist level. In

the field to the right the plain binding of the stem of a plant-scroll enters from the lower right, and from it emerges a stem which is carried across to touch the plain frame before curling back on itself and being brought round to touch the binding again. Here the tip curls to the right, and the stem terminates in a single-lobed, pointed leaf, with incised lines suggesting the veins. The back of the leaf rests on the binding. The stem encloses a frontally-placed bust with curly hair, and with the eyes outlined by incised lines and having drilled pupils. The bust is clothed in a round-necked garment, with an incised line paralleling the opening. Over the shoulders is a cloak from behind which the left arm emerges. The hand is placed palm inwards on the right breast. On the shoulders of the bust rest groups of narrow, expanding leaves developing from the encircling stem. Below a similar group of leaves emerges from the binding to curl down and over the head of a second bust, like the first, but cut off at nose level. In the angle between the upward and downward curling stems a small stem issuing from the binding is carried across to touch the frame before curling up and over to terminate in a leaf like that on the end of the upper main stem. A similar leaf lies next to the head of the lower bust, and to its right. There are extensive traces of a plaster ground. The background areas are painted red.[2]

DISCUSSION A detailed analysis of the art-historical context and date of the fragments certainly or probably deriving from Reculver is contained in the Introduction (see Chap. VI). The present discussion confines itself to addressing the problems of their relationship to one another. The lost fragments (nos. 2–3) as well as the stone catalogued in the present volume as Canterbury Old Dover Road 1, for which a Reculver origin has been claimed, are thus also discussed. It considers how many of these may have originally belonged to a single monument, the form this may have taken, and whether it can be identified with any of the descriptions of a cross at Reculver known from early documentary sources. Crucial to this last point is the iconography of the existing fragments, which is considered here in detail. Three criteria may be employed to establish the relationship between these fragments: the style of the figural decoration, both as regards the treatment of human bodies and the handling of draperies; the technique of

2. An examination of the paint deposits on Reculver 1a, 1b, and 1e, by J. K. Dinsmore and W. A. Oddy of the Conservation Department at the British Museum, was published as an appendix to Tweddle 1990, 154–6. Subsequent analysis suggests that the red pigment may be a lead oxide (Eds).

carving; and the geological composition of the stone from which they are carved. In analysing the style of the figure decoration two major factors merit discussion; the treatment of the bodies of the figures, and the handling of the draperies.

In her discussion of the treatment of the bodies on the Reculver fragments Kozodoy has isolated several features which she believes link 1a–e and separate Canterbury Old Dover Road from them. The most important of these features is the stance of the figures. On stones 1a, 1d, and the Canterbury piece, the figures have legs bent at the knees, whether, as on 1a and at Canterbury, they are frontally placed, or, as on 1d, half-turned to one side, possibly a misunderstanding of Classical *contrapposto* (Kozodoy 1976, 111–2). A version of this stance is used also on 1b in the ascending figure, and on 1c in the forward leaning figure. In both cases the weight of the body is carried on the figure's right leg, and the left leg is flexed. This is quite straightforward, but Kozodoy's analysis of stance breaks down when she attempts to separate the Canterbury fragment from the others on the basis of the assurance of its handling. She argues that on the former alone the figures are 'rendered with assurance', with 'subtle variations of axis.' For example on the left-hand figure she suggests that the head is turned to the right, the shoulders to the left, with the right shoulder slightly raised, and with the lower torso back to the frontal position again (ibid., 113). The poor condition of the figure makes these conclusions difficult to accept (Ills. 108–10). So great is the damage that it is not clear whether the head turns to one side, or is placed frontally, nor can a turning of the shoulders to the left be discerned. The right shoulder does have more bulk that the left, but this arises from the fact that the robe is gathered up over this shoulder, as on stone 1d. Indeed the most likely interpretation of the figures on the Canterbury fragment is that they are simply frontally placed as on stone 1a.

Kozodoy also uses specific features to link or divide the stones, including the shape of the heads, the size of the hands, and the treatment of the lower legs and feet. She points out that the head shape used on stones 1d and 1e is one in which there is a 'full, rounded jaw and cheeks, a low forehead, drilled eyes and a slightly flat-topped head shape' (ibid., 106). Most of these features are not diagnostic; they are the natural attributes of the human head. Drilled pupils to the eyes are so commonplace in sculpture that they cannot be considered a stylistic trait. Kozodoy's character-isation of the foreheads at Reculver is equally perplexing. A simple comparison of the overall length of the face with the distance from the eyes to the crown of the head yields a ratio of 1:3 on stone 1d and 1:5 on stone 1e; one figure has a high forehead and one a low forehead.

Stones 1a and 1c are linked by Kozodoy as she notes that they have the same stiff hands, which are small in proportion to the body (ibid., 109). Again this is a difficult argument to substantiate. The only way in which the hands could be characterised as small or large would be to establish the proportions in nature, and apply the same standards to the sculpture. Given the damage to the stones this is difficult, but on stones 1a and 1c the clenched hand holding the scroll can be compared with the length of the leg from hip to knee, which survives on both figures. On stone 1a the ratio is 1:4; on stone 1c, 1:3. In nature the ratio varies between 1:3 and 1:4. The hands, therefore, cannot be regarded as under-sized. In addition the term 'stiff' used by Kozodoy to characterise the hands is nowhere defined.

Kozodoy also links stones 1b and 1c since they have similar treatments of the lower legs and feet (ibid., 111–2). Here she is undoubtedly correct. On both stones 1b and 1c the lower legs of the figure are given roundness and solidity and in each case also one foot is shown in profile, and the other foreshortened to a greater or lesser degree. This naturalistic positioning of the feet is extremely difficult to achieve in stone, and the high degree of accomplishment shown on both stones 1b and 1c might serve to link them together. In contrast Kozodoy notes that on the Canterbury piece the figures have less of the lower legs exposed, and that the best preserved figure seems to stand on tip toe, a stance radically different from the naturalistic poses on stones 1b and 1c (ibid., 112). Full acceptance of this argument is, however, prevented by the degree of damage to the feet of the figure on the Canterbury fragment. This is so extensive that it is difficult to envisage the original appearance of the figures (Ills. 108–110).

In summary, the irreducible minimum which can be gleaned from a consideration of the body styles is that all the figures on the Reculver fragments are naturalistically treated, the figures being well proportioned. Except on stone 1e they all exhibit a version of Classical *contrapposto*. Difficult problems, such as the proportioning and positioning of the hands and feet, are successfully tackled, and in particular this seems to link stones 1b and 1c. Other features of the figure style defined by Kozodoy seem to be unreliable guides as to whether the stones are from one or more monuments.

Turning to the drapery style, Kozodoy has pointed out that a number of different styles are employed on the Reculver fragments, indeed in some respects the drapery style employed on each fragment is unique (ibid., 113–4). Kozodoy argues, however, that there are features which link the drapery styles of stones 1a–d, and which separate them from Canterbury Old Dover Road 1. In the case of stone 1e the features of the draperies are too few for meaningful discussion.

In her basic analysis of these drapery styles Kozodoy is undoubtedly correct. On stone 1a the draperies have distinctive zig-zag edges falling in cascades of folds on either side of the figures, and across their legs. The folds are crisp and angular, but not mechanically repetitive. The folding of the garments across the body is indicated by a series of closely-spaced, almost parallel pleats. There is an open hem at mid-calf level, which like the other edges of the garment is paralleled by an incised line. On stone 1b the draperies are in poor condition but are characterised by a series of long, almost parallel folds where the garment is folded over the body, a handling similar to that on stone 1a. On stone 1b, however, the only zig-zag folds are employed on the open hem of the garment, which again finishes at mid-calf level. The draperies of stone 1b thus have points of comparison with those of stone 1a, although they are more restrained. On stone 1c the form of the draperies is similar, any minor difference arising out of the different stance of the figure compared with those on stones 1a–b. Again the drapery is arranged over the body in a series of fine folds. Here they are not parallel but radiate from the out-stretched hands of the figure. As on stones 1a–b the hem is open, paralleled by an incised line, and is at mid-calf level. The hem is arranged in a series of gentle, wholly naturalistic folds, which closely resemble those on stone 1b.

On stone 1d again damage is extensive but the main features of the drapery style can be discerned. To the right of the left-hand figure there is a zig-zag cascade, although this feature is less prominent than on stone 1a. On stone 1d, as on stones 1a–b, there are almost parallel folds of the garment over the body. It is the treatment of the hem of the garment, however, which separates it from stones 1a–b. Here the hem, again paralleled by an incised line, forms a hood over the flexed knee; instead of the hem being arranged in a series of zig-zag folds, it forms a series of loops which defy gravity, the only non-naturalistic feature displayed by these draperies.

This slightly non-naturalistic treatment of the hem line is a feature which recurs on the Canterbury fragment. Here the hem of the overgarment falls from right to left. At the lower left the edge is curled up to form a volute to the side of the figure (Ill. 109). The open hem of the undergarment has a single central fold on the front edge, and to the left again tends to curl out and up. This is not such a pronounced feature as the similar curl in the hem of the overgarment (Ills. 108, 110). Apart from these features the draperies on the Canterbury fragment differ from those on stones 1a–b and d in that the overgarment does not have the series of diagonal, almost parallel pleats across the body; instead the bulk of the folds in the garment fall centrally between the figure's legs. Moreover, the hem line on the Canterbury stone is placed unusually low, just above the ankles, not at mid-calf level as elsewhere. Unfortunately its very poor state has obscured further detail of the draperies.

In the draperies of the figures on the Reculver fragments a number of different styles can be discerned. The differences between them, however, are for the most part not great, and they can best be regarded as variations on a theme. This treatment can be characterised by its wholly naturalistic style. Open hems paralleled by incised lines and falling to mid-calf level are used consistently, as are close almost parallel folds over the body, serving to emphasise the pose. Zig-zag folds are used for hems, and occasionally for cascades of fabric. These features link stones 1a–c. The dress on 1d has a slightly non-naturalistic treatment of the hem, but this is not enough to separate it from that seen on the other stones. On the Canterbury fragment this non-naturalistic treatment of the hem, and the fact that here alone it falls to ankle level, are features which have lead Kozodoy to separate it from the others (loc. cit.). This may be justified, but, as noted above, stone 1d also has a non-naturalistic hem which similarly defies gravity, the difference between the two stones is one of degree.

As shown above (pp. 153–4), there is a certain variety of style among the different Reculver fragments and it is difficult to establish whether this variety is sufficient to separate one or more stones from the group. An analysis of the sculptural techniques may contribute towards this discussion, since it is evident that four different techniques are used on the Reculver fragments. On stone 1a the figures are in high relief of up to 3 cm, with great variation in relief apparent in the profiles. These are characterised by a series of humps separated by deep hollows, sometimes cut down to the same level as the flat background. There is also a little undercutting, not evident on the profiles, particularly on the zig-zag

folds on the edge of the garment. This technique yields figures with a well modelled, plastic appearance (Ills. 115–17). On stones 1b–c the relief may again be as high as 3 cm, but is more often of the order of 1 cm. There is little variation in the relief visible in the profiles, the deep hollows characteristic of 1a being absent. The figure sculpture of stone 1b–c, therefore, has a flat, shallow appearance (Ills. 116–18). It is to this group that the technique of the busts on stone 1e apparently belongs (Ills. 119–20). On the Canterbury fragment the figures are in uniformly high relief of up to 3.5 cm. There is little variation in relief apparent in the profiles, but there is deep undercutting both on the figures and the dividing columns giving an almost three-dimensional effect to the sculpture (Ills. 108–9). On stone 1d the techniques of stones 1a and the Canterbury fragment are apparently combined. The profiles have the humped and hollowed appearance characteristic of stone 1a and also the heavy undercutting of the Canterbury stone, particularly around the heads of the figures, and on the dividing column (Ills. 111–12).

The interpretation of this use of four different sculptural techniques presents a number of problems. It is possible that this indicates that the stones were derived from different monuments, stones 1a, 1d, and the Canterbury fragment from one, and stones 1b–c and 1e from another. Alternatively, these different sculptural techniques may indicate that more than one hand was employed on a single work. Equally, the stones could all be the work of a single sculptor, the differences in technique perhaps reflecting a growing assurance in handling, with the sculptor moving from the flat technique of stones 1b–c to the more plastic technique of stone 1a, and then to the almost three-dimensional technique of the Canterbury fragment. It does, however, seem unlikely that such accomplished work was in any way experimental, and it is more likely that the sculptor varied his technique according to the subject matter. A flat technique, for example, is employed for the narrative scenes where the emphasis is on the action. On stone 1d and the Canterbury piece a three-dimensional technique more appropriate to the architectural settings may have been selected. Alternatively, the technique might be related to the height and, therefore, distance from the observer of the various drums.

In his original publication of the Reculver fragments Peers reported that the stone of the cross-head (no. 3), discovered in his own excavations, was of continental origin, either from Italy or, more probably, France (Peers 1927b, 254). Unfortunately

since the cross-head is lost this conclusion cannot be tested. However, it does fit with the geological work undertaken by Worssam (above pp. 138, 151) who reports that all of the surviving drum fragments are of foraminiferal limestone with Ditrupa from the Calcaire Grossier (Middle Eocene) of the Paris basin. Presumably the material was reused Roman stone. This new and conclusive work contradicts the attempt by Kozodoy to separate Canterbury Old Dover Road 1 from the remaining fragments on the grounds that it is of Kentish Rag, not limestone (Kozodoy 1976, 22, 93, 180; eadem 1986, 76, 82).

The evidence presented above suggests that stones 1a–d and Canterbury Old Dover Road 1 derive from the same monument, particularly as there is some evidence that the latter, which was discovered in Canterbury, was brought there from Reculver (see Canterbury Old Dover Road 1, Evidence for Discovery). Stone 1e is more difficult to place as its decoration is very different from that of the other fragments. It is so closely related to them stylistically, however, that it probably derives from the same monument, as does the lost fragment (no. 2). There is no conclusive evidence that the lost cross-head (no. 3), formed part of the same monument as the other fragments, but Peers' geological identification of the stone from which it was made is consistent with it having formed part of the same monument, and, as noted below, it must be of very similar date to the drum fragments.

Starting from this basis, the monument from which these pieces came was evidently made up from several drums dowelled together. The precise number depends on whether stones 1d and the Canterbury fragment, which have a similar height, are regarded as representing two sections of the same drum or two different ones, and similarly, whether the two narrative scenes (1b–c) should be seen as deriving from a single drum or from two different ones. The difference in sculptural technique, described above, proves that stone 1d and the Canterbury fragment are from separate drums, as does the occurrence of the guilloche on the underside of the latter (Ill. 109), but not on 1d. The radical differences in subject matter between the two narrative scenes (see below) suggest that they also are more probably from separate drums. This produces a shaft made up of seven drums, allowing for the decoration of stone 1e to continue on to another drum, or six drums if 1e represents only a single drum. The maximum original length of this reconstructed section of the shaft is 2.5 m. If the drums are arranged in descending order of diameter

and then height (as is the case, for example, with the shaft from Wolverhampton, Staffordshire), this would produce a monument which is slightly stepped, a feature which is inherently improbable and unparalleled elsewhere in Anglo-Saxon sculpture. However, the steps are so small, of the order of 7 cm, or 3.5 cm at each side, and the difficulty of accurately reconstructing the diameters of the drums is so great, that it is possible to reconstruct the shaft with a fairly uniform taper, regarding the steps as the products of inaccuracies in measurement. Alternatively, extra drums might be postulated where the steps occur, which suggests a monument with as many as 10 or 11 drums and standing $c$. 4 metres high. A third possibility is that there was at least one of the smaller drums beneath stone 1a, producing a column or shaft with entasis. If either stone 1d or the Canterbury fragment was regarded as the lowest drum, followed by 1b, 1a, and either 1d or the Canterbury fragment, then a column with an alternating scheme of standing figures and narrative scenes might be envisaged. None of these reconstructions allows the guilloche on the underside of the Canterbury fragment (Ill. 109) to be visible. As this was surely meant to be seen, the original Reculver shaft must be reconstructed with this stone projecting, perhaps with the stones arranged in the ascending order 1a–e, followed by the Canterbury stone at the top. The order of stones 1b–d is not fixed, as they have the same diameter, and at least one further drum is necessary to accompany stone 1e, as noted above. This arrangement would allow the Canterbury stone to project by 4 cm, thus fully revealing the guilloche.

In all of these alternative reconstructions the Reculver shaft is viewed as of circular section for the whole of its height. This is a type of monument which is uncommon in Anglo-Saxon sculpture, but which does occur, most notably at Wolverhampton, where the columnar monument is perhaps a work of the tenth century (Cramp 1975, 187–9, pls. XVI–VIII). A similar form may be argued for the Masham shaft; the reconstruction proposed by Collingwood (1927, 6–7, fig. 13) in which there is an upper portion of square section produces a monument of immense and improbable size. It seems likely that at Reculver, Wolverhampton, and Masham, Roman columns have simply been recycled, but it is possible that such monuments were made *de novo* in south-east England. Fragments of round shafts from south-east England may also have come from columnar monuments; there are fragments from Winchester (Priors Barton 1 and High Street 1), and Wantage, Berkshire. They may,

however, have had upper portions of square section, as is argued for the shaft from St Augustine's abbey, Canterbury (no. 1). Exactly how the monument may have been finished at the top remains entirely unclear. It may have tapered to a cross-head, or alternatively, like the Wolverhampton shaft, it may have supported a capital, perhaps with a cross-head on top of that.

Having established the likelihood that the surviving fragments belong to a single monument and explored their possible relationships to each other, their iconography will next be analysed, since this is an essential preliminary to considering the relationship of these stones to the monument recorded at Reculver in early documentary sources.

The diameter of the drum of stone 1a was originally of the order of 53 cm, allowing space for at least six figures around the circumference. Kozodoy has equated this drum with that on a cross seen in $c$. 1540 at Reculver by John Leland (see further below, p. 160) and described by him as decorated with the figures of Christ with Saints Peter, Paul, James and John (Kozodoy 1976, 39; eadem 1986, 70). The figure holding a scroll is identified as Christ since he often has this attribute, emphasising his role as a teacher. However, it is not certain that the figure carrying the scroll was the only one in the range originally to do so. This may have been the case, but three figures are entirely lost and another figure is extensively damaged. However, the fifth figure has the left hand intact and does not carry a scroll. Kozodoy, following Beckwith (Beckwith 1968, 8), has further identified the figure on the right-hand side of the putative Christ as St Peter, because of its position (Kozodoy 1976, 39–40; eadem 1986, 70). This identification is over ambitious, both because of the uncertainty over the identification of the supposed figure of Christ, and because the suggested figure of St Peter carries no identifying symbol. It is possible that the figures represent Apostles or Prophets.

Peers has suggested that the metal fittings, now lost, on the mouldings separating the figures originally carried inscriptions identifying them (Peers 1927b, 251). Such inscriptions commonly occur on the frames of narrative scenes in manuscript art, beginning in the Late Antique period, as in the St Augustine Gospels (Weitzmann 1977, pls. 41–2). From such works the feature was transmitted into Carolingian art, as in manuscripts of the Tours school (Kozodoy 1976, 45–6), and from both sources into Insular art. Inscriptions are found, for example, in the early tenth-century Anglo-Saxon miniatures added to the Aethelstan Psalter, which are based, at least in part, on

Late Antique exemplars (Temple 1976, 37). In these examples the text is usually placed horizontally; it is more difficult to find a precise parallel for the placing of such texts vertically between standing figures, but on the front of the eighth-century Anglo-Saxon reliquary from Mortain there are three figures separated by plain frames bearing vertical inscriptions identifying them (Okasha 1971, no. 93, pl. 93; Webster and Backhouse 1991, no. 137). Vertical inscriptions flanking standing figures and identifying them occur also on the St Cuthbert stole and maniple, although they are less rigidly organised than on the Mortain reliquary (Battiscombe 1956, pl. XXIV). The lost metal strips from Reculver may have carried similar inscriptions; alternatively, they may have been purely decorative. The hole in the hand of the figure on stone 1b may also have been the point of attachment for an element, such as a scroll or staff made in another material, probably metal. Below and to the right the scene is enclosed by a curved moulding of square section rebated to take a metal fitting, as on stone 1a possibly originally bearing an inscription.

The scene on stone 1b is evidently narrative (Ill. 116) and has usually been identified as the Ascension (Taylor 1968, 292–3; Beckwith 1968, 18; Kozodoy 1976, 48; idem 1986, 71–3). There are several iconographic variants of the Ascension in late Classical and early medieval art, but one of the most usual ways of portraying the scene in western art is for the figure of Christ to be shown in profile striding up a low hill and grasping with his hand the outstretched Hand of God issuing from a cloud. As Taylor has pointed out this is the iconographical scheme employed on the fifth-century ivory in the Bayerisches National-museum, Munich (Taylor 1968, 292–3) and it is common in western art from that date, for example, in the Drogo Sacramentary (loc. cit.; Hubert *et al.* 1970, pl. 146). However, it is evident that the Reculver scene cannot be derived solely from this iconographical type, since there is a frame held by a second figure to the right. Kozodoy has suggested that these two elements derive from a second iconography in which Christ floats above the ground, standing or striding upwards within a mandorla which is supported by angels (Kozodoy 1976, 53; 1986, 72–3). This type is represented first in the sixth century, as in the Rabbula Gospels (Weitzmann 1977, pl. 36), and on some of the sixth-century Palestinian ampullae from Monza (Grabar 1969, pls. 194 and 275) and Bobbio (ibid., pl. 319); it is usually regarded as being of eastern origin (Dewald 1915, 282), but was widely influential in western art. In

Anglo-Saxon art the type occurs in the early tenth-century additions to the Aethelstan Psalter on fol. 120v (Temple 1976, no. 5, ill. 31), and in the late tenth-century Benedictional of St Aethelwold on fol. 64v, although here the supporting angels have been virtually suppressed (ibid., no. 23; Rice 1952, pl. 50b). The Reculver scene might thus represent a conflation of the two iconographic traditions of portraying the Ascension current in the west.

Although this interpretation of the iconography of stone 1b is attractive, it cannot be uncritically accepted. Because the central figure of the scene is incomplete, the features which would normally serve to identify it as Christ (the cruciform nimbus and long-stemmed cross held in the left hand) are lost. Moreover the extensive damage to the area of the supposed Hand of God makes it impossible to be sure that this is what the feature was. The identification of the figure to the right also remains problematical, particularly as the relationship between it and the suggested Hand of God is unclear. If the putative Hand of God forms part of this figure, then it could be identified as God the Father. The Father is occasionally portrayed in early medieval art, as in the illustration to *Psalms* 18, 6–8 in the Stuttgart Psalter, made *c.* 820–30. Here Christ is depicted as striding up a low hill and grasping the Hand of God who is placed horizontally, appearing from a cloud bank along the upper edge of the miniature (Dodwell 1971, 42). At Reculver doubt is cast on the identification of the right-hand figure as God the Father by the fact that the putative figures of Christ and God the Father are of radically different size. This might be held to imply a difference in status, thus smacking of heresy. If this interpretation is rejected, then the figures at Reculver might represent a man and child, possibly even Abraham and Isaac who, as will be argued below, are depicted on 1c.

Beckwith identified the scene on fragment 1c (Ills. 117–18) as the Baptism of Christ. The hand in front of the block-like feature at the bottom right of the fragment would then, he suggested, belong to a river personification (Beckwith 1968, 18). Alternatively, he suggested that the scene may represent the raising of Lazarus (loc. cit.). Kozodoy has rightly pointed out that both of these interpretations disregard the fact that the leaning figure is apparently winged, and must, therefore, be an angel, not John the Baptist as in a baptism scene, or Christ as in the raising of Lazarus (Kozodoy 1976, 71; eadem 1986, 73). The block-like feature to the right is also absent from the known iconography of these two scenes. Instead, Kozodoy has

interpreted the scene as a crucifixion (ibid., 71–3, fig. 87; eadem 1986, 74–5, fig. 1). This explains the block-like feature as one arm of the cross, with the outstretched hand of the crucified Christ in front of it. The forward-leaning angel could then be explained as one of a pair flanking the head of the cross, a usage widely paralleled in Late Antique, Carolingian, and Anglo-Saxon art, as, for example, on the crucifixion panel from Romsey, Hampshire (no. 2; Ills. 453, 455). The identification of this scene would also fit well with the suggested Ascension on stone 1b, the two scenes forming part of a sequence depicting the Passion, Resurrection and Ascension of Christ.

Such an ingenious identification raises a number of problems particularly in the shape and proportion of the elements of the supposed cross as reconstructed by Kozodoy. In this reconstruction the horizontal limbs of the cross, whose shape is fixed by the surviving block to the right on stone 1b, are unusually wide in proportion to their length. Moreover, the horizontal section of the supposed left-hand cross-arm is abnormal, having a markedly triangular profile, with the apex of the triangle lying close to the left-hand end of the arm. This is a feature which is unparalleled elsewhere in pre-Conquest sculptures of the crucifixion. In addition Kozodoy has been forced to propose that the head of the cross was vestigial, as the space between the two putative angels would be extremely small. The position of the figure of Christ on the cross would also be unusual in having the arms sloping sharply upwards towards the shoulders, an angle fixed by the remains of the arm on stone 1b; in Kozodoy's reconstruction the angle of the arm is lessened (ibid., fig. 3). Like the vestigial head of the cross this is a feature which it is difficult to parallel elsewhere.

The positioning of the angels flanking the cross-head in Kozodoy's reconstruction is also disquieting. In the parallels for this arrangement cited by her the angels stand on the upper edges of the cross-arms, and face inwards; they are normally smaller in size than the crucified figure of Christ. In Kozodoy's reconstruction the angels stand next to the ends of the cross-arms, on what is evidently an undulating ground surface, and are apparently larger than the figure of Christ. Kozodoy has explained this apparent discrepancy by suggesting that the hand, which is all that survives of the putative crucified Christ, is portrayed as small in scale compared with the figure to which it originally belonged, as are the other hands on the Reculver fragments. This is not a convincing argument: on stones 1a–e only two hands survive in a good enough

condition for such a comparison to be made. On stone 1a (Ills. 113, 115) careful measurement reveals that the hand is in perfect scale with the figure; on stone 1e (Ills. 119–20) the hand is if anything proportionately larger than in life. A final difficulty in accepting Kozodoy's reconstruction of the scene on stone 1c is that, for the cross to be reconstructed successfully, the lower limb must have projected onto another drum. On most of the other fragments from Reculver the decoration is confined to a single drum. Only on stone 1e did the decoration continue onto the drum below. Stone 1e, however, stands out from the other drums in that it is decorated with panels of plant ornament within interlace borders, not the figural scenes used consistently elsewhere.

Kozodoy's reconstruction of the scene on stone 1c as a crucifixion, therefore, requires the acceptance of a number of novel features: in the proportions of the cross, the placing of the figure of Christ, the handling and positioning of the flanking angels, and in the disposition of the scene over two drums. Individually any of these oddities might be possible, together they are more difficult to accept, and it is apparent that an alternative explanation for the scene is necessary. One possible interpretation is that the scene represents the Sacrifice of Isaac. The leaning figure could then be identified as the angel intervening to prevent Abraham striking the fatal blow. The block to the right could plausibly be identified as an altar. In this interpretation the swirling feature on top of it would not be an element of the angel's drapery, as suggested by Kozodoy (1976, 70, 79), but a flame on the altar. The hand developing from the right would fall into place as that of the kneeling Isaac. This interpretation has the merit of explaining several of the aberrant features in Kozodoy's reconstruction, but there are some objections to it. The most important of these is presented by the supposed angel to the left, a figure which was rarely portrayed in this scene in early Christian and medieval art, although it does occur, for example, on two late antique ivory pyxes (one of sixth-century date) in the Museo Terme, Rome (van Woerden 1961, 246, fig. 10), and another of sixth- or seventh-century date in the British Museum (ibid., 246). It was also more usual for Abraham to be placed on the left of the altar, not on the right as proposed here. Similar divergences from the normal western iconography are, however, encountered on the Ascension scene on stone 1b, and are, therefore, perhaps not out of place here.

The diameter of the drum of fragment 1d was originally *c.* 46 cm, allowing a possible eight or nine

original figures. The precise identification of these figures is problematical (Ills. 111–12). Of the two surviving figures, only the head of that to the right survives, and this has a veil or cloth over it with an incised nimbus behind. Kozodoy has suggested that it must, therefore, represent the Virgin (Kozodoy 1976, 83; eadem 1986, 75). This is a plausible suggestion as the Virgin is the most commonly portrayed of the female saints in early Christian and medieval art, but there are possible alternatives. The figure to the left is male, bearded, and clad in a *pallium* and *tunica*. The use of Classical dress suggests that he is one of the Apostles or Old Testament prophets, as these are normally portrayed clad in Classical dress. The figure is holding something in his left hand. Kozodoy has suggested that this long narrow feature might be an axe or mallet (Kozodoy 1976, 83; eadem 1986, 75). Neither of these interpretations is satisfactory, and the simplest explanation is that the object is a scroll, often carried, in particular, by the four Evangelists.

The eight or nine original figures are too few for the Apostles, and the Virgin would be out of place in such a scheme. A more likely alternative is that the drum was decorated with the figures of the four Evangelists, plus accompanying figures. However, Kozodoy has pointed out that the figures on stone 1d are not frontally placed and static, but instead face each other and appear to converse. The figures could, therefore, form part of a narrative scene rather than of a static series (Kozodoy 1976, 85–6; eadem 1986, 75). The setting of narrative sculpture within a range of columns can be paralleled in early Christian art, as on the fifth-century ciborium columns from St Mark's, Venice (Kozodoy 1976, 85); and in Anglo-Saxon art on the late eighth-or early ninth-century slab from Hovingham, Yorkshire (Collingwood 1927, 42–3, fig. 54). Even if this suggestion is accepted it makes the identification of the figures no clearer and it should be admitted that there is too little evidence for any satisfactory analysis of the iconography of this drum.

The decoration of stone 1e, with its borders filled with interlace and its panel of inhabited plant-scroll, differs radically from that of the other, exclusively figural, fragments (Ills. 119–20). The inhabited scroll is a straightforward Hellenistic motif, and the busts within the scroll are probably not intended to represent particular figures. In the left-hand panel the remains of a wing and an edge of drapery suggest that it was originally filled with a frontally-placed angel. The rectangular feature at waist level has been interpreted as a book by Kozodoy (Kozodoy 1976, 96; eadem 1986, 77). Stone 1e is 38 cm in diameter and

could plausibly have been decorated with four narrow, rectangular panels enclosed within interlace borders. Kozodoy has suggested that the panels were short and fitted onto a single drum of which stone 1e forms the cut-down remains (Kozodoy 1976, fig. 89; eadem 1986, fig. 2). This is possible, but it is equally plausible that stone 1e survives to its original height, and that the decoration continued onto one or more drums. Certainly in Anglo-Saxon art vine- or plant-scroll was normally used in long panels. It is possible, as Kozodoy suggests (loc. cit.), that the interlace along the upper edge of stone 1e merely paralleled the edge, but it can be equally plausibly reconstructed as extending upwards onto another drum, forming the vertical border between two further rectangular panels. Not enough evidence survives for any reasoned choice between these various alternative reconstructions.

The diameter of the drum of Canterbury Old Dover Road 1 was probably originally *c.* 46 cm in diameter, allowing space for eight to ten figures around the circumference. The two surviving figures are frontally placed and clad in Classical dress (*tunica* and *pallium*) and can probably therefore be identified as two of the Apostles or prophets (Ills. 108–10). It is unusual for a selection of the Apostles (apart from the Evangelists) to be depicted, but a selection of the prophets would be possible. Again, there is little or no evidence on which to base a more specific attribution.

Despite numerous attempts to identify the iconography of the surviving fragments, the above analysis has suggested that their subject-matter remains largely elusive. The strongest case that can be made is for identifying the scene on 1c as the Sacrifice of Isaac, and it is conceivable that a depiction of this was also intended on stone 1b, though the Ascension perhaps remains more likely. The iconography of the other fragments remains uncertain: the figures on 1b and Canterbury Old Dover Road 1 may represent Apostles or prophets, and this may also be true of those on 1c, though these may more probably represent Evangelists with supporting figures, one of them perhaps the Virgin.

How may the surviving fragments be related to the iconography of the cross described in the church at Reculver by the antiquary John Leland, who visited the church at Reculver in *c.* 1540 and afterwards described a cross which he saw there? Leland's description is worth quoting in full:

'Yn the enteryng of the quyer ys one of the fayrest, and the most auncyent crosse that ever I saw, a ix. footes, as I ges, yn highte. It standeth lyke a fayr columne. The base great stone ys not wrought. The second stone being rownd hath

curiusly wrought and paynted the images of Christ, Peter, Paule, John and James, as I remember. Christ sayeth, *ego sum Alpha et ω*. Peter sayith, *Tu es Christus filius dei vivi*. The saing of the other iii. wher painted *majusculis literis Ro.* but now obliterated. The second stone is of the Passion. The iii. conteineth the xii. Apostles. The iiii. hath the image of Christ hanging and fastened with iiii. nayles, and *sub pedibus sustentaculum*. The hiest part of the pyller hath the figure of a crosse.' (Smith 1964, IV, 59–60).

From this description it is possible partially to reconstruct the monument which Leland saw. The cross was about nine feet high, and stood on a base which Leland describes as, 'not wrought'. In this context he is probably using the word in the sense of undecorated rather than unworked, as he uses the word 'wrought' to describe the decoration of the shaft. That the base was square or rectangular is suggested by Leland's specific statement that the second stone was round, as if in contradistinction to the base, when he had already described the monument as shaped like a column. Leland's description of the shaft as 'lyke a fayr columne' and as a 'pyller' may have been referring to the fact that it was of circular section, but it is possible that the shaft also resembled a column in shape, and was apparently only slightly tapered. The shaft which Leland saw was composed of four drums, and supported a cross-head; however, it is possible that Leland only described the figure-decorated portion of the monument which he saw.

The lowest drum of the shaft was decorated with the figures of Christ with Saints Peter, Paul, John, and James, each accompanied by an inscription painted in red in Roman capitals. Of these only that of Christ and St Peter survived. The inscription concerning Christ is from *Revelation* 22, v. 13, and that of Peter from *Matthew* 16, v. 16. On the topmost drum Leland particularly noted that there were four nails used in the crucifixion, which suggests that the feet of Christ were placed side by side and nailed separately to the *suppedaneum* in the manner of the Romsey 1 crucifixion (Ills. 451–2). In contrast to these detailed comments Leland's description of the two remaining drums is cursory. The second drum he describes as, 'of the passion', and the third as containing the twelve Apostles. If these identifications are correct then a curiously repetitive scheme of Apostles, Passion, Apostles, Passion results. A shaft with two Passions on it is unknown elsewhere, and it is, therefore, possible that Leland's description of these two drums is inaccurate or incomplete: an impression supported by his specific statement that he was working from memory. Alternatively, in describing the scene as 'of the Passion' he may have been referring to other events of the story than the crucifixion itself (Bailey, pers. comm.).

In archbishop Winchelsea's Register, under the date 11th April 1296, is recorded an ordinance between the vicar and parishoners of Reculver, '. . . concerning offerings or alms placed in a certain trunk beside the great stone cross between the church and the chancel'.[3] That this is the same cross as that which Leland saw there can be little doubt, as in both sources it is described as situated between the nave and the chancel of the church. It must, therefore, have, dated to before 1296. Indeed, it is likely that the monument mentioned in both these sources was of pre-Conquest date, and, if so, the fragments under discussion may have formed part of it. Supporting evidence is derived from the fact that the erection of standing crosses was a pre- rather than a post-Conquest custom. There are some post-Conquest crosses, but the few that are known from the immediately post-Conquest period in southern England, such as that from Castle Hedingham, Essex, have shafts of rectangular section (Brown 1903–37, VI (2), 147–8, pl. XL.2), unlike the round shaft described by Leland. In the later medieval period when standing crosses again became common the shafts were usually of polygonal section and undecorated, supporting elaborately sculptured heads. In the pre-Conquest period, although round shafts like that from Reculver are relatively uncommon in southern England, they do occur (see pp. 23–4).

That the cross seen by Leland is the same monument as that represented by the Reculver fragments has been too often uncritically accepted. The main difficulty in comparing the two sets of evidence is that Leland's description of the cross he saw is brief, generalised, and apparently based only on memory, while the surviving stones are fragmentary, and sometimes badly weathered. A comparison is, therefore, unsatisfactory as it deals almost wholly in generalities.

That both crosses were of circular section and drum built may suggest that Leland's cross and that represented by the surviving fragments are the same. Round shafts are not common among pre-Conquest monuments in southern England, but are found at Wantage, Berkshire (Ills. 474–7), Winchester High Street 1 (Ills. 679–82) and Priors Barton 1 (Ills. 686–90), Hampshire, and Melbury Bubb, Dorset (Cramp 1975, 198, pl. XXI). The construction of the shaft in drums is a technique employed both at Winchester (Priors Barton 1) and Wantage. Leland's description of the shaft which he saw

---

3. '. . . super oblacionibus seu elemosinis in quodam trunco juxta magnam crucem lapideam inter ecclesiam et cancellum repositis . . .' (Peers 1927b, 250).

as a column suggests that, like a column, it had little or no taper, a fact which accords well with the fact that the surviving drums from Reculver, except stones 1a and 1e, all have a diameter of *c.* 46 cm, again indicating a shaft with little taper. This is an extremely rare feature among surviving pre-Conquest sculptures and is only paralleled on the lower portion of the decorated column at Wolverhampton, Staffordshire. (ibid., 187–9, pls. XVI–VII). It may also be significant that both the cross which Leland saw and that represented by the surviving fragments have the decoration arranged in superimposed registers, although this feature can also be observed on the Winchester (Priors Barton 1; Ills. 687–90), Melbury Bubb (ibid., 198, pl. XXI), and Wolverhampton shafts (ibid., 187–9, pls. XXVI–VII).

In form and in the disposition of the ornament the shaft seen by Leland and that represented by the surviving fragments resemble each other closely. It is, however, more difficult to relate the decorative programmes. On Leland's cross were narrative scenes of the Passion, and figures of the Apostles, although he says nothing of their arrangement. On stones 1a, 1d, and Canterbury Old Dover Road are robed figures which, as noted above (p. 159), are probably to be interpreted as the Apostles or Prophets. The identification of the surviving narrative fragments with the narrative of the Passion seen by Leland is more doubtful. Stone 1b may well be decorated with an Ascension scene which would form the natural conclusion to the narrative of the Passion. Unfortunately no such scene is specifically described by Leland, and the interpretation of the scene on stone 1b is not wholly secure. Kozodoy's interpretation of the scene on stone 1c as part of a Crucifixion scene is not acceptable, and the alternative proposed above—the Sacrifice of Isaac—finds no place in the programme of decoration described by Leland, although the Sacrifice of Isaac is an Old Testament type of the Crucifixion, and if stone 1b does represent the Ascension, this scene might have concluded a sequence of Passion scenes.

A major difference between the surviving fragments and Leland's shaft lies in the number of drums in each. Leland's monument was composed of only four drums, but the surviving fragments represent a shaft composed of at least six. This assumes that the two narrative scenes (fragments 1b–c) come from a single drum (which is perhaps unlikely), that each of the other stones represents one drum, and that at least one further drum would have been necessary to complete the decoration on stone 1e. This reconstruction of the fragments can only be made to harmonize with Leland's description if two of the drums belonged to

another monument. Alternatively, Leland may have simply miscounted the drums in the shaft he saw.

Leland also estimated that the monument he saw was about nine feet in hight. If all the surviving drums from Reculver belonged to a single monument, however, it must have originally exceeded nine feet in height, taking into account the drum needed to complete the decoration on stone 1e, the cross-head and base, and the fact that little more than half of the original height of stones 1a–c survives. Again, the reconstruction can only be made to harmonize with Leland's description if some of the stones belonged to another shaft. Ultimately, the relationship of the existing fragments with the monument Leland described must remain an open question.

DATE Early ninth century

REFERENCES Duncombe 1784, 71–2; Hastead 1778–99, III, 637 note m; Smith 1850, 195; Dowker 1878, 252, 266–8; Brown 1903–37, VI (2), 22, 169–75, pl. XLV-VI; Peers 1927b, 250–1, 252–6, fig. 7, pls. XLII-III, XLVI; Clapham 1929b; (——) 1930, 113, no. 16; Clapham 1930, 62, 68–9, 133, pl. 20; Casson 1932, 273; Kendrick and Hawkes, 1932 341–2, pl. XXXVIII; Livett 1932, 4, col. 3; Jessup 1936, 184–6; Kendrick 1938, 115–8, pl. XLVI; Graham 1944, 3–4, pl. I; Saxl and Wittkower 1948, 20, pls. 1, 6 and 7; (——) 1949, 5, col. 1; Clapham 1951, 191–2, 195, n., pl. I; Gardner 1951, 41, pl. 62–3; Rice 1952, 96–8, pl. 9b; Gilbert 1954, 97; Stone 1955, 19–20, pl. 10A; Wilson 1960, 61; Jope 1964, 59–60; Cramp 1965, 5; Taylor and Taylor 1965–78, II, 503–4, 508–9; Taylor and Taylor 1966, 41; Okasha 1967, 249; Beckwith 1968, 17–18, taf. 9.1–13.1; Taylor 1968, 291–5, fig. 1B; Taylor 1969, 225, 227; Cramp 1972, 143; Cunliffe 1973, 43; Kozodoy 1976; Newman 1976, 194–6, pls. 8–9; Hinton 1977, 56; Cramp 1978, 4; Campbell 1982, 107, pl. 99; Service 1982, 176; Fernie 1983b, 35–6; Tweddle 1983b, 30–5, fig. 6; Backhouse *et al.* 1984, 40–1, no. 22, pl. 22; Wilson 1984, 71–2, pls. 65–8; Kozodoy 1986, 67–94, figs. 1–4, pls. XXXI–II, XXXIV, XXXVI; Tweddle 1986b, I, 95, 255–330, II, 435–43, III, figs. 41, 44–5, pls. 75–6; Coatsworth 1988, 164–5, 181, 191; Tweddle 1990, 147–50, 154–6, pls. 1–2; Worssam and Tatton-Brown 1990, 54–7, 63

D.T.

## 2. Fragment of cross-shaft                    (Ill. 122)

PRESENT LOCATION Lost

EVIDENCE FOR DISCOVERY Discovered during excavations at Reculver by Peers (Peers 1927b, 251)

MEASUREMENTS Unobtainable

STONE TYPE Unobtainable

PRESENT CONDITION Unknown

DESCRIPTION A small, irregularly shaped fragment of a shaft of circular section, roughly broken behind, and to each side. On the surviving portion of the decorative face is a stem which curls down from the upper right to the lower left. From its upper edge develops a subsidiary stem curling round to touch the main stem once more, and ending in a single-lobed, pointed leaf, with its back resting on the main stem.

DISCUSSION The fact that this is part of a round shaft, allied with the precise nature of the decoration, makes it almost certain that it is a fragment of the same shaft as 1a–e. The comparison with the decoration of 1e is particularly striking.

DATE Early ninth century

REFERENCES Peers 1927b, 253, fig. 8; Jessup 1936, 184; Taylor and Taylor 1965–78, II, 509; Taylor 1969, 227; Tweddle 1983b, 32; Backhouse *et al.* 1984, 40; Kozodoy 1986, 69, 78; Tweddle 1986b, I, 266, II, 443–4, III, fig. 42
                                                                            D.T.

### 3. Part of cross-arm                              (Fig. 31; Ill. 121)

PRESENT LOCATION Lost

EVIDENCE FOR DISCOVERY Discovered in excavations at Reculver by Peers (Peers 1927b, 251)

MEASUREMENTS Unobtainable

STONE TYPE Limestone, Middle Eocene, non-British (Peers 1927b, 253)

PRESENT CONDITION Unobtainable

FIGURE 31
Reculver 3A, reconstruction, nts

DESCRIPTION Part of the arm of a cross-head, having concave sides, but roughly broken at each end.

*A (broad):* Along each edge is a triple roll moulding, of which the outer moulding is the most prominent. These overlap the edge of a dished disc with a central drilled hole. A plain moulding of square section runs from the edge of the disc off the lower edge of the fragment.

DISCUSSION Part of a free-armed cross-head of type A9 or 10. The disc and moulding on face A suggest it was of the 'lorgnette' or 'spine and boss' type, where the principal face was decorated with five discs or bosses, one in the centre and one on each arm, linked by plain mouldings (Collingwood 1927, 94–8). The deeply drilled hole in the centre of the dished boss at Reculver may, as Peers suggested, have been intended to take a metal fitting (Peers 1927b, 253). There is evidence on other fragments from Reculver of this practice, on 1e for example, but it is difficult to envisage what sort of fitting would be appropriate to the centre of a dished disc. It is possible that the drilled hole was merely intended to give emphasis to the centre of the disc.

It is unclear whether this cross-head formed part of the monument represented by Reculver 1a–e and probably also Canterbury Old Dover Road 1, or an entirely different monument. There is nothing in the decoration to link the cross-head with the other stones, although they must be of broadly the same date. The only link is provided by the stone type. The cross-head was identified in 1927 as of a non-British limestone, probably from France, and recent work on the other fragments have demonstrated that they are made of a northern French limestone. As a fact, this is suggestive, but not conclusive. It may be that there was abundant stone of this type at Reculver available for reuse from the ruined Roman buildings.

DATE Early ninth century

REFERENCES Peers 1927b, 253, fig. 9; Jessup 1936, 184; Jope 1964, 98, n. 46; Taylor and Taylor 1965–78, II, 509; Taylor 1969, 227; Tweddle 1983b, 32; Backhouse *et al.* 1984, 40; Kozodoy 1986, 69, 78; Tweddle 1986b, I, 266–7, II, 444–5, III, fig. 43; Worssam and Tatton-Brown 1990, 54–5
                                                                            D.T.

### 4a–b. Two columns                                 (Ills. 123–38)

PRESENT LOCATION In crypt of Canterbury cathedral

EVIDENCE FOR DISCOVERY First recorded *in situ* in late eighteenth century (Hastead 1778–99; Duncombe

1784); purchased when church demolished in 1805 by a Mr Francis and deposited in his orchard near Canterbury, where rediscovered (minus one capital) in 1859 by J. B. Sheppard, who also relocated missing capital in 'Mr Deene's stackyard' at Reculver; all later acquired by Dean and Chapter of Canterbury and located first in Deanery garden, then moved inside cathedral in 1932

H.   490 cm (193 in)
Diameter of bases 69 cm (27.2 in)

STONE TYPE Pale grey, oolitic limestone; Marquise stone, Oolithe de Marquise Formation, Bathonian, Middle Jurassic; Boulonnais, France

PRESENT CONDITION Broken and worn

DESCRIPTION The bases are sculptured in one piece with the lower drum of the column and are separated from them by a triple cable moulding. Immediately below these is a bold projection, in section, tapering slightly towards the flat outer faces. Along the upper and lower edges of the faces are cable mouldings which flank a fret composed of a series of interlocking incised Ts. Below this projection the bases are deeply recessed, and terminate in a second bold projection of fundamentally square section, with the upper edges rounded. The bases are heavily damaged and have been partially cut away to one side to form the seatings for a vertical element. The capitals each consist of four undecorated, superimposed fasciae.

DISCUSSION The drawings of the columns *in situ*, before Reculver church was demolished, demonstrate their function, which was to support the triple arcade between the nave and chancel (Ills. 124–5, 127). The use of triple arcades in this position occurs elsewhere among the early Kentish churches at St Pancras's, Canterbury, where columns were also used (Ills. 59–60), and Rochester, although there the evidence is tenuous. Outside Kent a similar arrangement may be inferred from the surviving fabric at Bradwell-juxta-mare, Essex. Both at Rochester and Bradwell there is so little surviving evidence that it is unclear whether either piers or columns were used. Apart from the columns under discussion and the column base from St Pancras, Canterbury (no. 1), the only free-standing columns from the pre-Conquest period in south-east England are those that may be inferred from the surviving capitals at St Augustine's abbey, Canterbury (nos. 5–7; Ills. 29–40).

Blagg has pointed out that the best parallels for both the capitals and bases at Reculver lie in east Mediterranean material of the fifth and sixth century (Blagg 1981, 52–3). This implies that the pieces must belong to a post-Roman context and are not directly reused Roman material. Within the corpus of Anglo-Saxon sculpture, the only parallels for the form of the capitals are provided by an undated capital from Betchworth, Surrey (Ill. 2), a capital from Ripon, possibly from St Wilfrid's church (Taylor and Taylor 1965–78, II, 517), and two bases or capitals from St Mary, Castlegate, York, reused in an eleventh-century context (Wenham *et al.* 1987, 153–5, fig. 47, Lang 1991, 117, ills. 413–15).

DATE Seventh century

REFERENCES Hastead 1778–99, III, 637, note m; Duncombe 1784, 85, 88; Smith 1848–80, VI, 222–7, fig. on 227, pl. X, VII, 163; Smith 1850, 198, figs. on 197 and 198; Talbot 1860, 135–6, fig. facing 136; Sheppard 1861, 369–73; Scott 1862–3, 9–10; Puckle 1864, 34–5, fig. facing 8; Dowker 1878, 352; Fox 1896, 355; Micklethwaite 1896, 298–9; Brown 1900a, 307, figs. 7c and e; Brown 1900b, 336; Cabrol and Leclercq 1907–53, II.1, col. 1184, fig. 1636; Brown 1925, 256–9, figs. 156C, E; Peers 1927b, 244–7, 250–6, fig. 5; Clapham 1929, 266; Peers 1929, 72; Clapham 1930, 24, 62, 122, fig. 38, pl. 3; Livett 1932, 4, cols. 3–4; Cox and Johnston 1935, 108, 251; Jessup 1936, 184, n. 8; Mee 1936, 364; Gilbert 1954, 96–7, 97, n.; Fisher 1962, 364; Taylor and Taylor 1965–78, II, 504, 506, 508–9, fig. 248; Taylor and Taylor 1966, 41, 51; Taylor 1968, 291–2, n. 6; Taylor 1969; Cherry 1976, fig. 4.12d; Blagg 1981, 51–3, fig. 7b and c; Fernie 1983b, 36; Tweddle 1983b, 30–1, fig. 6c; Tweddle 1986b, II, 433–5, III, pl. 1, 74; Wenham *et al.* 1987, 153–4; Worssam and Tatton-Brown 1990, 51–3, fig. 18

D.T.

# REIGATE, Sr. (St Mary)

TQ 259502

**1. Fragment of cross-shaft** (Ills. 139–40)

PRESENT LOCATION In church library

EVIDENCE FOR DISCOVERY First recorded in Malden 1911

H. 18 cm (7 in)   W. 12 cm (4.7 in)
D. 15 cm (6 in)

STONE TYPE Light grey (with a greenish tinge), fine-grained, sandstone, finely glauconitic and micaceous; Reigate stone, Upper Greensand, Gault Group, Lower Cretaceous

PRESENT CONDITION Broken and worn

DESCRIPTION The fragment is of square section. It is dressed flat to the left, is horizontally broken below, and is trimmed above, to the right, and to the rear.

*A (broad):* Along the upper and left-hand edges is a plain raised border. The face is decorated with an incomplete tight plain plait (probably originally six-trand) composed of broad low relief strands, and fitting closely against the border.

*B–D:* Cut away.

DISCUSSION The small size of this piece makes its original function very difficult to discern. However, the nature of the decoration, interlace within bordered panels, and the square section of the fragment, are consistent with it having been used as a cross-shaft. The only clue as to its date is provided by the interlace decoration. The use of wide, flat, strands without interstices is typical of the tenth and eleventh centuries, especially in northern England as, for example, at Sockburn, co. Durham (Cramp 1984, I, 138–9, II, pl. 136 (734–6)) and Middleton, Yorkshire (Lang 1991, ills. 676, 678).

DATE Tenth to eleventh century

REFERENCES Malden 1911, 240; Johnston 1913, 51; Hooper 1945, 50; Kendrick 1949, 86; Nairn and Pevsner 1971, 425; Tweddle 1986b, I, 95, 247, II, 445–6, III, pl. 78b

D.T.

# ROCHESTER, K. (cathedral, St Andrew)

TQ 743685

**1. Fragment of cross-shaft(?)** (Ills. 141–2)

PRESENT LOCATION Guildhall Museum, Rochester

EVIDENCE FOR DISCOVERY Found during excavations in 1976 on site of east wing of bishop's palace, sealed below floor

H. 16 cm (6.3 in)   W. 22 cm (8.7 in)
D. 12 cm (4.7 in)

STONE TYPE Pale brownish-yellow, oolitic limestone, unevenly graded fine to coarse, with scattered limonitic pellets and shell fragments; of uncertain provenance; has some resemblance lithologically to Canterbury St Augustine's 9

PRESENT CONDITION Broken and worn

DESCRIPTION The fragment is of sub-rectangular section. It is vertically dressed to the left but roughly broken above, below, to the right, and on the back.

*A (broad):* Along the left-hand edge are five parallel roll mouldings (the outer one heavily damaged). Along the upper edge is part of a similar moulding cut away by the break. The face is decorated with approximately one quarter of a complex geometrical interlace, apparently surrounded pattern D with included U-bend terminals.

*B–D:* Broken away.

DISCUSSION Although this piece is very small, and all the faces except one have either been roughly broken, or dressed flat, the nature of the decoration, with a plain border containing interlace, corresponds to that seen on other cross-shafts from south-east England. Close parallels are provided by the shafts from Barking, Essex (no. 1; Ills. 256–9), and Kingston upon Thames, Surrey (Ills. 95–6).

The only evidence on which to base the dating of the piece is the interlace. This has been reconstructed as an encircled pattern with bifurcating strands (Harrison and Williams, 1979, 34–5, fig. 7), but the pattern can be reconstructed more convincingly without these features. Whatever its precise reconstruction, the fine strand of the interlace and well worked-out nature of the pattern can best be compared with that on Reculver 1e (Ills. 119–20) and a similar, ninth-century, date can be tentatively suggested.

DATE Ninth century

REFERENCES Harrison and Williams 1979, 34–5, fig. 7, pl. VI; Tweddle 1983b, 36–7; Tweddle 1986b, I, 95, 161–2, II, 448–9, III, pl. 79b

D.T.

## 2. Fragment of grave-marker (Ills. 143–5)

PRESENT LOCATION Lost; formerly in crypt

EVIDENCE FOR DISCOVERY Discovered 'somewhere under the nave floor' during underpinning of west front in 1888–9 (Livett 1889)

H. 15 cm (5.9 in)  W. 9 cm (3.5 in)
D. 8 cm (3.2 in)

STONE TYPE Unobtainable

PRESENT CONDITION Unobtainable

DESCRIPTION Since the description of this piece relies entirely on a drawing, it is impossible to be certain of the relationship of the edge with the runic inscription to the other two faces, or of which way up they were originally meant to be seen. Ills. 143–5 are placed as in Livett 1889, and all locational terms should be understood as referring to these.

The carving is small, sub-rectangular, and tapers slightly to the left. One edge is vertically dressed, and the remaining edges are roughly broken.

*A (broad):* A pair of incised lines curves down in parallel from the upper left to the lower right, and is paralleled below by a third incised line bifurcating at its lower end. The bifurcations, paralleled by a second pair of incised lines, curve backwards.

D.T.

*B (narrow): Inscription* The edge of the fragment as depicted in the drawing bears what appear to be runic characters. Though they might be Anglo-Saxon, the likelihood is that they are Scandinavian, given the nature of the decoration on faces A and C. The runes, if that is indeed what they are, run up or down the edge. They are transliterated below from top to bottom of Ill. 144, with the tops of the characters assumed to lie to the right. Two characters and a divider are visible, and parts of two further characters.

[.]**ki**:[.]

The third rune is furnished with a dot on the left of its upper part. This might indicate a dotted **i** (then probably with the value [e] or [æ]), but the diacritic was normally placed much closer to the middle of the rune and, in carefully executed inscriptions at least, centrally on the incision. The likelihood must be that what is depicted here is a chance mark.

M.P.B.

*C (broad):* A band defined by parallel incised lines curves down from the upper right to the lower left. It is crossed at right angles by narrower curving bands near the top and at the bottom; the latter forms one element of a bifurcation which, to the right of the junction, is itself crossed by a pair of transverse incised lines.

*D (narrow):* Broken away.

DISCUSSION The occurrence of decoration on opposite faces suggests that the piece stood upright; the probable inscription on the edge is in exactly the same position as that on the grave-marker from St Paul's in London (Ill. 350), and also seems to employ runes. It is, therefore, highly likely that this is also a grave-marker. The ornament on faces A and C appear to be fragments of tendril decoration consistent with the Scandinavian Ringerike style, although, admittedly, very little of the decoration survives. These traces of ornament and the other analogies with the St Paul's stone in London point to a date in the reign of Cnut (1016–42); the possible epigraphic evidence, though slight, is not inconsistent with this (see below). For the possible context of this piece, see no. 3.

D.T.

*Inscription* The (apparent) inscription is too fragmentary to be edited into a text and translated,

and it is impossible, on the basis of what the drawing shows, even to hazard a guess as to dating and provenance. On the assumption that the inscription was made in or near Rochester, however, and that it is Scandinavian, one would think the first half of the eleventh century a likely period.

M.P.B.

DATE Eleventh century

REFERENCES Livett 1889, 267, pl. II, 110; Tweddle 1986b, I, 93–4, 232–3, II, 447–8, III, fig. 51

## 3. Grave–marker                            (Pl. 1; Ills. 147–50)

PRESENT LOCATION Cathedral stone store

EVIDENCE FOR DISCOVERY Discovered by Mrs M. Covert *c.* 1984, built internally into south staircase turret of cathedral

H.   19 cm (7.5 in)   W.   17 cm (6.7 in)
D.   *c.* 11 cm (*c.* 6.2 in)

STONE TYPE Pale yellowish-brown, fine-grained sandstone, even-grained with a slightly friable 'sandrock' texture; Hastings Beds division of the Wealden Group, Lower Cretaceous

PRESENT CONDITION Original faces extensively bruised; the broken edges are much fresher. The faces are unweathered, preserving original colouring (see Pl. 1).[1]

DESCRIPTION Approximately one quarter of a semicircular headed monument; the only original edge is part of the curve of the head, now forming one side of a roughly triangular fragment. The remaining faces are roughly broken.

*A (broad):* There is a broad plain border along the curved edge. The rest of the face is decorated in the Ringerike style in low, flat relief with what may be plant tendrils or lappets from an animal's body. These are sometimes paired, having clubbed ends, and often with subsidiary lobes developing from them close to their ends.

1. X-Ray powder diffraction analysis of the surface decoration by Mr A. P. Middleton of the British Museum Research Laboratory has revealed traces of four distinct elements: haematite (purple-red); red lead (bright red); white lead, plus minor calcite (white); and gypsum (grey, probably originally white). The white lead, which seems to have been applied to faces A and C as a ground, is overlain by both the haematite and red lead, though elsewhere these appear to have been applied directly to the stone. The gypsum seems to be confined to face A and is probably secondary, perhaps post-dating the fragment's reuse as building stone. Its present colour is probably due to local atmospheric pollution, though deliberate tinting by adding a pigment, such as carbon black, cannot be ruled out. I am grateful to Mr Middleton for making his preliminary results available.

*B, D and E (narrow sides and top):* The two outer strips beyond the incised framing lines are coloured red. No colour is now visible to the naked eye either within the inscribed field or in the grooves of the letters.

D.T.

*Inscription* The fragmentary inscription (Okasha 1992a, 52) is incised along the flat surface of the curving outer rim (Ills. 149–50), which is set at right angles to faces A and C. The letters are carved within the field defined by two parallel incised lines that run about 6.6 cm (2.75 in) apart. The surviving letters are between 3.8 and 4.3 cm (1.5 and 1.7 in) high. The inscription is incomplete at either end. The surviving letters are capitals and can be transcribed:

—[E]+[A]ME[.]—

The first letter is clearly E but it could perhaps be in ligature with another letter or be part of the diphthong Æ. The next character, which consists of a cross set within a pointed oval, was probably intended as a cross. The fragmentary letter at the end could be either N or M. If it is taken as N, the following reading is possible:

—E + AME[N] —

The inscription might then be interpreted as the word *amen* at the end of a brief prayer. The language of the rest of the text is uncertain.

The lettering is cut with even and shallow grooves. Strokes are finished either with very slight serifs or with none at all. The following capital forms are used: A with no cross-bar but with a long bar over the top (of which only the seriffed ends remain); a very narrow form of E; a broader form of E (unless it is part of the diphthong Æ); M with vertical outer strokes and a central 'V' which occupies slightly more than half the height of the letter.

J.H.

*C (broad):* The border is similar to that on face A. The face is decorated with one arm of a cross with the outer end terminating against it. The arm, in low, flat relief, expands regularly towards the outer end, and is defined by a narrow incised line paralleling the edges. On one long edge this has been lost by the later break. In the outer corners of the cross-arm, an arc defined by a pair of parallel incised lines links the frames, and a single incised line cuts each of them. This feature is partially obscured in the broken corner.

DISCUSSION This is probably part of a semicircular head- or foot-stone of the type encountered at Whitchurch, Hampshire, Stedham, Sussex (nos. 7,

10–11), and at Winchester (New Minster 2 and St Pancras 1). The piece is probably thick enough to have sat directly on the surface without having been sunk into the ground. It is impossible to tell which face is the front and which the back. If the inscription was read from the foot of the grave, then the tendril-decorated side (face A), would have faced the front, but there can be no certainty that this was so. It is, however, suggestive that this is the face with the most elaborate colour scheme.

It is possible partially to reconstruct the original decoration of face A. The thicker strand to the bottom left of the face, with an incised line paralleling its outer edge, is suggestive of an animal body; the animal bodies on a number of Ringerike-style pieces, such as the vane from Kallunge, Sweden (Fuglesang 1980, no. 44, pl. 24–5), or the slab from Husaby church, Sweden (ibid., no. 74, pl. 44b), take precisely this form. The tight curve of the body on 3A suggests that the animal originally had a coiled body, a form familiar in the Ringerike style in England as, for example, on two panels of the disc brooch from Sutton in the Isle of Ely (ibid., no. 50, pl. 28) and an initial D from the Winchcombe Psalter (ibid., no. 109, pl. 70c). If the main decorative feature of this face was an animal, then the pair of tendrils developing from the broken edge to the left towards the head of the stone fall into place quite naturally as lappets developing from the back of the animal's head, a form encountered on the St Paul's stone (Ill. 351) and which is commonplace in the Ringerike style both in England and elsewhere. The feature is employed, for example, in the manuscript initial cited above, and on the front of the vane from Heggen, Norway (ibid., no. 42, pl. 22). Not enough of the present piece survives for a complete reconstruction of the decoration of face A to be attempted, but its main outline as a coiled animal with the head at the top of the stone facing left seems clear enough.

Together with no. 2, it is probable that this piece was part of the group of Ringerike style pieces from the region, embracing London (St Paul's 1, All Hallows by the Tower 3, and City 1) and Great Canfield 1, Essex. All of them may be products of a single workshop, given their restricted distribution and uniform style of carving. It is noteworthy that three pieces in this group, the present piece and no. 2 from this site, and London All Hallows 3, take the form of two-sided head- or foot-stones, a form rarely encountered in the region outside the group.

<div align="right">D.T.</div>

*Inscription* The form of the A (with a top bar but no cross-bar) is fairly unusual but it occurs on a small number of Anglo-Saxon inscriptions that probably all date from between the ninth and eleventh centuries (Okasha 1968, 322–8). Canterbury St Augustine's 2 also has an example of A without a cross-bar, but that letter lacks the pronounced top bar seen here. The Ringerike ornament on one face of the stone allows the lettering to be dated with some probability to the first half of the eleventh century. Okasha compares the cross to one on an early inscribed stone on Lundy Island (Okasha 1992a, 52; eadem 1993, fig. II, 26). In that case, however, the cross is contained within a circle. It is a form which also appears on uninscribed stones from early medieval Wales (Nash-Williams 1950, fig. 5.1).

If the fragment is part of the head- or foot-stone from a grave, the positioning of the text on the outer upward-facing curving rim can be compared with the headstone in Whitchurch, Hampshire (Ills. 482, 485–9). If the monument was funerary, the inscription was probably some form of memorial text.

Texts with the word *amen* seem not to have been common on Anglo-Saxon inscribed stones. There is a Latin memorial text ending with the word *amen* on the cross-base from Haddenham (Cambridgeshire) but certain oddities about this inscription raise doubts about its pre-Conquest date (Okasha 1971, 74–5; Higgitt 1986, 130). Another possible example is the Latin inscription ending with *amen* on the font at Potterne in Wiltshire (Okasha 1983, 96–7), which probably dates from the late Anglo-Saxon period but could be a little later. The cross before *amen* is in part punctuation and in part an invocation of the deity. Crosses are sometimes used in Anglo-Saxon inscriptions to mark the start of a new section of text as, for example, on the grave-cover at Stratfield Mortimer (Ill. 708). The invocatory function is clear in the multiple crosses in the epitaph on the cross from Yarm, Yorkshire (Okasha 1971, 130).

<div align="right">J.H.</div>

DATE Eleventh century

REFERENCES Cather, Park and Williamson 1990, v, pls. 1–3; Okasha 1992a, 52

## 4. Decorative panel[1]                                      (Ill. 146)

PRESENT LOCATION Cathedral treasury

EVIDENCE FOR DISCOVERY Found built into late Norman plinth during underpinning of west front in 1888–9 (Livett 1889)

---

1. The following is an unpublished manuscript reference to no. 4: BL Add. MS 37550 no. XII, items 569–70.

H.   18 cm (7 in)   W.   32 cm (12.6 in)
D.   11 cm (4.3 in)

STONE TYPE Yellowish-grey, medium-grained, shelly, oolitic limestone, with scattered 0.9-mm pellets; possibly Barnack stone

PRESENT CONDITION Broken and very worn

DESCRIPTION It is sub-rectangular. The upper edge is horizontally dressed, the left-hand edge vertically broken, and the right-hand edge roughly broken and projecting prominently. The lower edge is roughly broken and rises slightly from right to left.

*A (broad):* A plain vertical relief moulding divides the face into two fields, that to the left three times larger than that to the right, and unites with a plain, low-relief border along the upper edge of the panel. To the right of the junction this is narrow, but to the left doubles in width, and has a median-incised line. In the right-hand field two V-shaped interlace bands, the upper overlapping the lower, develop from the right, their apices touching the vertical border. In the left-hand field are the well modelled hindquarters of a slender animal facing to the left. The body tapers to the right, and the back is concave before curving up over the hindquarters. The nearside thigh tapers straight down, and the offside thigh angles to the left.

The slender tail curves up and over the hindquarters touching the upper border before encircling the body and being carried off to the upper left.

DISCUSSION The original function of this piece is almost impossible to identify, particularly as only one original edge may survive. The shape of the piece is not consistent with it  having been a cross-shaft, and the nature of the decoration does not correspond with that encountered among the grave-covers of south-east England. The probability is that it was architectural in function.

The date of the fragment is equally difficult to define. Thin animals with bulbous thighs and the tails looping round the body occur on fol. 11r of the mid eighth-century Codex Aureus, although also enmeshed in interlace (Alexander 1978, no. 30, ill. 152). Similar animals are, however, encountered in later works, as, for example, on fol. 1v of the *Vita Cuthberti*, dated to *c.* 937 (Temple 1976, no. 6, ill. 29), and fol. 57r of Durham Cathedral Library MS A. IV. 19, dated to the early eleventh century (ibid., no. 3, ill. 8).

DATE Tenth to eleventh century

REFERENCES Livett 1889, 267, pl. II.9; Swanton 1973, 201–3, fig. 1; Tweddle 1986b, I, 112, 253–4, II, 446–7, III, pl. 79a

D.T.

# SANDWICH, K.

## 1. Grave-marker[1]                                      (Ills. 155–7)

PRESENT LOCATION Royal Museum, Canterbury. Accession number RM 1141

EVIDENCE FOR DISCOVERY Found (together with no. 2) by labourers employed by a Mr Boys digging in an open field near Sandwich, probably in 1830s; he gave both stones to a Mr Rolfe, who donated them to Canterbury Museum. Earliest published source, however, gives the provenance as Richborough (Wright 1845, 12). Two locations close together, so accounts not necessarily at variance

H.   40.5 cm (15.9 in). W.   15 cm (5.9 in).
D.   14.5 cm (5.7 in).

STONE TYPE Pale greyish-yellow, finely granular limestone, with moulds of shell fragments and (in a cored sample) the foraminifer *Alveolina*; Calcaire Grossier Formation, Palaeogene, Tertiary; Paris Basin[2]

PRESENT CONDITION Heavily worn

DESCRIPTION Tapering pillar of square section, cut off flat above and rounded below.

*A:* A pair of incised lines parallels the upper three-fifths of the right-hand edge, and towards the upper end of the vertical axis of the face is a runic

1. The following is an unpublished manuscript reference to no. 1: BL Add. MS 37580, items 379, 394.
2. Identification checked by Dr J. E. Robinson.

inscription, framed by a pair of incised lines running off the upper edge.

<div align="right">D.T.</div>

*Inscription* The runes are cut between framing lines, running left to right from the wide end. The stone is soft and the inscription extremely worn. It may be read:

[.]æ★æ[.]u[.]

No incised lines of the first rune remain. The third, transcribed ★, is formally identical with a Roman *N*, but could also perhaps be a variant form of runic 's' or 'h'. The fifth rune is clearly 'r' or 'b'. To the right of 'u' is a distinct diagonal line, discussed further below. The final rune is a stave with a roughly worn patch to the right of its top, where there could perhaps have been an arm. This rune could therefore be 'i' or 'l'. The inscription is closed by a faint vertical framing line of quite different character to the other incisions.

<div align="right">D.P.</div>

*B:* A pair of incised lines parallels the upper half of the left-hand edge of face B.

*C and D:* Undecorated.

DISCUSSION The two stones from this site are very closely related in form, and must have served the same function. Their use as grave-markers is suggested by the fact that the roughly-tapering bases were evidently inserted in the ground and the upper ends left exposed, as is the case with grave-markers. In addition, if the runic inscription on no. 1 may be interpreted as a personal name, this would again suggest a commemorative function.

Linguistic features may be tentatively interpreted as pointing to a date anywhere between the fifth and eighth centuries (see Parsons below). The absence of Christian symbolism on what are apparently memorial sculptures may point to the earlier part of that period, as may their possible relationship to wooden prototypes, rather than the standard stone sculptural forms of the region. Merovingian funerary monuments of comparable form are also unlikely to date from after the seventh century (Cramp 1993, 70).

<div align="right">D.T.</div>

*Inscription* The reading 'ræhæbul', considered to be a personal name, was first proposed by Haigh (Haigh 1861, 52), and supported by Stephens (Stephens 1866–1901, I, 365). Both scholars published drawings which do indeed clearly show the first rune as 'r', the fifth as 'b', the sixth as 'u', with no mark to its right, and the final rune as 'l',

the others being as transcribed above. On their evidence the reading is correct, providing that the third rune is read as 'h', and not 's' or *N*.

As I examine in more detail elsewhere, however, there is considerable reason to doubt the evidence for this reading (Parsons 1994). An earlier drawing than those of Haigh and Stephens (who corresponded and knew each other's work) is found in Thomas Wright's *Archaeological Album* (Wright 1845, 12). It is the work of the illustrator F. W. Fairholt, whose notebooks survive in the Victoria and Albert Museum. Comparison between the published and unpublished Fairholt drawings shows that, although he worked up his first sketch to give a more 'runic' appearance, each of his series agrees with my reading against that of Haigh and Stephens, in so far as the first rune is not 'r', the fifth is not 'b', the mark to the right of the 'u' bow is clearly shown, and there is no arm on the final stave nor a framing line closing the inscription. In fact, Fairholt's first drawing is closely similar to mine, and suggests that the inscription, already described by Wright as 'much defaced', has deteriorated very little from their day to this.

Wright's evidence is central, but it is supported by two other observations. First, the stone has been in the museum at Canterbury throughout this time, and so considerable wear is unlikely. Second, Haigh's reputation as an accurate scholar is poor, as was his command of philology. When he initially proposed the reading he regarded it as a name 'supported as to both its elements by Rahulf . . . and Theabul' (Haigh 1861, 52), names that he had found in Anglo-Saxon charters. These forms are indeed evidenced (Sawyer 1968, nos. 19, 21, and 1548), but a combination of *Rah-* and *-abul* will not do: the first is probably a spurious parallel (*Rahulf* is likely to be *Raulf*, a contracted form of *Radulf* from a late manuscript), and no etymology can be suggested that would divide *The-abul*. It is likely, therefore, that 'ræhæbul' simply represents Haigh's best efforts to marry attested names with the fragments that were visible on the stone, efforts which were accepted by the uncritical Stephens and became the authoritative reading.

'ræhæbul' remains a possible reading of the inscription, provided that the line carved to the right of 'u' is regarded as an error. But even with the same proviso it is only one of many permutations allowed by my examination. The first problem is the initial rune. Here the soft stone is heavily worn and I found no trace of incision, but in some photographs (e.g. Elliott 1959 (and idem 1989), pl. X, fig. 27) there are the faintest indications of marks in the space preceding

the second rune. If they are not illusory (and Fairholt's first drawing encouragingly shows one of them) they could be consistent with the stave and top part of a rather straight bow of 'r', but they would also allow 'b' and perhaps 'w'; alternatively they might not both belong to a single rune. Taking 'r' or 'b' as most likely adds twenty-three possibilities to 'ræhæbul' (i.e. by combining 'ræhæ-', 'rænæ-', 'ræsæ-', 'bæhæ-', 'bænæ-', 'bæsæ-', with '-rul', ' rui', '-bul', '-bui') and there is no formal means of choosing between them. I can see no straightforward interpretation amongst the combinations. Dickins did manage to justify an etymology for 'ræhæbul' (Dickins 1938, 84), but his suggestions are based wholly on elements not attested in Old English (or Norse) and must be regarded as strained. Moreover, recent work on the etymology of *Theabul* (Insley 1991, 331) throws considerable doubt on the way in which Dickins uses this as a parallel.

So far, possible readings have ignored the diagonal to the right of 'u'. Attention was first drawn to this line, 'sharply incised like the rest of the inscription', and to the insecurity of the traditional reading, by Evison (Evison 1960, 243–4). However, her reinterpretation of this part of the text as 'i' followed by a variant form of 's' is unconvincing, for the bow of what I consider to be 'u' curves very sharply; the fact that it does not join with the stave at the top is readily paralleled and probably insignificant. Nonetheless there could conceivably be a bind-rune with the 'u', as 'u/s', or, if the line belonged to a Scandinavian-looking form of **k**, as **u/k**.

This last possibility is an attractive one because it gives the only intelligible permutation that I can see: -**bu/ki** could be the recorded Old Norse personal name element -*bogi* (for example, *Finnbogi*, *Húnbogi* (Lind 1905–15, 269–70, 598)). Accepting this interpretation would call for a series of further comments. First, an inscription running vertically up or down the side of a stone links with early Scandinavian, rather than Anglo-Saxon, practice. None of the clear rune-forms speaks against such a link, and if the third rune were read as 'h' (which remains possible but unprovable) this would speak in its favour, for the Scandinavian **h** has one cross-bar, in contrast to the usual Anglo-Saxon double-barred form. Second, the interpretation would give some indication of date. **buki** for *bogi* uses Viking-age runic orthography, which replaced earlier, more precise, spellings during the seventh and eighth centuries. On the other hand the form and probable value of the second and fourth runes point towards the older system, so a date during the transitional period would suggest itself.

The reading -**bu/ki** must remain uncertain, however, for the bind-rune is not of a usual type; it is possible that the diagonal to the right of 'u', though intentionally incised, is simply a mistake. Without the reading, the Scandinavian connection is much less persuasive and the arguments for dating no longer valid. Other indications must be proposed very tentatively indeed. If the third rune is read as 'h' then its retention between vowels is an early feature of both Old English and Old Norse. If the text is Old English, *æ* between name-elements or final *i* would also point to a relatively early period, probably no later than the eighth century. But it must be stressed that dating on linguistic grounds is a perilous science at the best of times; for the present stone it is not even possible to propose a secure reading of the text.

D.P.

DATE Fifth to eighth century?

REFERENCES Wright 1845, 12, fig. on 12; Haigh 1861, 52, fig. 21, pl. III; Haigh 1872, 164, 227, 265, pl. on 226; (——) 1875a, 516; King 1876, 749, 751–3; Taylor 1879, 137; Stephens 1866–1901, I, xxvi, 363–7, fig. on 367; Stephens 1884, 112; Allen 1885b, 357; Sweet 1885, 129; Allen 1889, 205; Stephens 1894, 37, no. 29; Browne 1899–1901, 169; Brown 1903–37, III, 181–2, fig. 8, pl. XIX.2; Shore 1906, 102, 186; Page 1908c 341, fig. 2; Marstrander 1929, 66–7, n.; Jessup 1930, 266; Dickins 1932, 19; Dickins 1938; Samuels 1952, 36, n.; Blair 1956, 309; Elliott 1959, 71, 81, figs. 26–7, pl. X; Evison 1960, 243–4; Page 1960, 169–70; Marquardt 1961, 124–5; Bowen and Page 1967, 291; Duwel 1968, 45–6; Page 1973, 28, 37, 135–6, 146; Tweddle 1983b, 30, pl. IXa; Page 1985, 44–5; Tweddle 1986b, I, 38, 94–5, 124–6, II, 454–5, III, pl. 83; Hines 1990, 448; Cramp 1993, 70; Parsons 1994, 310–20

## 2. Grave-marker (Ills. 151–4)

PRESENT LOCATION Royal Museum, Canterbury. Accession number RM 1142

EVIDENCE FOR DISCOVERY See no. 1.

H. 42 cm (16.5 in)   W. 20.5 cm (8 in)
D. 23 cm (9 in)

STONE TYPE Pale greyish-yellow, finely granular limestone, with moulds of shell fragments and (in a cored sample) the foraminifer *Alveolina*; Calcaire Grossier Formation, Palaeogene, Tertiary; Paris Basin[1]

PRESENT CONDITION Broken and heavily worn

1. Identification checked by Dr J. E. Robinson.

DESCRIPTION Pillar of square section tapering irregularly to a rounded end. It is dressed flat above. The upper part of face A is occupied by a rectangular panel delimited by incised lines, a second incised line paralleling the edges below and to the right. On face B a pair of incised lines parallel the upper end of the left-hand edge. Their lower ends return part of the way across the face. Faces C and D are undecorated.

DISCUSSION See no. 1.

DATE Fifth to eighth century?

REFERENCES Wright 1845, 12, fig.; Haigh 1872, 164, 265; King 1876, 751–3; Stephens 1866–1901, I, xxvi, 363–7, fig. on 366; Stephens 1884, 113; Allen 1885b, 357; Allen 1889, 205; Stephens 1894, 37, no. 30; Browne 1899–1901, 169; Brown 1903–37, III, 181–2; Shore 1906, 102, 186; Page 1908c, 341; Jessup 1930, 266; Dickins 1938, 83–4; Elliott 1959, 81; Evison 1960, 243; Page 1969, 31–2, 40; Marquardt 1961, 124–5; Tweddle 1983b, 30, pl. IXb; Tweddle 1986b, I, 38, 94–5, 124–6, II, no. 125, III, pl. 84

D.T.

# SELSEY, Sx. (St Peter)

## SZ 868948

## 1. Fragment                                          (Ill. 161)

PRESENT LOCATION Incorporated into west side of war memorial base, outside Selsey parish church

EVIDENCE FOR DISCOVERY Prior (n. d.) records five fragments incorporated into base of First World War memorial, though only four now visible. Nos. 1–2 removed from porch of parish church, nave of which was moved from old church at Church Norton following demolition in 1864 and rebuilt at Selsey

H.   30 cm (11.8 in)   W.   19 cm (7.5 in)
D.   Built in

STONE TYPE Pale yellowish-grey, fine- to medium-grained, granular limestone (0.1–0.3 mm particles) with very fine (0.1–0.2 mm) shell detritus; Tertiary, Eocene, probably Bembridge Formation (Bembridge limestone), or possibly Solent Formation (Headon Hill limestone)

PRESENT CONDITION Broken and worn

DESCRIPTION It is rectangular and incomplete with a narrow relief border of square section along the lower and right-hand edges. The trimming of the remaining edges has involved the loss of part of the decoration. This consists of a circular relief strand encircled by a second strand whose upper ends cross and are then bent back to form interlacing, pointed-ended diagonals. Both bands have a median-incised line, and the diagonals a median line of drilled holes. Between the diagonals below and to the right, V-shaped motifs, open ends outward, link the inner and outer circles.

Between the diagonals above and interlacing with their looped ends is a semicircular, median-incised strand forming a swag linked to the central circle by a plain vertical moulding.

DISCUSSION The fact that this piece has been squared and reused as building material means that its original function is impossible to ascertain. Its date is equally difficult to establish, but the interlace is based on a closed circuit pattern with some affinities to the Borre-style ring-chain. On this basis a tenth or eleventh century date is plausible.

DATE Tenth to eleventh century

REFERENCES Heron-Allen 1911, 102–3, pl. XXII; Heron-Allen 1935, 37–8, pl. on 31; Mee 1937, 331; Aldsworth 1979, 106, fig. 2.3, pl. 2.3; Tweddle 1986b, I, 112, 251–2, II, 456–8, III, pl. 85a; Prior n. d., 19

D.T.

## 2. Fragment                                          (Ill. 160)

PRESENT LOCATION Incorporated into the west side of war memorial base

EVIDENCE FOR DISCOVERY See no. 1.

H.   30 cm (11.8 in)   W.   28 cm (11 in)
D.   Built in

STONE TYPE Pale grey (with a slight brownish tinge), finely pellety limestone, with *Chara* nucules and a gastropod cast; see no. 1.

PRESENT CONDITION Badly broken and worn

DESCRIPTION It is rectangular, incomplete, and heavily weathered. There is a narrow border of square section along the upper edge, the remaining edges are trimmed. The face is decorated with an irregular interlace from which develops a three-element leaf. The lower part of the decoration is weathered away.

DISCUSSION As with no. 1, the original function of the piece is impossible to establish. The incoherent nature of the interlace suggests a date in the late pre-Conquest period, and this is supported by the form of the leaf. This is best paralleled in works of the tenth century, for example, on the shaft from East Stour, Dorset (Cramp 1975, fig. 19). However, the present carving is too weathered for detailed comparisons to be drawn.

DATE Tenth to eleventh century

REFERENCES Heron-Allen 1911, 102–3, pl. XXII; Heron-Allen 1935, 37–8, pl. on 31; Mee 1937, 331; Aldsworth 1979, 106, fig. 2.4, pl. 2.4; Tweddle 1986b, I, 112, 251–2, II, 458, III, pl. 85a; Prior n. d., 19

D.T.

### 3. Fragment                                    (Ill. 159)

PRESENT LOCATION Incorporated into north face of war memorial base

EVIDENCE FOR DISCOVERY Nos. 3–4 discovered by Heron-Allen built into wall of summer house at Grange Farm, Selsey (Heron-Allen 1911)

H.   15 cm (5.9 in)   W.   25 cm (9.8 in)
D.   Built in

STONE TYPE Whitish-grey, finely granular limestone, with *Chara* nucules and a gastropod cast; Tertiary, Eocene, probably Bembridge Formation (Bembridge Limestone), or possibly Solent Formation (Headon Hill limestone)[1]

PRESENT CONDITION Badly broken and worn

DESCRIPTION It is rectangular and heavily weathered, the edges are trimmed. The face is decorated with an irregular interlace.

1. Identification by Prof. D. Curry.

DISCUSSION As with nos. 1 and 2, no function can be suggested for this piece. The flaccid and disorganised nature of the interlace suggests a date late in the pre-Conquest period.

DATE Tenth to eleventh century

REFERENCES Heron-Allen 1911, 102–3, pl. XXI; Heron-Allen 1935, 34, 37–8, pl. on 32; Mee 1937, 331; Aldsworth 1979, 106, fig. 2.2, pl. 2.2; Tweddle 1986b, I, 112, 251–2, II, 458–9, III, pl. 85b; Prior n. d., 19

D.T.

### 4. Fragment                                    (Ill. 158)

PRESENT LOCATION Incorporated into south face of war memorial base

EVIDENCE FOR DISCOVERY See no. 3.

H.   15 cm (5.9 in)   W.   25 cm (9.8 in)
D.   Built in

STONE TYPE Pale yellowish-grey, fine- to medium-grained granular limestone, with very fine (0.1–0.2 mm) shell detritus; see no. 1.

PRESENT CONDITION Chipped, but fairly well preserved

DESCRIPTION It is rectangular with a damaged, broad, relief border to the left. The trimming of the remaining edges has involved the loss of part of the decoration, a six-strand plain plait with median-incised strands, below and to the right.

DISCUSSION As with nos. 1–3, no original function can be suggested for this piece. The interlace, with its rounded, median-incised strands, finds its closest parallel on the chancel arch at Selham, Sussex, for which a twelfth-century date can be suggested. However, the parallel is not exact, and an earlier date for this fragment is plausible.

DATE Tenth to eleventh century

REFERENCES Heron-Allen 1911, 102–3, pl. XXI; Heron-Allen 1935, 34, 37–8, pl. on 32; Mee 1937, 331; Aldsworth 1979, 106, fig. 2.1, pl. 2.1; Tweddle 1986b, I, 112, 251–2, II, 459, III, pl. 86a; Prior n. d., 19

D.T.

# SOMPTING, Sx. (St Mary)

TQ 161056

## 1. Part of string-course[1]                          (Ill. 162)

PRESENT LOCATION Reused as the head of a niche in the north wall of the sanctuary

EVIDENCE FOR DISCOVERY None; niche of which this frieze forms a part could have been inserted at any time between construction of wall *c.* 1180–90 and first mention of frieze in 1898 (André 1898)

H.   11.5 cm (4.5 in)   W.   59 cm (23 in)
D.   26 cm (10.2 in)

STONE TYPE Pale grey to yellowish, fine-grained, soft limestone; Caen stone, Calcaire de Caen Formation, Bathonian, Middle Jurassic; Caen, Normandy

PRESENT CONDITION Broken; carving fairly well preserved

DESCRIPTION It is roughly broken at each end. On the only carved face, plant stems (some straight, others curved) leaning alternately to the right and left, and interlacing where they cross, emerge from a narrow border of square section along the upper edge. The lengths of the stems, and the angles they make with the border, are irregular. Each stem develops into a central leaf, with two backward-curling lateral leaves. The leaves are narrow, parallel-sided, and have rounded or slightly-pointed ends. Each leaf is of concave section. The hollows of the lateral leaves are carried down the length of the stem. The hollows on the stems leaning to the left are more prominent than on those leaning the other way.

DISCUSSION As with nos. 2 and 3, it is evident that the border at some stage has been cut back and dressed flat. The same fine claw tooling seen on this secondary working is apparent also on the surface of the carving, and this suggests that it too has been redressed. The close correspondence in size, material and decoration between nos. 1–3 suggests that they originally formed part of the same feature; nos. 5–8 may also have come from the same source. The leaf decoration on these fragments does not match nos. 1–3 exactly, but the handling of the leaves is very similar, and again both the size and material of the pieces is the same. The total length of these pieces is 372 cm, and since no stone is complete the original length must have been much greater. Both this great length and the form of the pieces suggests that they have come from a string-course. The lack of weathering indicates that this was internal.

The foliage on the fragments is best paralleled in the borders of late Anglo-Saxon manuscript miniatures, as on fols. 17v and 126v of the Arenberg Gospels of *c.* 990–1000 (Temple 1976, no. 56, ill. 169). It is encountered also in late Anglo-Saxon metalwork and ivory. Taken together, these parallels suggest an eleventh-century date for the fragments. For further detailed discussion, see Chap. VII.

DATE Eleventh century

REFERENCES André 1898, 17, fig. on 21; Crouch 1910, pl. 36; Gardner 1915–16, 69, fig. 1a, pl. VIII; Clapham 1935a, 407–8, pl. VIIc; Mee 1937, 343; Kendrick 1941, 135, fig. 4; Kendrick 1949, 103, pl. LXX.1; Zarnecki 1951a, 183–4, pl. 67C; Rice 1952, 144; Quirk 1961, 32; Fisher 1962, 381; Nairn and Pevsner 1965, 331; Taylor and Taylor 1965–78, II, 562; Fisher 1970, 181; Kirby 1978, 165; Gem 1983, 128; Tweddle 1986b, I, 72–3, 180–2, II, 459–60, III, pl. 86b

D.T

## 2. Part of string-course[2]                          (Ills. 165, 167)

PRESENT LOCATION Eastern element of triangular headed niche in south wall of sanctuary

EVIDENCE FOR DISCOVERY See no. 1.

H.   11.5 cm (4.5 in)   W.   49.5 cm (19.5 in)
D.   26 cm (10.2 in)

STONE TYPE Pale grey to yellowish, fine-grained, soft limestone; Caen stone, Calcaire de Caen Formation, Bathonian, Middle Jurassic; Caen, Normandy

PRESENT CONDITION Broken and chipped; carving fairly well preserved

DESCRIPTION See no. 1.

DISCUSSION See no. 1.

1. The following is an unpublished manuscript reference to no. 1: BL Add. MS 37509, item 197.

2. The following is an unpublished manuscript reference to no. 2: BL Add. MS, 37509, item 197.

DATE Eleventh century

REFERENCES André 1898, 16, fig. on 17; Page 1907, 363; Crouch 1910, pl. 39; Jessep 1914, 38; Clapham 1935a, 407–8; Mee 1937, 343; Kendrick 1949, 103; Rice 1952, 144; Quirk 1961, 32; Fisher 1962, 381, pl. 219; Nairn and Pevsner 1965, 331; Taylor and Taylor 1965–78, II, 562; Fisher 1970, 181; Kirby 1978, 165; Gem 1983, 128; Tweddle 1986b, I, 72–3, 180–2, II, 460–1, III, pl. 87a

D.T.

### 3. Part of string-course[1]                    (Ills. 165, 168)

PRESENT LOCATION Western element of the triangular headed niche in south wall of sanctuary

EVIDENCE FOR DISCOVERY See no. 1.

H.   11.5 cm (4.5 in)   W.   56.5 cm (22.2 in)
D.   26 cm (10.2 in)

STONE TYPE Pale grey to yellowish, fine-grained, soft limestone; Caen stone, Calcaire de Caen Formation, Bathonian, Middle Jurassic; Caen, Normandy

PRESENT CONDITION Broken and badly chipped; otherwise good

DESCRIPTION See no. 1.

DISCUSSION See no. 1.

DATE Eleventh century

REFERENCES André 1898, 16, fig. on 17; Crouch 1910, pl. 39; Page 1907, 363; Jessep 1914, 38; Clapham 1935a, 407–8; Mee 1937, 343; Kendrick 1949, 103; Rice 1952, 144; Quirk 1961, 32; Fisher 1962, 381, pl. 219; Nairn and Pevsner 1965, 331; Taylor and Taylor 1965–78, II, 562; Fisher 1970, 181; Kirby 1978, 165; Gem 1983, 128; Tweddle 1986b, I, 72–3, 180–2, II, 460–1, III, pl. 87a

D.T.

### 4. Length of string-course                    (Ills. 169–70)

PRESENT LOCATION Incorporated into lower part of nineteenth-century reredos immediately behind altar

EVIDENCE FOR DISCOVERY None; first recorded in Clapham 1935a

H.   12 cm (4.7 in)   W.   50 cm (19.7 in)
D. (visible) 8 cm (3.2 in)

STONE TYPE Pale grey to yellowish, fine-grained, soft limestone; Caen stone, Calcaire de Caen Formation, Bathonian, Middle Jurassic; Caen, Normandy

1. The following is an unpublished manuscript reference to no. 3: BL Add. MS, 37509, item 197.

PRESENT CONDITION Broken and worn

DESCRIPTION Like nos. 1–3, except that some of the backward-curling lateral leaves are tightly scrolled.

DISCUSSION Local oral tradition describes the friezes behind the altar as nineteenth-century copies of nos. 1–3, but they are of the same type of stone as 1–3, and each piece is roughly broken at the ends, an unnecessary elaboration in fragments which can never have been intended to be seen if they were made for their present position. Nor are they exact copies of 1–3. It seems more likely that local tradition has confused the date of the reredos itself with that of the fragments reused in it. Nos. 5–8 exhibit no sign of the re-tooling seen on nos. 1–3.

DATE Eleventh century

REFERENCES Clapham 1935a, 407–8, pl. VIIIB; Kendrick 1949, 103; Rice 1952, 144; Quirk 1961, 32; Fisher 1962, 381; Nairn and Pevsner 1965, 331; Taylor and Taylor 1965–78, II, 562; Fisher 1970, 181; Kirby 1978, 165; Gem 1983, 128; Tweddle 1986b, I, 72–3, 180–2, II, 461–2, III, pl. 87b

D.T.

### 5. Part of string-course                    (Ills. 169, 171)

PRESENT LOCATION Incorporated into the lower part of reredos immediately behind altar

EVIDENCE FOR DISCOVERY See no. 4.

H.   12 (4.7 in)   W.   48 cm (18.9 in)
D. (visible) 8 cm (3.2 in)

STONE TYPE Pale grey to yellowish, fine-grained, soft limestone; Caen stone, Calcaire de Caen Formation, Bathonian, Middle Jurassic; Caen, Normandy

PRESENT CONDITION Broken and worn

DESCRIPTION See no. 4.

DISCUSSION See no. 4.

DATE Eleventh century

REFERENCES Clapham 1935a, 407–8, pl. VIIIB; Kendrick 1949, 103; Rice 1952, 144; Quirk 1961, 32; Fisher 1962, 381; Nairn and Pevsner 1965, 331; Taylor and Taylor 1965–78, II, 562; Fisher 1970, 181; Kirby 1978, 165; Gem 1983, 128; Tweddle 1986b, I, 72–3, 180–2, II, 462–3, III, pl. 87b

D.T.

### 6. Part of string-course                    (Ills. 166, 169)

PRESENT LOCATION Incorporated into lower part of reredos immediately behind altar

EVIDENCE FOR DISCOVERY See no. 4.

H.   12 cm (4.7 in)   W.   35 cm (13.8 in)
D.   (visible) 5 cm (2 in)

STONE TYPE Pale grey to yellowish, fine-grained, soft limestone; Caen stone, Calcaire de Caen Formation, Bathonian, Middle Jurassic; Caen, Normandy

PRESENT CONDITION Broken and worn

DESCRIPTION From a border of square section along the upper edge, and at right angles to it, emerge thick plant stems terminating in groups of leaves. Each leaf is narrow, round ended, and backward curling. The leaves are of concave section, the concavities being carried down the stem to give a reeded effect. The outer pair of leaves curls back first, followed by subsequent pairs, although the median leaf is straight. The irregular trimming of the lower edge has damaged some of the tips of the leaves. These stems alternate with shorter, rounded-ended stems, similarly reeded but without leaves.

DISCUSSION See no. 4.

DATE Eleventh century

REFERENCES Clapham 1935a, 407–8, pl. VIIIB; Kendrick 1949, 103; Rice 1952, 144; Quirk 1961, 32; Fisher 1962, 381; Nairn and Pevsner 1965, 331; Taylor and Taylor 1965–78, II, 562; Fisher 1970, 181; Kirby 1978, 165; Gem 1983, 128; Tweddle 1986b, I, 72–3, 180–2, II, 463, III, fig. 27, pl. 87b

D.T.

### 7. Part of string-course                    (Ills. 163, 169)

PRESENT LOCATION Incorporated into base of reredos immediately behind altar

EVIDENCE FOR DISCOVERY See no. 4.

H.   12 cm (4.7 in)   W.   37 cm (14.6 in)
D.   (visible) 5 cm (2 in)

STONE TYPE Pale grey to yellowish, fine-grained, soft limestone; Caen stone, Calcaire de Caen Formation, Bathonian, Middle Jurassic; Caen, Normandy

PRESENT CONDITION Broken and worn

DESCRIPTION See no. 1.

DISCUSSION See no. 4.

DATE Eleventh century

REFERENCES Clapham 1935a, 407–8, pl. VIIIB; Kendrick 1949, 103; Rice 1952, 144; Quirk 1961, 32; Fisher 1962, 381; Nairn and Pevsner 1965, 331; Taylor and

Taylor 1965–78, II, 562; Fisher 1970, 181; Kirby 1978, 165; Gem 1983, 128; Tweddle 1986b, I, 72–3, 180–2, II, 463–4, III, fig. 27, pl. 87b

D.T.

### 8. Part of string-course                    (Ills. 164, 169)

PRESENT LOCATION Incorporated into base of reredos immediately behind altar

EVIDENCE FOR DISCOVERY See no. 4.

H.   12 cm (4.7 in)   W.   40.5 cm (16 in)
D.   (visible) 5 cm (2 in)

STONE TYPE Pale grey to yellowish, fine-grained, soft limestone; Caen stone, Calcaire de Caen Formation, Bathonian, Middle Jurassic; Caen, Normandy

PRESENT CONDITION Broken and worn

DESCRIPTION See no. 6.

DISCUSSION See no. 4.

DATE Eleventh century

REFERENCES Clapham 1935a, 407–8, pl. VIIIB; Kendrick 1949, 103; Rice 1952, 144; Quirk 1961, 32; Fisher 1962, 381; Nairn and Pevsner 1965, 331; Taylor and Taylor 1965–78, II, 562; Fisher 1970, 181; Kirby 1978, 165; Gem 1983, 128; Tweddle 1986b, I, 72–3, 180–2, II, 464, III, fig. 27, pl. 87b

D.T.

### 9. Frieze or blind arcade fragment[1]        (Ills. 172–4)

PRESENT LOCATION Reused as head of niche in east wall of chancel, north of reredos

EVIDENCE FOR DISCOVERY None; first recorded in André 1898

H.   26 (10.2 in)   W.   c. 53 cm (21 in)
D.   6 cm (2.4 in)

STONE TYPE Pale yellowish-grey, fine-grained, pelletal limestone; Caen stone, Calcaire de Caen Formation, Bathonian, Middle Jurassic; Caen, Normandy[2]

PRESENT CONDITION Broken, but carving well preserved

DESCRIPTION It is rectangular and decorated with a semicircular border composed of four narrow roll

1. The following are unpublished manuscript references to no. 9: BL Add. MS 37509, item 196; BL Add. MS 47693, fol. 136r.
2. Identification based on thin-section examination by R. W. Sanderson.

mouldings. To the right this extends slightly beyond the lower margin of the panel. Here the outer moulding unites with that of the remnant of a second similar border. Within the semicircular field the lower margin of the panel is chamfered. The field is decorated with two thick half-round stems which develop from near the lower ends of the border. They curl up and back on themselves and are linked by a collar where they touch. Each terminates in a pair of expanding, pointed-ended leaves separated from the stem by a collar. The other ends of the stems emerge from the far side of the border. To the right the stem is linked by a collar to another emerging from the adjacent border before being carried over the head of the main field. From here it develops three short upward-pointing branches. The first of these bifurcates, the bifurcations are square ended. The other stems terminate in trefoil leaves. The main stem then divides into two interlacing subsidiaries which reunite before joining the stem emerging from the border to the left. This runs straight up and off the edge of the stone. A subsidiary branch, emerging from the point of junction of the two stems runs down off the lower edge of the stone. To the right the stem emerging from the fragmentary border is carried off to the right. From it develops a short, upward-pointing stem whose end is defaced.

DISCUSSION It is evident that this fragment, nos. 10 and 11 all derive from the same feature. As the remains of five arch heads survive, this feature must originally have been more than 500 cm in length. Close examination of the pieces reveals that the junctions of the arch heads were originally carried down to form piers. Moreover, in each case the careful confinement of the plant ornament to the tympanum suggests that it did not extend down between each pair of piers. Instead the piers must have flanked niches, or possibly separate sculptured panels. The fragments must, therefore, be reconstructed as either a frieze or blind arcade (Fig. 19, p. 70). Alternatively, the pieces may have formed part of a free-standing screen. This, perhaps, is less likely as no. 11 has the arch carved only on the lower half of a larger stone, the upper part of which is only roughly dressed. If this were a frieze or blind arcade then the upper part could have been plastered, but if the fragments formed part of a screen it is difficult to see how this could have been disguised, particularly as the other fragments lack such a feature.

As with the string-course fragments nos. 1–8, the best parallels for the form of the arch heads and their decoration are provided by late pre-Conquest

manuscripts, notably the Trinity Gospels, dated to the second quarter of the eleventh century (Temple 1976, no. 65), and Warsaw, Bibl. Narodowa MS I. 3311, dated to about the year 1000 (ibid., no. 92, figs. 51–5, ills. 281–4). For further discussion see also Chap. VII.

DATE Eleventh century

REFERENCES André 1898, 18; Crouch 1910, pl. 39; Clapham 1935a, 407–8, pl. VIIIA; Nairn and Pevsner 1965, 331; Taylor and Taylor 1965–78, II, 562; Kirby 1978, 165; Tweddle 1986b, I, 80, 183–5, II, 464–5, III, figs. 3, 28, pl. 88a

<div align="right">D.T.</div>

## 10. Frieze or blind arcade fragment[1]

<div align="right">(Ills. 175–8, 180)</div>

PRESENT LOCATION Reused (with no. 11) for Romanesque panel of Christ in Majesty at north-west end of nave

EVIDENCE FOR DISCOVERY None; twelfth-century Christ in Majesty was first recorded in the late eighteenth century, and first published in Horsefield 1835, when it was in the north transept; in nave by 1898, though had apparently been outside at some time (André 1898)

H.   25 cm (9.8 in)   W.   47 cm (18.5 in)
D.   8 cm (3.2 in)

STONE TYPE Pale yellowish-grey, fine-grained, pelletal limestone; Caen stone, Calcaire de Caen Formation, Bathonian, Middle Jurassic; Caen, Normandy[2]

PRESENT CONDITION The lower and left-hand edges have been trimmed flat, the upper edge roughly broken, and the upper right-hand corner lost.

DESCRIPTION It is rectangular. The decorative face is divided by two arcs of a circle, each composed of a triple roll moulding, which touch close to the lower edge of the panel. The arc to the left is the shorter. Within the one to the right are two thick, half-round plant stems. That to the right develops from the lower end of the mouldings, and that to the left from the broken edge. The stems curve up and back, and are linked where they touch by a collar. Each terminates in a pair of tight, outward-facing scrolls. The other end of the left-hand stem emerges from the far side of

---

1. The following is an unpublished manuscript reference to no. 10: BL Add. MS 5673, fol. 53r.
2. Identification based on thin-section examination by R. W. Sanderson.

the arc where it is linked by a collar to the similar stem emerging from the adjacent arc. Each stem then curves up and back to terminate in a tight inward-facing scroll. From each stem develops two upward pointing subsidiary stems. Each terminates in an inward-facing scroll which touches its neighbours. Within the left-hand arc a plant stem emerges from the lower end of the mouldings, but is cut off by the trimming of the lower edge of the panel. Above it, developing from the trimmed edge to the left, is a pair of tight outward-facing scrolls.

DISCUSSION See no. 9.

DATE Eleventh century

REFERENCES Horsefield 1835, I, 205; André 1898, 18–19, fig. 5; Clapham 1935a, 407–8; Nairn and Pevsner 1965, 331; Taylor and Taylor 1965–78, II, 562; Kirby 1978, 165; Tweddle 1986b, I, 80, 183–5, II, 466–7, III, figs. 3, 28, pl. 88b

D.T.

## 11. Frieze or blind arcade fragment[1]

(Ills. 175–80)

PRESENT LOCATION Reused (with no. 10) for Romanesque panel of Christ in Majesty at north-west end of nave

EVIDENCE FOR DISCOVERY See no. 10.

H. 40 cm (15.8 in)   W. 47 cm (18.5 in)
D. 8 cm (3.2 in)

STONE TYPE Pale yellowish-grey, fine-grained, pelletal limestone; Caen stone, Calcaire de Caen Formation, Bathonian, Middle Jurassic; Caen, Normandy[2]

PRESENT CONDITION Broken, with the edges trimmed flat; carving well preserved

DESCRIPTION It is rectangular. Only the upper half of the panel is decorated. The decorated area is divided by two arcs of a circle, each composed of a triple roll moulding, which touch close to the upper edge of the panel. The arc to the left is the shorter. Within the frame to the right two stems, whose upper ends have been cut off by the trimming of the edge, are linked together by a collar before curving down and back. That to the right is cut off by the trimming of the edge, but that to the left terminates in an animal head

separated from the stem by a collar. The head is small and has an open mouth and an incised reversed lentoid eye. An incised dot indicates the pupil. Within the spandrel formed by the two curving stems is the lightly incised sketch of a backward-looking animal, and in the space defined by each scroll is a pair of incised lines crossing each other at right angles. In the left-hand field there is also an incised curved arc along the upper edge, and in the right-hand field a lightly incised cross, in the upper right-hand quadrant defined by the major incised lines. Within the arc to the left is a stem, cut off by the trimming of the edge to the left and terminating in a downward-facing scroll. A subsidiary downward-pointing stem develops from the main stem to terminate in a similar scroll. Between the two arcs a stem develops from each close to their junction. The stems are linked by a collar where they touch before each curves down and back to terminate in an inward-facing scroll. Each stem has one subsidiary also terminating in an inward-facing scroll. The two subsidiary scrolls touch.

DISCUSSION This fragment clearly forms part of the same feature as no. 9. The precise function of the incised sketch and lines remains unclear. It is possible that they represent the beginning of a second stage of decoration which would have filled the (now blank) backgrounds to the scrolls with decoration.

DATE Eleventh century

REFERENCES Horsefield 1835, I, 205; André 1898, 18–19, fig. 5; Clapham 1935a, 407–8; Nairn and Pevsner 1965, 331; Taylor and Taylor 1965–78, II, 562; Kirby 1978, 165; Tweddle 1986b, I, 80, 183–5, II, 467–8, III, figs. 3, 28, pl. 88b

D.T.

## 12. Fragment

(Ill. 182)

PRESENT LOCATION Incorporated internally into east wall of chapel on north side of tower, south of altar

EVIDENCE FOR DISCOVERY First recorded in Clapham 1935, built into exterior of blocking of one of the arches in north wall of nave; probably removed to present position in 1971 when ruined chapel north of nave and tower rebuilt

H. 13.5 cm (5.3 in)   W. 19 cm (7.5 in)
D. Built in

STONE TYPE Pale yellowish-grey, soft, apparently silty limestone; Caen stone, Calcaire de Caen Formation, Bathonian, Middle Jurassic; Caen, Normandy

---

1. The following is an unpublished manuscript reference to no. 11: BL Add. MS 5673, fol. 53r.
2. Identification based on thin-section examination by R. W. Sanderson.

PRESENT CONDITION Broken and worn

DESCRIPTION It is sub-rectangular. The lower and left-hand edges are trimmed, and the upper and right-hand edges roughly broken. The face is divided into two by a broad moulding of rectangular section curving down from the upper right-hand corner across the face before curving back towards the lower right. Each edge of the moulding is paralleled by an incised line. These are defaced towards the lower end. Close to this moulding and to the left is a longitudinally ribbed band (the ribbing suggested by incised lines) which expands slightly towards its lower end. An interlace strand developing from the lower right crosses the face and interlaces with these two mouldings, before looping back and interlacing with them again. From above the point of origin of this strand emerges a plant stem which is carried up to interlace with the curving mouldings before terminating in a tight scroll. A secondary stem develops from its base and curls tightly up and back. Between the two a short stem is carried across to terminate on the curving moulding.

DISCUSSION The fragmentary nature of the piece makes it impossible to identify the original function. The only evidence for dating is the form of the leaf ornament. This is reminiscent of Winchester-style acanthus of the late tenth and eleventh centuries.

DATE Eleventh century

REFERENCES Clapham 1935a, 407–8; Taylor and Taylor 1965–78, II, 562; Kirby 1978, 165; Tweddle 1986b, I, 112, II, 468–9, III, pl. 89a

D.T.

### 13. Figural panel[1]                               (Ill. 181)

PRESENT LOCATION Incorporated internally into the east wall of the south transept, north of the apse

EVIDENCE FOR DISCOVERY None; first noted between 1732 and 1796 by Burrell; in present location when first published in Horsefield 1835

H.   51 cm (20 in)   W.   43 cm (17 in)
D.   Built in

STONE TYPE Whitish-grey, fine-grained limestone; Caen stone, Calcaire de Caen Formation, Bathonian, Middle Jurassic; Caen, Normandy

1. The following are unpublished manuscript references to no. 13: BL Add. MS 5673, fol. 53r; BL Add. MS 47694, fol. 194v.

PRESENT CONDITION Chipped, but otherwise well preserved

DESCRIPTION It is rectangular and decorated with a figure beneath an arch. The arch is supported by two half-round columns. That to the left rests on a plain rectangular base, the base to the right is damaged. Each capital is decorated with a row of upright, parallel-sided, pointed-ended, hollowed leaves developing from the collar separating the capital from the column. Each capital supports a plain abacus with up-turned ends. The arch head is narrow and in high relief, and consists of a median moulding with a convex face flanked by a pair of narrower mouldings with pointed faces. At each end where the median moulding rests on the abacus it unites with the stem of a five-lobed, outward-curling leaf, with the lobes facing inwards. The junctions of the stems and moulding are relieved by hollowed triangles with concave sides. The outer moulding of the arch head is extended to enclose each leaf before terminating on the abacus. Beneath the arch is a robed, nimbed, frontally-placed figure, with the head and feet turned to the right. The nimbus is dished and the facial features well marked. The lentoid eye is placed high up, and the hair confined to the back of the head. The figure's left forearm is stretched out to the left at waist level and holds a book. Just above it the figure's right arm is held out across the body. Two fingers of the hand are extended in blessing to touch the book, the others are curled back. The robe is pulled tight over the chest and legs and falls to each side about the feet. The sleeves are loose, but below the elbow are more tightly fitting with close lateral ribbing. The book which the figure holds is supported by a vertical stand resting on the lower edge of the panel. The stem is half-round in section and bends back at waist level before rising vertically once more, now in square section, and then turning in at right angles to enclose the book on three sides. To the figure's left is a vertically-placed crozier, also standing on the lower edge of the panel. This has a half-round stem separated from the head by a collar. The head curls over towards the figure, and has an incised median line.

DISCUSSION The identification of the figure presents a number of problems. The figure is tonsured and has to the left a crozier and to the right a reading desk. It must, therefore, represent a monk who was also a bishop and possibly an author. Unfortunately, there is no comparable figure in stone, metalwork, or ivory from southern England, and it is necessary to turn to

the manuscripts for comparative iconography. These depict five possible candidates: St Gregory; St Benedict; St Aldhelm; St Dunstan; and St Aethelwold.

St Dunstan and St Aethelwold are depicted twice in pre-Conquest manuscripts, in BL MS Cotton Tiberius A. III, fol. 2v (Temple 1976, no. 100, 118–19, ill. 313), and in a copy of it, Durham Cathedral Library MS B. III. 32, fol. 56v (ibid., no. 101, 119, ill. 315). In both scenes the two figures occur seated together, each holding a Tau-shaped crozier and an opened scroll. St Dunstan wears the *pallium*. The only point of resemblance with the Sompting figure is in the form of St Dunstan's tonsure where the front and top of the head are bald and the hair is gathered at the back of the head: precisely the arrangement seen at Sompting. This feature is not confined to depictions of St Dunstan, however. The figure of St Aldhelm in Lambeth Palace Library MS 200, fol. 68v, has a similar tonsure (ibid., no. 39, 62–3, ill. 132). In contrast, the drawings of St Aldhelm in the Bodleian Library, Oxford, MS Bodley 577, fols. 1r, 1v (ibid., no. 57, 75–6, ills. 179–80) show the saint with a normal tonsure. On fol. 1r he has a lectern to the right as on no. 13, but on fol. 1v he is standing, facing right and presenting his book (*De Virginitate*) to the nuns of Barking. In neither case is the figure accompanied by a crozier.

St Benedict is depicted three times in pre-Conquest manuscripts, in BL MS Arundel 155, fol. 133v (Temple 1976, no. 66, 84–5, ill. 213); BL MS Cotton Tiberius A. III, fol. 117v (ibid., no. 100, 118–19, ill. 314); and in Orléans, Bibl. Mun. MS 175, fol. 149r (ibid., no. 43, 66, ill. 144). In Arundel 155 and Tiberius A. III the figure is seated, has the figure of a monk at his feet and is tonsured; in the former he holds a crozier. In Tiberius A. III there is a lectern to the right of the saint, but in Arundel 155 a manuscript of his rule is presented to him by a monk. In the Orléans manuscript the saint is standing and facing left and tonsured in the same way as the Sompting figure, but there is no crozier or reading desk. The three depictions of St Benedict between them, therefore, cover all of the iconographic features encountered at Sompting, although no individual representation provides an adequate parallel in itself.

The same situation is encountered in the two pre-Conquest depictions of St Gregory. In the Orléans manuscript, fol. 149r (Temple 1976, no. 43, ill. 144), the saint is tonsured, standing, and facing right. He holds a crozier and an open book in his left hand and at his feet is a monk. In Oxford, Bodleian Library MS Tanner 3, fol. 1v (ibid., no. 89, 105–6, ill. 298), the saint is seated and has a book on a reading stand to the

right. The figure may originally have been tonsured, but in a twelfth-century overpainting a mitre and crozier have been added. In Anglo-Saxon manuscript art the Sompting figure, therefore, seems to have most in common with the depictions of St Gregory or St Benedict and may represent one or other of them. There is no reason to assume, however, that the iconographic traditions of the sculptor were necessarily those of the manuscript painter. Nevertheless, both the stye of the figure and the form of the arch find close parallels in late pre-Conquest manuscripts, suggesting an eleventh century date for the piece. For more detailed discussion of its dating see Chap. VII.

DATE Eleventh century

REFERENCES Horsefield 1835, I, 205; André 1898, 18; Jessep 1914, 38; Clapham 1935a, 408–9, pl. IX; Mee 1937, 343, pl. facing 273; Rice 1947 11; Rice 1952, 107, pl. 15b; Fisher 1959, 90; Quirk 1961, 31; Fisher 1962, 381, pl. 218; Nairn and Pevsner 1965, 331; Taylor and Taylor 1965–78, II, 562; Fisher 1970, 181–2; Kirby 1978, 165; Tweddle 1986b, I, 76–8, 211–14, II, 469–71, III, pl. 89b

D.T.

## 14a–b. Two capitals and imposts[1]      (Ills. 183–91)

PRESENT LOCATION *in situ* in the tower arch

EVIDENCE FOR DISCOVERY First recorded by Buckler in 1825 (BL Add. MS 27765, fol. 83v); first published in Wright 1844

a (north):
capital: H.   24 cm (9.5 in)   W.   39 cm (15.4 in)
    D.   16.5 cm (6.5  in)
impost: (west side, south face) H.   28 cm (11 in)
    W.   21 cm (8.3 in); (west face) H.   28 cm (11 in)
    W.   53 cm (20.9 in); (east side, south face)
    H.   26 cm (10.2 in)   W.   21.5 cm (8.5 in); (east
    face) H.   26 cm (10.2 in)   W.   47 cm (18.5 in)

b (south):
capital: H.   23 cm (9 in)   W.   47 cm (18.5 in)
    D.   15 cm (5.9 in)
impost: (west side, north face) H.   28.5 cm (11.2 in)
    W.   20 cm (7.9 in); (west face) H.   28.5 cm (11.2
    in)   W.   22 cm (8.7 in); (east side, north face) H.
    25 cm (9.8 in)   W.   23 cm (9 in); (east face) H.   25
    cm (9.8 in)   W.   39.5 cm (15.6 in)

1. The following are unpublished manuscript references to no. 14: BL Add. MS 27765c, fol. 83v; BL Add. MS 37509, items 194, 196; BL Add. MS 37601, items 429–34; BL Add. MS 37802, fol. 9v.

STONE TYPE (capitals): Pale grey (with a greenish tinge), shell-fragment limestone; Quarr stone, Bembridge Formation, Palaeogene, Tertiary; Isle of Wight

(imposts): Pale yellow, soft, fine-grained limestone; Caen stone, Calcaire de Caen Formation, Bathonian, Middle Jurassic; Caen, Normandy

PRESENT CONDITION Fairly well preserved

DESCRIPTION The tower arch is of square section with soffit shafts carried round the head of the arch as a soffit roll. At each side the soffit shaft and roll are separated by a narrow abacus supported by a capital. The arch head and jambs are in turn separated by narrow recessed abaci below which are imposts flanking the capital and of similar height. These stand slightly proud of the jambs and are separated from them by narrow roll mouldings. At each side the abaci and imposts are returned along the east and west walls.

On the north side, a, the capital is decorated with three superimposed zones of narrow upright leaves with clubbed, out-turned ends. On each of the flanking strips is a large, inward-facing, tightly-scrolled volute composed of a half-round, tapering moulding encircling a domed berry bunch. The individual berries are in relief. The squared bases of the volutes touch the capital close to its lower edge. The inner edges of the volutes touch the capital, and the outer edges the return angles of the impost. The east face of the impost is decorated with a pair of similar outward-facing volutes with their squared bases touching its lower edge. The triangular area between the volutes is left in relief and longitudinally grooved. From the tip of the volute to the right a square-ended, expanding, relief moulding curves up to flank the volute. The west face of the impost is similarly decorated except that secondary, expanding, half-round mouldings develop from the tip of each volute.

On the south side, b, the capital and imposts are similar to those on the north side, except that the heavily damaged eastern volute flanking the capital faces outwards, and has a secondary, half-round, expanding moulding curving downwards and outwards developing from the tip. On the west face of the impost there is only a single volute.

DISCUSSION The tower arch, with its use of a soffit roll and shafts, is of Romanesque form, and eleventh-century date; it is clearly of the same date as the upper stages of the west tower which employs applied half-round shafts and one similar capital. The lower stage of the tower represents the west end of the nave of a pre-

Conquest church (Aldsworth and Harris 1988, fig. 8). Soffit shafts, such as those employed here, occur first on the continent from the second quarter of the eleventh century, as at Speyer in the Rhineland, in work of *c.* 1030–61 (Gem 1973, II, 494; Conant 1974, ill. 90), or Le Mont St Michel in Normandy, under construction between 1034 and 1064 (loc. cit.). Soffit rolls, used in conjunction with shafts, are similarly a late feature, occurring first in the crypts of Auxerre and Nevers cathedrals in Burgundy, of *c.* 1030 and 1029 respectively (Bony 1967, 75; Conant 1974, 162, ill. 115). It is difficult to conceive of these features being introduced into England before the middle of the eleventh century, and indeed it is arguable that the tower arch at Sompting is as late as the 1080s or 1090s (Gem 1983, 128).

Further slight evidence for dating derives from the layout and form of the decoration. The use of capitals flanked by decorated imposts is unusual and is paralleled in England only at Langford, Oxfordshire, on the belfry windows (no. 4; Ills. 297–312), and on the continent at Bernay where similar imposts and capitals occur in the south transept in work dated to 1017–55 (Gem 1973, II, 495, 522; Gem 1983, 126). The use of debased composite or Corinthian forms, as here, where the volutes have been separated from the zone of upright leaves is difficult to parallel, but the suppression of one or other of these decorative zones to leave either upright leaf capitals or voluted capitals does occur, particularly in Lincolnshire. At Bracebridge and Glentworth there are volute capitals with the zone of upright leaves suppressed (Brown 1925, fig. 192, VII, XVI), and at Great Hale upright leaf capitals with volutes suppressed (ibid., fig. 192, XII, XIV). All of these capitals adorn belfries of the Lincolnshire type, for which a firm post-Conquest date can be argued (D. A. Stocker, pers. comm.).

Even if the tower arch as it stands is of later eleventh century date, not all the elements of it need be contemporary. As has been pointed out (Aldsworth and Harris 1988, 121–2, fig. 14), the flanking imposts have every appearance of having been reshaped and reused in their present positions, presumably from the earlier building.

DATE Eleventh century

REFERENCES Wright 1844, 34, fig. 20; Rickman 1848, xxvii-iii, fig. on xxvii; Bloxham 1882, I, 62; Lynham 1886, 304; Allen 1889, 198; André 1898, 12; Brown 1900a, 307, fig. 8; Brown 1900b, 336; Page 1907, 364; Tavenor-Perry 1909, 69; Crouch 1910, pl. 39; Jessep 1914, 38; Brown 1925, 202, fig. 118; Clapham 1930, 126, 130, pl. 47; Cottrill 1931, appendix; Clapham 1935a, 405–7, pl. VIIIB; Rice 1952, 145, pl. 26b; Fisher 1962, 380, pl. 217; Nairn

and Pevsner 1965, 330; Taylor and Taylor 1965–78, II, 561–2, fig. 274, III, 784, fig. 648; Taylor and Taylor 1966, 51; Fisher 1969, 177, pl. p. 71; Fisher 1970, 180–1, pl. on 90; Gem 1973, II, 493, 495, 503; Kirby 1978, 165; Gem 1983, 125, fig. 4; Tweddle 1986b, I, 59–61, 173–4, II, 471–3, III, pl. 90; Aldsworth and Harris 1988, 121–2, figs. 13–14

<div align="right">D.T.</div>

## 15. String-course[1]                              (Ills. 192–5)

PRESENT LOCATION *in situ* externally between the ground and first floor of the tower

EVIDENCE FOR DISCOVERY First recorded by Buckler in 1825 (BL Add. MS 36432, item 1252); first published in Rickman

L.   *c.* 1789 cm (704 in)   H.   25 cm (9.8 in)
D.   10 cm (3.9 in)

STONE TYPE Partly of grey, flaky-weathered limestone (Quarr stone); partly of pale yellow-grey, cavernous-weathered limestone (Bembridge limestone); and partly of soft yellowish limestone (Caen stone)

PRESENT CONDITION Broken in places; heavily weathered

DESCRIPTION It is of fundamentally square section, but has been modified to leave a series of raised rectangular fields, alternately above and below the mid-line of the string-course. Each touches its neighbours and is divided into two equal, vertical facets which slope inwards towards the vertical axis of the field. The recessed fields are similarly facetted, the facets sloping up towards the vertical axis.

DISCUSSION The string-course probably belongs with the construction of the upper stages of the tower in the mid to late eleventh century (Aldsworth and Harris 1988, 114–5). Gem has interpreted the decoration of the string-course as an upright leaf motif. This is possible, but it seems to have more in common with geometrical ornament (Gem 1983, 123).

DATE Eleventh century

REFERENCES Rickman 1848, xxix, fig. on xxix; Allen 1889, 197; Page 1907, 364; Tavenor-Perry 1909, 60; Crouch 1910, pls. 37–8; Jessep 1914, 37; Brown 1925, 201;

1. The following are unpublished manuscript references to no. 15: BL Add. MS 27765C, fol. 83r; BL Add. MS 36432, item 1252; BL Add. MS 37601, item 587; BL Add. MS 37802, fols. 9v, 11r; BL Add. MS 42000, fol. 3r.

Fisher 1962, 276–7; Taylor and Taylor 1965–78, II, 560–1, fig. 273; Taylor and Taylor 1966, 51; Fisher 1969, 177; Fisher 1970, 175; Gem 1973, II, 492; Gem 1983, 123; Tweddle 1986b, I, 71–2, 173, II, 473–4, III, pl. 91a; Aldsworth and Harris 1988, 114–15, figs. 1–3

<div align="right">D.T.</div>

## 16. Capital                                          (Ill. 196)

PRESENT LOCATION *in situ* externally on the central pilaster of the south face of the tower, just below the belfry windows

EVIDENCE FOR DISCOVERY First published in Lynham 1886

H.   *c.* 50 cm (19.7 in)   W.   *c.* 50 cm (19.7 in)

STONE TYPE Greenish-grey limestone; Quarr stone, Bembridge Formation, Palaeogene, Tertiary; Isle of Wight

PRESENT CONDITION Badly eroded

DESCRIPTION It is separated from the pilaster by a narrow roll moulding along its lower edge. It is so heavily damaged that the form of its foliate decoration is lost. It may have been similar to that of no. 19.

DISCUSSION It has been suggested (Aldsworth and Harris 1988, 124–5, fig. 15) that this capital, and those in the corresponding positions on the other faces of the tower were originally functional, supporting a shingled gable and helm roof. Only later, they suggest, were the gables rebuilt in masonry and these capitals left floating free. The use of median half-round pilasters on the upper stages of the tower links them architecturally with the tower arch. Like the soffit shafts and roll of the tower arch (no. 14), these are a feature of Romanesque architecture. Such half-round shafts made their first appearance in Europe towards the middle of the eleventh century as at St Maria im Kapitol, Cologne, building 1049–65 (Gem 1973, II, 494; Conant 1974, ill. 337), and St Remi, Rheims dedicated in 1049 (Gem 1973, II, 494).

Although very heavily damaged, the capital appears to have had a volute form, paralleled on nos. 17 and 19. Such volute capitals, like the upright leaf capitals on the tower arch, represent the debasement of Classical composite or Corinthian forms, with the complete suppression of one of the zones of decoration. On the tower arch it is the volutes which are displaced to form impost-like strips flanking the capitals; they are completely suppressed on no. 18. On this piece it is the zone of upright leaves which is lost.

This type of debasement is paralleled in Lincolnshire where, at Bracebridge and Glentworth, there are similar volute capitals with the zone of upright leaves suppressed (Brown 1925, fig. 192, VII, XVI).

DATE Eleventh century

REFERENCES Lynham 1886, 304; André 1898, 12; Page 1907, 364; Jessep 1914, 37; Brown 1925, 201; Fisher 1962, 377; Nairn and Pevsner 1965, 330; Taylor and Taylor 1965–78, II, 558; Taylor and Taylor 1966, 51; Fisher 1970, 176; Gem 1983, 123; Tweddle 1986b, I, 62–3, 173–4, II, 474, III, pl. 91b; Aldsworth and Harris 1988, 115–16, fig. 9

D.T.

## 17. Capital                                    (Ills. 197–9)

PRESENT LOCATION *in situ* externally on the central pilaster of the east face of the tower, just below the belfry windows

EVIDENCE FOR DISCOVERY First published in Lynham 1886

H.   *c.* 50 cm (19.7 in)    W.   *c.* 50 cm (19.7 in)

STONE TYPE Yellowish-grey limestone (with a greenish (possibly algal) coating in places); Caen stone

PRESENT CONDITION Badly eroded

DESCRIPTION It is separated from the pilaster by a narrow roll moulding along its lower edge. It is heavily damaged, but to each side of the capital a half-round, inward-facing volute emerges from the lower edge. The stem slopes back to touch the wall where it is tightly scrolled around a domed berry bunch.

DISCUSSION The form of the volutes used here, apparently incorporating berry bunches, links directly with the volutes on the strips flanking the soffit capitals of the tower arch, nos. 14a–b. The similarity in form suggests that they are not far apart in date, even if, as has been suggested recently, the tower arch strips are reused (Aldsworth and Harris 1988, 121–2). See also nos. 16 and 19.

DATE Eleventh century

REFERENCES Lynham 1886, 304; André 1898, 12; Page 1907, 364; Jessep 1914, 37; Brown 1925, 201; Nairn and Pevsner 1965, 330; Taylor and Taylor 1965–78, II, 558; Taylor and Taylor 1966, 51; Gem 1983, 123; Tweddle 1986b, I, 62–3, 174–5, II, 476, III, pl. 93a; Aldsworth and Harris 1988, 115–16, fig. 9

D.T.

## 18. Capital and impost                         (Ills. 200–1)

PRESENT LOCATION *in situ* externally on the central pilaster strip on the north face of the tower, just below the belfry windows

EVIDENCE FOR DISCOVERY First published in Rickman 1848

H.   *c.* 48 cm (18.9 in)    W.   *c.* 48 cm (18.9 in)

STONE TYPE Grey to yellowish (with a greenish (possibly algal) coating in places) limestone; Caen stone

PRESENT CONDITION Complete but worn

DESCRIPTION It is separated from the pilaster by a narrow roll moulding along its lower edge. It is decorated with two superimposed zones of narrow upright leaves with out-turned clubbed ends. The capital supports a narrow impost of rectangular section sculptured in one piece with it.

DISCUSSION This capital is very similar in form to those of the soffit shafts of the chancel arch. Like them and nos. 16, 17 and 19, it represents a debasement of the Classical composite or Corinthian capital. In this case it is the zone of upright leaves which is preserved, with nos. 16, 17 and 19 it is the volutes. For further discussion see no. 14a–b.

DATE Eleventh century

REFERENCES Rickman 1848, fig. on xxviii; Lynham 1886, 304; André 1898, 12; Page 1907, 364, fig. on 363; Crouch 1910, pl. 38; Jessep 1914, 37; Brown 1925, 201; Fisher 1962, 377, fig. 43; Nairn and Pevsner 1965, 330; Taylor and Taylor 1965–78, II, 558, fig. 273; Taylor and Taylor 1966, 51; Fisher 1970, 176, fig. 12; Gem 1983, 123, fig. 3; Tweddle 1986b, I, 59–61, 174–5, II, 475, III, pl. 92b; Aldsworth and Harris 1988, 115–16, fig. 9

D.T.

## 19. Capital and impost                         (Ills. 202–4)

PRESENT LOCATION *in situ* externally on the central pilaster of the west face of the tower, just below the belfry windows

EVIDENCE FOR DISCOVERY First published in Rickman 1848

H.   *c.* 46 cm (18 in)    W.   *c.* 46 cm (18 in)

STONE TYPE Yellowish limestone, much weathered; Quarr stone

PRESENT CONDITION Heavily weathered

DESCRIPTION It is separated from the pilaster by a narrow roll moulding along its lower edge. From the mid-point of this develops a pair of outward-facing volutes. The broad low-relief stems are hollowed, and the scrolls almost touch the lower moulding. The capital supports a damaged impost of rectangular section sculptured in one piece with it.

DISCUSSION See no. 16.

DATE Eleventh century

REFERENCES Rickman 1848, fig. on xxviii; Lynham 1886, 304; André 1898, 12; Page 1907, 364; Crouch 1910, pl. 37; Jessep 1914, 37; Brown 1925, 201; Fisher 1962, 377; Nairn and Pevsner 1965, 330; Taylor and Taylor 1965–78, II, 558, fig. 273; Taylor and Taylor 1966, 51; Fisher 1970, 176; Gem 1983, 123; Tweddle 1986b, I, 62–3, 174–5, II, 474–5, III, pl. 92a; Aldsworth and Harris 1988, 115–16, fig. 9

<div align="right">D.T.</div>

## 20. Capital[1]    (Ills. 205–8)

PRESENT LOCATION *in situ* on the mid-wall shaft of the easternmost belfry window on the north face of the tower

EVIDENCE FOR DISCOVERY First published in Rickman 1848

H.  *c*. 38 cm (15 in)   W.  *c*. 23 cm (9 in)
D.  *c*. 62 cm (24.4 in)

STONE TYPE Pale brown, glauconitic, medium-grained, quartzose sandstone; Hythe Beds, Lower Greensand Group, Lower Cretaceous; Petersfield to Pulborough area

PRESENT CONDITION Broken and worn; partially restored with new stone

DESCRIPTION It is of circular plan below, but of narrow rectangular plan above. The east and west faces rise vertically, but the north and south faces expand before being cut off vertically in the same plane as the interior and exterior walls. The capital is separated from the shaft by a narrow roll moulding along its lower edge. From this, on the east and west faces, emerges a pair of outward-leaning, half-round stems terminating in tight scrolls in the upper, outer corners of the face. In the angle between them is a second similar pair of stems.

DISCUSSION It seems clear that the eastern half of this capital is a later replacement. Aldsworth and Harris

have suggested that the tower at Sompting was originally crowned with shingled gables and a helm roof, and that only later were masonry gables substituted, although probably not very much later (Aldsworth and Harris 1988, 124–5, fig. 15). This would place the two capitals nos. 20–1 very late in the eleventh century. This is unsatisfactory as the capitals are decorated in what appears to be a derived version of Winchester-style acanthus, or even the Scandinavian Ringerike style. In either case a date towards the middle of the eleventh century would fit these capitals better. For further discussion see Chap. VII.

DATE Eleventh century

REFERENCES Rickman 1848, fig. on xxvii; Crouch 1910, pl. 39; Page 1907, fig. on 363; Brown 1925, fig. 26.VI; Clapham 1930, 135; Clapham 1935a, 405–7; Nairn and Pevsner 1965, 330; Taylor and Taylor 1965–78, II, 558, fig. 273; Taylor and Taylor 1966, 51; Fisher 1970, 179–80; Gem 1973, II, 493, 495; Gem 1983, 125, 128; Tweddle 1986b, I, 65, 174, II, 476–7, III, pl. 93b; Aldsworth and Harris 1988, 117, fig. 11a

<div align="right">D.T.</div>

## 21. Capital[2]    (Ills. 209–12)

PRESENT LOCATION *in situ* on the mid-wall shaft of the westernmost belfry window on the north face of the tower

EVIDENCE FOR DISCOVERY First published in Rickman 1848

H.  *c*. 38 cm (15 in)   W.  *c*. 23 cm (9.1 in)
D.  *c*. 62 cm (24.4 in)

STONE TYPE Pale brown, glauconitic, medium-grained, quartzose sandstone; Hythe Beds, Lower Greensand Group, Lower Cretaceous; Petersfield to Pulborough area

PRESENT CONDITION Worn and probably partially restored with new stone

DESCRIPTION See no. 20.

DISCUSSION The upper part of the capital may be a replacement. See also no. 20.

DATE Eleventh century

REFERENCES Rickman 1848, fig. on xxvii; Crouch 1910, pl. 39; Page 1907, fig. on 363; Brown 1925, fig. 26.VI;

---

1. The following is an unpublished manuscript reference to no. 20: BL Add. MS 37601, item 434.

2. The following is an unpublished manuscript reference to no. 21: BL Add. MS 37601, item 434.

Clapham 1930, 135; Clapham 1935a, 405–7; Nairn and Pevsner 1965, 330; Taylor and Taylor 1965–78, II, 558, fig. 273; Taylor and Taylor 1966, 51; Fisher 1970, 179–80; Gem 1973, II, 493, 495; Gem 1983, 125, 128; Tweddle 1986b, I, 65, 174, II, 477, III, pl. 93b; Aldsworth and Harris 1988, 117, fig. 11a

D.T.

## 22a–b. Two bases                               (Ill. 213)

PRESENT LOCATION *in situ* on the angle shafts of the pair of triangular-headed windows on the north side of the tower at first floor level

EVIDENCE FOR DISCOVERY Rickman shows windows of which a and b form part with massive sills, each decorated close to outer end with a volute-like feature (Rickman 1848, fig. on xxviii); presumably he mistakenly interpreted a and b as ends of decorated sills which had already weathered away

H.   *c.* 15 cm (5.9 in)   W.   *c.* 30 cm (11.8 in)

STONE TYPE Yellowish, soft, much weathered limestone; Caen stone

PRESENT CONDITION Heavily weathered

DESCRIPTION Each of the triangular-headed windows has an angle shaft and angle roll carried around the triangular head. Between them the half-round median pilaster of the tower forms a common shaft. Each of the angle shaft bases terminates in an out-turned volute.

DISCUSSION These volutes reflect a general interest in the form exhibited throughout the decoration at Sompting, as on the impost-like strips flanking the tower arch capitals (no. 14) and three of the pilaster capitals on the tower (nos. 16–17, 19). The dating of them must depend solely on the dating of the fabric, which places them in the mid to late eleventh century.

DATE Eleventh century

REFERENCES Rickman 1848, fig. on xxviii; Gem 1973, II, 492; Gem 1983, 124; Tweddle 1986b, I, 173, II, 477–8, III, pl. 94a

D.T.

## 23. Capital                               (Ills. 214–15)

PRESENT LOCATION On the interior on the shaft between the two triangular-headed windows on the north face of the tower at first floor level

EVIDENCE FOR DISCOVERY First recorded by Gem in 1973

H.   *c.* 40 cm (15.8 in)   W.   *c.* 30 cm (11.8 in)

STONE TYPE Uncertain; stone whitewashed

PRESENT CONDITION Broken and worn

DESCRIPTION The half-round shaft applied to the interior face of the walling between the two windows has a simple capital in the form of a human face mask. The features, in low relief, are crudely drawn. The figure has a prominent moustache.

DISCUSSION As there is no close parallel to this capital, its dating must derive from that of the fabric; that is, it belongs to the mid or late eleventh century.

DATE Eleventh century

REFERENCES Gem 1973, II, 493; Gem 1983, 124; Tweddle 1986b, II, 478, III, fig. 53; Aldsworth and Harris 1988, 117, fig. 10b, pl. I

D.T.

STEDHAM, **1–11.** See Appendix A, p. 193.

STEYNING, **1–2.** See Appendix A, p. 197.

# STOKE D'ABERNON, Sr. (St Mary)[1]

## TQ 129584

### 1. Sundial                    (Ill. 216)

PRESENT LOCATION Destroyed. Formerly built externally into the south wall, east of the south door

EVIDENCE FOR DISCOVERY First recorded by Baldwin Brown in 1900 (Brown 1900b). The dial fell and was shattered in 1933; former position now marked by circular modern stone

H. *c.* 30 cm (11.8 in)  W. *c.* 30 cm (11.8 in)
D. Unobtainable

STONE TYPE Calcareous sandstone

PRESENT CONDITION Destroyed

DESCRIPTION On a square stone is a high-relief circular dial, the lower part of which is extensively damaged. There is a small central gnomon hole. The lower part of the dial is calibrated using incised lines, there being a pair of horizontals, a vertical, and three

1. The following is an unpublished manuscript reference to no. 1: BL Add. MS 37601, item 538.

equally-spaced lines between each horizontal and the vertical.

DISCUSSION The dial was built into a wall which was substantially pre-Conquest in date, apart from later fenestration. Presumably it was an original feature. The form of the dial, a circular dial projecting from a rectangular stone, was certainly popular in the late pre-Conquest period, occurring at the following Hampshire sites: Winchester St Michael 1 (Ill. 671); Warnford 1 (Ill. 478); and Corhampton 1 (Ill. 438). The calibration of the dial is also consistent with a pre-Conquest date.

DATE Tenth to eleventh century

REFERENCES Brown 1900b, 337; Gatty 1900, 68–9, fig. on 68; Johnston 1900b, 78, fig. 21; Malden 1905, 447; Johnston 1907, 16–17, fig. 4; Johnston 1913, 65; Green 1928, 504; Cox and Johnston 1935, 165, 193; Zinner 1939, 8; Zinner 1964, III, 190; Taylor and Taylor 1965–78, II, 574; Taylor and Taylor 1966, 25; Tweddle 1986b, I, 84–5, 189, II, 493, III, fig. 55

D.T.

TANDRIDGE, **1.** See Appendix A, p. 198.

# TANGMERE, Sx. (St Andrew)

## SU 902062

### 1. Panel reused as window head    (Ill. 219)

PRESENT LOCATION *in situ* over the window in the south wall of the nave to the east of the porch

EVIDENCE FOR DISCOVERY First recorded in 1907 (Page 1907)

H.  44 cm (17.3 in)  W.  55 cm (21.7 in)
D.  Built in

STONE TYPE Greenish-grey or olive-grey, fine- to medium-grained (0.2 to 0.3–mm quartz grains), glauconitic sandstone; some weathered-out sharp ridges may be cherty streaks; probably Hythe Beds,

Lower Greensand Group, Lower Cretaceous; Petersfield to Pulborough area

PRESENT CONDITION Heavily worn

DESCRIPTION It is sub-rectangular with the arch of the head of the window cut into the lower edge. There is an irregular, broad, low-relief border along the remaining edges. It is decorated with two crude, inward-facing figures, in low relief, one on each side of the window head. That to the left is frontally placed with the head turned to the right, bare legs, and well-marked female genitalia. The body tapers towards the round head. There is no neck. Incised lines indicate

the nose, ears, and mouth. The eye is drilled. One arm, with upturned fingers, is extended horizontally towards the second figure. This is in profile. It has bare legs, a parallel-sided body, and an oval head. There is no neck. Incised lines indicate the facial features. The eye is drilled. One arm is extended horizontally holding a heavily weathered object. Above the extended arms, and between the figures, there is to the left a disc, and to the right a crescent, possibly representing the sun and the moon.

DISCUSSION This panel is arguably reused. The feet of the right-hand figure are cut away, and the upper left-hand corner is lost. As it is now incorporated into a twelfth-century window head, this argues for

primary use perhaps in the eleventh century, or conceivably earlier. The simplicity of the carving renders any attempt at art-historical dating impossible.

DATE Eleventh century

REFERENCES Page 1907, 365; Mee 1937, 361, pl. facing 273; Poole 1948, 70, pl. XI; Salzman 1953, 238; Nairn and Pevsner 1965, 347; Fisher 1970, 202; Tweddle 1986b, I, 70, 217, II, 497–8, III, pl. 107b

<div align="right">D.T.</div>

TITSEY, 1–5. See Appendix A, p. 199.

WALBERTON, 1. See Appendix C, p. 201.

# WEST WITTERING, Sx. (Sts Peter and Paul)

## SZ 776984

### 1. Architectural feature        (Ills. 217–18)

PRESENT LOCATION In a case fixed to the east face of the westernmost pillar of the arcade between the chancel and the south chapel

EVIDENCE FOR DISCOVERY Found 'embedded in the masonry' of a wall (perhaps east wall or south aisle wall) during restoration in 1875 ((——) 1875b); kept loose in the south chapel until placed in present position in 1958

H.  22 cm (8.7 in)    W.  24 cm (9.5 in)
D.  10 cm (3.9 in)

STONE TYPE Greyish-yellow, medium- to coarse-grained, oolitic limestone, with a millet-seed texture and without obvious shell fragments; of uncertain provenance, perhaps Great Oolite Group, Middle Jurassic

PRESENT CONDITION Broken and chipped; otherwise well preserved

DESCRIPTION It is sub-rectangular and dressed flat on faces D and F. Only two faces are carved; both use incised lines of V-shaped section.

A (broad): The damaged right-hand edge slopes inwards, and the upper edge is broken and rises to the right. The break has partially removed the irregular

circle enclosing a Greek cross. Its centre is roughly hollowed.

C (broad): There is a saltire cross, its centre drilled, within a circle.

DISCUSSION The east wall of the church is early thirteenth century and the south aisle wall of c. 1175–1200 (Nairn and Pevsner 1965, 377; Done 1965, 8). The piece must be of earlier date if it was reused as building material in one of these walls. As Radford has pointed out (Done 1965, fig. on 7), the piece was first used as a gable cross, actually forming the apex stone of the gable, and probably with an incised Greek cross. Subsequently the stone must have been turned over, rotated through about 135 degrees, and used again at the apex of the gable, this time probably with an incised saltire cross. Radford has suggested that the primary use was as early as a charter mentioning West Wittering in c. 740, and the secondary use was late Anglo-Saxon (Done 1965, 5); however, there is no clear dating evidence. Allowing a reasonable period of primary and secondary use before the stone was used as building material, then the period of primary use at least was probably before the Conquest, and the period of secondary use may have been. The form of the cross on both sides is related to circle-headed crosses, such as that from near-by

Pagham (Ills. 99–100). This may also point to a pre-Conquest date, and one at the earliest in the tenth century, when this type of head was introduced.

DATE Tenth to eleventh century

REFERENCES (——) 1875b, 276; Salzman 1953, 220; Done 1958–62, 228–9; Done 1965, 4–8, fig. on 7, pls. following 20; Tweddle 1986b, I, 85–6, II, 505, III, pl. 112

D.T.

# APPENDIX A

# STONES DATING FROM SAXO-NORMAN OVERLAP PERIOD OR OF UNCERTAIN DATE

## CHITHURST, Sx. (dedication unknown)[1]

SU 832231

**1. Grave-cover** (Ill. 220)

PRESENT LOCATION Outside near the north wall of the church

EVIDENCE FOR DISCOVERY None; first recorded in Lower 1870

L. 182 cm (71.7 in)  W. 55 cm (21.7 in)
D. 17 cm (6.7 in)

STONE TYPE Greenish-grey, medium-grained (3–mm quartz grains), glauconitic sandstone; Hythe Beds, Lower Greensand Group, Lower Cretaceous; Petersfield to Pulborough area

PRESENT CONDITION Worn but complete

DESCRIPTION Tapering cover with a square head and foot.

*A (top):* There is a narrow, relief, median moulding crossed close to each end by a moulding spanning the width of the stone. At the head end a pair of narrow, oblique, relief mouldings link the ends of the cross piece with the median moulding, about half-way along its length. The opposing ends are carried around the head to form a border.

DISCUSSION The church at Chithurst is a substantially intact eleventh-century structure. It therefore seems very unlikely that the covers could have been recovered

during later rebuilding, as they were at near-by Stedham. Instead, it is probable that the covers have been discovered piecemeal during grave digging, and have gradually accumulated along the north wall of the church. That the recovery of the grave-covers has taken place over a relatively long period is suggested by the fact that some, particularly those alongside the church, are only slightly sunk into the modern ground surface. Others, particularly to the north west of the church have been overwhelmed by the gradual accumulation of spoil from grave digging, and are buried up to 10 cm below the modern ground surface. Only the edges, alongside the path to the church are visible.

The covers at Chithurst seem to represent a very highly localised group; only no. 1 overlaps in its decoration with covers from the near-by group of material at Stedham (e.g. no. 4; Ill. 241). Similarly, the median ridge type with crossed ends, which predominates at Chithurst, is not found at Stedham.

DATE Eleventh century

REFERENCE Tweddle 1986b, I, 90, 220–1, II, 370–1, III, pls. 33b, 34a

D.T.

**2. Grave-cover** (Ill. 221)

PRESENT LOCATION Outside near the north wall of the church

EVIDENCE FOR DISCOVERY See no. 1.

L. 94 cm (37 in)  W. 42 cm (16.5 in)
D. 11 cm (4.3 in)

---

1. The following is an unpublished manuscript reference to the Chithurst stones: BL Add. MS 47693, fol. 28r. The following are general references to the Chithurst stones: Lower 1870, I, 113; Johnston 1912, 106, pl. VI; Jessep 1914, 61; Johnston 1921, 182; Mee 1937, 99; Kendrick 1949, 86; Salzman 1953, 6; Fisher 1970, 81–2

STONE TYPE Greenish-grey, medium-grained (3–mm quartz grains), glauconitic sandstone; Hythe Beds, Lower Greensand Group, Lower Cretaceous; Petersfield to Pulborough area

PRESENT CONDITION Worn but complete

DESCRIPTION Tapering grave-cover with squared ends. It has a broad relief median moulding crossed close to each end by a similar moulding spanning the width of the stone.

DISCUSSION See no. 1.

DATE Eleventh century

REFERENCE Tweddle 1986b, I, 90, 220–1, II, 371–2, III, pls. 33b, 35b

D.T.

## 3. Grave-cover                                    (Ill. 222)

PRESENT LOCATION Outside near the north wall of the church

EVIDENCE FOR DISCOVERY See no. 1.

L.   90 cm (35.4 in)   W.   41 cm (16 in)
D.   11 cm (4.3 in)

STONE TYPE Greenish-grey, medium-grained (3–mm quartz grains), glauconitic sandstone; Hythe Beds, Lower Greensand Group, Lower Cretaceous; Petersfield to Pulborough area

PRESENT CONDITION Worn but complete

DESCRIPTION See no. 2.

DISCUSSION See no. 1.

DATE Eleventh century

REFERENCE Tweddle 1986b, I, 90, 220–1, II, 371, III, pls. 33b, 34b

D.T.

## 4. Grave-cover                                    (Ill. 223)

PRESENT LOCATION Outside near the north wall of the church

EVIDENCE FOR DISCOVERY See no. 1.

L.   85 cm (33.5 in)   W.   37 cm (14.6 in)
D.   12 cm (4.7 in)

STONE TYPE Greenish-grey, medium-grained (3–mm quartz grains), glauconitic sandstone; Hythe Beds, Lower Greensand Group, Lower Cretaceous; Petersfield to Pulborough area

PRESENT CONDITION Worn but complete

DESCRIPTION See no. 2.

DISCUSSION See no. 1.

DATE Eleventh century

REFERENCE Tweddle 1986b, I, 90, 220–1, II, 371, III, pls. 33b, 35a

D.T.

## 5. Grave-cover                                    (Ill. 224)

PRESENT LOCATION Outside near the north wall of the church

EVIDENCE FOR DISCOVERY See no. 1.

L.   76 cm (29.9 in)   W.   49 cm (19.3 in)
D.   13 cm (5 in)

STONE TYPE Greenish-grey, medium-grained (3–mm quartz grains), glauconitic sandstone; Hythe Beds, Lower Greensand Group, Lower Cretaceous; Petersfield to Pulborough area

PRESENT CONDITION Broken and worn

DESCRIPTION Incomplete tapering grave-cover; about half of the length is lost. It is decorated with a high-relief Latin cross.

DISCUSSION The decoration may originally have resembled that of no. 2, but as half is lost this is uncertain. See no. 1 for discussion of the group as a whole.

DATE Eleventh century

REFERENCE Tweddle 1986b, I, 90, 220–1, II, 372, III, pls. 33b, 36a

D.T.

## 6. Grave-cover                                    (Ill. 225)

PRESENT LOCATION Outside near the north wall of the church

EVIDENCE FOR DISCOVERY See no. 1.

L.   100 cm (39.4 in)   W.   59 cm (23.2 in)
D.   15 cm (5.9 in)

STONE TYPE Greenish-grey, medium-grained (3–mm quartz grains), glauconitic sandstone; Hythe Beds, Lower Greensand Group, Lower Cretaceous; Petersfield to Pulborough area

PRESENT CONDITION Worn but complete

DESCRIPTION Tapering grave-cover decorated with a low-relief Latin cross.

DISCUSSION See no. 1.

DATE Eleventh century

REFERENCE Tweddle 1986b, I, 90, 220–1, II, 372–3, III, pls. 33b, 37a

D.T.

### 7. Grave-cover                                    (Ill. 226)

PRESENT LOCATION Outside near the north wall of the church

EVIDENCE FOR DISCOVERY See no. 1.

L.   94 cm (37 in)   W.   43 cm (16.9 in)
D.   10 cm (3.9 in)

STONE TYPE Greenish-grey, medium-grained (3-mm quartz grains), glauconitic sandstone; Hythe Beds, Lower Greensand Group, Lower Cretaceous; Petersfield to Pulborough area

PRESENT CONDITION Broken and worn

DESCRIPTION Tapering grave-cover with a narrow, high relief, median moulding. This is crossed close to each end by a similar moulding spanning the width of the stone.

DISCUSSION See no. 1.

DATE Eleventh century

REFERENCE Tweddle 1986b, I, 90, 220–1, II, 373, III, pls. 33b, 37b

D.T.

### 8. Grave-cover                                    (Ill. 227)

PRESENT LOCATION Outside near the north wall of the church

EVIDENCE FOR DISCOVERY See no. 1.

L.   38 cm (15 in)   W.   34 cm (13.4 in)
D.   6 cm (2.4 in)

STONE TYPE Greenish-grey, medium-grained (3-mm quartz grains), glauconitic sandstone; Hythe Beds, Lower Greensand Group, Lower Cretaceous; Petersfield to Pulborough area

PRESENT CONDITION Broken and worn

DESCRIPTION About half of the length of the cover is lost. See no. 7.

DISCUSSION Like no. 7, the decoration may originally have resembled that of no. 2.

DATE Eleventh century

REFERENCE Tweddle 1986b, I, 90. 220–1, II, 373–4, III, pls. 33b, 36b

D.T.

# COCKING, Sx. (dedication unknown)

## SU 879175

### 1. Grave-cover                                    (Ill. 228)

PRESENT LOCATION Incorporated internally into the north wall of the chancel

EVIDENCE FOR DISCOVERY Found reused in foundation of north wall of chancel when rebuilt in 1896

L.   75 cm (29.5 in)   W.   62 cm (24.4 in)
D.   Built in

STONE TYPE Greyish (thinly whitewashed), medium-grained (0.3-mm quartz grains), glauconitic sandstone; Hythe Beds, Lower Greensand Group, Lower Cretaceous; Petersfield to Pulborough area

PRESENT CONDITION Broken; carving well preserved

DESCRIPTION Incomplete tapering grave-cover terminating below in a roughly horizontal break. The lower half is lost.

A (top): An incised median line bifurcates well short of the head end, the bifurcations being carried into the upper corners where they unite with an incised line delimiting the broad plain border. Immediately below the bifurcation the median line is crossed by an incised line whose ends touch the inner edge of the border.

DISCUSSION Cocking, like Chithurst, was a small two-celled eleventh-century Sussex church, dated by Johnston to *c.* 1080 (Johnston 1921, 182). In 1896 the chancel was greatly enlarged, and the stone recovered from the foundations of the north wall of the eleventh-century chancel. Taken with the evidence from Stedham, Sussex, which has produced similar covers, this suggests that monuments of this type were in use in the mid to late eleventh century, although it is impossible to be sure if the series began before the Conquest.

This cover has decoration of the same pattern as one of the examples from Stedham (no. 4; Ill. 241), but incised and not in relief.

DATE Eleventh century

REFERENCES Jessep 1914, 61; Johnston 1921, 182, fig. 1; Tweddle 1986b, I, 90, 220–1, II, 374, III, pl. 38a

D.T.

# JEVINGTON, Sx. (St Andrew)

## TQ 561015

### 1. Figural panel[1]                                        (Ills. 232–4)

PRESENT LOCATION Incorporated internally into the south face of the north arcade at the west end

EVIDENCE FOR DISCOVERY Discovered in 1785 by Sir William Burrell 'in a stone chest', when second stage of tower refloored; originally fixed over south door, inside

H.  96 cm (37.8 in)   W.  57.5 cm (22.6 in)
D.  Built in

STONE TYPE Yellowish-grey, soft, fine-grained limestone; Caen stone, Calcaire de Caen Formation, Bathonian, Middle Jurassic; Caen, Normandy

PRESENT CONDITION Broken and worn

DESCRIPTION Sub-rectangular panel decorated with a half-round, full-length, frontally-placed figure. It has a dished cruciform nimbus, and wears a short featureless skirt. The legs are together, but the feet and *suppedaneum* are broken away. The figure's left arm is bent so that the hand is placed palm outwards, touching, but not resting on, the hip. The right arm is extended and bent upwards at the elbow. The hand is turned inwards at the wrist to hold the shaft of a long-stemmed cross. This has a splayed-armed cross-head. The lower end is thrust into the mouth of an inward-facing animal at the foot of the figure. The head of the animal is up-turned and backward looking, with an open mouth, reversed lentoid

eye, and pointed ears. Its body and front legs are naturalistically treated, but the front legs rest on interlacing loops developing from the back legs. A tail with a lobed tip curls down and across the hindquarters. To the figure's left is a second inward-facing animal. This has a low relief, contoured, ribbon-like body which develops into interlacing coils. The jaws are drawn out and back. There is a reversed lentoid eye and small oval ears. The animal is in combat with a second similar, but smaller, ribbon-like animal. The panel tapers abruptly below the level of the figure's waist but widens irregularly to accommodate the two animals.

DISCUSSION The panel has been re-shaped to the lower left and right to leave the animals to either side of the foot of the figure projecting. The figure is identified by its cruciform nimbus as Christ, and the careful differentiation of the two animals at his feet suggests that the piece depicts Christ as treading on the beasts, as in *Psalms* 91, 13. This differentiation in form between the two animals is echoed in pre-Conquest depictions of this scene, most notably in Oxford, Bodleian Library MS Douce 296, fol. 40r (Temple 1976, no. 79, 96–7, ill. 259) and New York, Pierpont Morgan Library MS 869, fol. 13v (ibid., no. 56, 74–5, ill. 168). There seems little doubt, however, that this piece belongs to the immediately post-Conquest period. The left-hand animal is plainly in the Urnes style, and the right-hand animal shares elements of this style. The Urnes style developed in Scandinavia *c.* 1025–50, but probably did not reach England until after the Conquest (Wilson and Klindt-Jensen 1966, 153, 160).

---

1. The following are unpublished manuscript references to no. 1: BL Add. MS 36631, fol. 141v; BL Add. MS 37603, vol. LXV, items 356, 357.

DATE Late eleventh century

REFERENCES Horsefield 1835, I, 288; Hussey 1852, 245; Lower 1870, II, 1; Allen 1887, 276–7; André 1898, 18; Legge 1901, 152–3, fig. on 152; Keyser 1904, lv; Page 1907, 364, fig. on 363; Jessep 1914, 32, 61; Row 1914, 52; Hartland 1918–19, 153; Brown 1925, 462; Cottrill 1931, appendix; Mee 1937, 230; Kendrick 1949, 120, pl. LXXXV; Gardner 1951, 42, fig. 64; Rice 1952, 95, 100–1, 131, pl. 10a; Moe 1955, 18; Stone 1955, 47, pl. 29; Rice 1960, 206; Quirk 1961, 31; Fisher 1962, 375; Taylor and Taylor 1965–78, I, 350; Nairn and Pevsner 1965, 42–3, 546; Wilson and Klindt-Jensen 1966, 154, pl. LXXIXa; Fisher 1970, 134; Smart 1973, 20–1; Kirby 1978, 165; Laing and Laing 1979, 179; Owen 1979, no. 20, 150–1, 157, 169, 174, 228, pl. 20; Graham-Campbell 1980a, 152; Roesdahl et al. 1981, no. L10; Tweddle 1986b, I, 78, 214–7, II, 394–5, III, pls. 53b, 54a

D.T.

## 2a–b. Two baluster shafts (Ills. 229–30)

PRESENT LOCATION North and south belfry openings of west tower

EVIDENCE FOR DISCOVERY First recorded in Page 1907

MEASUREMENTS Unobtainable

STONE TYPE Greenish-grey, fine-grained quartzose sandstone, highly glauconitic (0.1-mm grains) and slightly micaceous; Upper Greensand, Gault Group, Lower Cretaceous; Eastbourne vicinity

PRESENT CONDITION Heavily weathered, particularly on the capitals; shaft b made up inaccurately in cement

DESCRIPTION Each shaft has a tall circular base on which sits an oblate moulding with a narrow roll above. The lower part of the shaft tapers towards a group of mouldings placed just below the mid-point. This consists of a prominent roll moulding flanked by narrower, recessed roll mouldings. Above this point the shaft either tapers very slightly, or is parallel-sided, terminating at the upper end in an elaborately moulded capital which is partially weathered away. This consists of a single roll moulding with a short length of plain shaft above it. It then curves out slightly towards a vertical fillet crowned by a projecting roll moulding, then by a second, recessed vertical fillet, and then by a series of three roll mouldings, each projecting further than the one below.

DISCUSSION The west tower at Jevington is broad and rather squat with dressed stone quoins, which suggests a post-Conquest date. The appearance of the north and south belfry windows before their radical modification in 1873 supports this view, as they originally had angle-shafts as well as the existing freestanding balusters (Brown 1925, 461). Nonetheless, the latter do resemble elaborately moulded pre-Conquest examples, such as those at St Augustine's Canterbury (nos. 6–7; Ills. 41–9) or St Mary in Castro at Dover (nos. 2–3; Ills. 64–7, 71–5). The major significant difference lies in the fact that the Kentish shafts expand towards the mid-point, and taper towards the base and capital. It remains possible, however, that the Jevington examples are pre-Conquest material reused in an early Romanesque context, like the shafts from St Albans, Hertfordshire (no. 1; Ills. 376–96).

DATE Eleventh century

REFERENCES Page 1907, 364; Brown 1925, 461; Taylor and Taylor 1965–78, I, 350

D.T.

# OXTED, Sr. (St Mary)

TQ 391530

## 1. Grave-cover (Ill. 235)

PRESENT LOCATION On the ground outside the church in the angle between the south wall of the chancel, and the east end of the south aisle

EVIDENCE FOR DISCOVERY Discovered (with no. 2) about four feet down in its present location; first published in Leveson Gower 1893

L. 134 cm (52.8 in)   W. 57 cm (22.4 in)
D. 15 cm (5.9 in)

STONE TYPE Pale yellowish-grey (with a greenish

tinge), medium-grained, finely glauconitic sandstone; Hythe Beds, Lower Greensand Group, Lower Cretaceous; vicinity of Limpsfield, Surrey

PRESENT CONDITION Broken and worn

DESCRIPTION It is rectangular, slightly coped, and decorated with a high relief Greek cross with slightly expanding arms terminating on the edges of the stone.

DISCUSSION Both grave-covers from this site are closely related to the near-by examples at Titsey and Tandridge. There is no archaeological evidence which contributes to their dating, but the monuments at these three sites share many of the features of the Sussex covers from the Midhurst region, at Stedham, Cocking, and Chithurst. The archaeological evidence from the first two sites suggests that these were reused as building material in the late eleventh and twelfth centuries. A mid eleventh-century date for their primary use, therefore, seems likely.

DATE Eleventh century

REFERENCES Leveson Gower 1893, 30–2, figs. A–B; Home 1904, 17; Tweddle 1986b, I, 90, 220, II, 430–1, III, pl. 70b

D.T.

## 2. Grave-cover (Ill. 236)

PRESENT LOCATION See no. 1.

EVIDENCE FOR DISCOVERY See no. 1.

L.   167 cm (65.7 in)   W.   52 cm (20.5 in)
D.   15 cm (5.9 in)

STONE TYPE Pale yellowish-grey (with a greenish tinge), medium-grained, finely glauconitic sandstone; Hythe Beds, Lower Greensand Group, Lower Cretaceous; vicinity of Limpsfield, Surrey

PRESENT CONDITION Worn but complete

DESCRIPTION It is rectangular and decorated with a relief Latin cross, the parallel-sided arms terminating on the edges of the stone.

DISCUSSION See no. 1.

DATE Eleventh century

REFERENCES Leveson Gower 1893, 30–2, figs. A–B; Home 1904, 17; Tweddle 1986b, I, 90, 220, II, 431, III, pl. 70b

D.T.

# STEDHAM, Sx. (St James)

## SU 864227

## 1. Part of grave-cover[1] (Ill. 237)

PRESENT LOCATION Placed near south wall of nave, outside

EVIDENCE FOR DISCOVERY Found built into lower part of nave walls during rebuilding of old church by Butler in 1850, who describes parts of walls as built of slabs set on edge (Butler 1851), presumably forming facings to a rubble core

L.   96 cm (37.8 in)   W.   57 cm (22.4 in)
D.   17 cm (6.7 in)

STONE TYPE Brownish-grey (with a greenish tinge), medium-grained (0.3-mm quartz grains), glauconitic

sandstone; Hythe Beds, Lower Greensand Group, Lower Cretaceous; Petersfield to Pulborough area

PRESENT CONDITION Broken. carving well preserved

DESCRIPTION The lower third of the stone is lost.

*A (top):* A half-round median moulding bifurcates half-way along the surviving length. The bifurcations terminate on the narrow end, near the corners.

DISCUSSION Butler's illustration shows the cover as intact, although this could be an interpretative drawing. Although closely corresponding in size, it is unlikely that no. 6 is the other end of this stone. The mouldings are of rectangular section, not half-round section as on the present piece.

The evidence for their discovery suggests that these

1. The following is an unpublished manuscript reference to no. 1: BL Add. MS 37552 no. XIV, item 390.

covers were reused as building material in the twelfth century when the nave of the church was rebuilt. Allowing for a reasonably long period of primary use, this points to an eleventh-century date for their manufacture. Evidence from Cocking, Sussex, supports this suggestion. There a similar cover (no. 1; Ill. 228) was recovered from a wall foundation dated to c. 1080.

The eleventh-century date suggested for these grave-covers by the archaeological evidence is reinforced by the decoration on some of them. The use of a median ridge bifurcating at either end, and sometimes with a cross-bar at the point of bifurcation, as on no. 4, can be paralleled in the late pre-Conquest grave-covers of East Anglia discussed by Fox (1920–1). This type of cover did reach south-east England: see for example, Milton Bryan, Bedfordshire (Ill. 361) and London St Benet Fink (Ills. 345–6). The covers from the present site, together with those at Chithurst and Cocking, also in Sussex, may derive in part from these types.

DATE Eleventh century

REFERENCES Butler 1851, 19–20, fig. 1; Lower 1870, II, 176; Page 1907, 365; Johnston 1912, 106; Jessep 1914, 60–1; Johnston 1921, 182; Kendrick 1949, 86; Salzman 1953, 84; Fisher 1970, 81–2; Tweddle 1986b, I, 90, 220–1, II, 484, III, pl. 100a

D.T.

## 2. Part of grave-cover[1]                          (Ill. 239)

PRESENT LOCATION Placed near south wall of nave, outside

EVIDENCE FOR DISCOVERY None; probably discovered during reconstruction of church in 1850

L.  35 cm (13.8 in)   W.   36 cm (14.2 in)
D.  13 cm (5 in)

STONE TYPE Brownish-grey (with a greenish tinge), medium-grained (0.3–mm quartz grains), glauconitic sandstone; Hythe Beds, Lower Greensand Group, Lower Cretaceous; Petersfield to Pulborough area

PRESENT CONDITION Broken; carving fairly well preserved

DESCRIPTION The bulk of the tapering cover is lost. The corners of the surviving, narrow, end are rounded. There is a narrow relief border, and a

median moulding which is crossed close to the surviving end by a similar moulding spanning the width of the stone, forming a type G1 cross (Cramp 1991, fig. 2).

DISCUSSION That this stone belongs with the other eleventh-century sculptures from this site is suggested by the use of a median ridge crossed near the end. This form of decoration is encountered on near-by grave-covers at Chithurst (e.g. no. 2; Ill. 221), but not on later medieval slabs from the region. Only the relief border is a novelty.

DATE Eleventh century

REFERENCES Butler 1851, 19–20, fig. 1; Lower 1870, II, 176; Page 1907, 365; Johnston 1912, 106; Jessep 1914, 60–1; Johnston 1921, 182; Kendrick 1949, 86; Salzman 1953, 84; Fisher 1970, 81–2; Tweddle 1986b, I, 90, 220–1, II, 485, III, pl. 100b

D.T.

## 3. Grave-cover                                    (Ill. 238)

PRESENT LOCATION Placed near south wall of nave, outside

EVIDENCE FOR DISCOVERY Removed from west nave wall during reconstruction of 1850 (Butler 1851)

L.   144 cm (56.7 in)   W.   50 (19.7 in)
D.   18 cm (7 in)

STONE TYPE Brownish-grey (with a greenish tinge), medium-grained (0.3-mm quartz grains), glauconitic sandstone; Hythe Beds, Lower Greensand Group, Lower Cretaceous; Petersfield to Pulborough area

PRESENT CONDITION Worn but complete

DESCRIPTION At each end is a splayed-armed Greek cross, the head and lateral arms of which run to the edge.

DISCUSSION The whole of the nave walling at Stedham church appears to have belonged to the twelfth century, with changes to the fenestration being the only later alterations. It is likely that this cover was reused in the primary phase of building, as were those reused in the nave foundations. The use of crosses at both ends is paralleled on Steyning 1 (Ill. 249), and it is likely that the type of cover, decorated with a median ridge crossed near either end, ultimately derive from this type. Examples of the derived form are known from Chithurst, near-by (no. 2; Ill. 221), and probably also from this site (no. 2; Ill. 239).

---

1. The following is an unpublished manuscript reference to no. 2: BL Add. MS 37552 no. XIV, item 390.

DATE Eleventh century

REFERENCES Butler 1851, 19–20, fig. 5; Lower 1870, II, 176; Page 1907, 365; Johnston 1912, 106; Jessep 1914, 60–1; Johnston 1921, 182; Kendrick 1949, 86; Salzman 1953, 84; Fisher 1970, 81–2; Tweddle 1986b, I, 90, 220–1, II, 485, III, pl. 101a

<div align="right">D.T.</div>

## 4. Grave-cover[1]                                     (Ill. 241)

PRESENT LOCATION Placed near south wall of nave, outside

EVIDENCE FOR DISCOVERY See no. 1.

L.   99 cm (39 in)   W.   40 cm (15.8 in)
D.   11 cm (4.3 in)

STONE TYPE Brownish-grey (with a greenish tinge), medium-grained (0.3-mm quartz grains), glauconitic sandstone; Hythe Beds, Lower Greensand Group, Lower Cretaceous; Petersfield to Pulborough area

PRESENT CONDITION Worn but complete

DESCRIPTION It has a square head and foot and tapers. There is a median half-round moulding which bifurcates about a third of the way in from each end. Each pair of mouldings diverges and is carried into the corners. At the head a moulding of similar form spans the width of the stone and crosses the median moulding at the point of bifurcation.

DISCUSSION See no. 1.

DATE Eleventh century

REFERENCES Butler 1851, 19–20, fig. 1; Lower 1870, II, 176; Page 1907, 365; Johnston 1912, 106; Jessep 1914, 60–1; Johnston 1921, 182; Kendrick 1949, 86; Salzman 1953, 84; Fisher 1970, 81–2; Tweddle 1986b, I, 90, 220–1, II, 486, III, pl. 101b

<div align="right">D.T.</div>

## 5. Grave-cover                                        (Ill. 242)

PRESENT LOCATION North side of chancel, outside

EVIDENCE FOR DISCOVERY None; possibly found at same time as nos. 1–4; not mentioned in Butler 1851

L.   60 cm (23.5 in)   W.   41.5 in (16.5 in)
D.   12.5 cm (5 in)

STONE TYPE Brownish-grey (with a greenish tinge), medium-grained (0.3-mm quartz grains), glauconitic

sandstone; Hythe Beds, Lower Greensand Group, Lower Cretaceous; Petersfield to Pulborough area

PRESENT CONDITION Broken, edges bruised, moderately weathered

DESCRIPTION The grave-cover expands slightly towards the head, which is slightly convex, and is roughly broken in two about half-way along its length.

*A (top):* Decorated with a Latin cross (type B6, with elongated uper arm), the upper arm of which expands and stops just short of the head. The lateral arms are parallel-sided and of slightly unequal length, the left-hand one stopping short of the edge, while the right-hand one runs off the edge.

DISCUSSION The decoration of this carving is more closely related to that of the series from Chithurst, Sussex (e.g. no. 5; Ill. 224), than to that of the other covers from this site. A comparable (eleventh-century) date seems likely.

DATE Eleventh century

Unpublished

<div align="right">D.T.</div>

## 6. Grave-cover                                        (Ill. 245)

PRESENT LOCATION North side of chancel, outside

EVIDENCE FOR DISCOVERY None; possibly found at same time as nos. 1–4, but not recorded in Butler 1851

L.   75 cm (29.5 in)   W.   57 cm (22.5 in)
D.   *c.* 12 cm (4.7 in)

STONE TYPE Brownish-grey (with a greenish tinge), medium-grained (0.3-mm quartz grains), glauconitic sandstone; Hythe Beds, Lower Greensand Group, Lower Cretaceous; Petersfield to Pulborough area

PRESENT CONDITION Bruised and moderately weathered

DESCRIPTION The stone expands slightly towards the complete end which is convex and is roughly broken in two half-way along its length.

*A (top):* Decorated with a median ridge of rectangular section which bifurcates at the complete end. One of the bifurcations runs towards each corner, but stops just short of it with a square end.

DISCUSSION Clearly a grave-cover of the same type as no. 1. The two pieces derive from different monuments, however, as on no. 1 the decoration is of

---

1. The following is an unpublished manuscript reference to no. 4: BL Add. MS 37552 no. XIV, item 390.

semicircular section, whereas here it is rectangular. Although no details of the discovery are known, a similar date to no. 1 is likely.

DATE Eleventh century

Unpublished

D.T.

### 7. Grave-marker                                    (Ills. 243–4)

PRESENT LOCATION Placed externally near the south wall of the nave

EVIDENCE FOR DISCOVERY None; possibly found at same time as nos. 1–4

H.   62 cm (24.4 in)   W.   38 cm (15 in)
D.   21 cm (8.3 in)

STONE TYPE Brownish-grey (with a greenish tinge), medium-grained (0.3-mm quartz grains), glauconitic sandstone; Hythe Beds, Lower Greensand Group, Lower Cretaceous; Petersfield to Pulborough area

PRESENT CONDITION Intact, though bruised and moderately weathered

DESCRIPTION The stone is rectangular with a semicircular head. It tapers slightly towards the base.

*A and C (broad):* Decorated with a splayed-armed cross in relief, the lower limb of which is cut off short. The remaining arms terminate on the edges of the face.

DISCUSSION Two of the other grave-markers recovered from the west gable and the walling of the nave by Butler, nos. 10–11 (Ills. 246, 248), were of this form, although neither of them was intact. As with the grave-covers, the archaeological evidence points to an eleventh-century date for these grave-markers. Markers with semicircular heads are encountered elsewhere among the pre-Conquest sculpture of south-east England, notably at Rochester 3 (Ills. 147–50) where the piece is decorated in the Scandinavian Ringerike style, pointing to a date in the first half of the tenth century, and probably to the period of Scandinavian supremacy between 1016 and 1042. The carving from White Notley in Essex may also have had a semicircular head (Ill. 375), and there are semicircular headed grave-markers among the mid eleventh-century material from Cambridge castle (Fox 1920–1, pl. VII). The grave-marker from Whitchurch in Hampshire also has a semicircular head, but is of much earlier date.

DATE Eleventh century

REFERENCES Butler 1851, 20; Lower 1870, II, 176; Page 1907, 365; Salzman 1953, 84; Tweddle 1986b, I, 92, 231–2, II, 486–7, III, pl. 102a

D.T.

### 8. Grave-marker                                    (Ill. 240)

PRESENT LOCATION Lost; possibly reused in fabric of present church

EVIDENCE FOR DISCOVERY Found built into west gable or nave walling during reconstruction of 1850 (Butler 1851)

MEASUREMENTS Unobtainable

STONE TYPE Unobtainable

PRESENT CONDITION Unknown

DESCRIPTION It was similar to no. 7, but incomplete. Almost half of the piece to the left of the vertical axis is lost.

DISCUSSION See no. 7.

DATE Eleventh century

REFERENCES Butler 1851, fig. 1; Tweddle 1986b, I, 92, 231–2, II, 487, III, fig. 54

D.T.

### 9. Grave-marker or -cover                          (Ill. 247)

PRESENT LOCATION Lost

EVIDENCE FOR DISCOVERY Found with nos. 10–11; see no. 8.

MEASUREMENTS Unobtainable

STONE TYPE Unobtainable

PRESENT CONDITION Unknown

DESCRIPTION Rectangular grave-marker.

*A (broad):* Decorated with a relief Latin cross (arm type B6). The arms run to the edge of the face.

DISCUSSION The only record of this piece is Butler's sketch, in which it is romantically depicted beneath nos. 10–11; it could equally have been one end of a grave-cover decorated with a median ridge crossed near the ends.

DATE Eleventh century

REFERENCES Butler 1851, 20–1, fig. 2; Tweddle 1986b, I, 92, 231–2, II, 488, III, fig. 54

D.T.

## 10. Grave-marker                                    (Ill. 246)

PRESENT LOCATION Lost

EVIDENCE FOR DISCOVERY See no. 8.

MEASUREMENTS Unobtainable

STONE TYPE Unobtainable

PRESENT CONDITION Unknown

DESCRIPTION It is similar to no. 7, but roughly broken below the lateral arms of the cross.

DISCUSSION See no. 7.

DATE Eleventh century

REFERENCES Butler 1851, 20–1, fig. 2; Tweddle 1986b, I, 92, 231–2, II, 487, III, fig. 54

D.T.

## 11. Grave-marker                                    (Ill. 248)

PRESENT LOCATION Lost

EVIDENCE FOR DISCOVERY Found with nos. 9–10; see no. 8.

MEASUREMENTS Unobtainable

STONE TYPE Unobtainable

PRESENT CONDITION Unknown

DESCRIPTION It is rectangular with a semicircular head.

*A (broad):* Decorated with a small, relief, splayed-armed, Greek cross (arm type B6).

DISCUSSION See no. 7.

DATE Eleventh century

REFERENCES Butler 1851, 20–1, fig. 2; Tweddle 1986b, I, 92, 231–2, II, 488, III, fig. 54

D.T.

# STEYNING, Sx. (St Andrew)

## TQ 179114

## 1. Grave-cover                                      (Ill. 249)

PRESENT LOCATION In the south porch fixed to the wall east of the south door

EVIDENCE FOR DISCOVERY Found on site of western extension of church, and placed in vicarage rockery (Bloxham 1864); in south porch by 1915 (Johnston 1915). Another record of 'stones bearing incised crosses' found in foundations of an early chancel arch (Jessep 1914) must either refer to other fragments now lost, or is a garbled version of facts recorded by Bloxham

L.   157 cm (61.8 in)   W.   59 cm (23.2 in)
D.   12 cm (4.7 in)

STONE TYPE Yellowish-grey to pale yellow, fine- to medium-grained (0.2 to 0.3-mm quartz grains), finely glauconitic sandstone; Hythe Beds, Lower Greensand Group, Lower Cretaceous; Petersfield to Pulborough area

PRESENT CONDITION Bruised and heavily weathered

DESCRIPTION It is incomplete, a rough break rising steeply from right to left before falling slightly again. The cover is parallel sided before tapering slightly towards the foot.

*A (top):* A narrow border is defined by an incised line paralleling the edge of the stone, except where it curves round the lower corners. At the bottom is a Latin cross outlined by incised lines. Its foot rests on the lower border, but the arms stop short of the borders to each side. The limbs are parallel sided, but the foot expands abruptly just before it touches the borders; the head of the cross expands in a similar fashion. At the head end a similar cross faces in the opposite direction, and the heads of the two crosses touch.

DISCUSSION Its find-spot suggests that this stone had either been used in the foundations of the twelfth-century church, or covered by them, although the evidence is hardly conclusive. Additional dating evidence derives from the comparison which can be drawn between this piece and a grave-cover from Stedham (no. 3; Ill. 238) which is also decorated with

two crosses, one at either end, and for which an eleventh-century date is argued above. Other eleventh-century Sussex covers at Stedham and Chithurst (e.g. no. 2; Ill. 221) employ a median ridge which is crossed near each end, a type which must ultimately derive from the double cross form.

DATE Tenth to eleventh century

REFERENCES Bloxham 1864, 238; Jessep 1914, 60; Johnston 1915, 150, 161, fig. on 150; Mee 1937, 352; Kendrick 1949, 86; Fisher 1970, 81; Steer 1976b, 5; Tweddle 1986b, I, 90, 220–1, II, 491–2, III, pl. 103b

D.T.

## 2. Grave-cover (Ill. 250)

PRESENT LOCATION Inside the south porch, against the east wall

EVIDENCE FOR DISCOVERY Apparently found in 1938 near eastern entrance to churchyard (Steer 1976b), and to be identified with stone in unpublished photograph (in Department of Medieval and Later Antiquities, British Museum) showing it when discovered, near a gateway, where it had possibly been used as a sill. Exact date of discovery unclear; Johnston (1915) already notes two grave-covers in the south porch

L.   187 cm (73.6 in)   W.   50 cm (19.7 in)
D.   26 cm (10.2 in)

STONE TYPE Brownish-grey, fine- to medium-grained (0.2-mm quartz grains), finely glauconitic sandstone; Hythe Beds, Lower Greensand Group, Lower Cretaceous; Petersfield to Pulborough area

PRESENT CONDITION Worn but complete

DESCRIPTION It tapers and is square ended.

*A (top):* There is a narrow, low-relief border along the long edges. There is a broad, low-relief median band which bifurcates about a third of the way in from each end. Each pair of bifurcations diverges and runs off the end alongside, but not touching, the borders. Towards the upper end of the median moulding is an incised Latin cross from the lower end of which develops a pair of complete incised lozenges, and half of a third, placed one above the other, and spanning the width of the moulding. From the head of the cross develops a similar lozenge and half of a second. At each point of bifurcation one of a pair of expanding relief mouldings runs from each edge of the median band to the edge of the face, crossing the border.

DISCUSSION There is no archaeological evidence for the dating of this cover, but the form, with a median ridge bifurcating at either end and with subsidiary cross-bars at the points of bifurcation, can be paralleled among the eleventh-century Sussex covers from Stedham (no. 4; Ill. 241) and Cocking (Ill. 228), and there is a variant form at Chithurst (no. 1; Ill. 220). Reasonably convincing archaeological evidence is available for the dating of the Cocking and Stedham covers. The bifurcating mid-rib employed on these grave-covers may be derived from the mid-ribs with U-shaped ends seen among East Anglian examples of the early to mid eleventh century (Fox 1920–1, pl. III). Covers of this type certainly reached south-east England, as at Milton Bryan (Ill. 361) and Cardington (Ill. 264) in Bedfordshire, and St Benet Fink (Ills. 345–6) in London.

DATE Eleventh century

REFERENCES Johnston 1915, 150, 161; Kendrick 1949, 86; Fisher 1970, 81; Steer 1976b, 9; Tweddle 1986b, I, 90, 220–1, II, 492–3, III, pl. 104a

D.T.

# TANDRIDGE, Sr. (St Peter)

## TQ 374512

## 1. Grave-cover (Ill. 231)

PRESENT LOCATION Outside the church to the west of the south porch

EVIDENCE FOR DISCOVERY First recorded in present location by Leveson Gower 1893; no positive support

for conjecture (Lane, pers. comm.) that it originally came from Tandridge Priory near-by

L.   110 cm (43.3 in)   W.   57 cm (22.4 in)
D.   30 cm (11.8 in)

STONE TYPE Greenish-grey, medium-grained, finely

glauconitic sandstone; Hythe Beds, Lower Greensand Group, Lower Cretaceous; vicinity of Limpsfield, Surrey

PRESENT CONDITION Heavily worn

DESCRIPTION It is rectangular and coped, the coping displaced slightly to the left. On the flattened ridge is the low relief, parallel-sided vertical limb of a Latin cross. The head is co-terminus with the head of the stone, the foot is heavily damaged. The square ends of the expanding lateral arms terminate short of the edges of the stone.

DISCUSSION The cover can only be dated by virtue of the general comparisons which can be drawn with the material from Oxted and Titsey in Surrey. Most of these grave-covers are decorated with simple Latin crosses, as at Oxted (Ills. 235–6), but one of the pieces from Titsey (no. 4; Ill. 255) employs the bifurcated mid-rib with a cross-bar at the point of bifurcation. This links it directly with the eleventh-century Sussex examples from Stedham, Cocking, and Steyning, and suggests a similar date for the whole group of Surrey covers.

DATE Eleventh century

REFERENCES Leveson Gower 1893, 31, fig. C; Johnston 1913, 67; Cox and Johnston 1935, 168; Tweddle 1986b, I, 90, II, 496–7, III, pl. 107a

D.T.

# TITSEY, Sr.

## TQ 406550

### 1. Grave-cover                                                                (Ill. 252)

PRESENT LOCATION On the site of the old church close to the south front of Titsey Place

EVIDENCE FOR DISCOVERY Discovered (together with nos. 2–5) when old Rectory destroyed by fire in 1842, reused face-down as steps to entrance; probably removed from site of old church (adjacent to rectory) when demolished in 1776; placed in present location in 1842

L.   186 cm (73.2 in)   W.   51 cm (20 in)
D.   15 cm (5.9 in)

STONE TYPE Pale greyish-brown (with a greenish tinge), medium-grained, glauconitic sandstone; Hythe Beds, Lower Greensand Group, Lower Cretaceous; vicinity of Limpsfield, Surrey

PRESENT CONDITION Bruised and heavily weathered

DESCRIPTION It is rectangular and ornamented with a low-relief Latin cross with slightly expanding arms terminating on the edges of the stone.

DISCUSSION Of the five grave-covers from this site all except no. 4 are decorated with relief Latin crosses. They clearly relate to the covers from Oxted (Ills. 235–6) and Tandridge (Ill. 231) which are similarly decorated. No. 4, with its bifurcating median ridge and cross-bar at the point of bifurcation, links these with examples from Stedham, Steyning, and Cocking, all in Sussex, where this type also occurs. As argued above, there is good archaeological evidence for placing these covers in the eleventh century, and perhaps as early as the middle of the century.

DATE Eleventh century

REFERENCES Leveson Gower 1893, 30–2, figs. 1–5; Bannerman 1909, xx; Johnston 1913, 69; Tweddle 1986b, I, 90, 220–1, II, 498, III, pl. 108a

D.T.

### 2. Grave-cover                                                                (Ill. 251)

PRESENT LOCATION See no. 1.

EVIDENCE FOR DISCOVERY See no. 1.

L.   127 cm (50 in)   W.   52 cm (20.5 in)
D.   15 cm (5.9 in)

STONE TYPE Pale greyish-brown (with a greenish tinge), medium-grained, glauconitic sandstone; Hythe Beds, Lower Greensand Group, Lower Cretaceous; vicinity of Limpsfield, Surrey

PRESENT CONDITION Bruised and moderately heavily weathered

DESCRIPTION It is tapering and ornamented with a low-relief Latin cross. The arms terminate on the edges of the stone.

DISCUSSION See no. 1.

DATE Eleventh century

REFERENCES Leveson Gower 1893, 30–2, figs. 1–5; Bannerman 1909, xx; Johnston 1913, 69; Tweddle 1986b, I, 90, 220–1, II, 499, III, pl. 108a

D.T.

### 3. Grave-cover, in two joining pieces          (Ill. 253)

PRESENT LOCATION See no. 1.

EVIDENCE FOR DISCOVERY See no. 1.

L.   *c.* 64 cm (25.2 in)   W.   40 cm (15.8 in)
D.   11 cm (4.3 in)

STONE TYPE Pale greyish-brown (with a greenish tinge), medium-grained, glauconitic sandstone; Hythe Beds, Lower Greensand Group, Lower Cretaceous; vicinity of Limpsfield, Surrey

PRESENT CONDITION Broken and badly worn

DESCRIPTION It is parallel sided. The upper right-hand corner is lost. An oblique break separates the upper left-hand corner from the rest of the stone, which is decorated with a low-relief Latin cross, the arms terminating on the edges.

DISCUSSION See no. 1.

DATE  Eleventh century

REFERENCES Leveson Gower 1893, 30–2, figs. 1–5; Bannerman 1909, xx; Johnston 1913, 69; Tweddle 1986b, I, 90, 220–1, II, 499, III, pl. 109a

D.T.

### 4. Part of grave-cover                        (Ill. 255)

PRESENT LOCATION See no. 1.

EVIDENCE FOR DISCOVERY See no. 1.

L.   54 cm (21.3 in)   W.   33 cm (13 in)

STONE TYPE Pale greyish-brown (with a greenish tinge), medium-grained, glauconitic sandstone; Hythe Beds, Lower Greensand Group, Lower Cretaceous; vicinity of Limpsfield, Surrey

PRESENT CONDITION Broken and badly worn

DESCRIPTION The head is horizontally broken and the lower corners lost. It is decorated with a broad, high-relief median moulding bifurcating just short of the head of the stone, and crossed just above its mid-point by a second similar moulding terminating on the edges.

DISCUSSION See no. 1.

DATE Eleventh century

REFERENCES Leveson Gower 1893, 30–2, figs. 1–5; Bannerman 1909, xx; Johnston 1913, 69; Tweddle 1986b, I, 90, 220–1, II, 499–500, III, pl. 109b

D.T.

### 5. Part of grave-cover                        (Ill. 254)

PRESENT LOCATION Lost

EVIDENCE FOR DISCOVERY See no. 1.

L.   *c.* 40 cm (15.8 in)   W.   27.5 cm (10.8 in)
D.   Unobtainable

STONE TYPE Unobtainable

PRESENT CONDITION Unobtainable

DESCRIPTION Small sub-rectangular fragment with each edge roughly broken. It is decorated with a heavily-weathered, low-relief Greek cross displaced slightly below and to the right of centre.

DISCUSSION Although the surviving carving was a cross with arms of equal length, it is equally possible that this formed part of a cover decorated originally with a Latin cross.

DATE Eleventh century

REFERENCES Leveson Gower 1893, 30–2, fig. 5; Bannerman 1909, xx; Johnston 1913, 69; Tweddle 1986b, I, 90, 220–1, II, 500, III, pl. 109b

D.T.

# APPENDIX C
# LOST STONES FOR WHICH NO ILLUSTRATION HAS SURVIVED

WALBERTON, Sx. (St Mary, SU 971057)

**1. Gable cross?**

PRESENT LOCATION Lost

EVIDENCE FOR DISCOVERY Removed from apex of west gable in 1903

MEASUREMENTS Unobtainable

STONE TYPE Unobtainable

PRESENT CONDITION Unobtainable

DESCRIPTION No description or illustration of the piece survives.

DISCUSSION Fisher records that Johnston believed this to be a forgery, but it is the modern, interlace-decorated font base, erroneously identified in the literature as the gable cross, which Johnston states to have been carved by the then vicar's daughter, not the gable cross itself. The cross was put on the vicarage rockery and is now lost.

DATE Pre-Conquest

REFERENCES Johnston 1921, 187–8, 88, n.; Nairn and Pevsner 1965, 362; Steer 1976a, 1; Jessep 1914, 56

D.T.

CATALOGUE

# NORTH OF THE THAMES

# BARKING, Ess. (St Margaret)

## TQ 441839

### 1. Part of cross-shaft (Ills. 256–9)

PRESENT LOCATION West end of the north nave arcade, inside

EVIDENCE FOR DISCOVERY Found in 1910, built into churchyard wall

H. 30 cm (11.8 in) W. 23.5 cm (9.3 in)
D. 21.5 cm (8.5 in)

STONE TYPE Pale brownish-grey, medium- to coarse-grained, shelly oolitic limestone with planar bedding; Barnack stone, Lincolnshire Limestone Formation, Inferior Oolite Group, Middle Jurassic

PRESENT CONDITION Broken and extensively weathered

DESCRIPTION It is of square section and roughly broken, so that much of faces A and D is lost. All faces have double border mouldings.

A (broad): Decorated with one complete and parts of two other units of encircled pattern C interlace. At the bottom the circuiting strands are interlaced with closed circuit loops in the spaces between the pattern units.

B (narrow): Decorated with an irregularly set out pattern F with added outside strands and diagonals. There are angular links between the pattern units.

C (broad): There are the remains of a complex geometrical interlace, now too worn to be certain of the pattern; it may have been a form of surrounded or encircled pattern D.

D (narrow): There are the remains of a complex geometrical interlace, now too worn to be certain of the pattern; it lacks the angular links between pattern units seen on the other faces.

E (top): There is a central dowel-hole.

DISCUSSION The parish church adjoins the site of Barking abbey, founded in the seventh century (Deansley 1961, 206), and the piece may have come from there.

The presence of a dowel hole in the upper end suggests that the rough break at this end which has involved the loss of much of faces A and D took place close to the end of a section of the shaft. The shaft may originally have been decorated solely with interlace, perhaps panelled, or alternatively, predominantly with interlace, but with the admixture of other motifs as at Bishops Waltham (Ill. 421). Not enough survives for certainty on this point. The use of encircled patterns, coupled with the disorganisation of the interlace, points to a date comparatively late in the pre-Conquest period for the piece.

DATE Early tenth century

REFERENCES Clapham 1911–13, 86, pl. facing; Fox 1920–1, 19; R.C.H.M. 1921, 7; R.C.H.M. 1923, xxx-xxxi, fig. on xxxi; (——) 1930, 114, no. 18; Cottrill 1931, appendix; Brown 1903–37, VI(2), 96–7, 102, pl. xxv.2; Kendrick 1949, 85–6; Pevsner 1954, 21, 63–4; Tweddle 1986b, I, 246, II, 348, III, pls. 17b–19

D.T.

### 2. Fragment of impost (Ills. 260–2)

PRESENT LOCATION Passmore Edwards Museum, Archaeology and Local History Centre, Stock Street, Plaistow (reference number BA.I.85.153)

EVIDENCE FOR DISCOVERY Found in 1985 during controlled excavations on site of Barking abbey

H. 16.5 cm (6.5 in) W. 14 cm (5.5 in)
D. 12.5 cm (4.75 in)

STONE TYPE Unobtainable

PRESENT CONDITION Light bruising to the edges, but unweathered

DESCRIPTION A corner fragment of an impost of square section, roughly broken to the rear and below. There are traces of red paint.

*A:* A roll moulding above and below frames a range of plain balusters in low relief, each with a rounded profile; only the one at the angle is half-round.

*B:* As face A.

*E (top):* Dressed flat.

*F (bottom):* Below a recessed roll moulding is a fragment of indecipherable carving.

DISCUSSION The simplest way to view this fragment is as part of an impost, supported by a chamfered zone which also seems to have been decorated, perhaps with more baluster ornament or with conventionalized leaves; not enough survives for either interpretation to be supported.

The use of plain baluster ornament as decoration points to an early date. In south-east England its use is paralleled only at the Old Minster, Winchester (nos. 37–40, 42). In Northumbria comparable ornament occurs in late seventh- and early eighth-century contexts (see Chap. V). Such a date is perfectly consistent with the present piece. A monastery at Barking was founded by Eorcanwald, bishop of London, for his sister Aethelburh (Bede 1969, 354–7 (IV, 6)). The recent excavations have produced extensive evidence for seventh- to eighth-century activity on the site (Webster and Backhouse 1991, 88–94, no. 67a–w).

DATE Late seventh to eighth century

Unpublished

D.T.

# BEDFORD, Bd. (St Peter)[1]

## TL 050501

**1. Part of cross-shaft** (Ills. 265–7)

PRESENT LOCATION Built into the north jamb of the doorway in the east wall of the first stage of the tower

EVIDENCE FOR DISCOVERY First recorded in Wyatt 1868

H.   38 cm (15 in)   W.   28 (11 in)
D.   15 cm (5.9 in)

STONE TYPE Light grey, medium-grained, shelly, oolitic limestone; Barnack stone, Lincolnshire Limestone Formation, Inferior Oolite Group, Middle Jurassic

PRESENT CONDITION Broken and moderately weathered

DESCRIPTION It is of rectangular section and roughly broken above, below, and to the rear.

*A (broad):* Along the left and right-hand edges is a plain, raised border. The face is decorated with a pair of heavily-weathered, confronted, winged bipeds. The mouth of each animal is open, and the upturned ends of the tongues touch. Each animal has a short, backward-pointing ear overlapping the border. The bodies taper and curve inwards to touch on the vertical axis of the face before curving outwards once more and developing into angular interlace. A loose strand of interlace with a clubbed end turns up to touch the tip of the downward-pointing kite-shaped wing of each animal. Each animal has an upturned leg, terminating in a triangular, three-toed foot, with incised nicks indicating the toes. The feet touch on the vertical axis of the face.

*B (narrow) and C (broad):* Built in.

*D (narrow):* Has a plain raised border along its left-hand edge, but the right hand edge is roughly broken. The face is decorated with a four-cord interlace, a simple pattern F.

DISCUSSION The confronted animals on face A most closely resemble those on the shaft from Elstow (Ill. 269), two miles south of Bedford. The present stone is, however, part of a much smaller and slighter monument.

The use of winged bipeds in the decoration points to an eighth- or early ninth-century date for the piece, and this is supported by the fact that the animals

1. The following is an unpublished manuscript reference to no. 1: BL Add. MS 37549, item 1.

actually develop into interlace, a trick first introduced into Anglo-Saxon art in the middle of the eighth century (Chap. V).

DATE Late eighth century

REFERENCES Wyatt 1868, fig. facing 265; Allen 1885b, 357; Page 1912b, 26; Fisher 1962, 152; Taylor and Taylor 1965–78, I, 60, fig. 28; Smith 1966, 9, fig. 3; Tweddle 1983b, 18; Tweddle 1986b, I, 140–41, II, 349, III, pls. 20a–b

D.T.

# CARDINGTON, Bd. (St Mary)

## TL 086480

### 1. Grave-cover                                                    (Ill. 264)

PRESENT LOCATION Built internally into the east wall of the south chancel chapel

EVIDENCE FOR DISCOVERY Discovered during reconstruction of central tower between 1898 and 1901

H.  89 cm (35 in)   W.   50 cm (19.7 in)
D.   Built in

STONE TYPE Yellowish-grey, medium-grained, shelly, oolitic limestone; Barnack stone, Lincolnshire Limestone Formation, Inferior Oolite Group, Middle Jurassic

PRESENT CONDITION Cut down for reuse and moderately weathered

DESCRIPTION Part of a tapering grave-cover which is incomplete above and below, where it has been roughly horizontally trimmed.

*A (top):* The slightly convex face is decorated with a low-relief Latin cross (type A1). The expanding lateral arms terminate on the edges of the stone. Below each lateral arm, and separated from it by an incised line, is a broad, plain, low-relief border. Its inner end terminates on the lower limb of the cross and is separated from it by an incised line. The outer end unites with a broad, plain lateral border. Each of the fields thus defined is decorated with a four-strand plain plait. The decoration above the lateral limbs is similar except that each of the decorative fields has an inner broad, plain, low-relief border flanking the head of the cross, and separated from it by an incised line. The interlace in the upper fields is median-incised.

DISCUSSION Both in terms of material and in the layout and handling of the decoration, this forms one the East Anglian group of grave-covers, first recognised by Fox (1920–21). It belongs with his group B, those with incised crosses, and within that group to his type 4. If so, then the mid-rib would have originally terminated in a cross with expanding arms at either end, as at Rampton, Cambridge castle, and Little Shelford, all in Cambridgeshire (ibid., pl. IV).

A *terminus ante quem* for this group of covers is provided by the discovery of examples sealed by the rampart of Cambridge castle, constructed in 1068 (ibid., 20–1, appendix). Two similar examples were discovered *in situ* outside the pre-Conquest church under Peterborough cathedral, which has been assigned to the refoundation of the monastery under Aethelwold in 970 (ibid., 23–4, 31–2).

DATE Tenth to eleventh century

REFERENCES (——) 1901, 3, cols. 1–2; Pevsner 1968, 63; Hare 1972, 83–5, fig. 4; Tweddle 1986b, I, 218–20, II, 369–70, III, pl. 33a

D.T.

# ELSTOW, Bd. (Sts Mary and Helen)

TL 040474

**1. Part of cross-shaft** (Ills. 268–272)

PRESENT LOCATION Moot Hall Museum, Elstow (no accession number)

EVIDENCE FOR DISCOVERY Found during restoration of Elstow abbey in 1967, built into outer face of east wall

H. 56 cm (22 in) W. 32 cm (12.6 in)
D. 20.5 cm (8 in)

STONE TYPE Pale brownish-grey, medium-grained, shelly, oolitic limestone with planar bedding; Barnack stone, Lincolnshire Limestone Formation, Inferior Oolite Group, Middle Jurassic

PRESENT CONDITION Lightly weathered and with minor abrasions to the angles

DESCRIPTION It is of rectangular section. The upper end is stepped and roughly broken, and the lower end is dressed flat.

*A (broad):* Has a narrow, plain, raised border containing a pair of confronted winged bipeds developing into interlace. The muzzle of the animal to the left is square ended. The open mouth is contoured by an incised line, and the long thick tongue hangs limply down. The upper canine tooth is well marked. The head is domed over the lentoid eye. The eye is defined by incised lines and has a pecked pupil. The ear is long and backward pointing with a clubbed end and incised central line. It is placed well back on the head. The expanding neck curves inwards to join the outward-curving, tapering body, which develops into well-ordered interlace, complete pattern D, filling the lower half of the face. From the junction of the neck and body develops a tapering, upward-pointing wing. Its inner edge follows the curve of the neck, and its out-turned, clubbed end interlaces with that of the ear. A short foreleg hangs limply down. The wing, neck, and body are contoured by incised lines, that of the body being extended to form median-incised interlace. The animal to the right is a mirror image of that to the left, the interlace developing from it forming part of the interlace pattern.

*B (narrow):* The border is like that on face A. Within is a single winged biped. The top of its head is placed against the upper left-hand border. The muzzle is rounded-ended, and the mouth, contoured by an incised line, slightly open. The head is domed over the lentoid eye which is indicated by incised lines. The pupil is pecked. The ear runs into the left-hand corner of the face. It is small, hollowed, and pointed. From the lower jaw develops a short lappet. A second lappet, terminating in a clubbed, out-turned end, develops from the back of the expanding neck which curves round the upper end of the panel and is carried across to join the tapering body. This continues the curve of the neck towards the left-hand border before curling back in a tight spiral. The downward-pointing tapering wing has a rounded base. Its tip is extended to form a diagonal interlacing with the spiral. The loose ends of the spiral and wing develop into well-ordered interlace, an element of spiralled pattern A and, below, an element of pattern C with bar-terminal. The short foreleg of the animal is bent upwards against the left-hand border. A pair of short incised lines indicate the toes. The neck, body, and wing are contoured with incised lines. Those of the body and wing are extended to form median-incised interlace strands.

*C (broad):* The border is like that on face A and contains a register of complete pattern C, the upper terminal cross-joined and the lower alternate-joined, composed of thick strands in high relief.

*D (narrow):* The border is like that on face A. Within is a pair of outward-facing, inward-looking winged bipeds. The head of the upper animal is placed against the upper left-hand border and resembles that of the animal on face B except that the ear has a incised central line, is long, and has a clubbed end. The animal's foreleg is bent upwards and placed against the upper border. A pair of short incised lines indicate the toes. The narrow tapering body curves to the left beneath the muzzle before curving back. The tail interlocks with that of the second animal to form a spiral and terminates in a barbed tip placed against the underside of the second, lower animal. This resembles the first except that its head is against the lower right-hand border. An incised line contours the body of each of the animals, in each case being extended to form the median-incised line of the tail. The thick tongues of the two animals are linked across and

interlace with the spiral formed by the tails, and have median-incised lines.

DISCUSSION The fragment had been reused as building material in the blocking of the eastern end of the nave, once the conventual part of the church had been demolished. This demolition took place in 1539 (Baker 1969, 30–1).

This piece represents part of one element of a square cross-shaft originally constructed in sections. The trimming of the upper end has shortened the fragment, but a slight stepping in of the faces can still be detected, suggesting the piece originally came from a stepped shaft. Even though the upper end has been trimmed, remains of a rectangular socket survive, presumably intended to receive a

tenon on the lower end of the next element of the shaft.

The dating of this piece is determined by the use of winged bipeds, an eighth- and early ninth-century phenomenon, and by the fact that the bipeds on faces A and B develop into interlace. This trick was introduced into Anglo-Saxon art in the mid eighth century. The decoration on face A is closely comparable to that on face A of Bedford 1 (Ill. 265).

DATE Late eighth to early ninth century

REFERENCES Baker 1969, 30–1, pl. Ib; Baker 1970, 6, pl. facing 11; Cramp 1977, 230, figs. 62j, 62k, 63n; Cramp 1978, 10, figs. 1k, 2s; Tweddle 1983b, 18; Tweddle 1986b, I, 134–140, II, 382–5, III, pls. 43–44; Webster and Backhouse 1991, 242, no. 207

D.T.

# GREAT CANFIELD, Ess. (dedication unknown)[1]

TL 594180

## 1. Part of grave-cover or sarcophagus
(Fig. 32; Ill. 263)

PRESENT LOCATION Built face up into the south impost of the chancel arch

EVIDENCE FOR DISCOVERY First recorded by J. G. Waller before 1884

L.   94 cm (37 in)   W.   36 cm (14.2 in)
D.   12.5 cm (4.9 in)

STONE TYPE Light grey, fine- to medium-grained (0.2 to 0.3-mm quartz grains), glauconitic sandstone, cross-bedded and with burrows of 8 to 9-mm diameter; possibly Thanet Beds, Palaeogene, Tertiary; from Reculver, Kent

PRESENT CONDITION Fragmentary and moderately weathered

DESCRIPTION The south jamb of the chancel arch is of fundamentally square section, with an engaged western angle shaft, and supports an abacus of square section, its lower edge chamfered. This, in turn, supports an impost, also of square section. The arch is

FIGURE 32
Great Canfield 1A, nts

substantially narrower than the jamb, and its full width is supported by a grave-cover reused face upwards, which forms the bulk of the impost. Only the boldly projecting west end of the impost, supported by the angle shaft, is composed of a separate stone. The grave-cover is roughly broken, both where it abuts this stone and to the rear. The front and left-hand edges are dressed flat.

*A (top):* The upper face is partially concealed by the soffit of the chancel arch which is recessed only 12 cm behind the front edge, leaving a narrow band of decoration exposed. It is decorated in the Ringerike style. From the mid-point of the soffit edge emerges a pair of diverging, tapering foliate tendrils. That leaning to the left terminates close to the left-hand edge against a second similar tendril emerging from the soffit edge; that leaning to the right is shorter and terminates close to a similar tendril emerging from the soffit edge. To the right of this is a tight interlace knot.

1. The following is an unpublished manuscript reference to no. 1: BL Add. MS 37550 no. XII, items 499–500.

A broad, irregular curved band is superimposed on this pair of tendrils, and a series of minor tendrils interlace with it.

DISCUSSION The piece was probably broken up for building material when the present chancel was constructed in the first half of the twelfth century. The sheer size of the surviving fragment, nearly a metre wide and 35 cm thick, is suggestive. It is both wider and much thicker than London St Paul's 1, which is interpreted as a grave-marker. It is very thick even for a grave-cover, where the normal thickness is of the order of 11–12 cm. Of course, it is perfectly possible that it is merely a very large example of a well-known type, and that it is a fragment of a grave-marker. Alternatively, it could be the side panel of a box tomb or sarcophagus. The Ardre tomb, for example, has side panels 83 cm wide. No other box tomb is, however, known from England.

Although only part of the decorated face survives, and only a part of that is visible, there is little doubt that the decoration is in the Ringerike style. The use of this style, together with the very flat style of carving, links the carving with pieces from London (St Paul's 1, City 1, and All Hallows 3), and Rochester 2 and 3, Kent.

DATE Eleventh century

REFERENCES Waller 1884; R.C.H.M. 1923, xxxi, fig. on xxxi, 90; Clapham 1930, 135; Cottrill 1931, 50, appendix; Cobbett 1937, 45, pl. I; Brand 1936–40, 367–9, pl. facing 358; Shetelig 1940–54, VI, 142; Kendrick 1941, 134; Shetelig 1948, 103; Kendrick 1949, 100; Holmqvist 1951, 25; Tweddle 1986b, I, 94, 232–4, II, 388–9, III, pl. 49a

D.T.

# GREAT MAPLESTEAD, Ess. (St Giles)

## TL 808345

### 1. Fragment of grave-cover                (Ills. 273–6)

PRESENT LOCATION On the sill of the east window of the north aisle.

EVIDENCE FOR DISCOVERY Discovered c. 1921 in rockery in garden of Monk's Lodge (near church and once home of a former vicar of Great Maplestead) and given to church by Mr. T. F. Miller; probably found when new vestry built in 1849

H.   28 cm (11 in)   W.   39 cm (15.4 in)
D.   11.5 cm (4.5 in)

STONE TYPE Yellowish-grey, medium-grained, oolitic limestone, with scattered 5–10 mm shell fragments; Barnack stone, Lincolnshire Limestone Formation, Inferior Oolite Group, Middle Jurassic

PRESENT CONDITION Trimmed for reuse; face A lightly weathered

DESCRIPTION It is cut down to form a regular rectangular block, with the edges and back dressed flat.

A (top): A broad median moulding, partly cut back, is flanked by a pair of narrower plain relief mouldings. These are, in turn, flanked by zones of interlace decoration. The interlace, in high relief, is in each case a three-strand plain plait with median-incised strands. The outer edge of each zone has been partially destroyed by the shaping of the block.

B and D (sides): On the vertical axis of the left and right-hand sides are narrow, rectangular slots, each tapering a little towards the flat base.

DISCUSSION The slots on the edges appear to be carrying handles, cut at about the time of the removal of the piece to the church.

The arrangement of the decoration suggests that this is part of a grave-cover of the East Anglian type first defined by Fox (1920–1). These employ a median ridge, crosses in the middle and towards each end (or, alternatively, with the ends developing either into U- or V-shapes or small crosses). The median ridge is flanked by panels of interlace. This fragment probably comes from near the foot of such a cover, as the interlace is a three-strand plain plait. The fields further towards the head end were usually decorated with four-strand plaits, one strand being lost towards the foot as the panels there were narrower to accommodate the taper.

There is archaeological evidence for a late Anglo-Saxon date for this group (see Cardington 1).

DATE Tenth to eleventh century

REFERENCES Sperling 1921–3, 139–40, pl. on 139; R.C.H.M. 1923, xxxi, fig. on xxxi; Cottrill 1931, appendix; Cox *et al.* 1938, 206; Tweddle 1986b, I, 90, 219, II, 389–90, III, pl. 49b

D.T.

# HADSTOCK, Ess. (St Botolph)

## TL 559448

### 1a–e. Doorway with decorated capitals (a–b), imposts (c–d), and hood mould (e)[1]
(Ills. 277–284)

PRESENT LOCATION *in situ* on the north side of the nave

EVIDENCE FOR DISCOVERY None; doorway first recorded in sketch of 1746 by William Cole, though foliate decoration not recorded until sketch by Kerrich of *c.* 1800

Capital (a, east): H. 20 cm (7.9 in) W. 17 cm (6.7 in)
   D. 19 cm (7.5 in)
Capital (b, west): H. 24 cm (9.5 in) W. 20 cm (7.9 in)
   D. 19 cm (7.5 in)
Impost (c, east): H. 26 cm (10.2 in) W. 62 cm
   (24.4 in)
   D. 75 cm (29.5 in)
Impost (d, west): H. 26 cm (10.2 in) W. 82 cm
   (32.3 in)
   D. 74 cm (29 in)

STONE TYPE Pale yellowish-grey, medium- to coarse-grained, shelly, oolitic limestone, bedding generally planar; Barnack stone, Lincolnshire Limestone Formation, Inferior Oolite Group, Middle Jurassic

PRESENT CONDITION The decoration on the hood mould and north faces of the imposts and capitals is fairly heavily weathered. That on the other faces is in good condition with only slight bruising

DESCRIPTION The jambs, which are square internally but recessed externally, are composed of through stones. Each has a free-standing external angle shaft

with a sloping annular base and an angular cushion capital. Each face of the west capital, (a), is filled with a single group of narrow, expanding, square-ended, hollowed leaves fanning out from a point on the lower edge. The east capital, (b), is similarly treated. The jambs and angle shafts support imposts, (c and d), of fundamentally square section returned along the exterior wall face. In each case there is a roll moulding along the lower edge which is returned across the narrow end of the north face. Both imposts are decorated with leaf ornament like that on the capitals. The semicircular head of the doorway is composed of a single order of through stones, square internally but recessed externally, with a roll moulding round the arris. Externally the head is outlined by a hood mould, (e), of square section with a narrow roll moulding along the inner edge and terminating on the imposts. It is decorated in the same manner as the impost and capitals.

DISCUSSION Rodwell has argued that the north doorway of the nave is a medieval reconstruction, either in its original location or moved here from elsewhere in the building (Rodwell 1976, 64). Clearly much more has been lost from the original building, including the north porticus arch and the chancel arch, both probably decorated in the same manner as the surviving north doorway and south porticus arch. In addition a sketch by William Cole reveals that a second doorway, similar to the north door of the nave, survived as late as 1746 in the north wall of the medieval chancel. Like the surviving doorway, it was probably decorated.

   The use of early Romanesque architectural features, in particular angle shafts and soffit rolls, in this building serve to place it in the middle of the eleventh century, either just before or just after the Norman

---

1. The following are unpublished manuscript references to no. 1: BL Add. MS 5836, fol. 18v; BL Add. MS 6744, fol. 3r; BL Add. MS 47697, fols. 15v–16r.

Conquest. Similarly the parallels for the plant ornament lie on either side of the Conquest. For example, there is very similar leaf ornament on fol. 171 of the Winchcombe Psalter, a work of *c.* 1030–50 (Temple 1976, no. 80, ill. 253) and on the mid twelfth-century east impost of the south doorway at Great Canfield, Essex.

DATE Mid eleventh century

REFERENCES R.C.H.M. 1916, 144, pl. facing xxviii; Clapham 1930, 130; Cobbett 1937, 44–5, pls. I, IIa, IIIa; King 1942–5, 30; Pevsner 1954, 199; Fisher 1962, 302, fig. 33c; Taylor and Taylor 1965–78, I, 274, II, pl. 480, III, 1058; Taylor and Taylor 1966, 36, 50, fig. 15; Rodwell 1976, 56, 69, pl. Xb; Fernie 1983a, pl. IVa; Fernie 1983b, 171, pl. 100; Tweddle 1986b, I, 63–4, 66–7, 69–70, 177–8, II, 390–1, III, pls. 50–51a

D.T.

## 2a–f. Arch with decorated capitals (a–d) and imposts (e–f)[1]   (Ills. 285–91)

PRESENT LOCATION Opening into the south porticus

EVIDENCE FOR DISCOVERY First recorded by Leach in 1913

Capitals:
(south-east) W.  23.5 cm (9.25 in)
  D.  23 cm (9 in)
(north-east) W.  23 cm (9 in)
  D.  24 cm (9.5 in)
(south-west) W.  23 cm (9 in)
  D.  24 cm (9.5 in)
(north-west) W.  22 cm (8.6 in)
  D.  24 cm (9.5 in)
Other measurements unobtainable

1. The following is an unpublished manuscript reference to no. 2: BL Add. MS 47697, fols. 15v–16r.

STONE TYPE Yellowish-grey, medium- to coarse-grained, shelly oolitic limestone (much restored with cement and with some surfaces coated with whitewash or white emulsion paint);. Barnack stone, Lincolnshire Limestone Formation, Inferior Oolite Group, Middle Jurassic

PRESENT CONDITION Very badly damaged, with a large part of the capitals and imposts on both sides made up in plaster

DESCRIPTION The jambs, resting on stepped plinths of four orders, are of square section. Each has a pair of angle shafts which support cushion capitals, (a–d), ornamented like those of the north door (no. 1a–b). At each side the capitals support an impost returned along the north and south faces of the wall e–f). Both imposts are of fundamentally square section with a prominent moulding of sub-rectangular section along the lower edge. The vertical faces have leaf ornament similar to that on the imposts of the north door (no. 1c–d).

DISCUSSION Rodwell has suggested that the whole arch is a thirteenth-century construction reusing Roman material for the lower order of the plinth, combined with the angle shafts, capitals and imposts from a pre-Conquest arch. Fernie, however, believes the whole arch to be of a single date, and *in situ*. For further discussion see no. 1a–e.

DATE Mid eleventh century

REFERENCES R.C.H.M. 1916, 144, pl. facing xxviii; Clapham 1930, 130, pl. 44; Cobbett 1937, 44–5, pl. IIIb; King 1942–5, 30; Pevsner 1954, 200; Fisher 1962, 302; Taylor and Taylor 1965–78, I, 275; Taylor and Taylor 1966, 36, 50; Radford 1973, 134; Rodwell 1976, 56, 62, 69; Rodwell 1981, 128, pl. 60; Fernie 1983a, pl. II; Tweddle 1986b, I, 66–7, 177–8, II, 391–2, III, pls. 51a–52b

D.T.

# LANGFORD, O. (St Matthew)

SP 249025

## 1. Crucifixion scene[1]                                    (Ills. 292–3)

PRESENT LOCATION *ex situ*, built in externally over the entrance to the south porch

EVIDENCE FOR DISCOVERY First recorded (in present location) in drawing by Buckler of 1821

H.  *c.* 170 cm (67 in)   W.  *c.* 90 cm (35.5 in)
D.  Built in

STONE TYPE Yellowish-grey, medium-grained, variably shelly oolitic limestone, with a possible calcite veinlet on the lower part of the central figure; possibly Taynton stone, Taynton Stone Formation, Great Oolite Group, Middle Jurassic

PRESENT CONDITION Heavily weathered

DESCRIPTION The scene consists of the crucifixion with the Virgin and St John. The cross is composed of three stones, one forming the vertical limb and the others the horizontal limbs. The high-relief, frontally-placed figure of Christ has the head, with a cruciform nimbus, resting on its right shoulder. The face is bearded but the remaining features are lost. The arms curve out and down, and the well-modelled hands, palm outwards, are bent sharply upwards. The figure is naked to the waist, incised lines indicate the musculature of the torso, and he wears a knee-length garment which is slightly longer behind. A pair of parallel, horizontal incised lines indicate its upper edge. The legs are bent to the left, and the feet are out-turned. To the right, on a separate stone with its upper edge butting onto the lower edge of the horizontal arm of the cross, is the outward-facing nimbed figure of the Virgin. The figure wears a full-length robe. Over this is a cloak joined on the left shoulder. There is a cloth over the head. The figure's left arm is raised close to the body, and the right arm is held across the chest. In the corresponding position to the left is the frontally-placed, nimbed figure of St John. The figure wears a full-length robe. Over this is a cloak draped over the left arm which holds a book against the body. The right arm is held across the waist.

DISCUSSION The piece must be *ex situ*, as it is built into a thirteenth century porch. In resetting the piece, the figures of the Virgin and St John have clearly been reversed; they were originally intended to face inwards towards the figure of the crucified Christ. The arms of the cross have also been reversed. The arms of Christ were originally intended to slope upwards, and the hands hang down from the wrists as at Breamore 1, Hampshire (Ill. 428).

DATE Tenth to eleventh century

REFERENCES (——) 1886, 14–15, pl. B; (——) 1899, 50–2, pl. on 50; Gatty 1900, 73; Keyser 1904, liii; Prior and Gardner 1912, 137; Rice 1947, 14; Kendrick 1949, 47; Gardner 1951, 45; Rice 1952, 98–99, pl. 11a; Fisher 1959, 89; Rice 1960, 198, 200, pl. IIIB; Quirk 1961, 29; Fisher 1962, 231, 393, pl. 114; MacKay 1963, 88–9, pls. V.3, VII.13; Taylor and Taylor 1965–78, I, 367, 372, III, 1056; Taylor and Taylor 1966, 6, 13, 22; Gem 1973, II, 504; Sherwood and Pevsner 1974, 348, 681; Coatsworth 1979, I, 281, 292, 296–9; II, 34–5, pls. 151–3; Rodwell and Rouse 1984, 315, 318, fig. 8, pl. XLIb; Tweddle 1986b, I, 73–4, 189–208, II, 396–8, III, pl. 55b; Coatsworth 1988, 173–5, 190, pl. IIIa; Raw 1990, 210–11

D.T.

## 2. Crucifixion[2]                                          (Ills. 294–5)

PRESENT LOCATION *ex situ*, built externally into east wall of south porch

EVIDENCE FOR DISCOVERY See no. 1.

H.  183 cm (72 in)   W.  216 cm (85 in)
D.  Built in

STONE TYPE Pale yellowish-brown, medium- to coarse-grained, shelly, oolitic limestone, with near planar bedding and some calcite veinlets; Combe Down Oolite, Great Oolite Formation of Bath area, Great Oolite Group, Middle Jurassic

PRESENT CONDITION Largely complete, but surfaces worn

---

1. The following are unpublished manuscript references to no. 1: BL Add. MS 17457, fols. 198r, 199r; BL Add. MS 36356, item 200; BL Add. MS 47695, fol. 105r.

2. The following are unpublished manuscript reference to no. 2: BL Add. MS 17457, fol. 198r, 199r; BL Add. MS 36356, item 200; BL Add. MS 37509, item 216; BL Add. MS 37601, items 536–7; BL Add. MS 47695, fol. 105r–v.

DESCRIPTION It is composed of four joined elements. The head and lower limb of the cross are made separately, and set with a space between them. Into this gap are inserted tenons on the inner ends of the horizontal arms, which meet on the vertical axis.

The high-relief, frontally-placed, robed figure is intact except for the head. The arms are outstretched at right angles to the body. Each hand rests palm outwards on a vertical bar of triangular section, and is well modelled and deeply undercut. The hands protrude from the hollowed ends of the expanding sleeves of the robe. This has a rounded neck and falls to the ankles. It is tied at the waist with a knotted belt, the long expanding ends of which are cut off square at knee level. There is close vertical ribbing beside the legs. The feet protrude from the robe but are heavily damaged.

DISCUSSION As with no. 1, the piece is clearly *ex situ*, as it is built into the same thirteenth-century fabric. The pieces have, however, been reconstructed in the correct order.

DATE Eleventh century

REFERENCES (——) 1886, 13–15, pl. B; Allen 1889, 198; (——) 1899, 51–2, pl. on 51; Gatty 1900, 73; Prior and Gardner 1912, 132, fig. 112; MÉle 1928, 256; Clapham 1930, 138, pl. 61; Cottrill 1931, 53, appendix; Rivoira 1933, II, 208; Salzman 1939, 369, 371; Rice 1947, 14; Saxl and Wittkower 1948, 27, pl. 4; Kendrick 1949, 48, 51–2; Clapham 1951, 193–4, pls. III-IV; Gardner 1951, 45, fig. 70; Rice 1952, 101–6, 152, pl. 17; Fisher 1959, 89; Rice 1960, 200–1, pl. IIIB; Quirk 1961, 29; Fisher 1962, 393, 231, pl. 114; Pocknee 1962, 43; Taylor 1962b, 19; MacKay 1963, 89; Taylor and Taylor 1965–78, I, 74–5, 367, 372, II, 630, III, 1056; Taylor and Taylor 1966, 6, 13, 22; Zarnecki 1966, 89, pl. 1a; Gem 1973, II, 496–7; Sherwood and Pevsner 1974, 348, 681, pl. 9; Coatsworth 1979, I, 151–73, 281, II, 35, pl. 61; Tweddle 1986b, I, 73–4, 189–208, II, 398–9, III, pl. 56a; Coatsworth 1988, 173–5, 190; Raw 1990, 92, 210

D.T.

## 3. Sundial[1]                                        (Ill. 296)

PRESENT LOCATION Built into the median pilaster of the south external face of the tower at first floor level

EVIDENCE FOR DISCOVERY See no. 1.

H.   102 cm (40 in)   W.   58 cm (23 in)
D.   Built in

STONE TYPE Inaccessible, but apparently a yellowish limestone, fairly soft and including fossil shells, perhaps ostreids, of 3–5 mm diameter; possibly from Inferior Oolite Group, Middle Jurassic of Cotswolds, or from Corallian Beds, Upper Jurassic, from east of Oxford

PRESENT CONDITION Heavily weathered

DESCRIPTION On the lower edge of the trapezoidal panel, which is widest at the top, stands a pair of figures. Each is clad in a knee-length garment and a cloak falling to mid-calf level. Their feet are out-turned, and the legs bent to the right. The figures look upwards and inwards, having their arms bent and raised to grasp the heavily-damaged, narrow, plain raised edge of a semicircular dial whose horizontal edge is co-terminus with the upper edge of the panel. The lines of calibration are lost.

DISCUSSION It is difficult to decide if this piece is *in situ* or not. It is placed extremely high up to be read with ease, but could, nevertheless, be read. The figures holding the dial find their best parallels in Anglo-Saxon art of the late tenth and early eleventh centuries, for example, in the Presentation scene in the Foundation Charter of the New Minster, dated to after 966 (Temple 1976, no. 48, ills. 155–6), and the illustrations of the Labours of the Months in BL MS Cotton Tiberius B. V, dated to the second quarter of the eleventh century (ibid., no. 87, ills. 273–4). The architectural features of the tower, in contrast, suggest a later date for its construction. Soffit shafts and rolls which are employed abundantly on the belfry stage were only introduced as late as the second quarter of the eleventh century on the continent (Bony 1967, 75), and their appearance in England before the Conquest would be precocious. The most likely conclusion is that the sundial came originally from an earlier fabric, and has been reused in its present location.

DATE Eleventh century

REFERENCES (——) 1886, 13–14, pl. C; (——) 1899, 52; Gatty 1900, 72–3, fig. on 72; Clapham 1930, 138; Cottrill 1931, appendix; Salzman 1939, 367, 371, pl. xxixf; Zinner 1939, 8, 12, abb. 7; Rice 1952, 152; Quirk 1961, 31; Fisher 1962, 229; Taylor 1962b, 19; MacKay 1963, 84, 93; Zinner 1964, IV, 115; Taylor and Taylor 1965–78, I, 369–70, fig. 167; Taylor and Taylor 1966, 22–3, 50, fig. 10; Zarnecki 1966, 91, pl. V; Gem 1973, II, 501, 503; Sherwood and Pevsner 1974, 348, 681; Tweddle 1986b, I, 84, 175–7, II, 399–400, III, pl. 56b

D.T.

1. The following are unpublished manuscript references to no. 3: BL Add. MS 36356, item 200; BL Add. MS 37601, items 553–4.

## 4a–d. Belfry capitals                   (Ills. 297–312)

PRESENT LOCATION Upper stage of tower

EVIDENCE FOR DISCOVERY None; *in situ*

(capitals of central pier): H.   *c.* 22 cm (8.7 in)
W.   *c.* 52 cm (20.5 in)
D.   *c.* 24 cm (9.5 in)
Other measurements unobtainable

STONE TYPE Inaccessible, but with a weathered appearance very similar to that of the window surrounds and the quoin stones of the tower, which are of shelly, oolitic limestone, with calcite veinlets; probably Combe Down Oolite, Great Oolite Formation of Bath area, Great Oolite Group, Middle Jurassic

PRESENT CONDITION Heavily weathered

DESCRIPTION Each face of the tower has a pair of round-headed openings, each of two orders. The outer has quarter-rolls which continue downwards as jamb-shafts; the rolls meet in the middle so that the central jamb continues down as a half-round shaft. The inner order consists entirely of half-round soffit rolls continued as shafts. Between the arches and jambs are continuous strip-like capitals delimited by a narrow, plain moulding of square section below, with a wider one above. Each is decorated with foliate ornament consisting of semicircular groups of leaves, each having a series of narrow, rounded-ended,

hollowed elements radiating from the point where it emerges from the lower moulding. Above the central capital, where the quarter-round rolls of the outer order join, there is a larger foliate element of this form.

DISCUSSION The architectural features of the belfry stage suggest a date for the tower no earlier than the middle of the eleventh century (see no. 3). The decoration of the capitals and flanking strips, nonetheless, looks back towards Anglo-Saxon art; similar plant decoration occurs widely in the borders of pre-Conquest manuscripts, notably on fol. 4v of the late tenth-century Sherborne Pontifical (Temple 1976, no. 35, ill. 13) and on the scene of the Miracle of the Tribute Money in the Gospel Lectionary fragment formerly in the Musée van Maerlant, Damme, Belgium, dated to *c.* 1000 (ibid., no. 53, ill. 176). Similar compositions are encountered in metalwork, as on the inlaid silver plates around the base of the Canterbury censer cover (Wilson 1964, no. 8, pls. XII–XIV; Backhouse *et al.* 1984, no. 73, pl. XXII).

DATE Mid eleventh century

REFERENCES Brown 1925, 463; Clapham 1930, 130; Rivoira 1933, II, 206–8; Fisher 1962, 229; Taylor 1962a, 164; Taylor 1962b, 19; Mackay 1963, 83, 90; Taylor and Taylor 1965–78, I, 368–9, figs. 165–6; Taylor and Taylor 1966, 37, 40, 50, fig. 16; Tweddle 1986b, I, 59–61, 175–6, II, 400–2, III, pl. 57a

D.T.

# LAVENDON, Bk. (St Michael)

## SP 916537

## 1. Fragment                              (Ill. 313)

PRESENT LOCATION Built into the south-east quoin of the tower, below the level of the second storey window, abutting no. 2

EVIDENCE FOR DISCOVERY First recorded in Taylor and Taylor 1965–78

MEASUREMENTS Unobtainable

STONE TYPE Inaccessible, but apparently of light grey limestone, rough-surfaced and lichen-covered; probably Barnack stone

PRESENT CONDITION Weathered

DESCRIPTION Only face A is visible. It is approximately square and has a plain, low-relief border above and below. It is roughly broken to the left and right. The face is decorated with a pair of closed circuit loops spanning the full width of the face. Each is composed of a broad, low relief strand with a median-incised line.

DISCUSSION Without closer examination the function of this piece remains entirely uncertain. Its overall size, and the nature of decoration, are consistent with an

interpretation of the piece as part of a square cross-shaft. The use of closed circuit patterns is consistent with a late pre-Conquest date (Collingwood 1927, 65, 68).

DATE Tenth to eleventh century

REFERENCES Taylor and Taylor 1965–78, I, 376; Tweddle 1986b, I, 112, 247–8, II, 402, III, pl. 57b

D.T.

## 2. Fragment                                            (Ill. 315)

PRESENT LOCATION Built into the south-east quoin of the tower, abutting no. 1

EVIDENCE FOR DISCOVERY See no. 1.

MEASUREMENTS Unobtainable

STONE TYPE Inaccessible, but apparently of light grey limestone, rough-surfaced and lichen-covered; probably Barnack stone

PRESENT CONDITION Weathered

DESCRIPTION It is roughly broken to the left and to the rear.

*A:* There is a low-relief border along the upper and lower edges; the decoration is a fragmentary interlace, perhaps closed circuit pattern D. The east face is dressed flat.

DISCUSSION As with no. 1, the size and decoration are consistent with a square cross-shaft. It may even have belonged to the same shaft as no. 1; it employs similar closed circuit patterns, again suggestive of a late pre-Conquest date.

DATE Tenth to eleventh century

REFERENCES Taylor and Taylor 1965–78, I, 376; Tweddle 1986b, I, 112, 248, II, 402–3, III, pl. 57b

D.T.

# LEWKNOR, O. (St Margaret)

## SU 716977

## 1. Fragment                                            (Ill. 316)

PRESENT LOCATION Built externally into the blocking of the arch in the west wall of the north chapel

EVIDENCE FOR DISCOVERY First recorded by author

H.   16.5 cm (6.5 in)   W.   22 cm (8.7 in)
D.   Built in

STONE TYPE Pale greyish-yellow, shelly, oolitic limestone, similar in appearance to the stone of Sonning 1; possibly Taynton Stone Formation, Great Oolite Group, Middle Jurassic

PRESENT CONDITION Broken and worn

DESCRIPTION It is sub-rectangular with each of the edges roughly broken, and is decorated with simple pattern F interlace. There is a single intact knot, with part of a second similar knot above, and the remains of a third to the left.

DISCUSSION Nos. 1 and 2 are linked by having the same decoration. As no original edges survive on

either of them, their function remains obscure. However, the interlace pattern on them, while rare in southern England, is consistently used on some Lincolnshire grave-covers, as at Cammeringham (Davies 1926, 9, pl. facing 14), Northorpe (ibid., 17–18, fig. 3), and Stow (ibid., 19, fig. 4). Its occurrence here may suggest a similar function for those pieces, but it is very slender evidence.

DATE Tenth to eleventh century

REFERENCE Tweddle 1986b, I, 112, 252, II, 403, III, pl. 58a

D.T.

## 2. Fragment                                            (Ill. 317)

PRESENT LOCATION Built externally into the blocking of the arch in the west wall of the north chapel

EVIDENCE FOR DISCOVERY See no. 1.

H.   18 cm (7 in)   W.   22 cm (8.7 in)
D.   Built in

STONE TYPE Pale greyish-yellow, shelly, oolitic limestone, similar in appearance to the stone of Sonning 1; possibly Taynton Stone Formation, Great Oolite Group, Middle Jurassic

PRESENT CONDITION Broken and worn

DESCRIPTION It is sub-rectangular and decorated with simple pattern F interlace. Two knots survive, one below and slightly to the left of the other. Next to, and to the left of the lower knot are the remains of a third.

DISCUSSION See no. 1.

DATE Tenth to eleventh century

REFERENCE Tweddle 1986b, I, 112, 252, II, 403–4, III, pl. 58b

D.T.

# LITTLE MUNDEN, Hrt. (All Saints)

## TL 334219

### 1a–b. Imposts (Ills. 318–19)

PRESENT LOCATION *in situ* on the west and east side of the westernmost arch of the north arcade of the nave

EVIDENCE FOR DISCOVERY First recorded in R.C.H.M. 1911

a: H.   24 cm (9.5 in)   W.   73.5 cm (28.9 in)
   D.   35 cm (13.8 in)
b: H.   26 cm (10.2 in)   W.   75 cm (29.5 in)
   D.   36 cm (14.2 in)

STONE TYPE White soft limestone, coated with pale yellow emulsion paint; Middle Chalk or Upper Chalk, Upper Cretaceous

PRESENT CONDITION Good

DESCRIPTION The jambs of the arch are of square section supporting moulded imposts. The western impost, (a), is returned along the north and south faces of the wall, and ornamented with three cable mouldings twisted alternately in opposite directions. Incised lines indicate the twists. Each moulding projects slightly beyond the one below. Along the upper edge is a narrow moulding of square section. The eastern impost, (b), is of identical form.

DISCUSSION The western arch of the north nave arcade originally had a round head which was replaced in 1868 by the present two-centred arch. Presumably it is the survivor from an original arcade of this form opening into a north aisle; the rest of the openings were rebuilt in the fourteenth century.

In form and decoration the imposts compare closely with the surviving example at near-by Walkern (no. 2). The form of the cabled ornament, with modelled strands, each with a median groove of V-shaped profile, is paralleled elsewhere in southern England at Dartford in Kent and on the cross-shaft from London All Hallows 1. All of the pieces are arguably of mid eleventh-century date.

DATE Eleventh century

REFERENCES R.C.H.M. 1911, 10, 148; Page 1912c, 134; Pevsner 1953, 162; Smith 1973, 17, 256; Tweddle 1986b, I, 68, 178–9, II, 404, III, pl. 59a

D.T.

# LONDON (All Hallows by the Tower)

## TQ 334808

### 1a–b. Part of cross-shaft in two pieces

(Fig. 33; Ills. 320–40)

PRESENT LOCATION In crypt

EVIDENCE FOR DISCOVERY Found reused in wall at west end of south nave arcade after bomb damage in 1940

a i–iii: H.   55 cm (21.7 in)   W.   32 cm (12.6 in)
     D.   33 cm (13 in)
b: H.   30.5 cm (12 in)   W.   13 cm (5 in)
     D.   29.5 cm (11.6 in)

STONE TYPE Pale yellowish-grey, medium- to coarse-grained, shelly oolitic limestone, with a calcite veinlet; Combe Down Oolite, Great Oolite Formation of Bath area, Great Oolite Group, Middle Jurassic

PRESENT CONDITION Broken and differentially worn

DESCRIPTION The fragments can be reconstructed to form part of a tapering shaft of square section, dressed flat above and below. Fragments a i–iii join. Fragment b apparently belongs to the same shaft. Only face B, and parts of faces A and C survive. There are also traces of red pigment on this stone (Kendrick and Radford 1943, 14; Tweddle 1990, 151).

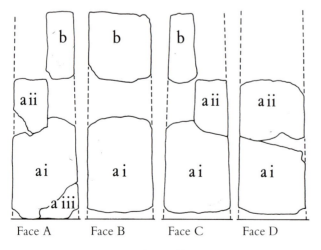

FIGURE 33
London All Hallows 1, labelling of fragments and faces, nts

Fragment a:

*A (broad):* Along the left and right-hand edges is a bold cable moulding of fundamentally square section, the strands are well modelled and have a V-shaped median groove. Inside each is a narrow, plain raised moulding of square section. Along the lower edge a broad, plain raised moulding of rectangular section partially survives, broken away to the left and right. The face is divided into two unequal fields by a broad, plain horizontal moulding of rectangular section with a wide, deep incised median line stopping short of the vertical mouldings and widening abruptly short of its left-hand end; the right-hand end is damaged. Just short of each end a pair of oblique incised lines emerge from the median line, one above and one below, and run into the corners of the moulding. In the lower, smaller, field is a pair of addorsed animals facing inwards. That to the left has its mouth open, the ends of the jaws are out-turned, and the head bulges over the prominent incised reversed lentoid eye. The ear has its end curled down. the narrow body curves towards the vertical axis of the field where it touches that of the second animal before curving out again. Three incised lines span the width of the body just above the hindquarters, which rest on the lower border. The rear legs are bent at the knee and the paws placed against the border, while the front legs are also bent and the paws placed against the border; the toes are indicated by incised lines. The second animal is a mirror image of the first except that the ear is longer and the end up-turned. The protruding tongues of the animals are linked and drawn out across the body of the right-hand animal. In the upper, larger, field is the lower part of a robed figure, surviving to the left from mid-thigh level and to the right from knee level. The upper part of the knee-length robe has close vertical ribbing and is separated by a pair of narrow horizontal mouldings from the lower part of the garment which expands and is composed of a series of stiff vertical folds. Each of the bare legs, in high relief and with a degree of undercutting, is separated by a pair of narrow horizontal mouldings from the frontally-placed unshod foot. The toes are indicated by incised lines. The feet rest on a broad plain zone recessed behind

the borders. The area between the legs, and between the legs and the frame is further recessed and bears the heavily-damaged inscription.

<div align="right">D.T.</div>

*Inscription* The inscription (Ills. 323–4, 327; Okasha 1971, 99–100; eadem 1992b, 341, 345) is in two lines divided into three vertical sections by the legs of the standing figure. The letters vary in height from about 4.3 cm (1.7 in) for the R of the upper line to 2.8 cm (1.2 in) in the lower line. There is now no colour visible in or near the lettering. The inscription can be transcribed as follows:

[.E] || [RH] || [*E.*]
[—] || Þ OR || RD

This can be edited as:

.ERH[*E.*—]ÞORRD
(or perhaps [Þ]ERH[*E.*—]ÞORRD)

The interpretation of this text is uncertain. The damaged first letter could well have been part of Þ. It is also possible that this is not the beginning of the inscription and that it originally started higher on this face. About two letters are likely to have been lost at the start of the second line. The last element may represent the Old English word 'word', possibly in the Christian sense of the 'word of God' or the 'Word' (Okasha 1971, 100)). Alternatively, the whole or part of the text may have been a personal name, although it does not correspond to known Old English personal names. (Radford read 'WERHENWORRTH' and took that to be a personal name. That reading ignores the gap at the beginning of the second line and reads D as *eth* (Kendrick and Radford 1943, 16).)

The lettering is damaged and somewhat irregular. It may have been a little awkward cutting letters on the recessed ground close to the high relief of the legs. The serifs tend to be wedge-like in form. As far as they can now be judged, the letters seem to show more departures from normal Roman capital forms than other pre-Conquest inscriptions on stone in the south-east of England. D is the uncial letter (which is also used in Insular half uncial). It is open at the top and has a slight angle at the base. E is the Roman capital form. H is a non-capital form which is closer to the Insular half uncial than to the uncial letter in that the lower part of the right-hand stroke straightens out into a near vertical rather than continuing to curve (cf. Higgitt 1979, 361–2). The O is oblong, a rare form in Anglo-Saxon inscriptions on stone. Two forms of the capital R are

used: with the bow open at the bottom; and with the bow meeting the right leg half-way along its length. Runic *wynn* is used for W.

<div align="right">J.H.</div>

*B (narrow):* Only the decoration on stone a i survives. It is framed like face A. The decoration is divided into two unequal fields. The lower, smaller field, heavily damaged and apparently undecorated, lies flush with the inner frames and is separated from them by incised lines. Inside them the field has a further narrow plain frame defined by incised lines. The upper, larger, field is ornamented with a well-ordered six-strand plain plait; the broad strands are median-incised and the central crossing point at the bottom contains a pellet.

*C (broad):* The decoration on stone a ii is obliterated, and that on stone a i heavily damaged. Face C of stone i has borders like those of face A, the mouldings being largely destroyed. It is decorated with the lower part of a robed figure surviving from approximately knee level. Beside each border an edge of the robe falls in stiff vertical folds which flank a plain, vertical, median zone. From the lower end of the robe, foreshortened and portrayed as an oval, protrude the legs of the figure. The feet are out-turned.

*D (narrow):* The border mouldings are like those on face A, and the lower third of the face is ornamented with foliate decoration. From the lower corners of the face emerge narrow, diagonal plant stems, three from the right and two from the left, interlacing where they cross and terminating in pointed, oval, berry bunches. Each stem is median-incised and between the stems to the left are two short, expanding rounded-ended, hollowed leaves. The upper two-thirds of the face are occupied by a pair of elongated robed figures, side by side, and surviving from shoulder level. Each is clad in a horizontally-ribbed undergarment, with a vertically-ribbed overgarment thrown over the shoulders and gathered up across the body. The legs are clad in a close fitting trouser-like garment, laterally ribbed, which terminates at the ankle in a pair of narrow horizontal mouldings. The out-turned feet are shod and rest just above the foliate decoration. At ankle level the face is abruptly recessed allowing the legs to be treated in high relief with a degree of undercutting. The left-hand figure holds in its right hand a key. The right-hand holds an unidentified feature.

Fragment b:

*A (broad):* Along the right-hand edge is a prominent cable moulding identical to those on stone a i and ii.

Only a marginal fragment of the decorative field survives, apparently ornamented with part of a robed figure. The robe has close lateral ribbing.

*B (narrow):* The heavily-damaged edges have borders like those on face A, the face being decorated with two interlaces separated by a narrow, undecorated zone. Each is composed of broad strands with a median-incised line. The lower, cut off by the break below, is an eight-strand plain plait. The upper, cut off by the break above, is probably pattern D with an additional diagonal strand through the element.

*C (broad):* The surviving, left-hand, border resembles that of face A. The field is ornamented with the shoulders of a robed figure, the robe having close lateral ribbing. Traces of red paint survive in the ribbing.

*D (narrow):* Broken away.

DISCUSSION It seems clear that fragment 1b belongs to the same shaft as fragments 1a i and ii, although in the reconstruction of the shaft it has not necessarily been placed in the correct relationship to the other fragments.

An eleventh-century date for this shaft can be argued both from the iconography and from the handling of the figures and their drapery. Iconographically there is the use of what is probably a pair of seated figures in secular dress on face D (Ill. 336). The use of secular dress may in itself point to a late pre-Conquest date for the shaft;[1] it occurs in manuscript illustrations of the tenth and eleventh centuries, for example, in Cambridge, Corpus Christi College MS 183, fol. 1v, of the early tenth century, and fol. 2v of BL MS Cotton Tiberius A. III, a work of *c.* 1050 (Temple 1976, no. 100, ills. 29, 313). Similarly, the use of very elongated figures on no. 1 also finds its best parallel in the eleventh century, as in the Judith of Flanders Gospels (ibid., no. 93, ills. 285, 289) and Monte Cassino, Archivio della Badia MS BB. 437, 439, made *c.* 1050 (ibid., no. 95, ill. 287).

The folds of the robes on no. 1 are rigid and formalized, losing contact with the shape of the body beneath, and frequently employing nested U-shapes. This approach is closely paralleled in some eleventh-century manuscripts, notably in Aelfric's Pentateuch, a product of St Augustine's abbey, Canterbury, and dating to the second quarter of the eleventh century.

This handling of the draperies occurs also on other sculptures of the late Anglo-Saxon period, most obviously on the tenth- or eleventh-century cross-shaft from Shelford, Nottinghamshire (Kendrick 1949, 78–9, pl. LI). Here the robes of the Virgin and Child and those of the seraph on the opposite face share with the robes of the figures on no. 1 the use of narrow, closely spaced grooves to indicate the folds of the garment, again arranged in formalized patterns rather than naturalistically.

D.T.

*Inscription* The unusual oblong form of O can be best paralleled in eighth-century examples from Hartlepool, co. Durham, York, and also Hackness, Yorkshire (Okasha 1971, pls. 46–7, 151; Cramp 1984, I, 99–100, II, pl. 84 (436), 85 (440); Higgitt in Lang 1991, 138). (Okasha's late, probably eleventh-century, example at Aldbrough, Yorkshire (Okasha 1968, 323) is not borne out by an examination of the stone.) The letter is one of the forms used in the display script of Insular manuscripts of around the eighth century (see for example Gray 1986, 242–4, 247; Higgitt 1994, 229).

The general impression given by this lettering, with its wedge-like serifs, which probably reflect the fashion for wedge serifs in Insular book scripts of around the eighth century, and its letter forms, particularly the oblong O, suggests that it dates from a period in which early Anglo-Saxon traditions in lettering were still remembered. The eleventh-century date argued for this sculpture on other grounds (see above) seems remarkably late for lettering of this sort, particularly in the south of England. Anglo-Saxon inscriptions on stone of the tenth and eleventh centuries and the display scripts of southern English manuscripts of the same period favour a much more consistent use of Roman capitals with a few variants (e.g. Okasha 1971, pls. 1, 15, 28–9, 41, 64, 111, 146; Temple 1976, ills. 18, 26, 38–40, 54, 57, 70–5, 81, 83, 92–3, 113–17, 125–8, 133, 138–40, 152, 182, 200, 216–23, 232, 260, 262, 288, 290–1, 296–7, 300, 319; Heslop 1990, 162–5). Whilst lettering like that on this fragment might have survived into the eleventh century, there seem to be no parallels in contemporary manuscripts or stone inscriptions. A dating to around the ninth century would be more natural on epigraphic grounds, although a later date cannot, of course, be excluded.

The setting of an inscription within the sculptural field is relatively unusual in Anglo-Saxon stone sculpture but there are analogies (though none is exact) at Auckland St Andrew 1 and Chester-le-Street 1 in co. Durham (Cramp 1984, II, pls. 3 (6), 20 (102)),

1. Compare, however, the possible pre-Viking examples at Bewcastle, Cumberland (Bailey and Cramp 1988, ill. 96), and York, St Mary Bishophill Junior 1 (Lang 1991, ill. 216) (Eds).

Ipswich in Suffolk (Okasha 1971, pl. 58), Newent in Gloucestershire (eadem, pl. 94a), and Great Urswick in Lancashire (Bailey and Cramp 1988, ill. 564; Page 1987, 38; Higgitt 1986, 131).

J.H.

DATE Ninth to eleventh century

REFERENCES Kendrick and Radford 1943, 14–18, fig. I, pls. V–VI; Clayton 1944, 2–3, pls. on 3; Kent 1947, 95, pl. facing 94; Brett-James 1948, 69; Kendrick 1949, 83–5, pl. LV; Clayton 1951; Zarnecki 1951a, 183; Clayton 1952; Rice 1952, 143; Pevsner 1957, 30, 130; Wilson 1960, 160–1; Taylor and Taylor 1965–78, I, 399; Okasha 1967, 250–1; Okasha 1971, no. 88, pl. 88; Brooke 1975, 137, pls. 28–9; Merrifield 1975, 75–6; Cobb 1977, 141; Clark 1980, 14; Schofield 1983, 24, fig. on 22; Tweddle 1986b, I, 95, 117, 234–40, II, 404–8, III, fig. 37, pl. 60; Tweddle 1990, 151

## 2. Cross-head, in two joining pieces   (Ills. 343–4)

PRESENT LOCATION In crypt

EVIDENCE FOR DISCOVERY Found during reconstruction of church in 1951, lying face downwards about a foot below nave floor against base of one of Norman piers

Diameter *c.* 53 cm (21 in)
D.   10 cm (3.9 in)

STONE TYPE Light grey to brownish-grey, fine-grained (0.1–0.2 mm quartz grains) sandstone, with a very few 0.2-mm dark grains and no obvious cement; of uncertain provenance, perhaps Lower Cretaceous rather than Tertiary, and possibly Wealden

PRESENT CONDITION Chipped; edges worn

DESCRIPTION It is a form of circle-head with arms of type E8, broken roughly horizontally below, the lower arm and lower parts of the horizontal arms being lost. The sides of the expanding arms are concave, and the re-entrant angles acute. The ends of the arms are separated by incised lines from a narrow ring of rectangular section encircling the head. Traces of black and red paint survive on both broad faces (Tweddle 1990, 150–1). Only face A is carved.

D.T.

*A (broad): Inscription* The inscription (Okasha 1967; eadem 1971, 99; eadem 1992b, 335–6, 342, 345) is incised around the circumference of the ring. The letters run, with their feet facing towards the centre, between an incised circle which acts as the lower framing line and the outer edge of the face. The diameter of the head is about 53 cm (21 in) and the

distance between the incised circle and the edge of this face is about 4.5 cm (1.8 in). The height of the letters is around 4 cm. The two cut-out sectors, which are clumsily carved in comparison with the cutting and dressing of the rest of the head, are probably secondary and, on the right-hand side, cut into the inscribed area.

Okasha states that the '. . . inscribed face of the stone appears to have borne some red paint, both on the letters and on the central plain portion.' (Okasha 1967, 249; cf. Tweddle 1990, 150–1). Traces of red paint are still visible in one or two places on this face. Some colour can be seen within the (probably secondary) cut-out sectors, which suggests that, at least there, it is not primary. Small quantities of orangeish pigment can also be seen in the central serif of the first E and at the top of the first R. (There are also a few splashes of red wall paint.)

The inscription is damaged and incomplete at either end. What remains may be transcribed as follows:

—[S]TAN[ Þ]E]L[V.]RLE[TSE . . . —F]ER[H/E]R[E]—

There are some uncertain readings. The character transcribed as *wynn* could perhaps be *thorn*, or even D (Okasha 1967, 250). Between the letters V and R there is a stroke which leans markedly to the left away from the vertical. It may have been intended as a vertical and therefore perhaps as the letter I (Okasha 1967, 250). (The verticals of some other letters also lean away from the perpendicular.) If it was intended as a diagonal, it might have formed the right leg of an A but, if so, there is no trace of the rest of the letter. The bottoms of strokes of three probable letters are still traceable after the group LETSE. These are two verticals and two converging diagonals. These are compatible with the letters TTA, and in the context can probably be read as part of the formula *let settan* (Page 1971, 178). The probable F shortly after these letters seems to have been in ligature with Y or V. The ligatured letters, transcribed here as H/E, are less than certain because the verticals seem to have converged towards the top. Alternative readings would be A and E in ligature, or the Æ diphthong. H/E is, however, the most probable reading. The text is in Old English, and can perhaps be read as follows:

—[S]TAN  ÞELV[I]R (or  ÞELV[A]R) LET SE[TTAN] [.F]ER [H]/ERE—

This would mean: '—Welv[i]r (or Thelv[i]r, or Delv[i]r, or Welv[a]r, etc.) caused . . . stone to be raised over [H]ere —'. There are other possible ways

of dividing the first three syllables (Okasha 1967, 250–1; Okasha 1971, 99) but this seems the most satisfactory.

The lettering is shallowly cut and rather loosely designed. Some of the verticals are out of the perpendicular. Vertical strokes go down to the incised circular framing line but, to avoid losing the bottom horizontals of E and L by cutting them along the framing line, the letter-cutter has placed the horizontals some way above the framing line, with the effect that the verticals of E and L project below the bottom horizontals. The top edge of the inscription is worn and damaged, and so it is not always clear how letters finished at the top. The verticals of two of the Es (the first and the antepenultimate) seem also to project above the top horizontal as well as below the bottom one. Several of the strokes terminate in what Okasha has called 'dot seriffing'. These dots are not very deep. They were perhaps executed with a drill or by revolving a mason's point.

Apart from the unusual form of E with extended verticals described above, the letter forms are mostly Roman capitals or variants of them. The following are worthy of comment. A has an angular cross-bar and a bar over the top which meets the diagonals shortly before the point at which they would converge. The extension of the vertical of the L below the horizontal is analogous to the treatment of the E. N is the non-Classical form in which the diagonal meets one or both of the verticals short of the end. The R is an angular version of the letter which is very similar to the open form of runic 'r' as seen, for example, on Dover St Peter 1 (Ill. 76). The Old English graph *wynn* seems to be used for W, although, as noted above, *thorn* and D are other possible readings. There are one fairly certain and one possible example of ligaturing of letters. Words are undivided and there is no remaining evidence of punctuation.

<div style="text-align: right">J.H.</div>

DISCUSSION The form of the piece suggests a late date, that is, in the tenth or early eleventh century. As Collingwood has pointed out, circle- and plate-heads are variants of the ring-head, which was probably introduced to England by Scandinavian settlers in the early tenth century (Collingwood 1927, 137–9, fig. 153). The fact that no cross-head in England of this type has pre-Viking ornament, and that the surviving examples have decoration which depends on Scandinavian or Scandinavian-derived motifs lends strong support to Collingwood's dating (Bailey 1978, 178–9).

<div style="text-align: right">D.T.</div>

*Inscription* Page thinks that the underlying formula of the text is '*NN let settan ofer Here—*' (Page 1971, 178). He follows Okasha in suggesting *ofer* as the reconstruction for [.F]ER (Okasha 1967, 250–1; cf eadem 1992b, 335–6), but points out that it would be unparalleled in Old English, which would prefer *æfter*. They point, however, to the occasional use of *yfir* in similar contexts on Danish and Norwegian rune-stones and on one example on Iona. The letter in apparent ligature with F in this word could well be Y or V (giving [YF]ER or [VF]ER, a reading which would strengthen the suggestion of Old Norse influence). Okasha further suggested that Old English *stan*, if used in the sense of a 'grave-stone', might also reflect Old Norse usage (Okasha 1967, 250–1). Old Norse *steinn* is commonly used with this meaning on Scandinavian rune-stones.

The partially surviving portion of the inscription thus seems to have recorded both the name of the person who commissioned this monument and the name of the individual whom it commemorated and whose grave it perhaps marked. The formula used here seems to have been a variant of the quite common Old English *X sette æfter Y* (Higgitt 1986, 133). Analogous Latin formulae recording that X raised the cross *pro anima* or just *pro* Y are used on seven of the Welsh crosses (Higgitt 1986, 139).

The text seems to have contained two names. Okasha discusses Old English and Old Norse personal name elements that might lie behind the first probable name in the inscription (Okasha 1967, 250; eadem 1992b, 342). The second name fairly certainly began with the element *Here-*, a common Old English personal name element (Searle 1897, xvii, 292–5).

The use of dot seriffing is unusual in Anglo-Saxon inscriptions, but there are examples on stone at Bishopstone 1 in Sussex (Ills. 6–7) and Thornton le Moors in Cheshire, and on a piece of late Anglo-Saxon metalwork from Sandford, Oxfordshire (Okasha 1971, pl. 106; Higgitt 1983, 27–8; Okasha 1992a, 54–5; Hinton 1974, 56–60). Dot serifs are an embellishment that seems more natural to metalwork where they can be made simply with a punch, as they were on the Sandford inscription.

The apparent form of E with extended vertical is rare in Anglo-Saxon inscriptions, though it is used in the maker formula on the cross-shaft from Alnmouth, Northumberland (Okasha 1971, pl. 2a; Cramp 1984, II, pl. 157 (810)). It is a common form in pre-Carolingian Frankish inscriptions and appears occasionally in early medieval inscriptions in Britain, for example, at Lethnott (Angus), and Aberdaron and

Penmachno (Caernarvonshire), and in the display script of Insular manuscripts (Deschamps 1929, 11, 65–80; Higgitt 1982, 315; Okasha 1985, 47, pl. III; Nash-Williams 1950, 84, 224–5, figs. 62, 81, pl. VIII; Alexander 1978, ills. 49, 60, 68). The Ls on the cross-head are analogous in form to the Es.

The letter forms and seriffing on this stone are quite unrelated to those on the cross-shaft fragments from this site (no. 1). The cross-head lettering is in capitals and that on the shaft fragments in a mixed script. The shaft lettering is likely to be earlier, or at least has more affinities with early lettering. The Es and Ls on the present piece also look like an early form, although it could be a revival or an independent invention. Capitals are used, but in their irregularity, their unusual, perhaps archaic, forms of E and L, and the rune-like R, they are quite unlike the regular and comparatively Classical capitals of most pre-Conquest inscriptions in the south-east. They could be earlier, or, perhaps, just less influenced by the style of the lettering of the monastic reform period.

The placing of an inscription on the head of a cross is not unusual in Anglo-Saxon England (Higgitt 1986, 130). However, if we accept the suggestion made above that the original form of this cross-head was an unpierced disk, the only other example in the British Isles of an inscription in the outer ring of such a cross-head seems to be at Margam (Glamorganshire) (R.C.A.H.M.W. 1976, 46–8, pl. 8). The closest formal parallels for inscriptions ranged round a circumference in this way are on the circular sundials at Aldbrough, Yorkshire (Higgitt in Lang 1991, 123, Ill. 418) and Orpington, Kent (Ill. 105). It is uncertain, of course, whether no. 2 was originally completely circular, and, if so, whether the inscription followed the entire circumference.

J.H.

DATE Eleventh century

REFERENCES (——) 1951, 2; Zarnecki 1951a, 183; Clayton 1952; (——) 1952; Pevsner 1957, 130, 309; Wilson 1960, 160–1; Okasha 1967, 249–51, pl. XXIXa and b; Okasha 1971, 99, fig. 87; Page 1971, 175–81; Brooke 1975, 137; Merrifield 1975, 75–6; Cobb 1977, 141; Tweddle 1986b, I, 99, 117, 251, II, 408–9, III, pl. 59b; Tweddle 1990, 150–1

## 3. Part of grave-marker                     (Ills. 341–2)

PRESENT LOCATION In crypt

EVIDENCE FOR DISCOVERY Found during restoration in 1961; perhaps built into wall above surviving pre-Conquest arch, at west end of south arcade

H.   23 cm (9 in)   W.   43 cm (17 in)
D.   13 cm (5 in)

STONE TYPE Yellowish-grey, medium- to coarse-grained oolitic limestone, with a few shell fragments and one distinct calcite veinlet; a pinkish tinge on the front surface suggests burning; Combe Down Oolite, Great Oolite Formation of Bath area, Great Oolite Group, Middle Jurassic

PRESENT CONDITION Broken and worn

DESCRIPTION Two sub-triangular fragments fit together to form part of a grave-marker, roughly in the shape of a parallelogram. All the edges are roughly broken. The stone is decorated in the Ringerike style.

*A (broad):* Ornamented with the fore quarters of an animal. One leg, with an incised spiral hip, is arranged vertically, passing behind the other front leg which is extended almost horizontally and terminates in two curved claws. A foliate or interlace strand developing from the lower left loops around both legs before being carried up to join a series of tendrils or interlacing strands to the upper right.

*C (broad):* The centre of a cross with expanding arms survives, their junction enclosed by a circle defined by a broad, flat strand with which the ends of the arms interlace. They stop against the edges of a concave-sided lozenge contained within the circle, which is defined by broad bands. The points of the lozenge are extended beyond the circle, between each pair of cross-arms, but are then broken away.

*B, D and E (narrow sides and top):* Broken away.

DISCUSSION The fact that this piece has decoration both on the front and the back demonstrates that it was free-standing. The animal on face A links it with the St Paul's headstone (Ill. 351) and may suggest a similar function. A memorial function is supported by the occurrence of a cross on face C, as on Rochester 3 (Ill. 148).

As with two carvings from London (St Paul's 1 and City 1), Rochester 2–3, and the fragment from Great Canfield, Essex (Fig. 32), this piece is decorated in the Scandinavian Ringerike style. This was current in Scandinavia from the late tenth century to the third quarter of the eleventh century (Wilson and Klindt-Jensen 1966, 145–6). In England the style probably belonged to the period of Scandinavian rule, from 1016–42 (ibid., 145), which would serve to date no. 3

fairly precisely. There are so few Ringerike-style sculptures from the region, their distribution is so restricted, and the style of carving so similar, it is tempting to regard them as the products of a single workshop.

DATE Eleventh century

REFERENCES Wilson and Hurst 1961, 309; Musset and Mossé 1965, 431, no. 133; Foote and Wilson 1970, 310; Wilson 1974, 7–8, fig. on 7; Fuglesang 1980, 59, 64, no. 87, pl. 52; Wilson 1984, 209; Tweddle 1986b, I, 92–4, 232–4, II, 409–10, III, fig. 36, pl. 61

D.T.

# LONDON  (St Benet Fink)

## TQ 328811

### 1. Part of grave-cover                                 (Ills. 345–6)

PRESENT LOCATION Museum of London (accession number 4073)

EVIDENCE FOR DISCOVERY Found during demolition of church; perhaps one of 'several antiquities found on the site of the churchyard' donated to Guildhall Museum in 1846 by Mr. J. B. Bunning, clerk of works

L.   63 cm (24.8 in)    W.   54.5 cm (21.5 in)
D.   12 cm (4.7 in)

STONE TYPE Pale yellowish-grey to yellowish-brown, medium-grained, shelly, oolitic limestone; probably Barnack stone, Lincolnshire Limestone Formation, Inferior Oolite Group, Middle Jurassic

PRESENT CONDITION Broken and worn

DESCRIPTION Part of a tapering grave-cover, broken horizontally below and irregularly above. The break rises gently from left to right, but the upper right-hand corner is lost. Only one face is carved.

*A (top):* Along the left- and right-hand edges is a narrow, plain, raised border, the inner edge to the left also being defined by an incised line. There is a broad, plain, low-relief median moulding. This has a median-incised line which terminates in a drilled hole where the median moulding unites with a broad U-shaped moulding defined by incised lines at the upper end of the stone. This is placed open end outwards and is median-incised. The incomplete field defined by this moulding is undecorated apart from a pair of closely-spaced, parallel, incised lines developing from the

broken edge to the right of the vertical axis of the stone, and sloping down to the right. They stop short of the U-shaped moulding. Below, to the right of the median moulding and bounded by it and the right-hand border, is an incomplete rectangular panel decorated with a low relief four-strand plain plait. The field between the median moulding and the left-hand border is dressed roughly flat.

DISCUSSION This grave-cover is one of the east midlands types first described and classified by Fox (1920–1). It belongs to Fox's type 5, that is, with a median ridge and U- or V-shaped ends and flanking panels of interlace. Evidence from the excavations at Peterborough cathedral (ibid., 23–4) and Cambridge castle (ibid., 20–1) have demonstrated that grave-covers of this general type originated in the late pre-Conquest period, and probably continued in use after the Conquest. The present example represents the southern outlier of the group, although there are other examples of east midlands covers from the region, at Milton Bryan (Ill. 361) and Cardington (Ill. 264) in Bedfordshire, and Great Maplestead (Ill. 274), Essex. It is possible that these were made in the Barnack region and exported from there.

DATE Tenth or eleventh century

REFERENCES Lethaby 1902, 170, fig. 32; (——) 1903, 125; Page 1909, 170, fig. 34; Smith 1917, 237, 241; Fox 1920–1, 24–5; Wheeler 1927, 52; Vulliamy 1930, 255; Cottrill 1931, 51, appendix; Wheeler 1935, 108, 191; Kendrick 1949, 83; Tweddle 1986b, I, 89, 219, II, 411–2, III, pl. 62a

D.T.

# LONDON (St John Walbrook)

TQ 325809

## 1. Cross-head                                    (Ills. 347–9)

PRESENT LOCATION British Museum, accession number 56,7–1,1495

EVIDENCE FOR DISCOVERY According to C. R. Smith, 'found lying on the surface of the ground of the church of St John-upon-Walbrook' (Smith 1854, 111); acquired by British Museum in 1856

Diameter 26 cm (10.2 in)
D.   15 cm (5.9 in)

STONE TYPE Medium grey, finely glauconitic, sandy limestone, with some small dark grey inclusions that may be phosphatic nodules; Kentish Ragstone, Hythe Beds, Lower Greensand Group, Lower Cretaceous; Maidstone area

PRESENT CONDITION Complete, but surfaces badly damaged

DESCRIPTION It is a plate-head of narrow rectangular section. Only the broad faces are carved.

*A (broad):* The deeply dished centre is surrounded by a narrow relief moulding of indeterminate section, sub-divided by incised lines. The face of each sub-division is convex. This in turn is surrounded by a broad outer zone, subdivided radially. The face of each subdivision is convex, and the narrow mouldings forming the diagonals are pelleted; each pellet has a drilled centre. Superimposed on this is a cross formed from a pair of narrow relief mouldings drilled at the point of intersection. From the narrow moulding encircling the dished centre each arm expands; the expansions are subdivided lengthwise by incised lines.

*C (broad):* As face A, except that the marginal moulding of the central dishing is plain and the outer ends of the narrow mouldings forming the cross do not expand, but terminate on the edges of the face. The broad outer zone is also treated rather differently. The lower right-hand quadrant is divided into six parts of which the two outer and two middle parts are plain, and the remaining parts pelleted; the pellets are drilled. The upper left-hand quadrant is divided into eight parts of which the two middle pairs are pelleted; the pellets are drilled.

DISCUSSION This piece illustrates the typological relationship between the plate-head and the ring-head, since on it the arms of the cross are linked by a relief ring and the area between the ring and the narrow arms is deeply hollowed, but not pierced as it would be on a ring-head. The small size of the piece suggests that it may have performed a memorial function.

The relationship between ring-heads and plate-heads such as this serves to place the piece in the tenth or first half of the eleventh century (Collingwood 1927, 137–9, fig. 153; Bailey 1978, 178–9). The nature of the decoration adds little to a discussion of date, but the use of rows of pellets is not encountered elsewhere among the pre-Conquest sculpture of south-east England. They do appear frequently on Romanesque sculpture, and may serve to suggest a late date for the piece. It is, however, very insubstantial evidence.

DATE Eleventh century

REFERENCES Smith 1854, 111, no. 571; Lethaby 1902, 170–1, fig. 33; Page 1909, 169–70, pl. following 160; Smith 1917, 237, 239; Smith 1923, 126; Vulliamy 1930, 226; Cottrill 1931, 51, appendix; Wheeler 1935, 108; Kendrick 1949, 83; Tweddle 1986b, I, 99, 249–51, II, 412–13, III, pl. 62b

D.T.

# LONDON (St Paul's cathedral)[1]

## TQ 320810

## 1. Grave-marker, in four joining pieces

(Ills. 350–2)

PRESENT LOCATION Museum of London. Accession number 4075

EVIDENCE FOR DISCOVERY Discovered in August 1852 during excavations for Messrs. Cook's warehouse on south side of St Paul's churchyard, *c.* 25 feet down; north of stone was a rough hollow containing a human skeleton

H. 47 cm (18.5 in) W. 57 cm (22.4 in)
D. 10 cm (4 in)

STONE TYPE Pale yellowish-grey, medium-grained, oolitic limestone; probably Combe Down Oolite, Great Oolite Formation of Bath area, Great Oolite Group, Middle Jurassic

PRESENT CONDITION Edges chipped, but carved surfaces well preserved

DESCRIPTION It is rectangular and tapers slightly towards the base. It is broken into four. The lower part is separated by a break undulating from left to right, and is broken into two roughly equal parts by a vertical break. From slightly to the left of the point of junction of the breaks a third break rises steeply to the right and divides the upper portion into two unequal parts.

*A (broad):* There is a narrow, damaged, plain raised border along the upper edge and a similar, slightly wider one along the left- and right-hand edges; what now appears to be a broad low-relief border along the lower edge is probably the respult of modern recutting (cf. Ills. 351 and 352). In each of the upper corners a low-relief bulbous device protrudes into the decorative field, tapering towards the corner, where it is separated by a collar from a pair of strands defined by incised lines, one of these crosses the upper border, and the other the lateral one. Occupying the decorative field is a prominent Ringerike-style animal in low, flat relief, moving to the right, but looking to the left. The head is separated from the neck by a tight incised spiral, it is narrow, with a long muzzle and open mouth. The canine teeth are indicated. The long thick tongue with

an up-curled end protrudes. The animal's forehead bulges over the incised reversed lentoid eye, and from the top of the head a pair of tapering lappets with up-curled ends are drawn back. The inner edge of the boldly-curving neck is continuous with the animal's horizontal back, and its belly tapers towards the rounded hindquarters. The hip-joint is indicated by an incised spiral, and both of the tapering legs are indicated. The nearside leg, bent slightly forwards, terminates in a long claw, divided into two by an incised line, which curls under to almost touch the lower edge. The offside leg angles to the right and terminates in a similar claw. The animal's tail is brought down to interlace with the hind legs, as do a number of narrow, tapering, foliate tendrils, each with a tightly curled tip. Above the hindquarters a number of similar foliate sprays interlace together, and one is looped around the animal's body. The nearside shoulder joint is indicated by an incised spiral, the tapering leg angles to the right and terminates in a curved claw, divided into two by an incised line. The offside leg angles to the left and crosses over it. A strand brought across from the rear legs and from the interlace above the hindquarters interlaces with and loops around the front leg, and a stem is brought up in front of the animal. This develops into a tight scroll facing the animal and the head and neck of a second animal facing right. It has a long muzzle and a open mouth with an incised reversed lentoid eye. A long tapering lappet is drawn back from the top of the head. Extensive traces of paint survive applied on a thin plaster ground. The colours are red, blue and white (see Tweddle 1990, 151).

*B, C, E, and F:* Dressed flat.

D.T.

*D (narrow): Inscription* This edge of the stone carries a two-line inscription in Scandinavian runes. The characters run up the left side of the surface and down the right, covering the whole width. Their bases face inwards and there is a dividing line in the middle where they meet:

**:[*k.*]na:let:lekia:st**
**in:þe(*nsi*):auk:tuki:**

The only real doubt about the text of the inscription attaches to the initial name, where damage has

---

1. The following is an unpublished manuscript reference to no. 1: BL Add. MS 37550 no. XII, items 808–39.

obliterated part of the first and all of the second rune. Moreover, in the younger Viking age *futhark* there are only sixteen characters, each of which can denote several sounds. It is likely, though, that what we have here is Ginna, probably a familiar form of the female name Ginnlaug, recorded on several Swedish rune-stones. The text would then be as follows (in the normalized form usually adopted for the presentation of Danish and Swedish runic inscriptions):

*Ginna let læggia sten þensi ok Toki.*

(Translation: 'Ginna and Toki had this stone laid.')

M.P.B.

DISCUSSION The stone was originally *c.* 30 cm taller, the lower portion being roughly dressed for insertion into the ground. Of this the lower left-hand part was broken away during excavation, and thrown back into one of the trenches. The rest was probably removed when the stone was mounted for display in the warehouse, the construction of which led to its discovery.

It has been suggested that this piece is part of a box tomb or sarcophagus (Wilson and Klindt-Jensen 1966, 135). When discovered, however, there were no other pieces with it, as might have been expected with a box tomb. Moreover, it is clear that the lower, undecorated, portion was originally inserted into the ground to hold the stone upright. This is a feature not seen on Scandinavian box tombs. At Ardre, for example, the sides of the tomb rested on the ground, and the structure was held upright by the mutual support of the slabs, possibly with the aid of mortar in the joints (Graham-Campbell 1980b, 160–1, no. 538, pl. 538). On a grave-marker, however, the division between the visible, decorated, element, and the undecorated element, which was buried, is a consistent feature. It is, therefore, preferable to interpret the piece as a head- or foot-stone.[2]

The decoration is in the Ringerike style, current in Scandinavia from the late tenth century to the third quarter of the eleventh century (Wilson and Klindt-Jensen, 1966, 145–6). In England the style can probably be tied to the period of Scandinavian ascendancy, from 1016–42 (ibid., 145). Pieces from London (City 1 and All Hallows by the Tower 3), Rochester in Kent (nos. 2–3), and Great Canfield 1 in Essex (Fig. 32), are also decorated in the Ringerike style. Their restricted distribution, use of this style, and the similar technique of carving suggest that they are products of the same workshop.

D.T.

*Inscription* It is odd that there is no mention of the person in whose memory the inscription was made, nor of his or her relationship to Ginna and Toki, but it is possible that only part of what was once a much longer inscription survives. If this stone formed the upright gable of a composite tomb, there would have been a second gable at the end of the ledger, and this (and/or the ledger itself) may have carried a continuation of the inscription.[3] (Under the less plausible interpretation of the sequence **auk:tuki** as (*h*)*øgg Toki* ('Toki cut [the runes]')—which, with its loss of initial /h/ presupposes a Swedish carver (see below)—one would not expect there to have been a continuation since the statement 'NN cut' typically concludes an inscription.)

Rune types and orthography (the occurrence of ᛏ; ᚿ for /o/), language (the mixture of monographic and digraphic forms: **stin** *v.* **auk**), and wording (with *let læggia* for the more common late Viking-age *let ræisa* ('had raised')), combine strongly to suggest an early eleventh-century date for the inscription. The ornament on the face of the stone, which seems to be a development of that found on a number of late tenth-century Danish stones, including the famous Jelling 2 (Jacobsen and Moltke 1941–2, I, col. 478; Moltke 1985, 322–5), supports such a dating. The carver must almost certainly have been a Dane or a Swede (it is impossible to determine which), perhaps one who came over to England at the time of Cnut; a monument so typically Scandinavian can scarcely have been made by a descendant of one of those Vikings who settled in England in the ninth century. In view of this it is probable that the person commemorated was also of Scandinavian birth.

M.P.B.

DATE Eleventh century

REFERENCES Rafn 1845–9, 286–352, 313, tab. III; (——) 1850–3; (——) 1852, 6, cols. 1–2; Knowles 1852, 157, fig. on 157; Munch 1852, 209–10, fig. on 209; Rafn 1852, 271–301, tab. XII, fig. on 278; Rafn 1852–4, 9–10, fig. on 9; Knowles 1853, 254–86; Westwood 1853; Rafn 1854a; Rafn 1854b; Charlton 1855–7, 68; Rafn 1856, 230–1, fig.

---

2. It is conceivable that the piece might have formed part of a composite monument, with head- and foot-stones separated by an intervening recumbent grave-cover, comparable to the one excavated from Winchester (see Old Minster nos. 2 and 6). This might then explain the possibly incomplete nature of the inscription (see below), for the recumbent component of the Winchester assemblage (Old Minster no. 6) is also inscribed (though in that case the inscription is apparently complete in itself) (Eds).

3. See above, note 2.

on 230; Gibson 1858–9, 126, pl. I; Charlton 1859, 65–6; Thorsen 1864–80, 1, 275 n., 2.1, no. 89, 2.2, 213–4; Worsaae 1873, 37; Lewis 1877, 242 n. 1; Købke 1879, 27; Allen 1885b, 357; Browne 1885, 251–3, 255, pl. I; Westwood 1885–7, 226; Allen 1889, 222; Westwood 1890, 295, fig.; Bugge and Olsen 1891–1924, 1, 87; Wimmer 1893–1908, 1.1, cxxxiii–cxxxviii, fig. on cxxxv; Allen 1893–4a, 49; Allen 1893–4b, 65; Browne 1899–1901, 169–70; Lethaby 1902, 163–4, fig. 31; (——) 1903, 126, pl. LVII; Astley 1904, 152, 167, fig. 9; Keyser 1904, xvi, xxiii, xxvi, xxxix, xlv, 27, fig. 50; Bugge 1905, 331, 339, 340–1, 349–50, figs. on 339, 350; Shore 1905, 389; Collingwood 1908, 164; Page 1909, 167–9, fig. 3, pl. facing 68; Shetelig 1909, 97 n. 1, 97–8, 104; Smith 1909–11, 398; Gering 1910, 242; Shetelig 1911, 45; Prior and Gardner 1912, 130; March 1912–13, 178; Smith 1913–14, 67, 71; Lindqvist 1915, 75–9, fig. 39; Smith 1917, 238–9; Brøndsted 1920, 225; Plutzar 1922–4, 27, 37, 51; Smith 1923, 125; Beckett 1924, 30, fig. 36; Brøndsted 1924, 235–7, 289 n., 295, 299, fig. 170; Åberg 1925, 138–9, fig. 241; Collingwood 1927, 152; Wheeler 1927, 52; Neckel 1928, 37, abb. 6; Davis 1930, 218, fig. 2; (——) 1930, 11–12, 115; Clapham 1930, 135, pl. 58b; Ekwall 1930, 25; Kendrick 1930, 31; Vulliamy 1930, 251–55, pl. X; Åberg 1931, 108–9, abb. 241; Bugge 1931, 161–2, 165, fig. 4; Cottrill 1931, 50–1, appendix, fig. 14; Hallström 1931, 269; Lindqvist 1931, 165–6, fig. 19; Brix 1932, 143; Bæksted 1935, 47, 57; Wheeler 1935, 191; Åberg 1936, taf. LV.26; Rydbeck 1936, 7, 19–21, fig. 6; MacKenzie 1937, 157–8, 167, 169, fig. 9; Shetelig and Falk 1937, 289, 303; Åberg 1941, 46; Kendrick 1941, 134, pl. III.2; Jacobsen and Moltke 1941–2, I, cols. 476–80, no. 412, pls. 1017–19; Minns 1942, 37, pl. XXXVIIIB; Bæksted 1943, 100–101; Kent 1947, 55, 95; Shetelig 1948, 102–3, pl. 106; Kendrick 1949, 83, 99–100, 111, 117, pl. LXVII; Shetelig 1949, 139; Holmqvist 1951, 10, 11, 24–5, 48, 51; Rice 1952, 127–8, pl. 23a; Shetelig 1940–54, VI, 141–2, 144; Moe 1955, 26; Stone 1955, 38, pl. 23; Pevsner 1957, 30, pl. 2; Poole 1958, 491; Elliott 1959, 38; Fisher 1959, 86–7; Rice 1960, 205, pl. VIIA; Wilson 1960, 61, 155–6, 172, pl. 74; Arbman 1961, 143, 145, pl. 32; Marquardt 1961, 93–5; Wilson and Hurst 1961, 309; Jansson 1962, 51–2; Brøndsted 1965, 210; Musset and Mossé 1965, 252, 289, 431, no. 133; Wilson and Klindt-Jensen 1966, 135–6, 138–9, 140–3, 145, pl. LVIIIa; Zarnecki 1966, 90, 97; Okasha 1967, 249–50; Ørsnes 1968, 211–2; Anker 1970, 173–4, fig. 45; Foote and Wilson 1970, 310, 414, pl. 26a; Wilson 1970, 75, pl. 50; Page 1971, 166 and n., 168, 174–5; Cramp 1972, 147; Cunliffe 1973, 52, pl. facing 52; Jones 1973, 341; Wilson 1974, 3–8, figs. on 4–5, cover; Brooke 1975, pl. 30; Hinton 1977, 101; Loyn 1977, 114, 116; Fuglesang 1978, 212; Laing and Laing 1979, 178; Owen 1979, 19–34, fig. B, pl. 36; Fuglesang 1980, no. 88, 14, 27, 57, 59, 63–6, 71, 76, 78, 93–4, 100, pl. 53; Graham-Campbell 1980a, 149, 152, 161, pls. on 161; Graham-Campbell 1980b, no. 499, pl. 499; Graham-Campbell and Kydd 1980, 168–73, pl. 110; Wilson 1980, pl. on 165; Roesdahl *et al.* 1981, no. I19, pl. on 136; Dodwell 1982, 121; Schofield 1983, 24, pl. on 23; Wilson 1984, 209, pl. 271; Zarnecki *et al.* 1984, 146, 149, no. 95, pl. 95; Moltke 1985 36, 259, 263, 271, 322–6, 345, 407; Tweddle 1986b, I, 92–4, 232–4, II, 413–17, III, pls. 63–64a; Tweddle 1990, 151

# LONDON (City)[1]

## 1a–b. Part of grave-cover, in two pieces (Ill. 353)

PRESENT LOCATION British Museum, accession numbers 83,12–19,1 and 2

EVIDENCE FOR DISCOVERY None; found in City of London some time before Sir Augustus Franks gave stones to British Museum in 1884

a: H.  47.5 cm (18.7 in)  W.  55.5 cm (22 in)
D.  19.5 cm (7.7 in)
b: H.  37 cm (14.6 in)  W.  51 cm (20 in)
D.  19.5 cm (7.7 in)

STONE TYPE Pale brown, fine-grained (0.1–0.2 mm quartz grains) sandstone, with a small proportion of very fine (0.1 mm or less) dark grains, and no obvious cement or bedding; of uncertain origin, perhaps Lower Cretaceous rather than Tertiary, and possibly Wealden

PRESENT CONDITION Broken and chipped

DESCRIPTION Two fragments of a tapering grave-cover.[2]

*A (top):* Fragment a is broken roughly horizontally below, but irregularly above. The break rises from

---

1. The following is an unpublished manuscript reference to no. 1: BL Add. MS 37550 no. XII, item 840.

2. It has been claimed that the edge of one of these two fragments bears the Scandinavian runes **ki**, possibly followed by a divider. I have examined both pieces of stone for traces of runes and can find none. Judging from the brief description and rudimentary drawing found in the British Museum list of accessions (1883, 12–19), what have been taken to be runes are in fact part of a series of scratches. These are of varying depth and width, but none is in any way like the ornament on the stone and it is hard to think there can be a connection between the two (M.P.B.).

right to left. The upper left-hand corner is lost. Along the long edges of the convex upper face are narrow, plain, raised borders. The face is decorated in low, flat relief with a prominent cross placed diagonally, with bulbous, rounded-ended arms tapering markedly towards their inner ends and separated from the point of junction by pairs of transverse incised lines. From each re-entrant angle develops a pair of foliate tendrils which are linked together to encircle the cross-arms. To the left and right are three-element axial growths. Above, subsidiary tendrils run diagonally upwards to the left and right, with lobe-like axial growths at the junctions with the tendrils surrounding the cross-arms. In the V-shaped field thus created is a second pair of tendrils arranged in a V-shape with inward-facing, tightly-curled ends.

Fragment b is roughly broken horizontally above and below, but irregularly to the left. Along the right-hand edge of the convex, foliate decorated upper face is a narrow, plain, raised border. The face is decorated in low, flat relief with a pair of swags developing from the upper, broken, edge, and linked on the vertical axis by a union knot. Each swag is composed of three or more foliate tendrils. From them subsidiary groups of tendrils break away diagonally towards the lower left and right-hand corners. Of these only the left-hand group is well preserved with a branch from the outer tendril looping back around the inner tendril before dividing into two. Each division has a tightly-curled tip. The inner tendril breaks back and upwards towards the vertical axis of the stone, where it meets a similar tendril emerging from the damaged area to the right. On the vertical axis, developing from the lower edge, are two lobes clasped by a union knot.

DISCUSSION Browne, comparing the style and technique of the fragments with that of the grave-marker from St Paul's in London, above, has suggested that they are by the same hand, and from the same grave. That they come from the same grave is unlikely given the amount of detail recorded for the discovery of the St Paul's stone, although they might have come from the same site. As noted above (p. 227), there is evidence for the existence of a single workshop having produced all of these Ringerike-style pieces.

DATE Eleventh century

REFERENCES Allen 1885b, 357; Browne 1885, 252–3, pl. II; Wimmer 1893–1908, 1.1, cxxxviii; Browne 1899–1901, 170; Bugge 1905, 349–50, fig. on 350; Page 1909 168–9, fig. 32; Shetelig 1909, 97n.; Smith 1909–11, 398–9; Shetelig 1911, 45, 47, 49, fig. 7; Smith 1913–14, 71; Linqvist 1915, 75–80, fig. 40; Smith 1917, 239; Brøndsted 1920, 251–2, fig. 15; Smith 1923, 125–6, fig. 159; Brøndsted 1924, 235–6, 297, 300, figs. 170, 206; Åberg 1925, 146; Wheeler 1927, 52; Kendrick 1930, 31; Vulliamy 1930, 254–5; Cottrill 1931, 51, appendix; Wheeler 1935, 191; Shetelig 1940–54, VI, 141–2; Åberg 1941, 46, fig. 44; Kendrick 1941, 134; Jacobsen and Moltke 1941–2, I, cols. 480–81, no. 412a; Shetelig 1948, 102–3; Kendrick 1949, 100, pl. LXVIII; Holmqvist 1951, 24–5, 38, 40; Rice 1952, 128; Fisher 1959, 87; Rice 1960, 205; Marquardt 1961, 95–6; Jansson 1962, 51–2; Musset and Mossé 1965, 431, no. 133; Foote and Wilson 1970, 310; Page 1971, 166, n. 4; Wilson 1974, 7–8, fig. on 7; Fuglesang 1980, no. 89, 27, 57, 59, 63–4, 102–3, pl. 54; Roesdahl et al. 1981, no. I20, pl. on 163; Wilson 1984, 209; Tweddle 1986b, I, 91, 232–4, II, 418–20, III, pl. 64b

D.T.

# LONDON (Stepney, St Dunstan)

## TQ 360817

### 1. Crucifixion panel                                    (Ill. 354)

PRESENT LOCATION Incorporated internally into east wall of chancel

EVIDENCE FOR DISCOVERY First recorded in Malcolm 1793; formerly placed over south door, outside, and partly obscured by south porch; removed to north wall of nave following 1899 restoration

H. 99 cm (39 in)   W. 68.5 cm (27 in)
D. Built in

STONE TYPE Brownish-grey, medium- to coarse-grained, shelly, oolitic limestone, the shell fragments, up to 5 mm in diameter, being scattered flat-lying on the front surface of the stone; probably Barnack stone, Lincolnshire Limestone Formation, Inferior Oolite Group, Middle Jurassic

PRESENT CONDITION Complete; slightly worn

DESCRIPTION The panel is rectangular and delimited by a frame consisting of a broad decorated zone flanked by narrow, plain, relief mouldings of square section. The decoration consists of a repeated pattern of five-lobed leaves. The leaves are hollowed, and each is enclosed within a dished ovoid cut off by the inner and outer edge mouldings. The ovoids are separated by mouldings of indeterminate section with median-incised lines.

The panel is decorated in relief with a crucifixion scene. The moulded ends of the cross-arms and foot terminate on the inner edge of the frame. The cross bears a heavily-weathered, nimbed figure of Christ with the arms sloping up from the shoulders and the head inclined to the figure's right. He wears a loin-cloth, longer to the rear than at the front, and the bare legs are bent to the figure's right. The feet are out-turned. Two inward-facing figures flank the cross, standing on the lower frame. To the left is the robed and nimbed figure of the Virgin, her left hand is raised towards her face, and her right hand held across the breast. She is clad in an ankle length undergarment, with an overgarment falling in a V-shaped fold to knee level, and gathered up over the arms. To the right the robed and nimbed figure of St John rests his head on his right hand, his left arm crosses the body to support the right elbow. He wears an ankle-length undergarment, and a overgarment thrown over his left arm. On either side of the head of the cross is a heavily-weathered roundel, touching the horizontal but not the vertical limb. Each contains a robed bust representing, to the left, the sun, and to the right, the moon.

DISCUSSION This cover is clearly related to the large-scale crucifixion groups which survive both *in situ* and *ex situ* in south-east England. In particular, the group at Breamore 1 also includes roundels personifying the Sun and Moon, although placed at the ends of the lateral arms of the cross (Ill. 425), not above them, as here. This link suggests that the present piece should be dated to the late tenth or first half of the eleventh century, the period when, on architectural grounds, these groups were used. This dating is narrowed by comparison with manuscript depictions of the crucifixion. For example, in the Winchcombe Psalter, dated to *c.* 1030–50 (Temple 1976, no. 80), and BL MS Arundel 60, dated to *c.* 1060 (Temple 1976, no. 103, ill. 312), the personifications of the Sun and Moon are treated in exactly the same way as here, with the face and hands of the half-length figure veiled. Analysis of the leaf decoration of the borders also points to an eleventh-century date for the piece. The closest parallel to the leaf forms on the present panel is provided by the borders on fol. 23r of Rheims, Bibl. Mun. MS 9, dated to *c.* 1062 (ibid., no. 105, ill. 299). The borders of the present piece are, if anything, further conventionalised in a manner commonplace in Romanesque art, as in the frames of the Chichester panels (Zarnecki 1951b, pl. 80) (Fig. 22a).

DATE Eleventh century

REFERENCES Malcolm 1793, 714, fig. 5; Lysons 1792–6, 432–3; King 1851, 80–1, pl. VI; Lethaby 1902, 173; Pepys and Goodman 1905, 14, 36, fig. p. 19, pl. 8; Dalton 1908, 225–231, pl. facing 226; Prior and Gardner 1912, 137, 140, 143, fig. 118; Longhurst 1926, 7–8; (——) 1930, 69, 71, pl. 125; Clapham 1930, 130, 138–9, pl. 62; Cottrill 1931, 51, 52, appendix; Casson 1933, 26, 35, pl. IA; Rice 1947, 12; Kendrick 1949, 47–8, 83, pl. XL.2; Gardner 1951, 46, pl. 72; Green and Green 1951, 53; Rice 1952, 101, 111, pl. 9a; Zarnecki 1953, 106; Rice 1960, 200, pl. IIIC; Coatsworth 1979, I, 281, 293–6, II, 47–8, pl. 150; Rodwell and Rouse 1984, 318; Tweddle 1986b, I, 75–6, 209–11, II, 420–2, III, figs. 29, 33, pl. 65a; Coatsworth 1988, 181–2, 192, pl. IIIb
D.T.

# LONDON (Westminster abbey, St Peter)

TQ 301796

## 1. Coffin lid, in four joining pieces    (Ill. 355–7)

PRESENT LOCATION In chapter house vestibule

EVIDENCE FOR DISCOVERY Discovered in November 1869, 38 ft north of nave and 46 ft west of north transept, when level of North Green lowered; buried broad end to west under 2–3 ft of dark earth in loose sand which did not cover lid but which extended for 5 ft below coffin, suggesting that coffin was originally buried in sand with lid exposed

L.   216 cm (85 in)   W.   71 cm (28 in)
D.   17.5 cm (6.9 in)

STONE TYPE Greyish-yellow, medium- to coarse-grained, shelly, oolitic limestone; Barnack stone, Lincolnshire Limestone Formation, Inferior Oolite Group, Middle Jurassic

PRESENT CONDITION Good

DESCRIPTION The lid is tapering and slightly coped. Only the upper surface is carved.

*A (top):* Decorated with a low-relief Latin cross. The expanding head and horizontal limbs terminate on the edges of the face. The foot is parallel sided and divides into two tapering, out-turned tendrils flanking a pointed axial growth which touches the foot of the stone.

DISCUSSION When in use it seems clear that the lid was visible on the ground surface, covering an elaborately sculpted, re-used Roman coffin containing the burial, which was sunk into the ground. The use of a stone coffin may be an indicator of a relatively high status or prosperity; St Aethelthryth of Ely, for example, was buried in a Roman coffin brought from Grantchester, Cambridgeshire (Bede 1969, 395 (IV, 19)). In Anglo-Saxon England in general burial in stone coffins is unusual, but a number, with or without surviving lids, are known from the Old Minster, Winchester, from the area around the monument which Biddle has identified as marking the original burial place of St Swithun (Biddle 1967a, pls. LIII and LIVb; Biddle 1970, 317–21, fig. 12). There are other stone coffins in the cemetery outside the east end of the Minster and another in the nave (Biddle 1970, fig. 12). The prestigious position of many of these coffins reinforces the suggestion that a stone

coffin may be an indicator of status. Confirmation comes from the rural cemetery at Raunds, Northamptonshire, where, despite the almost total excavation of the cemetery, only a single stone coffin has been found, again in a prestigious position in front of the south door of the church. The cemeteries at both Winchester and Raunds also contained a number of cist burials, and the discovery of two cist burials oriented east–west near the stone coffin at Westminster may suggest that the nineteenth-century works at the abbey disturbed part of the pre-Conquest graveyard. In general form the decoration on the lid resembles that of the Sussex and Surrey grave-covers, for which an eleventh-century date can be argued on archaeological grounds. The foliated foot is treated in a manner reminiscent of a pilaster base at Corhampton, Hampshire (no. 2; Ill. 440), for which a tenth- to eleventh-century date has been argued. Certainly, the building of Westminster abbey by Edward the Confessor, beginning *c.* 1050, does not provide a *terminus post quem* for the slab, as there was a monastic community here at an earlier date (Hunting 1981, 14–19).

DATE Eleventh century

REFERENCES Stanley 1870, 104, 107–8, figs. facing pp. 104, 107; McCaul 1870, 110–111, 115–8; Poole 1870, 110–4, figs. 1, 3, plan facing 119; Allen 1887, 72–4, fig. 1; Lethaby 1902, 170, fig. 34; Styan 1902, 22–4, pl. IV; Page 1909, 13–14, fig. 3; Smith 1917, 239; Cabrol and Leclercq 1907–53, II, cols. 1226–8, figs. 1696–7; (——) 1928, 148, 165–6, 173, pl. 57; Clapham 1930, 75–6; Vulliamy 1930, 173–4; Cottrill 1931, 51, appendix; Higgitt 1973, 13; Tweddle 1986b, I, 89, 231, II, 422–3, III, fig. 52, pl. 65b

D.T.

# MARSH BALDON, O. (St Peter)[1]

## SU 562991

### 1. Sundial                                    (Ill. 358)

PRESENT LOCATION Built externally into the south wall of the church over the south door, inside the porch

EVIDENCE FOR DISCOVERY First recorded in Keyser 1904

H.   28.5 cm (11.2 in)   W.   34.5 cm (13.6 in)
Diameter of dial 28.5 cm (11.2 in)
D.   Built in

STONE TYPE Greyish-yellow, medium- to coarse-grained, slightly shelly, oolitic limestone with a 'millet-seed' appearance; possibly from the White Limestone Formation, Great Oolite Group, Middle Jurassic, of the Oxford vicinity

---

1. The following is an unpublished manuscript reference to no. 1: BL Add. MS 47709, fol. 77v.

PRESENT CONDITION Good

DESCRIPTION On a rectangular panel with its upper corners cut away is a circular dial framed by a half-round cable moulding. The small drilled gnomon hole is on the vertical axis, displaced towards the upper edge of the dial. The lower two-thirds of the face is calibrated by five equally-spaced incised lines. The vertical and outer lines terminate in short transverse incised lines. The ends of the intermediate lines are pecked.

DISCUSSION This dial uses the standard pre-Conquest calibration, but with the mid-tide lines at 6 am and 6 pm missing as a result of the gnomon hole being displaced towards the upper edge of the dial from its usual position in the centre. Only the dial at Winchester St Maurice (no. 2), shares this feature (Ill. 672).

DATE Eleventh century

REFERENCES Keyser 1904, 3; Green 1928, 513–4, fig. 22; Cottrill 1931, appendix; Salzman 1939, 369, 371; Lobel 1957, 45; Zinner 1964, IV, 127; Bowen and Page 1967, 288–9; Sherwood and Pevsner 1974, 698; Tweddle 1986b, I, 84–5, 187–9, II, 423–4, III, pl. 67a

D.T.

# MILTON BRYAN, Bd. (St Peter)[1]

## TL 971308

**1. Grave-cover**                                (Ill. 361)

PRESENT LOCATION In front of pulpit (on south side of chancel arch)

EVIDENCE FOR DISCOVERY Discovered *c.* 1840 during digging of tower foundations

L.   180 cm (71 in)   W.   65 cm (25.6 in)
D.   13 cm (5 in)

STONE TYPE Pale grey to brownish-grey, medium-grained, coarsely shelly, oolitic limestone; Barnack stone, Lincolnshire Limestone Formation, Inferior Oolite Group, Middle Jurassic

PRESENT CONDITION Good

DESCRIPTION The cover tapers pronouncedly. Only the upper surface is carved.

*A (top):* A high-relief central moulding of rectangular section is crossed at the mid-point by a second similar moulding spanning the width of the cover. Flanking the median moulding, leaving broad plain borders on the long edges, are two pairs of narrow, rectangular fields, ornamented in low relief. Those at the broad end contain four-strand plain plaits; those in the longer and narrower panels are three-strand. Their inner ends terminate on the cross piece, while their outer ends stop about a fifth of the way in from each end. Beyond, pairs of high relief mouldings of square section emerge from the median moulding and run towards the corners. Along the narrow ends of the cover are damaged, low-relief, plain borders.

DISCUSSION This cover belongs to type 2 of the east midlands series first described and classified by Fox (1920–1). In this type there is a median ridge, central cross-bar and the ridge has U- or V-shaped ends. Interlace is confined to four panels flanking the median ridge (ibid., 25, pl. III). Archaeological evidence from both Peterborough cathedral and Cambridge castle, where covers have been excavated *in situ*, points to a date in the late tenth and eleventh centuries for the series, probably ending after the Conquest (ibid., 20–1, 23–4, 31–2). It is possible that they were manufactured in the region of Barnack, Northamptonshire, and exported from there. See also Cardington and London St Benet Fink.

DATE Tenth to eleventh century

REFERENCES Smith 1905, 355–6, fig. on 356; Page 1912b, 420; Fox 1920–1, 24–5; Cottrill 1931, appendix; Kendrick 1949, 82, pl. LIV; Pevsner 1968, 16, 126, fig. on 126; Fisher 1970, 81–2; Hare 1972, 84; Tweddle 1986b, I, 89, 218–20, II, 424–5, III, pl. 67b

D.T.

NORTH LEIGH, **1.** See Appendix A, p. 244.

---

1. The following are unpublished manuscript references to no. 1: BL Add. MS 37547 no. IX, item 654; BL Add. MS 47700, fol. 45r.

# OXFORD, O. (cathedral, Christ Church)[1]

SP 516059

## 1. Grave-cover, in three joining pieces    (Ill. 362)

PRESENT LOCATION Oxford City Museum. Accession number 77.104

EVIDENCE FOR DISCOVERY Discovered in 1870 during alterations to east and south walls of chancel, apparently from rubble wall core; in church of St Peter in the East until placed in Oxford City Museum on permanent loan in 1977

L.  122 cm (48 in)   W.  64 cm (25.2 in)
D.  14.5 cm (5.7 in)

STONE TYPE Limestone, with a very fine-grained blue-grey to pale greyish-brown matrix, packed with Viviparid gastropod shells; Purbeck Marble, Durlston Formation, Purbeck Group, Lower Cretaceous, Isle of Purbeck

PRESENT CONDITION Broken, but carving fairly well preserved

DESCRIPTION The cover tapers, and the foot and lower right-hand side are lost. It is of fundamentally rectangular section, but the edges have a broad chamfer of concave profile. Only the upper face is carved.

*A (top):* On the vertical axis at what was presumably the head end is a low relief human mask. The square-ended, parallel-sided nose, linked eyebrows, eyes, and mouth, are indicated by incised lines. Enclosing the mask are six closely-spaced concentric semicircular mouldings of half-round section. Along each long side are two similar groups of seven such mouldings, the outer element of each group touching those of its neighbours. The group to the lower right is largely lost, and to the lower left are the remains of a third such group. Each of the two subsidiary fields thus created on the central long axis of the cover is filled with nested concave-sided lozenges.

DISCUSSION The contemporary record of discovery of this carving suggests that it was recovered from the rubble core of a twelfth-century wall, suggesting a date for it in the eleventh century or earlier, if a reasonable period of primary use is allowed. The decoration relates closely to that on the cross-shaft fragments from Saffron Walden, Essex (Ills. 371–3). Nested geometrical shapes are also encountered on grave-covers in the east midlands in the eleventh century, as at Waterbeach and Wood Walton, Cambridgeshire (Butler 1956, 90, figs. 1.1–1.2). On these grounds a mid eleventh-century date would be acceptable for the piece.

DATE Mid eleventh century

REFERENCES R.C.H.M. 1939, xix, 35, pl. 9; Sherwood and Pevsner 1974, 19; Tweddle 1986b, I, 89, 226–7, II, 427–8, III, pl. 68b

D.T.

1. The following are unpublished manuscript references to no. 1: BL Add. MS 27765E, fols. 45r–47r; BL Add. MS 27765G, fols. 31v, 32r.

# OXFORD, O. (St Michael)

SP 513064

## 1a–f. Seven baluster shafts[1]    (Ills. 364–370)

PRESENT LOCATION *in situ* in double belfry windows of west tower, four on second stage, three at belfry stage (fourth (east) side of belfry being a modern replacement)

EVIDENCE FOR DISCOVERY First recorded by John Buckler, probably in first quarter of nineteenth century, perhaps *c.* 1821 (cf. Langford 1)

MEASUREMENTS Unobtainable

STONE TYPE (second stage, south side): Brownish-yellow (2.5Y 8/3–4), medium-grained oolitic limestone, with ooliths 0.3–0.4 mm in diameter in a

1. The following are manuscript references to no. 1: BL Add. MS 27765C, fols. 44v–45r; BL Add. MS 36432, item 18; BL Add. MS 36438, items 504, 506–7; BL Add. MS 36441, item 8.

calcite matrix, and vertically aligned vague ribs or 'bars' on weathered surface; Taynton stone, Taynton Stone Formation, Great Oolite Group, Middle Jurassic; Taynton, Oxfordshire

(second stage, west and north sides): Brownish-yellow, shelly oolitic limestone, including streaks of comminuted (5-mm diameter) shell fragments; Taynton stone, Taynton Stone Formation, Great Oolite Group, Middle Jurassic; Taynton, Oxfordshire

(second stage, east side): Yellowish-brown (in places reddish-brown), very shelly limestone, including bivalves (possibly ostreids) up to 2.5 cm in diameter; Corallian beds, Upper Jurassic; from outcrop to east of Oxford

(belfry stage): inaccessible; apparently Taynton stone

PRESENT CONDITION Moderately weathered

DESCRIPTION Each shaft, without a capital, expands towards the mid-point where there is a roll moulding flanked by a pair of hollows. The shaft then tapers again towards the tall, almost conical, base.

DISCUSSION The seven surviving baluster shafts out of an original eight are each of identical form. The dating of them depends on the date ascribed to the tower of which they form *in situ* components. Taylor and Taylor place this in the mid eleventh century.

DATE Mid eleventh century

REFERENCES (———) 1910, fig. on 33; R.C.H.M. 1939, 143; Taylor and Taylor 1965–78, I, 481–2, fig. 235, II, pl. 546; Sherwood and Pevsner 1974, 294

D.T.

2. See Appendix A, p. 244.

# OXFORD, O. (New Examination Schools)

SP 519063

### 1. Grave-cover (Ill. 363)

PRESENT LOCATION Ashmolean Museum. Accession number 1876.94

EVIDENCE FOR DISCOVERY Found in 1876 on site of New Schools, formerly Angel Inn, High Street

L. 70 cm (27.6 in) W. 48 cm (19 in)
D. 11 cm (4.3 in)

STONE TYPE Yellowish-grey, medium-grained (but with some 0.9 mm pellets), moderately shelly, oolitic limestone; probably Combe Down Oolite, Great Oolite Formation of Bath area, Great Oolite Group, Middle Jurassic

PRESENT CONDITION Broken and worn

DESCRIPTION It is parallel-sided, slightly coped, and roughly broken at each end. The upper break rises gently to the left before falling again. The lower break rises abruptly to the right from slightly to the left of the vertical axis. The right-hand edge of the stone has been vertically trimmed, but along the left-hand edge is a plain, low-relief border. Only the upper face is carved.

*A (top):* There is a half-round median moulding

interlacing with an oval feature of similar section towards the upper end. In the fields to either side is heavily weathered foliate ornament. In each there is an undulating stem. Emerging from collars on it are subsidiary stems terminating in ragged acanthus leaves or flowers which fill the areas between the main stem and the edges of the field. At the lower end of the left-hand field is a bird in profile, facing to the right, having a hooked beak, and pecked eye. A pair of incised lines separate the leg from the body. The main stem crosses the bird's tail and wing tip, and from its beak issues a subsidiary stem crossing its neck to link with the foliage above.

DISCUSSION No medieval church is known to have occupied the site of the New Examination Schools. Either the stone was brought here as building material, or it represents the site of a pre-Conquest burial ground which did not survive into the later medieval period.

The close comparisons which can be drawn between the inhabited plant-scroll on this piece, and those on works of the early tenth century, such as the Presentation Scene of the *Vita Cuthberti* (Temple 1976, no. 6, ill. 29), allow a similar date to be proposed for it.

DATE Tenth century

REFERENCES Westwood 1890, 297–8, fig. on 297; R.C.H.M. 1939, xix, pl. 9; Tweddle 1983b, 28, 30, fig. 5, pl. VIIIa; Wilson 1984, 195, fig. 249; Tweddle 1986b, I, 154–5, II, 428–9, III, fig. 22, pl. 69a

D.T.

# OXFORD, O. (117–19 St Aldate's)

## SP 513062

**1. Fragment** (Ills. 359–60)

PRESENT LOCATION Ashmolean Museum. Accession number 1938.386. On loan to Oxford City Museum

EVIDENCE FOR DISCOVERY Found during excavations in 1937–8 and donated to Ashmolean Museum by Merton College in 1938; site occupied in later Middle Ages by Batte's inn, afterwards Fleur de Luce inn

H. 10 cm (4 in)   W. 30 cm (11.8 in)
D. 22 cm (8.7 in)

STONE TYPE Oolitic limestone, with light yellow ooliths close-packed in a fine grey matrix, including an ostreid fragment and pieces of fossil wood; Bladon stone, White Limestone Formation, Great Oolite group, Middle Jurassic; from Bladon, 10 km NW of Oxford

PRESENT CONDITION Broken and worn

DESCRIPTION Rectangular fragment, only one face of which is carved; the other edges are roughly broken. It is dressed flat above and below. The decorated edge is ornamented with tightly-packed undulating, half-round mouldings.

DISCUSSION The stone was identified in the contemporary excavation report as part of a grave-cover. This identification is improbable as the decoration is not paralleled elsewhere among surviving grave-covers in south-east England, nor is the shape of the fragment easily reconciled with the shape of any surviving grave-cover. In fact the decoration most closely resembles the depictions of the clouds from which the Hand of God issues at Breamore 1 (Ill. 427) and Headbourne Worthy 1 (Ill. 448) in Hampshire. Even so, the comparison is not particularly close, and perhaps the piece should not be regarded as securely associated with the pre-Conquest period.

DATE Tenth century

REFERENCES Daniell 1938, 172; R.C.H.M. 1939, xix, pl. 9; Tweddle 1986b, I, 112, 251, II, 429–30, III, pl. 69b

D.T.

# SAFFRON WALDEN, Ess. (St Mary)

## TL 538387

**1. Fragment of cross-shaft** (Ill. 371)

PRESENT LOCATION Built into base of east wall of south porch, outside

EVIDENCE FOR DISCOVERY Reused in fifteenth-century south porch; first recorded in R.C.H.M. 1916

H. 18 cm (7 in)   W. 29 cm (11.4 in)
D. Built in

STONE TYPE Light grey (with a brownish tinge), medium-grained, shelly, oolitic limestone; Barnack stone, Lincolnshire Limestone Formation, Inferior Oolite Group, Middle Jurassic

PRESENT CONDITION Broken and worn

DESCRIPTION Only one face is visible. It is sub-rectangular and roughly broken on all four sides. Along each of the upper and lower edges are two groups of three concentric, semicircular mouldings of half-round section. The outer moulding of each group unites with those of its neighbours, and the group to the lower left encloses part of a recessed, flat field. In the concave-sided, lozenge-shaped central field is a low relief boss.

DISCUSSION The decoration of this fragment is so closely related to that of no. 2 that it seems likely that they were part of the same cross-shaft.

The decoration of these pieces and that of the grave-cover from Oxford cathedral (Ill. 362) are closely related. The latter probably dates to the mid eleventh century, and a similar date is possible for the Saffron Walden fragments. The nature of the decoration provides some support for this dating. Nested geometrical shapes are used on a number of east midlands grave-covers which Butler dates to the eleventh century, such as the examples from Waterbeach and Wood Walton, Cambridgeshire (Butler 1956, 90, figs. 1.1–1.2).

DATE Eleventh century

REFERENCES R.C.H.M. 1916, 233; Tweddle 1986b, I, 95, 248, II, 453, III, pl. 82a

D.T.

## 2. Cross-shaft fragment                                   (Ill. 372)

PRESENT LOCATION Built into north chimney stack of Walden House, West Grinstead, Sussex, outside (TQ 189225)

EVIDENCE FOR DISCOVERY Discovered during demolition of The Close House (built 1554), which originally stood near Saffron Walden church; moved to present location when house re-erected there in 1934

H.   62 cm (24.4 in). W.   24.5 cm (9.7 in).
D.   Built in

STONE TYPE Pale grey, medium- to coarse-grained, shelly, oolitic limestone; Barnack stone, Lincolnshire Limestone Formation, Inferior Oolite Group, Middle Jurassic

PRESENT CONDITION Broken and worn

DESCRIPTION Part of a tapering shaft of square section.

*A:* Within plain relief edge-mouldings, the shaft is decorated with groups of concentric semicircular plain mouldings of half-round section. The outer element of each group unites with those of its neighbours, and each group delimits a recessed flat field.

*D:* Apparently plain.

DISCUSSION See no. 1.

DATE Eleventh century

REFERENCES (——) 1934, 10, col. 2; (——) 1936, 5, col. 1; Tweddle 1986b, I, 95, 248, II, 454, III, pl. 82b

D.T.

# ST ALBANS, Hrt. (cathedral)

## TL 145071

### 1a–p. Sixteen baluster shafts (Fig. 34; Ills. 376–396)

PRESENT LOCATION Reassembled into eight pairs and reused in the triforia on the east side of the north and south transepts, set alternately with early Norman monolithic columns (Ills. 376–8)

EVIDENCE FOR DISCOVERY None; *in situ* in their secondary, late 11th century position; first recorded in Buckler and Buckler 1847

STONE TYPE Yellowish-grey, medium- to coarse-grained, oolitic limestone, with numerous well-developed calcite veins; Combe Down Oolite, Great Oolite Formation of Bath area, Great Oolite Group, Middle Jurassic

PRESENT CONDITION Each of the balusters is probably complete and all are in good condition. They have probably never been exposed to the elements, but a–d and i–l are battered. The base of h has been very carefully restored when or before the column was placed in its present position. The junctions between the baluster shafts and between the shafts and the Norman components (usually

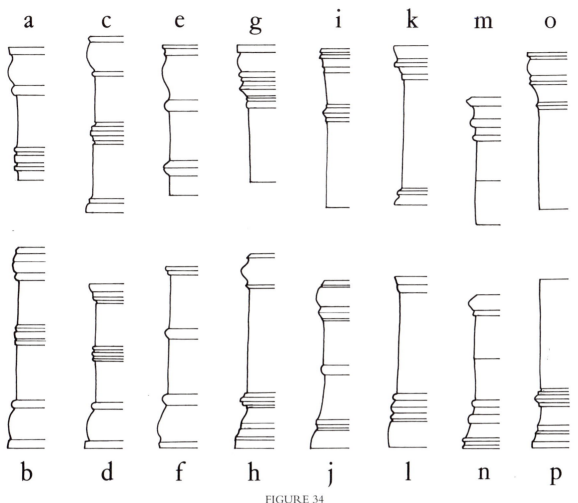

FIGURE 34
St Albans 1, Profiles of baluster shafts (1:16)

capitals and bases) are often covered with Norman mortar (removed by Neale where necessary for the taking of measurements). There are graffiti, later whitewash, and holes for fixtures in a few places.

l:  H.  73.6 cm (29.0 in)    Diameter 28.6 > 27.3 cm (11.25 > 10.75 in)
m: H.  54.6 cm (21.5 in)    Diameter 23.5 > 21.6 cm (9.25 > 8.5 in)
n:  H.  66.0 cm (26.0 in)    Diameter 23.5 > 21.6 cm (9.25 > 8.5 in)
o:  H.  68.0 cm (26.75 in)   Diameter 25.4 cm (10 in)
p:  H.  71.0 cm (28.0 in)    Diameter 25.4 cm (10 in)

a:  H.  57.5 cm (22.6 in)   Diameter 26.7 cm (10.5 in)
b:  H.  83.3 cm (32.8 in)   Diameter 26.7 cm (10.5 in)
c:  H.  75.0 cm (29.5 in)   Diameter 25.4 cm (10 in)
d:  H.  69.3 cm (27.3 in)   Diameter 26.0 cm (10.25 in)
e:  H.  63.5 cm (25.0 in)   Diameter 26.0 cm (10.25 in)
f:  H.  77.5 cm (30.5 in)   Diameter 26.0 cm (10.25 in)
g:  H.  58.4 cm (23.0 in)   Diameter 26.0 cm (10.25 in)
h:  H.  82.0 cm (32.3 in)   Diameter 26.6 cm (10.5 in)
i:  H.  68.6 cm (27.0 in)   Diameter 26.6 cm (10.5 in)
j:  H.  71.8 cm (28.3 in)   Diameter 26.6 cm (10.5 in)
k:  H.  67.3 cm (26.5 in)   Diameter 27.3 > 26 cm (10.75 > 10.25 in)

(assembled dimensions):
a–b:  141.6 cm (55.75 in)   (junction < 0.8 cm (0.3 in))
c–d:  145.6 cm (57.3 in)    (junction < 1.5 cm (0.6 in))
e–f:  142.2 cm (56.0in)     (junction < 1.5 cm (0.6 in))
g–h:  142.4 cm (56.1 in)    (junction < 3.0 cm (1.2 in))
i–j:   141.8 cm (55.8 in)    (junction < 1.4 cm (0.5 in))
k–l:  142.2 cm (56.0 in)    (junction < 1.3 cm (0.4 in))
m–n: 121.6 cm (47.9 in)     (junction < 1.0 cm (0.4 in))
o–p:  141.2 cm (55.6 in)    (junction < 2.2 cm (0.9 in))

DESCRIPTION The sixteen individual baluster shafts are assembled into eight small columns, each carefully put together, some in such a way that there is good reason to suppose that this is how they were meant to be assembled. In each case the top and bottom mouldings of the assembled column can be understood as a capital and a base; in no case do two such mouldings meet in the middle. The balusters are described in the pairs in which they are assembled. They can be divided into six types.

*Type i* (Ills. 381–4): Columns a–b and c–d are of the same general type as assembled. If the four balusters are considered separately, each has the bulbous moulding in common, say as a 'capital', but the 'bases' would then be different, since c–d would each end in a half-round band, b in a complete band, and a as a plain shaft without any moulding.

The almost invisible, narrow junction between a and b, and the fine stone-coloured mortar with which the two parts are fitted together, are quite different from the way in which the Norman shafts in the triforium arcades, when composed of more than one stone, have been fitted together. In almost every case the top and bottom edges of the individual stones of the Norman balusters are rough, the mortar is coarse (a mixture of dark yellow pebble and chalk) and the mortar courses are normally between 3 and 5 cm thick. All the Anglo-Saxon balusters except a–b are joined by yellow mortar of this Norman type. On a–b the junction is above the bulbous central moulding of b (Fig. 34); the diameters of the two shafts are the same. It would thus seem likely that this Anglo-Saxon column was reused here with its two parts still assembled as they had been at a pre-Norman stage in their life. The end mouldings of the two shafts are almost identical, and the other mouldings on both shafts are similar.

The junction between c and d is in the middle of the moulded central band (Fig. 34). The end mouldings are of the bulbous type similar to those on a–b. The bottom mouldings of b and d are virtually identical. The mid-shaft mouldings on c and d are similar, but not as alike as those on a and b. The diameter of c is less above the mid-shaft moulding; below this moulding, it has the same shaft diameter as d. The assembled column is harmonious, but each element could stand alone.

*Type ii* (Ills. 385–6). Column e–f is the only one of this type. As assembled, its 'capital' is slightly more elaborate and larger than the 'base'. Both are of the sagging ('base') or lifted ('capital') type. No other

baluster from this site has these end mouldings. If the two shafts are looked at individually, they have the bulbous moulding in common, say as a 'capital', but the 'bases' would be different, f ending in a narrow stepped moulding and e as a plain shaft.

The junction between e and f is above the stepped central moulding of f (Fig. 34). The end and the mid-shaft mouldings are similar, and the diameters of the shafts are the same. The two baluster shafts fit well together. The shafts would not have worked with any other shaft, because the only other shaft with a similar mid-shaft moulding is j, but here the moulding acts as the top of the splayed base, and neither e nor f would combine with j in a harmonious way.

*Type iii* (Ills. 387–8, 395–6): Columns g–h and o–p are of this type, although they are not identical and the shaft diameters are different, o–p being more slender than even the shorter shaft g. The 'bases' are concave with a complex upper band. The main difference is that g–h has a bulbous mid-shaft moulding, while o–p is plain. If the four baluster shafts are looked at individually, they have the end mouldings in common, say as 'capitals', but h alone would have a 'base' moulding. The four shafts could not be fitted to any other shaft without the resulting column being unduly short or long, or without bringing the mouldings out of harmony (as would be the case, for example, with g combined with b, or a with h).

The junction of g and h is above the bulbous central moulding on h (Fig. 34). The shafts are otherwise plain, but their diameters are different, as are the mouldings and diameters of the ends. The junction of o and p is in the middle of the two plain shafts. The shaft diameters are the same, but the end mouldings differ.

*Type iv* (Ills. 389–90): Column i–j is of this type. Diagnostic are the long tapered 'capital' and 'base' with a bottom band and a fairly simple top/bottom moulding. The 'capital' and 'base' are not identical, the 'base' being the simpler. No other balusters have this type of moulding. The two parts seem to belong together.

The junction of i and j is above the bulbous central moulding on j. The top and bottom mouldings are similar in character, but different in detail, the lower half of j being a splayed 'base' or 'capital'. There are no mid-shaft mouldings, because the apparent mid-shaft moulding on j is in fact the top of a slightly splayed 'base' moulding. The shaft diameters are the same.

*Type v* (Ills. 391–2): Column k–l is of this type. Diagnostic are the compact, fairly simple 'capital' and 'base'. The two parts are quite alike, the shafts tapered, and the junction is in the central moulding. The two shafts seem to belong together.

The junction is in the middle of the bulbous central moulding: compare c–d (Fig. 34). The top and bottom mouldings are similar but differ in detail. The shafts each become wider towards the bottom in such a way that the bottom diameter of k is the same as the top diameter of l.

*Type vi* (Ills. 393–4): Column m–n is of this type. It is smaller than all the others. The 'capital' and 'base' are virtually identical, the difference being a subtle turning in at the top of the 'capital', and a turning out at the 'base'. These would indicate that the 'capital' and 'base' were meant to be in this particular relationship, unlike the ambiguity of comparable features on several of the other columns. Furthermore, the two carinated shafts are identical and show that m has not been cut down, but was meant to join with n as assembled.

The junction is above the moulding at the top of n (Fig. 34). The two end mouldings are similar, and the shafts are both shorter than normal and have, uniquely, a sharp central carination. The diameters of both are the same, at the narrowest and widest points. These balusters belong together.

DISCUSSION With the exception of a–b, which has a narrower junction than any of the others and is filled with a different mortar (see above), the individual baluster shafts are fitted together with joints between 1–3 cm in width, filled with the yellow mortar of 'Norman' type. This method of joining the Anglo-Saxon balusters is quite different from the joining of the Norman shafts in the triforium arcades, which have joints normally 3–5 cm in width. Extra care has clearly been taken in fitting the Anglo-Saxon shafts together. It can be argued on independent and different criteria that a–b, i–j, k–l, and m–n are now assembled as they were intended to be assembled by the Anglo-Saxon masons. The other four are on balance probably also in their intended Anglo-Saxon relationship, but the reasons for supposing this are not individually as strong as for the other four.

Seven of the assembled columns are broadly similar, but m–n is part of another scheme, being when assembled 19.6 cm smaller than o–p, the shortest of the larger group. If the baluster shafts are looked at individually, m, at 54.6 cm (21.5 in), is 2.9 cm (1.1 in) shorter than the shortest of the remainder, a, while n, at 66 cm (26 in) in height, is the fifth shortest.

If the heights of the individual (i.e. disassembled) baluster shafts are compared to the sample of 102 shafts surviving from the co. Durham sites of Egglescliffe, Greatham, Hart, Monkwearmouth, and Jarrow, and from the Old Minster at Winchester, shaft m from this site is sixty-sixth out of 102 in length (whether broken or unbroken) and b, c, f, h, and l are taller than any of the others. The tallest, b, is 10.3 cm taller than the tallest baluster shaft from Jarrow. The same group of 102 shafts can also be ranked by diameter, which is at least as interesting since there are more fragments with complete or calculable diameters than there are complete heights. The smaller diameters of shafts m and n from the present site are joint thirty-sixth and thirty-seventh of 91 diameters (measurable or reconstructible); those from the Old Minster, Winchester, hold seventy-seventh to ninety-first place, larger than Jarrow, which covers sixtieth to seventy-sixth place. The smallest of the Winchester Old Minster shafts (no. 19), with a diameter of 32 cm (12.6 in), is 3.2 cm (1.25 in) larger than the largest St Albans baluster shaft, l, and the remainder from the Old Minster have diameters between 38 and 51.2 cm (15 to 20.2 in), and must be seen as deriving from full sized columns rather than small columns or colonnettes as here. The diameters of the Old Minster shafts are almost all calculated from fragments; ideally they (and the other balusters) should have been compared to the fragments found in the excavation of the monastic buildings at Monkwearmouth, but these are not included in Corpus I (Cramp 1984, I, 129).

The lack of weathering on the St Albans balusters suggests that they stood inside the church or, if used as mid-wall shafts, in sheltered positions. Neale compared them to those found by Scott in St Mary in Castro at Dover (nos. 2–3; Ills. 64–7, 71–5), and also to shafts from Ely, where 'Fragments of similar balusters were recently discovered . . ., with mouldings of the same character as at St Albans . . .' (Neale 1877, 26). The St Albans baluster shafts are unlike the Jarrow and Monkwearmouth shafts, and more like the Dover balusters (a point also made by Baldwin Brown (Brown 1925, 264–6)), and the mouldings are similar to some of the tenth-century Winchester mouldings (e.g. Old Minster, nos. 10, 11, 12, 15, 18); Neale alone compares them with Ely. There is no reason to associate them with king Offa of Mercia's refoundation of the St Albans community in 793; it is more likely that they are later, perhaps from the tenth century. An earlier date cannot, however, be excluded.

All previous commentators have assumed that the balusters from this site are Anglo-Saxon in date and

not *spolia* reused from the Roman city of *Verulamium*, despite the statement in *Gesta Abbatum* (Riley 1867–9, I, 24–8) that abbots Ealdred and Eadmer (both of whom probably held office in the first half of the eleventh century) collected materials from *Verulamium* towards the rebuilding of the abbey. Dr T. F. C. Blagg comments as follows on the character of the St Albans balusters in relation to pieces of comparable size from Romano-British buildings:

The techniques of workmanship are similar to those found on many Romano-British columns carved in oolitic limestone. The profiles are sharply cut, and the surfaces show the rilling typical of pieces which have been finished on a lathe. While the bold single mouldings of the capitals and bases of a–f would be unusual on Roman columns from southern Britain, most of the more complex mouldings of the remainder are not so different from the fairly wide range of variation in Romano-British profiles. Columns of this miniature size (20–30 cm in diameter) were used in the porticoes of villas and temples (standing on a low wall), as table supports, and possibly in window openings.

It would, however, be unusual to find such a variety of profiles on any one Roman site among columns otherwise so similar in size and execution. Moreover, there are two features which together rule out a Roman date quite firmly. First, the mouldings of Romano-British column capitals are invariably surmounted by a square abacus, and bases of this size were nearly always carved integrally with a square plinth; none of these baluster shafts has either. Second, Romano-British columns do not have mid-shaft mouldings. It is usual for a capital to have an astragalus, a ring of small mouldings a short distance below the main profile. Here, that feature is only to be seen on i–j. The intermediate mouldings are therefore quite uncharacteristic of Roman work.

DATE Tenth century or earlier

REFERENCES Buckler and Buckler 1847, 132–4; Neale 1877, 26–7, pl. 32; Page 1908b, 484, 499–500; R.C.H.M. 1911, 180–1; Brown 1925, 264–6; Taylor and Taylor 1965–78, II, 528

B.K.-B.; M.B.

SOUTH LEIGH, **1.** See Appendix A, p. 245.

STANBRIDGE, **1.** See Appendix A, p. 246.

# WALKERN, Hrt. (St Mary)

TL 293266

### 1. Crucifixion[1]  (Ill. 397)

PRESENT LOCATION Built into south face of wall above western arch of south nave arcade, inside

EVIDENCE FOR DISCOVERY None; first recorded in (———) 1883

H.  *c.* 135 cm (53 in)  W.  36 cm (14 in)
D.  Built in

STONE TYPE Inaccessible. A soft, white (possibly whitewashed) fine-grained stone, probably Chalk to judge from the way in which the lower part of the figure has been carved; Middle Chalk or Upper Chalk, Upper Cretaceous; from the Walkern vicinity

PRESENT CONDITION Unobtainable

1. The following is an unpublished manuscript reference to no. 1: BL Add. MS 47705, fol. 207r.

DESCRIPTION Only one face is visible. The vertical limb of the cross is composed of a single stone and has a broad plain raised border along the long edges. The horizontal limbs are lost, The head of the cross has been trimmed and only the tips of the fingers of the Hand of God above Christ's head survive. The head is in high relief with a degree of undercutting, and has well modelled features, short hair, and a moustache. Christ's torso is cut away to seat a joist. Below the waist the figure is in low relief, and robed. The folds of the garment and the knotted belt are indicated by incised lines. The bare ankles are separated, but the trimming of the foot of the cross has removed the feet.

DISCUSSION The crucifixion is *in situ* over what was originally the south door of the aisleless nave of the church. In the twelfth century an arcade was cut through this wall and an aisle created. This left one impost of the south door *in situ*, but removed the other (Taylor and Taylor 1965–78, II, 629–30, fig.

319). At the same time, or subsequently, the lateral arms of the crucifixion and the area of the figure's chest were cut away to accommodate a wooden beam.

The figure is a robed crucifixion of the same general type as Langford 2, Oxfordshire (Ills. 294–5), for which an eleventh-century date has been argued. For further discussion of the dating of the crucifixion groups from south-east England, see Chap. VII.

DATE Eleventh century

REFERENCES (——) 1883; Chittenden 1905–7, 295; R.C.H.M. 1911, 10, 224–5; Page 1912c, 155–6; Andrews 1934, 97; Quirk 1961, 30; Taylor and Taylor 1965–78, II, 630, figs. 319 and 600, III, 1056; Taylor and Taylor 1966, 9–11, 51, fig. 4; Smith 1973, 30–1, 33, fig. on 32, pl. 7; Pevsner and Cherry 1977, 18, 372; Coatsworth 1979, I, 151–73, II, 50, pls. 62–3; Tweddle 1986b, I, 73–5, 193–6, 204, II, 501–2, III, pl. 110a; Coatsworth 1988, 166, 192

D.T.

## 2. Impost                                        (Ills. 398–9)

PRESENT LOCATION *in situ* in eastern jamb of western bay of south nave arcade

EVIDENCE FOR DISCOVERY See no. 1.

H.   19 cm (7.5 in)   W.   77 cm (30.3 in)
D.   54 cm (21.3 in)

STONE TYPE Unidentified (thickly covered with greyish-white limewash or emulsion paint)

PRESENT CONDITION Apparently good

DESCRIPTION It is returned along the south face of the wall, and decorated with four cable mouldings twisted alternately in opposite directions. The strands are well modelled and each has an incised median line; the incision has a V-shaped profile. Each moulding projects slightly beyond the one below. Along the lower edge is a narrow moulding of square section. Along the upper edge is a plain narrow step.

DISCUSSION This piece originally formed the eastern impost of the south door of an aisleless nave, above which no. 1 was situated. The western impost was removed when, in the twelfth century, an aisle was built and an arcade cut through the south wall of the church.

Clearly the creation of the arcade implies that the impost is of earlier date, and an eleventh-century dating can be suggested if it is accepted that the door and the crucifixion figure belonged to the same architectural scheme (see no. 1 and Chap. VII). Confirmation of this dating derives from the form of the cabled mouldings on the impost. These are modelled with a V-shaped incision on the median line of each strand. This is precisely the form encountered elsewhere in works probably of the eleventh century, such as Little Munden in Hertfordshire (Ills. 318–19), and Dartford (Ill. 61) and Orpington (Ills. 105–7) in Kent.

DATE Eleventh century

REFERENCES (——) 1883; R.C.H.M. 1911, 224; Pevsner 1953, 255; Taylor and Taylor 1965–78, II, 629, fig. 319; Taylor and Taylor 1966, 10, 51, fig. 4; Smith 1973, 30–1, fig. on 32; Tweddle 1986b, I, 178–9, II, 502–3, III, pl. 110b

D.T.

# WEST MERSEA, Ess. (Sts Peter and Paul)

## TM 009124

### 1. Grave-cover                                  (Ill. 374)

PRESENT LOCATION Built into south aisle wall, inside, immediately west of south door

EVIDENCE FOR DISCOVERY Found in 1970 built into south aisle wall, outside

L.   35 cm (13.8 in)   W.   10.5 cm (4 in)

STONE TYPE Pale yellowish-grey (2.5Y 8/2–3), medium-grained, shelly oolitic limestone, with a

calcite matrix, and a laminated appearance resulting from parallel alignment of small worn shell fragments; Barnack stone, Lincolnshire Limestone Formation, Inferior Oolite Group, Middle Jurassic

PRESENT CONDITION Broken on all edges; face heavily weathered

DESCRIPTION Only one face is visible.

*A (broad):* A wide, flat, plain moulding towards the right-hand side divides the stone into two fields

(vertically as now set). Each is filled with interlace formed from narrow, rounded strands. That in the left-hand panel is probably a form of pattern A; the pattern to the right is too fragmentary to be identified.

DISCUSSION The disposition of the decoration, with interlace flanking a plain moulding, is reminiscent of that of late Anglo-Saxon grave-covers, such as those at Cardington (Ill. 264) and Milton Bryan (Ill. 361) in Bedfordshire. In those cases the plain moulding is the stem of a cross with interlace flanking it. Here,

however, the interlace is very much finer, suggesting an earlier date for the piece, although interlaces with very fine strands may have persisted in the south-east as late as the early tenth century: compare Barking 1, Essex (Ills. 256–9).

DATE Tenth to eleventh century

REFERENCES (——) 1971; Rodwell and Rodwell 1977, 114

D.T.

# WHITE NOTLEY, Ess. (dedication unknown)

## TL 786182

**1. Grave-marker**                              (Fig. 35; Ill. 375)

PRESENT LOCATION Reused as window frame in east wall of vestry

EVIDENCE FOR DISCOVERY First recorded in R.C.H.M. 1921

H.   66 cm (26 in)   W.   40 cm (15.8 in)
D.   Built in

STONE TYPE Yellowish-grey, oolitic limestone, with planar bedding of alternate medium-grained and coarser to pellety shelly layers, and lacking calcite veins; Barnack stone, Lincolnshire Limestone Formation, Inferior Oolite Group, Middle Jurassic

PRESENT CONDITION Worn, and damaged by reuse

DESCRIPTION It is used as the exterior frame of a semicircular-headed window. Only one face is visible.

*A (broad):* The upper part is decorated with the remains of a circular, splayed-armed cross, the fields between the arms being recessed. Only the curved outer ends of the recessed fields flanking the lower arm survive. The outer ends of the lateral and the upper arms of the cross have been destroyed by the rounding of the head of the stone. The lower arm and the centre of the cross have been destroyed by the cutting of the opening.

DISCUSSION The reconstruction of this fragment (Fig. 35) is slightly problematical, as it could either have been a square-headed grave-marker which has been completely

FIGURE 35
White Notley 1A, reconstruction, nts

reshaped, or one with a semicircular head which has merely been trimmed and pierced. Square-headed types are known from Peterborough with the same type of cross as here, and from Cambridge castle with a square-armed cross (Fox 1920–1, pl. VII). There is no adequate parallel for the putative semicircular headed type, although there is something similar, but with an almost circular head, from Cambridge castle (loc. cit.).

Dating is equally problematic. The Royal Commission places the window of which it now

forms the frame in the late eleventh century, and this certainly suggests a pre-Conquest date for the piece (R.C.H.M. 1921, 252). This date is supported by the parallels among other material from East Anglia. As Fox has pointed out, a pre-Conquest date must be preferred for the vast majority of this material (Fox 1920–1, 31–6).

DATE Tenth to eleventh century

REFERENCES R.C.H.M. 1921, 252–3; R.C.H.M. 1923, xxxi, fig. on xxxi; Cottrill 1931, appendix; Taylor and Taylor 1965–78, I, 475

D.T.

WING, **1.** See Appendix A, p. 246.

# APPENDIX A

# STONES DATING FROM SAXO-NORMAN OVERLAP PERIOD OR OF UNCERTAIN DATE

## NORTH LEIGH, O. (St Mary)

SP 387137

**1a–d. Four balusters** (Ills. 400–3)

PRESENT LOCATION *in situ* in belfry stage of west tower (one in each face)

EVIDENCE FOR DISCOVERY First recorded in (——) 1910

MEASUREMENTS Unobtainable

STONE TYPE Brownish-yellow, shelly, oolitic limestone, cross-bedded, with prominent ribs or 'bars' on weathered surfaces; Taynton stone, Tayton Stone Formation, Great Oolite Group, Middle Jurassic; Taynton, Oxfordshire

PRESENT CONDITION Intact, but heavily weathered

DESCRIPTION Each shaft has a facetted capital; the facets are sub-triangular, and with the angles between them rounded. The capital is separated from the shaft of the baluster by a roll moulding. The shaft itself is plain, but with entasis, and stands on a bulbous base.

DISCUSSION Plain balusters such as these are very difficult to date, and the occurrence on the present examples of entasis would even allow the possibility that they are reused Roman material. If they are medieval, they were presumably made for their present context, and can therefore only be dated by their presence in the fabric of a structure probably to be dated to the eleventh century.

DATE Eleventh century

REFERENCES (——) 1910, 32–5, fig. on 33; Taylor and Taylor 1965–78, I, 464–5, fig. 222, II, pl. 537; Sherwood and Pevsner 1974, 719

D.T.

## OXFORD (St Michael)

**2. Fertility figure** (Ill. 404)

PRESENT LOCATION On display in west tower

EVIDENCE FOR DISCOVERY Photographs formerly in vestry suggest that it had been removed from belfry stage of tower; in vestry by 1939 (R.C.H.M. 1939, 143)

H. 28 cm (11 in) W. 26 cm (10.2 in)
D. 10 cm (4 in)

STONE TYPE Pale yellowish-grey, fine- to medium-grained, shelly, oolitic limestone; possibly Taynton Stone Formation, Great Oolite group, Middle Jurassic

PRESENT CONDITION Worn

DESCRIPTION The stone is a square panel of fundamentally rectangular section. Only one face is carved.

*A (broad):* The surface is hollowed to leave a narrow, plain, relief frame. It contains a frontally-placed, naked, female figure positioned slightly to the left of the vertical axis of the face. The head, without facial features, overlaps the upper frame. The tapering, rounded-ended, left leg runs into the left-hand corner. The right leg is raised and slightly overlaps the right-hand border. The right arm curves out and down to touch the thigh, and the left arm, which is similarly curved, overlaps the border, and turns horizontally to touch the waist. The genitalia are marked.

DISCUSSION If, as records in the church suggest, this piece was removed from the belfry stage of the west tower, then it is possible that it is coeval in date with the tower. Taylor and Taylor regard the tower as mid to late eleventh century in date (Taylor and Taylor 1965–78, I, 481). The simplicity of the figure renders comparative dating impossible.

DATE Eleventh century

REFERENCES R.C.H.M. 1939, 143; Sherwood and Pevsner 1974, 29; Tweddle 1986b, I, 85, 217, II, no. 430, III, pl. 70a

D.T.

# SOUTH LEIGH, O. (St James)

SP 394090

## 1. Cross-head (Ill. 406)

PRESENT LOCATION Built in over entrance to south porch, outside

EVIDENCE FOR DISCOVERY None; first recorded by author in 1976

H. *c.* 20 cm (8 in) W. *c.* 40 cm (16 in)
D. Built in

STONE TYPE Inaccessible, but appears to be of greyish-yellow oolitic limestone, with weathered-out thin ridges; possibly Taynton stone or Bath stone, Great Oolite Group, Middle Jurassic

PRESENT CONDITION Worn

DESCRIPTION It is a ring-head. A horizontal break has involved the loss of the lower limb and the lower parts of the lateral arms. There is a central boss with a drilled centre encircled by a moulding of half-round section. The expanding, square-ended arms are separated at their inner ends, and have broad hollows paralleling the edges. At their outer ends they are linked by narrow, recessed, convex bars of rectangular section.

DISCUSSION This piece could either have come from a small memorial cross, or a larger standing cross. Its ring form points to a late date, as Collingwood has suggested that this form was introduced to England from the Celtic west by Scandinavian settlers in the early tenth century (Collingwood 1927, 137–9, fig. 153). The angular nature of the piece suggests a date late in the sequence of ring-heads; Collingwood, on these grounds, has suggested a post-Conquest date for a cross of very similar form from St Crux, York (ibid., 93–4, fig. 115). Similar crosses are encountered from the late twelfth-century Canon's cemetery at Old Sarum. Confirmation of a late date for this piece derives from archaeological evidence for the date of deposition of an almost identical cross-head from Glastonbury Tor, Somerset. This came from a context containing pottery of *c.* 1000–*c.* 1200 (Rahtz 1971, 31, 48, fig. 21).

DATE Eleventh to twelfth century

REFERENCE Freke 1981, 252

D.T.

# STANBRIDGE, Bd. (St John Baptist)[1]

## SP 966242

**1a–b. Cross-shaft, in two pieces**  (Ills. 409–12)

PRESENT LOCATION In churchyard (a, south of south door; b, east of church)

EVIDENCE FOR DISCOVERY Discovered in 1858 during grave digging in churchyard, buried five to six feet down

a: H.  80 cm (31.5 in)   W.  39 cm (15.4 in)
    D.  33 cm (13 in)
b: H.  83 cm (32.7 in)   W.  57 cm (22.4 in)
    D.  57 cm (22.4 in)

STONE TYPE Dark reddish-brown, medium- to coarse-grained, hard, ferruginous sandstone; Cretaceous, Lower Greensand, Woburn Sands Formation of the Stanbridge area

PRESENT CONDITION Damaged and worn

DESCRIPTION Fragment a is an irregularly-finished tapering shaft of square section, roughly broken above. Only one face is carved.

*A:* Towards the upper edge there is a Greek cross delimited by incised lines, with a shallow, circular depression in the centre.

Fragment b is an irregularly-finished shaft of approximately square section and tapering slightly towards the upper end. It is undecorated.

DISCUSSION Both stones are made from the same material, and may have derived from the same monument. If so, the dimensions of the pieces suggest that 1b must in fact have formed the lower part, and 1a the upper. The dating of the pieces remains problematical, but a shaft of this size from the post-Conquest period would be unusual in south-east England.

DATE Eleventh century?

REFERENCE Smith 1905, 354–5, fig. on 35

D.T.

1. The following is an unpublished manuscript reference to no. 1: BL Add. MS 37547, item 653

# WING, Bk. (All Saints)

## SP 880226

**1. Baluster**  (Ills. 407–8)

PRESENT LOCATION East wall of nave, above chancel arch

EVIDENCE FOR DISCOVERY Discovered in 1892 (Tatham 1892–7)

MEASUREMENTS Unobtainable

STONE TYPE Unobtainable

PRESENT CONDITION Fair

DESCRIPTION The shaft appears to be lathe-turned, and comprises a block-like super-capital which narrows to fit the shaft, and a base with a rounded moulding at its junction with the shaft.

DISCUSSION It has been suggested that this shaft represents a later modification of the opening; if so it cannot certainly be classed as Anglo-Saxon.

DATE Uncertain

REFERENCES Tatham 1892–7; Page 1925, 454; Jackson and Fletcher 1962; Taylor and Taylor 1965–78, II, 670–1, fig. 343, l–m, III, 1049–50

D.T.

# CATALOGUE

# HAMPSHIRE AND BERKSHIRE

# ABINGDON, Brk.

SU 496970

**1. Part of roundel**     (Fig. 36; Ills. 413–17)

PRESENT LOCATION Abingdon Museum (no accession number)

EVIDENCE FOR DISCOVERY Discovered in 1927 by E. A. G. Lamborn in garden wall (*c.* 1840) of The Square House, Abingdon; donated to museum when house demolished in 1934

H.   27 cm (10.6 in)   W.   50 cm (19.7 in)
D.   12 cm (4.7 in)
Reconstructed diameter *c.* 102 cm (40 in)

STONE TYPE Greyish-yellow, medium- to coarse-grained, shelly, oolitic limestone, with one surface showing cross-bedding; Taynton stone, Taynton Stone Formation, Great Oolite Group, Middle Jurassic

PRESENT CONDITION Broken and chipped

DESCRIPTION The lower edge of the fragment is horizontally dressed, and the left- and right-hand edges vertically dressed. The upper edge is formed by the arc of a circle.

*A (broad):* Along the upper edge is a broad, plain, raised border. To the left is a large interlace triquetra, broad end uppermost, the strands are median-incised, and the tip of the lower element is lost. To its left a half-round moulding rises from the lower edge sloping to the left, and a similar moulding slopes upwards to the right before bending sharply downwards to run parallel to the border a short distance from it.

*C (broad):* In the lower right-hand corner is a prominent reversed L-shaped moulding of square section. Above and to the left of its lower element is a narrow rectangular slot.

DISCUSSION The decoration can be reconstructed as a cross with a triquetra in each of the re-entrant angles (Fig. 36). The piece is normally interpreted as part of a disk-shaped cross-head, but this is unlikely as there is no trace of decoration on face C. Instead there is elaborate keying as if the roundel had formed part of a

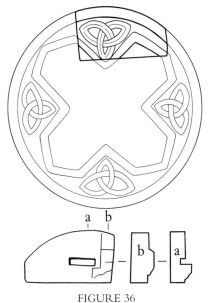

FIGURE 36
Abingdon 1A, reconstruction and cross-sections, nts

larger composite feature or structure. It is unlikely that the keying is secondary as it would have involved the skilful cutting back and re-shaping of the entire face removing all trace of any pre-existing decoration. In addition the piece is very large for a disk-head, with a reconstructed diameter of over 100 cm.

If it is not a cross-head, then the piece may have served an architectural function, perhaps as a decorative roundel. Two similar, but smaller, roundels survive at Edenham, Lincolnshire, where they form part of the string-course in the south wall of the nave. They are ornamented with foliage not interlace, but, as at Abingdon the decoration is arranged in a cruciform shape (Taylor and Taylor 1965–78, I, 227, II, pl. 459; Taylor and Taylor 1966, 35).

DATE Tenth to eleventh century

REFERENCES Lamborn 1935, 58–9, figs. 1–4; Lamborn 1937, 122; Tweddle 1986b, I, 86, 186–7, II, 346–7, III, pl. 16

D.T.

# BISHOPS WALTHAM, Ha. (St Peter)

## SU 555176

### 1. Part of cross-shaft      (Ills. 415, 418–19, 421–2)

PRESENT LOCATION Winchester City Museum. Temporary loan (no accession number)

EVIDENCE FOR DISCOVERY Found in 1974 in garden of house in St Peter's Street; photographs in Winchester City Museum show it formerly in churchyard

H.   68 cm (26.8 in)   W.   39 cm (15.4 in)
D.   34 cm (13.4 in)

STONE TYPE Pale brownish-grey, shelly, oolitic limestone; Middle Jurassic, of uncertain provenance

PRESENT CONDITION Chipped and differentially worn

DESCRIPTION It is of square section and tapers towards the upper end which, like the lower end, is dressed flat.

*A (broad):* Within a plain relief border moulding, which has a median-incised line except along the upper edge, is a panel of interlace: one complete unit and most of a second, of complete pattern A with rounded loops, turned through 180 degrees, plus a terminal unit at the lower end of the panel; here the two outer strands are left loose and finished with clubbed ends.

*B (narrow):* The borders are like those on face A, and contains an interlace of complete pattern F, irregularly set out and with a lower terminal in which the outer ends are left loose.

*C (broad):* Divided into three horizontal zones. The lowest and narrowest is decorated with an interlace of uncertain pattern. The second, twice as high as the first, has a plain raised border. It contains a pair of spiral, inward-facing animals. That on the left is head uppermost, it is open-mouthed, the jaws are pointed

and curve upwards, and the eye is marked. The body tapers and is tightly spiralled. The tail is drawn straight from the centre of the spiral, beneath the body, to terminate in the upper left-hand corner of the field in a fan shape, divided into three. A diagonal runs up from left to right, and is bitten by the animal before curling over at the end to touch the second animal. This is similar to the first, but turned upside-down. The third zone has a border like that of the second, and shares a moulding with it. It is divided into two equal fields by a plain vertical moulding, each containing a worn interlace. To the left was apparently a panel of complete pattern F; the pattern of the opposite panel is uncertain, but may have been pattern F with outside strands.

*D (narrow):* There is a triple plain border which is damaged towards the upper end of the shaft. The face is divided into two unequal fields by a single raised horizontal moulding. The lowest and deepest field contains an interlace of pattern F with outside strands, irregularly set out. The upper field is decorated with a heavily-damaged interlace, possibly also a form of pattern F.

DISCUSSION The surviving portion of the shaft represents one complete section of a shaft constructed in separate pieces. In the upper end is a central, circular hole. This may have accommodated a metal tie fixing this section to the one above it. However, the hole may not be an original feature. It is surrounded by a circle of twelve regularly-spaced, smaller holes, and clearly has been used, if not made for, the gnomon hole of a sundial.

DATE Tenth century

REFERENCES Hughes 1976, 47; Tweddle 1986b, I, 95, 244–6, II, 353–5, III, pl. 22a-23b

D.T.

# BOARHUNT, Ha. (St Nicholas)

## SU 604083

### 1. Window surround                                    (Ill. 420)

PRESENT LOCATION *in situ* in north window of chancel

EVIDENCE FOR DISCOVERY First recorded in Irvine 1877

H.   73 cm (28.7 in)   W.   47 cm (18.5 in)
D.   Built in
Aperture: H.   56 cm (22 in)   W.   18 cm (7 in)

STONE TYPE Yellowish-grey (2.5Y 7/3), shell-fragment limestone, much weathered and lichen-coated; Quarr stone, Bembridge Formation, Palaeogene, Tertiary; Isle of Wight

PRESENT CONDITION Complete but weathered

DESCRIPTION It is the mid-wall slab of a semicircular headed, double-splayed window. Around the exposed edge of the external face are two cable mouldings, twisted in opposite directions. These are separated by a broad undecorated zone from the chamfered edge of the aperture.

DISCUSSION Irvine records that when he saw it a small part of the interior face of the slab was visible behind a monument, and decorated in the same way as the exterior face. The inner splay has since been filled and plastered.

DATE Tenth to eleventh century

REFERENCES Irvine 1877b, 373, 379, fig. facing 368; (——) 1890–3, 255–6, fig. on 255; Nisbett 1891–3, 315; Brown 1900b, 337; Brown 1925, II, 105, fig. 56; Page 1908a, 146; Cox and Jowitt 1949, 50; Green and Green 1951, 3, n., 4, diagram 1; Taylor and Taylor 1965–78, I, 76–7; Taylor and Taylor 1966, 29, 49; Pevsner and Lloyd 1967, 111; Tweddle 1986b, I, 71, 166, 169–70, II, 355–6, III, l. 24

D.T.

# BREAMORE, Ha. (St Mary)

## SU 153189

### 1. Crucifixion[1]                                      (Ills. 425–8)

PRESENT LOCATION Above south nave door

EVIDENCE FOR DISCOVERY Discovered during plaster stripping in 1897

Figures. H.   *c.* 155 cm (61 in). Other measurements
     unobtainable
D.   Built in

STONE TYPE Pale greyish-yellow to yellowish-orange, oolitic limestone; probably Combe Down Oolite, Great Oolite Formation of the Bath area, Great Oolite Group, Middle Jurassic

PRESENT CONDITION Largely defaced

DESCRIPTION This is a crucifixion scene with the Virgin and St John. The cross is composed of four stones, two forming the broad vertical limb, and two others the narrower horizontal limbs. Along the left- and right-hand edges of the vertical limb, and along the upper and lower edges of the horizontal limbs, are borders decorated with three vertical mouldings. The outline of the figure of Christ can be discerned against a painted background, but is cut back flush with the wall. He is nimbed, and bent at the waist, the torso sloping to the right and the legs to the left. The arms slope upwards, and the hands hang down from the wrists. There is a dowel hole above each wrist, and another dowel hole at either side of the position of Christ's head. In the western hole is a wooden peg

1. The following are unpublished manuscript references to no. 1: BL Add. MS 37509, fols. 113v–114r, item 120; BL Add. MS 37580, items 682–90; BL Add. MS 47629, fols. 21r–21v.

with copper alloy staining. Above Christ's head the mutilated Hand of God develops from a cloud carved at the upper end of the stone forming the head of the cross. The cloud is composed of three undulating incised lines. A pair of incised, undulating lines curves down from the ends of the moulding behind the Hand of God.

Beyond the end of each horizontal arm of the cross is a rectangular panel, carved from the same piece of stone. Each is decorated with a mutilated disc within a border. Below that to the left, carved on two separate stones which parallel the lower limb of the cross, and extends beyond its foot, is the mutilated, inward-facing, robed and nimbed figure of the Virgin contained within a frame. In the corresponding position to the right, again carved on two stones, is the mutilated figure of St John, bent slightly forward at the waist; he is standing on a ground surface against which the border stops on either side.

Traces of original paint survive in a number of areas (Rodwell and Rouse 1984, 321–2; Rodwell 1990, 164): the cloud is primed with white, overpainted in bright red, with a fragment of gold leaf. The recessed field behind the Christ figure is primed white, and the moulded border is red, without priming. A fragment of original red survives between Christ's head and halo. The recessed field behind the Sun is again primed white, and the moulded border is deep red without priming, the paint turning into the joint above St Mary's head. There is also a fragment of red between her halo and head. The recessed field behind St John is primed white.

DISCUSSION Green and Green have suggested that it was removed from its original position, possibly over the chancel arch, and set up here when the church was enlarged in the fifteenth century, and that at the same time the porch was raised to form a chapel. This was based on the belief that the arms of the cross had been reversed. Recent work by Rodwell and Rouse has confirmed that the crucifixion is *ex situ*, but that the arms have not been reversed (Rodwell and Rouse 1984, 308, 311–2). The conclusion that the crucifixion group is *ex situ* derives from the fact that some stones are replacements, or missing completely. For example, the stone now forming the lower end of the vertical limb of the cross is not original, although there was an originally a stone in this position, and there must have been another stone on either side of the head of the cross, forming a larger cloud from which the Manus Dei develops. In addition many of the stones have their edges damaged and made up in

plaster in a manner suggestive of removal from another position. Also in a number of places, the original paint on the borders runs onto the edges of the stones into places which it could not have reached if the paint was applied in their present situation. Most notably, there is paint on the edge of the stone bearing the Sun actually in the joint between it and the stone bearing the figure of St Mary.

The original positioning of the crucifixion group remains problematical. Rodwell and Rouse (1984, 315–7) have pointed out that as it shows no sign of weathering, it must have come from one of three positions: inside the demolished western chamber over the west doorway; over the nave arch; or over the chancel arch (Rodwell and Rouse 1984, 315–17). They have pointed out that, although both the nave and chancel arch were rebuilt in the fifteenth century and widened, they were not raised significantly in height, so there was no need to remove any feature which survived above the pre-Conquest arches. Nor does the walling in these positions show any sign of disturbance. It seems likely, therefore, that the crucifixion group was placed over the west doorway inside the western chamber, as at Headbourne Worthy 1. The western chamber appears to have been demolished in the fifteenth century, and the west wall of the church rebuilt, virtually obliterating traces of the original west door. This operation would certainly have necessitated the removal of the crucifixion group.

Rodwell has interpreted the two dowel holes on either side of Christ's head as fixing points for a metal crown. Clearly they are points of attachments for some sort of metal fitting, that it was a crown seems unlikely. Christ's head has been cut away, but from the disposition of his body it is likely that his head lay at *c.* 50 degrees to the horizontal, and probably tilted forward. The dowel holes, however, lie on the horizontal, that is, they do not relate to the position of the head. Moreover, at Romsey 1, where the head of Christ survives intact and also wore a metal crown, it is the head itself which is flattened to allow a crown simply to be crimped in place (Ill. 456). Perhaps the dowel holes held a gilded appliqué which formed part of the nimbus. A distant parallel for such a feature is provided by a fragment of a wooden Christ figure from Jelling, Denmark, where the presence of a metal nimbus has also been suggested (Marxen and Moltke 1981, 274). Dowel holes above the position of each wrist of the figure of Christ at Breamore have been interpreted by Rodwell as the attachment points for metal strips representing bindings around the cross.

The metal fittings clearly constituted only one

element of a rich colour scheme which also involved paint and gilding. From the surviving traces of paint, it can be suggested that the borders to the fields were painted deep red, without priming, and the recessed backgrounds white. Traces of original red paint, without priming, survive between the head and halo of Christ and St Mary. The cloud from which the *Manus Dei* issues was primed white, then painted deep red, and was at least partially gilded.

DATE Tenth to eleventh century

REFERENCES Hill 1897a; Hill 1897b, 233; Hill 1898, 86–7, pl. II; Brown 1900a, 308; Doubleday and Page 1903, 238, 239–40; Page 1911, 601; Jessep 1913, 16, 19; Brown 1925, 351, 468; Clapham 1930, 140; Cottrill 1931, 52, appendix; Clapham 1947, 160; Cox and Jowitt 1949, 22, 56; Kendrick 1949, 46–7, pl. XLI.1; Green and Green 1951, 10, 33–9, pl. XII, diagram 9; Rice 1952, 99–101, pl. 16a; Gilbert 1954, 86; Stone 1955, 39–40; Blair 1956, 190; Rice 1960, 198–200, pl. IIIA; Deansley 1961, 349; Quirk 1961, 29, pl. VI.2; Fisher 1962, 393; Taylor 1962a, 169; Taylor 1962b, 19; Taylor and Taylor 1965–78, I, 76, 96, III, 1056; Radford 1966b; Taylor and Taylor 1966, 11; Pevsner and Lloyd 1967, 143; Gem 1973, II, 496, 498; Cramp 1975, 197–8; Light and Dampney 1980, 11; Rodwell 1981, 124, pl. 57; Service 1982, 149; Rodwell and Rouse 1984, 298–325, figs. 3, 5–7, 10, pls. XXXVI–IX; Tweddle 1986b, I, 73–5, 189–208, II, 357–9, III, pl. 26a; Coatsworth 1988, 169–70, 189, pl. Ic; Raw 1990, 52–3, 129, 194; Rodwell 1990, 163–5, pls. 6–7; Green n. d., i, 6

D.T.

## 2a–c. Imposts and inscribed voussoirs[1]

(Ills. 429–30, 433–7)

PRESENT LOCATION *in situ* on south porticus arch (inscription on north face)

EVIDENCE FOR DISCOVERY See no. 1.

a: H.   26 cm (10.2 in)   W.   92 cm (36.2 in)
   D.   50 cm (19.7 in)
b: H.   28 cm (11 in)   W.   89 cm (35 in)
   D.   55 cm (21.7 in)
c: (letters): H.   *c.* 15 cm (5.9 in)
   D.   Built in

STONE TYPE a-b, very pale orange to pale yellowish-brown, medium-to coarse-grained, oolitic limestone, in large blocks; Combe Down Oolite, Great Oolite Formation of the Bath area, Great Oolite Group, Middle Jurassic

1. The following are unpublished manuscript references to no. 2: BL Add. MS 37509, fol. 111v, item 119; BL Add. MS 37580, items 377, 682–90; BL Add. MS 47692, fol. 21v.

c, Greenish-grey, fine- to medium-grained, glauconitic sandstone; Hurdcot stone, Upper Greensand, Gault Group, Lower Cretaceous

PRESENT CONDITION a–b, chipped and partly recut; c, good (though in part renewed)

DESCRIPTION The jambs of the arch are of square section and support square imposts. That on the east side, (a), has the north and south faces cut back flush with the wall. The upper and lower edges of the west face are decorated with bold cable mouldings. The impost on the west side, (b), has its north face cut back flush with the wall, but the south face projects slightly and has the edges decorated with cable mouldings, as are the upper and lower edges of the east face. The arch head, (c), is also of square section and is composed of six non-radially jointed through stones.

D.T.

*Inscription* The inscription (Okasha 1971, 56; eadem 1992b, 334, 337, 340, 344; Gameson and Gameson 1993) is on the north face of the arch (Ills. 429–30, 433). The letters follow its curve, radiating from its centre and occupying the whole of the available area. They are large (ranging from about 13.1 and 15.5 cm (5.1 and 6.1 in) in height) and quite deeply cut. Three of the letters at the top of the arch (GEC) are cut onto an inserted modern block that is used to patch the face of the Anglo-Saxon through-stone. Hill noted that these three letters were cut on '. . . a piece of white stone inserted as a patch . . .', but he does not make it clear when the patching was done (Hill 1898, 85). It is likely that they were copied from the letters on the original, damaged, stone during this restoration. There may perhaps also have been some re-cutting of other letters at the same time. The letters are picked out in modern red paint. This replaces medieval colour observed at the time of the discovery, when the inscription was described as having been coloured red with '. . . a red line above and below the letters . . .' (Hill 1897a, 409; Tweddle 1990, 150). The letters are capitals and the language is Old English. There is no word-division or punctuation. Neither is there an initial or final cross to help resolve the question as to whether the text is complete in itself. The inscription may be transcribed:

## H/ERSꝥVT/ELAÐSEO[—ꝥ]YDRÆDN/ESÐE

Assuming that the modern letters GEC are an accurate copy of what originally stood in their place, the text may be read as follows:

## HER SꝹVTELAÐ SEO GECꝹYDRÆDNESS ÐE

Translation is more problematic. Okasha has suggested either 'Here is shown the agreement (or 'covenant') which —' or 'Here is shown the agreement (or 'covenant') to you' (Okasha 1971, 56; cf. Gameson and Gameson 1993). In the first case the text must be incomplete as it stands (see below, Discussion). More recently, taking the verb as being active and governing an object now missing, she offers revised alternative translations: 'Here the agreement reveals to you [that . . .]' or 'Here the agreement which . . . reveals . . . ' (Okasha 1992b, 337).

The lettering is bold and simple (Ills. 430, 432). The strokes are of more or less even breadth. There is no real seriffing but strokes seem to expand slightly towards the terminals. The details are, however, not very clear, as the carved edges are rather worn. The lettering is somewhat tall in proportion and somewhat tightly packed. In the effort to combine a large letter size with a relatively long text the designer also used the three ligatures (H/E, T/E, and N/E). The capitals approximate to the standard Roman forms with the following exceptions. A has a top which projects to the left but not to the right. (This detail seems to have been missed in the repainting.) The cross-bar of the A also projects to the left and within the letter it slopes down to the right. The diagonal of N (in ligature with E) meets the right vertical a little short of its base. S appears once in an angular variant and once in the standard round form. Y consists of a short diagonal on the left which meets the full-length diagonal on the right about half-way down. Capital forms of the Old English letters *eth* and *wynn* are used. The modern inserted block (Ill. 430) has square forms of C and G which may represent the forms of the original letters. (The G is similar to the fragmentary letter of no. 4 (see below).)

J.H.

DISCUSSION The paint observed in 1897 may have been original, but alternatively could represent a later medieval modification.

The arch can be dated by the fact that it is *in situ* in a fabric which can be placed in the late pre-Conquest period (Taylor and Taylor 1965–78, I, 94–6, fig. 42, pls. 405–6). Support for this dating derives from the use of cabled mouldings. Elsewhere in south-east England, as at Dartford, Kent, and Little Munden and Walkern 2 in Hertfordshire, these are exclusively a late phenomenon.

D.T.

*Inscription* The size of the lettering and the prominently architectural arrangement of the inscription on the extrados of an arch are both without parallel in surviving Anglo-Saxon inscriptions. The idea of large lettering prominently displayed in architecture derives ultimately from antique Roman models, but architectural inscriptions on a monumental scale might also have been known from early medieval Italy, as is clear from recent work at San Vincenzo al Volturno (Mitchell 1990, 205–11). It is possible that the use of the extrados as a field for an inscription might derive from the example of inscriptions in mosaic in some churches in Rome (see Introduction, p. 108) or elsewhere in Italy.

The very precise dating of the lettering to around 'the close of the reign of Ethelred II' (d. 1016) on the basis of lettering on coins (Green and Green 1951, 7) is unconvincing. Such precision is not possible with a purely palaeographical dating; furthermore, letters on coins are technically quite different (being formed with punches on the die) and seem often to have been independent of traditions of lettering in manuscript and on stone. The Breamore lettering would, however, fit well into the later tenth- or early eleventh-century period of the architecture with which it is likely to be contemporary (see Introduction, p. 112).

It is not certain whether the 'agreement' or 'covenant' referred to in the text is religious or legal in meaning. Okasha thinks it is more likely to be religious (Okasha 1971, 56), and the fact that the text is prominently displayed near what may have been the original position of the altar, at the east end of the nave, supports her view. Deansley, on the other hand, argues that the text is a 'legal record' and points to undeniable parallels for the wording in documents in Old English, although none is exact (Deansley 1963, 350–1). She cites several examples of documents opening with the clause: '*her swutelað*'. *Gecwidrædness* is not otherwise attested (Napier 1903–6, 292–3), but *gecwidrædden* 'agreement', 'contract', etc.) is known (Bosworth and Toller 1898, *s. v.*). A new study of this inscription provides a very thorough examination of its text and suggests an ingenious interpretation of its meaning (Gameson and Gameson 1993). The authors argue that the statement in the inscription is complete in itself and that it should be translated as: 'Here is made manifest the covenant to you.' The covenant is that given by God to Noah after the flood (*Genesis* 9, 8–17) and the arch itself could have been an iconographic representation of the sign of that covenant, the rainbow (*arcum*). Such a text might well

have referred to the function of the porticus beyond the arch, perhaps as a private chapel or baptistery.

Nos. 3–4 show that 2c was probably not the only architectural inscription on the original fabric of the church. The lost arches to the north, east and west might have carried comparable inscriptions. If a single text were to be read over the inner faces of the four arches of the crossing, it would presumably have followed the normal left to right direction of reading. If, therefore, the text began on the surviving southern arch—and *her swutelað* sounds like the opening of a text—it would have concluded on the eastern arch which opened into the chancel. Alternatively, some or all of the arches could also have carried texts that were complete in themselves.

<div style="text-align:right">J.H.</div>

DATE Later tenth to early eleventh century

REFERENCES Hill 1897a, 409; Hill 1897b, 233, fig. on 233; Hill 1898, 85–6, pl. I; Micklethwaite 1898, 346; Brown 1900b, 338, fig. 15; Doubleday and Page 1903, 234, 237; Napier 1903–6, 292–3; Förster 1906, 448–9; Page 1911, 600, pl. facing 600; Jessep 1913, 16, fig. 1; Brown 1925, 234, fig. 143; Rivoira 1933, II, 192, fig. 615; Clapham 1947, 160; Clapham 1948, 7; Cox and Jowitt 1949, 56–7, pl. 15; Green and Green 1951, 6–7, pl. VI; Blair 1956, pl. X; Deansley 1961, 351; Fisher 1962, 392, pl. 226; Taylor and Taylor 1965–78, I, 96, II, pl. 406; Radford 1966b; Taylor and Taylor 1966, 50; Pevsner and Lloyd 1967, 143; Fisher 1969, 153, fig. on 71; Okasha 1969, 29; Okasha 1971, 56, fig. 15; Cunliffe 1973, pl. on 43; Light and Dampney 1980, 11; Tweddle 1986b, I, 66–7, 70, 166, 170, II, 359–60, III, pls. 26b–27; Rodwell 1990, 165; Tweddle 1990, 150; Gameson and Gameson 1993; Green n. d., 4–5

## 3. Inscription[1]                                      (Ill. 431)

PRESENT LOCATION Built in above the chancel arch on the west face, just south of its apex

EVIDENCE FOR DISCOVERY See no. 1.

H.   *c.* 20 cm (8 in)   W.   (max.) 54 cm (21.25 in)
D.   Built in

STONE TYPE Inaccessible, but colour appears to be greenish; possibly Upper Greensand, Gault Group, Lower Cretaceous

PRESENT CONDITION Bruised and unweathered

DESCRIPTION The stone is sub-rectangular; the upper

1. The following are unpublished manuscript references to no. 3: BL Add. MS 37509, fol. 111v; BL Add. MS 37580, items 682–90.

and left-hand edges are roughly squared and the broken lower edge slopes slightly downwards. The roughly broken right-hand edge slopes up to the right, cutting off the lower part of the last letter of the (slightly deteriorated) inscription.

<div style="text-align:right">D.T.</div>

*Inscription* The letters (Okasha 1971, 56), which are boldly cut, seem to be *c.* 20 cm (8 in) high, that is, a little larger than those of no. 2c. They are capitals, and read:

—DE[S]—

The two complete letters, and probably also the fragmentary S, are of the standard Roman capital form. The language and meaning of this fragment are uncertain.

<div style="text-align:right">J.H.</div>

DISCUSSION This piece is clearly *ex situ* and is normally assumed to have been a voussoir (or part of one) from an arch-head similar to that opening into the south porticus (see no. 2). It may be from the destroyed pre-Conquest chancel arch or north porticus arch. The shape of the stone provides no supporting evidence for this hypothesis; only the upper edge may be original, but this is partially overlain by later plaster and it is not clear if its slight curvature is an original feature or the result of reuse. Whether or not the letters are arranged in a straight line or on a slight curve is impossible to ascertain without photography or drawing in the same plane as the stone. The fragment presumably reached its present position when the chancel arch was rebuilt in the fifteenth century, and it was used to patch the wall above the newly inserted arch head.

<div style="text-align:right">D.T.</div>

*Inscription* The style of cutting and letter forms are similar to those on no. 2c. The letters seem, however, to have been a little taller and to have had rather more definite serifs than on the latter. The forms are not diagnostic enough for dating, but there is no reason why this lettering should not be contemporary with that of no. 2c.

<div style="text-align:right">J.H.</div>

DATE Tenth or eleventh century

REFERENCES Hill 1898, 85; Doubleday and Page 1903, 237; Page 1911, 600; Clapham 1947, 160; Green and Green 1951, 7; Fisher 1962, 392; Taylor and Taylor 1965–78, I, 96; Radford 1966b; Pevsner and Lloyd 1967, 143; Okasha 1969, 29; Okasha 1971, 56, fig. 16; Light and Dampney 1980, 11; Tweddle 1986b, I, 70, 167, 170, II, 361, III, pl. 28a; Gameson and Gameson 1993, 2; Green, n. d., 5

**4. Inscription**                                    (Ill. 432)

PRESENT LOCATION Built into west wall of nave, outside, close to the ground

EVIDENCE FOR DISCOVERY First recorded by Light and Dampney in early 1970s

H.   9 cm (3.5 in)   W.   14 cm (5.5 in)
D.   Built in

STONE TYPE Very pale orange, medium- to coarse-grained, oolitic limestone; Combe Down Oolite, Great Oolite Formation of the Bath area, Great Oolite Group, Middle Jurassic

PRESENT CONDITION Lightly weathered

DESCRIPTION *Inscription* What seems to be the lower part of a letter, almost certainly a square version of capital G (Okasha 1983, 88), remains, and is set sideways with its left side to the ground:

—[G]—

J.H.

DISCUSSION Like the chancel arch the west wall of the church is a fifteenth-century rebuild. It appears that parts of a pre-Conquest inscription, possibly from the original chancel arch, or north porticus arch were reused as building material in these operations.

D.T.

*Inscription* Square G of this sort could easily be contemporary with no. 2, and is in fact used on the modern insert in no. 2 which may well preserve the original letter forms (see no. 2). The deep cutting and the slightly expanded terminal are comparable to those of no. 2c. The surviving height of the letter is about 9 cm (3.5 in) so it is of a large format similar to that of nos. 2c and 3. The stone type has been identified as being the same as that used for the imposts (nos. 2a–b) of the arch that opens to the southern porticus (but not for the voussoirs which carry the inscription, no. 2c). It is likely that this inscription came from another architectural inscription contemporary with no. 2c.

J.H.

DATE Tenth or eleventh century

REFERENCES Light and Dampney 1980, 11; Okasha 1983, no. 160, pl. Ib; Rodwell and Rouse 1984, 317; Tweddle 1986b, I, 70, 167, 170, II, 361–2, III, pl. 28b

# CORHAMPTON, Ha. (dedication unknown)

## SU 610203

**1. Sundial**[1]                                    (Ill. 438)

PRESENT LOCATION *in situ* in the south nave wall, just east of the south porch

EVIDENCE FOR DISCOVERY First recorded in Haigh 1846

H.   57 cm (22.4 in)   W.   45 cm (17.7 in)
Diameter of dial 29 cm (11.4 in)
D.   Built in

STONE TYPE Grey (with a greenish tinge and a variable yellow or red-brown lichen coating) limestone, composed of close-packed shell-fragment moulds; Quarr stone, Bembridge Formation, Palaeogene, Tertiary; Isle of Wight

1. The following are unpublished manuscript references to no. 1: BL Add. MS 37601, items 533, 552, 556; BL Add. MS 47962, fol. 18r.

PRESENT CONDITION Heavily weathered

DESCRIPTION On a sub-rectangular panel is a circular dial in relief, its frame delimited by an incised line paralleling its edge. In the centre is a drilled gnomon hole. The lower part of the dial is calibrated; the lines of calibration are incised. There is a pair of horizontals, a vertical, and a line mid-way between each horizontal and the vertical. The vertical and the lines to the right are crossed close to their ends, the ends of the cross-bar and principal lines being drilled. To the left, only the horizontal with its drilled end, and the inner end of the intermediate line survive. Above and below, and to each side of the dial are bulbous protrusions in relief, narrowing towards the dial. Between each pair a narrow relief stem develops from the dial and runs into the corner of the slab where it terminates in three long, narrow, convex-sided, hollowed leaves.

DISCUSSION The near-by dial from Warnford (no. 1; Ill. 478) and that from Winchester St Michael's (no. 1; Ill. 671), together with the present example, form a clear group. All use a circular dial on a square stone. They all share the same calibration, with the lower half of the dial only calibrated, the mid-tide lines crossed near their ends, and the use of drilled holes to end some of the lines, although there are minor variations between dials. They all have foliate ornament filling the corners. At Winchester and Warnford this ornament consists of conventionalized fleur-de-lys trefoil leaves. On no. 1 the leaf sprays are more realistic, consisting of three leaves on a longer stalk. The bulbous features between the leaf sprays, and forming a cross, are unique to the present stone. They appear to be derived from the Ringerike style, which employs just such a motif, as on a grave-cover from London (City 1; Ill. 353). If so, then this motif helps to fix the date of the present dial in the first half of the eleventh century.

DATE Eleventh century

REFERENCES Haigh 1846, 408, 414, fig. on 408; Hussey 1852, 199; Haigh 1857, 177–8, fig. on 178; Way 1868, 211; Haigh 1879, 135, 155–6, fig. on 156; Slessor 1888, 7–8; Allen 1889, 201; Gatty 1889, 424; Syers 1899, 18; Brown 1900b, 337; Doubleday and Page 1903, 240–1; Nisbett 1905–7, 37; Johnston 1907, 17; Page 1908a, 252; Jessep 1913, 17, fig. 5; Green 1926, 19–20, pl. V; Green 1928, 498–9; Cottrill 1931, appendix; Clapham 1935b, 415; Cole 1939, 148; Zinner 1939, 8, taf. 20, abb. 33; Green 1943, 269, 273; Cox and Jowitt 1949, 22, 71, 178; Green and Green 1951, 57, pl. XIX; Crowley 1956, 176; Fisher 1959, 95; Taylor 1962a, 169; Zinner 1964, IV, 65–6, 210, 216, abb. 7; Taylor and Taylor 1965–78, I, 178; Radford 1966a, 189; Taylor and Taylor 1966, 19–20, fig. 8; Bowen and Page 1967, 288; Pevsner and Lloyd 1967, 182; Tweddle 1986b, I, 84, 166, 170, 187–8, II, 374–5, III, pl. 38b

D.T.

## 2. Pilaster base                                                    (Ill. 440)

PRESENT LOCATION South-west pilaster of the nave

EVIDENCE FOR DISCOVERY First recorded in Page 1908a

H.   20 cm (8 in)   W.   24 cm (9.5 in)
D.   5.5 cm (2.2 in)

STONE TYPE Grey (with a greenish tinge and a variable yellow or red-brown lichen coating) limestone, composed of close-packed shell-fragment moulds; Quarr stone, Bembridge Formation, Palaeogene, Tertiary; Isle of Wight

PRESENT CONDITION Weathered

DESCRIPTION The base is wider than the pilaster and decorated with a pair of prominent, outward-facing volutes having an S-shaped profile, flanking a bulbous median feature.

DISCUSSION Apart from the bases catalogued below (nos. 3, 4c–d), three others may have had similar decoration. The south-east pilaster of the nave has been largely cut away, and the north-east pilaster of the chancel is masked by a Victorian vestry. No trace of decoration survives on the base of the median pilaster on the west wall. The incorrect reconstruction proposed by Taylor and Taylor for the pilaster bases from this site is apparently based on the south-east pilaster of the chancel, which is heavily weathered. The present well-preserved base is concealed by a grave-stone and escaped their notice.

As with the other sculptures from this site, the dating evidence depends closely on the architectural dating of the fabric. Taylor and Taylor suggested a date in the second half of the eleventh century (Taylor and Taylor 1965–78, I, 177), though, if the date suggested above for the sundial is correct, a date rather earlier in the eleventh century is possible.

DATE Eleventh century

REFERENCES Page 1908a, 252; Green and Green 1951, 13; Taylor and Taylor 1965–78, I, 177, fig. 75; Radford 1966a, 188; Taylor and Taylor 1966, 33; Tweddle 1986b, I, 68–9, 170–1, II, 376, III, fig. 24, pl. 39a

D.T.

## 3. Pilaster base                                                    (Ill. 439)

PRESENT LOCATION South-east pilaster of the chancel

EVIDENCE FOR DISCOVERY See no. 2.

H.   17 cm (6.7 in)   W.   17 cm (6.7 in)
D.   5 cm (2 in)

STONE TYPE Grey (with a greenish tinge and a variable yellow or red-brown lichen coating) limestone, composed of close-packed shell-fragment moulds; Quarr stone, Bembridge Formation, Palaeogene, Tertiary; Isle of Wight

PRESENT CONDITION Very heavily weathered

DESCRIPTION Originally decorated in the same manner as no. 2, but now heavily weathered.

DISCUSSION See no. 2.

DATE Eleventh century

REFERENCES Page 1908a, 252; Green and Green 1951, 13; Taylor and Taylor 1965–78, I, 177, fig. 75; Radford 1966a, 188; Taylor and Taylor 1966, 33; Tweddle 1986b, I, 68–9, 170–1, II, 377–8, III, pl. 40b

D.T.

### 4a–d. Doorway with bases and imposts

(Ills. 442–6)

PRESENT LOCATION *in situ* in stripwork surrounding blocked north door of nave, outside

EVIDENCE FOR DISCOVERY First recorded in Wright 1844

H.  *c.* 18 cm (7 in)   W.   18 cm (7 in)
D.   5 cm (2 in)

STONE TYPE Grey (with a greenish tinge and a variable yellow or red-brown lichen coating) limestone, composed of close-packed shell-fragment moulds; Quarr stone, Bembridge Formation, Palaeogene, Tertiary; Isle of Wight

PRESENT CONDITION Intact; moderately heavily weathered

DESCRIPTION The doorway of which the surviving stripwork would have formed the outer surround has disappeared in a later blocking and is covered by render.

The semicircular arch is supported at each side on an impost block. The eastern one, (a) (Ill. 445), has an outer face decorated with a broad median roll moulding, flanked above by a narrower roll moulding with a vertical fillet above and below. Beneath is a similar group of mouldings. The sides of the block are undecorated. The western impost, (b), was probably of identical form, but is more heavily weathered, blurring and obscuring the detail.

The imposts are carried on pilasters. Each terminates in a bulbous base (Ills. 444, 446) standing on a square block, and separated from the pilaster by a roll moulding. The lowest element of the pilaster is in each case carved from the same piece of stone as the base.

DISCUSSION See no. 2.

DATE Eleventh century

REFERENCES Wright 1844, 34; Brown 1925, 405, 449, fig. 191H; Clapham 1935a, 415; Green and Green 1951, 11–12, diagram 3 on 13; Taylor and Taylor 1965–78, I, 177, fig. 75, II, pl. 440; Pevsner and Lloyd 1967, 182

D.T.

# HANNINGTON, Ha. (All Saints)

## SU 539554

### 1. Sundial

(Ill. 441)

PRESENT LOCATION Built into south wall of nave, outside, east of blocked doorway

EVIDENCE FOR DISCOVERY First noticed by M. J. Hare in early 1970s; presumably exposed during plaster stripping, as not mentioned in Taylor and Taylor 1965–78

Diameter 38.5 cm (15 in)
D.   Built in

STONE TYPE Pale yellowish-grey (10YR 8/1–2), medium-grained, shelly oolitic limestone with numerous polyzoa fragments; Bath stone, possibly Ancliff Oolite, Great Oolite Formation, Great Oolite Group; Middle Jurassic; Bradford on Avon

PRESENT CONDITION Intact, somewhat bruised, and moderately heavily weathered

DESCRIPTION The stone is circular with a plain outer frame delimited by an incised line. There is a central circular gnomon hole, irregularly splayed towards the front. The calibration, in incised lines, consists of the mid tide lines at 6 am and 6 pm extending roughly horizontally to touch the edge of the stone. The mid tide lines at 9 am, noon, and 3 pm, touch the inner edge of the frame, and are crossed short of their ends. The ends of the line and the cross-arm terminate in drilled holes. The intervening lines, at 7.30 am, 10.30 am, 1.30 pm, and 4.30 pm, marking the beginnings and ends of the tides, terminate on the inner edge of the frame; they are not crossed.

DISCUSSION The calibration of the dial is done in the standard pre-Conquest fashion, employed also at Corhampton, Warnford, and Winchester St Michael 1 in Hampshire. The dial itself, however, is circular, as opposed to circular on a rectangular frame as with the other Hampshire dials. The close comparison between these dials, at least in calibration, suggests a similarity in date. That would suggest a date for the present dial in the eleventh century. Taylor and Taylor have assigned parts of the nave walls of the church at Hannington to the tenth or eleventh centuries (Taylor and Taylor 1965–78, I, 282–3), and it may be that the dial is actually still *in situ*.

DATE Tenth to eleventh centuries

REFERENCES Hare 1980, 199–201, fig. 4

D.T.

# HEADBOURNE WORTHY, Ha. (St Swithun)

SU 487320

## 1. Crucifixion[1]                                            (Ills. 448–50)

PRESENT LOCATION *in situ*, built externally into west wall of nave above door from western annexe

EVIDENCE FOR DISCOVERY First recognized as Anglo-Saxon in 1845 (Carter 1845; Haigh 1846)

H.   *c*. 327 cm (129 in)   W.   (across arms) 284 cm (112 in)

D.   Built in

STONE TYPE Light grey (emulsion painted) stone composed of closely packed shell-fragment moulds; Quarr stone, Bembridge Formation, Palaeogene, Tertiary; Isle of Wight

PRESENT CONDITION Largely defaced

DESCRIPTION The cross is composed of three stones, one forming the vertical limb, and two others the horizontal limbs. The figure of Christ has been cut back flush with the wall, and there is an irregular concavity in the position of the head. The surviving outline of the figure reveals that it was nimbed, frontally-placed, with the arms stretched out horizontally and the legs straight. Above the cross is the mutilated Hand of God issuing from a cloud, the texture of which is suggested by a series of receding, stepped, undulations. The cloud is carved on three stones wider than, but integral with the string-course of square section which crosses the gable. To the left of the cross the inward-facing figure of the Virgin is carved on a separate stone which abuts the horizontal arm of the cross above, and extends beyond the foot of the cross below. The figure is mutilated but was originally robed, and nimbed. In the corresponding position to the right is the mutilated figure of St John. Only a fold of his robe to the lower right has escaped destruction.

DISCUSSION Slessor, writing in 1888, noted that a sculptured hand had been discovered used as filling in the hollow in the position of the head of Christ, probably during the restoration of the annexe by G. E. Street, 1865–6. It is likely that the hand originally belonged to the one of the figures of the crucifixion group. It has since been lost.

It is likely that the area of chiselling at the base of the foot of the cross, just above the west door, represents a feature of the crucifixion group which, like the figures, has been destroyed. The most likely feature is a serpent which occupies this position on the crucifixion at Bitton, Gloucestershire (Taylor and Taylor 1965–78, I, fig. 33).

DATE Tenth to eleventh century

REFERENCES Carter 1845, 2–3, pl. II; Haigh 1846, 412, fig. on 412; (——) 1846; Allen 1887, 247; Slessor 1888, 8, 10, 13–14, pl. facing 13; Allen 1889, 198; Nisbett 1891–3, 311; Hill 1898, 87; Yarborough 1898–1903, 228; Brown 1900a, 308; Brown 1900b, 337; Keyser 1904, liii; (——) 1911; Prior and Gardner 1912, 132–3; Jessep 1913, 19; Brown 1925, 351, 458; Doubleday and Page 1903, 239; Page 1911, 398, 429; Porter 1928, 6; Clapham 1930, 140; Cottrill 1931, 52, appendix; Cox and Jowitt 1949, 22, 96; Kendrick 1949, 46; Gardner 1951, 45; Green and Green 1951, 33–7, pl. XI; Rice 1952, 99–100, 101, 113, pl. 16b;

---

1. The following are unpublished manuscript references to no. 1: BL Add. MS 37601, items 523, 532–5, 541; BL Add. MS 39986, item 132; BL Add. MS 47691, fol. 40v.

Gilbert 1954, 86; Rice 1960, 198; Quirk 1961, 28–9, 33, pl. VI; Fisher 1962, 393; Taylor 1962a, 169; Taylor 1962b, 19; Taylor and Taylor 1965–78, I, 291, fig. 128, III, 1056; Taylor and Taylor 1966, 4–6, 12, fig. 1; Pevsner and Lloyd 1967, 285; Gem 1973, II, 496, 498; Coatsworth 1979, I, 292–3, II, 26–7, pl. 149; Fernie 1983b, 150; Rodwell and Rouse 1984, 314, 317–18; Tweddle 1986b, I, 73–5, 189–208, II, 392–4, III, pl. 52b–53a; Coatsworth 1988, 170–1, 190, pl. 1d; Raw 1990, 53, 208

D.T.

**2.** See Appendix A, p. 335.

# LITTLE SOMBORNE, Ha. (All Saints)

## SU 382327

### 1a–c. Three fragments                              (Ill. 447)

PRESENT LOCATION Fixed into a rectangular slab of concrete, on display on the south splay of the west window

EVIDENCE FOR DISCOVERY Discovered built into fabric during restoration in 1970s

a: H.   12.5 cm (5 in)   W.   17.5 cm (6.9 in)
b: H.   13.5 cm (5.3 in)   W.   12.5 cm (5 in)
c: H.    5.5 cm (2.3 in)   W.   10.5 cm (4.25 in)

STONE TYPE Granular limestone (covered with pale yellow limewash), including rounded grains of about 0.4 mm diameter and rod-like bodies 1–2 mm long and many irregular pore spaces; origin uncertain, either Calcareous Tufa from Recent alluvial deposits of the River Test, or a variety of Bembridge limestone, Bembridge Formation, Palaeogene, Isle of Wight

PRESENT CONDITION All edges roughly broken, the carving chipped and bruised

DESCRIPTION Three irregular sculptured fragments; the edges are all broken and the pieces do not fit together. However, the stone type and decoration are identical and it is probable that they came from the same piece.

a: Sub-rectangular in shape, decorated at the upper end with a pair of crossing median-incised interlace strands. The central portion is decorated with a hatched and contoured tapering animal body curving down from the upper left to lower right, where it is transformed into a median-incised strand interlacing with others.

b: Sub-triangular in shape and decorated with either a double-incised interlace strand, or contoured animal body, curving down from the upper left to lower right, and interlacing with other strands.

c: Sub-rectangular in shape and decorated with two median-incised interlace strands, one looping around the other.

DISCUSSION The three fragments have very similar decoration and may come from the same piece. It is impossible to be certain what function that piece served, but the decoration, consisting of hatched and contoured animals enmeshed in interlace, is particularly common on cross-shafts. In Hampshire, there are examples from Upper Brook Street in Winchester (no. 1; Ill. 683), and Steventon (no. 1; Ills. 471–2). It is possible that the fragments were chipped from the decorated faces of a cross-shaft when it was later reshaped for use as building material.

The close comparison between the decoration of these fragments and that of the group of animal and interlace decorated sculptures distributed principally in south-western England, (above p. 37), serves to place them in the late eighth or early ninth century. This is a date earlier than that which can be suggested for the fragmentary surviving late Anglo-Saxon fabric at Little Somborne.

DATE Late eighth or early ninth century

Unpublished

D.T.

NEW ALRESFORD, **1–2.** See Appendix B, p. 341.

# ROMSEY, Ha. (abbey, St Mary)

## SU 351213

## 1. Crucifixion[1]                              (Ills. 451–2, 456)

PRESENT LOCATION Built externally into the west wall of the south transept

EVIDENCE FOR DISCOVERY First recorded by J. Carter in 1781

H.   225 cm (88.5 in)   W.   (across arms) 179 cm (70.5 in)

D.   Built in

STONE TYPE Greyish-yellow, medium- to coarse-grained, shelly, oolitic limestone with calcite veinlets; Combe Down Oolite, Great Oolite Formation of the Bath area, Great Oolite Group, Middle Jurassic

PRESENT CONDITION Chipped and weathered

DESCRIPTION The cross is composed of three stones, one forming the vertical and two others the horizontal limbs. The figure is frontally placed with the arms outstretched horizontally, and the legs straight. The figure has a cruciform nimbus, and looks slightly to the left. The top of the head is dressed flat, and the face is bearded, although the other facial features are heavily weathered. The figure is naked to the waist, and the musculature of the chest and arms is well modelled, a short section of the figure's right upper arm being cut away, and the left hand and forearm extensively damaged. The figure wears a knee-length robe clinging tightly to the thighs, and with the upper edge falling in a triangular fold between the legs. The legs are well modelled, and the feet placed side by side on a *suppedaneum* having a downward-sloping upper face. Above the figure the Hand of God issues from a cloud forming a lobe on either side of the sleeved wrist, the texture of the cloud is indicated by tight relief scrolls. The upper edge of the cloud is co-terminus with the upper edge of the vertical limb of the cross.

DISCUSSION The flattening of the head of the figure and the absence of the upper arm of the cross within the nimbus strongly suggest the original presence of a metal crown, later removed. As noted above (Chap. VII), there is good documentary evidence for the use of metal crowns with pre-Conquest crucifixion groups. The crucifixion may originally also have had accompanying figures as at Breamore 1 (Ill. 425), Langford 1, Oxfordshire (Ill. 293), and Headbourne Worthy 1 (Ills. 448–50), but if so, no trace of them remains. The figure of Christ is in repose, a type encountered elsewhere in south-east England only at Headbourne Worthy 1, Hampshire. For further discussion, see Chap. VII.

DATE Tenth century

REFERENCES Carter 1780–94, I, pl. II; Spence 1841, 22–3; Carter 1845, 2; Ashpitel 1846, 422–3, fig. on 423; Twining 1852, 6, pl. II.25; Allen 1887, 164, fig. 45; Hill 1898, 86; Yarborough 1898–1903, 228; Marshall 1900, 166–7; Doubleday and Page 1903, 240; Keyser 1904, liii; Liveing 1906, 36–7; Mason 1907, 260; Perkins 1907, 32–4, pl. on 33; Dalton 1908, 229; Page 1911, 398, 467; Prior and Gardner 1912, 133, 137, fig. 113; Thompson 1924, 337; Longhurst 1926, 22; Clapham 1930, 138, pl. 61; Cottrill 1931, 52, appendix; Casson 1932, 273–4, pl. IIA; Casson 1933, 35; Rivoira 1933, II, 208, fig. 640; Rice 1947, 9, 13–14, frontispiece; Cox and Jowitt 1949, 22, 142, 180, pl. 41; Kendrick 1949, 48–50; Clapham 1951, 192–3, pl. IIa; Gardner 1951, 45–6, fig. 71; Green and Green 1951, 33–43, pl. XB; Zarnecki 1951a, 152; Rice 1952, 83, 85, 98–9, pl. 13; Stone 1955, 40–1, pl. 21; Poole 1958, 491; Fisher 1959, 89; Rice 1960, 198, pl. IIA; Quirk 1961, 29; Fisher 1962, 393; Pocknee 1962, 65; Taylor 1962a, 169; Taylor 1962b, 19; Taylor and Taylor 1965–78, II, 521–2; Radford 1966c, 219–20; Taylor and Taylor 1966, 12; Zarnecki 1966, 89, 92, 98; Pevsner and Lloyd 1967, 17, 486; Cramp 1972, 146, taf. 69.2; Gem 1973, II, 496–7; Cramp 1975, 198; Coatsworth 1979, I, 281–5, II, 41–2, pl. 141; Dodwell 1982, 118; Service 1982, 177; Fernie 1983b, 150; Rodwell and Rouse 1984, 318; Wilson 1984, 196, pl. 257; Tweddle 1986b, I, 73–5, 189–208, II, 449–50, III, pls. 80–81a; Coatsworth 1988, 168–9, 192, pl. Ib; Raw 1990, 58, 118, 129, 150–1, 242

D.T.

## 2. Crucifixion panel[2]                        (Ills. 453, 455)

PRESENT LOCATION Built into the reredos of the altar of the chapel of St Anne, at the east end of the south choir aisle

---

1. The following are unpublished manuscript references to no. 1: BL Add. MS 29925, fol. 112r; BL Add. MS 37178, fol. 223r; BL Add. MS 37601, items 527–8, 533; BL Add. MS 33650, fols. 200v–201r; BL Add. MS 47691, fol. 46r; Society of Antiquaries MS, Red Portfolios, Hampshire, A-S, fol. 23r.

2. The following are unpublished manuscript references to no. 2: BL Add. MS 37178, fol. 223r; BL Add. MS 37601, item 531.

EVIDENCE FOR DISCOVERY Unidentified account of 1742 records that panel then 'stood by itself behind the communion table on the south wall' (Liveing 1906); apparently later lost and rediscovered by the Rev. E. L. Berthon (vicar 1860–92) built face-inwards into walling of chapel of St Mary in retro-choir (i.e. presumably in blocking of arch to former Lady Chapel)

H.   74 cm (29 in)   W.   44.5 cm (17.5 in)
Built in

STONE TYPE Pale yellow, fine-grained limestone, with signs of cavernous weathering; Caen Stone, Calcaire de Caen Formation, Bathonian, Middle Jurassic; Caen, Normandy

PRESENT CONDITION Good

DESCRIPTION On a narrow rectangular panel (the upper and lower edges being the shorter) is a low-relief cross standing on a double-stepped base which in turn rests on the lower edge of the panel. The head of the cross and each of the horizontal arms terminates in a narrow cross-piece, that of the head touching the upper edge of the panel. The nimbed figure of Christ is frontally placed, with the arms stretched out horizontally, and the legs straight and reaching barely half-way down the lower limb of the cross. The feet are out-turned. To the left of the head of the cross is a frontally-placed, one-third length angel which is nimbed and robed, with drilled eyes and an incised mouth. The left hand is raised, palm-outwards, towards the head of Christ, and in its right hand is a sceptre held at an angle. Its wings are spread. To the right is a similar angel, a mirror image of the first, except that its facial features and the tip of the sceptre are lost. On the lower edge of the panel, to the left, stands a figure with its left leg raised and bent at the knee. The figure wears a knee-length garment, and holds in both hands a long-stemmed spear, the point of which touches the chest of Christ. To the right is a similar figure holding in its left hand a long pole with a circular sponge on the end which touches the lower limb of the cross at the level of Christ's waist. In the figure's right hand is a cloth. Above the figure to the left the robed and nimbed figure of the Virgin is half-turned towards the cross, with her left hand raised, palm outwards. She wears a long robe reaching to the ankles, a cloak, and a head covering. In the corresponding position to the right the robed and nimbed figure of St John has a similar attitude. From the stem of the cross, at the level of the waists of the lower flanking figures, develop plant sprays. That to the left has a fleshy, upturned leaf with a lobed end,

and a similar, smaller leaf curving down to touch the thigh of the flanking figure. To the right an undulating stem, having two subsidiary downward-curling stems, flanks the cross, terminating in a triangular leaf on the level of the waist of St John. From the lower edge of the panel, to the right, below the right foot of the lower figure, develops a bulbous plant stem which divides into two fleshy backward-curling leaves. From the lower edge of the panel, to the left, develops a plant stem which rises vertically to touch the figure, and having a subsidiary leaf developing to the right.

DISCUSSION The function of this panel is difficult to establish, but, like the closely-related panel from Stepney in London, it must stand in some sort of relationship to the large-scale crucifixion groups also encountered in south-east England, such as no. 1 from this site, Langford 1–2 in Oxfordshire, and Breamore 1 and Headbourne Worthy 1 in Hampshire. Outside the area of the present study there are similar crucifixion panels at Daglingworth, Gloucestershire (Taylor and Taylor 1966, 15–16), Hexham, Northumberland (ibid., 16); Marton, Lincolnshire (ibid., 16), Westow, Yorkshire (ibid., 17–18, fig. 6), and Wormington, Gloucestershire (ibid., 13–14, fig. 5). All of these panels are *ex situ*, so their original functions are difficult to assess, but it has been suggested that they originally formed part of the interior fittings of the church, and were, perhaps, used in conjunction with the altars (Taylor and Taylor 1965–78, III, 1056; Taylor 1975, 167–8).

As noted in Chap. V, the acanthus sprays employed on the panel find their best parallels in works of the early tenth century, such as the St Cuthbert stole of *c.* 909–16 (Battiscombe 1956, pl. XXXIV) and the Aethelstan Psalter (Temple 1976, no. 5, ill. 33) traditionally associated with the reign of king Aethelstan, 924–39. There are, however, features pointing to an earlier date, notably the round staring eyes of the figures and the flat, linear treatment of the drapery, feature paralleled in west midland styles of the ninth century (Cramp 1972, 146).

DATE Ninth century

REFERENCES Yarborough 1898–1903, 228; Doubleday and Page 1903, 238, pl. facing 238; Liveing 1906, 36, pl. facing; Mason 1907, 260; Perkins 1907, 56–9, pl. facing 56; Dalton 1908, 229; Page 1911, 467; Prior and Gardner 1912, 137; Thompson 1924, 337; Cottrill 1931, 52–3, appendix; Casson 1933, 26; Rice 1947, 11; Cox and Jowitt 1949, 142, pl. facing 148; Kendrick 1949, 48, pl. XL.3; Green and Green 1951, 34–5, 53, pl. XA; Rice 1952, 108, pl. 18b; Stone 1955, 40; Fisher 1959, 89; Fisher 1962, 393;

Taylor and Taylor 1965–78, II, 522; Radford 1966c, 220; Taylor and Taylor 1966, 12–13; Pevsner and Lloyd 1967, 485, pl. 8; Cramp 1972, 146, taf. 69.1; Cramp 1975, 198; Coatsworth 1979, I, 278–81, II, 41, pl. 140; Tweddle 1983b, 28; Tweddle 1986b, I, 75–6, 155–6, II, 451–3, III, pl. 81b; Coatsworth 1988, 167–8, 191–2, pl. Ia

D.T.

# SONNING, Brk. (St Andrew)

## SU 756755

### 1. Fragment of panel                    (Fig. 37; Ill. 454)

PRESENT LOCATION Built into the south-west face of the western buttress of the north aisle

EVIDENCE FOR DISCOVERY First recorded in Cotton 1881–2

H.   22 cm (8.7 in)   W.   32 cm (12.6 in)
D.   Built in

STONE TYPE Pale greyish-yellow, oolitic limestone, with cross-bedding shown by shelly streaks; possibly Taynton stone, Taynton Stone Formation, Great Oolite Group, Middle Jurassic

PRESENT CONDITION Broken and worn

DESCRIPTION The lower, original, edge is horizontal with a plain raised border; the left and right-hand edges are vertically broken and the upper edge horizontally broken. The upper left-hand corner is lost.

*A (broad):* From the upper edge, to the right of the vertical axis of the panel, develops a concave-sided, rounded-ended cross-arm, type E6, stopping short of the half-round border moulding along the lower edge. The edges of the arm are paralleled by an incised line. Abutting the arm, to the left, is an incomplete ring-knot based on three concentric circles with interlacing diagonals. Two of the strands are carried between the lower border and the end of the cross-arm, where they cross, and off to the right. To the right a single strand abuts the arm; the rest of the interlace is lost.

DISCUSSION The fragment is probably to be reconstructed as a square decorated with a free-armed cross with a circular interlace in each of the re-entrant angles. As noted above (Chap. IV), it may be part of a closure screen, or alternatively, part of a box altar or shrine, both features which employ decorated slabs.

FIGURE 37
Sonning 1, reconstruction, nts

The evidence for the dating of this panel is ambiguous. The use of a free-armed cross might suggest a date before the tenth century, by which time ring-heads and their derivatives predominated. In contrast, the use of closed circuit loops in the interlace points to a late date, as this feature does not normally occur before the tenth century (Collingwood 1927, 65, 68). A late date may be confirmed by the uneven laying-out of the decoration, a feature more characteristic of later Anglo-Saxon interlaces than of earlier material. On this basis, perhaps a late date is to be preferred.

DATE Tenth to eleventh century

REFERENCES Cotton 1881–2, 1; Collingwood 1927, 183; Cottrill 1931, appendix; Lamborn 1937, 122; Tweddle 1986b, I, 81–2, 185–6, II, no. 155, III, fig. 5, pl. 94b

D.T.

# SOUTHAMPTON, Ha.

## SU *c.* 4211

### 1a–b. Two fragments of cross-shaft  (Ills. 457–64)

PRESENT LOCATION Gods House Tower Museum. No accession number

EVIDENCE FOR DISCOVERY None. First recorded by P. M. Johnston in 1933 (Green and Green 1951)

a: H.   35 cm (13.8 in)   W.   24 cm (9.5 in)
   D.   12 cm (4.7 in)
b: H.   22 cm (8.7 in)   W.   14 cm (5.5 in)
   D.   7 cm (2.8 in)

STONE TYPE Pale greyish-yellow, medium-grained, slightly shelly, oolitic limestone with calcite veinlets; Combe Down Oolite, Great Oolite Formation of the Bath area, Great Oolite Group, Middle Jurassic

PRESENT CONDITION a, carved surfaces good; b, more worn

DESCRIPTION Fragment a is part of a tapering shaft of square section trimmed flat above and below, but otherwise roughly broken so that only small parts of faces A and D survive. Face A has the lower and left-hand edges undamaged. The upper edge is horizontally trimmed and the right-hand edge is roughly broken, and slopes inwards towards the upper edge.

*A (broad):* Along the lower and left-hand edges is a border comprising a plain relief outer moulding inside which, to the left, is a second similar moulding with a double-stepped base. The face is divided into two roughly equal fields by a horizontal relief moulding whose rounded end protrudes into the inner moulding to the left, and is separated from it by an incised line, paralleled by a second similar line. Half-way along its length the moulding is double-stepped, reducing its width by two-thirds. On the narrow portion stands a double-stepped base supporting a stem terminating in a narrow *suppedaneum* which is wider than the stem. Standing on this is the out-turned right foot of a robed figure, most of which is lost. To the left a portion of the robe falls in three vertical folds of diminishing size to touch the moulding. Below the horizontal moulding are two naturalistically-modelled animals facing right, and crouched on the lower frame, that to the right partially overlapping the other; one appears to be leonine, the other may be a sheep.

*B (narrow):* Destroyed.

*C (broad):* The original face is entirely destroyed. There is a vertical half-round channel, with a second similar channel sloping up from it to the broken left-hand edge of face D.

*D (narrow):* Only a marginal fragment remains, having a broad plain border below, and a plain double moulded one to the right. From this develop four upward-pointing, expanding, rounded-ended leaves, placed one above the other.

Fragment b is part of the same tapering shaft of square section as fragment a. Only a small part of faces A and B survive; the rest is roughly broken away. On face A the upper and left-hand edges are roughly broken.

*A (broad):* Below and to the right is a narrow plain relief border, with a damaged upward-pointing, expanding, rounded-ended leaf developing from the upper border to the right. The face is decorated with a nimbed eagle facing to the right, its surviving wing outspread and the feathers indicated by incised lines. In its talons the eagle holds a closed book.

*B (narrow):* Only a marginal fragment survives, having a narrow plain border below and to the left. The surviving portion of the face is decorated with what appears to be an animal facing left and lying on the lower border.

DISCUSSION Since they are of the same material, decorated in the same sculptural technique, and with similar types of decoration, it seems likely that the two pieces derive from the same shaft, although they do not join.

As noted above (Chap. VII), the identification of the scene or scenes on this shaft remains speculative. The figure standing on the T-shaped support could be the crucified Christ, or one of the Evangelists, while the animals below the figure can only be identified as a sheep, and a predator, possibly a lion. The Eagle holding a book on fragment b must, however, be the symbol of St John.

Such stylistic links as can be drawn for the piece, particularly the hard mechanical fold of drapery falling down beside the figure on face A of fragment a, have parallels in mid eleventh-century works, when the flattering draperies of the Winchester style and the characteristic broken profile of the folds had become hardened and more regular. Similar draperies are seen, for example, in Aelfric's Pentateuch (Temple 1976, no. 86, ills. 269–72) and BL MS Cotton Tiberius B. V (ibid., no. 87, ills. 273–6), both works of the second quarter of the eleventh century. The form of the leaves developing from the frames of both fragments also points to a late date, as leaves of this particular form are commonest in metalwork of the Trewhiddle style (see Fig. 24a–d, and Introduction, Chap. VII).

DATE Eleventh century

REFERENCES Green and Green 1951, 50–2, pl. XVI; Tweddle 1986b, I, 95, 240–4, II, 479–81, III, pls. 95–6

D.T.

# SOUTH HAYLING, Ha. (St Mary)

## SU 722001

### 1. Cross-base[1]                               (Fig. 38; Ills. 465–9)

PRESENT LOCATION Near west end of nave, inside, opposite south door

EVIDENCE FOR DISCOVERY Found in 1827 in shallow well in parish, probably Slutt's well (300 yards from west end of church (SU 720001)), a natural spring, so font presumably used to collect water; removed to Westbourne, Sussex, where used successively as pump trough, and flower pot; later recovered by Rev. Hardy

H. 46 cm (18 in)          W.  60 cm (23.6 in)
D.   59 cm (23.2 in)
Diameter of bowl 68 cm (26.8 in)

STONE TYPE Pale grey to pale brownish-grey, finely granular, cavernous-weathered limestone; Bembridge limestone, Bembridge Formation, Palaeogene, Tertiary; Isle of Wight

PRESENT CONDITION Heavily weathered

DESCRIPTION It takes the form of an inverted truncated pyramid with the edges rounded to a greater or lesser degree by weathering. Around the upper edge is a heavily weathered, boldly-projecting moulding of square section which is partially broken away on faces A and D. The bowl of the font is circular with inward-curving sides and a flattened base. An irregular hole has been pierced through face B about a quarter of the way up from the mid-point of its lower edge. The decoration on all the faces has been badly damaged by weathering.

A: Decorated with a pair of broad, inward-scrolling mouldings linked together along the lower edge, and touching before curling  under. Each terminates in a U-shaped feature, the outer end of which is slightly concave and the edges extended to accommodate a disc. The outer edge is simply out-turned, but the inner edge of each motif develops into a narrow straight moulding running up towards the vertical axis of the face. The two mouldings converge and touch on the edge of the upper border.

B: Decorated with broad interlacing bands, the design rendered incoherent by weathering.

C: Two inward scrolling mouldings, one to each side of the face, interlace with various oblique strands; again the design is largely destroyed.

D: There is a number of broad interlacing strands, some of which appear to be longitudinally ribbed.

DISCUSSION The hole in face B may be of relatively modern date, since it is difficult to see how the piece

---

1. The following is an unpublished manuscript reference to no. 1: BL Add. MS 37601, item 565.

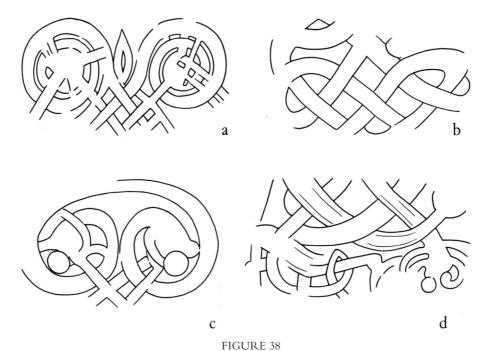

FIGURE 38
South Hayling 1, partial reconstruction of ornament, nts (KEY: Letters as Faces in Description)

could have been successfully used as a pump trough with a large hole in one side. As noted in Chap. IV, whatever its original function this piece is very unlikely to have begun life as a font. Every single surviving font from southern England is of circular section, as are those from other regions. If not a font, then it seems most likely to have been a cross-base of truncated pyramidal form, a type known at Raistrick and Walton, Yorkshire (Collingwood 1915, 231–3, 250–4).

The weathered nature of the decoration makes dating extremely hazardous, but the combination of spiral-based ornament and plant ornament is suggestive of a late eighth or early ninth-century date, a period when spiral ornament was dropping out of use and plant ornament making its first consistent appearance in Anglo-Saxon art (Budny and Graham-Campbell 1981, 11). This dating is supported if the decoration on face C can be interpreted as a double-spiral animal. This form is both distinctive and rare, occurring only on two eighth-century manuscripts, fol. 16r of the Leningrad Gospels (Alexander 1978, no. 39, ill. 190) and fol. 102r of Hereford Cathedral Library MS P. I. 2 (ibid., no. 38, ill. 199).

DATE Late eighth or early ninth century?

REFERENCES Longcroft 1856, 205, 303; Harris 1885, 413; Harris 1886, 65–7, fig. facing 66; Hudd 1887, 89; Allen 1888a, 171; Allen 1889, 200–1; Larkby 1902, 261, 265–6, figs. 9–10; Doubleday and Page 1903, 239, fig. facing 238; Bond 1908, 127, 138; Page 1911, 306–7; Hemp 1925, 434; Cottrill 1931, appendix; Cox and Jowitt 1949, 95; Green and Green 1951, 47–50, pl. XV; Tweddle 1986b, I, 100–1, 146–7, II, 481–3, III, fig. 18, pls. 97–8

D.T.

# STEVENTON, Ha. (St Nicholas)

## SU 551472

### 1. Part of cross-shaft[1]                    (Fig. 9; Ills. 470–2)

PRESENT LOCATION In the north-east corner of the nave

EVIDENCE FOR DISCOVERY Found reused (together with Norman and thirteenth-century carved stones) during reconstruction of Steventon Manor (SU 550472) in 1877 (letter, December 27 1893, from owner to Sumner Wilson in Allen papers at British Library) and built into porch; presented to church in 1952. Building materials for sixteenth-century manor presumably came from near-by parish church

H.   94 cm (37 in)   W.   36 cm (14.2 in)
D.   28 cm (11 in)

STONE TYPE Pale brownish-grey, medium-grained, oolitic limestone, with some worn shell fragments; Middle Jurassic, of uncertain provenance

PRESENT CONDITION Broken and worn

DESCRIPTION Part of a tapering shaft of square section, dressed roughly flat above and below.

A (broad): Extensively damaged, the lower left-hand corner of the face is lost, and the face is dressed flat to the left of a line between the upper left and lower right-hand corners. Above and to the right is a plain, low-relief, border with double mouldings. The face is divided into two fields, of which the upper is slightly the larger, by a narrow horizontal moulding of square section. The decoration of the lower field has been entirely defaced, but in the upper field is a thick, ribbon-like animal body, forming a loop touching the upper and lateral borders, before the tapering ends of the body cross and develop into disorganised interlace. The principal feature of this interlace is a pair of pointed loops, one running into each of the upper corners, through which the body passes. The interlace strands are median-incised (Fig. 9b, p. 37).

B (narrow): Face B has been trimmed back to the right, but to the left has a border with broad, low-relief, plain, double mouldings. The face is divided into two fields of which the upper is the larger, by a

plain horizontal moulding of indeterminate section. In the upper field a thick ribbon-like animal body forms a loop almost touching the lower border. The body tapers towards the upper ends, which cross and develop into disorganised interlace with median-incised strands. A prominent feature of this is a pair of pointed interlace loops, one running into each of the lower corners, through which the animal's body passes. In the lower field is a pair of confronted interlocking ribbon-like animals whose bodies taper towards the head. The head of the first is placed in the upper left-hand corner of the field and faces outwards and downwards, its body curves across to touch the right-hand border before curving back to the left. The second animal is similarly posed, but faces in the opposite direction. It has a square snout, a slightly upward-curving upper jaw, a prominent bulging forehead, and a small pointed ear. Under its chin is a pellet. The head of the first animal is similar, but has a pecked eye, and no pellet. The bodies of both animals are contoured with an incised line and hatched. They are involved in disorganised, median-incised interlace issuing from the animals' mouths (Fig. 9a, c).

C (broad) and D (narrow): Destroyed.

DISCUSSION This shaft, together with the piece from Winchester Upper Brook Street (Ill. 683), an impost or frieze from the Old Minster, Winchester (no. 64; Ill. 601), and the fragments from Little Somborne (Ill. 447), is clearly related to a group of sculptures which are widely distributed in south-western England, and first defined by Cottrill (Cottrill 1935). The Hampshire material constitutes the eastern outliers of this group. The repertoire of ornament, consisting of paired or single ribbon-like animals enmeshed in and/or developing into interlace, the use of spiral elements, and the appearance of plant ornament on some of the pieces, all point to a date in the late eighth or early ninth century. This dating is confirmed by the specific comparisons which can be drawn between the material in this group and the mid to late eighth-century Leningrad Gospels (Alexander 1978, no. 39, ills. 188–95). For further discussion of this group, see Chap. V.

DATE Late eighth or ninth century

---

1. The following is an unpublished manuscript reference to no. 1: BL Add. MS 37550, items 548–50.

REFERENCES Doubleday and Page 1903, 238–9; Page 1911, 173; Cottrill 1931, 29, appendix; Cottrill 1935, 151; Kendrick 1938, 211, pl. XCVIII; Cox and Jowitt 1949, 163; Green and Green 1951, 44–5, pl. XIII; Rice 1952, 128; Fisher 1959, 80; Pevsner and Lloyd 1967, 17, 611; Cramp 1975, 187; Tweddle 1983b, 18–20, 29; Backhouse *et al.* 1984, 42; Wilson 1984, 146, pl. 182; Tweddle 1986b, I, 141–6, II, 488–91, III, fig. 14, pls. 102b–103a

D.T.

STRATFIELD MORTIMER, **1.** See Appendix A, p. 335.

# WANTAGE, Brk. (Sts Peter and Paul)

## SU 397879

### 1. Part of cross-shaft[1]                    (Ills. 474–7)

PRESENT LOCATION Near font close to south door of church

EVIDENCE FOR DISCOVERY Discovered by J. D. de Vitre in Wantage in 1892; perhaps reused in walls of chapel formerly in churchyard (Goddard 1893–4)

H.   34 cm (13.4 in). W.   29.5 cm (11.5 in)

STONE TYPE Pale yellow, medium- to coarse-grained, oolitic limestone, with shell fragments and a calcite veinlet; bedding is parallel to axis of shaft; Combe Down Oolite, Great Oolite Formation of the Bath area, Great Oolite Group, Middle Jurassic

PRESENT CONDITION Broken and chipped

DESCRIPTION The shaft is of circular section, trimmed flat below, but roughly broken above and to the rear. About half the original circumference survives and is occupied by a rectangular field delimited (except on the upper, broken, edge) by plain, raised borders. The field is filled with an encircled pattern C interlace with median-incised strands. Above and to the right are the marginal remains of interlace of a similar pattern.

*F (bottom):* In the base is a prominent dowel hole.

DISCUSSION The presence of a dowel hole in the base suggests that this piece derives from a round shaft built in drums, in the manner of the shaft from Reculver (pp. 155–6). The small diameter of the hole suggests a metal fitting was used to hold the drums together.

This piece must date to the ninth century or later, as it was not until the ninth century that the round shaft was introduced (see p. 41). However, an even later date is suggested by the use of rather thick, heavy interlace, with median incisions, characteristics usually employed on interlaces of the tenth and eleventh centuries, as on the Bishops Waltham and Wherwell shafts.

DATE Tenth to eleventh century

REFERENCES Allen 1893–4b, 58, fig. 12; Goddard 1893–4, 47, fig. on 47; (——) 1903–4, 179; Page and Ditchfield 1924, 329; Collingwood 1927, 183; Cottrill 1931, 36, appendix; Peake 1931, 168; Piggott 1934–7, 149–50, fig. 27; Lamborn 1937, 122; Seaby 1944, 93, fig. 1; Tweddle 1986b, I, 95, 248–9, II, 503, III, pl. 111a

D.T.

---

1. The following is an unpublished manuscript reference to no. 1: BL Add. MS 37547 no. IX, items 356–61.

# WARNFORD, Ha. (dedication unknown)

SU 623226

**1. Sundial** (Ill. 478)

PRESENT LOCATION In the south porch of the church, over the south door

EVIDENCE FOR DISCOVERY First recorded in Haigh 1846

H.   47 cm (18.5 in)   W.   47 cm (18.5 in)
D.   Built in
Dial diam. 43 cm (16.9 in)

STONE TYPE Unidentified; inaccessible, and thickly covered with whitewash

PRESENT CONDITION Good

DESCRIPTION On a sub-rectangular panel is a large circular relief dial delimited by a low relief frame having a median roll moulding. The gnomon hole is represented by an irregular hollow in the centre of the dial, the lower half of which is calibrated. There is a pair of lateral lines, a vertical, and a line mid-way between each lateral and the vertical. Each line is incised, terminates on the frame, and is crossed short of its outer end by an incised line with drilled ends. From the outer edge of the frame develop four plant stems, one running into each of the corners of the panel, and each terminating in a convex-sided, pointed-ended, hollowed leaf. This is flanked by two similar out-turned leaves, the hollows of which are carried down the short stems.

DISCUSSION Although this piece is *ex situ*, a pre-Conquest date can be argued from the very close relationship between it and the dial from near-by Corhampton (no. 1), which is *in situ* in a late pre-Conquest fabric. A very similar dial is also known from Winchester St Michael (Ill. 671), although again *ex situ*.

DATE Tenth to eleventh century

REFERENCES Haigh 1846, 410, 414, fig. on 410; Hussey 1852, 199; Haigh 1857, 178, fig. on 178; Way 1868, 211; Haigh 1879, 135, 155–6, fig. on 155; Slessor 1888, 7–8; Allen 1889, 201; Gatty 1889, 424; Syers 1899, 18; Gatty 1900, 67–8; Nisbett 1905–7, 37; Johnston 1907, 17; Doubleday and Page 1903, 240; Page 1908a, 272; Jessep 1913, 17; Green 1926, 18–19, fig. on 18; Green 1928, 491, 493, 497; Cottrill 1931, appendix; Cole 1939, 148; Zinner 1939, 8–9; Green 1943, 273; Cox and Jowitt 1949, 178; Green and Green 1951, 58–9, pl. XIX; Crowley 1956, 176; Taylor 1962a, 169; Zinner 1964, IV, 210, 216; Taylor and Taylor 1965–78, II, 640; Radford 1966a, 189; Taylor and Taylor 1966, 19, 25, fig. 8; Bowen and Page 1967, 288; Pevsner and Lloyd 1967, 17, 642; Tweddle 1986b, I, 84, 187–8, II, 503–4, III, pl. 111b

D.T.

# WEYHILL, Ha. (St Michael)

SU 318467

**1. Grave-cover** (Ill. 473)

PRESENT LOCATION Built externally into the west wall of the vestry which is on the north side of the chancel

EVIDENCE FOR DISCOVERY Uncertain: found built into either south wall of nave, remodelled in 1863 when south aisle added (Page 1911), or west wall of tower, dating from 1907 (church guide)

H.   122 cm (48 in)   W.   32 cm (12.6 in)
D.   Built in

STONE TYPE Yellowish-grey to pale orange, medium- to coarse-grained, slightly shelly, oolitic limestone, with some ovoid pellets up to 3 mm long; probably Combe Down Oolite, Great Oolite Formation of the Bath area, Great Oolite Group, Middle Jurassic

PRESENT CONDITION Weathered

DESCRIPTION The cover tapers towards the lower end.

*A (top):* The lower border does not survive; that to the left has a narrow, plain, low-relief moulding, and those above and to the right have plain, low-relief, double mouldings. A similar double moulding divides the face into two fields, the lower of which is the larger. The upper field is undecorated but heavily chiselled. The lower field is decorated with a Latin cross, the head and horizontal arms of which are expanding and concave sided, with curved re-entrant angles. Their square ends terminate on the border. Each arm is separated by a pair of narrow transverse cabled mouldings from the point of junction which is decorated with a rosette which has a central boss and seven expanding, rounded-ended petals. The lower limb of the cross is straight sided and slightly expanding, and stands on an elaborate base which in turn rests on the lower edge of the stone. The lower element of the base consists of a broad roll moulding with rounded ends which supports a similar narrow recessed moulding on which rests a short tapering stem. This supports a series of five mouldings, each with rounded ends, and projecting beyond the stem. The upper and lower mouldings are cabled, and the median moulding pelleted. A broad low-relief moulding with rounded ends separates this group of mouldings from the lower limb of the cross.

DISCUSSION The area of rough chiselling in the upper, undecorated, field suggests that a feature has been cut away in the manner of the crucifixion groups at Breamore (no. 1) and Headbourne Worthy (no. 1). Possibly the feature was a Hand of God. The only evidence for dating derives from the form of the cross on the lower part of the stone. There is no close parallel for its form, but the cross on the panel from London Stepney 1 has a similar elaborately-moulded base (Ill. 354), and there are similar bases in the crucifixion scene on fol. 9v of the Arenberg Gospels of *c.* 990–1000 (Fig. 21c; Temple 1976, no. 56, ill. 171) and in the presentation scene on fol. 6r of the *Liber Vitae* of the New Minster, dated to *c.* 1031 (ibid., no. 78, ill. 244). In each case, however, the ends of the arms of the cross as well as the base are also elaborately moulded. There is no obvious parallel for the transverse mouldings on the cross-head and arms here, although something similar is encountered on a tenth or eleventh-century Anglo-Saxon or Danish ivory crucifixion now in the National Museum of Denmark (Beckwith 1972, no. 36, pl. 73).

DATE Eleventh century

REFERENCES Page 1911, 398; Cox and Jowitt 1949, 180; Green and Green 1951, pl. XVII; Coatsworth 1979, I, 43–4, 281, II, 50, pl. 7; Tweddle 1986b, I, 89, 222–3, II, 505–7, III, pl. 113a

D.T.

# WHERWELL, Ha. (St Peter and Holy Cross)

## SU 391408

### 1. Part of cross-shaft                    (Ill. 479–81)

PRESENT LOCATION On the bench at the west end of the north aisle

EVIDENCE FOR DISCOVERY None; probably found during rebuilding of church between 1856 and 1858

H.  86 cm (34 in)   W.  34 cm (13.4 in)

STONE TYPE Yellowish-grey, medium-grained, oolitic limestone, with shell fragments including a lunate Ostreid; Middle Jurassic, of uncertain provenance

PRESENT CONDITION Worn; damaged by reuse

DESCRIPTION The stone was reshaped as a corbel in the thirteenth century.

The shaft is of rectangular section and tapers towards the upper end which has been re-cut to form a conical corbel whose face is on the same plane as face A. The shoulders between the corbel and the shaft are irregularly stepped.

*A (broad):* On the face of the corbel is a heavily damaged encircled interlace of pattern C, the ends of the diagonals having been cut away by the shaping of the corbel. The rest of the face is undecorated.

*B (narrow):* Face B is decorated with a single rectangular panel, incomplete above and damaged to the right, which is decorated with interlace, a unit of complete pattern A.

*C (broad):* Irregularly cut back.

*D (narrow):* There is a single rectangular panel in the corresponding position to that on face B. This has a plain relief border above, but is damaged to the left, and is filled with an encircled pattern C interlace or ring-knot, with median-incised strands.

DISCUSSION Despite the later reshaping of this piece to form a thirteenth-century corbel, there is no doubt that it was originally a cross-shaft of square section. Like the shafts from Bishops Waltham, Hampshire, Barking, Essex (no. 1), and probably Kingston upon Thames, Surrey, this shaft may have been predominantly interlace decorated. This gives few clues as to date, but the use of rather a thick strand, in one case median-incised, suggests a later rather than earlier date.

DATE Tenth to eleventh century

REFERENCES Page 1911, 414; Atkinson 1938–40, 369–70; Cox and Jowitt 1949, 181; Green and Green 1951, 45–6, pl. XV; Pevsner and Lloyd 1967, 650; Tweddle 1986b, I, 95, 244, 246–7, II, 507–8, III, pls. 114–15

D.T.

# WHITCHURCH, Ha. (All Hallows)

## SU 460478

**1. Grave-marker**[1]                                              (Ills. 482, 485–9)

PRESENT LOCATION Near north respond of chancel arch

EVIDENCE FOR DISCOVERY Found during restoration of 1868, built into north aisle wall

H.  58 cm (22.8 in)   W.  51 cm (20 in)
D.  27.5 cm (10.8 in)

STONE TYPE Grey (with a greenish tinge), fine-grained (0.2 mm  quartz grains), glauconitic sandstone, possibly with a cherty cement; Upper Greensand, Gault Group, Lower Cretaceous; perhaps from near Kingsclere, Hampshire

PRESENT CONDITION Chipped

DESCRIPTION The stone is straight-sided with a semicircular head.

*A (broad):* The decorated portion of this, the principal face, comprises a recessed field following the outline of the stone from 17 cm (6.7 in) above the base, the edge of the recess being stepped. An incised bordering line below the recess may have outlined the whole, but is obscured by damage. Within the recess is a high-relief, half-length robed figure with a cruciform nimbus. The robe is draped over the shoulders, and is looped over the figure's left arm which holds a book. The right arm is raised in blessing.

D.T.

*B, D and E (narrow sides and top): Inscription* The inscription (Okasha 1971, 125–6) is set within a panel on the flat surface of the curving outer edge of the monument (Ills. 485–9). The panel occupies most of the available space and is defined by an incised framing line. Within the panel the inscription is set out in an orderly manner in two lines and at the left-hand end of the panel there is an incised cross which occupies the height of the two lines of text (Ill. 482). The cross is marked off by a rectangular incised frame within the main framing lines which continues and is overlain by the first few letters of the inscription (Ill. 489). A group of three points marks the end (Ill. 485). The letters are between about 4.6 and 6.3 cm (1.8 and 2.5 in) in height. The inscription has suffered damage and abrasion, especially at the top of the stone. The text, which seems to have had no word-division, is in capitals and can be transcribed as follows:

+HICCO[RPV]S[F]RI[ÐB]VRG[AEREQ]VI
E[SC]IT[INP.C]E[.S]EPVLTVM:

The text is clearly in Latin and, apart from the personal name, the reading is generally straightforward. Okasha reads the name as FRI[Ð]BVRGAE (genitive), that is, Friðburg, a recorded feminine personal name. This may have been

---

1. The following are unpublished manuscript references to no. 1: BL Add. MS 37550, item 548; BL Add. MS 37580, items 267–76, 377, 561; BL Add. MS 37581.

the intended name, but the first letter has a short horizontal stroke at the bottom which makes it at first sight like an E, although the horizontal is not as pronounced as in the other examples of E on the stone (Ill. 488). This may be an example of 'E-shaped F' (see below), if it is not simply a carver's error. The fourth letter (Ill. 488) looks more like O with damage to its upper right quadrant than *eth* (usually shown as a D with a horizontal stroke cutting the vertical in inscriptions in capitals). Searle accepts Hübner's reading of O, and therefore records the name as *Frioberga* (Searle 1897, 247; Hübner 1876, 61). If, as seems likely, the intended reading was FRIO-, this should be identified as the recorded but rare first element *Frio-/Freo-*. In this case, assuming that the name form represents the West Saxon dialect, the spelling *io* would suggest a date not much later than the ninth century (Campbell 1959, 125–6).[2] There is confusion or indecision at the end of the name. The penultimate character (Ill. 487) has been cut as two different letters: V and A. The V is cut more deeply than the A. It looks as if the A, which is required for the genitive in AE, is a modification of the earlier V. The change was apparently made while work was in progress. The result is now confusing, but if the inscription were originally painted, as seems to have been usual (see Introduction, p. 113), the corrected reading would have been picked out in paint. The text may be read as:

+ HIC CORPVS FRI[O]BVRGAE (or FRI[Ð]BVRGAE?) REQVIESCIT IN [PA]CE[M] SEPVLTVM :

(Translation: '+ Here rests the body of Frioburga (or Frithburga?) buried in(to) peace.') *in pacem* seems to be the most likely reading and, if the accusative is deliberate and not just a mistake for the more normal *in pace*, it implies burial into peace rather than merely resting in peace.

Much of the finer detailing of the lettering is lost through wear. Letter strokes seem to have been of fairly even thickness and strokes terminate in fairly pronounced, almost wedge-shaped, serifs. The capitals are of standard 'Roman' forms, with the following exceptions. C is square (Ill. 489). F (if that is what it is: see above) is unusual in having a third short horizontal at the bottom of the vertical. G is angular (Ill. 487). M has vertical outer legs and a shallow 'V' (Ill. 486). Q is the uncial letter (Ill. 486).

J.H.

2. I would like to thank David Parsons for his advice on the interpretation of this damaged name.

*C (broad)*: In the curved upper part is a semicircular field outlined by a double-incised line, and containing a stylised plant motif. The scrolls of the plant are disposed symmetrically on either side of the vertical axis of the field, three subsidiary scrolls occupying the interstices between the main scrolls and the edge of the panel. Below this field the stone thickens abruptly, the upper edge of the thickening being chamfered.

DISCUSSION The content of the inscription provides direct confirmation of the function of the piece.

The cruciform nimbus of the figure on face A identifies him as Christ. As noted above (Chap. V), the leafless tree-scroll within a semicircular border on face C was a popular motif in the late eighth and early ninth centuries, particularly in metalwork. It finds an almost exact parallel on a *pressblech* disc from Hedeby which is of ninth-century date and Anglo-Saxon origin (Fig. 13d; Capelle 1968, no. 72, taf. 25.1). The motif occurs in sculpture locally on a cross-shaft from Winchester (High Street; Ill. 679).

D.T.

*Inscription* The underlying formula of the text, *hic requiescit*, is common in Christian inscriptions from the fifth century onwards and was used elsewhere in Anglo-Saxon England, at Monkwearmouth, co. Durham (Okasha 1971, 101; Higgitt 1979, 365; Cramp 1984, I, 124, II, pl. 110 (604)), Canterbury, Kent, and Ripon, Yorkshire (Cabrol and Leclercq 1907–53, VI.2, col. 2373 (s. v. *Hic*); Higgitt 1979, 365). *Hic requiescit* combined with *in pace* is common as an introductory formula in fifth- and sixth-century inscriptions, especially in southern France and Italy, and continues to be used in the region of the Rhine for the next century or so (Krämer 1974, 39–47, 119 (Anhang 1)). Diehl cites an early medieval epitaph in Bologna containing the wording 'Martini . . . corpus hic in pace requiescit sepultum . . .' (Diehl 1925–67, I, 455–6, no. 2349), the same words as at Whitchurch, though not in the same order. There is unlikely to be a direct connection. Instead the two epitaphs reflect a common early medieval epigraphic tradition. Behind this wording there might ultimately be a reminiscence of *Ecclesiasticus* 44, 14: 'Corpora ipsorum in pace sepulta sunt'. The Whitchurch epitaph sounds too as if it might have been adapted from a metrical model. The last two words would certainly fit the end of a hexameter.

As on London All Hallows 1, the form of the seriffing probably reflects the wedge serifs of Insular book scripts of around the eighth century (Bischoff 1990, 86) and argues for a date not much later than the end of the ninth century.

There seem to be no parallels in pre-Conquest inscriptions in England for the form of the possible letter F (Okasha 1968), but Nash-Williams illustrates three examples on inscriptions in Wales which he dates to the fifth or early sixth centuries Nash-Williams 1950, 102, 195, 213, 224–5). The form is found on the continent in some Early Christian and early medieval inscriptions (Le Blant 1896, 345–9; Gauthier 1975, 28). In origin the bottom horizontal is an exaggerated treatment of the base serif of the Roman capital script (Bischoff 1990, figs. 1–3). None of these parallels is close to the present example, so a carver's error seems the more likely explanation here.

The setting of the inscription on the outer rim of the monument between the two decorated vertical faces is unusual, but was perhaps paralleled on Rochester 3 (Ills. 147–50). It could be fairly conveniently read, when set in the ground as a grave-marker, although, given the curvature of the stone, it would not be possible to see the whole of the inscription from the same viewpoint. The text is arranged to be read by a reader who is facing face A, the side with the figure of Christ.

J.H.

DATE Ninth century

REFERENCES Smith 1871, 884, fig. on 886; Hübner 1876, 61, no. 165; Browne 1884–8, 12–13; Browne 1885, 255; Allen 1885b, 358; Browne 1886, 31; Allen 1887, 125, fig. 27; Allen 1888a, 166–7; Allen 1889, 213, 216, 221, 228; Shore 1898, 124; Minns 1899–1900, 171–4, pl. I; Doubleday and Page 1903, 234, 236–7; Brown 1903–37, VI (2), 254–5, pl. LXXXIX; Page 1911, 302–3, fig. on 304; (——) 1930, 114, no. 9; Clapham 1930, 141; Cottrill 1931, 48, appendix; Kendrick 1938, 182–3, 187, pl. LXXVII; Clapham 1948, 7; Cox and Jowitt 1949, 182; Gardner 1951, 42; Green and Green 1951, 53–4, pl. XVIII; Rice 1952, 89, 107; Pevsner and Lloyd 1967, 17, 651, pl. 6; Okasha 1971, 125–6, pl. 135; Cunliffe 1973, 43; Higgitt 1973, 13; Hughes 1976, 138, 140; Hinton 1977, 100–1; Tweddle 1983b, 20–2, fig. 4a, pl. VIIa–b; Wilson 1984, 108, pls. 132–3; Tweddle 1986b, I, 92, 149–51, II, 508–9, III, pls. 116–17a

WINCHESTER (Hyde Abbey), **1.** See Appendix B, p. 341.

# WINCHESTER, Ha. (Old Minster)[1]

SU 482293

### 1. Part of grave-marker                                    (Ills. 490–3)

PRESENT LOCATION Winchester City Museum, Historic Resources Centre, Hyde House, Winchester, accessions no. 2943 WS 23

EVIDENCE FOR DISCOVERY Found in archaeological excavation north of Winchester cathedral in 1965 in fill of Anglo-Saxon Grave 110, a burial in the south transept of New Minster belonging to the first or second New Minster grave generation; Final Phase 36–9 (Provisional Phase 671), early to mid tenth-century. Residual in Grave 110 (*pace* Okasha 1971, no. 140), standing at an angle at bottom of grave, with inscribed edge facing vertically towards east; probably disturbed from earlier grave in Old Minster cemetery which occupied site before construction of New Minster in *c.* 901–3.

H.   6.3 > 6 cm (2.5 > 2.4 in)   W.   31.6 > 30.05 cm (12.5 > 12 in)
D.   23 > 14 cm (9 > 5.5 in)

STONE TYPE Yellowish-grey, medium- to coarse-grained, shelly, oolitic limestone; Combe Down Oolite, Great Oolite Formation of the Bath area, Great Oolite Group, Middle Jurassic

PRESENT CONDITION Slightly worn, the inscribed face, A, chipped, the rear (or lower?) part, opposite face A, broken away

DESCRIPTION Only one face is carved. The four other surviving faces of the stone are dressed with diagonal tooling. On face F (bottom) this continues to a depth of between 17 and 13 cm, at which point the face breaks forward to a more roughly tooled surface, much of which has been lost.

*A:* On the narrow complete face is an inscription,

1. It has not proved possible to provide more than a generic description for the stone types of nos. 22, 25–6, 29, 31, 39, 43, 45–6, 61, 68, 71–2, and 93

contained within framing lines above, below, and perhaps also to the left (but see Inscription, below). The right-hand edge of the stone is complete, but the right-hand framing line is absent.

M.B.; B.K.-B.

*Inscription* The inscription (Okasha 1971, 127–8; Okasha 1983, 110) is set between two incised guide-lines, which are set about 3 cm (1.2 in) apart (Ill. 490). It is probable that the inscription is incomplete as it stands. The vertical line to the left of the first V looks at first sight like the left end of the incised frame but it is unlikely to be so, given that it stops short of where it would have met the lower horizontal framing line. It is more probably a letter or part of one (see below), in which case the inscription is incomplete at the beginning. The gap after the final M suggests that the text stopped here but there is no indication of a vertical framing line linking the horizontals at the end of the inscription. The letters are small (around 1.9 > 2 cm (0.75 > 0.8 in) high). The inscription is in capitals and, although the surface is damaged, it remains largely legible:

—[*I*]V[IV]ATI[N*E*V]VM—

The language is clearly Latin and the reading is plain except at the beginning:

—[*I*] VIVAT IN EVVM—

(Translation: '— may he/she live for ever —'). If the vertical stroke before the first V is indeed a letter or part of one (see above), I is perhaps the most likely, but not the only possible, reading. As it now stands the text lacks an explicit subject.

The lettering is small and regular. Neat serifs can still be seen on some letters, for example, the cross-bar of the T. The forms are Roman, but only seven different letters are represented. A has no top bar and its cross-bar is inclined a little down to the right. The outer strokes of the M are vertical and its central 'V' occupies only the upper part of the letter. There is no word-division nor any trace of punctuation.

J.H.

DISCUSSION The change from smooth to rough tooling on the lower face of the stone should be compared to the treatment of the lower parts of other stones from Winchester which were certainly meant to be set upright in the ground as grave-markers (e.g. Old Minster nos. 2 and 4 (Ills. 498, 503). If no. 1 was also meant to be set upright, it could have been either the head- or foot-stone of a grave with the name of the deceased on a stone at the other end; or it might

have been a part of a kerb around the grave. The grave-marker at Whitchurch, Hampshire (Ills. 482, 485–9) provides a parallel for a Latin inscription on the upper edge of a memorial stone, and the runic inscription from the city (Winchester St Maurice 1; Ills. 667–670; Fig. 42) appears to have been similarly placed (Kjølbye-Biddle and Page 1975).

M.B.; B.K.-B.

*Inscription* The formula is likely to have been memorial. A fragmentary Early Christian inscription from the cemetery of Priscilla in Rome '—um ut uiuat in aeuum') matches the Winchester words (Diehl 1925–67, I, 428–9, no. 2188), but I can find no other close parallels. In the Vulgate *in aeternum* is frequent but there are only two cases of *in aevum* (*Ecclesiasticus* 41, 16 and *Baruch* 3, 3). The sentence implies a subject, probably the name of the person commemorated. This might have appeared on the left of the present text, or perhaps on an adjacent stone.

The archaeological context in which this stone was found suggests that it came from a monument that was displaced at the time of the construction of the New Minster. The inscription would therefore date from before *c.* 901–3. It is therefore one of the earliest surviving Anglo-Saxon inscriptions in the south-east and provides interesting evidence that Roman capitals were being used in Winchester for inscriptions on stone by the ninth century, perhaps under Carolingian influence, or possibly even earlier.

J.H.

DATE Pre- *c.* 901–3

REFERENCES Okasha 1971, no. 140; Biddle and Kjølbye-Biddle 1973, no. 12; Biddle and Kjølbye-Biddle forthcoming a, Fig. 159, no. 108

## 2. Grave-marker                                    (Ills. 497–500)

PRESENT LOCATION Winchester City Museum, Historic Resources Centre, Hyde House, Winchester, accessions no. 2943 WS 104.1

EVIDENCE FOR DISCOVERY Found in archaeological excavation north of Winchester cathedral in 1965 in cemetery at east end of Old Minster, marking the foot of Anglo-Saxon Grave 119, a burial of a man in his twenties; Final Phase 50–1 (Provisional Phase 639), early eleventh-century; see no. 6.

H.   70 > 69 cm (27.6 > 27.2 in)   W.   47.5 > 43 cm
     (18.7 > 16.9 in)

D.   18.5 > 14.5 cm (7.3 > 5.7 in)

STONE TYPE Pale brownish-grey, fine-grained limestone, with moulds of shell fragments and of *Chara* nucules; Bembridge limestone, Bembridge Formation, Palaeogene, Tertiary; Isle of Wight

PRESENT CONDITION The carved surface is crisp, but the edges are damaged

DESCRIPTION Only one broad face is decorated.

*A (broad):* The lower 27 cm or so is left roughly tooled and was meant to be buried. This lower part is recessed 1.5 cm behind the decorated surface. This consists of an arched frame surrounding a field 34.3 cm high, 37–8 cm wide, recessed 1.2 cm behind the frame. The carving is in several planes with the highest, the back of the hand, level with the surface of the frame. The relief shows a right hand coming from the left and sloping slightly downwards. The hand holds a cross between the thumb and the extended second and third fingers, the fourth and fifth fingers being folded in. The hand measures 31.5 cm from frame to fingertip; it is about 10.5 cm wide at the wrist and 13.5 cm across the thumb. The cross spans the whole field diagonally, from high right to low left. The shaft with the right edge of the cross-shaft lying below the junction between fingers and hand is 32–3 cm long and 4.2 cm wide; the arms start about 26.5 cm from the bottom and are slightly expanded. The right arm is the shortest, *c.* 2 cm long from the shaft, the left arm is *c.* 2.3 cm long. The top of the cross is 3–3.5 cm long and 3.3 cm wide. The cross-arms are 2.6–2.8 cm wide.

*C (broad):* The upper part is smoothly dressed, the lower (not originally intended to be visible) much more roughly finished.

DISCUSSION The carving is confident and clever, but not expert. A feeling of greater depth is achieved by having the most prominent part, the back of the hand, at the same level as the surrounding frame, accentuating the depth of the other features. The lower right-hand edge of the cross rises onto the inner chamfer of the bottom frame, further emphasising the three-dimensional effect. There is on the stone a clear circular depression ending in a point, situated between thumb and hand. This probably marks the position from which the layout of the design was set out with a pair of compasses. The finger position is that of a hand in blessing. The thumb is not hidden, but can be seen alongside the second finger. On the Bayeux Tapestry, in the scene where Harold swears on a shrine, his right hand is shown palm forwards but in a similar position, except that the thumb is folded completely under and would not have been visible from the back (Wilson

1985, 26). This is also the case with, for example, the middle figure on face A of the base of the cross from Auckland St Andrew, co. Durham. This figure is giving a blessing, or could be pointing in a holy way, to the figure on the right. The figures to right and left are, however, pointing towards him using four fingers, not two, so it is likely that the middle figure is giving a blessing (Cramp 1984, I, 37–8, II, pls. 1 (1), 5 (15)). On the painted stone from the foundation of the New Minster church (Winchester CG WS 435) one of the figures is pointing with one finger. In the contemporary illumination in the New Minster *Liber Vitae*, Christ in Majesty is blessing Cnut and Emma with his right hand, with the fingers as on no. 2, but with the thumb sticking up almost vertically (BL MS Stowe 944, fol. 6; Temple 1976, no. 78., ill. 244).

There is no parallel to the isolated depiction of a horizontal hand holding a cross with the fingers in a blessing position. The best parallel is the carving from Bristol cathedral showing the harrowing of Hell, where Christ holds a cross on a long staff, the cross itself being similar to that on no. 2. On the Bristol stone, Christ's left hand holds the cross and his right hand is in a blessing gesture, either in front of the cross or perhaps holding it (Stone 1955, 39, pl. 24; Zarnecki *et al.* 1984, 96). The Bristol stone, which is best dated *c.* 1050, was found in 1832 forming a coffin lid over one of twelve coffins below the chapter house. The relief, as on no. 2, occupies a field scooped out of the surface of the stone.

There are also several manuscript paintings which show Christ in Majesty holding a cross on a long staff, but in his left hand, for example, Christ Enthroned with Martyrs, Confessors and Virgins in the Aethelstan Psalter (BL MS Cotton Galba A. XVIII, fol. 21, 302 (Temple 1976, no. 5, ill. 33)); or Christ in Majesty from the Tiberius Psalter (BL MS Cotton Tiberius C. VI, fol. 18v (ibid., no. 98, ill. 302)). No close parallel to no. 2. has been found outside Winchester, where New Minster 1 (Ill. 657) and St Pancras 1 (Ill. 675) are of similar type. But the style of carving is similar to that seen on roods in Hampshire; for discussion and reference, see New Minster 1. When found, the finished east end of grave-cover no. 6 was fitted below the bottom frame of no. 2.

DATE Early eleventh century

REFERENCES Biddle 1966a, 325, pls. LXI a–b; Biddle and Kjølbye-Biddle 1972, 13; Biddle and Kjølbye-Biddle 1973, 11; Oddy 1990, 69, pl. 1; Biddle and Kjølbye-Biddle forthcoming a, fig. 155, no. 95

M.B.; B.K.-B.

### 3. Fragment of grave-marker(?)    (Ills. 494–6)

PRESENT LOCATION Winchester City Museum, Historic Resources Centre, Hyde House, Winchester, accessions no. 2943 WS 404

EVIDENCE FOR DISCOVERY Found in archaeological excavation north of Winchester cathedral in 1966 in medieval burial earth above western part of Old Minster; Final Phase 80 (Provisional Phase 1434), early to mid fifteenth-century

H.   17 > 11 cm (6.7 > 4.3 in)   W.   17 > 12 cm (6.7 > 4.7 in)
D.   8.3 > 6.6 cm (3.3 > 2.6 in)

STONE TYPE Greyish-yellow, medium-grained oolitic limestone, with calcite veinlets; Combe Down Oolite, Great Oolite Formation of the Bath area, Great Oolite Group, Middle Jurassic

PRESENT CONDITION Face A is very damaged, but the details of the surviving corner are crisp

DESCRIPTION This is the bottom left corner of the upper part of a stone with a complex curving outline. Two cylindrical holes rising from faces A and C have just survived in the bottom edge, one with a diameter of approximately 2.5 cm, the other of 3.4 cm.

*A:* Carved in its upper part and plain in the lower, a flat horizontal band 6.6 cm wide. The carving consists of the top of a circular band, a diagonal 'stem', and elaborate folds with a clearly defined frilly edge. At the extreme left-hand edge an element projects upwards.

*B:* Broken away.

*C:* Decorated with a motif of stepped triangles.

*D:* Smoothly dressed.

DISCUSSION The carving is excellent, in the best Winchester style, and looks like the edges of borders of several illuminated manuscripts of the Winchester school, such as the Pentecost from the Pontifical of archbishop Robert of Jumièges (Rouen, Bibl. Mun. Y.7, fol. 29v (Temple 1976, no. 24, frontispiece)). The stone frill seen on the present carving would give the same effect in stone as does the white lining along the edges of the draperies on many manuscripts of this school and later (see, for example, Temple 1976, no. 16, ill. 84). This piece could be part of a very elaborate grave-marker, even more elaborate than no. 4 from this site.

The triangle pattern on face C is not like tegulation because the triangles with their point down are no more strongly emphasized than those with their point up. It is a very effective three-dimensional geometric pattern, stronger than that seen on no. 87 (Ill. 639).

DATE Late tenth century

REFERENCE Biddle and Kjølbye-Biddle forthcoming a, fig. 155, no 97

                                          M.B.; B.K.-B.

### 4. Grave-marker    (Ills. 502–8)

PRESENT LOCATION Winchester City Museum, Historic Resources Centre, Hyde House, Winchester, accessions no. 2943 WS 97

EVIDENCE FOR DISCOVERY Found in archaeological excavation north of Winchester cathedral in 1965 in rubble filling *aussenkrypta* of late tenth-century east apse of Old Minster; Final Phase 59 (Provisional Phase 644), *c.* 1093–4

H.   63 > 61.5 cm (24.8 > 24.2 in)   W.   50 > 30 cm (19.7 > 11.8 in)
D.   18.5 > 9.4 cm (7.3 > 3.7 in)

STONE TYPE Yellowish-grey, medium- to coarse-grained, shelly oolitic limestone, including pellets up to 1 mm in length, and calcite veinlets; Combe Down Oolite, Great Oolite Formation of the Bath area, Great Oolite Group, Middle Jurassic

PRESENT CONDITION Good, though the bottom right-hand corner is damaged and the top of the right-hand arch of face A is a modern repair

DESCRIPTION The stone has a flat back and sides. The top is shaped into three arches. Only one face is decorated.

*A (broad):* The decoration is divided into three zones. The lowest is flat, its surface level with that of the arcades and the strip on which they stand (Ills. 506–7). The height of this zone is irregular due to the chamfers on the bottom of the stone. The middle zone is a horizontal slot, 4 cm deep and 13 cm high. There is a small square scar, 4 by 4 cm, cut diagonally into the face of the slot (Ill. 508). The upper zone, 34 cm high, consists of a deeply recessed triple arcade (maximum depth *c.* 7 cm) which sits on a flat base, 4 cm high. The arcade is composed of two smaller arches, that on the left 23 cm high and 11 cm wide, that on the right 24 cm high and 10 cm wide. These flank a tall central arch, 27 cm high and 16 cm wide. Four columns with moulded bases and capitals carry the arches (total height of the columns 17–18 cm, the

shafts 9.6–10 cm high). From the centre of the middle arch, a lamp hangs on a long cord, attached to the rim of the lamp by three strands. The lamp has a globular body and a small foot ring. Around it radiate a series of cuts into the background of the relief. Suspended from the intrados of the central arch are curtains, which swing behind the central columns and knot themselves around the back of the smaller arcades.

*B–E (back, sides and top):* Smoothly dressed.

*F (bottom):* There is a chamfer along the front and left side, meeting in a diagonal edge. The chamfered area ends to the right in a stop with a vertical edge (Ill. 504).

DISCUSSION The chamfers on face F and the square scar on face A suggest that the stone has been reused as an architectural element. The horizontal slot was probably cut to take the end of a stone grave-cover, as was the case with the foot-stone for Anglo-Saxon Grave 119 (no. 2 (Ill. 498); cf. the associated cover, no. 6). The present carving is probably the foot-stone from one of the several stone-covered graves found east of Old Minster, and was probably thrown with the rubble from the walls into the deep area over the *aussenkrypta*, together with other large stones, such as no. 88. The carving is excellent, in good Winchester style.

The iconography of the curtains pulled back to reveal an important scene is common, and can be seen with a central lamp between curtains suspended from an arch in a mid twelfth-century Winchester miniature of the nativity (Temple 1976, fig. 45). Curtains hanging from rods, pulled to the side and fastened to columns, are accurately shown on mosaics and in illuminations until some stage in the late tenth century, when they begin to be shown, as on this stone, attached impractically to the underside of arches and with decorative, rather than functional, knots (Gervers 1984, 73). The arcade may be a representation of the polygonal building around the Tomb of Christ in the church of the Holy Sepulchre in Jerusalem, which from the fourth century onwards is frequently depicted as a large central arch flanked by two smaller arches, to give an illusion of perspective. In such images a lamp often hangs in the central arch between open curtains (Wilkinson 1972, 92–3). The lamp would symbolize the resurrection and eternal life, and 'the gift of the Holy Spirit, the *mare vitreum*, the baptism' (Sauer 1964, 227), hence the rays shining from it.

DATE Early to mid eleventh century

REFERENCES Biddle and Kjølbye-Biddle 1972, 11–12, no. 15; Biddle and Kjølbye-Biddle 1973, 12, no. 17; Biddle and Kjølbye-Biddle forthcoming a, fig. 156, no. 100

M.B.; B.K.-B.

## 5. Fragment of grave-marker        (Fig. 39; Ill. 501)

PRESENT LOCATION Winchester City Museum, Historic Resources Centre, Hyde House, Winchester, accessions no. 2943 WS 93

EVIDENCE FOR DISCOVERY Found in archaeological excavation north of Winchester cathedral in 1965 in rubble deriving from tenth-century east apse of Old Minster; Final Phase 58 (Provisional Phase 643), *c.* 1093–4

H.   16 > 10 cm (6.3 > 3.9 in)   W.   31 > 18 cm (12.2 > 7.1 in)
D.   19 > 13.8 cm (7.5 > 5.4 in)

STONE TYPE Greyish-yellow, medium- to coarse-grained, oolitic limestone, consisting of ooliths of 0.2 mm diameter in a calcite matrix, among which larger ooliths and pellets of 0.5–0.8 mm diameter are unevenly scattered, with some bivalves preserved in crystalline calcite—a much less evenly-graded texture than is typical of Combe Down Oolite; probably Great Oolite Group, Middle Jurassic; provenance uncertain

PRESENT CONDITION The carved surface is battered, and all original edges have been cut away

DESCRIPTION Only one face is decorated.

*A (broad):* A linear pattern is marked by deep V-shaped grooves. The outer line of the pattern is present only

FIGURE 39
Winchester Old Minster 5A, reconstruction, nts

at the top where its outer edge is broken away. Parts of two inner lines are preserved, one curling back on itself to form a pointed circle. The surviving lines seem to define one arm of a cross, a simplified type E9, as suggested in the reconstruction (Fig. 39).

DISCUSSION There is no close parallel in stone to this decoration, but the way the end of the arm curls back recalls the terminals of the most elaborate iron coffin-fittings from Old Minster (e.g. G.821, probably of the mid ninth century), and the overall effect is like that achieved by combining two such fittings to form a cross, as was done on the lid of G.68 in the tenth century. A design like this could be achieved on wood, either carved or painted. Since the outer edge of the stone nowhere survives, its shape is unknown, although it was probably round-headed, like no. 94.

DATE Late tenth or early eleventh century

REFERENCES Biddle and Kjølbye-Biddle 1973, 19, no. 59; Biddle and Kjølbye-Biddle forthcoming a, fig. 157, no. 101

M.B.; B.K.-B.

## 6. Grave-cover                  (Ills. 509–13, 521)

PRESENT LOCATION Winchester City Museum, The Square, Winchester, accession no. 2943 WS 104.2

EVIDENCE FOR DISCOVERY Found covering Anglo-Saxon grave 119, foot of which marked by no. 2; see no. 2.

L.   148.6 cm (58.5 in)   W.   53.6 > 48.6 cm (21.1 > 19.1 in)

D.   39.6 > 32.8 cm (15.6 > 12.9 in)

STONE TYPE Pale grey fine-grained limestone, with moulds of gastropods and of *Chara* nucules; Bembridge limestone, Bembridge Formation, Palaeogene, Tertiary; Isle of Wight

PRESENT CONDITION A little weathered, with some slight deterioration of the inscription

DESCRIPTION A coped stone of complex geometry. The long sides rise in convex curves to a flat axial band into which the greater part of the inscription is cut. To either end this flat upper surface expands and curves downwards to form the ends of the coping. The expanded areas are concave across the width of the stone and thus form elegant arrises at each of the four angles. The inscription begins and finishes on the concave end surfaces rather more than half-way down. The entire surface of the coping is dressed smooth, so that the tooling is barely visible. Below the rounded

surfaces, the four sides of the stone are vertical and dressed flat, but the tooling remains partly visible. On the two long sides, the curved surfaces pass directly into the vertical edges over a slight arris (Ill. 521). Both ends carry angled rebates between the curved and vertical surfaces (Ill. 510). The left-hand (or western) part of the front (or southern) vertical face is roughly dressed over rather more than half its length, and this dressing continues up into the rounded side above (Ill. 521). The underside of the stone has not yet been inspected.

A hint of a pattern of triangular incisions can sometimes be seen in the right light along the upper bevel on the south side. Whether it reflects the original adzing of the block not entirely smoothed away, or a possible intention, subsequently abandoned, to indicate tegulation, seems quite uncertain. When the grave-cover is properly bedded (as it is in Winchester City Museum) the west end is noticeably higher and wider than the east end.

M.B.; B.K.-B.

*Inscription* The inscription (Okasha 1971, 126–7; eadem 1983, 110; eadem 1992b, 340–1, 345) is incised in a single line along the central axis of the stone. When it was in its original position the inscription ran from west to east and was to be read from the south side, that is, the text began at the head end of the grave. Letters vary a little in height. The initial cross is about 7 cm (2.75 in) and the final A is 7.9 cm (3.1 in). Letters along the ridge are somewhat constricted by the narrow field but are also more worn and so difficult to measure: the S at the end of the ridge is about 5.8 cm (2.3 in) high. The letters increase in height again as the field flares out again at the end of the stone. The inscription is in capitals and may be transcribed as follows:

+HERLI[Ð]G[VNNI:EO]R[LE]SF/E[O]L/AGA

The language is Old English and the reading is straightforward:

+ HER LIÐ GV[N]N[I] [:] EOR[L]ES FEOLAGA

(Translation: '+ Here lies Gu[n]n[i], the earl's companion', or perhaps 'Here lies Gu[n]n[i], Eorl's companion' (Okasha 1971, 127).) As there seems to be only one recorded example from England of Eorl as a personal name (Okasha 1971, 127), 'earl's companion' is the more probable reading. '*Feolaga*' is an anglicization of Old Norse *félagi* (Page 1971, 180). This word appears in a number of Norse rune-stones with meanings such as 'partner', 'comrade', or

'comrade-in-arms' (Page 1987, 51; Moltke 1985, 20–1, 196–7, 551, etc.). A possibly relevant English use is in manuscript D of the *Anglo-Saxon Chronicle*, under the year 1016, to describe a formal sworn friendship and compact between Cnut and Edmund (Earle and Plummer 1892–9, I, 152).

There is no obvious modelling of strokes and no definite seriffing, although damage to the coarse-grained stone prevents certainty on this question. The letters approximate to the standard 'Roman' forms. The following forms are to be noted. One or both of the two As may have had a short bar across the top (Ill. 513). The cross-bar of the first A is horizontal but that of the second slopes down to the right. G is angular (Ill. 513). The vertical of the second L leans backwards noticeably (Ill. 513). N is the 'Roman' form; R is closed (Ill. 512). The Old English graph *eth* is in its capital form based on Roman D (Ill. 511). The F and E of FEOLAGA (Ill. 513) are linked by the extended lower horizontal of F which runs into the middle horizontal of E, a decorative feature rather than a space-saver, if it is not a slip of the chisel. L and A are linked at the base in a similar way in the same word.

There may have been a punctuation mark in the form of two points dividing the final phrase (EORLES FEOLAGA), which is in apposition to the name, from the main clause, although the stone is too worn to be sure.

J.H.

DISCUSSION The grave-cover was found in position with a vertical marker (Old Minster no. 2) at the foot end. (For the iconography of the surviving foot-stone in relation to the burial covered by no. 6, see no. 2.) There was no marker at the head end, but it is likely that there had been one originally, in part because the grave itself extends further west than the west end of the stone (Biddle and Kjølbye-Biddle forthcoming a, fig. 51), but also because the rebate across the head end (Ills. 509–10) suggests that the stone had been prepared to fit under a corresponding rebate on the lower part of a head-stone, as seen on foot-stone no. 2 (Ill. 498) or even into a slot, such as that present on the lower part of grave-marker no. 4 (Ill. 503). The rough tooling along the western part of the south side of the present carving (Ill. 521) may be primary rather than secondary. It may represent either the original dressing of the block as received from the quarry, or (less likely) the original dressing of the block as it was taken from some Roman structure for reuse.

The sophisticated shape of the coped surface of the present stone seems not to be precisely paralleled. An elaborately decorated early eleventh-century coped grave-cover from Durham (Cramp 1984, II, pl. 49) offers an approximate analogy, but a series of simpler early Romanesque coped grave-covers from Denmark, one from Lovenholm, Djursland, and two from Jutland (Hadbjerg and Baelum) are better parallels (Andersen 1986, 38–48). Whether these stones, including the present carving, should be regarded as in any way related to hogbacks seems to us now uncertain (cf. Lang 1984, 172). The concave ends of the Winchester cover seem to argue against this. The shape is more elaborate than grave-markers of Corpus type g, but not as elaborate as the typical hogbacks (Cramp 1991, p. xviii). The shape would be relatively easy to carve in wood and it may be worth considering that this is a stone example of a now vanished series of recumbent wooden grave-markers. Support for this view is provided by the remarkable series of wooden coffins from the Merovingian cemetery at Oberflacht (Landkreis Tuttlingen, Baden-Württemberg) (Schiek 1992, taf. 2, 6–8, 11, 39, 40, 42–3, 45–6, 52, 55, 57, 93A, 98, 105–7, 109–11; Paulsen 1992, 23–40), where the coffins and coffin-lids are carved out of a single trunk, split and hollowed. The lids are rounded to either side, following the natural curve of the trunk, worked flat on top, and bevelled at each end (like a gable), often with a slight hollow, as on the present stone. Of the 23 coffin-lids of this type illustrated in Schiek 1992, twelve have a snake carved in low relief along the length of the flattened top, while the remaining eleven are plain. The Oberflacht lids demonstrate how naturally the shape of the Winchester cover might be worked in wood, while the wide distribution in space and date of grave-covers of this type (seventh-century Germany, eleventh-century England, and twelfth-century Denmark) suggests that the form may once have been widespread, whether for grave-covers or coffin-lids.

M.B.; B.K.-B.

*Inscription* Her *lið* is unique in Anglo-Saxon inscriptions. As *hic iacet* seems not to have been a current memorial formula in England before the Conquest, *her lið* is perhaps a translation of *hic requiescit*, which was used at Monkwearmouth, co. Durham (Cramp 1984, I, 124, II, pl. 110 (604)), Whitchurch 1 (pp. 271–3), and in inscriptions recorded by Bede at Canterbury and Ripon, Yorkshire (Okasha 1971, 101, 126; Higgitt 1979, 365). Gunni is a name of Old Norse origin (Searle 1897, 272, 557–8; Feilitzen 1937, 277).

The archaeological context (see above) makes an early eleventh-century date for the inscription very probable. This inscription has therefore added importance as an approximately datable piece of incised lettering (Introduction, p. 110). Although the inscription shows Scandinavian influence in language and name and although it may have marked the burial of 'one of Cnut's men', it is English in language and lettering and forms, as Page points out, an interesting contrast with the approximately contemporary Scandinavian rune-stone from the city (Winchester St Maurice no. 1 (Ills. 667–70; Kjølbye-Biddle and Page 1975, 392, 394)).

J.H.

DATE Early eleventh century

REFERENCES Biddle 1966a, 325, pls. LXI, LXV; Okasha 1971, no 138; Roesdahl *et al.* 1981, 168, no. J2; Lang 1984, 172; Andersen 1986; Biddle and Kjølbye-Biddle forthcoming a, fig. 158, no. 107

## 7. Part of column    (Fig. 40; Ills. 522–3)

PRESENT LOCATION Winchester City Museum, Historic Resources Centre, Hyde House, Winchester, accessions no. 2943 WS 441

EVIDENCE FOR DISCOVERY Found in archaeological excavation north of Winchester cathedral in 1966, in rubble fill of Anglo-Saxon cesspit (F. 307); Final Phase 66–7 (provisional phase 1188), early twelfth century

H.   28.5 > 21 cm (11.2 > 8.3 in)   W.   18 > 17 cm (7.1 > 6.7 in)
D.   18 > 17 cm (7.1 > 6.7 in)

STONE TYPE Pale yellowish-grey, medium- to coarse-grained, shelly, oolitic limestone; Combe Down Oolite, Great Oolite Formation of the Bath area, Great Oolite Group, Middle Jurassic

PRESENT CONDITION Battered; one bed face, F (bottom), survives. There are traces of whitewash in places, and evidence of secondary working

DESCRIPTION Throughout the length of the column there is a hole which is now off-centre. At the upper, broken surface the hole is circular with a diameter of 2.7 cm. On face F (the bed face) it is square (Ill. 522), measuring 5 × 5 cm on the surface, narrowing to *c.* 3.2 × 3.2 cm. The hole is square for a length of *c.* 20 cm, and circular for the remaining (upper) part. Originally it had a steep outward splay, 7 cm wide, at the top, which would, if complete, have placed the

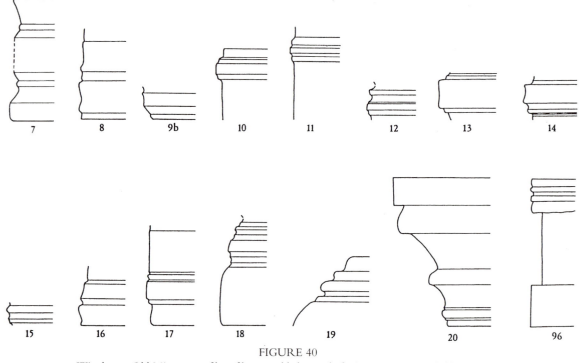

FIGURE 40
Winchester Old Minster, profiles of bases and baluster shafts (1:8 approx., not half-diameters)

circular hole at the centre of a column with a diameter about 21 cm.

Externally, on the narrow part of the column, there is a damaged, raised middle band, 9 cm wide, which may once have projected far enough for the middle portion to have had the same diameter as the top and bottom of the column (see Fig. 40). The secondary working consists of trimming back the middle moulding throughout, and trimming the upper splay almost entirely away. A small area of the splay survives opposite the point where the column has been trimmed flat by diagonal tooling.

DISCUSSION This small column is probably derived from the westwork of Old Minster.

DATE Late tenth century

REFERENCE Biddle and Kjølbye-Biddle forthcoming a, fig. 141, no. 4

M.B.; B.K.-B.

## 8. Fragment of column          (Fig. 40; Ills. 524–5)

PRESENT LOCATION Winchester City Museum, Historic Resources Centre, Hyde House, Winchester, accessions no. 2943 WS 1

EVIDENCE FOR DISCOVERY Found in archaeological excavation north of Winchester cathedral in 1964 in rubble derived from demolition of high altar area of Old Minster as reconstructed in c. 993–4, i.e., raised above crypt created over original square east end of Old Minster (c. 648), itself replaced by an apse in eighth century; Final Phase 59 (Provisional Phase 819), c. 1094

H.   16.5 > 14.8 cm (6.5 > 5.8 in)
Diameter 27.1 > 25.4 cm (10.7 > 10 in)

STONE TYPE Yellowish-grey, medium- to coarse-grained, shelly, oolitic limestone; Combe Down Oolite, Great Oolite Formation of the Bath area, Great Oolite Group, Middle Jurassic

PRESENT CONDITION One bed face, F (bottom), survives; approximately 55 per cent of the circumference is preserved (Ill. 525). The mouldings are clear, but chipped and bruised, and a few traces of a pale pink rendering survive in the hollows

DESCRIPTION The moulding on the drum consists of two slightly hollowed bands, c. 5 cm wide, separated by a flat strip, 1.5 cm wide, with a similar strip at the top and bottom of the stone. The tooling on the bed face, F, which is concave, is well finished and smooth except over a crystalline fault in the stone.

DISCUSSION A strip of a second bed face may also exist on the more damaged 'upper' face, in which case the height of 16.5 cm becomes significant, being half a Carolingian foot of 0.333 m. The drum probably derives from the reconstruction of Old Minster in c. 993–4, but it could be an earlier column incorporated in the new work.

DATE Late tenth century?

REFERENCE Biddle and Kjølbye-Biddle forthcoming a, fig. 141, no. 5

M.B.; B.K.-B.

## 9a–b. Two fragments of lathe-turned column or baluster          (Fig. 40; Ills. 531–2)

PRESENT LOCATION Winchester City Museum, Historic Resources Centre, Hyde House, Winchester, accessions nos. 2943 WS 89 (9a), 2943 WS 38 (9b)

EVIDENCE FOR DISCOVERY Found in archaeological excavation north of Winchester cathedral in 1965. Fragment a, in masons' chippings layer derived from demolition of tenth-century east apse of Old Minster; Final Phase 60 (Provisional Phase 677), c. 1094 to late eleventh-century. Fragment b, in rubble from destruction of tenth-century east apse of Old Minster; Final Phase 59 (Provisional Phase 644), c. 1093–4

a: H.   7.2 > 3 cm (2.8 > 1.2 in)   W.   9.5 > 2.5 cm
     (3.7 > 1 in)
    D.   3.6 > 0.5 cm (1.4 > 0.2 in)
b: H.   7 > 3 cm (2.8 > 1.2 in)   W.   6.5 > 3 cm
     (2.6 > 1.2 in)
    D.   2.5 > 0.2 cm (1 > 0.1 in)

STONE TYPE Pale yellowish-grey, medium-grained, shelly, oolitic, limestone; Combe Down Oolite, Great Oolite Formation of the Bath area, Great Oolite Group, Middle Jurassic

PRESENT CONDITION a: no bed face survives; the carved surface is somewhat battered. b: one bed face is just present; the carved surface is crisp

DESCRIPTION a: Reconstructed column diameter 44.4 cm (17.5 in). Two bands c. 2 cm wide are separated by a moulding almost 1 cm wide, raised 0.5 cm, with a sloping upper side and almost horizontal underside. The upper edge turns in towards another element. b: Reconstructed column diameter at bed face 44.4 cm. The incomplete moulding is composed of a sharply angled lower part and a concave upper band or bands.

DISCUSSION The two fragments were found near each other and are from the same drum. This drum probably came from the tenth-century east apse of Old Minster, completed *c.* 993–4.

DATE Late tenth century

REFERENCE Biddle and Kjølbye-Biddle forthcoming a, fig. 141, no. 6 (fragment a), no. 13 (fragment b)

M.B.; B.K.-B.

## 10. Fragment of lathe-turned column or baluster
(Fig. 40; Ills. 533–4)

PRESENT LOCATION Winchester City Museum, Historic Resources Centre, Hyde House, Winchester, accessions no. 2943 WS 3

EVIDENCE FOR DISCOVERY Found in archaeological excavation north of Winchester cathedral in 1964 in demolition rubble derived from nave of Old Minster; Final Phase 60–70 (Provisional Phase 931), late eleventh- to late twelfth-century

H. 14.5 > 5 cm (5.7 > 2 in) W. 16 > 5 cm (6.3 > 2 in)
D. 4.5 > 0.5 cm (1.8 > 0.2 in)

STONE TYPE Pale greyish-yellow, medium- to coarse-grained, oolitic limestone, with a prominent calcite veinlet; Combe Down Oolite, Great Oolite Formation of the Bath area, Great Oolite Group, Middle Jurassic

PRESENT CONDITION Part of one bed face survives; the carved surface is somewhat battered

DESCRIPTION Reconstructed column diameter 38 cm (15 in). A rounded tripartite stepped moulding, 4 cm wide, projects about 1.5 cm, with a central rounded band, 2 cm wide, a sharper lower, and a rounder upper band.

DISCUSSION The drum was probably made for the remodelling of the nave of Old Minster, completed *c.* 993–4.

DATE Late tenth century

REFERENCE Biddle and Kjølbye-Biddle forthcoming a, fig. 141, no. 7

M.B.; B.K.-B.

## 11. Fragment of lathe-turned column or baluster
(Fig. 40; Ill. 535)

PRESENT LOCATION Winchester City Museum, Historic Resources Centre, Hyde House, Winchester, accessions no. 2943 WS 414

EVIDENCE FOR DISCOVERY Found in archaeological excavation north of Winchester cathedral in 1966 in robbing fill of Anglo-Saxon monolithic coffin, G.155; Final Phase 83 (Provisional Phase 1524), mid sixteenth- to late seventeenth-century

H. 19 > 4 cm (7.5 > 1.6 in) W. 13 > 1 cm (5.1 > 0.4in)
D. 5.8 > 3 cm (2.3 > 1.2 in)

STONE TYPE Pale yellowish-grey, medium-grained, shelly, oolitic limestone, with some pellets of 0.6 mm diameter, 1 mm long; Combe Down Oolite, Great Oolite Formation of the Bath area, Great Oolite Group, Middle Jurassic

PRESENT CONDITION No bed face survives; the carved surface is battered

DESCRIPTION Column diameter 38 cm (14.9 in). A shallow horizontal tripartite moulding, 4.3 cm wide, forms a band in which the central element is the highest. About 6.3 cm below this there are slightly marked horizontal lines, probably from the lathe turning.

DISCUSSION The drum probably came from the tenth-century westwork of Old Minster.

DATE Late tenth century

REFERENCE Biddle and Kjølbye-Biddle forthcoming a, fig. 141, no. 8

M.B.; B.K.-B.

## 12. Fragment of lathe-turned column or baluster
(Fig. 40; Ill. 527)

PRESENT LOCATION Winchester City Museum, Historic Resources Centre, Hyde House, Winchester, accessions no. 2943 WS 32

EVIDENCE FOR DISCOVERY Found in archaeological excavation north of Winchester cathedral in 1965 in fill of Norman bell-foundry cut into demolished tenth-century east apse of Old Minster; Final Phase 65 (Provisional Phase 734), early twelfth-century

H. 7 > 5.4 cm (2.8 > 2.1 in) W. 8 > 5 cm (3.1 > 2 in)
D. 2.5 > 1 cm (1 > 0.4 in)

STONE TYPE Whitish-grey (weathered pale buff), finely granular, porous limestone, with numerous *Orbitolites*, a few shell fragments, and prominent *Ditrupa* tubes; *Ditrupa* limestone (Banc de St Leu), Calcaire Grossier Formation, Palaeogene, Tertiary; Paris basin

PRESENT CONDITION No bed face survives; the carved surface is battered

DESCRIPTION Reconstructed diameter of column, 40.4 cm (15.9 in). The small fragment is composed of a complex stepped and sloping horizontal moulding.

DISCUSSION The stone is Calcaire Grossier of the variety found in East Kent and used, for example, for the Reculver cross fragments (no. 1). The drum probably came from the tenth-century east end of Old Minster, but could have derived from the seventh- or eighth-century east end, the robbing of which is also cut by the bell-foundry in which the carving was reused.

DATE Late tenth century or earlier, perhaps seventh or eighth

REFERENCE Biddle and Kjølbye-Biddle forthcoming a, fig. 141, no. 9

M.B.; B.K.-B.

### 13. Fragment of lathe-turned column or baluster
(Fig. 40; Ill. 528)

PRESENT LOCATION Winchester City Museum, Historic Resources Centre, Hyde House, Winchester, accessions no. 2943 WS 446

EVIDENCE FOR DISCOVERY Found in archaeological excavation north of Winchester cathedral in 1966 in wall of later medieval chapel built around tomb of St Swithun; Final Phase 74 (Provisional Phase 1511), mid thirteenth-century

H.   8.3 > 4.5 cm (3.3 > 1.8 in)   W.   8.8 > 2 cm (3.5 > 0.8 in)
D.   3.8 > 1 cm (1.5 > 0.4 in)

STONE TYPE Pale yellow, medium-grained, oolitic limestone, with evenly sized (0.3–0.4 mm) ooliths in a calcite matrix; Combe Down Oolite, Great Oolite Formation of the Bath area, Great Oolite Group, Middle Jurassic

PRESENT CONDITION No bed face survives; the carved surface is well preserved

DESCRIPTION Reconstructed diameter of column 42.4 cm (16.6 in). The moulding is composed of a central band, 4.6 cm wide, with a step, 1.1 cm deep, to the next element above and a step, 0.8 cm deep, to the element below, which itself projects 1 cm.

DISCUSSION The drum probably came from the tenth-century westwork of Old Minster.

DATE Late tenth century

REFERENCE Biddle and Kjølbye-Biddle forthcoming a, fig. 141, no. 10

M.B.; B.K.-B.

### 14. Fragment of lathe-turned column or baluster
(Fig. 40; Ill. 529)

PRESENT LOCATION Winchester City Museum, Historic Resources Centre, Hyde House, Winchester, accessions no. 2943 WS 27

EVIDENCE FOR DISCOVERY Found in archaeological excavation north of Winchester cathedral in 1965 in Norman destruction spread above tenth-century east apse of Old Minster; Final Phase 60 (Provisional Phase 645), late eleventh-century

H.   9 > 4 cm (3.5 > 1.6 in)   W.   8.5 > 4 cm (3.3 > 1.6 in)
D.   3.8 > 1 cm (1.5 > 0.4 in)

STONE TYPE Greyish-yellow, medium-grained, oolitic limestone; Combe Down Oolite, Great Oolite Formation of the Bath area, Great Oolite Group, Middle Jurassic

PRESENT CONDITION No bed face survives; the carved surface is well preserved

DESCRIPTION Reconstructed column diameter 39.2 cm (15.4 in). The moulding is composed of a hollow central band, 3 cm wide, with a step, 1.2 cm deep, to the next element above and a step, 1 cm deep, to the element below, which itself projects slightly.

DISCUSSION The drum probably came from the tenth-century east apse of Old Minster.

DATE Late tenth century

REFERENCE Biddle and Kjølbye-Biddle forthcoming a, fig. 141, no. 11

M.B.; B.K.-B.

### 15. Fragment of lathe-turned column or baluster
(Fig. 40; Ill. 530)

PRESENT LOCATION Winchester City Museum, Historic Resources Centre, Hyde House, Winchester, accessions no. 2943 WS 79

EVIDENCE FOR DISCOVERY Found in archaeological excavation north of Winchester cathedral in 1965 in same Norman destruction spread as no. 14, above

tenth-century east apse of Old Minster; Final Phase 60 (Provisional Phase 692), late eleventh-century

H.   5 > 1 cm (2 > 0.4 in)    W.   9.5 > 2.2 cm (3.7 > 0.9 in)
D.   2.5 > 1 cm (1 > 0.4 in)

STONE TYPE Pale yellowish-grey, medium-grained, oolitic limestone, with evenly sized (0.3–0.5 mm) ooliths; Combe Down Oolite, Great Oolite Formation of the Bath area, Great Oolite Group, Middle Jurassic

PRESENT CONDITION No bed face survives; the carved surface is fairly well preserved

DESCRIPTION Reconstructed column diameter 45.4 cm (17.9 in). The incomplete moulding is composed of two rounded and stepped elements.

DISCUSSION The drum probably came from the tenth-century east apse of Old Minster.

DATE Late tenth century

REFERENCE Biddle and Kjølbye-Biddle forthcoming a, fig. 141, no. 12

M.B.; B.K.-B.

## 16. Fragment of lathe-turned column or base
(Fig. 40; Ill. 514)

PRESENT LOCATION Winchester City Museum, Historic Resources Centre, Hyde House, Winchester, accessions no. 2943 WS 4

EVIDENCE FOR DISCOVERY Found in archaeological excavation north of Winchester cathedral in 1964 in rubble from destruction of tenth-century and earlier nave of Old Minster; Final Phase 48 (Provisional Phase 832), late tenth-century

H.   13.2 > 11 cm (5.2 > 4.3 in)    W.   20 > 15 cm (7.9 > 5.9 in)
D.   10 > 6 cm (3.9 > 2.4 in)

STONE TYPE Whitish-grey limestone, end-bedded; Combe Down Oolite, Great Oolite Formation of the Bath area, Great Oolite Group, Middle Jurassic

PRESENT CONDITION One bed face survives; the carved surface is battered

DESCRIPTION Reconstructed diameter at bed face, 49.8 cm (19.6 in). The moulding is composed of two bands, c. 3.5 cm wide, separated by a deep groove. The lower band has a curved outline, the upper slopes quite sharply inwards.

DISCUSSION This carving could have been an earlier piece incorporated in the tenth-century work. It has a different feel from nos. 9–15 which (apart from no. 10) are from the demolition of tenth-century parts of Old Minster, where there is little likelihood of earlier pieces having been reused. But this drum could come from the seventh-century nave. The diameter of 50 cm or 1.5 Carolingian (Drusian) feet should be noted.

DATE Late tenth century or earlier, perhaps late seventh

REFERENCE Biddle and Kjølbye-Biddle forthcoming a, fig. 141, no. 14

M.B.; B.K.-B.

## 17. Fragment of lathe-turned column or base
(Fig. 40; Ill. 515)

PRESENT LOCATION Winchester City Museum, Historic Resources Centre, Hyde House, Winchester, accessions no. 2943 WS 29

EVIDENCE FOR DISCOVERY Found in archaeological excavation north of Winchester cathedral in 1965 in rubble from destruction of tenth-century east apse of Old Minster; Final Phase 59 (Provisional Phase 691), c. 1093–4

H.   17.8 > 10 cm (7.0 > 3.9 in)    W.   25.6 > 19 cm (10.1 > 7.5 in)
D.   10 > 3.5 cm (3.9 > 1.8 in)

STONE TYPE Greyish-white, medium- to coarse-grained, shelly, oolitic limestone, with a calcite veinlet, and end-bedded; Combe Down Oolite, Great Oolite Formation of the Bath area, Great Oolite Group, Middle Jurassic

PRESENT CONDITION One bed face survives; the carved surface is battered

DESCRIPTION Reconstructed diameter at bed face 51.2 cm (20.2 in). The moulding is composed of a tripartite band, 5.5 cm wide. The slightly hollowed middle band is 3 cm wide.

DISCUSSION This column probably derives from the late tenth-century eastern apse of Old Minster.

DATE Late tenth century

REFERENCE Biddle and Kjølbye-Biddle forthcoming a, fig. 141, no. 15

M.B.; B.K.-B.

## 18. Fragment of lathe-turned base

(Fig. 40; Ill. 516)

PRESENT LOCATION Winchester City Museum, Historic Resources Centre, Hyde House, Winchester, accessions no. 2943 WS 455

EVIDENCE FOR DISCOVERY Unstratified; found lying in external western bay, north of Winchester cathedral, in 1967. Probably derived from west end of Old Minster

H.  18.8 > 16 cm (7.4 > 6.3 in)   W.  15 > 7 cm
    (5.9 > 2.8 in)
D.  14 > 7 cm (5.5 > 2.8 in)

STONE TYPE Whitish-grey, medium- to coarse-grained, shelly, oolitic limestone, apparently end-bedded; Combe Down Oolite, Great Oolite Formation of the Bath area, Great Oolite Group, Middle Jurassic

PRESENT CONDITION One bed face survives; the carved surface is fairly well preserved

DESCRIPTION Reconstructed diameter at bed face, 46 cm (18.1 in). The moulding is quite elaborate: starting 10 cm from the bottom there is a twice repeated pattern of narrow and wide shallow bands.

DISCUSSION This column probably comes from the late tenth-century west end of Old Minster.

DATE Late tenth century

REFERENCE Biddle and Kjølbye-Biddle forthcoming a, fig. 141, no. 16

M.B.; B.K.-B.

## 19. Fragment of base

(Fig. 40; Ill. 517)

PRESENT LOCATION Winchester City Museum, Historic Resources Centre, Hyde House, Winchester, accessions no. 2943 WS 103

EVIDENCE FOR DISCOVERY Found in archaeological excavation north of Winchester cathedral in 1965 reused in Norman bell-foundry which cuts tenth-century east apse of Old Minster; Final Phase 65 (Provisional Phase 679), early twelfth-century

H.  12.4 > 9 cm (4.9 > 3.5 in)   W.  16.4 > 8 cm
    (6.5 > 3.1 in)
D.  13 > 3 cm (5.1 > 1.2 in)

STONE TYPE Whitish-grey, fine-grained, porous, foraminiferal limestone, with numerous moulds of cerithiid gastropods and some of fine-ribbed bivalves; *Cerithium* limestone, from upper part of Calcaire Grossier Formation, Palaeogene, Tertiary; Paris basin

PRESENT CONDITION One bed face survives; the carved surface is battered

DESCRIPTION Reconstructed diameter at bed face, 32 cm (12.6 in). Fig. 40 shows the fragment as if it is part of the top of a base. The mouldings are deep and bulge strongly outwards.

DISCUSSION This base probably came from the late tenth-century east apse of Old Minster, but the bell-foundry also cuts the seventh- and eighth-century east end. This fragment has an earlier feel. The top diameter as calculated, of almost one Carolingian (Drusian) foot, should be noted.

DATE Late tenth century or earlier

REFERENCE Biddle and Kjølbye-Biddle forthcoming a, fig. 141, no. 17

M.B.; B.K.-B.

## 20. Fragment of capital or base

(Fig. 40; Ills. 518–20)

PRESENT LOCATION Winchester City Museum, Historic Resources Centre, Hyde House, Winchester, accessions no. 2943 WS 405

EVIDENCE FOR DISCOVERY Found in archaeological excavation north of Winchester cathedral in 1966 reused in later medieval chapel built around tomb of St Swithun; Final Phase 74 (Provisional Phase 1512), mid thirteenth-century

H.  33 > 32 cm (12.9 > 12.5 in)   W.  20 > 12 cm
    (7.9 > 4.7 in)
D.  12.8 > 8 cm (5.1 > 3.1 in)

STONE TYPE Yellowish-grey, medium-grained, shelly, oolitic limestone; Combe Down Oolite, Great Oolite Formation of the Bath area, Great Oolite Group, Middle Jurassic

PRESENT CONDITION Two bed faces, E (top) and F (bottom), survive; the carved surface is battered

DESCRIPTION Reconstructed diameter at lower bed face, (F), 26 cm (10.2 in), at upper bed face, (E), 48.2 (19 in); distance between bed faces 32.6 (12.8 in). Below the right-angled abacus(?), the piece narrows in two down-turned mouldings, with a more standard tripartite band at the lower edge. The piece has been pierced from top to bottom by a square(?), perhaps central, hole.

DISCUSSION There is no comparable capital or base from Winchester. It need not come from the west end of Old Minster, where the medieval chapel of St Swithun was built, but there is no reason why it should not have done.

DATE Late tenth century or earlier

REFERENCE Biddle and Kjølbye-Biddle forthcoming a, fig. 142, no. 18

M.B.; B.K.-B.

### 21. Shaft of engaged colonnette                  (Ill. 526)

PRESENT LOCATION Winchester City Museum, Historic Resources Centre, Hyde House, Winchester, accessions no. 2943 WS 49

EVIDENCE FOR DISCOVERY Found in archaeological excavation north of Winchester cathedral in 1965 in destruction rubble deriving from tenth-century east apse of Old Minster; Final Phase 59 (Provisional Phase 644), *c.* 1093–4

H.   20 > 14 cm (7.9 > 5.5 in)   W.   19 > 13 cm (7.5 > 5.2 in)
D.   16 > 2.5 cm (6.4 > 1 in)

STONE TYPE Yellowish-grey, medium-grained, oolitic limestone, with detrital-shelly streaks, and end-bedded; Combe Down Oolite, Great Oolite Formation of the Bath area, Great Oolite Group, Middle Jurassic

PRESENT CONDITION One bed face survives; the surfaces are battered

DESCRIPTION Reconstructed diameter of column 14 cm (5.5 in). The colonnette was part of a decorative scheme projecting 14.7 cm (5.8 in) from the wall face. The capital does not survive.

DISCUSSION This piece probably comes from the tenth-century east end. It was found near no. 22 and in a demolition layer of the same date.

DATE Late tenth or early eleventh century

REFERENCE Biddle and Kjølbye-Biddle forthcoming a, fig. 142, no. 21

M.B.; B.K.-B.

### 22. Capital and shaft of engaged colonnette

(Ills. 536–7)

PRESENT LOCATION Winchester City Museum, Historic Resources Centre, Hyde House, Winchester, accessions no. 2943 WS 63

EVIDENCE FOR DISCOVERY See no. 21.

H.   20.5 > 5.5 cm (8.1 > 2.1 in)   W.   17.4 > 5 cm (7 > 2 in)
D.   31.5 > 30.5 cm (12.4 > 12 in)

STONE TYPE Combe Down Oolite, Great Oolite Formation of the Bath area, Great Oolite Group, Middle Jurassic

PRESENT CONDITION One bed face survives; the surfaces are battered

DESCRIPTION Reconstructed diameter of column 9 cm (3.5 in). The colonnette was part of a decorative scheme projecting 15.8 cm (6.2 in) from the wall-face.

DISCUSSION This architectural fragment probably comes from the tenth-century east end. But the capital (surviving height 15.5 cm (6 in)) is almost of cushion type and seems late.

DATE Late tenth or early eleventh century

REFERENCE Biddle and Kjølbye-Biddle forthcoming a, fig. 142, no. 22

M.B.; B.K.-B.

### 23. Fragment of lathe-turned column or baluster                                          (Ill. 538)

PRESENT LOCATION Winchester City Museum, Historic Resources Centre, Hyde House, Winchester, accessions no. 2943 WS 47

EVIDENCE FOR DISCOVERY Found in archaeological excavation north of Winchester cathedral in 1965 in destruction rubble deriving from tenth-century east apse of Old Minster; Final Phase 60 (Provisional Phase 645), late eleventh-century

H.   14 > 1 cm (5.5 > 0.4 in)   W.   29 > 6 cm (11.4 > 2.3 in)
D.   26 > 21 cm (10.2 > 8.2 in)

STONE TYPE Yellowish-grey, medium-grained, oolitic limestone; Combe Down Oolite, Great Oolite Formation of the Bath area, Great Oolite Group, Middle Jurassic

PRESENT CONDITION One bed face survives; the carved surface is battered

DESCRIPTION Reconstructed diameter 38 cm (15 in). A round hole (diameter 5 cm (2 in)) has been drilled off-centre at a slight angle to the vertical axis. There are no mouldings on this piece but there are traces of lathe turning.

DISCUSSION This drum probably comes from the tenth-century east end, but cannot be dated within the Anglo-Saxon period.

DATE Late tenth century or earlier

REFERENCE Biddle and Kjølbye-Biddle forthcoming a, fig. 143, no. 23

M.B.; B.K.-B.

## 24. Fragment of lathe-turned column or baluster                          (Ills. 542–3)

PRESENT LOCATION Winchester City Museum, Historic Resources Centre, Hyde House, Winchester, accessions no. 2943 WS 57

EVIDENCE FOR DISCOVERY See no. 21.

H.   25 > 18 cm (9.8 > 7 in)   W.   27 > 2 cm (10.6 > 0.8 in)
D.   23 > 10 cm (9 > 3.9 in)

STONE TYPE Yellowish-grey, medium-grained, oolitic limestone, with a calcite veinlet; Combe Down Oolite, Great Oolite Formation of the Bath area, Great Oolite Group, Middle Jurassic

PRESENT CONDITION One bed face, F (bottom), survives; the carved surface is battered, and partly cut away by a diagonally-tooled right-angled cut

DESCRIPTION Reconstructed diameter 44 cm (17.3 in). A round hole (diameter 5 cm (2 in)) has been drilled off-centre vertically through the drum. A shallow, slightly concave, moulding extending horizontally around the drum, and fainter horizontal traces below, show that this piece has been lathe-turned.

DISCUSSION This column drum probably comes from the tenth-century east end, but cannot be dated within the Anglo-Saxon period.

DATE Late tenth century or earlier

REFERENCE Biddle and Kjølbye-Biddle forthcoming a, fig. 143, no. 24

M.B.; B.K.-B.

## 25. Fragment                                    (Ills. 544–6)

PRESENT LOCATION Winchester City Museum, Historic Resources Centre, Hyde House, Winchester, accessions no. 2943 WS 444

EVIDENCE FOR DISCOVERY Found in archaeological excavation north of Winchester cathedral in 1966 in rubble deriving from north wing added to nave of Old Minster during tenth century; Final Phase 68–70 (Provisional Phase 1099), twelfth-century

H.   14.2 > 12.6 cm (5.6 > 5 in)   W.   7.8 > 5 cm (3.1 > 2 in)
D.   6 > 4 cm (2.4 > 1.6 in)

STONE TYPE Combe Down Oolite, Great Oolite Formation of the Bath area, Great Oolite Group, Middle Jurassic

PRESENT CONDITION No bed faces survive; the carved surface is battered

DESCRIPTION The pattern, which is incomplete, consists of three horizontal steps, projecting up to 3.5 cm from the background.

DISCUSSION This fragment could be part of an elaborate string, but is more likely to come from a complex scene.

DATE Tenth century

REFERENCE Biddle and Kjølbye-Biddle forthcoming a, fig. 144, no. 25

M.B.; B.K.-B.

## 26. Fragment                                    (Ills. 547–8)

PRESENT LOCATION Winchester City Museum, Historic Resources Centre, Hyde House, Winchester, accessions no. 2943 WS 283.1

EVIDENCE FOR DISCOVERY Found in archaeological excavation north of Winchester cathedral in 1964 in rubble deriving from north wing added to nave of Old Minster during tenth century; Final Phase 69 (Provisional Phase 1000), mid to late twelfth-century

H.   8.5 > 3 cm (3.3 > 1.2 in)   W.   7.5 > 2.5 cm (3 > 1 in)
D.   3 > 1.2 cm (1.2 > 0.5 in)

STONE TYPE Combe Down Oolite, Great Oolite Formation of the Bath area, Great Oolite Group, Middle Jurassic

PRESENT CONDITION One bed face survives; the decorated surface is battered and overlain with plaster

DESCRIPTION This sliver has a diagonal dressed face to the right. The surface has two flat-topped horizontal mouldings, 2.5 cm (1 in) and 1 cm (0.4 in) wide. An almost triangular element hangs from the lower moulding, with its left side almost parallel to the dressed face. The interior of the triangle is filled with plaster.

DISCUSSION Possibly part of an elaborate string

DATE Tenth century

REFERENCE Biddle and Kjølbye-Biddle forthcoming a, fig. 144, no. 26

M.B.; B.K.-B.

## 27. Fragment of string-course          (Ill. 541)

PRESENT LOCATION Winchester City Museum, Historic Resources Centre, Hyde House, Winchester, accessions no. 2943 WS 65

EVIDENCE FOR DISCOVERY Found in archaeological excavation north of Winchester cathedral in 1965 in rubble deriving from tenth-century east apse of Old Minster; Final Phase 59 (Provisional Phase 691), c. 1093–4

H.   14.5 > 10 cm (5.7 > 3.9 in)   W.   22 > 17.5 cm (8.7 > 6.9 in)
D.   7.5 > 2.5 cm (3 > 1 in)

STONE TYPE Greyish-yellow, medium- to coarse-grained, oolitic limestone, with a calcite veinlet; Combe Down Oolite, Great Oolite Formation of the Bath area, Great Oolite Group, Middle Jurassic

PRESENT CONDITION One bed face survives; the carved surface is damaged

DESCRIPTION An elegant curve carries the projection 3.6 cm outwards. The lower step then slopes backwards, while the element above again slopes outwards. The overall projection is 5.2 cm.

DISCUSSION The piece is competently carved. Its surviving height is 14.2 cm (5.6 in). Since it looks as if the bottom of the string might have been near, the total height of the block probably did not much exceed 14.2 cm. This piece is very like, but not identical to, no. 28, found near-by. They have the same overall projection and could have been part of the same string.

   H. M. Taylor discusses and analyses string-courses (Taylor and Taylor 1965–78, III, 902–14, figs. 696–8). Nos. 27 and 28 seem more elaborate than the strings with hollow chamfers he describes, which are generally from early churches, and are best placed amongst the moulded string-courses which come from churches of a wide date span. Moulded string-courses occurred seven times, that is, in eight per cent of the 88 churches accepted as Anglo-Saxon on primary and secondary evidence.

DATE Tenth century

REFERENCE Biddle and Kjølbye-Biddle forthcoming a, fig. 144, no. 27

M.B.; B.K.-B.

## 28. Fragment of string-course          (Ill. 540)

PRESENT LOCATION Winchester City Museum, Historic Resources Centre, Hyde House, Winchester, accessions no. 2943 WS 62

EVIDENCE FOR DISCOVERY Found in archaeological excavation north of Winchester cathedral in 1965 in rubble deriving from tenth-century east apse of Old Minster; Final Phase 59 (Provisional Phase 644), c. 1093–4

H.   12 > 5.5 cm (4.8 > 2.2 in)   W.   20 > 8 cm (7.9 > 3.1 in)
D.   8 > 1 cm (3.1 > 0.4 in)

STONE TYPE Yellowish-grey, medium- to coarse-grained, shelly, oolitic limestone; Combe Down Oolite, Great Oolite Formation of the Bath area, Great Oolite Group, Middle Jurassic

PRESENT CONDITION No bed faces survive; the carved surface is battered and eroded

DESCRIPTION A good curve carries the projection 2.4 cm out; the lower step is then vertical, and the next element slopes outwards. The overall projection is 5.2 cm.

DISCUSSION This is very like (but not identical to) no. 27, found near-by. They have the same overall projection and could have been part of the same string. For discussion and references, see no. 27.

DATE Tenth century

REFERENCE Biddle and Kjølbye-Biddle forthcoming a, fig. 144, no. 28

M.B.; B.K.-B.

## 29. Fragment of string-course or impost

(Ill. 539)

PRESENT LOCATION Winchester City Museum, Historic Resources Centre, Hyde House, Winchester, accessions no. 2943 WS 294

EVIDENCE FOR DISCOVERY Found in archaeological excavation north of Winchester cathedral in 1964 in rubble deriving from Old Minster nave; Final Phase 60–67 (Provisional Phase 992), late eleventh- to early twelfth-century

H. 7.8 > 6.5 cm (3.1 > 2.6 in)   W. 9 > 7 cm (3.5 > 2.8 in)

D. 2.9 > 1 cm (1.1 > 0.4 in)

STONE TYPE Combe Down Oolite, Great Oolite Formation of the Bath area, Great Oolite Group, Middle Jurassic

PRESENT CONDITION One bed face survives; the carved surface is somewhat battered

DESCRIPTION The upper part has a well defined band, 4.5 cm high projecting 1 cm beyond the lower element which slopes inwards. The top is flat with a maximum width of 1.5 cm. There are chisel marks on the bed face.

DISCUSSION This is very well cut, and could have come from a moulding like no. 27, but the fragment is too small to be sure.

DATE Tenth century

REFERENCE Biddle and Kjølbye-Biddle forthcoming a, fig. 144, no. 29

M.B.; B.K.-B.

## 30. Fragment of capital(?)   (Ills. 549–51)

PRESENT LOCATION Winchester City Museum, Historic Resources Centre, Hyde House, Winchester, accessions no. 2943 WS 107

EVIDENCE FOR DISCOVERY Found in archaeological excavation north of Winchester cathedral in 1965 in rubble deriving from tenth-century east apse of Old Minster; Final Phase 56–63 (Provisional Phase 724), late eleventh- to early twelfth-century

H. 10 > 4.5 cm (3.9 > 1.8 in)   W. 14 > 4.5 cm (5.5 > 1.8 in)

D. 7 > 6 cm (2.8 > 2.4 in)

STONE TYPE Pale yellowish-grey, medium- to coarse-grained, oolitic limestone with a 7 mm-diameter contemporary burrow; Combe Down Oolite, Great Oolite Formation of the Bath area, Great Oolite Group, Middle Jurassic

PRESENT CONDITION One bed face survives; the carved surface is battered

DESCRIPTION A rounded element, diameter *c.* 4.2 cm, curves out of an opening and folds back over.

DISCUSSION An incomprehensible part of a three-dimensional sculpture of very high relief.

DATE Tenth century

REFERENCE Biddle and Kjølbye-Biddle forthcoming a, fig. 144, no. 30

M.B.; B.K.-B.

## 31. Fragment of moulding   (Ill. 555)

PRESENT LOCATION Winchester City Museum, Historic Resources Centre, Hyde House, Winchester, accessions no. 2943 WS 3037

EVIDENCE FOR DISCOVERY Found in archaeological excavation north of Winchester cathedral in 1963 in burial earth earlier than construction of New Minster; Final Phase 27–32 (Provisional Phase 541), late eighth- to late ninth-century

H. 7 > 2.5 cm (2.8 > 1 in)   W. 7 > 2 cm (2.8 > 0.8 in)

D. 3.3 > 1.5 cm (1.3 > 0.6 in)

STONE TYPE Combe Down Oolite, Great Oolite Formation of the Bath area, Great Oolite Group, Middle Jurassic

PRESENT CONDITION No bed faces survive; the carved surface is well preserved

DESCRIPTION One moulded surface only on this chip. The main element is a roll moulding, 3.5 cm wide, with a slight sag. The surface rises perhaps vertically above it and slopes roundly inwards below.

DISCUSSION This could be part of a moulding like no. 32. The early date of its context is interesting; if the context is correct, the present piece must derive at the latest from a construction spread associated with re-shaping stones for New Minster. It was, however, found not far from the north-east corner of the seventh-century north porticus of Old Minster, where spreads associated with the eighth-century reconstruction of the seventh-century east end could have existed. The carving may have been redeposited from one of these.

DATE Seventh to ninth century

REFERENCE Biddle and Kjølbye-Biddle forthcoming a, fig. 144, no. 31

M.B.; B.K.-B.

## 32. Fragment of impost(?)   (Ills. 552–3)

PRESENT LOCATION Winchester City Museum, Historic Resources Centre, Hyde House, Winchester, accessions no. 2943 WS 52

EVIDENCE FOR DISCOVERY See no. 28.

H.   12.5 > 5 cm (4.9 > 2 in)   W.   14 > 5.5 cm (5.5 > 2.2 in)

D.   6 > 1 cm (2.4 > 0.4 in)

STONE TYPE Pale yellowish-grey, slightly greenish, shell-fragment limestone, including some recognizable gastropod moulds; Quarr Stone, Bembridge Formation, Palaeogene, Tertiary; Isle of Wight

PRESENT CONDITION No bed faces survive; the carved surfaces are battered but clear

DESCRIPTION Two moulded surfaces meet in a right angle. The upper part of the stone appears to have been vertical. Below this there is a rounded element, 3 cm wide, above a series of receding horizontal bands.

DISCUSSION This is closely paralleled by Hexham, Northumberland, no. 29 (Cramp 1984, I, 188, II, pl. 183 (997, 999)) which is seen as Roman or of the last quarter of the seventh century. The present piece was probably reused in the tenth-century eastern extension, but it may alternatively be an example of the 'Carolingian revival' of Classical forms.

DATE Seventh or tenth century

REFERENCE Biddle and Kjølbye-Biddle forthcoming a, fig. 144, no. 32

M.B.; B.K.-B.

### 33. Fragment of impost or abacus    (Ills. 556–7)

PRESENT LOCATION Winchester City Museum, Historic Resources Centre, Hyde House, Winchester, accessions no. 2943 WS 50

EVIDENCE FOR DISCOVERY See no. 28.

H.   11 > 3 cm (4.3 > 1.2 in)   W.   23 > 7 cm (9.1 > 2.8 in)

D.   23 > 3 cm (9.1 > 1.2 in)

STONE TYPE Yellowish-grey, medium-grained, shelly, oolitic limestone; Combe Down Oolite, Great Oolite Formation of the Bath area, Great Oolite Group, Middle Jurassic

PRESENT CONDITION Only one bed face survives; the carved surface is battered

DESCRIPTION Part of two surfaces meeting at a right angle. The vertical face has a narrow bevel, 6 cm in width, on its lower edge, which stops against the more massive moulding of the other face. This has a deep continuous and slightly hollowed splay, 6 cm wide, angled at approximately 45 degrees, rising to a vertical

face above which is an angular recess. The outline on the underside indicates a capital or column shaft c. 28 cm (11 in) in diameter.

DISCUSSION There is a parallel in Jouarre, column 7 (de Maillé 1971, 163–4, fig. 52) which is regarded as seventh century.

DATE Seventh or tenth century

REFERENCE Biddle and Kjølbye-Biddle forthcoming a, fig. 144, no. 33

M.B.; B.K.-B.

### 34. Fragment of impost or string-course(?)
(Ill. 559)

PRESENT LOCATION Winchester City Museum, Historic Resources Centre, Hyde House, Winchester, accessions no. 2943 WS 242

EVIDENCE FOR DISCOVERY Found in archaeological excavation north of Winchester cathedral in 1964 in rubble deriving from nave of Old Minster; Final Phase 58 (Provisional Phase 950), c. 1093–4

H.   13 > 3 cm (5.1 > 1.2 in)   W.   13 > 5 cm (5.1 > 2 in)

D.   6 > 1 cm (2.4 > 0.4 in)

STONE TYPE Pale greyish-yellow, medium- to coarse-grained, shelly, oolitic limestone; Combe Down Oolite, Great Oolite Formation of the Bath area, Great Oolite Group, Middle Jurassic

PRESENT CONDITION Only one bed face survives; the carved surface is battered, and there are traces of plaster and whitewash

DESCRIPTION The moulding consists of two rounded horizontal elements, separated by a deep V-cut, below a wider, shallower, and backward sloping element, and above a vertical face. The bed face is at a steep angle to the mouldings.

DISCUSSION This could be part of a string or impost.

DATE Seventh or tenth century

REFERENCE Biddle and Kjølbye-Biddle forthcoming a, fig. 144, no. 34

M.B.; B.K.-B.

### 35. Part of string-course or base(?)    (Ill. 558)

PRESENT LOCATION Winchester City Museum, Historic Resources Centre, Hyde House, Winchester, accessions no. 2943 WS 427

EVIDENCE FOR DISCOVERY Found in archaeological excavation north of Winchester cathedral in 1966 in fill of Medieval Grave 269, dug into west end of Old Minster; Final Phase 73 (Provisional Phase 1510), early to mid thirteenth-century

H.   20 > 4 cm (7.9 > 1.6 in)   W.   20 > 4 cm (7.9 > 1.6 in)
D.   4 > 1 cm (1.6 > 0.4 in)

STONE TYPE Pale yellowish-grey, oolitic limestone; Combe Down Oolite, Great Oolite Formation of the Bath area, Great Oolite Group, Middle Jurassic

PRESENT CONDITION No bed faces survive; the carved surface is crisp

DESCRIPTION The upper part of the piece, which consists of a sequence of horizontal rolls separated by a hollow set off by fillets, appears to slope steeply back from the presumably vertical plane of the lower part. The latter consists of semicircles pendant from the lowest roll.

DISCUSSION The pendant semicircles are seen on Jouarre, column 16 (de Maillé, 1971, 163–4, fig. 68), possibly of seventh-century date. Jouarre has similar semicircles at the corners of the capital, but the mouldings above slope outwards, rather than inwards as on the present piece.

DATE Seventh or tenth century

REFERENCE Biddle and Kjølbye-Biddle forthcoming a, fig. 144, no. 35

M.B.; B.K.-B.

## 36. Fragment of string-course(?)          (Ill. 554)

PRESENT LOCATION Winchester City Museum, Historic Resources Centre, Hyde House, Winchester, accessions no. 2943 WS 207

EVIDENCE FOR DISCOVERY Found in archaeological excavation north of Winchester cathedral in 1964 in rubble above robbed baptistery of Old Minster; Final Phase 60–6 (Provisional Phase 1965), late eleventh- to early twelfth-century

H.   9.5 > 7 cm (3.8 > 2.8 in)   W.   14 > 9.5 cm (5.5 > 3.7 in)
D.   2.5 > 0.2 cm (1 > 0.08 in)

STONE TYPE Yellowish-grey, medium-grained, shelly, oolitic limestone with some pellets of up to 1 mm length; Combe Down Oolite, Great Oolite Formation of the Bath area, Great Oolite Group, Middle Jurassic

PRESENT CONDITION No bed face survives. The carved surface is  damaged, and whitewash is present in the deeper areas

DESCRIPTION A plain band, 2 cm wide, separates a row of colonnettes from a dentil pattern. The colonnettes have bases or (if the carving is envisaged the other way up from its position in Ill. 554) capitals. These are splayed and one has a damaged roll moulding at the transition to the shaft. The colonnettes are about 3 cm wide and are separated one from another by gaps of 0.8 to 1 cm. The dentil pattern consists of 1.5-cm projections separated by rectangular slots, 1 cm wide. The slots have pointed bottoms (some still retaining whitewash).

DISCUSSION This is one of several fragments of border patterns or friezes with dentils. They probably form part of miniature baluster friezes like those found at Jarrow (Cramp 1984, I, 118–20, II, pls. 101–2), dated to the late seventh or early eighth century. Seven of the Winchester pieces of this type, nos. 36–8, 40, 42 and 44, come from immediately above or near the Old Minster baptistery, and could be derived from the original mid seventh-century decoration of this part of the church. It is also possible that the present piece is part of an elaborate string-course. For further discussion and references, see no. 47.

DATE Seventh century or later

REFERENCE Biddle and Kjølbye-Biddle forthcoming a, fig. 145, no. 36

M.B.; B.K.-B.

## 37. Fragment of frieze          (Ills. 560–1)

PRESENT LOCATION Winchester City Museum, Historic Resources Centre, Hyde House, Winchester, accessions no. 2943 WS 206

EVIDENCE FOR DISCOVERY Found in archaeological excavation north of Winchester cathedral in 1964 in rubble above robbed north-west wing of Old Minster, west of, and near to, baptistery; Final Phase 67–8 (Provisional Phase 1002), early to mid twelfth-century

H.   7 > 6 cm (2.8 > 2.4 in)   W.   12 >10 cm (4.7 > 3.9 in)
D.   2.8 > 1.5 cm (1.1 > 0.6 in)

STONE TYPE Pale yellowish-grey, medium-grained, very shelly, oolitic limestone; Combe Down Oolite, Great Oolite Formation of the Bath area, Great Oolite Group, Middle Jurassic

PRESENT CONDITION One bed face survives. The carved surface is well preserved; there are possible traces of burning. Whitewash or plaster is present in the deeper areas.

DESCRIPTION The fragment consists of a row of dentils framed by flat borders. The lower border (as shown in Ill. 561) is 2.6 cm wide and carries possible traces of the original tooling in the form of barely discernable steep zig-zag markings. The dentils are 2.6 cm high, between deeply angled slots, 0.5 cm wide. The bases of the slots contain a little plaster or whitewash. The point of the tool used to split the stone has corroded into one of the slots. On the lower bed face about 2 cm behind the carved face and parallel to it, a groove, 3 mm deep, has barely survived. It may be like that on nos. 44 and 47.

DISCUSSION The present piece is like no. 44, which was found in rubble above the nave (immediately to the south of the Old Minster baptistery). WS 445, found near-by in an equivalent rubble, is a more damaged fragment of a similar pattern (not further discussed). No. 37 is thus one of several fragments of border patterns or friezes with dentils. For further discussion see no. 36.

It is also possible that no. 37 is part of an elaborate string-course, projecting 2 cm from the wall face. For further discussion and references see no. 47.

DATE Seventh-century or later

REFERENCE Biddle and Kjølbye-Biddle forthcoming a, fig. 145, no. 37

M.B.; B.K.-B.

## 38. Fragment                                    (Ill. 563)

PRESENT LOCATION Winchester City Museum, Historic Resources Centre, Hyde House, Winchester, accessions no. 2943 WS 234

EVIDENCE FOR DISCOVERY Found in archaeological excavation north of Winchester cathedral in 1964 in rubble deriving from nave of Old Minster; Final Phase 58 (Provisional Phase 835), c. 1093–4

H.  8.8 > 2.5 cm (3.5 > 1 in)   W.  9 > 2 cm (3.5 > 0.8 in)
D.  2.3 > 0.5 cm (0.9 > 0.2 in)

STONE TYPE Pale creamy-yellow, medium-grained, oolitic limestone, grain-supported, the close-set ooliths having only sparse interstitial cement; Portland stone, Portland Limestone Formation, Portland Group, Upper Jurassic; Isle of Portland or Isle of Purbeck

PRESENT CONDITION No bed face survives; the surviving carving is damaged and cracked, and there are traces of mortar overlying pink whitewash

DESCRIPTION A plain band, 3 cm wide, separates a colonnette or dentil, 2–3 cm wide, from a pattern which has a lower element, but cannot be understood.

DISCUSSION This small fragment is probably part of a border or string comparable to nos. 36–40, 42, 44, and 47. For discussion and references, see nos. 36 and 47.

DATE Seventh century or later

REFERENCE Biddle and Kjølbye-Biddle forthcoming a, fig. 145, no. 38

M.B.; B.K.-B.

## 39. Fragment                                    (Ill. 564)

PRESENT LOCATION Winchester City Museum, Historic Resources Centre, Hyde House, Winchester, accessions no. 2943 WS 584

EVIDENCE FOR DISCOVERY Found in archaeological excavation north of Winchester cathedral in 1969 in great charnel placed in Norman robbing of Anglo-Saxon westwork; Final Phase 62 (Provisional Phase 1662), c. 1100

H.  12 > 7.5 cm (4.7 > 3 in)   W.  6.2 > 2 cm (2.4 > 0.8 in)
D.  6.5 > 1 cm (2.6 > 0.4 in)

STONE TYPE Combe Down Oolite, Great Oolite Formation of the Bath area, Great Oolite Group, Middle Jurassic

PRESENT CONDITION Only one bed face survives; the carved surface is well preserved

DESCRIPTION The fragment consists of a row of dentils, 2.2 cm high. Below the dentils there is a border, 2 cm wide, above a band recessed 3 mm, which is in turn above a 3 mm wide raised band. The decoration is not horizontal, but on a slight curve. The dressed face is on the left side. There is a hint that the decoration continues round the corner on the bottom 2 cm of the dressed face side.

DISCUSSION The present piece is perhaps part of complex decoration around an opening: compare no. 91. It could be derived from anywhere in Old Minster.

DATE Seventh-century or later

REFERENCE Biddle and Kjølbye-Biddle forthcoming a, fig. 145, no. 39

M.B.; B.K.-B.

## 40. Fragment (Ills. 565–7)

PRESENT LOCATION Winchester City Museum, Historic Resources Centre, Hyde House, Winchester, accessions no. 2943 WS 3019

EVIDENCE FOR DISCOVERY Found in archaeological excavation north of Winchester cathedral in 1963 in rubble deriving from baptistery of Old Minster; Final Phase 58 (Provisional Phase 863), *c.* 1093–4

H. 14.5 > 6.5 cm (5.7 > 2.6 in) W. 13 > 2.5 cm (5.1 > 1 in)

D. 8.5 > 1 cm (3.3 > 0.4 in)

STONE TYPE Very pale brown (10YR 8/2–3), medium- to coarse-grained, shelly, oolitic limestone; Combe Down Oolite, Great Oolite Formation of the Bath area, Great Oolite Group, Middle Jurassic

PRESENT CONDITION Only one bed face survives; the carved surfaces are battered

DESCRIPTION A corner element, part of a frame, with decorative strips running as raised bands along the adjacent face, one band, 8 cm, the other 9.4 cm in width. A pattern of almost square boxes, separated by narrow ridges, runs along each face, set back 2 to 2.4 cm from the dressed face. The boxes are *c.* 2.5 cm square and 1.2 to 1.4 cm deep, and on the wider band retain patches of thick whitewash.

DISCUSSION This fragment was probably part of the frame of an opening or simply the decoration of an angle. An impost from Bywell, Northumberland, dated to the late seventh or early eighth century, may provide a parallel (Cramp 1984, I, 168, II, pl. 161 (847–8)). The present piece may have come from the elaborate internal decoration of the baptistery.

DATE Seventh century or later

REFERENCE Biddle and Kjølbye-Biddle forthcoming a, fig. 145, no. 40

M.B.; B.K.-B.

## 41. Fragment of column (Ill. 562)

PRESENT LOCATION Winchester City Museum, Historic Resources Centre, Hyde House, Winchester, accessions no. 2943 WS 227

EVIDENCE FOR DISCOVERY Found in archaeological excavation north of Winchester cathedral in 1964 in rubble derived either from demolition of north wing added to Old Minster during tenth century, or from

baptistery; Final Phase 67–8 (Provisional Phase 1002), early to mid twelfth-century

H. 8 > 4 cm (3.1 > 1.6 in) W. 7 > 3 cm (2.8 > 1.2 in)

D. 3.3 > 0.5 cm (1.3 > 0.2 in)

STONE TYPE Near-white (2.5Y 8/2), medium-grained, oolitic limestone, grain-supported, with interstitial voids; Portland stone, Portland Limestone Formation, Portland Group, Upper Jurassic; Isle of Portland or Isle of Purbeck

PRESENT CONDITION The carved surface is well preserved, with faint traces of whitewash

DESCRIPTION S-twist about 6.5 cm wide composed of rounded but flattened bands 3.5 cm wide. The finishing at both sides apparently against the background shows that the relief was about 2 cm high.

DISCUSSION This fragment may have been part of a frame like no. 42, to which it is very similar, but the twist here has a smaller diameter. Both reliefs have a very similar stone type and were found near one another. The present piece could have formed part of the decorative scheme of the Old Minster baptistery. For discussion and references, see nos. 42 and 47.

DATE Seventh century or later

REFERENCE Biddle and Kjølbye-Biddle forthcoming a, fig. 145, no. 41

M.B.; B.K.-B.

## 42. Fragment of frame and column (Ills. 568–9)

PRESENT LOCATION Winchester City Museum, Historic Resources Centre, Hyde House, Winchester, accessions no. 2943 WS 263

EVIDENCE FOR DISCOVERY Found in archaeological excavation north of Winchester cathedral in 1964 in rubble from demolition of Old Minster baptistery or north wall of nave; Final Phase 58 (Provisional Phase 990), *c.* 1093–4

H. 20 > 8 cm (7.9 > 3.1 in) W. 13.5 > 7 cm (5.3 > 2.8 in)

D. 6 > 0.5 cm (2.4 > 0.2 in)

STONE TYPE Pale yellowish-grey, medium-grained, oolitic limestone, grain-supported, with interstitial voids; Portland stone, Portland Limestone Formation, Portland Group, Upper Jurassic; Isle of Portland or Isle of Purbeck

PRESENT CONDITION One dressed face survives, covered with smooth pink whitewash; the carved surfaces are battered

DESCRIPTION An upright or perhaps a corner element with an elaborate deep relief framed at the bottom by a flat border, 2 cm wide, and by a ridged border to the left. The relief stands 3.5 cm from the background surface and shows the bottom three twists of a S-twisted column composed of bands 3.5 cm wide. The diameter of the column is 8 cm, and it stands on a horizontal band or 'plinth', below which just enough survives to show that there once was a line of dentils separated by angled rectangular slots. The whitewash on the left side is applied as if this surface was meant to be seen when the piece was *in situ*.

DISCUSSION This fragment may have been part of the frame of a window or door, or could be from the decoration of some other salient angle, probably internal because of the whitewash. It could also come from an elaborate monument. It may have formed part of the decorative scheme of the Old Minster baptistery. Twisted columns, as distinct from columns with spiral fluting like those from Hart 11a–d, co. Durham, dated to the earlier ninth century (Cramp 1984, I, 96–7, II, pl. 83 (422–4)), are rare. But cable patterns like that on the present carving were found at Monkwearmouth 23, co. Durham (Cramp 1984, I, 132, II, pl. 124 (684)), dated to the seventh to ninth centuries. This little column, no. 42, with twists almost half as wide as the diameter, is comparable to the monumental twisted columns in the Repton crypt (Biddle and Kjølbye-Biddle forthcoming b). These have a bottom diameter of 40–42 cm (15.7–16.5 in) and twists 15 cm, and 20–22 cm wide, about half the column diameter. The twists of the Winchester column are bulging, like the Repton twists, and not at all like the hollow spiral flutes of a Classical column. It may be significant that the Repton crypt may have been a baptistery in an initial stage of its development. For a general discussion, see no. 47.

DATE Seventh century or later

REFERENCE Biddle and Kjølbye-Biddle forthcoming a, fig. 145, no. 42

M.B.; B.K.-B.

## 43. Fragment of frame        (Fig. 41; Ills. 574–5)

PRESENT LOCATION Winchester City Museum, Historic Resources Centre, Hyde House, Winchester, accessions no. 2943 WS 451

EVIDENCE FOR DISCOVERY Found in archaeological excavation north of Winchester cathedral in 1966 reused in Medieval Grave 255; Final Phase 73 (Provisional Phase 1426), early to mid thirteenth-century

H.   21 cm (8.3 in)   W.   9 > 7.5 cm (3.5 > 3 in)
D.   22.5 > 16 cm (8.9 > 6.3 in)

STONE TYPE Combe Down Oolite, Great Oolite Formation of the Bath area, Great Oolite Group, Middle Jurassic

PRESENT CONDITION One bed face survives; the carved surface is battered, the hollows filled with whitewash and pink mortar

DESCRIPTION The stone is roughly cut into shape to be reused as a slab in a medieval cist grave. The surviving original bed face is taken as being the top of the stone. The surfaces are damaged, but not by wear. Neither the step nor the face with guilloche are at right angles to the original bed face, but the line between the clear stone surface and the finely rendered surface on the step side is at right angles to the bed face.

*A:* There is a frame, 4 cm wide, to the right, flanking part of a three-strand guilloche composed of flat-bands, 3 cm wide. The surviving section of the pattern is 4–5 cm wide. The relief is 16 mm deep. Thick whitewash survives in the grooves, in one place overlain by pink, tile-mixed mortar.

*B:* A step, 22 mm deep, lies 11 cm away from the corner at the top, and about 8.5 cm away from the (broken) corner at the bottom. The step is thus diagonal to face A. Thick whitewash survives in the angle of the step, which is slightly undercut. About 15 cm from the top of the stone the whitewash overlaps and covers the surface of a fillet of pale yellow mortar, *c.* 5 mm wide, containing occasional tile flecks. The thick whitewash does not extend behind this mortar: in other words, when the thick whitewash was applied, the lower 5 cm of the step had already had mortar added, bringing the edge of the step nearer the lower (now broken) corner of the stone. From this corner there is an area, 5 cm wide at the top and 4 cm wide at the bottom, which is clear stone, with chisel marks visible, but entirely without any render. Between this area and the step the stone has a fine render, pale yellow in colour, finished with a very thin layer of whitewash. This render runs below the fillet of mortar in the step and has one surviving splash of the pale yellow mortar with tile flecks, with its associated thick whitewash. The top of the step is pink in places, probably because it had been painted, perhaps directly on the stone.

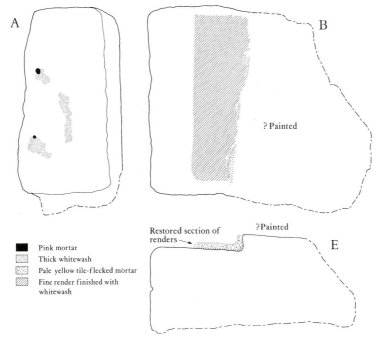

A

B

? Painted

? Painted

Restored section of
renders

E

■  Pink mortar

▦  Thick whitewash

▦  Pale yellow tile-flecked mortar

▨  Fine render finished with
    whitewash

FIGURE 41
Winchester Old Minster 43, distribution and stratigraphy of renders

DISCUSSION This fragment may have been part of a frame comparable to no. 42, but it is very complex. It would seem that the primary carving is the step which slopes back in relation to the vertical, and perhaps the guilloche which slopes forward in relation to the vertical. The area to the right of the step was visible, because it was painted. The unrendered area may have been hidden behind another stone or perhaps a wooden frame. The splayed area, with the fine render, may then have held something. At some stage the stone was reset with pale yellow tile-flecked mortar, sealed by a thick, uneven whitewash. A similar wash was applied to the guilloche, perhaps at the same time. The pink mortar is the latest element on the stone, suggesting a secondary Anglo-Saxon use, since this mortar was not found in the medieval walls and graves at Winchester. Lastly the stone was cut down for use as a slab in a cist grave of the first medieval grave-generation, dug into the area of the tenth-century west end of Old Minster, immediately west of the seventh-century nave, and east of St Swithun's shrine. The stone could have come from any of these parts of Old Minster.

DATE Seventh century or later

REFERENCE Biddle and Kjølbye-Biddle forthcoming a, fig. 145, no. 43

M.B.; B.K.-B.

## 44. Fragment of frieze                    (Ill. 570)

PRESENT LOCATION Winchester City Museum, Historic Resources Centre, Hyde House, Winchester, accessions no. 2943 WS 2

EVIDENCE FOR DISCOVERY Found in archaeological excavation north of Winchester cathedral in 1964 in masons' debris from Norman re-cutting of robbed stones in area above Old Minster nave, south of baptistery; Final Phase 70 (Provisional Phase 993), mid to late twelfth-century

H.   16 > 7 cm (6.3 > 2.8 in)   W.   12 > 5 cm (4.7 > 2 in)

D.   7.7 > 1.5 cm (3 > 0.6 in)

STONE TYPE Pale greyish-yellow, medium- to coarse-grained, shelly, oolitic limestone; Combe Down Oolite, Great Oolite Formation of the Bath area, Great Oolite Group, Middle Jurassic

PRESENT CONDITION One bed face (F, bottom?) and one dressed face survive; the carved surface is somewhat battered

DESCRIPTION *A:* This is the lower part of a frieze much like no. 47, where parts of three of the scrolled elements have survived. On the present carving two decorative bands survive, the upper with a pattern of adjoining ovals

formed of flat ribbons, 1.4 cm wide, the lower element consisting of two plain borders, 3 cm wide, framing a dentil frieze. The dentils are formed by deep rectangular slots, 0.6 cm wide, with angled bottoms.

*F:* On the bed face, 2 cm behind and parallel to the carved face, there is a triangular groove, 0.5 cm deep, similar to that on no. 47.

DISCUSSION The groove on face F could be a construction line indicating that the stone was placed in the wall, projecting about 2 cm from the face. The piece could have formed an elaborate string-course. It is like no. 37, which was found in rubble above the north-west wing of Old Minster, west of, and near to the baptistery. WS 445, found near-by in an equivalent rubble, is a more damaged fragment of a similar pattern (not further discussed). Nos. 36–40, 42, and 47 are also of this type. See no. 47.

DATE Seventh century or later

REFERENCE Biddle and Kjølbye-Biddle forthcoming a, fig. 146, no. 44

M.B.; B.K.-B.

## 45. Fragment                                         (Ill. 572)

PRESENT LOCATION Winchester City Museum, Historic Resources Centre, Hyde House, Winchester, accessions no. 2943 WS 81

EVIDENCE FOR DISCOVERY Found in archaeological excavation north of Winchester cathedral in 1965 in rubble from demolition of tenth-century eastern apse of Old Minster; Final Phase 65 (Provisional Phase 679), early twelfth-century

H.   10 > 9 cm (3.9 > 3.7 in)   W.   8.5 > 6 cm (3.3 > 2.4 in)
D.   4.5 > 2 cm (1.8 > 0.8 in)

STONE TYPE Combe Down Oolite, Great Oolite Formation of the Bath area, Great Oolite Group, Middle Jurassic

PRESENT CONDITION No dressed face survives; the relief of the carving is well preserved

DESCRIPTION This is part of a running scroll as seen best on no. 47 (Ill. 576). The relief of the scroll is 2 cm high.

DISCUSSION See no. 47.

DATE Tenth century or earlier

REFERENCE Biddle and Kjølbye-Biddle forthcoming a, fig. 146, no. 45

M.B.; B.K.-B.

## 46. Fragment                                         (Ill. 573)

PRESENT LOCATION Winchester City Museum, Historic Resources Centre, Hyde House, Winchester, accessions no. 2943 WS 468

EVIDENCE FOR DISCOVERY Found in archaeological excavation north of Winchester cathedral in 1967 in demolition rubble over west end of Old Minster; Final Phase 65 (Provisional Phase 1186), early twelfth-century

H.   12.5 > 11 cm (4.9 > 4.3 in)   W.   8.5 > 6 cm (3.3 > 2.4 in)
D.   4.5 > 2 cm (1.8 > 0.7 in)

STONE TYPE Combe Down Oolite, Great Oolite Formation of the Bath area, Great Oolite Group, Middle Jurassic

PRESENT CONDITION No dressed face survives; there are traces of burning

DESCRIPTION This is a less well preserved part of a running scroll as seen best on no. 47 (Ill. 576). The relief is 1.5–2 cm high.

DISCUSSION See no. 47.

DATE Seventh century or later

REFERENCE Biddle and Kjølbye-Biddle forthcoming a, fig. 146, no. 46

M.B.; B.K.-B.

## 47. Part of frieze                                   (Ills. 576–8)

PRESENT LOCATION Winchester City Museum, Historic Resources Centre, Hyde House, Winchester, accessions no. 2943 WS 102

EVIDENCE FOR DISCOVERY Found in archaeological excavation north of Winchester cathedral in 1965 reused in furnace wall of Norman bell-foundry; Final Phase 64 (Provisional Phase 678), early twelfth-century

H.   27 > 22 cm (10.6 > 8.7 in)   W.   15 > 12.5 cm (5.9 > 4.9 in)
D.   19.5 > 15 cm (7.7 > 5.9 in)

STONE TYPE Yellowish-grey, medium- to coarse-grained, very shelly, oolitic limestone, bedding parallel to the long axis of the stone; Combe Down Oolite, Great Oolite Formation of the Bath area, Great Oolite Group, Middle Jurassic

PRESENT CONDITION One original bed face (F, bottom) survives; a secondary diagonal dressed face

(chamfer?) has been cut across the top. The left side of the stone (face B) has been trimmed back to ashlar size. The carving is damaged and cracked due to burning. Traces of mortar on the carved surface suggest secondary use before incorporation in the Norman bell-foundry, where the piece was burnt.

DESCRIPTION *A:* Three horizontal elements have survived. The central element consists of circles, diameter 10 cm, formed by the interweaving loops of two ribbons of rectangular section. Above and below there are dentil patterns, that below being *c.* 7.5 cm wide with dentils 3 cm high, formed by rectangular slots, 1 cm in width, the bottom angled. The pattern above was probably similar.

*F:* On the bottom bed face, about 2 cm behind the carved face and parallel to it, there is a groove, 3 mm deep, like that on no. 44 and perhaps on no. 37.

DISCUSSION This is the best preserved section of the frieze, a variation of which is seen in no. 44, and perhaps in no. 37. The pattern also occurs on no. 48 (found near the present piece) and on no. 49 (no provenance). The scroll has survived on nos. 45–6. Together these stones would make a border or string at least 80 cm long and 25 cm high. It is one of several types of border patterns or friezes with dentition which are comparable to miniature baluster patterns found at Jarrow and dated to the late seventh or early eighth century (Cramp 1984, I, 118–20, II, pls. 101–2). Seven of the Winchester pieces of this type, nos. 36–7, WS 445 (see no. 37), 38, 40, 42 and 44, come from immediately above or near the Old Minster baptistery, and could well have derived from the original mid seventh-century decoration of this part of the church. Nos. 45, 47, and 48, are from further east but could still have come from the seventh- or eighth-century east end. No. 46 is from the west end. H. M. Taylor discusses and analyses string-courses in churches established as Anglo-Saxon on primary or secondary evidence (Taylor and Taylor 1965–78, III, 902–14, figs. 696–8). No. 47, with its height of over 27 cm, would be taller than the sculptured string-course from Monkwearmouth, co. Durham, no. 12 (height *c.* 24 cm), and more than twice as tall as those from Hexham, Northumberland, nos. 36–7 (Cramp 1984, I, 127–8, 191, II, pls. 117 (621–5), 185 (1016–17)); but the present stone is much smaller than the string-course from Barnack, Northamptonshire, which is 56 cm high and is carved on a single stone across the inner face of the west wall. Barnack was probably built before the end of the

ninth century (Taylor and Taylor 1965–78, I, 303). Nos. 36–8, 40, 42, and 44–9 are best placed amongst Taylor's 'special' string-courses, which include sculpted examples from churches of a wide date range. Special string-courses occurred in five of 88 cases (six per cent).

DATE Seventh century or later

REFERENCE Biddle and Kjølbye-Biddle forthcoming a, fig. 146, no. 47

M.B.; B.K.-B.

## 48. Fragment of frieze (Ill. 579)

PRESENT LOCATION Winchester City Museum, Historic Resources Centre, Hyde House, Winchester, accessions no. 2943 WS 70

EVIDENCE FOR DISCOVERY Found in archaeological excavation north of Winchester cathedral in 1965, in debris from collapsed excavation baulk. Unstratified, but probably from Norman spreads in or above robber-trench of tenth-century east apse of Old Minster

H.  12.5 > 11 cm (4.9 > 4.3 in)  W.  7 > 4.5 cm (2.8 > 1.8 in)
D.  6.5 > 0.5 cm (2.6 > 0.2 in)

STONE TYPE Pale yellowish-grey, medium- to coarse-grained, very shelly, oolitic limestone, bedding parallel to the long axis of the stone; Combe Down Oolite, Great Oolite Formation of the Bath area, Great Oolite Group, Middle Jurassic

PRESENT CONDITION No dressed face survives, but there is a sliver of carved surface, which is damaged

DESCRIPTION Part of the same border or string pattern as nos. 47 and 49.

DISCUSSION This pattern has also been found on no. 47 (found near the present piece). See no. 47.

DATE Seventh century or later

REFERENCE Biddle and Kjølbye-Biddle forthcoming a, fig. 146, no. 48

M.B.; B.K.-B.

## 49. Part of frieze (Ills. 580–1)

PRESENT LOCATION Winchester cathedral crypt

EVIDENCE FOR DISCOVERY No provenance, but probably from Old Minster, and reused in fabric of Norman cathedral

H.   13.5 > 12.5 cm (5.3 > 4.9 in)   W.   44 > 42 cm
      (17.3 > 16.5 in)
D.   38.5 > 37 cm (15.2 > 14.6 in)

STONE TYPE Pale yellow (10YR 8/3), medium-grained, shelly, oolitic limestone; Combe Down Oolite, Great Oolite Formation of the Bath area, Great Oolite Group, Middle Jurassic

PRESENT CONDITION Three bed faces survive, indicating a block originally 38 cm in depth, and at least 44 cm long. The upper surface is completely broken away and retooled, the surviving height of the block not exceeding 24 cm at any point; the carving is somewhat battered. There is evidence for several stages of re-use.

DESCRIPTION *A:* This is the longest run of the border or string seen on nos. 47–8 and, with variations, on nos. 44 and perhaps nos. 37 and 45–6. Two horizontal elements have survived on the present carving. The central element consists of the lower parts of the circles formed by the interweaving loops of two ribbons of rectangular section. Below there is a dentil pattern *c.* 7.5 cm wide with dentils 3 cm high formed by cutting rectangular slots, 1 cm wide, with angled bottoms.

*F:* There is a groove on the underside, as on nos. 44 and 47, but it has been damaged on this piece.

DISCUSSION See no. 47.

DATE Seventh century or later

REFERENCE Biddle and Kjølbye-Biddle forthcoming a, fig. 146, no. 49

                                                    M.B.; B.K.-B.

## 50. Fragment                                (Ills. 586–7)

PRESENT LOCATION Winchester City Museum, Historic Resources Centre, Hyde House, Winchester, accessions no. 2943 WS 9

EVIDENCE FOR DISCOVERY Found in archaeological excavation north of Winchester cathedral in 1964. Although found on spoil heap, date of discovery suggests derivation from demolition rubble of Old Minster; unstratified

H.   10 > 8 cm (3.9 > 3.1 in)   W.   9.8 > 9.5 cm (3.9
      > 3.7 in)
D.   5.5 > 1 cm (2.2 > 0.4 in)

STONE TYPE Pale yellowish-grey, medium-grained, shelly, oolitic limestone, including a small turreted gastropod and an echinoid spine; Combe Down Oolite, Great Oolite Formation of the Bath area, Great Oolite Group, Middle Jurassic

PRESENT CONDITION One bed face and an adjacent dressed face survive; the carved face is slightly battered, and pale pink render survives in a few places

DESCRIPTION The moulding is very precise, with a concentric pattern around a point outside the preserved corner. The moulding is composed, from the corner inwards, of a background area, 1.5 cm wide and 1.5 cm deep, a rounded, flat-topped moulding a pointed V-shaped cut, a flat-band, *c.* 2.5 cm wide, another V-shaped cut, and a rounded, flat-topped moulding which, at its outer edge continues deeper than the V-cuts, to the same depth as the background area first mentioned.

DISCUSSION This piece is confidently carved and unusual in its symmetry. It may not fit very well with the liveliness of the Winchester style.

DATE Seventh to ninth century?

REFERENCE Biddle and Kjølbye-Biddle forthcoming a, fig. 147, no. 50

                                                    M.B.; B.K.-B.

## 51. Fragment of column(?)                  (Ill. 585)

PRESENT LOCATION Winchester City Museum, Historic Resources Centre, Hyde House, Winchester, accessions no. 2943 WS 245

EVIDENCE FOR DISCOVERY Found in archaeological excavation north of Winchester cathedral in 1964 in rubble from demolition of nave or baptistery of Old Minster; Final Phase 68–70 (Provisional Phase 1021), twelfth-century

H.   4.6 > 2 cm (1.8 > 0.8 in)   W.   5 > 3.5 cm (2 >
      1.4 in)
D.   2.3 > 1 cm (0.9 > 0.4 in)

STONE TYPE Pale brownish-yellow, medium- to coarse-grained, shelly, oolitic limestone; Combe Down Oolite, Great Oolite Formation of the Bath area, Great Oolite Group, Middle Jurassic

PRESENT CONDITION One bed face with traces of mortar survives; the carved surface is burnt pink, but well preserved

DESCRIPTION A twisted column with a diameter of about 5 cm turned in a Z-twist. The flattened bands, *c.* 2 cm wide, are almost half the diameter.

DISCUSSION The carving is precisely done, like the S-twist on no. 42 (Ill. 569), and others from Winchester. Twisted columns are rare (for discussion, see no. 42),

but cable patterns like this have been found at Monkwearmouth 23, co. Durham, dated to the late seventh to ninth centuries (Cramp 1984, I, 132, II, pl. 124 (684)).

DATE Seventh to ninth century

REFERENCE Biddle and Kjølbye-Biddle forthcoming a, fig. 147, no. 51

M.B.; B.K.-B..

## 52. Fragment of column(?)                (Ill. 584)

PRESENT LOCATION Winchester City Museum, Historic Resources Centre, Hyde House, Winchester, accessions no. 2943 WS 230

EVIDENCE FOR DISCOVERY See no. 41.

H.   9.5 > 1 cm (3.7 > 0.4 in)   W.   8 > 3 cm (3.1 > 1.2 in)
D.   3.3 > 0.5 cm (1.3 > 0.2 in)

STONE TYPE Pale yellowish-grey, medium-grained, shelly, oolitic limestone; Combe Down Oolite, Great Oolite Formation of the Bath area, Great Oolite Group, Middle Jurassic

PRESENT CONDITION One bed face survives; the carved surface is well preserved, with traces of whitewash

DESCRIPTION The fragment has a steep Z-twist about 7 cm in diameter, composed of bands 3 cm wide. The right-hand band is rounded, but the upper surface of the next band is flattened. The relief is 2.5–3 cm deep.

DISCUSSION This fragment may have been part of a frame like no. 42, and perhaps also no. 41, but these are in a different stone and have S-twists rather than a Z-twist, and are of different diameters. The present carving was found in the same layer as no. 41; but no. 58, with its steep Z-twist (Ill. 590) is a better parallel, and comes from an earlier context in the same area.

DATE Seventh century or later

REFERENCE Biddle and Kjølbye-Biddle forthcoming a, fig. 147, no. 52

M.B.; B.K.-B.

## 53. Fragment                           (Ills. 588–9)

PRESENT LOCATION Winchester City Museum, Historic Resources Centre, Hyde House, Winchester, accessions no. 2943 WS 581

EVIDENCE FOR DISCOVERY Found in archaeological excavation north of Winchester cathedral in 1969 in rubble below Norman Memorial Court and above westwork of Old Minster. Final Phase 65 (Provisional Phase 1859), early twelfth-century

H.   11 > 7 cm (4.3 > 2.8 in)   W.   20 > 8 cm (7.9 > 3.1 in)
D.   11 > 3 cm (4.3 > 1.2 in)

STONE TYPE Yellowish-grey, medium-grained, shelly, oolitic limestone; Combe Down Oolite, Great Oolite Formation of the Bath area, Great Oolite Group, Middle Jurassic

PRESENT CONDITION One bed face survives; the moulding is battered

DESCRIPTION If the moulding is seen vertically, the bed face is at the bottom. To the left a dressed face meets the carved face in a wide angle. The ground of the carved surface has survived to the left of the moulding and can just be seen again to the right. There are two parts to the moulding: an angled rib, 3.6 cm wide, on the left, and a cable, c. 4 cm in diameter, with rounded horizontal segments, 2.3 cm wide, on the right.

DISCUSSION The carving is precise. This carving could have come from the eighth-century St Martin's Tower, later incorporated in the tenth-century westwork.

DATE Seventh to ninth century or later

REFERENCE Biddle and Kjølbye-Biddle forthcoming a, fig. 147, no. 53

M.B.; B.K.-B.

## 54. Fragment with human figure(?)        (Ill. 583)

PRESENT LOCATION Winchester City Museum, Historic Resources Centre, Hyde House, Winchester, accessions no. 2943 WS 200

EVIDENCE FOR DISCOVERY Found in archaeological excavation north of Winchester cathedral in 1964 in rubble deriving from Old Minster baptistery; Final Phase 60–6 (Provisional Phase 1965), late eleventh- to early twelfth-century

H.   8.5 > 3.5 cm (3.3 > 1.4 in)   W.   9.5 > 4 cm (3.7 > 1.6 in)
D.   4.2 > 1 cm (1.7 > 0.4 in)

STONE TYPE Greyish-yellow, medium-grained, oolitic limestone; Combe Down Oolite, Great Oolite Formation of the Bath area, Great Oolite Group, Middle Jurassic

PRESENT CONDITION No bed or dressed faces survive. The carved surface is well preserved, and white render and whitewash are present in the grooves

DESCRIPTION The inner element of this relief is what appears to be a bent arm. This consists of a vertical upper arm sloping slightly upwards, 6 cm of which survives, with rounded muscles, and a horizontal lower arm expanding into the palm of the hand, which is open but broken away where the fingers should start, measuring (from the point of the elbow to the broken edge) about 7 cm. A small part of the background is preserved behind the crook of the arm. To the left of the arm there is a vertical Z-twisted cable, each strand almost half-round and half the total diameter of the cable. To the left of the cable there is an uneven rounded moulding, which may be widening in its upper part, and is not unlike the raised arm. There is no sign of any continuation to the left of this, other than that of the background surface.

DISCUSSION This is a fragment of a complex carving with part of one figure and perhaps traces of a second. The quality of the carving, as shown by the cable, is very high. The arm may be that of a person praying with raised arms, as shown on the sarcophagus of Agilbert (d. 667) in Jouarre (de Maillé 1971, 195–216, figs. 75–82, 86). The arms on the sarcophagus are much the same size as the possible arm on the present carving, but the Jouarre arms are raised higher and the upper arms are therefore at a steeper slope. Significantly, the mandorla of Christ in Majesty on the Jouarre sarcophagus is composed of an opposed twist much less three-dimensional than the cable on the present carving; on a sarcophagus from Ecija, Spain, however, the upper arms more closely resemble it. A similar arm position can be seen on the Repton stone, perhaps of the eighth century, where the arms are raised in a triumphant gesture. The Repton figure is, however, twice as large and clad in mail. The nearest parallel is to be seen in the arms of the prostrate figure on no. 88 (Ill. 646).

DATE Seventh to ninth century or later

REFERENCE Biddle and Kjølbye-Biddle forthcoming a, fig. 147, no. 55

M.B.; B.K.-B.

## 55. Fragment of engaged colonnette         (Ill. 582)

PRESENT LOCATION Winchester City Museum, Historic Resources Centre, Hyde House, Winchester, accessions no. 2943 WS 64

EVIDENCE FOR DISCOVERY Found in archaeological excavation north of Winchester cathedral in 1965 in medieval burial earth above demolished tenth-century east apse of Old Minster; Final Phase 73–4 (Provisional Phase 700), early to mid thirteenth-century

H.  8 > 3.3 cm (3.1 > 1.3 in)   W.   5.5 > 4.5 cm
    (2.2 > 1.8 in)
D.  4.5 > 2.5 cm (1.8 > 1 in)

STONE TYPE Yellowish-grey, medium-grained, oolitic limestone; Combe Down Oolite, Great Oolite Formation of the Bath area, Great Oolite Group, Middle Jurassic

PRESENT CONDITION Only one dressed face survives; the moulding is battered

DESCRIPTION The dressed face on the left cuts across the colonnette before it has completed its curvature, so that a second stone is needed to complete it. A rounded band, 1 cm wide and about 4 cm in diameter, gathers in the colonnette horizontally. The upper and lower elements flare out from this central band. The lower has a carved bottom edge and thus completes the scheme; it is 2.3 cm high. The upper element is similar but broken away; it survives to a height of 2.6 cm. The background surface survives to the right and below the carving.

DISCUSSION This may be a small part of a complex carving, a horizontal or vertical moulding of egg-and-dart type: compare, for example, baluster friezes like those at Jarrow, co. Durham  (nos. 25 and 28), and Hexham, Northumberland (nos. 25–6). The Jarrow pieces are dated by Cramp to the late seventh or early eighth century, the Hexham pieces to the last quarter of the seventh century (Cramp 1984, I, 118–120, 188–9, II, pls. 101 (540), 102 (547), 183 (983, 989)).

DATE Seventh to ninth century

REFERENCE Biddle and Kjølbye-Biddle forthcoming a, fig. 147, no. 56

M.B.; B.K.-B.

## 56. Fragment                                (Ill. 596)

PRESENT LOCATION Winchester City Museum, Historic Resources Centre, Hyde House, Winchester, accessions no. 2943 WS 203

EVIDENCE FOR DISCOVERY Found in archaeological excavation north of Winchester cathedral in 1964 in rubble deriving from nave or baptistery of Old

Minster; Final Phase 58 (Provisional Phase 1020), *c*. 1093–4

H.  10 > 5 cm (3.9 > 2 in)   W.  10.8 > 7 cm (4.3 > 2.8 in)

D.  4 > 2 cm (1.6 > 0.8 in)

STONE TYPE Pale yellow, medium-grained, oolitic limestone; Combe Down Oolite, Great Oolite Formation of the Bath area, Great Oolite Group, Middle Jurassic

PRESENT CONDITION To the left there is a dressed face, with traces of mortar or rendering; this may simply be the left face of the carving. The carved surface is bruised

DESCRIPTION This is a large slightly facetted Z-twist, turning at a low angle. The strands are 3 cm wide. To the left there is a plain area, 1.7 cm wide, which ends in a dressed face which may itself form a plain right-angled projection in the decoration.

DISCUSSION The twist is noticeably flatter than that on nos. 54 and 57, but no. 56 may be part of the same scheme.

DATE Seventh to ninth century or later

REFERENCE Biddle and Kjølbye-Biddle forthcoming a, fig. 147, no. 57

M.B.; B.K.-B.

## 57. Fragment with part of human figure(?)
(Ill. 591)

PRESENT LOCATION Winchester City Museum, Historic Resources Centre, Hyde House, Winchester, accessions no. 2943 WS 205

EVIDENCE FOR DISCOVERY See no. 56.

H.  8.6 > 2.5 cm (3.4 > 1 in)   W.  8.8 > 3.5 cm (3.5 > 1.4 in)

D.  4.8 > 3.3 cm (1.9 > 1.3 in)

STONE TYPE Pale yellow, medium-grained, oolitic limestone; Combe Down Oolite, Great Oolite Formation of the Bath area, Great Oolite Group, Middle Jurassic

PRESENT CONDITION No dressed or bed face survives; the carved surface is bruised

DESCRIPTION There are two elements: to the left a steep Z-twisted cable, in almost half relief, the strands 1.1 cm in width, a little less than half the diameter of the cable. To the right there is an irregular element,

4.5 cm wide at the top and 3.8 cm at the bottom, with an almost bevelled edge towards the cable. At the top, just below the break, there is a clear line, indicating that some other, projecting, element started here.

DISCUSSION This is not simply a plain panel with a cable twist, but part of an elaborate scene with perhaps a figure (a leg?) or plants, framed or divided by the cable. No. 54 may have been from the same decorative scheme; no. 56 is from the same layer as the present carving.

DATE Seventh to ninth century or later

REFERENCE Biddle and Kjølbye-Biddle forthcoming a, fig. 147, no. 58

M.B.; B.K.-B.

## 58. Fragment
(Ill. 590)

PRESENT LOCATION Winchester City Museum, Historic Resources Centre, Hyde House, Winchester, accessions no. 2943 WS 212

EVIDENCE FOR DISCOVERY Found in archaeological excavation north of Winchester cathedral in 1964 in rubble deriving from north wing added to nave of Old Minster during tenth century; Final Phase 58 (Provisional Phase 1001), *c*. 1093–4

H.  15.7 > 7 cm (6.2 > 2.8 in)   W.  10 > 3 cm (3.9 > 1.2 in)

D.  6 > 2 cm (2.4 > 0.8 in)

STONE TYPE Pale yellow, poorly graded, medium- to coarse-grained, shelly, oolitic limestone; Combe Down Oolite, Great Oolite Formation of the Bath area, Great Oolite Group, Middle Jurassic

PRESENT CONDITION One bed face (F, bottom?) survives, and perhaps a dressed face to the right; alternatively, the latter may simply be the edge of the carving, the surface of which is damaged

DESCRIPTION The bottom bed face is at an obtuse angle to the carved surface, which thus appears to slope forward. The carving consists of two cable twists. The smaller, to the left, is a Z-twist, fairly steep, with a lively turn in the twist. The strands are *c*. 2 cm wide, flatly rounded. To the right there is a much larger, S-twisting cable, more steeply angled. The strands are 3.5 cm wide and flattened. There is a sharp angle between the two cables.

DISCUSSION This has a different feel to the treatment of nos. 54 and 56–7, and is unique among the

Winchester pieces in having two different cables on the same stone.

DATE Tenth century

REFERENCE Biddle and Kjølbye-Biddle forthcoming a, fig. 147, no. 59

M.B.; B.K.-B.

### 59. Fragment of frieze(?)                    (Ills. 597–8)

PRESENT LOCATION Winchester City Museum, Historic Resources Centre, Hyde House, Winchester, accessions no. 2943 WS 202

EVIDENCE FOR DISCOVERY Found in archaeological excavation north of Winchester cathedral in 1964 in a masons' chipping layer above robbed baptistery of Old Minster; Final Phase 70 (Provisional Phase 993), mid twelfth-century

H.   18.5 > 7 cm (7.3 > 2.8 in)   W.   10 > 2 cm (3.9 > 0.8 in)
D.   9.5 > 2 cm (3.8 > 0.8 in)

STONE TYPE Pale yellowish-grey, medium-grained, shelly, oolitic limestone; Combe Down Oolite, Great Oolite Formation of the Bath area, Great Oolite Group, Middle Jurassic

PRESENT CONDITION The carved surface is clear but bruised, and the stone has been trimmed for reuse

DESCRIPTION A corner fragment with two surviving dressed faces at right angles. The bands of the interlace are almost 3 cm wide with a central strip, 1.2 cm wide, subdivided by shallow cuts into flat, rounded pellets. A plain, flat diagonal bar, 3.2 cm wide, limits one side of the interlaced area. The surface of the interlace stands 1.8 cm above the background, but the carving is otherwise about 1 cm deep. The upper dressed (bed?) face slopes slightly inwards in relation to the carved face. The carving is cleanly and confidently done.

DISCUSSION The interlace continues to the left, so that at least one more ashlar would have been needed to continue the pattern. It is possible, but not certain, that this stone is derived from Old Minster. It could have come from the baptistery, which was part of the first church, built c. 648, and was continually in use, probably with alterations, until massively reconstructed c. 993–4.

DATE Possibly ninth century, but more likely tenth

REFERENCE Biddle and Kjølbye-Biddle forthcoming a, fig. 148, no. 60

M.B.; B.K.-B.

### 60. Fragment                                (Ills. 594–5)

PRESENT LOCATION Winchester City Museum, Historic Resources Centre, Hyde House, Winchester, accessions no. 2943 WS 270

EVIDENCE FOR DISCOVERY Found in archaeological excavation north of Winchester cathedral in 1964 in robber-trench of Old Minster baptistery; Final Phase 58 (Provisional Phase 1001), c. 1093–4

H.   8.5 > 7 cm (3.3 > 2.8 in)   W.   9.5 > 7.5 cm (3.7 > 3 in)
D.   8 > 5 cm (3.1 > 2 in)

STONE TYPE Pale yellowish-grey, medium-grained, shelly, oolitic limestone, including part of an echinoid test; Combe Down Oolite, Great Oolite Formation of the Bath area, Great Oolite Group, Middle Jurassic

PRESENT CONDITION Only one dressed face survives. The carved surface is well preserved; the stone has been trimmed for reuse and whitewashed

DESCRIPTION The main interlace band is about 5.6 cm wide with a central area, 2.4 cm wide, with large flat, regular pellets, 2 cm in diameter. The surface of the carving is about 1.5 cm above the background. Three bands meet on this small piece, but the pattern continued to the right on to another ashlar. Coarse, pale, brown-pink mortar with tile and chalk inclusions adheres especially to the lower broken surface but also occurs sporadically on the other broken surface and on the carved face. On the dressed face a thin spread of this mortar, with traces of whitewash, appears towards the bottom. The stone was thus already reused before Old Minster was demolished in 1093–4. The carving is confident, the pelleting more circular and better formed than the pellets on no. 59.

DISCUSSION It is possible, but not certain, that this stone is derived from the baptistery or nave of Old Minster. The baptistery was part of the first church, built c. 648, and continually in use, probably with alterations, until reconstructed c. 993–4. The exceptional quality of this piece may indicate that it is comparatively early.

DATE Ninth century?

REFERENCE Biddle and Kjølbye-Biddle forthcoming a, fig. 148, no. 61

M.B.; B.K.-B.

### 61. Fragment                                (Ill. 593)

PRESENT LOCATION Winchester City Museum, Historic Resources Centre, Hyde House, Winchester, accessions no. 2943 WS 239 (temporarily mislaid)

EVIDENCE FOR DISCOVERY Found in archaeological excavation north of Winchester cathedral in 1964 in burial earth inside south aisle of New Minster, deriving from graves belonging to first or second New Minster grave generations; Final Phase 36–9 (Provisional Phase 602), early to mid tenth-century

H.   4.2 > 3.6 cm (1.7 > 1.4 in)   W.   4.4 > 3.6 cm (1.7 > 1.4 in)
D.   1.2 > 0.4 cm (0.5 > 0.2 in)

STONE TYPE Combe Down Oolite, Great Oolite Formation of the Bath area, Great Oolite Group, Middle Jurassic

PRESENT CONDITION No bed or dressed faces survive; the carved surface is perhaps bruised

DESCRIPTION There is a band c. 2.8 cm wide, with pellets 0.8 cm in diameter.

DISCUSSION This fragment is from the same layer as no. 65, which contained three other fragments of Anglo-Saxon carved stone not included in the present volume: WS 240; WS 272.1; and WS 272.2. All are of Bath oolite and all probably derive from the construction of New Minster. The latter incorporated stone from one or more earlier buildings in its fabric (see no. 64), and this piece of interlace seems likely to belong to this earlier group, rather than to be an accidental chip discarded from a block being carved for New Minster itself.

DATE Pre-c. 901–3

REFERENCE Biddle and Kjølbye-Biddle 1990b; Biddle and Kjølbye-Biddle forthcoming a, fig. 148, no. 62

M.B.; B.K.-B.

## 62. Part of frieze                              (Ill. 592)

PRESENT LOCATION Winchester cathedral, in crypt of Lady Chapel (Winchester Research Unit, Cathedral Green, WS 3092)

EVIDENCE FOR DISCOVERY Found in archaeological excavation north of Winchester cathedral in 1964 in demolition rubble of central crypt of Old Minster; Final Phase 59 (Provisional Phase 777), c. 1094

H.   70.4 > 7.2 cm (27.7 > 2.8 in)   W.   33.5 > 31 cm (13.2 > 12.2 in)
D.   79.2 > 13.6 cm (31.2 > 5.4 in)

STONE TYPE Yellow-brown (10YR 8/4), medium- to coarse-grained, shelly, oolitic limestone; Combe Down Oolite, Great Oolite Formation of the Bath area, Great Oolite Group, Middle Jurassic

PRESENT CONDITION Five dressed faces (one incomplete) survive. The decorated surface has been almost entirely cut away by an area of rough tooling which passes into a deeply angled cut. A small area of the original bed face may still survive, being broken away at the corner. This (perhaps original) dressed face has been crisply chamfered in a 'Norman' fashion. The surviving carved surface is well preserved.

DESCRIPTION The stone was originally an ashlar measuring c. 79 cm by c. 70 cm, and 33 cm in thickness. It has two stages of secondary working, first seen in the trimming back of the carved surface by a sloping, but almost vertical face about 20 cm wide. This meets a sloping face, 39 cm long, which ends about 25 cm from the back of the stone in the original bed face. The same tooling as the recut sloping face has also cut away some of the same dressed face quite roughly. This tooling is made by a wide instrument, probably an adze, and is of Anglo-Saxon type. The original dressed face has also been cut by a (probably Norman) chamfer 11 cm (4.3 in) wide. This chamfer ends in a vertical face which cuts the earlier secondary tooling. The interlace bands are almost 5 cm wide with a central strip, 3.5 cm wide, subdivided into well defined flat, rounded pellets (diameter, 2–2.5 cm). The carving is about 1 cm deep.

DISCUSSION This stone was found in robber-trench D surrounded by stone chippings and lying on top of a moulded voussoir of early Norman type. It seems clear that both the voussoir and the present piece were abandoned among the demolition rubble of Old Minster after the rough dressing and chamfering of the latter. The interlace pattern continued to the left and right, as well as above, so that at least three more ashlars would have been needed to continue the pattern. The stone could have been associated with the first east end of Old Minster, which was remodelled at least twice: in the mid to late eighth century; and again in the late tenth century.

DATE Tenth century or earlier

REFERENCE Biddle and Kjølbye-Biddle forthcoming a, fig. 148, no. 63

M.B.; B.K.-B.

## 63. Fragment                                   (Ill. 599)

PRESENT LOCATION Winchester City Museum, Historic Resources Centre, Hyde House, Winchester, accessions no. 2943 WS 273

EVIDENCE FOR DISCOVERY Found in archaeological excavation north of Winchester cathedral in 1964 in

burial earth below New Minster; Final Phase 32 (Provisional Phase 575), late ninth-century

H.　7.5 > 1 cm (3 > 0.4 in)　W.　11.5 > 1.5 cm (4.5 > 0.6 in)
D.　8.5 > 7 cm (3.3 > 2.8 in)

STONE TYPE Whitish-grey (10YR 8/1–2), fine-grained limestone, mottled with pale yellow (2.5Y 8/6) patches of 5 mm diameter; the stone is riddled with circular to elongate perforations of 0.2–0.3 mm diameter, and includes smooth-shelled gastropods of 6 mm whorl diameter and vacant moulds of gastropod shell fragments; Bembridge limestone, Bembridge Formation, Palaeogene, Tertiary; Isle of Wight

PRESENT CONDITION Two dressed faces and the carved face survive, all very worn and rounded; there are smears of chalk on the upper face

DESCRIPTION A border, 1–1.5 cm wide, runs along one edge of the interlace. Two pelleted bands, each c. 2.5 cm wide, survive.

DISCUSSION The carving of the interlace bands is barely more than incision, and the effect is weak by comparison with nos. 59–60 and 62. The stone is unusually worn, and might possibly be part of a grave-marker, weathered in the open. The stone was already broken in its late ninth-century context, and is therefore earlier.

DATE Late ninth century or earlier

REFERENCES Biddle and Kjølbye-Biddle 1990b; Biddle and Kjølbye-Biddle forthcoming a, fig. 148, no. 64
　　　　　　　　　　　　　　　　　　　M.B.; B.K.-B.

### 64. Part of frieze, in two joining pieces.

(Ills. 600–2)

PRESENT LOCATION Winchester City Museum, Historic Resources Centre, Hyde House, Winchester, accessions no. 2943 WS 231

EVIDENCE FOR DISCOVERY Found in archaeological excavation north of Winchester cathedral in 1964 in spread below re-laid floor in south aisle of New Minster; Final Phase 46–52 (Provisional Phase 605), late tenth- to mid eleventh-century

H.　13.5 > 5 cm (5.3 > 2 in)　W.　48.5 > 10.5 cm (19.1 > 4.1 in)
D.　22 > 10 cm (8.7 > 3.9 in)

STONE TYPE Medium light grey, fine-grained, slightly silty, moderately hard limestone; Lower Chalk, Chalk

group, Upper Cretaceous; perhaps from Chilcombe inlier, near Winchester

PRESENT CONDITION Three dressed faces survive as reassembled; the carved surface is very damaged and worn

DESCRIPTION A: A border, 1.5–2 cm wide, surrounds the interlace on at least three sides. A pelleted band, c. 3 cm wide, forms an oval interlacing with a strand or strands crossing almost at right angles in the middle of the loop. There are hints of further complications to the right.[1]

D, E, and F: The surviving parts of the dressed faces have crisp chisel marks, 1–1.5 cm wide.

DISCUSSION The stone is unusual, both because it is cut in chalk, and thus clearly meant only for internal use, and because it is a regular ashlar more than 30 cm long (11.8 in), 29 cm (11.4 in) deep, and 13.8 (5.4 in) high. The stone could conceivably have belonged to an early stage of New Minster, or could have been introduced simply for reuse in the New Minster church, and found unsuitable. This is rather more likely, since the walls of the New Minster church incorporate stone from at least one earlier Anglo-Saxon building (the painted stone, WCM accession number 2943, WS 435, for the discovery of which, see Biddle 1967a; idem 1967b).

DATE Ninth or tenth century

REFERENCES Biddle 1967a, 272, pls. LIV, LIX; Biddle 1967b; Biddle and Kjølbye-Biddle 1990b; Biddle and Kjølbye-Biddle forthcoming a, fig. 148, no. 65
　　　　　　　　　　　　　　　　　　　M.B.; B.K.-B.

### 65. Fragment

(Ills. 603–4)

PRESENT LOCATION Winchester City Museum, Historic Resources Centre, Hyde House, Winchester, accessions no. 2943 WS 204

EVIDENCE FOR DISCOVERY See no. 61.

H.　12.5 > 7.5 cm (4.9 > 3 in)　W.　9 > 7 cm (3.5 > 2.8 in)
D.　6.5 > 2 cm (2.6 > 0.8 in)

STONE TYPE Greyish-yellow, medium-grained, shelly, oolitic limestone; Combe Down Oolite, Great Oolite Formation of the Bath area, Great Oolite Group, Middle Jurassic

---

1. This may alternatively be interpreted as part of the body of a ribbon animal (Eds).

PRESENT CONDITION Only one dressed face survives; the carved surface is crisp. The stone is burnt red and black on both the broken and carved surfaces, and has a straight fracture on the left side; it tapers towards the top

DESCRIPTION The carving is very precise and of high quality. The interlace consists of two broad bands crossing at right angles in two planes. The lower band comprises a broad rounded central element, 4.5 cm wide, bordered to one side by a two-strand ribbon, each strand 1.2 cm wide and angled in section, and to the other by a single similar ribbon, perhaps originally one of a pair. Crossing above at right angles there is what seems to be an even broader band consisting of a two-strand ribbon, flat in section, bordering the lower edge of a very broad, slightly rounded element, *c.* 4.5 cm in width.

DISCUSSION The fragment is from the same layer as no. 61, and is probably derived from the construction of New Minster, though, like nos. 61 and 64, it was probably residual in that context. See nos. 61 and 64.

DATE Pre-*c.* 901–3

REFERENCES Biddle and Kjølbye-Biddle 1990b; Biddle and Kjølbye-Biddle forthcoming a, fig. 149, no. 66

M.B.; B.K.-B.

## 66. Fragment                                    (Ill. 605)

PRESENT LOCATION Winchester City Museum, Historic Resources Centre, Hyde House, Winchester, accessions no. 2943 WS 454

EVIDENCE FOR DISCOVERY Unstratified; found in 1967 north of Winchester cathedral, lying loose in north-west bay of buttresses of north aisle; probably derived from tenth-century west end of Old Minster

H.   18 > 12 cm (7.1 > 4.7 in)   W.   14 > 9 cm (5.5 > 3.5 in)
D.   7 > 3 cm (2.8 > 1.2 in)

STONE TYPE Pale yellowish-grey, medium- to coarse-grained, shelly, oolitic limestone; Combe Down Oolite, Great Oolite Formation of the Bath area, Great Oolite Group, Middle Jurassic

PRESENT CONDITION A small area of one dressed face survives, lower right; the carved surface is well preserved

DESCRIPTION The carved pattern is divided by a right-angled border with an interlaced lower corner consisting of inner and outer loops. To the lower right

the field is triangular, the dressed face forming the hypotenuse, and the interior has three diagonal bands. The top right field is framed at the top by a curving element which passes under the upright of the outer framing loop. This field has two right angled corners and five diagonal bands which continue the bands in the field below. The top left field has the same upper limit as the top right field but, instead of diagonal interior bands, has one slightly curved vertical ribbon. The bottom frame is formed by the top of the outer loop of the lower corner, and is thus not right-angled. There is a hint of another curved element to the left.

DISCUSSION The fragment is probably part of a major scene.

DATE Tenth century

REFERENCE Biddle and Kjølbye-Biddle forthcoming a, fig. 149, no. 67

M.B.; B.K.-B.

## 67. Foliate fragment                            (Ill. 606)

PRESENT LOCATION Winchester City Museum, Historic Resources Centre, Hyde House, Winchester, accessions no. 2943 WS 41

EVIDENCE FOR DISCOVERY Found in archaeological excavation north of Winchester cathedral in 1965 in rubble from demolition of tenth-century east apse of Old Minster; Final Phase 60 (Provisional Phase 645), late eleventh-century

H.   15 > 9 cm (5.9 > 3.5 in)   W.   18 > 9 cm (7.1 > 3.5 in)
D.   8 > 2.5 cm (3.1 > 1 in)

STONE TYPE Pale greyish-yellow, medium- to coarse-grained, oolitic limestone; Combe Down Oolite, Great Oolite Formation of the Bath area, Great Oolite Group, Middle Jurassic

PRESENT CONDITION One dressed face survives; the carved face is slightly battered

DESCRIPTION Deeply carved foliate ornament, possibly part of a capital. The dressed face is diagonal to the main pattern to the top left, and splays outwards to the back. The carving is divided into two parts by a curved vertical stem with a keeled profile. To the left there is a leaf of three elements, each hollowed. To the right there is a second, less deeply hollowed, tripartite leaf or plant stem. The leaves project forward of the stem, from which they are divided by deep V-cuts. The relief is 2.5–4 cm deep, but if the dressed face in

section is set vertically or horizontally, the whole piece is seen to be in very high relief, as one would expect of a capital.

DISCUSSION This piece has a very three-dimensional appearance and the way the curves and divisions are cut adds shadow and life. Many examples of comparable foliate ornament can be seen in the Benedictional of St Aethelwold (e.g. Wormald 1959, pls. 4, 6, 7). No. 69 is of the same style and was found near-by.

DATE Late tenth century

REFERENCE Biddle and Kjølbye-Biddle forthcoming a, fig. 150, no. 68

                                                    M.B.; B.K.-B.

## 68. Foliate fragment          (Ills. 608, 610)

PRESENT LOCATION Winchester City Museum, Historic Resources Centre, Hyde House, Winchester, accessions no. 2943 WS 46

EVIDENCE FOR DISCOVERY See no. 67.

H.   12 > 10 cm (4.7 > 3.9 in)   W.   7 > 5 cm (2.8 > 2 in)
D.   7 > 3 cm (2.8 > 1.2 in)

STONE TYPE Combe Down Oolite, Great Oolite Formation of the Bath area, Great Oolite Group, Middle Jurassic

PRESENT CONDITION No dressed face survives; the carved face is slightly battered

DESCRIPTION This is a deeply carved leaf, apparently naturalistic, perhaps oak. Part of the face, with a strongly marked central spine, and the left side survive, with part of the top and a very small part of the right side towards the top. The relief is up to 4 cm deep on the left.

DISCUSSION This piece is very three-dimensional, as are nos. 67 (found in the same layer), and 69–70 (found near-by in the same context). See no. 67.

DATE Late tenth century

REFERENCE Biddle and Kjølbye-Biddle forthcoming a, fig. 150, no. 69

                                                    M.B.; B.K.-B.

## 69. Foliate fragment          (Ill. 607, 609)

PRESENT LOCATION Winchester City Museum, Historic Resources Centre, Hyde House, Winchester, accessions no. 2943 WS 25

EVIDENCE FOR DISCOVERY Found in archaeological excavation north of Winchester cathedral in 1965 in rubble from demolition of tenth-century east apse of Old Minster; Final Phase 60 (Provisional Phase 677), late eleventh-century

H.   8 > 4 cm (3.1 > 1.6 in)   W.   13.5 > 8 cm (5.3 > 3.1 in)
D.   6 > 1 cm (2.4 > 0.4 in)

STONE TYPE Greyish-yellow, medium-grained, oolitic limestone; Combe Down Oolite, Great Oolite Formation of the Bath area, Great Oolite Group, Middle Jurassic

PRESENT CONDITION No dressed face survives; the carved face is slightly battered

DESCRIPTION Deeply carved foliate ornament, possibly part of a capital. There are two tripartite branches, each with a wide-narrow-wide moulding. The V between the branches is expanding and almost 3 cm deep. One certainly, and perhaps both, of the narrow mouldings have cable twisting. The two branches are not symmetrical. To the left the outer edge is concave; to the right, the piece splays towards the back in a flat well-preserved lower surface. The upper part of this edge is slightly set forward as if another element of the carved ornament was to start above.

DISCUSSION This piece is very three-dimensional. A capital with similar elements can be seen in the Benedictional of St Aethelwold, fol. 92v (reproduced in Warner and Wilson 1910), below the scribe. Nos. 67–8 are in the same style and were found near-by. Nos. 67–9 may be part of the same composition but the pieces do not join.

DATE Late tenth century

REFERENCE Biddle and Kjølbye-Biddle forthcoming a, fig. 150, no. 70

                                                    M.B.; B.K.-B.

## 70. Foliate fragment          (Ills. 611–13, 616)

PRESENT LOCATION Winchester City Museum, Historic Resources Centre, Hyde House, Winchester, accessions no. 2943 WS 45

EVIDENCE FOR DISCOVERY See no. 67.

H.   21 > 7 cm (8.3 > 2.8 in)   W.   13 > 1.5 cm (5.1 > 0.6 in)
D.   15 > 3.5 cm (5.9 > 1.4 in)

STONE TYPE Pale yellowish-grey, medium-grained, slightly shelly, oolitic limestone; Combe Down Oolite, Great Oolite Formation of the Bath area, Great Oolite Group, Middle Jurassic

PRESENT CONDITION Two dressed faces survive; the carved face is slightly battered, and there are slight traces of a pink rendering

DESCRIPTION The bottom of the piece is formed by a rectangular area of dressed (bed?) face, 9 by 4.5 cm, indicating that the carved leaf sloped to the left. This bottom face is rectangular and ends in a straight line. There is a second dressed face on the left with a slight lean to the left in relation to the bottom face and at a right angle to the carved face. To the right, the background is about 8 cm behind the uppermost surface of the leaf, which is almost fleshy in its rounded three-dimensionality. To the left there is another element, possibly a stem. To the right there is a horizontal tripartite motive with hollowed parts, like the leaves on no. 67, which was found in the same layer. It is impossible to say which way up this piece should be.

DISCUSSION This piece is very three-dimensional. A capital with similar elements can be seen in the Benedictional of St Aethelwold, fol. 92v (reproduced in Warner and Wilson 1910). No. 67 is of the same style and may be part of the same capital, although there is no direct fit. Nos. 67 and 68, which is also similar, were found in the same layer as no. 70, while no. 69, also in the same style, was found very near the other three in an equivalent context.

DATE Late tenth century

REFERENCE Biddle and Kjølbye-Biddle forthcoming a, fig. 150, no. 71

M.B.; B.K.-B.

## 71. Foliate fragment (Ill. 615)

PRESENT LOCATION Winchester City Museum, Historic Resources Centre, Hyde House, Winchester, accessions no. 2943 WS 422

EVIDENCE FOR DISCOVERY Found in archaeological excavation north of Winchester cathedral in 1966 reused in medieval boundary wall (W. 111); Final Phase 73 (Provisional Phase 1202), early to mid thirteenth-century

H. 28 > 16 cm (11 > 6.3 in) W. 24 > 12 cm (9.4 > 4.7 in)
D. 19 > 18 cm (7.5 > 7.1 in)

STONE TYPE Combe Down Oolite, Great Oolite Formation of the Bath area, Great Oolite Group, Middle Jurassic

PRESENT CONDITION All dressed faces survive, two (C and E) apparently original bed faces; the carved face is battered, with part of the carving cut away, and there are lumps of mortar adhering

DESCRIPTION Only one face is carved.

*A:* This is an element of a relief including a larger than life acanthus. It is described as if the stem is at the bottom and the leaves spread out at the top. Part of the plant pattern was secondarily isolated so that it is the motif of a label, basically rectangular but with an asymmetrical triangular bottom, a steep left side, *c.* 7 cm high, a flat middle part, *c.* 9 cm wide, and a less steep, slightly curved right side, *c.* 7 cm high at the front and *c.* 10 cm high at the back. The left side has a smooth area, gently curved from top to bottom and slightly sloped from back to front, possibly as a result of the secondary tooling on this side. The bottom slopes up from front to back, and slightly down toward the right. The bottom face meets the left side in a bevel, *c.* 2.5 cm wide, but meets the right side in a sharp angle. The lower part of the right side is slightly curved and slopes down toward the back. This concave surface is very smooth and may be original. The way it meets the bottom facet could suggest that the latter also, although not so smooth, is primary. The right side has wide chisel marks, is quite rough, and slightly bulging, apart from a small area at the bottom, joining the concave part, which is smooth and slopes slightly outward. The smooth part of the left side as well as the bevel may also be original. The relief is up to 3.5 cm deep, and the plant fills the whole height of the stone. Where the original surface survives, it is beautifully finished. The acanthus has a central stem, *c.* 4 cm wide at the bottom, which splits into three elements. To the bottom left is a well preserved tripartite leaf with only the lower point damaged. The central stem flares to the left and at the top left corner curves sharply back toward the middle, but its upper part is missing. The third element curves gently up into the top right corner; its outline is clear, but the upper surface is badly damaged. The background areas, where they could be easily reached, are smooth, as are the vertical sides of the plant, whereas in the middle of the top, where access was difficult, the finish is more irregular with individual tool marks visible. The finish along the top and on the left is smooth, in the middle and on the right rough, suggesting that there once was some further element on the right, a fragment of which may survive at the bottom right corner.

*C and E:* The back and top are well finished and smooth with fairly narrow chisel marks and a chalky slightly smothered feel; these may be original.

*B and D (sides):* The two sides are more irregular, with a distinctive orange colour in some of the secondarily tooled areas. Wide smooth chisel marks survive giving a bevelled impression near the front. The left side is at right angles to the carved surface for the first 3–4 cm and then slopes inwards; the right side is more damaged, but has a deeper area at right angles to the carved surface and a smaller, not very distinctive, inward slope at the back. The left side is as a whole clearly curved; the right side may have been similar, but it is difficult to be sure.

DISCUSSION It is impossible to be sure which way round this carving was originally intended to be seen, but if the stone is placed as here described, the carved face slopes noticeably backwards and the relief is dead, whereas if the stone is placed with the rectangular upper bed face at the bottom, the relief is vertical and springs to life. When the block was recut to its present shape, the intention seems to have been to display the plant upright (as shown in Ill. 615), with the re-cut triangular part of the stone at the bottom. This piece belongs with the other three-dimensional fragments of Winchester style sculpture, nos. 67–70, all probably deriving from the late tenth-century eastern apse. The present carving may have had two Anglo-Saxon uses, since all the tooling on it is of Anglo-Saxon character. Its primary shape cannot be determined but involves the right side. In its reused form the stone may have been part of a larger scheme or could have been set as an individual decorative label. Similar floral elements can be seen in the Benedictional of St Aethelwold, where an acanthus of this type can be seen on its side on fol. 92v (reproduced in Warner and Wilson 1910).

This stone was built into the thirteenth-century western boundary wall of the medieval Paradise cemetery: it might therefore have come from the tenth-century westwork, but could have come from any part of the Old or New Minsters.

DATE Late tenth century

REFERENCE Biddle and Kjølbye-Biddle forthcoming a, fig. 150, no. 72

M.B.; B.K.-B.

## 72. Foliate fragment (Ill. 614)

PRESENT LOCATION Winchester City Museum, Historic Resources Centre, Hyde House, Winchester, accessions no. 2943 WS 55

EVIDENCE FOR DISCOVERY Found in archaeological excavation north of Winchester cathedral in 1965 in rubble from demolition of tenth-century east apse of Old Minster; Final Phase 64–5 (Provisional Phase 646), early twelfth-century

H.  10.5 > 3 cm (4.1 > 1.2 in)    W.    18 > 4.5 cm (7.1 > 1.8 in)
D.  7.5 > 2 cm (3 > 0.8 in)

STONE TYPE Combe Down Oolite, Great Oolite Formation of the Bath area, Great Oolite Group, Middle Jurassic

PRESENT CONDITION One dressed face survives; the carved face is battered

DESCRIPTION Deeply carved foliate ornament. The stem splits into three parts. The relief is *c.* 2 cm deep, the background smooth.

DISCUSSION This piece belongs with the other Winchester style pieces from the east end of Old Minster. See nos. 67–70.

DATE Late tenth century

REFERENCE Biddle and Kjølbye-Biddle forthcoming a, fig. 150, no. 73

M.B.; B.K.-B.

## 73. Fragment (Ills. 623–4)

PRESENT LOCATION Winchester City Museum, Historic Resources Centre, Hyde House, Winchester, accessions no. 2943 WS 243

EVIDENCE FOR DISCOVERY Found in archaeological excavation north of Winchester cathedral in 1964 in rubble from demolition of central crypt and earlier east end of Old Minster; Final Phase 58 (Provisional Phase 795), *c.* 1093–4

H.  7.5 > 6 cm (3 > 2.4 in)    W.    7 > 4 cm (2.8 > 1.6 in)
D.  7 > 5 cm (2.8 > 2 in)

STONE TYPE Pale yellowish-grey, medium- to coarse-grained, slightly shelly, oolitic limestone; Combe Down Oolite, Great Oolite Formation of the Bath area, Great Oolite Group, Middle Jurassic

PRESENT CONDITION One dressed face survives; the carved surface is well preserved and there are traces of whitewashed render

DESCRIPTION The carving is on a curved surface with a diameter of about 57 cm (22 in). The dressed

face lies at about 40 degrees to the curve. In Ill. 623 the dressed face is seen vertically to the right. The carving consists of two elements: a moulding, *c*. 2.5 cm wide, with a flattened top curving slightly to the right, and a small part of another moulding curving away to the left.

DISCUSSION The carving is precisely done, but cannot be understood.

DATE Seventh to eleventh century

REFERENCE Biddle and Kjølbye-Biddle forthcoming a, fig. 150, no. 74

M.B.; B.K.-B.

## 74. Fragment with bird's head            (Ill. 617)

PRESENT LOCATION Winchester City Museum, Historic Resources Centre, Hyde House, Winchester, accessions no. 2943 WS 3071

EVIDENCE FOR DISCOVERY Found in archaeological excavation north of Winchester cathedral in 1963 in demolition rubble over the north porticus of Old Minster, and perhaps derived from the baptistery; Final Phase 58 (Provisional Phase 863), *c*. 1093–4

H.  8 > 4 cm (3.1 > 1.6 in)   W.  9 > 4 cm (3.5 > 1.6 in)
D.  4 > 0.5 cm (1.6 > 0.2 in)

STONE TYPE Pale grey, slightly yellowish, medium-grained, oolitic limestone, with little or no interstitial cement and a few thin shell fragments; Portland stone, Portland Limestone Formation, Portland Group, Upper Jurassic; Isle of Portland or Isle of Purbeck

PRESENT CONDITION No dressed faces survive; the carved face is well preserved, and there are traces of whitewash

DESCRIPTION This is the head of a bird looking left, raised 10–16 mm above the background. The head has a curved outline. The beak is indicated by two lines and the eye by a pointed circle with a deep central puncture. The junction between head and neck is perhaps indicated by a groove.

DISCUSSION This could be the head of a dove, which would be appropriate for the baptistery. The piece is similar in feel to the head of a fish from Hexham, Northumberland, no. 20 (Cramp 1984, II, pl. 179 (956)).

DATE Late seventh century?

REFERENCE Biddle and Kjølbye-Biddle forthcoming a, fig. 151, no. 75

M.B.; B.K.-B.

## 75. Figural fragment            (Ills. 618–19)

PRESENT LOCATION Winchester City Museum, Historic Resources Centre, Hyde House, Winchester, accessions no. 2943 WS 480

EVIDENCE FOR DISCOVERY Found in archaeological excavation north of Winchester cathedral in 1967 in fill of Anglo-Saxon Grave 225; Final Phase 40 (Provisional Phase 1388), mid ninth-century

H.  10.5 > 4 cm (4.1 > 1.6 in)   W.  18 > 5 cm (7.1 > 2 in)
D.  6 > 1.5 cm (2.4 > 0.6 in)

STONE TYPE Yellowish-grey, medium- to coarse-grained, shelly, oolitic limestone; Combe Down Oolite, Great Oolite Formation of the Bath area, Great Oolite Group, Middle Jurassic

PRESENT CONDITION One possible dressed face survives; the carved surface is well preserved, and there is evidence of burning on one side

DESCRIPTION What survives is the left eye and part of the nose area of part of a human face. The pupil is deep and round and the brow strongly marked. The scale is twice life-size.

DISCUSSION The nose area is not as one would expect: a clear edge runs between the nose and the eye and the whole nose area is raised. The eyebrow is also more marked than might be expected. It seems possible that the nose area represents the nasal guard of a helmet, such as that from Coppergate, York (Tweddle 1984, 13–15), and this may also explain the moulding of the eyebrow.

DATE Mid ninth century or earlier; perhaps eighth

REFERENCES Biddle and Kjølbye-Biddle forthcoming a, fig. 151, no. 76

M.B.; B.K.-B.

## 76. Figural fragment in five joining pieces

(Ill. 625)

PRESENT LOCATION Winchester City Museum, Historic Resources Centre, Hyde House, Winchester, accessions no. 2943 WS 219, 220

EVIDENCE FOR DISCOVERY Found in archaeological excavation north of Winchester cathedral in 1964: WS 219 in trample above Norman masons' chipping layer over west end of seventh-century nave of Old Minster, Final Phase 68–70 (Provisional Phase 1022), twelfth-century; WS 220 in spreads inside Old Minster nave

earlier than final demolition, Final Phase 49–55 (Provisional Phase 1018), late tenth- to late eleventh-century

H.   17 > 11 cm (6.7 > 4.3 in)   W.   9.5 > 2 cm (3.7 > 0.8 in)
D.   4.5 > 2 cm (1.8 > 0.8 in)

STONE TYPE Greyish-yellow, medium-grained, oolitic limestone; Combe Down Oolite, Great Oolite Formation of the Bath area, Great Oolite Group, Middle Jurassic

PRESENT CONDITION No dressed faces survive, and the carved surface is battered; one of the five joining fragments, WS 220 is also worn and has traces of whitewash

DESCRIPTION This seems to be the top and back of the hair of a human figure. Faint traces show that the left side rises from the background of the relief. The right side shows a change in a ridge, perhaps to the right temple. The hair is shown as 3–6 mm wide plain bands.

DISCUSSION The nearest parallel is the hair of the figure in the elaborate scene from this site (no. 88; Ill. 647). These fragments are likely to have come from a relief of about the same size as no. 88, and perhaps of the same date. Since the part of the present piece found in layers sealed before the final demolition in *c.* 1093–4, WS 220, was damaged and worn, perhaps from having been walked upon, the relief must have been in position and damaged well before the end of the eleventh century.

DATE Late tenth to early eleventh century

REFERENCE Biddle and Kjølbye-Biddle forthcoming a, fig. 151, no. 77

M.B.; B.K.-B.

## 77. Figural fragment                    (Ill. 622)

PRESENT LOCATION Winchester City Museum, Historic Resources Centre, Hyde House, Winchester, accessions no. 2943 WS 7

EVIDENCE FOR DISCOVERY Found in archaeological excavation north of Winchester cathedral in 1964 in Norman rubble derived from nave and baptistery of Old Minster; Final Phase 60–7 (Provisional Phase 992), late eleventh- to early twelfth-century

H.   8.8 > 4.5 cm (3.5 > 1.8 in)   W.   6 > 4 cm (2.4 > 1.6 in)
D.   2.5 > 0.5 cm (1 > 0.2 in)

STONE TYPE Pale yellowish-grey, medium-grained, oolitic limestone; Combe Down Oolite, Great Oolite Formation of the Bath area, Great Oolite Group, Middle Jurassic

PRESENT CONDITION One possible dressed face survives, the carved surface is in fairly good condition; burnt, with traces of whitewash

DESCRIPTION This appears to be hair, with strands almost right-angled in cross-section. The left of the head is at the bottom of the relief.

DISCUSSION The nearest parallel is the hair of the figure in the elaborate scene from this site (no. 88; Ill. 647). The present fragment is likely to have come from a relief of about the same size as no. 88, and perhaps of the same date.

DATE Late tenth to early eleventh century

REFERENCE Biddle and Kjølbye-Biddle forthcoming a, fig. 151, no. 78

M.B.; B.K.-B.

## 78. Fragment                    (Ill. 621)

PRESENT LOCATION Winchester City Museum, Historic Resources Centre, Hyde House, Winchester, accessions no. 2943 WS 69

EVIDENCE FOR DISCOVERY Found in archaeological excavation north of Winchester cathedral in 1965 in medieval burial earth above, and east of, tenth-century east apse of Old Minster; Final Phase 81–2 (Provisional Phase 657), mid fifteenth- to early sixteenth-century

H.   4 > 2.5 cm (1.6 > 1 in)   W.   13.5 > 4 cm (5.3 > 1.6 in)
D.   6 > 3 cm (2.4 > 1.2 in)

STONE TYPE Greyish-yellow, medium-grained, shelly, oolitic limestone, including echinoid fragments; Combe Down Oolite, Great Oolite Formation of the Bath area, Great Oolite Group, Middle Jurassic

PRESENT CONDITION No dressed face survives; the carved surface is battered

DESCRIPTION The piece has a long projecting central element, rounded but flattened. There is a tripartite pattern below and a flat surface above.

DISCUSSION The piece cannot be interpreted, but must be part of a carving in high relief.

DATE Late tenth to eleventh century

REFERENCE Biddle and Kjølbye-Biddle forthcoming a, fig. 151, no. 79

M.B.; B.K.-B.

## 79. Figural fragment (Ill. 620)

PRESENT LOCATION Winchester City Museum, Historic Resources Centre, Hyde House, Winchester, accessions no. 2943 WS 22

EVIDENCE FOR DISCOVERY Found in archaeological excavation north of Winchester cathedral in 1965 in rubble deriving from the demolition of the south wall of New Minster; Final Phase 67 (Provisional Phase 736), *c.* 1110

H.   7 > 3.5 cm (2.7 > 1.4 in)   W.   5.5 > 4 cm (2.2 > 1.6 in)

D.   2.5 > 1 cm (1 > 0.4 in)

STONE TYPE Pale greyish-yellow, medium- to coarse-grained, oolitic limestone, with calcite veinlet; Combe Down Oolite, Great Oolite Formation of the Bath area, Great Oolite Group, Middle Jurassic

PRESENT CONDITION One bed face survives at the top; the carved surface is somewhat battered, and there are traces of whitewash

DESCRIPTION This is the inside of a clenched right hand, carved at about two-thirds life size. The distal end of the little finger and parts of the other three fingers and the thumb can be seen. The palm of the hand can never have been shown in full since the fingers are overridden, at least in part, by another element, which cannot be understood.

DISCUSSION This fragment was found in the robber-trench of the south wall of New Minster but it could derive from the tenth-century east end of Old Minster (immediately south of this part of the New Minster robbing), with which similar pieces (nos. 80–1 and 88) are probably to be associated (see above p. 102; and below pp. 316–17). Similar to the hands on no. 88 (Ill. 646) and probably from a comparable relief.

DATE Late tenth to early eleventh century

REFERENCE Biddle and Kjølbye-Biddle forthcoming a, fig. 151, no. 80

M.B.; B.K.-B.

## 80. Figural fragment (Ills. 626–7)

PRESENT LOCATION Winchester City Museum, Historic Resources Centre, Hyde House, Winchester, accessions no. 2943 WS 443

EVIDENCE FOR DISCOVERY Found in archaeological excavation north of Winchester cathedral in 1966 in Norman masons' chipping layer over west end of seventh-century nave of Old Minster; Final Phase 68 (Provisional Phase 1098), early to mid twelfth-century

H.   8.5 > 6 cm (3.4 > 2.4 in)   W.   8.3 > 5 cm (3.3 > 2 in)

D.   3 > 1.5 cm (1.2 > 0.6 in)

STONE TYPE Pale greyish-yellow, medium-grained, oolitic limestone, with a prominent calcite veinlet; Combe Down Oolite, Great Oolite Formation of the Bath area, Great Oolite Group, Middle Jurassic

PRESENT CONDITION No dressed faces survive; the carved surface is somewhat battered and there are traces of whitewash

DESCRIPTION The outer side of a left hand beginning to curve to grip an upright, for example, a staff. The scale is a little less than life size.

DISCUSSION This fragment is similar to the hands on no. 88 (Ill. 646) and probably from a comparable relief.

DATE Late tenth to early eleventh century

REFERENCE Biddle and Kjølbye-Biddle forthcoming a, fig. 151, no. 81

M.B.; B.K.-B.

## 81. Figural fragment (Ills. 630–1)

PRESENT LOCATION Winchester City Museum, Historic Resources Centre, Hyde House, Winchester, accessions no. 2943 WS 19

EVIDENCE FOR DISCOVERY Found in archaeological excavation north of Winchester cathedral in 1965 in medieval burial earth above tenth-century east apse of Old Minster; Final Phase 81–2 (Provisional Phase 682), mid fifteenth- to early sixteenth-century

H.   11 > 4 cm (4.3 > 1.6 in)   W.   6.5 > 4 cm (2.6 > 1.6 in)

D.   3.5 > 1.5 cm (1.4 > 0.6 in)

STONE TYPE Pale greyish-yellow, medium- to coarse-grained, oolitic limestone; Combe Down Oolite, Great Oolite Formation of the Bath area, Great Oolite Group, Middle Jurassic

PRESENT CONDITION No dressed faces survive; the carved surface is somewhat battered and there are traces of whitewash

DESCRIPTION This is the inside of a clenched right hand; the scale is approximately life size. The distal end of the little finger and parts of the next two fingers can be seen. The fingernails of the two lower fingers are indicated, which makes it clear that this is a hand in spite of the angular impression. The swelling form of some object appears immediately below the lower finger.

DISCUSSION Possibly a hand grasping a vertical object, for example a staff, and if so, similar to no. 80. It probably derives from the east end of Old Minster.

DATE Late tenth to early eleventh century

REFERENCE Biddle and Kjølbye-Biddle forthcoming a, fig. 151, no. 82

M.B.; B.K.-B.

## 82. Fragment                                     (Ills. 632–4)

PRESENT LOCATION Winchester City Museum, Historic Resources Centre, Hyde House, Winchester, accessions no. 2943 WS 225

EVIDENCE FOR DISCOVERY Found in archaeological excavation north of Winchester cathedral in 1964 in Norman rubble deriving from Old Minster baptistery; Final Phase 60–6 (Provisional Phase 1965), late eleventh- to early twelfth-century

H.   13 > 10 cm (5.1 > 3.9 in)   W.   8 > 4 cm (3.1 > 1.6 in)
D.   8.5 > 5 cm (3.3 > 2 in)

STONE TYPE Pale greyish-yellow, medium-grained, shelly, oolitic limestone, with echinoid fragments; Combe Down Oolite, Great Oolite Formation of the Bath area, Great Oolite Group, Middle Jurassic

PRESENT CONDITION Only one dressed face survives; the carved surface is somewhat battered

DESCRIPTION An incomprehensible fragment of relief in at least three planes and on two faces set at a right angle. The lower edge is curved, while the steps above are straight.

DISCUSSION The stone type is identical to that of no. 83, found near the present piece in the same layer. No. 78 also has echinoids but was found over the tenth-century east apse. Nos. 82–3 may well be from the same relief. The detail, depth, and diversity of the carving would have been at least as great as that on the figural scene on no. 88 (Ill. 646). Nos. 82–3 may be derived from the late tenth-century decoration of the baptistery.

DATE Late tenth century

REFERENCE Biddle and Kjølbye-Biddle forthcoming a, fig. 151, no. 83

M.B.; B.K.-B.

## 83. Figural(?) fragment                          (Ills. 628–9)

PRESENT LOCATION Winchester City Museum, Historic Resources Centre, Hyde House, Winchester, accessions no. 2943 WS 226

EVIDENCE FOR DISCOVERY See no. 82

H.   9 > 6 cm (3.5 > 2.4 in)   W.   11 > 8.5 cm (4.3 > 3.3 in)
D.   4 > 3 cm (1.6 > 1.2 in)

STONE TYPE Pale yellowish-grey, medium-grained, shelly, oolitic limestone with echinoid fragments; Combe Down Oolite, Great Oolite Formation of the Bath area, Great Oolite Group, Middle Jurassic

PRESENT CONDITION Only one dressed face survives; the carved surface is somewhat battered and there are traces of whitewash

DESCRIPTION Incomprehensible fragment of relief. The side which may be the bottom of the relief is slightly concave. Most of the surface is blank, to either side of which there are different patterns, the upper with deep, straight, narrow ridges, the lower with shallow curved ribs, like the hair on no. 76 (Ill. 625).

DISCUSSION This fragment might be from a human figure, possibly showing the rucking of a garment like the sleeve on the left arm of the mailed figure on no. 88 (Ill. 646).

DATE Late tenth century

REFERENCE Biddle and Kjølbye-Biddle forthcoming a, fig. 151, no. 84

M.B.; B.K.-B.

## 84. Figural fragment                             (Ills. 635–8)

PRESENT LOCATION Winchester City Museum, Historic Resources Centre, Hyde House, Winchester, accessions no. 2943 WS 462

EVIDENCE FOR DISCOVERY Found in archaeological excavation north of Winchester cathedral in 1967 in Norman rubble deriving from westwork of Old Minster; Final Phase 61 (Provisional Phase 1602), late eleventh-century

H.   16 > 3 cm (6.3 > 1.2 in)   W.   9 > 6.5 cm (3.5
     > 2.6 in)

D.   4.5 > 3.5 cm (1.8 > 1.4 in)

STONE TYPE Very pale brown (10YR 8/3), medium-
to coarse-grained, shelly, oolitic limestone; Combe
Down Oolite, Great Oolite Formation of the Bath
area, Great Oolite Group, Middle Jurassic

PRESENT CONDITION One dressed face (F, bottom)
survives; the carved surface is somewhat battered

DESCRIPTION This is a human left leg; the calf, heel,
and the beginning of the foot, with the top line of a
shoe, survive.

DISCUSSION This piece is comparable to the legs of
the mailed figure on no. 88 (Ill. 646), and is of
approximately the same scale.

DATE Late tenth or early eleventh century

REFERENCE Biddle and Kjølbye-Biddle forthcoming a,
fig. 151, no. 85

                                        M.B.; B.K.-B.

## 85. Figural fragment                          (Ill. 641)

PRESENT LOCATION Winchester City Museum,
Historic Resources Centre, Hyde House, Winchester,
accessions no. 2943 WS 498

EVIDENCE FOR DISCOVERY Found in archaeological
excavation north of Winchester cathedral in 1968 in
rubble deriving from double-apsed building around St
Swithun's tomb added to west end of Old Minster;
Final Phase 42 (Provisional Phase 1248), late tenth-
century

H.   6.5 > 4 cm (2.6 > 1.6 in)   W.   6 > 1.5 cm (2.4
     > 0.6 in)

D.   2.5 > 1 cm (1 > 0.4 in)

STONE TYPE Whitish to very pale brown (10YR
8/1–3), shell-fragment limestone; matrix finely
granular and opaque, crowded with dark blue-grey
comminuted shell fragments, apparently mostly bivalve
but with a few micromorphic gastropods; an unusual
variety of Purbeck Marble, Durlston Formation,
Purbeck Group, Lower Cretaceous; Isle of Purbeck

PRESENT CONDITION No dressed faces survive; the
carved surface is battered

DESCRIPTION To the left, the drapery hangs
in deeply carved folds; to the right (the front?), the
folds are much less deep and the surface is subtly
modelled.

DISCUSSION There is no other carved stone from Old
Minster like this. The lively carving of the drapery is
clear even on this small piece. Combinations of deep
vertical and diagonal surface folds, as seen on this
fragment, are characteristic of the draped figures of the
mature Winchester Style, for example in the
Benedictional of St Aethelwold, fol. 1v (The Choir of
Virgins), fol. 4r (St Peter with two Apostles), and fol.
90v (St Aethelthryth) (reproduced in Warner and
Wilson 1910; Wormald 1959). The skilled carving,
the unusual use of a stone otherwise unparalleled in
Old Minster (see above, p. 103), and the probable
projection of the relief, suggest a free-standing figure
of exceptional quality, its scale about one-fifth life size.
The stratigraphy suggests that this figure formed part
of the original decoration of the double-apsed
building constructed around St Swithun's tomb in the
years after 971 but demolished and replaced by the
westwork before 980.

DATE Late tenth century

REFERENCE Biddle and Kjølbye-Biddle forthcoming a,
fig. 152, no. 86

                                        M.B.; B.K.-B.

## 86. Figural(?) fragment                       (Ill. 640)

PRESENT LOCATION Winchester City Museum,
Historic Resources Centre, Hyde House, Winchester,
accessions no. 2943 WS 236

EVIDENCE FOR DISCOVERY Found in archaeological
excavation north of Winchester cathedral in 1964 in
Norman rubble deriving from nave or baptistery of
Old Minster; Final Phase 58 (Provisional Phase 950),
c. 1093–4

H.   15 > 7.5 cm (5.9 > 3 in)   W.   8.5 > 5.5 cm (3.3
     > 2.2 in)

D.   7 > 1.5 cm (2.7 > 0.6 in)

STONE TYPE Very pale brown (10YR 8/2–3),
medium- to coarse-grained, shelly, oolitic limestone;
Combe Down Oolite, Great Oolite Formation of the
Bath area, Great Oolite Group, Middle Jurassic

PRESENT CONDITION One possible dressed face
survives; the carved surface is somewhat battered. Pink
mortar adhering to the broken rear surface suggests
reuse

DESCRIPTION The dressed face forms the right side;
only one face is carved.

The main carved surface is raised 2 cm from the
background and has an undecorated sloping area 1 cm

wide along the front right edge. At the top the background is broken away, but the carved surface ends in a smooth curve which rises vertically (as on the right) above the now missing background. Diagonally across the piece there is a pattern of raised ribs, 3–4 mm wide, joined by smaller ribs, partly in a herring-bone pattern, which gives the surface a 'knitted' texture. At the bottom left corner the relief is raised 3 cm above the background in a sub-rectangular area which rises 1 cm above the main surface and is *c.* 5 × 3.5 cm in area. This raised area has five ribs, each *c.* 8 mm wide, and each perhaps with a twist. These ribs are angled to right of vertical and thus run at an angle to the main pattern. Towards the bottom the pattern on the raised area ends in a straight line, at right angles to the direction of the ribs.

DISCUSSION It is impossible to interpret this complex piece, but it may be part (possibly the shoulder) of a figure clad in armour. The square area might then be the sword-pommel. It is best compared to the armoured figure in the scene on no. 88 (Ill. 646), but the armour pattern is not the same, and the present carving could be part of an entirely different scene. Its place of discovery would place it in the western part of the nave, and not at the east end of the later apse where no. 88 was found. Moreover, the pink brick-filled mortar on the broken back of the present fragment suggests that the carving of which it formed part was broken up and reused as rubble in the Anglo-Saxon period. If so, it is likely to be earlier than the rebuildings of the later tenth century.

DATE Late tenth to early eleventh century or earlier

REFERENCE Biddle and Kjølbye-Biddle forthcoming a, fig. 152, no. 88

M.B.; B.K.-B.

## 87. Figural(?) fragment (Ill. 639)

PRESENT LOCATION Winchester City Museum, Historic Resources Centre, Hyde House, Winchester, accessions no. 2943 WS 252

EVIDENCE FOR DISCOVERY Found in archaeological excavation north of Winchester cathedral in 1964 in Norman rubble deriving from nave or baptistery of Old Minster; Final Phase 58 (Provisional Phase 990), *c.* 1093–4

H.   12 > 4 cm (4.7 > 1.6 in)   W.   8.5 > 4 cm (3.3 > 1.6 in)
D.   8 > 3 cm (3.3 > 1.2 in)

STONE TYPE White to very pale brown (10YR 8/1–2), medium-grained, oolitic limestone, with a calcite veinlet; Combe Down Oolite, Great Oolite Formation of the Bath area, Great Oolite Group, Middle Jurassic

PRESENT CONDITION No dressed faces survive; the carved surface is burnt pink and somewhat battered

DESCRIPTION The carved surface is flat, the background (if this was a raised relief) nowhere surviving. The pattern is formed by cutting out triangles which compose the lower halves of a series of equilateral parallelograms formed by a 60-degree grid of parallel lines at 14 mm intervals. The pattern achieved is horizontal or diagonal rows of small triangles.

DISCUSSION If this pattern is not simply decorative, it might be intended to represent tegulation, or could indicate a flat, mailed surface, as on no. 88 (Ill. 646).

DATE Late tenth or early eleventh century

REFERENCE Biddle and Kjølbye-Biddle forthcoming a, fig. 152, no. 89

M.B.; B.K.-B.

## 88. Part of figural narrative frieze (Ills. 642–9)

PRESENT LOCATION Winchester City Museum, The Square, Winchester, accessions no. 2943 WS 98

EVIDENCE FOR DISCOVERY Found in archaeological excavation north of Winchester cathedral in 1965 in rubble filling of robbed external eastern crypt of Old Minster; Final Phase 59 (Provisional Phase 644), *c.* 1094

H.   69.5 cm (27.4 in)   W.   52 cm (20.5 in)
D.   27 cm (10.6 in)

STONE TYPE Pale yellowish-grey, medium- to coarse-grained, shelly (but not conspicuously so), oolitic limestone; includes two short calcite veinlets; Combe Down Oolite, Great Oolite Formation of the Bath area, Great Oolite Group, Middle Jurassic

PRESENT CONDITION The block is intact except for the top left-hand corner of face A and a larger section missing from face C. In consequence, the left-hand figure on face A has lost his chest, left hand, and right leg below the knee. The lower right arm (but not the hand) and tether of the recumbent figure are broken away, and his face and the upper part of the animal's muzzle have been damaged. The carving remains

crisp, but the stone is slightly weathered or worn (e.g. on the elbow of the left-hand figure, at one of the highest points of the relief) and generally bruised.

DESCRIPTION Only Face A is decorated. The figures extend beyond the stone on all sides and must have been continued on adjacent blocks (see Discussion). The remaining faces are undecorated and all except the back (face C) must have been in direct contact with other stones. Face B carries a double rebate (2.5 by 5 cm; 5 by 7.4 cm) and Face D a single rebate (5 by 10.2 cm). There is nothing to suggest that these features are necessarily secondary; their tooling remains crisp. Faces E (top) and F (bottom) are more roughly tooled and the former seems worn. Face C is smoothly dressed.

*A (broad)*: A slightly curved rectangular hole, probably a lewis-hole, at the centre of this face is filled with pink plaster. The outline of the seat of the mailed figure is skilfully accommodated to the convex side of the hole, perhaps following an early change in design, before the outline of the figure had been settled, in which the sword was shortened and narrowed, as the scar of its former outline shows.

The figures rise *c.* 7 cm above the flat background. Since their surface is also generally flat, they have a somewhat slab-like, 'blocky' appearance. This is particularly noticeable along the back of the mailed figure, where the angles between the background, the back, and the surface of the figure are almost right angles. The angle between the background and the figures is emphasized throughout by a slight groove, giving a clean outline (a similar groove is found on the Repton Stone: Biddle and Kjølbye-Biddle 1985, 241).

The left-hand figure appears to be walking to the left. He wears a coat of mail from the shoulders to the middle of the thighs, which are distinctly separate. There is no sign of any covering on the rest of the legs. The mail is shown by alternately recessed squares and is finished on each thigh with a plain band, probably to indicate edge binding. On the left leg the band continues round the inside of the thigh as far as the background of the sculpture, while on the right leg the band continues back to butt the left leg at a higher level than that leg's band: clear indications that separate leggings are being shown, each with its own edge binding. The mail continues up below the arm on to the chest and over the shoulder; the back is plain, but scarcely visible. The mail extends on to the upper part of the arm where it ends at the first of a series of rucked bands. These continue down the arm to the wrist, but at the elbow, where the relief is

exceptionally high, they have been almost worn away.

The fingers of the left hand are carved on the left edge of the stone (Face D: Ill. 649) which here forms part of the relief. The knuckles and back of the hand are broken away, but the relative positions show that the hand, although clenched, does not grasp the sword. Instead the wrist passes in front of the hilt. The broad sword is carried in a scabbard on the left hip and hung from a belt. The belt is clearly marked round the back of the figure, although the pattern indicating mail is omitted in this relatively invisible area. A thinner strap runs down from the back of the belt, without any sign of a junction between the two, to join the scabbard at a point where a crossed binding is shown. Both the belt and angled strap pass behind the scabbard. What was previously seen as a quillon (Biddle 1966b, 329) is part of the belt which widens slightly as it approaches the scabbard: the guard and pommel are invisible, except for a small part of the grip or possibly the lower edge of the pommel, which survives just above the wrist. As noted above, the sword was originally roughed out both longer and broader.

The figure on the right is shown in false perspective, lying on his back with his hands, palms upwards, raised to either side of his face. He is bound round his neck with a single broad tether which twists over his right wrist and continues towards the bottom edge of the stone. The lower part of the tether is broken away, but there is the scar of both sides of a wider feature, such as a post, to which the tether might have been fastened. The tether does not continue up around the left arm; rather it appears to return round the neck. The left arm, lying over the animal's paw and under its muzzle, with the fingers just appearing beyond, seems to be free and may be attempting to ward the animal off.

A series of shallow curving lines shows that the man's hair is worn shoulder-length, tucked behind the ear, as if tied back. The ear, jaw-line, and chin are well preserved up to and including the lower lip. The face has been partly removed by two distinct adze cuts, but the upper and lower lips are intact, except for a slight loss where they join, and they show that the mouth is open. The outlines of the nose and forehead can be traced where they have been broken away, but a tiny part of the right-hand edge of the right nostril survives where it projects from the upper lip. There is no sign of a moustache. A deep accidental scar marks the cheek, but the prominent brow ridge and the greater part of the eye are preserved. The upper edge, outer end, and outer part of the lower edge of the eye,

and part of the inner end survive, showing that the eye was lentoid. The brow ridge returns sharply down the inner end of the eye before being broken away (cf. no. 75 (Ills 618–19)).

An animal is shown on top of the human figure, its muzzle at the man's face, and one of its forepaws appearing from beneath the man's left hand to rest on, and force or hold open, his lower jaw. The paw has three bulbous toes, each with a claw; a fourth toe, higher up and clearly separated from the other three, is a dew-claw, showing that this is a canid, i.e. a dog, fox, or wolf, and specifically not a bear. Roughening on the neck suggests a mane; the ear(s) are indicated, but, together with the upper part of the face, are broken off, only the clear outline of the forehead and top of the muzzle surviving over the fingers of the man's left hand.

The animal's mouth is open but not biting and reveals the upper and lower tooth rows, where the individual teeth are separated by small (drilled?) indentations. The outline of the lower jaw is intact, but the extremity of the upper jaw is broken away, together with any trace of the canine teeth (fangs) in either jaw. The animal's tongue is shown the length of the open mouth. Although partly broken away, the tongue crosses the gap between the animal's muzzle and the man's face and descends in a curve up to, and apparently into, the man's open mouth (*pace* Wilson 1985, 206, 'the critical portion of the stone' is not so damaged as to make this unclear; it can be photographed with appropriate lighting (Ills. 646–7)). If the broken ridge passing into the man's mouth is not the animal's tongue, it can only be the man's tongue projecting to touch the animal's. There is no surviving trace of any distinction between the two, and the proposition seems too unlikely to maintain.

*Composition* The vertical centre line of the stone passes tangentially by the crown of the recumbent man's head and through the lower tip of the sword, effectively splitting the stone into two scenes. The horizontal centre line bisects the vertical axis just below the crown of the man's head, continues along the straight part of the hair and the upper edge of his ear. To the left it runs through the sword, body, and clad thighs of the standing figure at no immediately obvious point. However, a grid with intervals of 173 mm divides the width of the stone into thirds and the height into quarters. A line drawn from the top left corner of the stone (as reconstructed) to a point two-thirds along the bottom from the left corner runs exactly along the left edge of the sword, the most prominent diagonal line in the composition. This

line represents the golden proportion, dividing the area into three eighths and five eighths. A line drawn parallel to the left, from the lower right corner to a point one-third from the upper left corner (as reconstructed) passes through the knot of the tether, touches the point of the ear and the eye-brow of the recumbent man, and runs along the slope of the shoulder of the standing man. If the diagonals are drawn in the opposite direction, that running from a point one-third from the lower left corner to the upper right corner runs along the tongue of the wolf and perhaps once along the line of the mouth of the man. This is the strongest line in this direction and lies parallel to the rope around the neck.

*Reconstruction* If the warrior on the left is completed with a head the same size as that of the recumbent man (who may actually be somewhat larger), one module of 173 mm would be sufficient. To complete the recumbent man at least four modules would be needed, which suggests that more than one stone of the size of the present block is required. Were there to be a border above and below the narrative scene, stones measuring 2 modules (346 mm) in height would be needed, each half as high as the central stone. In the Bayeux Tapestry the narrative frieze occupies two-thirds of the height with a border above and below, each one-sixth of the total height. The proportions of the Winchester frieze may well have been similar, with the figured frieze taking up perhaps six modules, and any border above and below one module each. On this calculation the frieze would be 138.4 cm high, virtually 4.5 English feet or 4 'northern' feet (in length around 34 cm).

DISCUSSION The date of this piece depends in the first instance on the archaeological context in which it was discovered. The block was found in the rubble filling of the external eastern crypt of Old Minster (Biddle 1966a, 325; idem 1966b, 329, pls. LIXb, LXV), in layers derived from the levelling of the robbed east end. The block was covered by 75 cm of rubble and it is quite certain that it was discarded at the demolition of Old Minster in 1093–4. It cannot therefore have come from New Minster which was not demolished until *c.* 1110. The demolition materials of New Minster were quite different in character and (in this area) spatially distinct from those of Old Minster. It might be argued that no. 88 was discarded during the construction of the present cathedral and thrown away among the rubble from the demolition of Old Minster which was in progress at the same time. Extensive layers of oolite chips and the

discovery of a few mouldings of Norman type in the demolition materials of Old Minster show that its site was being used as a quarry where Anglo-Saxon stones were dressed for reuse. Many of the carved fragments from Old Minster in this Corpus are chips from precisely this process. But these chips include fragments of hair (nos. 76–7 (Ills. 622, 625) and limbs (nos. 79–81 and 84 (Ills. 620, 626–7, 630–1, 635–8)) derived from figures similar to those on the present piece. These chips, the general bruising of no. 88, and the absence of any obvious damage which might have led to its abandonment, all indicate that no. 88 once formed part of the decoration of Old Minster and was discarded in 1093–4, along with a few other large blocks (nos. 4 (Ill. 503), and 62 (Ill. 592) which were lost in the muddle of the robbing.

The carving appears to show parts of two scenes, the subjects divided here, as sometimes on the Bayeux Tapestry, by the first or last figure of a scene turning its back on the scene which precedes or follows (Wilson 1985, pls. 9, 20–1, 24–5, 46, 49–50, 55, 63, 72). Here a mailed warrior walks left into a scene beyond the surviving stone, his back turned to the scene on the right and separated from it by an open field. As shown above, at least two blocks of similar size would be needed to complete the figure of the bound man, and if the scenes are of comparable size, the mailed warrior can only have been one of several figures in a scene extending to the left over at least two further blocks. Five blocks of similar size would thus probably have been needed to complete the scenes partly preserved on the present carving, indicating a minimum length of 2.6 m.

Nor are the figures on this block complete in themselves: portions of the top and bottom of each scene must have been shown on blocks above and below. As indicated above, these blocks need have been no more than about 17.5 cm high, but the disparity in size between this and the main block, 69.5 cm in height, may suggest that the upper and lower blocks were larger and carried a running border above and below. If these borders were also about 17.5 cm high, the top and bottom blocks would each have been about 35 cm high, and the whole scheme on three blocks about 140 cm high, the central block accounting for just half the total.

There are only a few purposes for which a carved panel at least 240 cm long and possibly 140 cm high can have been intended: as decoration for a free-standing monument of royal proportions; as part of a narrative frieze round the interior or exterior of Old Minster; or as the decoration of a free-standing screen.

The rebating of the sides of the block is relevant here, for it might seem more suited to interlocking the sides and corners of a free-standing tomb or screen than to a frieze continuous in the plane of a wall. But the double rebate, perhaps suitable for keying a corner, lies behind the bound man, at a point where it would seem impossible to imagine a right-angled turn. The size of the scheme indicated by the surviving block seems also too large even for a royal tomb at this date. The smoothness of the back and the use of rebates to key adjacent blocks could be features of a free-standing screen. The possibilities seem therefore to suggest a narrative frieze, either on a screen or on an interior or exterior wall face.

But was the sculpture carved on a newly quarried stone or on a reused block taken from a Roman structure? If the rebates and smooth back derive from a previous use, they are irrelevant to the possible setting of the stone after it had been carved. The lewis-hole might indicate a Roman date, but it seems to be only an assumption that lewises were not used in the Anglo-Saxon period (see above, pp. 103–4). The central position of the lewis-hole suggests either that the shape of the Roman block, if that is what it is, has not been much changed, or that the lewis was used to move the block selected for this carving. The flat surface of the carvings indicates that they were cut on a surface already flat and square to the rest of the stone, but this could reflect the shape of the block as it came from the quarry, and need not imply that the block was reused. Very large blocks of oolite for making coffins must have been brought overland in the Anglo-Saxon period from the quarry some 80 miles away, for it seems highly unlikely that these could have been cut on stones recovered from Roman buildings. Roman architectural fragments from Winchester are usually of different geological types, including sandstones and limestones as well as oolitic limestone (see above p. 103), while the overwhelming preponderance of carved stones from Old Minster in this Corpus are of Combe Down Oolite, as here. Since no. 88 is not therefore necessarily a reused Roman block, the rebates and smooth back may be significant in discussion of its Anglo-Saxon use.

The distinctive feature of the iconography is the dog or wolf with its tongue at or in the open mouth of the bound man. The scene may be from some lost or unidentified story, such as a saint's life, but an incident in Vǫlsunga Saga provides a close parallel, as was suggested when the stone was first published (Biddle 1966b, 330–1). Sigmund and his nine brothers were clamped by their legs into a large pair of stocks

in the forest. For nine successive nights a large and evil-looking old she-wolf appeared, and killed and ate one of the nine brothers until Sigmund alone remained. On the tenth night Signy, Sigmund's twin sister, sent her trusted servant to smear honey on Sigmund's face and to put some of it in his mouth. When the wolf came she sniffed the honey, licked Sigmund's face 'and then thrust her tongue into his mouth. He took heart and bit into the wolf's tongue. At this she gave a violent jerk and strained backwards, pressing hard with her paws against the stocks which as a result split apart. But he held on so firmly that the wolf's tongue was torn out by the roots, and that finished her.' (Finch 1965, 7–8).

The armed figure to the left might be Signy's trusted servant, but it seems unlikely that the story was shown in such detail, and some earlier episode (if this is a narrative frieze) is probably represented. There is one difference between the saga and the sculpture, for in the latter the bound figure is shown lying on (and apparently tethered to) the ground, rather than seated in the stocks, as the only manuscript specifically states (Finch 1965, 7). But such stocks should not be thought of as incorporating a wooden seat: early stocks consisted of two large baulks of timber, cut to fit over the legs, and fastened by iron clamps. The prisoner sat or could lie on the ground (Utrecht Psalter, c. 820 (De Wald 1933, pls. 98, 120, 130); BL MS Harley 603, fol. 54v, c. 1000 (Temple 1976, no. 64, ill. 206)). Whether or not the stocks were shown on his legs, the essential point is that the wolf is at the man's face in precisely the way the saga specifies— licking or thrusting and not biting.

Although the only manuscript of Vǫlsunga saga dates from c. 1400, and 'the saga itself was compiled not later than c. 1260–70, probably in Iceland, though possibly in Norway' (Finch 1965, ix), references to the Vǫlsung legend in Beowulf, Widsith, and Waldere in Old English (Kennedy 1943, 45–8), and in Eiríksmál in Old Norse, show that the story was well known at the latest by the tenth century and probably well before. Scenes from the Völsungar cycle relating to the deeds of Sigurd have been found carved on wood or stone in Sweden, Norway, England, and possibly the Isle of Man (Blindheim 1972; Ploss 1966), but no representation of the incident of Sigmund and the wolf appears to have been recorded.

Since the royal houses of Wessex and Denmark claimed descent from the same ancestor, Scyld, and thus shared a tradition in which Sigmund had played a part, Biddle suggested in 1966 that no. 88 might be part of a narrative frieze celebrating the shared origins

of the two royal houses: 'There could be no more suitable setting for such a frieze than the eastern arm of the Old Minster, in which . . . the royal burials probably lay. Among these was Cnut himself.' (Biddle 1966b, 331). This interpretation has often been repeated, not always with conviction (Davidson 1967, 127; Gatch 1971, 33–5; Cramp 1972, 148; Lang 1976, 94; Jacobs 1977, 40, n. 81; Hinton 1977, 95–6; Brooks 1978, 96; Dodwell 1982, 137–8; Zarnecki 1984, 150–1 (cat. no. 97); Wilson 1984, 198–200; Wilson 1985, 206–8; Zarnecki 1986a; Zarnecki 1986b, 8 and n. 7; Kahn 1992), but, as Wilson notes 'nobody has produced a better explanation' (Wilson 1984, 200).

Two alternatives have since been suggested. The first, biblical, has not been argued in detail. It suggests that the subject is likely to be dogs licking the blood of Naboth, stoned on the order of Jezebel, as recorded in *I Kings* 21 (Zarnecki 1986b, 25, n. 7 (suggestion by Jolanta Zaluska)). This subject is excessively rare at any date, does not occur in surviving Anglo-Saxon manuscript illumination (Ohlgren 1986; but neither does Sigmund and the wolf), and has no discernable relevance to Old Minster or to Winchester: it celebrates the perfidy of kings.

The second suggestion is that the scene represents the rescue of the king of the Garamantes by his dogs (Alexander 1987; cf. Kahn 1992, 71). The story is represented in art in the section on dogs in a number of Latin bestiaries written and illuminated in England in the later twelfth and thirteenth centuries, the earliest of c. 1170. It is ultimately derived from Classical sources via Isidore of Seville, but the earliest occurrence in an English manuscript quoted by Alexander is in BL MS Stowe 1067, of c. 1120, where the story is not illustrated. In Alexander's opinion the late twelfth- and early thirteenth-century illustrations suggest that the pictorial tradition, already then corrupted, preserves accurately the form and style of considerably earlier models, of Carolingian or even Late Antique date: 'it is possible and even likely that the story was known in visual form at least by the end of the eleventh century' (Alexander 1987, 5).

Alexander's thesis poses a number of difficulties, several of which he underlines. It does not account for the tether around the neck of the recumbent man, nor for the juxtaposition of the animal's open (but not biting) mouth with the man's open mouth, and does not explain why the animal's tongue is at least in contact with the man's open mouth and probably within it, an action made possible by the man's jaw being held down by the animal's paw. Alexander

rightly suggests that the scene of the king of the Garamantes rescued by his dogs would be more suited to the decoration of a royal palace, quoting the pertinent parallel of the painting of what must be this subject ordered by Henry III in 1256 for the decoration of the 'wardrobe where the king washes his head' in the palace at Westminster (Alexander 1987, 6). He then goes on to argue that the Winchester stone may have been discarded from some earlier structure when William the Conqueror rebuilt the royal palace at Winchester in 1070, and may have lain around for some years before being incorporated in the destruction rubble of Old Minster. This, he admits, 'is pure speculation'. It must be added that it conflates sites and events in central Winchester and ignores the discovery of fragments of similar figures elsewhere in the rubble of Old Minster (as noted above; see also Biddle 1984, 133). Fig. 27 shows how the carved fragments from Old and New Minster form clear patterns of discard probably reflecting their original positioning (see Introduction, Chap. VIII) and provides additional confirmation that no. 88 belongs to Old Minster. There is also the chronological gap: no literary or pictorial evidence for the Garamantes story survives in England before the twelfth century. Ogilvy suggests that no Anglo-Latin authors used the *Physiologus* and that it is doubtful that the English had a full copy of the Bestiary (Ogilvy 1967, 100, 222); Ohlgren 1986 provides no evidence of the story in manuscript illumination.

This leads us directly to the question of date and style. The archaeological evidence provides a *terminus ante quem* of 1093–4. Since the eastern part of Old Minster, in the eastern extremity of which no. 88 was found, was not begun until after *c.* 980 and was dedicated in 993–4, the stone can be dated to the century between *c.* 980 and 1093–4. It cannot in any case be later. The condition of the stone, slightly weathered or worn and generally bruised, and the discovery elsewhere in the rubble of chips from similar figures, derived from knocking salient detail off other blocks to prepare them for reuse in building the Norman cathedral, show that no. 88 was not new when discarded and must be related to the decoration of the building then being demolished. If the suggestion that the stone formed part of a narrative frieze celebrating the shared origins of England and Denmark is accepted, a date in the reign of Cnut (1016–35) after his marriage to Emma in 1017 seems indicated. There is, however, no record of any structural work at Old Minster after 993–4 and the possibility cannot be excluded that the stone

(whatever its subject) belongs to the great enlargement of the east end completed in 993–4 (cf. Jacobs 1977, 40, n.51).

Against this must be set the view that the piece is Romanesque in style: 'Is it from the reign of king Cnut or is it Romanesque? The archaeological evidence points to the former, but the style to the latter' (Zarnecki 1986b, 8). The discussion resolves into three themes: the style of the figure carving; the comparisons which have been drawn between no. 88 and the Bayeux Tapestry; and the likelihood that Cnut permitted the display of an incident from the pagan past in the cathedral church at Winchester, a city described in the Winchester Annals as *regni soli solium* (Luard 1865, *s. a.* 1017; cf. Biddle 1976, 289, notes 3–4).

Zarnecki has stated that 'the solid round forms with well-defined contours [of no. 88] are Romanesque rather than Anglo-Saxon' (Zarnecki 1984, 151). As Kauffmann has argued, Norman book illumination produced 'a harder, drier, more solid version of the Anglo-Saxon style and to this extent was more Romanesque in character' (Kauffmann 1975, 19), but this is in a field where there is ample material for comparison. In stone sculpture there has been less material by which to define the late Saxon figural style in Wessex, but it is doubtful whether no. 88 could be regarded as more solid or well-defined than, for example, the Bradford-on-Avon angels, the Romsey 1 crucifixion (Ills. 451–2), or the Bristol harrowing of Hell, and it shares with them the flattened rather than rounded surface which seems both characteristic of Wessex sculpture of the period and is probably a reflection of the technique used to work back the flat surfaces of the blocks as received from the quarry. There seems, moreover, little in the corpus of Anglo-Norman Romanesque sculpture to which no. 88 may be directly compared.

As Wilson points out, by comparison with the Bayeux Tapestry, no. 88 'being carved in stone, is of course more solid and rounded' (Wilson 1985, 208). Dodwell suggests 'on stylistic grounds' that its dating 'by archaeologists to the late tenth or early eleventh century is too early' (1982, 138), but gives no details, and Wilson concludes that Zarnecki's claim that no. 88 is Romanesque 'is a happy solution' (1984, 200).

Much of this debate has confused style with date, as Zarnecki's proposed dating '1016–35 or Romanesque' in the 1066 Exhibition Catalogue shows (Zarnecki 1984, 150). This compels him to the complex question: 'could it be that [no. 88] is a Romanesque copy of a subject which was depicted at Winchester

on an embroidered hanging presented by Cnut . . .?' (ibid. 151). Wilson's argument for a post-Conquest date adopts Zarnecki's view that the style is Romanesque rather than Anglo-Saxon, and adds two points: the 'remarkable parallel' which no. 88 provides for the Bayeux Tapestry, and the suggestion that since the carving is unpainted, it 'was abandoned unfinished (perhaps due to damage) at some time not long before the building of the present cathedral [which began in 1079]' (Wilson 1985, 206, 208). Since, however, only one of the pieces of sculpture from Old and New Minsters in this Corpus bears any trace of paint (no. 43), although whitewash and plaster survive in the nooks and crannies of twenty-one of the carvings, and there is paint over whitewash on one of the mouldings (New Minster no. 4), this last suggestion has little force.

If there seems to be scant difference between 'the solid round forms with well-defined contours' of no. 88 and the style of the other figural carvings from Old Minster in this Corpus, albeit very fragmentary, one must conclude, accepting these features as Romanesque, that there was a significant Romanesque element in the Old Minster sculpture. It seems hardly likely that this sculpture can all belong to some unrecorded major building campaign between 1066 and the commencement of the new cathedral in 1079. As Biddle wrote in 1984, Zarnecki's view that the piece is 'Romanesque rather than Anglo-Saxon is 'a crucial comment, which, if the archaeological evidence is allowed its proper weight, places the advent of the Romanesque style in England before the Conquest' (Biddle 1984, 134). Romanesque elements are present by the 1050s in architecture (the beginnings of the Confessor's abbey church at Westminster) and in manuscript painting (e.g. BL MS Cotton Tiberius C. VI), and the Winchester carving may suggest, if it does show Romanesque traits, that these were present even earlier in sculpture.

The comparison of no. 88 to the Bayeux Tapestry was made as soon as it was found (Biddle 1966b, 329, 332). Three points are relevant: both are friezes; both show a method of scene division whereby one figure turns its back on another; and they share similarities in figure shape, hair style, dress, and accoutrements. The third point needs some expansion. The left-hand figure on no. 88 has the long, thin legs typical of the Tapestry. The hair of the recumbent figure is worn long and tucked behind the ears, like the hair of the English on the Tapestry (e.g. Harold: Wilson 1985, pl. 2, etc.). The strong jaw-line of the recumbent figure is characteristic of the figures on the Tapestry (e.g.

Harold: ibid. pl. 14, etc.). The mail shirt, with its trouser-like thigh protection and edge binding (Brooks 1978, 94–6), short sleeves, and undershirt with sleeves rucked to the wrist, is seen repeatedly on the Tapestry. The long, straight sword worn in a scabbard hung from a belt on the left hip is a commonplace (e.g. Wilson 1985, pls. 7, 9 (unbuckled with belt hanging loose), 10–13, 15, 19, 56, 69), but here there are two discrepancies of uncertain significance. First, the angled strap from belt to scabbard shown on the carving does not appear on the Tapestry, although it would seem essential to be able to adjust the angle at which the sword was worn, at least when walking. Second, when the sword was worn over mail the Tapestry normally shows both Normans and English wearing it without a belt (ibid. pls. 22–3, 51, 55, 64, 70, 72), as if supported by a belt worn underneath and fastened to the scabbard through a slit or slits in the side of the mail. In the two cases where a sword belt is shown over the mail, the figures are both English foot soldiers (ibid. pls. 56, 69). In the scene where Duke William gives Harold arms, Harold's scabbard is shown inside his mail, the hilt of the sword appearing outside in the normal position, and the end of the scabbard poking out from beneath the skirt (ibid. pl. 24). This may be a simple error (ibid. 221–2), but the writer has worn his sword as orderly officer in exactly this way under a greatcoat, with the hilt exposed, and scabbard and belt concealed. It would indeed be awkward to wear a sword belt over either a greatcoat or a mail shirt, especially when riding. It looks as if the Tapestry may show two practices: the English, fighting on foot and wearing mailed trousers (Brooks 1978, 94–6; Brooks and Walker 1979, 19–20), when they carried a sword at all, wore a sword belt over mail, as on no. 88, whereas the Normans, mounted and wearing mailed skirts, perhaps strapped over the legs like a modern riding coat, sometimes wore the sword under the mail.

There seems no doubt that the relief 'provides the closest parallel for the Tapestry' (Zarnecki 1986a), and that it is 'a worthy prelude' to its narrative art (Cramp 1972, 148). The fact, as Wilson has noted, that the sculpture is the more finely detailed of the two (1985, 208) may account for minor variations like the presence on the stone of the angled sword strap. The similarities have even led Wilson to suggest that the Tapestry may have been made at Winchester (ibid. 212; but cf. his earlier comments, 1984, 200). The attribution to Canterbury rests on much firmer ground, however (Brooks and Walker 1979, 17–18).

There remains the question of whether Cnut would

have permitted the display in the cathedral of an incident from the pagan past. Wilson rejects this on the grounds that Cnut was 'intent on becoming a Christian king and would probably not want to advertise his pagan ancestry' (1984, 200; 1985, 208). But it is the heroic and not the pagan which matters here (Davidson 1967, 127–8; Gatch 1971, 27–36; Hinton 1977, 95–6). The appearance of Sigurd and Weland on pre-Conquest Christian carvings from northern England has even been seen as a 'pointed juxtaposition of mixed iconography' (Lang 1976, 94), where the Christian connotations of these scenes may be an attempt to redeem pagan ancestors (Ploss 1966, 96ff.). This too is the period when all the surviving manuscripts containing heroic stories of the pagan past, such as Beowulf, or extensive references to that past, as in the poem Deor, were written (Ker 1957, nos. 101, 116, 216, 282; Gneuss 1981, nos. 257, 399, 816). In the case of Beowulf alone, this is sufficient to demonstrate a living acquaintance in the early eleventh century with the saga of Sigmund, episodes of which appear in lines 867–900.

If the Winchester stone was part of a narrative frieze recording the shared ancestry of the English and Danish royal houses in the way suggested, and in the detail indicated by the inclusion of so slight but dramatic an incident as Sigmund and the wolf, the total length must have been very great. On the supposition that it was set on the interior walls of the eastern arm of Old Minster, east of the lateral apses, a length of 80 feet (24.4 m) is possible. There is nothing to show that it was not even longer, for it could have run around an even greater length of the exterior of the building, or have been in more than one register, whether inside or out. The similarities of the Winchester frieze to the Bayeux Tapestry may therefore have included length, for it should be remembered that the Tapestry was over 230 feet (70.4 m) long. The other figural fragments from Old Minster in this Corpus are the merest wreck of what once existed, but they provide a context for no. 88 in Old Minster which was not available when the stone was first published. Another context is provided by the evidence for the sculptural decoration on a very large scale of the late tenth-century tower of New Minster, which Quirk argued thirty years ago consisted of a series of friezes representing the dedication of each of the six stories of the tower (Quirk 1961, 33–5).

The part this particular frieze played in the evolution of such a concept as the Bayeux Tapestry is problematical. Despite the general similarity and the particular parallels, it would perhaps be wiser to see

both emerging from a wider and older tradition of narrative art displayed in a variety of media, painting both small and large, carving in wood, stone, and ivory, and embroidery. Vǫlsunga saga itself contains two specific descriptions of narrative hangings: one embroidered by Brynhild which showed the deeds of Sigurd, and one woven by Guðrún which illustrated among other actions the fight of Sigar and Siggeir and the ship of Sigmund sailing along the land (Finch 1965, 42, 62). These are, of course, literary creations. Their appearance in Vǫlsunga saga need only reflect the existence of such pieces in eleventh- or twelfth-century Norway or Iceland at the time Guðrúnarkviða II, which is the source of the Guðrún material noted here, was compiled (Neckel 1927, Guðrúnarkviða II, st. 16). The earliest English reference to an actual narrative hanging belongs to the late tenth century. After the death of ealdorman Byrhtnoth at the battle of Maldon in Essex in 991, his widow Aelfflaed gave to the monastery at Ely a number of lands, a golden collar, 'et cortinam gestis viri sui intextam atque depositam, depictam in memoriam probitatis eius' (Blake 1962, 136).

The Byrhtnoth cortina is alone sufficient to show that a tradition of secular narrative depiction existed in England at or before the proposed date of the Winchester sculpture. There is, in addition, independent Scandinavian evidence for the existence of some kind of narrative embroidery at an even earlier date, for the Oseberg ship-burial of c. 800 contained fragments of a long narrow hanging possibly showing scenes from a saga (Hougen 1940). Had Brynhild and Guðrún embroidered in reality the deeds of Sigurd and Sigmund, this is perhaps how their work would have looked.

To sum up, no. 88 has been tentatively identified as part of a very long frieze depicting the shared traditional history of England and Denmark, a history symbolically united in the marriage of Cnut to Aelfgifu-Emma, widow of Aethelred II, in 1017. The place of their marriage is unknown, but in time both were buried in Old Minster, Cnut in 1035 and Emma in 1052.

DATE Between c. 980/993–4 and 1093–4, probably 1017–35

REFERENCES Biddle 1966a, 325, pls. LIXb, LXII, LXV; Biddle 1966b, Biddle 1967c, 661, pl. 7; Davidson 1967, 127; Gatch 1971, 33–5, pl. 1; Biddle and Kjølbye-Biddle 1972, no. 16; Cramp 1972, 148; Biddle and Kjølbye-Biddle 1973, no. 18; Kjølbye-Biddle and Page 1975, 390; Lang 1976, 94; Hinton 1977, 95–6; Jacobs 1977, 40 and n. 81;

Brooks 1978, 94–6, pl. 1; Brooks 1979, 19; Biddle 1981, 166, 168, cat. no. J1; Dodwell 1982, 137–8, pl. 31; Zarnecki 1984, 150–1, cat. no. 97; Wilson 1984, 198–200, ill. 258; Biddle 1984, 133–5, cat. no. 140; Wilson 1985, 206–8, fig. 5; Zarnecki 1986a; Zarnecki 1986b, 8 and n. 7; Alexander 1987; Kahn 1992, 71; Biddle and Kjølbye-Biddle forthcoming a, fig. 153, no. 90

M.B.; B.K.-B.

### 89. Fragment                                        (Ill. 653)

PRESENT LOCATION Winchester City Museum, Historic Resources Centre, Hyde House, Winchester, accessions no. 2943 WS 201

EVIDENCE FOR DISCOVERY See no. 77.

H.   9 > 4 cm (3.5 > 1.6 in)   W.   10.8 > 9 cm (4.3 > 3.5 in)
D.   3 > 1.5 cm (1.2 > 0.6 in)

STONE TYPE Pale yellowish-grey, medium-grained, shelly, oolitic limestone, including crinoid ossicles and brachiopod, bivalve, and fish fragments; Combe Down Oolite, Great Oolite Formation of the Bath area, Great Oolite Group, Middle Jurassic

PRESENT CONDITION No dressed faces survive; the carved surface is somewhat battered and smoothed

DESCRIPTION This is a typical mason's chipping, representing debris left after the carved surface had been knocked off in preparing the stone for reuse. The decoration covers the whole surface ending to the left in a blank, concave edge. At the bottom the decoration dies away into an uncarved band. The pattern is composed of bands, *c.* 1 cm wide, in which S-twists alternate with plain ribbons.

DISCUSSION Similar patterns can be seen on nos. 90–1 and New Minster 6.

DATE Tenth or early eleventh century

REFERENCE Biddle and Kjølbye-Biddle forthcoming a, fig. 154, no. 91

M.B.; B.K.-B.

### 90. Fragment                                        (Ill. 652)

PRESENT LOCATION Winchester City Museum, Historic Resources Centre, Hyde House, Winchester, accessions no. 2943 WS 319

EVIDENCE FOR DISCOVERY Found in archaeological excavation north of Winchester cathedral in 1964 in rubble deriving from west end of Old Minster; Final

Phase 68 (Provisional Phase 1927), *c.* 1110

H.   8 > 7 cm (3.1 > 2.8 in)   W.   5 > 4.5 cm (2 > 1.8 in)
D.   6 > 4.5 cm (2.4 > 1.8 in)

STONE TYPE Greyish-yellow, medium-grained, oolitic limestone; Combe Down Oolite, Great Oolite Formation of the Bath area, Great Oolite Group, Middle Jurassic

PRESENT CONDITION No dressed faces survive; the carved surface is somewhat battered, and there are traces of burning

DESCRIPTION The relief is 4 cm deep with a blank, well finished, slightly concave face to the right. Here a scar indicates the start of the next decorative element. On the front and turning into the right there is a cluster of four alternately twisted bands (Z-S-Z-S) spreading from 1.4 cm to a total width of 4.4 cm., each band widening towards the bottom. On the left the relief is *c.* 1.6 cm deep, and a new decorative element starts at the point where the stone breaks off.

DISCUSSION Compare nos. 89, 91, and New Minster 6.

DATE Tenth or early eleventh century

REFERENCE Biddle and Kjølbye-Biddle forthcoming a, fig. 154, no. 93

M.B.; B.K.-B.

### 91. Part of frieze                              (Ills. 650–1, 656)

PRESENT LOCATION Winchester City Museum, Historic Resources Centre, Hyde House, Winchester, accessions no. 2943 WS 585

EVIDENCE FOR DISCOVERY Found in archaeological excavation north of Winchester cathedral in 1966 reused in east wall of later medieval chapel built around tomb of St Swithun; Final Phase 74 (Provisional Phase 1511), mid thirteenth-century

H.   22 > 18 cm (8.7 > 7.1 in)   W.   72.8 > 67.6 cm (28.7 > 26.6 in)
D.   34.4 > 19.2 cm (13.5 > 7.5 in)

STONE TYPE Pale yellowish-grey, medium-grained, slightly shelly, oolitic limestone, including irregular pellets of 0.5 mm diameter, and 1–1.5 mm in length; Combe Down Oolite, Great Oolite Formation of the Bath area, Great Oolite Group, Middle Jurassic

PRESENT CONDITION The stone was found almost immediately below the present surface and as a result is frost-shattered horizontally along the bedding planes

(Biddle 1967a, pl. LV). The carved surface is damaged and has been extensively repaired. Face E (top) is probably an original bed face and has been dressed smooth with a broad-bladed tool, probably an adze. A small area at the left end of face F (bottom) may also be an original bed face: the rest of that face, which was uppermost when found, appears to have been lost due to frost action (Ill. 656). All the other surfaces, apart from the carved face, are probably secondary and show a quite different, very coarse and irregular working, to produce a large ashlar for reuse.

DESCRIPTION Only one face is carved.

*A (broad):* The left-hand section has the head, hair, and the beginning of the neck, of a beast looking right. The eye is almost round, with a tear-fold at the right edge. The hair or mane is rich, at least 23 cm wide and composed of twisted strands. A projection from the forehead, set back 1 cm from the face, may be horns or a forelock. The snout, which overhangs the lower jaw, slightly overlaps the frame. The frame has a central pattern of rectangular cuts, producing a billet-like appearance, with a plain band to the right; the left edge has broken away throughout the height of the stone. To the right of the frame there is a triangular (or, more likely, oval) bunch of berries, perhaps grapes, hanging from the innermost of a spray of at least three elements.

DISCUSSION The beast has a wavy mouth and a pronounced snout. The design is not unlike the relief from York, Holy Trinity Micklegate 1, which also has its snout against a frame. But the York example has more upturned snout, is much more exaggerated, has a double outline, and is of inferior design (Lang 1991, ill. 203). The York example is thought to have been part of a tympanum. The quality of the carving of the Winchester head is as good as that of the head from Monkwearmouth, co. Durham, no. 16 (Cramp 1984, II, pl. 124 (673–6)). The scroll is like that on the cross-shaft from Heversham, Westmorland (no. 1), especially face D, which has a plant with split stem and a leftward-turning tight tendril from which hangs a single bunch of berries (Bailey and Cramp 1988, ill. 354). A spiral scroll does not exist on the Winchester piece, but could have been adjacent. The pattern on the frame is similar to nos. 40 and 47 (Ills. 565–6, 576), and the head is like the bird, no. 74 (Ill. 617). The present stone has carving of very high quality, seen both in the beast head and the naturalistic plant. It may be derived from Old Minster, perhaps from the area of the western addition, but because it was re-shaped for reuse in a thirteenth-century building it could have been brought from any building in the area and could be an early piece.

DATE Tenth century or earlier

REFERENCES Biddle 1967a, pl. LVb; Biddle and Kjølbye-Biddle forthcoming a, fig. 154, no. 94

M.B.; B.K.-B.

**92–6.** See Appendix A, p. 337.

# WINCHESTER, Ha. (New Minster)[1]

## SU 482293

**1. Fragment of grave-marker**                    (Ills. 657–8)

PRESENT LOCATION Winchester City Museum, Historic Resources Centre, Hyde House, Winchester, accessions no. 2943 WS 550

EVIDENCE FOR DISCOVERY Found in archaeological excavation north of Winchester cathedral in 1970 in eastern part of area called Paradise, over demolished domestic buildings of New Minster; Final Phase 252 (Provisional Phase 2978), early sixteenth-century

H.  30 > 5 cm (11.8 > 2 in)   W.  30 > 10 cm (11.8 > 3.9 in)
D.  13 > 10.8 cm (5.1 > 4.3 in)

STONE TYPE Grey, porous, shell-fragment limestone; Quarr stone, Bembridge Formation, Palaeogene, Tertiary; Isle of Wight

---

1. It has not proved possible to provide more than a generic description for the stone types of nos. 3–5

PRESENT CONDITION The carved surface is crisp; all other original surfaces have been cut away in breakage and secondary tooling

DESCRIPTION Only one carved face survives.

*A (broad):* A straight ridge running horizontally across the face is likely to be the remains of the lower frame. To the left, just above the upper arm of the cross, a curved edge may reflect the inner edge of the left-hand frame. A right hand, palm outwards, holding a horizontal cross, comes vertically down from above. The hand is in a blessing position, the second and third fingers outstretched, with the cross-shaft held between thumb and forefinger, and by the two folded fingers. The thumb would not have been visible if the hand had been shown from the other side. The cross has a long shaft, 14.5 cm surviving, and 2.8 cm wide. The cross-head has four arms expanding from a round central area, diameter 5.6 cm, in which the central setting-out point still survives. Only the lower arm of the cross survives to its whole length, projecting 5 cm from the central area and 7.3 cm from the centre-point. The arm splays from 2.8 to 4.8 cm, and is crossed by two incised lines set 0.9 cm apart and equidistant from the outer end and from the central circle.

DISCUSSION The carving is of better quality than Old Minster no. 2 (Ill. 498). If the stone is correctly aligned in Ill. 657, the Hand of God appears to come down from above, like Winchester St Pancras 1 (Ill. 675), and not from the side, as on Old Minster 2. At first glance the present piece is very like St Pancras 1, which is much less well preserved, but the two are not identical, the latter being smaller and differently proportioned. There is no sign of a cloud on New Minster 1, but this could have been broken away. The Hand of God blessing from the top right, without a cloud, can be seen in the Old English Hexateuch, a manuscript of the second quarter of the eleventh century, fol. 26v. But the more usual way for the Hand of God to be shown is coming from a sleeve (much more rarely from a sleeve and a cloud, or from a cloud alone), as on roods like Breamore (no. 1; Ill. 427), Headbourne Worthy (no. 1; Ill. 448), and Romsey (no. 1; Ill. 452), all in Hampshire. At Romsey the hand is well enough preserved to determine how the fingers are shown: they are stretched and the palm is outwards, the hand projecting from a sleeve which comes out of a stormy cloud. It is much more common in ivory, stone, and illumination to have the Hand of God coming out of a wide sleeve, and it is usual for the Hand not to be in a blessing position, but

with an open palm, and outstretched fingers (like a helping hand rather than a blessing hand). This can be seen, for example, in the late tenth-century Winchester manuscript, the Benedictional of archbishop Robert (Rouen, Bib. Mun. MS Y. 7, fol. 29v (Temple 1976, no. 24, frontispiece)). The Hand of God can also be seen on coins of Aethelred II, who may have intended the Hand of God to be the distinctive emblem on the reverse of his coinage. Initially an open hand coming down from above out of a sleeve, palm forwards and fingers outstretched (the so-called 'First Hand' and 'Second Hand' types of *c.* 979–85 and *c.* 985–91), the Third Hand type of *c.* 991 (the so-called 'Benedictional Hand') shows the hand as previously but now with the fingers in the blessing position and with a small equal-armed cross on the sleeve above (Blackburn 1991, 158–60, pls. 8.4–6). In manuscripts, hands in a blessing position more often come from the top right, for example, in the York Gospels (York Minster, Chapter Library MS Add. 1, fols. 22v, 60v, 85v (Temple 1976, no. 61, ills. 181, 183–4)) and in Oxford, Bodleian Library MS Bodley 155, fol. 93v (ibid., no. 59, ill. 178), but there are good examples of a blessing hand, with the thumb not folded over, coming directly from above, straight out of a cloud, in the Judith of Flanders Gospels, fol. 1v (ibid., no. 93, ill. 289), and the Hereford Troper, fol. 31 (ibid., no. 97, ill. 295). None of these hands holds a cross, however. The Hand of God also appears in several Norman tympana, but again does not hold a cross. For further discussion, see Old Minster 2.

DATE Late tenth or early eleventh century

REFERENCE Biddle and Kjølbye-Biddle forthcoming a, fig. 155, no. 96

M.B.; B.K.-B.

## 2. Part of round-headed grave-marker(?)

(Ills. 661–3)

PRESENT LOCATION Winchester City Museum, Historic Resources Centre, Hyde House, Winchester, accessions no. 2943 WS 3024

EVIDENCE FOR DISCOVERY Found in archaeological excavation north of Winchester cathedral in 1963 in demolition rubble derived from south wall of New Minster; Final Phase 67 (Provisional Phase 561), *c.* 1110

H.   35.3 > 12.5 cm (13.9 > 4.9 in)   W.   36 > 15 cm
      (14.2 > 5.9 in)

D.   9.6 > 5 cm (3.8 > 2 in)

STONE TYPE Grey, porous, shell-fragment limestone, including some recognizable gastropod moulds; Quarr stone, Bembridge Formation, Palaeogene, Tertiary; Isle of Wight

PRESENT CONDITION The carved surface crisp, but damaged; the original edge survives to the right

DESCRIPTION This is the right-hand half of the upper, semicircular part of what was probably a grave-marker. Only one face is carved.

*A (broad):* At the bottom there is a ruler-straight, almost polished, edge forming the upper side of a horizontal slot 1.2 cm wide and 3.2 cm deep from the surface of the upper part of the stone. The lower part of the stone is broken away and the nature and projection of its surface is unknown. The carved scene starts immediately above this slot. The outer edge is formed by a curving frame, 5.4 cm wide. The background of the relief lies 3.1 cm behind the surface of the frame, and the relief itself at its highest is only about 2 mm lower than the frame. If the bottom of the horizontal slot is used, the upper part of the stone consists of a perfect semicircle with a diameter of between 32.6 and 33 cm. The mark at the centre-point may have survived on the lower edge of the slot. Immediately to the right of the centre there is a cross, 17.6 cm tall, the three surviving arms being 15.3 cm long from its centre, and of the same expanded shape (type B6) as on no. 1 from this site and St Pancras 1 (Ills 657, 675); there may also have been incised lines parallel to the ends of the arms, as on the latter two monuments, and the cross has a narrow shaft of the same type as theirs. The cross stands on a low hill, which lies in front of the steep hill or cave in the lower right-hand corner. This latter hill is shaped as a circular segment with incised lines.

*B, D, and E (narrow sides and top):* Plain.

*C (broad):* Plain.

DISCUSSION The carving is as fine as that of New Minster no. 1. No parallel to this scene has been found. The hill on the right is not dissimilar to some of the hills on the Bayeux Tapestry, but none is exactly similar, having for example, wavy lines (Wilson 1985, 19), or horizontal ones (idem 1985, 49–50). The steep hill or cliff side on the present carving with its lines may also represent a cave opening or tomb. There are depictions of hills which may represent tombs or Valhöll on some of the Gotland picture-stones (Nylén 1978, 69–73), but they are not like the hill on the present carving. The cross is a little larger than that on

no. 1. There is room on the stone for a larger cross to the left of centre and another smaller cross to the left of that. It is thus possible that this is a Golgotha with the three crosses and the Tomb of Christ in the background. This stone need not be a grave-marker, but could have been at the end of a flat surface, for example, as the background to an altar table. The horizontal groove is singular, and much more precise than the wide cut on Old Minster nos. 2 and 4.

DATE Late tenth or early eleventh century

REFERENCE Biddle and Kjølbye-Biddle forthcoming a, fig. 155, no. 99

M.B.; B.K.-B.

## 3. Fragment of lathe-turned(?) capital     (Ill. 664)

PRESENT LOCATION Winchester City Museum, Historic Resources Centre, Hyde House, Winchester, accessions no. 2943 WS 105.

EVIDENCE FOR DISCOVERY Found in archaeological excavation north of Winchester cathedral in 1965 in rubble deriving from demolition of the south wall of New Minster; Final Phase 67 (Provisional Phase 737), *c.* 1110

H.   11.7 > 9 cm (4.6 > 3.5 in)   W.   19.2 > 16 cm
     (7.6 > 6.3 in)
D.   8 > 4 cm (3.1 > 1.6 in)

STONE TYPE Combe Down Oolite, Great Oolite Formation of the Bath area, Great Oolite Group, Middle Jurassic

PRESENT CONDITION One bed face survives; the carved surface is battered

DESCRIPTION The diameter at the surviving (upper) bed face is *c.* 20 cm (7.9 in). The upper moulding, 3 cm high, is damaged but was perhaps rounded; the lower, major, part is bulbous. The left side is flattened for the inner 2 cm, as if it had been built into a wall.

DISCUSSION Comparable capitals can be seen in, for example, the late tenth-century Benedictional of St Aethelwold (fol. 118v) or on a ninth-century ivory casket of the Metz School (Temple 1976, no. 23, ill. 91, fig. 17).

DATE Tenth century, perhaps early

REFERENCE Biddle and Kjølbye-Biddle forthcoming a, fig. 142, no. 19

M.B.; B.K.-B.

**4. Fragment of lathe-turned(?) capital**     (Ill. 666)

PRESENT LOCATION Winchester City Museum, Historic Resources Centre, Hyde House, Winchester, accessions no. 2943, WS 559

EVIDENCE FOR DISCOVERY Found in archaeological excavation north of Winchester cathedral in 1970 in Dean Kitchin's excavation backfill, and probably derived from demolition of New Minster domestic buildings; Final Phase 262 (Provisional Phase 2113), *c.* 1885–6

H.   5.5 > 0.5 cm (2.2 > 0.2 in)   W.   17.5 > 4 cm (6.9 > 1.6 in)
D.   9.5 > 4 cm (3.7 > 1.6 in)

STONE TYPE Combe Down Oolite, Great Oolite Formation of the Bath area, Great Oolite Group, Middle Jurassic

PRESENT CONDITION One bed face survives; the carved surface is well preserved with thick whitewash, painted red

DESCRIPTION Diameter at the surviving, lower, bed face *c.* 22 cm (8.7 in). On the underside, about 3 cm from the beginning of the outer curve, there is a line marking the area where the capital sat on the shaft. This projecting area has traces of whitewash and red paint. The lower moulding, 4 cm high, is rounded with a slight sag; apart from the scar of its beginning none of the next moulding survives. The whitewash is thick with a smooth surface; the paint is a deep shade of pink-red, lighter than the Roman oxblood colour.

DISCUSSION Whitewash occurs on 21 stones from the Old and New Minsters, but only in this case does paint appear on the whitewash (see above, p. 104).

DATE Tenth century, perhaps early

REFERENCE Biddle and Kjølbye-Biddle forthcoming a, fig. 142, no. 20

M.B.; B.K.-B.

**5. Fragment**     (Ill. 665)

PRESENT LOCATION Winchester City Museum, Historic Resources Centre, Hyde House, Winchester, accessions no. 2943 WS 3085

EVIDENCE FOR DISCOVERY Found in archaeological excavation north of Winchester cathedral in 1963 in rubble deriving from the demolition of New Minster; Final Phase 67 (Provisional Phase 528), *c.* 1110

H.   7 > 2 cm (2.8 > 0.8 in)   W.   12 > 7 cm (4.7 > 2.8 in)
D.   2 > 0.5 cm (0.8 > 0.2 in)

STONE TYPE Combe Down Oolite, Great Oolite Formation of the Bath area, Great Oolite Group, Middle Jurassic

PRESENT CONDITION No bed or dressed faces survive; the moulding is battered

DESCRIPTION A flat, horizontal moulding, 1 cm wide, forms part of a curve with a large diameter. Below, there is a concave moulding over an expanding slope; above, there are traces of what may be a twisted colonette, *c.* 7 cm in diameter, with another element coming in from the left.

DISCUSSION The carving is precise, but cannot be understood.

DATE Tenth century or later

REFERENCE Biddle and Kjølbye-Biddle forthcoming a, fig. 147, no. 54

M.B.; B.K.-B.

**6. Fragment**     (Ills. 654–5)

PRESENT LOCATION Winchester City Museum, Historic Resources Centre, Hyde House, Winchester, accessions no. 2943 WS 430

EVIDENCE FOR DISCOVERY Found in archaeological excavation north of Winchester cathedral in 1966 in rubble deriving from demolition of New Minster; Final Phase 67 (Provisional Phase 1349), *c.* 1110

H.   8.8 > 3 cm (3.5 > 1.2 in)   W.   8.5 > 5 cm (3.3 > 2 in)
D.   4.8 > 2.5 cm (1.9 > 1 in)

STONE TYPE Pale yellowish-grey, medium-grained, oolitic limestone; Combe Down Oolite, Great Oolite Formation of the Bath area, Great Oolite Group, Middle Jurassic

PRESENT CONDITION Only one dressed face survives; the carved surface is somewhat battered

DESCRIPTION The left side is slightly splayed with reference to the main surviving surface. The angle is decorated with a Z-twist which runs around the corner and dies away into a dressed face. On the front there are three vertical blank bands alternating with a Z-twist at the corner, an S-twist, and a second Z-twist. The bands are about 8 mm wide. The blank band on the right ends in a good surface, 6 mm wide,

down the right edge. Either the full width of the stone has survived, at *c.* 9 cm, or there is an extra deep groove between the right-hand band and any band which may once have existed beyond it.

DISCUSSION Similar patterns can be seen on Old Minster nos. 89–91 (Ills. 651–3) but this piece of alternating decorative 'bands' is more formal and might be an architectural decoration (e.g. of a string or pilaster strip) rather than a 'naturalistic' representation.

DATE Tenth or early eleventh century

REFERENCE Biddle and Kjølbye-Biddle forthcoming a, fig. 154, no. 92

<div style="text-align: right">M.B.; B.K.-B.</div>

## 7. Fragment (Ills. 659–60)

PRESENT LOCATION Winchester City Museum, Historic Resources Centre, Hyde House, Winchester, accessions no. 2943 WS 574

EVIDENCE FOR DISCOVERY Found in archaeological excavation north of Winchester cathedral in 1970 in pit (F. 473) associated with Anglo-Saxon monastic buildings belonging to New Minster; Final Phase 236 (Provisional Phase 2626), late eleventh century

H.  13 > 9 cm (5.1 > 3.4 in)   W.   10.3 > 6 cm (4.0 > 2.4 in)
D.  5 > 3 cm (2 > 1.2 in)

STONE TYPE Very pale brown (10YR 8/3), medium- to coarse-grained, shelly, oolitic limestone; Combe Down Oolite, Great Oolite Formation of the Bath area, Great Oolite Group, Middle Jurassic

PRESENT CONDITION No dressed faces survive; the carved surface is deeply burnt and eroded

DESCRIPTION The vertical mouldings to the left may be from drapery, an interpretation perhaps supported by the shallow diagonal mouldings to the right which may be from surface folds.

DISCUSSION The mouldings suggests drapery folds like Old Minster no. 85 (Ill. 641), but of a cruder quality. The piece is one of very few Anglo-Saxon carved stones from the domestic buildings of New Minster, which were extensively excavated.

DATE Late tenth century?

REFERENCE Biddle and Kjølbye-Biddle forthcoming a, fig. 152, no. 87

<div style="text-align: right">M.B.; B.K.-B.</div>

# WINCHESTER, Ha. (St Maurice)

## SU 484294

## 1. Grave-cover (Fig. 42; Ills. 667–670)

PRESENT LOCATION Winchester City Museum. Accession number 334

EVIDENCE FOR DISCOVERY Found in 1970 by a Mr Gardiner in core of east wall of tower when new first-floor doorway inserted

L.   19 cm (7.5 in)   W.   18 cm (7.1 in)
D.  12 cm (4.7 in)

STONE TYPE Grey (with a greenish tinge), shell-fragment limestone; Quarr stone, Bembridge Formation, Palaeogene, Tertiary; Isle of Wight

PRESENT CONDITION Broken and worn

DESCRIPTION It is sub-rectangular and roughly broken at either end and below. The long edges to the left and right are dressed flat, and only slightly damaged.

<div style="text-align: right">D.T.</div>

*A (top): Inscription* The face of the stone contains the remains of an inscription in Scandinavian runes. Standing opposite each other are two fragmentary sequences of runic characters, (*a*) and (*b*), placed between framing lines that parallel the edges of the stone. The bases of the runes point inwards, which suggests that the inscription ran up one edge of the face and down the other. Although the runes and dividers are damaged in a number of places, they are not significantly worn and several look quite fresh. In addition, there are clear traces of red paint here and

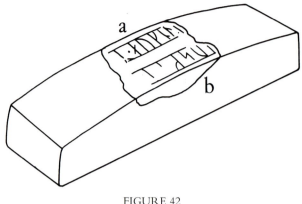

FIGURE 42
Winchester St Maurice 1, reconstruction, nts

there in the framing lines and in most of the characters. Apparently the stone was not exposed to wind and weather for very long.

Since the layout of the inscription provides no guidance about which way up the stone stood, it is difficult to know whether text (*a*) or text (*b*) should be read first (see, however, the discussion below).

(a) —(**R**)[:]**auk[o]l**[: .]—
(b) —[.](**u**)**sk**[. .]—

<div align="right">M.P.B.</div>

DISCUSSION The monument can be reconstructed as of square section with a convex upper face which carries the inscription (see Fig. 42). While the form of the monument is uninformative in terms of dating, it is likely that the inscription is in Old Norse, which would point to the period of Scandinavian political dominance in Winchester for its making, probably in the period 1016–42 (see below).

<div align="right">D.T.</div>

*Inscription* Given the fragmentary nature of the inscription, it is impossible to produce a text. The few runes that survive are susceptible to differing interpretations. If it is assumed that the carver placed his or her dividers at word boundaries, (*a*) is most likely to contain a personal name (Old Norse Auðkell). Dividers were, however, sometimes placed within words, and often used only sporadically. This makes it possible to suggest that (*a*) preserves a sliver of text from the beginning of a typical memorial inscription, in which the names of those who commissioned the inscription are recorded. — (**R**) might then be the nominative singular termination of a name (probably male) and the following three characters could denote *auk* ('and') and the remainder of the fragment the beginning of a further name (perhaps Óláfr). It is harder to select a linguistic

context for fragment (*b*). A rounded vowel plus /sk/ is a common sequence in verbal endings and adjectival roots, as well as in other parts of speech. It may even be that more than one word is involved here, or perhaps two elements of a compound. If the latter is supposed, the word *húskarl* ('retainer', 'member of the king's bodyguard') becomes a distinct possibility.

Rune forms (or, more precisely, the likely rune-phoneme correspondences ᚠ/a/, ᚾ/s/, and possibly ᚼ/R/) and layout combine to suggest a tenth- or eleventh-century, Danish-inspired inscription. That a Dane would have raised a memorial stone in tenth-century Winchester seems improbable, and the likelihood must rather be that it dates from the time of Cnut or thereabouts, when it would not be unexpected to find Scandinavian *húskarlar* in this centre of royal and ecclesiastical power (cf. Winchester Old Minster 6).

<div align="right">M.P.B.</div>

DATE Eleventh century

REFERENCES Kjølbye-Biddle and Page, 1975, 389–94, fig. 1, pl. LXXXII; Tweddle 1986b, I, 90–1, 230–1, II, 512–13, III, fig. 8, pl. 119a; Tweddle 1990, 150, pl. 3

## 2. Sundial    (Ill. 672)

PRESENT LOCATION Built into south wall of upper stage of tower, outside

EVIDENCE FOR DISCOVERY First recorded in Page 1912a

MEASUREMENTS Unobtainable

STONE TYPE Inaccessible; a greyish-yellow stone (paler than Caen stone blocks elsewhere in the tower wall), one or two fine ribs traversing the surface perhaps being weathered-out calcite veinlets; Probably Combe Down Oolite, Great Oolite Formation, Great Oolite Group, Middle Jurassic; Bath area

PRESENT CONDITION Heavily weathered

DESCRIPTION Only one face is visible.

The dial is made from a single circular stone. The gnomon hole is on the vertical axis, but displaced towards the upper edge of the stone, and obscured by a modern openwork, wrought-iron gnomon. From the hole radiate incised lines of calibration terminating on the incised line delimiting the broad plain frame. Four lines are visible to the left of the gnomon and three to the right, but all are heavily damaged.

DISCUSSION The fact that the dial is carved on a separate circular stone is suggestive of an early date; for

example, it compares closely in form with the dial at Hannington, Hampshire (Ill. 441). Likewise, the manner of calibration appears to be related to that of the pre-Conquest dials in Hampshire, at Hannington, Corhampton 1, Warnford, and St Michael's, Winchester. However, the poor condition of the dial leaves this matter open to debate.

DATE Tenth to eleventh century

REFERENCES Page 1912a, 73; Green 1943, 273; Cox and Jowitt 1949, 22; Green and Green 1951, 58, pl. XIX; Zinner 1964, IV, 216; Tweddle 1986b, I, 84–5, 187, 189, II, 511–12, III, pl. 118b

D.T.

# WINCHESTER, Ha. (St Michael)

## SU 480289

### 1. Sundial                                              (Ill. 671)

PRESENT LOCATION Built into south wall of nave, outside

EVIDENCE FOR DISCOVERY First recorded in Haigh 1846

H. 38 cm (15 in)   W. 46 cm (18.1 in)
Diameter of dial 38 cm (15 in)
D. Built in

STONE TYPE Inaccessible; appears to be of limestone with shell fragments and a projecting fine rib which may be a calcite veinlet; probably Combe Down Oolite, Great Oolite Formation, Great Oolite Group, Middle Jurassic; Bath area

PRESENT CONDITION Good; slightly chipped

DESCRIPTION Only one face is visible.

On a rectangular panel is a circular relief dial having a narrow, plain, raised frame. In the centre is a drilled gnomon hole from close to which radiate the incised lines calibrating the lower half of the dial, and which terminate on the frame. There is a pair of lateral lines placed just above the horizontal, and a vertical line. There are five equally-spaced lines between the vertical and lateral lines to the left, and three to the right. The vertical line is crossed close to its outer end by a short bar with drilled ends. The median line between the vertical and lateral lines to the left is similarly treated, as is that immediately below the lateral to the right. From the frame develop four, heavily damaged, short stems, one running into each corner of the panel where it terminates in a short pointed leaf flanked by a pair of similar out-turned leaves.

DISCUSSION The dial is plainly *ex situ*, as it is incorporated into a later medieval fabric. Nonetheless, its pre-Conquest date is evident as it is of very similar form to dials elsewhere in Hampshire, at Warnford (no. 1; Ill. 478) and Corhampton (no. 1; Ill. 438). As noted above (p. 72), the Corhampton dial is *in situ* in a demonstrably late pre-Conquest fabric.

DATE Tenth to eleventh century

REFERENCES Haigh 1846, 410, 414, fig. on 410; Haigh 1857, 178, fig. on 178; Way 1868, 211; Haigh 1879, 198, fig. on 198; Allen 1889, 201; Gatty 1889, 424; Gatty 1900, 67–8, fig. on 67; Doubleday and Page 1903, 240–1; Johnston 1907, 17; Page 1912a, 73; Jessep 1913, 17; Green 1926, 20–1, fig. on 20; Green 1928, 499; Cottrill 1931, appendix; Zinner 1939, 9, abb. 34; Green 1943, 273; Cox and Jowitt 1949, 22, 196; Green and Green 1951, 59, pl. XIX; Taylor 1962a, 169; Zinner 1964, IV, 216, abb. 8; Taylor and Taylor 1965–78, I, 178; Taylor and Taylor 1966, 19, 25, fig. 8; Bowen and Page 1967, 288; Hinton 1977, 90; Tweddle 1986b, I, 84–5, 187–8, II, 513–14, III, pl. 119b

D.T.

# WINCHESTER (St Pancras)

## SU 484295

### 1. Round-topped grave-marker                (Ills. 673–5)

PRESENT LOCATION Winchester City Museum, Historic Resources Centre, Hyde House, Winchester, accessions no. 2941 WS 270

EVIDENCE FOR DISCOVERY Found in archaeological excavation at Lower Brook Street (formerly Tanner Street), Winchester, in 1971 in northern foundation (F. 597) for bell turret added to west front of St Pancras's church; Final Phase 14 (Provisional Phase 515), thirteenth to early fourteenth century

H.   39 > 38 cm (15.4 > 15 in)   W.   26 > 9 cm (10.2 > 3.5 in)
D.   9.6 > 7.5 cm (3.8 > 3 in)

STONE TYPE Pale grey, porous, shell-fragment limestone; Quarr stone, Bembridge Formation, Palaeogene, Tertiary; Isle of Wight

PRESENT CONDITION Badly damaged

DESCRIPTION This is the left side of a rounded grave-marker sitting on a narrower neck. The rounded upper part forms more than a semicircle, being gathered in towards the lower edge of the frame.

A (broad): The carving is recessed 2.4 cm deep within an arched area, the surface of which is level with the surface of the frame and neck. The bottom of the recessed area forms a straight line. A Hand of God, palm outwards, comes down out of what appears to be a cloud, which may have had its surface at the level of the frame. The Hand is in a blessing gesture with the second and third fingers extended and the thumb lying on top, and it holds a horizontal cross with the head to the left. The cross has expanded arms, like the cross on Winchester New Minster 1 and probably also had parallel lines on each arm (Ill. 657).

DISCUSSION The carving is very damaged but looks as if it was of good quality, like New Minster 1, and better than Old Minster no. 2 (Ill. 498). All the dimensions are smaller than those on New Minster no. 1, which did not apparently have a narrower neck (Ill. 657). No rounded central area survives on the cross of the present piece, but there is perhaps a hint that there was once a central boss. The remains of a setting-out point survive in the middle of the palm of the hand, 18.5 cm (7.3 in) from the outer edges of the external curve. There may be another setting-out point in the head of the cross. For further discussion about hand position and the holding of a cross, see Old Minster 2 and New Minster 1.

It is possible to suggest where this stone may originally have come from, although it was found as rubble in a late foundation in St Pancras's Church. On the Lower Brook Street site there were two churches, St Mary and St Pancras. There were no Late Saxon graves around St Mary's, but at St Pancras three graves were found which were earlier than the context of the present piece: two were Anglo-Saxon (G.20 inside the church and not disturbed; and G.21 south of the church and cut by the first south porticus), and one perhaps of early twelfth-century date (G.17). This grave-marker could have come from G.21, where it would have been disturbed when the first south porticus was built in the early eleventh century; ultimately it found its way into the foundation of a later medieval bell-turret together with pink brick-filled plaster (or 'somp') of Anglo-Saxon type, which could have come from the demolition of the Anglo-Saxon south (or north) porticus, along with the present (already reused) carving.

DATE Late tenth or early eleventh century

REFERENCES Biddle forthcoming b; Biddle and Kjølbye-Biddle forthcoming a, fig. 155, no. 98

M.B.; B.K.-B.

# WINCHESTER, Ha. (High Street)

SU 482295

## 1. Part of cross-shaft                    (Ills. 679–682)

PRESENT LOCATION Winchester City Museum stores

EVIDENCE FOR DISCOVERY Discovered in 1963 when wall in basement of what was then National Provincial Bank demolished; twelfth-century capital also recovered

H. 19.5 cm (7.7 in)   W. 16.5 cm (6.5 in)
D. 10.5 cm (4.1 in)

STONE TYPE Light grey, medium-grained, oolitic limestone, with shell detritus, possible echinoid fragments, and planar bedding; Middle Jurassic; of uncertain provenance

PRESENT CONDITION Broken and chipped

DESCRIPTION Part of a shaft of circular section, dressed flat below but broken above and to the rear, so that less than one-third of the circumference survives.

Along the lower edge is a broad, plain frame of convex section, above which is a second, narrower, plain relief frame. Above this the shaft is decorated with a bush scroll. The stem stands on a stepped base and is median-incised; only a single pair of scrolled branches survive, each is median-incised and leafless. The end of each scroll is turned up to form a diagonal which interlaces with the scroll before curving up to flank the main stem and run off the broken edge above.

DISCUSSION Probably part of a round shaft built in section, as the lower face appears to be original and dressed flat. As the round shaft was a ninth-century innovation (Cramp 1978, 9), this provides a *terminus post quem* for the piece. This dating is confirmed by the decoration. As noted in Chap. V, the occurrence of plant ornament points to a date in the late eighth century at the earliest, as before this date plant ornament was not established in the repertoire of Anglo-Saxon art in south-east England. Tree-scrolls, the form employed here, were widely used in the late eighth and ninth centuries, and persisted as late as the early tenth century, as on the shaft from East Stour, Dorset (Backhouse *et al.* 1984, no. 23, pl. 2).

DATE Ninth century

REFERENCES Tweddle 1983b, 22, pl. VIIa; Tweddle 1986b, I, 95, 150–1, II, 514–15, III, pl. 120a

D.T.

# WINCHESTER, Ha. (Lower Brook Street)

SU 484295

## 1. Plaque                                (Ills. 676–8)

PRESENT LOCATION Winchester City Museum, Historic Resources Centre, Hyde House, Winchester, accessions no. 2941 WS 271

EVIDENCE FOR DISCOVERY Found in archaeological excavation at Lower Brook Street (formerly Tanner Street), Winchester, in 1971 in pit (Pit 244) behind House XII, 12 metres (40 feet) north-north-west of site of St Mary's church, and 20 metres (66 feet) east of site of St Pancras's church; Final Phase 38 (Provisional Phase 726), early to mid(?) eleventh-century

H. 8.5 cm (3.3 in)   W. 9.7 cm (3.8 in)
D. 2.7 > 2.2 cm (1 > 0.8 in)

STONE TYPE Whitish-grey, medium- to coarse-grained, shelly, oolitic limestone; Combe Down Oolite, Great Oolite Formation of the Bath area, Great Oolite Group, Middle Jurassic

PRESENT CONDITION Unworn; the top right-hand corner is broken away

DESCRIPTION A flat plaque, only one face of which is carved. The four edges of the stone are carefully dressed, the tooling still visible. None of the tooling appears to be secondary. The piece is therefore complete except for a small loss affecting the top bar of the square capital C on face A. The left-hand edge (face D) is flat. The back (face C) is tooled flat, but not smooth; the top edge (face E) is bevelled smoothly into the back; the bottom and right-hand edges are bevelled more roughly.

*A:* The only carved face is dressed smooth, bearing a deeply incised inscription (see below).

M.B.; B.K.-B.

*Inscription* The letters of the inscription (Okasha 1983, 102–3) are incised with broad strokes of unusual section (Ill. 678). The letter-strokes consist of roughly flat-bottomed troughs and are wider at the bottom of the trough than at the surface of the stone. The sides are therefore somewhat undercut. This would preclude the use of the letters as moulds because cast letters could not be extracted in one piece without breaking the overhanging edges of the letter strokes. The cross-section of the troughs is, however, very suitable for holding inlaid lettering, though there is no visible evidence of inlay. The letters vary between about 4.8 cm (1.9 in) (H and C) and about 5 cm (2 in). The inscription, which is in capitals, reads:

—HIC—

This is presumably the Latin word *hic* ('here'). This would make little sense on its own and so further text must have been lost (or at least intended) at one or both ends.

The lettering consists of three capitals. H and I conform to the standard Roman forms. C is square. There are no true serifs. Instead strokes expand gradually towards the ends in a manner which Okasha has called 'stem thickening' (Okasha 1968, 332; Higgitt 1990, 35–6, which fails to refer to this example of incised 'stem thickening').

J.H.

DISCUSSION It is perhaps possible that this was a trial piece, but its size would have made it difficult to hold while being worked. It may alternatively have been cut down for reuse, but it is not obvious why this should have been done. The tooling, the surface appearance, and the slight degree of weathering, all suggest that the surfaces are contemporary and that the stone is complete in itself. If so, it must have formed part of an inscription (see below), presumably from a burial, with the remaining words cut on another stone

or stones. A small cemetery of seventh to early-eighth century date lay below the later church of St Mary, 12 m. to the south of the find-spot. A more likely source, however, may be the church of St Pancras, 20 m. to the west, where two burials of tenth- or early eleventh-century date were found. The digging of tanning and other pits in the tenth and eleventh centuries could easily explain the removal of the stone from its original position.

It seems possible that the cuts in the stone were intended to hold metal letters, perhaps lead, which had been poured into the deep shapes. Because the edges of the letters are undercut the casts could not have been easily removed and the stone is not therefore a mould (see above). Grave-stones with legends in lead letters between 40 and 60 mm high let into the surface of the stone are, however, known from Saint-Martin at Tours (Deschamps 1929, P1. II, fig. 2; Vieillard-Troiekouroff 1962, 112–13, figs. 33–5; Gray 1986, fig. 69: see Mitchell 1992, 212, n. 51) and are apparently dated to the second quarter of the ninth century.

M.B.; B.K.-B.

*Inscription* The word HIC might come from a memorial inscription with a formula of the *hic requiescit* type or something similar. This, however, is only one possibility.

An interesting parallel for 'stem thickening' in incised lettering can be seen in a fragment of a probably pre-Conquest inscription found in 1904 in Shaftesbury (Okasha 1983, 98). This has subsequently been lost and can now only be judged from a rubbing. The lettering clearly was embellished with 'stem thickening'. The best explanation for such broad strokes and 'stem thickening' in an incised inscription would be that the letters were designed for an inlay. This may also have been the case with the Winchester stone, any possible material used for inlay having perhaps been subsequently destroyed; or perhaps the stone was never used for its intended purpose. If it is true that none of the tooling is secondary (see above), it is possible that the inscription was made up of several blocks with inlaid lettering fitting together, possibly as part of a floor.

If, as has been suggested, the Shaftesbury fragment once formed part of the inscription that is mentioned by William of Malmesbury (William 1870, 186), it must have dated from no earlier than the time of Alfred (and more probably later) and was old by William's time (Radford 1970, 87). The archaeological evidence suggests that the Winchester fragment was made some

time before the middle of the eleventh century (see below).

It is possible that the Winchester and Shaftesbury fragments represent an otherwise unrecorded tradition of inlaid lettering in southern England in the later pre-Conquest period. The idea might have been Carolingian in origin: the epitaph of Adelberga in Tours (*c.* 840) has lead-filled letters (Gray 1986, fig. 69). Lettering cut with similar broad, flat-bottomed strokes, perhaps also intended for some kind of inlay, can be seen in the memorial inscription to bishop Bernward of Hildesheim (993–1022) which was formerly on the exterior of the western choir of his church of St Michael (Berges and Rieckenberg 1983,

101–3, 179, taf. 18; Brandt and Eggebrecht 1993, I, pl. on 24).

J.H.

DATE A date in the eleventh century has been suggested (Okasha 1983, no. 183), but, on the evidence of the archaeological context (probably not later than the mid eleventh century, and almost certainly residual), an earlier date is possible

M.B.; B.K.-B.

REFERENCES Biddle and Kjølbye-Biddle 1972, no. 11; Biddle and Kjølbye-Biddle 1973, no. 13; Okasha 1983, no. 183; Biddle forthcoming b; Biddle and Kjølbye-Biddle forthcoming a, fig. 159, no. 109

# WINCHESTER, Ha. (Priors Barton)

## SU 478284

### 1. Part of cross-shaft

(Ills. 686–690)

PRESENT LOCATION Winchester City Museum, accession number 848

EVIDENCE FOR DISCOVERY Found in 1910 in garden of Priors Barton; Close suggests perhaps originally from St Faith's churchyard near-by (Close and Collingwood 1922)

H.   69 cm (27.2 in)
Diameter 173 cm (68 in)

STONE TYPE Pale grey (speckled dark green), fine-grained (0.2-mm quartz grains), glauconitic sandstone, with possibly cherty cement; Upper Greensand, Gault group, Lower Cretaceous; Hampshire or Wiltshire

PRESENT CONDITION Broken and worn

DESCRIPTION The shaft is of circular section and tapers towards the upper end where it is broken roughly horizontally. The underside is dressed flat. Around the lower edge is a broad, plain raised border, and the circumference is divided into four equal fields by similar vertical borders on stepped bases.

*A:* This field contains a bush scroll. The thick half-round stem develops from the lower frame. From each side of the stem emerges one of a pair of thick, out-turned subsidiary stems, each of which develops into

tight interlace filling the interstices between the main stem and the edge of the field. Above them is a pair of upward-leaning, expanding stems, each terminating in an inward-facing animal head touching the main stem, and curling round one of a pair of thick, down-turned stems developing from the main stem just above the scrolls. From the upper part of the stem develop six closely-spaced pairs of narrow, outward-curving leaves.

*B:* This field is decorated with a naturalistically-modelled stag facing left, with its hindquarters against the right-hand frame. It is heavily damaged but has a long neck, and antlers developing into disorganised interlace filling the interstices between the animal and the border.

*C:* This area is decorated with a bush- or tree-scroll, now largely destroyed. It has a vertical stem with two subsidiary stems curling back, one on each side of the main stem. Each is brought round to touch the main stem before terminating in a berry bunch, and acanthus leaves filling the space between the main stem and the border.

*D:* This field is decorated with interlace, now largely destroyed.

DISCUSSION The piece is probably a single drum from a round shaft built in sections. As with

Winchester High Street no. 1 (Ills. 679–82), the use of this form points to a date no earlier than the ninth century when the round shaft appears to have been introduced (Cramp 1978, 9). As noted in Chap. V, despite the occurrence here of acanthus ornament, the repertoire of decoration and the way that it is combined would point to a date in the ninth rather than the tenth century.

DATE Ninth century

REFERENCES Close and Collingwood 1922, 219–20, figs. following 220; Cottrill 1931, appendix; Kendrick 1938, 191–2, pl. LXXXV; Atkinson 1938–40, 369; Green and Green 1951, 46–7, pl. XIV; Stone 1955, 25; Rix 1960, 78; Cunliffe 1973, 43; Cramp 1975, 189–191; Tweddle 1983b, 22–8, 30, pl. VIIIb; Backhouse *et al.* 1984, 42; Budny and Tweddle 1984, 80–2; Tweddle 1986b, I, 95, 151–4, II, 515–16, III, fig. 19, pl. 121–2a

D.T.

# WINCHESTER, Ha. (Upper Brook Street)

## SU 483297

### 1. Fragment of cross-shaft          (Fig. 10a; Ill. 683)

PRESENT LOCATION Built into south wall of 'Southern Echo' building, outside

EVIDENCE FOR DISCOVERY Wall incorporates other fragments, principally of twelfth-century date; attached notice suggests fragments came originally from demolished near-by church of St Ruel, immediately south of 'Southern Echo' office

H.   37 cm (14.6 in)   W.   22 cm (8.7 in)
D.   Built in

STONE TYPE Pale brownish-grey, medium-grained, shelly, oolitic limestone, with some pellets up to 1 mm in length; Middle Jurassic; of uncertain provenance

PRESENT CONDITION Worn

DESCRIPTION Part of a tapering shaft of square section; only part of one broad face is exposed.

A (broad): There is a narrow plain relief border along the lower edge, the upper edge being heavily damaged. The face is decorated with a heavily-damaged pair of ribbon animals whose bodies curve in from either end and meet towards its centre. They are enmeshed in interlace. The body of the left-hand animal is partially pelleted (see Fig. 10a, p. 37).

DISCUSSION The decoration of the piece links it with the cross-shaft from Steventon, also in Hampshire (Ills. 471–2). As noted in Chap. V, these are the eastern outliers of a group of sculptures whose distribution is firmly south-western, and which was first defined by Cottrill (1935). The dating of this group presents a number of problems, but the use within it of features (such as spirals) which were dropping out of use in Anglo-Saxon art in the late eighth century, together with others (such as plant ornament) which were being introduced at that date, points to a late eighth-century *floruit* for the group. Some sculptures clearly could be earlier in date than this, and others rather later.

DATE Late eighth to ninth century

REFERENCES Cramp 1975, 191–2; Tweddle 1983b, 18–20, 29; Tweddle 1986b, I, 95, 141–6, II, 516–17, III, pl. 120b

D.T.

# APPENDIX A

# STONES DATING FROM SAXO-NORMAN OVERLAP PERIOD OR OF UNCERTAIN DATE

## HEADBOURNE WORTHY

**2. Grave-cover** (Ills. 684–5)

PRESENT LOCATION Outside south door of church, east of path

EVIDENCE FOR DISCOVERY None; perhaps discovered during extensive rebuilding in 1865–6

L.   115 cm (45.3 in)   W.   49 cm (19.3 in)
D.   13 cm (5.1 9 in)

STONE TYPE Yellowish-grey (2.5Y 7/2–3) shell-fragment limestone, in places stained brownish-yellow (10YR 7/6), and much encrusted by lichen; Quarr stone, Bembridge Formation, Palaeogene, Tertiary; Isle of Wight

PRESENT CONDITION Face and edges extensively bruised; heavily weathered

DESCRIPTION Only the upper surface is carved.

*A (top):* A slightly coped grave-cover with a squared foot; the head is broken diagonally away. The upper face is decorated with a narrow median moulding of rectangular section. Just short of the lower end separate similar mouldings develop, one running into each of the corners.

DISCUSSION The Y-shaped disposition of the decoration links this cover with some of those from Stedham, Chithurst, Cocking, and Steyning, all in Sussex, and Titsey 4 in Surrey (Ill. 255). Grave-covers from all these sites have similar decoration. They are dated archaeologically to the mid to late twelfth century, and a similar date can be suggested for this example.

Unpublished

D.T.

## STRATFIELD MORTIMER, Brk. (St Mary)

SU 668641

**1. Grave-cover, in two joining pieces**
(Ills. 695–709)

PRESENT LOCATION Fixed upright to the south wall of the chancel

EVIDENCE FOR DISCOVERY Discovered in 1866 broken in two and lying face down beneath floor of tower during demolition of old church

H.   202.5 cm (79.7 in)   W.   56 > 37 cm (22 > 14.5 in)
D.   11.5 cm (4.5 in)

STONE TYPE Medium light grey, shell-fragment limestone; (Quarr stone)

PRESENT CONDITION Complete, but chipped

DESCRIPTION The tapering grave-cover is broken into two approximately equal parts.

D.T.

*A (top): Inscription* The inscription (Ill. 695; Okasha 1971, 114–15) runs between framing lines that follow the edge of the upper surface of the stone. The text

starts at the left-hand corner of the head of the stone and continues around the whole perimeter. The feet of the letters face inwards. The interval between the framing lines varies between 5.5 and 7 cm (2.2 and 2.75 in) and the letters are between about 3.4 and 4.8 cm high. The letters were quite deeply cut into the coarse-grained stone. Though there is considerable damage to the surface, some of the grooves and parts of the framing lines preserve traces of reddish colouring. The inscription (Ills. 698–709) is in capitals and can be transcribed as follows:

(top): +VIII:[K]L̄:OCTB:
(right):
FVI[T]:POS[IT]VS:ÆG[EL]ᚹ[AR]DVS:FILIVS:
KY[ᚹ]PINGVS:INISTO[:]L[OC]O
(bottom): BEATV
(left):
S:SIT[:]OMO:QVIO[R]AT:PROANI[MA]:EIVS:
+TOKI:M[E]:S[CRIP]SI[T]:

The language is clearly Latin. Although two letters are damaged on both the left and right sides by the crack that runs across the stone, enough remains of the two most damaged letters to confirm the readings demanded by the context (the R of ÆG[EL]ᚹ[AR]DVS and the second A of ANI[MA]). Otherwise the reading is straightforward:

+ VIII : K(A)L(ENDAS) : OCT(O)B(RES) : FVIT : POSITVS : ÆGELᚹA[R]DVS : FILIVS : KYPPINGVS : IN ISTO [:] LOCO BEATVS : SIT [:] OMO : QVI ORAT : PRO ANIM[A] : EIVS : + TOKI : ME : SCRIPSIT :

(Translation: '+ On the eighth day before the Kalends of October [24 September] Ægelward son of Kypping was buried in this grave. Blessed be the man who prays for his soul. + Toki wrote me.')

The inscription is in boldly cut capitals. The strokes are of even breadth and are consistently seriffed. The letters approximate to the standard Roman forms with the following exceptions. There are three variants of A, each with a bar across the top (Ills. 700, 704, 707). In two variants (one with a straight cross-bar and the other with an angular one) the top bar cuts the diagonals before they can meet to form an angle. In the other (with an angular cross-bar) the top bar rests on the angle formed by the diagonals. C is angular on two occasions and round on one (Ills. 698, 703). A square form of G is used (Ills. 700, 702). K consists of a vertical linked to a shorter C-shaped form by a short horizontal (Ills. 698, 701, 708). M has vertical outer strokes and a shallow central 'V' (Ill. 705). Q is the

uncial form (Ill. 705). Y consists of a short diagonal on the left which meets the full-length right diagonal half-way down and has a dot in the upper angle (Ill. 702). The Old English masculine personal name ÆGELᚹARDVS is spelled with the Æ diphthong and the Old English graph *wynn* (Ill. 700–1). In the word FILIVS the second I is shortened and fitted above the leg of the L (Ill. 701).

Words are generally separated by a mid-line point. The principal exceptions are short preceding words such as prepositions which are not divided from the following word. A group of three dots similar to that used at the end of the inscription from Whitchurch, Hampshire (Ill. 486) marks the end of the top line and fills the awkward corner space. Introductory crosses mark off the two principal sections: the epitaph and the 'signature'.

The Latin shows one or two non-Classical features: *fuit positus* for perfect passive; *Kyppingus* instead of genitive *Kyppingi*; *omo* for *homo*.

J.H.

DISCUSSION *Inscription* The form of the Y was probably derived from Carolingian minuscule and does not seem to appear on surviving Anglo-Saxon inscriptions of earlier date than the Brussels cross of the early eleventh century; the form is also used on the Bayeux Tapestry (Okasha 1971, pl. 17c; Stenton 1957, pls. 19, 65; Wilson 1985, pls. 17, 64).

The principal text is an epitaph which records the date of burial, rather than that of death, and the name and patronymic of the deceased, and continues with a request for prayers for his soul. The phrase 'POSITUS . . . IN ISTO LOCO' may reflect the biblical 'venite et videte locum ubi positus erat dominus' (*Matthew* 28, 6). The elements *positus* and *in hoc loco* seem to be characteristic of the Early Christian period and appear separately quite commonly in Early Christian epitaphs and in one or two cases together (Diehl 1925–67, II, 223, 231, nos. 3503, 3527A, III, 546–7, 567). Requests for prayers for the soul of the deceased are common in medieval memorial inscriptions and are found from the Early Christian period onwards (Marucchi 1912, 137–89). 'BEATUS SIT (H)OMO QUI' echoes the biblical 'beatus vir qui' (*Psalms* 1, 1, etc.) and 'beatus homo qui' (*Job* 5, 17; *Psalms* 88, 13; 99, 12; *Proverbs* 3, 13; 28, 14), although the subjunctive *sit* is not biblical. The second text ('TOKI ME SCRIPSIT') is a 'signature' of the type common in the Anglo-Saxon period in which the object is made to speak. The verb *scripsit* may refer to the drafting of the text and/or the design of the lettering rather than to the cutting of the letters (Higgitt 1990, 151–2).

The names Ægelwardus and Kyppingus represent the Old English masculine personal names Æthelweard and Cypping; Toki is a masculine personal name of Old Norse origin (Feilitzen 1937, 102–6, 188–9, 221–2, 385–6; Okasha 1971, 115, 152–4). Campbell suggests that the spelling Ægel- for Æðel- in Old English charters and on coins, which is frequent from the late tenth century onwards, was an affectation due to a sound-change in French (Campbell 1959, 195, n. 5). Kypping may have been related to the Cheping who held Stratfield in the time of Edward the Confessor (Okasha 1971, 115).

The lettering, the presence of a Scandinavian name, and the form of the name Ægelwardus, would fit a date in the eleventh century, not necessarily before the Conquest.

J.H.

DATE Eleventh century

REFERENCES Westwood 1885–7, 224–6; Westwood 1886–93; Westwood 1890, 293–5, fig. on 294; Cameron 1901–2, 71–3; Ditchfield and Page 1906, 248–9; Page 1915, 99; Page and Ditchfield 1923, 427; Peake 1931, 168; Feilitzen 1937, 222; Pevsner 1966, 20, 229; Okasha 1971, 114–15, pl. 114; Tweddle 1986b, I, 39, 224, II, 494–5, III, pl. 105b

# WINCHESTER (Old Minster)

## 92. Grave-marker (Ills. 691–4)

PRESENT LOCATION Winchester City Museum, Historic Resources Centre, Hyde House, Winchester, accessions no. 2943 WS 410.1

EVIDENCE FOR DISCOVERY Found in archaeological excavation north of Winchester cathedral in 1966 reused in medieval cist grave (MG 287); probably derived from cemetery around west end of Old Minster; Final Phase 75 (Provisional Phase 1287), mid to late thirteenth-century

H.  56 > 52.5 cm (22 > 20.7 in)   W.   36 > 35 cm (14.2 > 13.8 in)
D.  11 > 6.5 cm (4.3 > 2.6 in)

STONE TYPE Pale grey, porous, shell-fragment limestone; Quarr stone, Bembridge Formation, Palaeogene, Tertiary; Isle of Wight

PRESENT CONDITION The carved surfaces are somewhat battered; a strip about 5 cm wide has been trimmed off the left side in reuse

DESCRIPTION A and C (broad): Both faces are carved with a cross with wedge-shaped arms and narrow curves (type B8). The centre of the cross is marked on both sides with a compass point from which five circles were set out creating an inner band, 2.5 cm wide, and two outer bands, 2.5 cm and 2 cm wide, respectively. The radius to the inner band is 4.8 cm, to the inner edge of the double band 15.5 cm; the diameter to the outer line is c. 35 cm. The arms start at the outer edge of the inner band, but are interrupted by the passage of the outer bands, and are then open to the edge of the stone.

B, D and E (narrow sides and top): Plain.

DISCUSSION The carving is assured. It is of the same family as the cross-heads from Chollerton, Northumberland, although they are of type E8 (Cramp 1984, I, 239, II, pl. 236).

DATE Mid to late eleventh century

REFERENCE Biddle and Kjølbye-Biddle forthcoming a, fig. 157, no. 102

M.B.; B.K.-B.

## 93. Fragment of grave-marker (Ills. 710–12)

PRESENT LOCATION Winchester City Museum, Historic Resources Centre, Hyde House, Winchester, accessions no. 2943 WS 429c

EVIDENCE FOR DISCOVERY Found in archaeological excavation north of Winchester cathedral in 1966 reused in medieval boundary wall; probably derived from cemetery around west end of Old Minster; Final Phase 73 (Provisional Phase 1202), early to mid thirteenth-century

H.  20 > 10 cm (7.9 > 3.9 in)   W.   13.2 > 6 cm (5.2 > 2.4 in)
D.  16.9 > 15 cm (6.7 > 5.9 in)

STONE TYPE Combe Down Oolite, Great Oolite Formation of the Bath area, Great Oolite Group, Middle Jurassic

PRESENT CONDITION Carved surface battered

DESCRIPTION This is part of the left-hand side of what was probably a round-topped grave-marker, decorated on one side only with an expanding-arm cross. Two holes have been drilled horizontally through the stone from the front to the back: the smaller, 2.6 cm in diameter, at the lower corner of the sunken field at the bottom of the cross; the larger, 3 cm in diameter, below it and a little to the left, in the lower field.

*A (broad):* The design, which can only be understood by reference to no. 94, was achieved by recessing the field between the arms to a depth of 1.8 cm, and chamfering the edges of the cross thus formed. The edges of face A (and to a lesser degree those of face C) were also chamfered, but on A they end in an elegant curved stop 5 cm above the point at which the stone breaks off. At this point the edge of the stone appears to be curving outwards. The lower part of the stone is slightly cut back behind the main plane of the face (which would be part of the cross) on a gently curved line which rises to the foot of the cross.

DISCUSSION The design and carving are accomplished. Although found near Old Minster 94, and given the same WS number (with a different letter suffix) on discovery, this piece cannot be from the same stone. For discussion and references, see no. 94.

DATE Mid to late eleventh century

REFERENCE Biddle and Kjølbye-Biddle forthcoming a, fig. 157, no. 103

M.B.; B.K.-B.

### 94a–b. Two fragments of grave-marker
(Fig. 43; Ills. 713–16)

PRESENT LOCATION Winchester City Museum, Historic Resources Centre, Hyde House, Winchester, accessions nos.: a, 2943 WS 429a; b, 2943 WS 429b

EVIDENCE FOR DISCOVERY Found in archaeological excavation north of Winchester cathedral in 1966 reused in medieval boundary wall; probably derived from cemetery around west end of Old Minster; Final Phase 73 (Provisional Phase 1202), early to mid thirteenth-century

a: H.   32.4 > 12.5 cm (12.8 > 4.9 in)   W.   20.2 > 4
    cm (8 > 1.6 in)
    D.   16.4 > 3.8 cm (6.5 > 1.5 in)
b: H.   19 > 18 cm (7.5 > 7.1 in)   W.   21 > 11 cm
    (8.3 > 4.3 in)
    D.   10.5 > 8 cm (4.1 > 3.1 in)

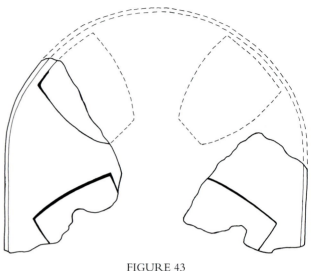

FIGURE 43
Winchester Old Minster 94a–bA, reconstruction, nts

STONE TYPE Pale yellowish-grey, medium-grained, shelly, oolitic limestone, with calcite veinlets; Combe Down Oolite, Great Oolite Formation of the Bath area, Great Oolite Group, Middle Jurassic

PRESENT CONDITION The carved surface is battered

DESCRIPTION Only one face is carved. A hole, 3 cm in diameter, in the lower sunken field passes horizontally through fragment a, and another hole, c. 3.5 cm in diameter, likewise passes through fragment b.

*A (broad):* Fragment a is part of the left side of a round-topped grave-marker and fragment b part of its right side. The face is decorated with an expanding armed cross achieved by cutting away the space between the arms to a depth of 1.2 cm and chamfering the edges thus formed. The front and back edges of the stone are finished with a similar chamfer. The cross-arms end before the edge of the stone.

DISCUSSION The design and carving are accomplished. Fragments a and b are almost certainly part of the same stone; no. 93, even though very similar and found near-by (and given on discovery the same WS number with a letter suffix), cannot be from the same stone. This is not quite a plate-type cross-head, because the cross-arms do not reach to the edges. They are nearest to type E8, but the sides of the arms are elegantly curved, the angles between them are wider, and the junction between the arms has evidently been extended into a lozenge. In heraldic terms this is a cross formy quadrate couped (i.e. cut off

before the edge of the shield) and is a sophisticated and elegant design. Comparison with no. 93, where a lower part of a very similar design is preserved, suggests the possibility that the cross on the present stone originally stood on a rising feature (a hill?) indicated by the upwards curving edge of the slightly recessed area of the lower face. Since, however, this lower rising field is recessed rather than proud, it may have been cut to receive the end of a grave-cover of corresponding section, much in the way that Old Minster no. 2 was recessed to take the foot of no. 6 (Ill 498). If this is so, the cross of the present piece would have appeared (when the cover and foot-stone were correctly positioned) to stand on the 'hill' represented by the ridge of the grave-cover.

A much less successful attempt at a similar effect can be seen in a grave-marker from Whithorn, Wigtownshire (Bailey and Cramp 1988, ills. 688–91), or (with a rounder head) on the crosses from Chollerton, Northumberland. These have a narrow shaft and are dated by Cramp to the Saxo-Norman overlap period, perhaps to the later eleventh century (Cramp 1984, I, 239, II, pl. 236). A similar date for the present fragments is quite likely. The cemetery west of Old Minster, whence these stones are most likely to have come, continued in use until Old Minster was demolished in 1093–4. It was in this area that chalk cist graves were found, the only ones belonging to the Old Minster cemetery, but the type was to become common in the medieval Paradise cemetery.

DATE Mid to late eleventh century

REFERENCE Biddle and Kjølbye-Biddle forthcoming a, fig. 157, no. 104

M.B.; B.K.-B.

## 95. Cross-head and fragment of shaft

(Ills. 717–18)

PRESENT LOCATION Winchester City Museum, Historic Resources Centre, Hyde House, Winchester, accessions no. 2943 WS 101

EVIDENCE FOR DISCOVERY Found in archaeological excavation north of Winchester cathedral in 1965 reused in Norman bell-foundry; probably derived from cemetery around east end of Old Minster; Final Phase 65 (Provisional Phase 679), early twelfth-century

H.   (overall) 30.8 > 24 cm (12.1 > 9.4 in)
W.   (head) 27.5 cm (10.8 in) (shaft) 10.6 > 2 cm (4.2 > 0.8 in)
D.   14 > 2 cm (5.5 > 0.8 in)

STONE TYPE Pale yellowish-grey, medium-grained, shelly, oolitic limestone; Combe Down Oolite, Great Oolite Formation of the Bath area, Great Oolite Group, Middle Jurassic

PRESENT CONDITION The carved surfaces are battered and the upper perimeter extensively restored; the underside of the shaft (face F) appears to be an original bed face

DESCRIPTION The circular head is carved only on the broad faces; the arms, type E8, are separated by rather irregular oval perforations. The front and back can be distinguished. The surviving part of the shaft is only 3 cm long and has a lozenge shape, with the narrowest face and longer sides forward.

*A (broad):* At the centre of the front there is a flower composed of eight circular bosses around a central boss and the arms on this face are deeply chamfered.

*C (broad):* The back has a damaged, apparently once similar, central element but the facetting of the arms is less marked.

DISCUSSION The head type is a mixture of E8 and E12. For similar heads, see Heddon-on-the-Wall, Northumberland (Cramp 1984, I, 241–2, II, pl. 237 (1341–3)).

DATE Mid to late eleventh century

REFERENCE Biddle and Kjølbye-Biddle forthcoming a, fig. 157, no. 106

M.B.; B.K.-B.

## 96. Small column in two joining pieces

(Fig. 40; Ills. 719–722)

PRESENT LOCATION Winchester City Museum, Historic Resources Centre, Hyde House, Winchester, accessions no. 2943 WS 96

EVIDENCE FOR DISCOVERY Found in archaeological excavation north of Winchester cathedral in 1965, in rubble fill of Anglo-Saxon well (F. 154); Final Phase 65 (Provisional Phase 734), early twelfth-century

H.   33 > 8 cm (13 > 3.1 in)   W.   12 > 7.5 cm (4.7 > 3 in)
D.   12 > 7.5 cm (4.7 > 3 in)

STONE TYPE Pale yellowish-grey, very porous, shell-fragment limestone; Quarr stone, Bembridge Formation, Palaeogene, Tertiary; Isle of Wight

PRESENT CONDITION Broken; corners somewhat battered, but carved surfaces crisp. There is whitewash on one face of the base

DESCRIPTION The column is slightly flattened in section (diameter, 7.8–8 cm). Base and capital are rectangular and precisely tooled to a smooth surface. There is vertical tooling on the column, but diagonal and horizontal tooling on the capital and base. The faces of the capital are concave and decorated with two raised bands of semicircular section, giving the impression of four horizontal bands of reeding. Its underside (Ill. 722) has a raised triangle pointing outwards to each corner. The base is plain apart from a shallow semicircular incision on one of the narrower sides. On one of the wider sides of the base the central area shows the faint outline of a tall round-topped outline, the interior of which is filled with whitewash.

DISCUSSION This could be a Saxo-Norman piece, for the tooling is more diagonal and detailed than on the other Anglo-Saxon worked stones.

DATE Mid to late eleventh century?

REFERENCE Biddle and Kjølbye-Biddle forthcoming a, fig. 141, no. 3

M.B.; B.K.-B.

# APPENDIX B
## STONES WRONGLY ASSOCIATED WITH PRE-CONQUEST PERIOD

NEW ALRESFORD, Ha. (St John the Baptist, SU 588326)

### 1. Romanesque crucifixion

REFERENCE Green and Green 1951, 40–1, pl. XII; Taylor and Taylor 1966, 15; Coatsworth 1988, 193

### 2. Romanesque crucifixion

REFERENCE Green and Green 1951, 40–1, pl. XII

WINCHESTER, Ha. (Hyde Abbey, SU 482301)

### 1. Purported inscription

Mention should also be made of an inscription bearing the date 881 (Milner 1798–9, I, pl. facing 449; Cottrill 1947, 8, pl. on back cover; Okasha 1971, 149). The inscription is on a stone in the Winchester City Museum and is set in a panel with a heavily moulded frame; it reads: 'ÆLFRED REX DCCCLXXXI:'. It is said to have been found in the ruins of Hyde abbey more then forty years before 1798–9 (Milner 1798–9, II, 228). It is unusual for year dates in medieval inscriptions to appear without some kind of introductory *anno* formula. (The date intended was probably that of Alfred's accession in 871.) The first two words are in a form of Anglo-Saxon minuscule, a script not otherwise known in Anglo-Saxon inscriptions on stone. The alleged find-spot as well as various features of the lettering (see below) indicate that this is a pastiche rather than an inscription of the ninth century. Milner thought that the inscription was probably carved following the move of the New Minster community to the new site of Hyde abbey in the early twelfth century. The lettering, with its contrast of thick and thin and its use of fine hair-lines looks like an attempt to reproduce a book-script. The model would have been an Anglo-Saxon square minuscule or perhaps a twelfth-century minuscule used for Old English like that in Oxford, Bodleian Library MS Hatton 38 (Ker 1957, pl. VII). The sunken panel, the centred layout, and aspects of the lettering, such as the proportion of the letters and the unseriffed straight tops to I and L, make it probable that the inscription is a product of post-medieval (probably eighteenth-century) rather than twelfth-century antiquarianism.

J.H.

341

# ALL SITES BY COUNTY

(boundaries prior to 1974)

# FORM AND MOTIF TABLE

EXPLANATORY NOTE

Since crosses can occur in many different iconographic contexts in these monuments, the cross-head type has only been specified under 'MONUMENT TYPE' where it is the sole or predominant motif. This is most often the case with respect to grave-markers. The item G.I. in the Key refers to the General Introduction in Volumes I and II, which is now off-printed as *Grammar of Anglo-Saxon Ornament* (Cramp 1991).

|  |  | KEY |
| --- | --- | --- |
| MONUMENT TYPE | CROSS-SHAFT | ■ = Angular; R = Round |
|  | CROSS-HEAD | Arm types after G.I., fig. 2; D = Disk; P = Plate; R = Ring or infill, after G.I., fig. 3; X = Type unknown |
|  | CROSS-BASE | Cross types after G.I., fig. 2; X = presence |
|  | GRAVE-MARKER OR -COVER/ TOMB OR MEMORIAL | Cross types after G.I., fig. 2; X = without crosses; H = Hogback |
|  | ARCHITECTURAL FEATURE | Cross types after G.I., fig. 2; Ba = Baluster; Bs = Base; Ca = Capital; Co = Column; F = Frieze; Im = Impost; P = Panel; St = String-course; Su = Sundial; O = Other; X = presence |
|  | FURNITURE | X = presence |
|  | FRAGMENT | X = presence |
|  | INSCRIPTION | R = Runic; NR = Non-runic; RNR = Runic and non-runic; I = Illegible |
|  | ARRANGEMENT OF ORNAMENT | C = Continuous; P = In panels; Blank = Insufficient data |
| DECORATIVE ELEMENT | INTERLACE | C = Closed-circuit motif; G = Geometric; P = Plain plait; O = Other; X = presence |
|  | CABLE/CHAIN/TWIST/LINKED OR LOOPED PATTERNS | Ca = Cable; Ch = Chain; L = Linked or looped pattern; T = Twist; X = presence |
|  | CURVILINEAR ORNAMENT | C = Circle; S = Scroll; O = Other; X = presence |
|  | BOSSES AND PELLETS | B = Boss; P = Pellet |
|  | KEY/FRET PATTERN | X = presence |
|  | STRAIGHT LINE PATTERN | X = presence |
|  | BALUSTER ORNAMENT | X = presence |
|  | PLANT MOTIF | F = Floral; O = Other; X = presence |
|  | PLANT-SCROLL | X = presence |
|  | INHABITED SCROLL | B = Biped; Bi = Bird; H = Human figure; P = Profile; Q = Quadruped |
|  | ANIMAL | B = Biped; Bi = Bird; C = Centaur; E = End beast; F = Fish; P = Profile; Q = Quadruped; R = Ribbon; S = Snake; O = Other |
|  | CHRIST-FIGURE/ CRUCIFIXION | C = Christ-figure; X = Crucifixion |
|  | SAINT | A = Apostle; An = Angel; E = Evangelist; F = Female saint; M = Virgin Mary; O = Other |
|  | EVANGELIST'S SYMBOL | X = presence |
|  | BIBLICAL SCENE | X = presence |
|  | MYTHOLOGICAL OR SECULAR SCENE | X = presence |
|  | HUMAN FIGURE | E = Ecclesiastic; F = Female; H = Horseman; W = Warrior; O = Other; X = presence |

| | Abingdon 1 | Arundel 1 | Barking 1 | Barking 2 | Bedford 1 | Betchworth 1 | Bexhill 1 | Bishopstone 1 | Bishops Waltham 1 | Boarhunt 1 | Bosham 1 | Botolphs 1 | Breamore 1 | Breamore 2 | Breamore 3 | Breamore 4 | Canterbury St Augustine 1 | Canterbury St Augustine 2 | Canterbury St Augustine 3 | Canterbury St Augustine 4 |
|---|---|---|---|---|---|---|---|---|---|---|---|---|---|---|---|---|---|---|---|---|
| **MONUMENT TYPE** | | | | | | | | | | | | | | | | | | | | |
| CROSS-SHAFT | | | ■ | | ■ | | | | ■ | | | | | | | | ■ R | | | |
| CROSS-HEAD | | | | | | | | | | | | | | | | | | | | |
| CROSS-BASE | | | | | | | | | | | | | | | | | | | | |
| GRAVE-MARKER OR –COVER/ TOMB OR MEMORIAL | | B6 | | | | | E12 | | | | | | | | | | | X | | |
| ARCHITECTURAL FEATURE | X | | | Im | Ca | | | Su | | O | Ca | Ca | X | ImO | O | O | | | Ca | Ca |
| FURNITURE | | | | | | | | | | | | | | | | | | | | |
| FRAGMENT | X | | | | | | | | | | | | | | X | X | | | | |
| INSCRIPTION | | | | | | | | NR | | | | | | NR | NR | NR | NR | | | |
| ARRANGEMENT OF ORNAMENT | | P | P | | | | P | . | P | | | | | | | | P | | | |
| **DECORATIVE ELEMENT** | | | | | | | | | | | | | | | | | | | | |
| INTERLACE | C | | G | | G | | CO P | | G | | | | | | | | X | | | |
| CABLE/CHAIN/TWIST/LINKED OR LOOPED PATTERNS | | | | | | | Ca | Ca | | | | | | Ca | | | | | | |
| CURVILINEAR ORNAMENT | | | | | | | | | | | X | | | | | | | | S | S |
| BOSSES AND PELLETS | | | | | | | | | | | | | | | | | | | | |
| KEY/FRET PATTERN | | | | | | | X | X | | | | | | | | | | | | |
| STRAIGHT LINE PATTERN | | | | | | X | X | | | | | X | | | | | X | | | |
| BALUSTER ORNAMENT | | | | X | | | | | | | | | | | | | | | | |
| PLANT MOTIF | | | | | | | X | | | | X | X | | | | | | | X | X |
| PLANT-SCROLL | | | | | | | X | | | | | | | | | | | | | |
| INHABITED SCROLL | | | | | | | | | | | | | | | | | | | | |
| ANIMAL | | | | | | BR | R | | PR | | | | | | | | | BiQ | | |
| CHRIST-FIGURE/ CRUCIFIXION | | | | | | | | | | | | | X | | | | | | | |
| SAINT | | | | | | | | | | | | | EM | | | | | | | |
| EVANGELIST'S SYMBOL | | | | | | | | | | | | | | | | | | | | |
| BIBLICAL SCENE | | | | | | | | | | | | | | | | . | | | | |
| MYTHOLOGICAL OR SECULAR SCENE | | | | | | | | | | | | | | | | | | | | |
| HUMAN FIGURE | | | | | | | | | | | | | | | | | | | | |

| | SITE AND NO. | Canterbury St Augustine 5 | " 6 | " 7 | " 8 | " 9 | " 10 | " 11 | Canterbury St Martin 1 | Canterbury St Pancras 1 | Canterbury Old Dover Road 1 | Cardington 1 | Chithurst 1 | " 2 | " 3 | " 4 | " 5 | " 6 | " 7 | " 8 | Cocking 1 |
|---|---|---|---|---|---|---|---|---|---|---|---|---|---|---|---|---|---|---|---|---|---|
| MONUMENT TYPE | CROSS-SHAFT | | | | | | | | | | R | | | | | | | | | | |
| | CROSS-HEAD | | | | | | | | | | | | | | | | | | | | |
| | CROSS-BASE | | | | | | | | | | | | | | | | | | | | |
| | GRAVE-MARKER OR -COVER/ TOMB OR MEMORIAL | | | | | | | | | | | A1/B6 | A1 | A1 | A1 | A1 | A1 | A1 | A1 | A1 | X |
| | ARCHITECTURAL FEATURE | Ca | Ba | Ba | Ba | | | | | Co Bs | | | | | | | | | | | |
| | FURNITURE | | | | | | | | | | | | | | | | | | | | |
| | FRAGMENT | | | | | X | | X | X | | | | | | | | | | | | |
| | INSCRIPTION | | | | | | | R | NR | | | | | | | | | | | | |
| DECORATIVE ELEMENT | ARRANGEMENT OF ORNAMENT | | | | | P | | | | | | P | P | | | | | | | | |
| | INTERLACE | | | | | G | | | | | | | P | | | | | | | | |
| | CABLE/CHAIN/TWIST/LINKED OR LOOPED PATTERNS | | | | | | | | | | | T | | | | | | | | | |
| | CURVILINEAR ORNAMENT | S | | | | X | | | | | | | | | | | | | | | |
| | BOSSES AND PELLETS | | | | | X | | | | | | | | | | | | | | | |
| | KEY/FRET PATTERN | | | | | | | | | | | | | | | | | | | | |
| | STRAIGHT LINE PATTERN | | X | X | X | | | | | X | | | | | | | | | | | X |
| | BALUSTER ORNAMENT | | | | | | | | | | | | | | | | | | | | |
| | PLANT MOTIF | X | | | | X | | | | | X | | | | | | | | | | |
| | PLANT-SCROLL | | | | | | | | | | | | | | | | | | | | |
| | INHABITED SCROLL | | | | | | | | | | | | | | | | | | | | |
| | ANIMAL | | | | | | | | | | | | | | | | | | | | |
| | CHRIST-FIGURE/ CRUCIFIXION | | | | | | | | | | | | | | | | | | | | |
| | SAINT | | | | | | | | | | AO | | | | | | | | | | |
| | EVANGELIST'S SYMBOL | | | | | | | | | | | | | | | | | | | | |
| | BIBLICAL SCENE | | | | | | | | | | | | | | | | | | | | |
| | MYTHOLOGICAL OR SECULAR SCENE | | | | | | | | | | | | | | | | | | | | |
| | HUMAN FIGURE | | | | | | | | | | | | | | | | | | | | |

| | | Corhampton | " | " | " | Dartford | Dover St Mary In Castro | " | " | " | Dover St Peter | Elstow | Ford | Godalming | " | Great Canfield | Great Maplestead | Hadstock | " | Hannington | Headbourne Worthy |
|---|---|---|---|---|---|---|---|---|---|---|---|---|---|---|---|---|---|---|---|---|---|
| SITE AND NO. | | 1 | 2 | 3 | 4 | 1 | 1 | 2 | 3 | 4 | 1 | 1 | 1 | 1 | 2 | 1 | 1 | 1 | 2 | 1 | 1 |
| **MONUMENT TYPE** | CROSS-SHAFT | | | | | | | | | | | ■ | | | | | | | | | |
| | CROSS-HEAD | | | | | | | | | | | | | | | | | | | | |
| | CROSS-BASE | | | | | | | | | | | | | | | | | | | | |
| | GRAVE-MARKER OR -COVER/ TOMB OR MEMORIAL | | | | | | X | | | A1 | B10 E9 | | | | | X | X | | | | |
| | ARCHITECTURAL FEATURE | Su | Bs | Bs | Im Bs | Im | | Ba | Ba | FP | | | | | | | | Im CaO | Im Ca | Su | X |
| | FURNITURE | | | | | | | | | | | | | X | | | | | | | |
| | FRAGMENT | | | | | | | | | | | | X | | X | | | X | | | |
| | INSCRIPTION | | | | | | | | | | R | | | | | | | | | | |
| **DECORATIVE ELEMENT** | ARRANGEMENT OF ORNAMENT | | | | | | | | | | P | P | | | | | P | | | | |
| | INTERLACE | | | | | | | | | C | | G | CG | C | | | P | | | | |
| | CABLE/CHAIN/TWIST/LINKED OR LOOPED PATTERNS | | | | | CA | | | | | | | | L | | | | | | | |
| | CURVILINEAR ORNAMENT | | S | | | | | | | S | | | | | | | | | | | |
| | BOSSES AND PELLETS | | | | | | | | | | | | | | | | | | | | |
| | KEY/FRET PATTERN | | | | | | | | | | | | | | X | | | | | | |
| | STRAIGHT LINE PATTERN | | | | | | X | X | X | | | | | | | | | | | | |
| | BALUSTER ORNAMENT | | | | | | | | | | | | | | | | | | | | |
| | PLANT MOTIF | O | | | | | X | | | X | | | | | | X | | X | X | | |
| | PLANT-SCROLL | | | | | | | | | | | | | | | | | | | | |
| | INHABITED SCROLL | | | | | | | | | | | | | | | | | | | | |
| | ANIMAL | | | | | | | | | | | BR | | RO | | | | | | | |
| | CHRIST-FIGURE/ CRUCIFIXION | | | | | | | | | | | | | | | | | | | | X |
| | SAINT | | | | | | | | | | | | | | | | | | | | EM |
| | EVANGELIST'S SYMBOL | | | | | | | | | | | | | | | | | | | | |
| | BIBLICAL SCENE | | | | | | | | | | | | | | | | | | | | |
| | MYTHOLOGICAL OR SECULAR SCENE | | | | | | | | | | | | | | | | | | | | |
| | HUMAN FIGURE | | | | | | | | | | | | | | | | | | | | |

| SITE AND NO. | Headbourne Worthy 2 | Jevington 1 | " 2 | Kingston upon Thames 1 | Langford 1 | " 2 | " 3 | " 4 | Lavendon 1 | " 2 | Lewknor 1 | " 2 | Little Somborne 1 | Little Munden 1 | London All Hallows 1 | " 2 | " 3 | London St Benet Fink 1 | London St John Walbrook 1 | London St Paul's 1 |
|---|---|---|---|---|---|---|---|---|---|---|---|---|---|---|---|---|---|---|---|---|
| **MONUMENT TYPE** | | | | | | | | | | | | | | | | | | | | |
| CROSS-SHAFT | | | | ■ | | | | | | | | | | | ■ | | | | | |
| CROSS-HEAD | | | | | | | | | | | | | | | | R E8 | | | P E1 | |
| CROSS-BASE | | | | | | | | | | | | | | | | | | | | |
| GRAVE-MARKER OR -COVER/ TOMB OR MEMORIAL | X | | | | | | | | | | | | | | | | R 9/10 | X | A1 B2 | X |
| ARCHITECTURAL FEATURE | | P | Ba | | X | X | Su | Ca | | | | | | Im | | | | | | |
| FURNITURE | | | | | | | | | | | | | | | | | | | | |
| FRAGMENT | | | | X | | | | | X | X | X | X | X | | | | | | | |
| INSCRIPTION | | | | | | | | | | | | | | | NR | NR | | | | R |
| ARRANGEMENT OF ORNAMENT | | | | | | | | | | | | | | | P | | | | P | P |
| **DECORATIVE ELEMENT** | | | | | | | | | | | | | | | | | | | | |
| INTERLACE | | | | G | | | | | C | C | G | G | X | | GP | | | X | P | |
| CABLE/CHAIN/TWIST/LINKED OR LOOPED PATTERNS | | | | | | | | | | | | | | Ca | Ca | | | L | | L |
| CURVILINEAR ORNAMENT | | | | | | | | | | | | | | | | | | | | |
| BOSSES AND PELLETS | | | | | | | | | | | | | | | P | | | | P | |
| KEY/FRET PATTERN | | | | | | | | | | | | | | | | | | | | |
| STRAIGHT LINE PATTERN | X | | | | | | | | | | | | | | | | | | X | |
| BALUSTER ORNAMENT | | | | | | | | | | | | | | | | | | | | |
| PLANT MOTIF | | | | | | | | X | | | | | | | X | | | X | | X |
| PLANT-SCROLL | | | | | | | | | | | | | | | | | | | | |
| INHABITED SCROLL | | | | | | | | | | | | | | | | | | | | |
| ANIMAL | | Q PR | | | | | | | | | | | R | | Q | | | R | | P |
| CHRIST-FIGURE/ CRUCIFIXION | | C | | | X | X | | | | | | | | | C | | | | | |
| SAINT | | | | | EF | | | | | | | | | | | | | | | |
| EVANGELIST'S SYMBOL | | | | | | | | | | | | | | | | | | | | |
| BIBLICAL SCENE | | | | | | | | | | | | | | | | | | | | |
| MYTHOLOGICAL OR SECULAR SCENE | | | | | | | | | | | | | | | | | | | | |
| HUMAN FIGURE | | | | | | | X | | | | | | | | X | | | | | |

| MONUMENT TYPE / DECORATIVE ELEMENT | London City (1) | London Stepney (1) | London Westminster Abbey (1) | Marsh Baldon (1) | Milton Bryan (1) | North Leigh (1) | Orpington (1) | Oxford Cathedral (1) | Oxford New Schools (1) | Oxford St Aldate's (1) | Oxford St Michael (1) | Oxford St Michael (2) | Oxted (1) | Oxted (2) | Pagham (1) | Preston by Faversham (1) | Reculver (1) | Reculver (2) | Reculver (3) | Reculver (4) |
|---|---|---|---|---|---|---|---|---|---|---|---|---|---|---|---|---|---|---|---|---|
| CROSS-SHAFT | | | | | | | | | | | | | | | | ■ | R | | | |
| CROSS-HEAD | | | | | | | | | | | | | | | R E11 | | | | A9/10 | |
| CROSS-BASE | | | | | | | | | | | | | | | | | | | | |
| GRAVE-MARKER OR -COVER/ TOMB OR MEMORIAL | G2 | | B6 | | A1 | | | | X | X | | | A1 | A1 | | | | | | |
| ARCHITECTURAL FEATURE | | P | | Su | | Ba | Su | | | | Ba | P | | | | | | | | Bs Ca Co |
| FURNITURE | | | | | | | | | | | | | | | | | | | | |
| FRAGMENT | | | | | | | | | | X | | | | | | | | X | X | |
| INSCRIPTION | | | | | | | NR R | | | | | | | | | | | | | |
| ARRANGEMENT OF ORNAMENT | | P | | | P | | | | P | | | | | | | P | | | | |
| INTERLACE | | | | | P | | | | | | | | | | X | O | G | | | |
| CABLE/CHAIN/TWIST/LINKED OR LOOPED PATTERNS | L | | Ca | | | | Ca | | | | | | | | | | | | | Ca |
| CURVILINEAR ORNAMENT | | | | | | | | X | X | | | | | | | | | | | |
| BOSSES AND PELLETS | | | | | | | | | | | | | | | | | | | | |
| KEY/FRET PATTERN | | | | | | | | | | | | | | | | | | | | X |
| STRAIGHT LINE PATTERN | | | | | X | | | | | | X | | | | | | | | | X |
| BALUSTER ORNAMENT | | | | | | | | | | | | | | | | | | | | |
| PLANT MOTIF | | | | | | | | | | | | | | | | | X | | | |
| PLANT-SCROLL | X | X | X | | | | | | X | | | | | | | | | X | | |
| INHABITED SCROLL | | | | | | | | | | | | | | | | | H | | | |
| ANIMAL | | | | | | | | | Bi | | | | | | | | | | | |
| CHRIST-FIGURE/ CRUCIFIXION | | X | | | | | | | | | | | | | | | C | | | |
| SAINT | | EM | | | | | | | | | | | | | | | AAn EMO | | | |
| EVANGELIST'S SYMBOL | | | | | | | | | | | | | | | | | | | | |
| BIBLICAL SCENE | | | | | | | | | | | | | | | | | X | | | |
| MYTHOLOGICAL OR SECULAR SCENE | | | | | | | | | | | | | | | | | | | | |
| HUMAN FIGURE | | | | | | | | X | | | | F | | | | | X | | | |

| SITE AND NO. | Reigate 1 | Rochester 1 | Rochester 2 | Rochester 3 | Rochester 4 | Romsey 1 | Romsey 2 | Saffron Walden 1 | Saffron Walden 2 | St Albans 1 | Sandwich 1 | Sandwich 2 | Selsey 1 | Selsey 2 | Selsey 3 | Selsey 4 | Sompting 1 | Sompting 2 | Sompting 3 | Sompting 4 |
|---|---|---|---|---|---|---|---|---|---|---|---|---|---|---|---|---|---|---|---|---|
| **MONUMENT TYPE** | | | | | | | | | | | | | | | | | | | | |
| CROSS-SHAFT | ■ | ■ | | | | | | ■ | ■ | | | | | | | | | | | |
| CROSS-HEAD | | | | | | | | | | | | | | | | | | | | |
| CROSS-BASE | | | | | | | | | | | | | | | | | | | | |
| GRAVE-MARKER OR -COVER/ TOMB OR MEMORIAL | | | X | X | | | | | | | X | X | | | | | | | | |
| ARCHITECTURAL FEATURE | | | | | X | X | P | | | Ba | | | | | | | St | St | St | St |
| FURNITURE | | | | | | | | | | | | | | | | | | | | |
| FRAGMENT | X | X | | | | | | | | | | | X | X | X | X | | | | |
| INSCRIPTION | | | R | NR | | | | | | | R | | | | | | | | | |
| ARRANGEMENT OF ORNAMENT | | | | P | | | | | | | | P | | | | | | | | |
| **DECORATIVE ELEMENT** | | | | | | | | | | | | | | | | | | | | |
| INTERLACE | P | | G | X | | | | | | | | | C | X | X | P | | | | |
| CABLE/CHAIN/TWIST/LINKED OR LOOPED PATTERNS | | | | | | | | | | | | | | | | | | | | |
| CURVILINEAR ORNAMENT | | | X | | | | | X | X | | | | | | | | | | | |
| BOSSES AND PELLETS | | | | | | | | | | | | | | | | | | | | |
| KEY/FRET PATTERN | | | | | | | | | | | | | | | | | | | | |
| STRAIGHT LINE PATTERN | | X | X | | | | | | | X | X | X | | | | | | | | |
| BALUSTER ORNAMENT | | | | | | | | | | | | | | | | | | | | |
| PLANT MOTIF | | | X | X | | | | | | | | | | X | | | X | X | X | X |
| PLANT-SCROLL | | | | | | | X | | | | | | | | | | | | | |
| INHABITED SCROLL | | | | | | | | | | | | | | | | | | | | |
| ANIMAL | | | | | X | | | | | | | | | | | | | | | |
| CHRIST-FIGURE/ CRUCIFIXION | | | | | | X | X | | | | | | | | | | | | | |
| SAINT | | | | | | O | An EM | | | | | | | | | | | | | |
| EVANGELIST'S SYMBOL | | | | | | | | | | | | | | | | | | | | |
| BIBLICAL SCENE | | | | | | | | | | | | | | | | | | | | |
| MYTHOLOGICAL OR SECULAR SCENE | | | | | | | | | | | | | | | | | | | | |
| HUMAN FIGURE | | | | | | | | | | | | | | | | | | | | |

| SITE AND NO. | 5 | 6 | 7 | 8 | 9 | 10 | 11 | 12 | 13 | 14 | 15 | 16 | 17 | 18 | 19 | 20 | 21 | 22 | 23 | 1 |
|---|---|---|---|---|---|---|---|---|---|---|---|---|---|---|---|---|---|---|---|---|
| | Sompting | " | " | " | " | " | " | " | " | " | " | " | " | " | " | " | " | " | " | Soming |
| **MONUMENT TYPE** | | | | | | | | | | | | | | | | | | | | |
| CROSS-SHAFT | | | | | | | | | | | | | | | | | | | | |
| CROSS-HEAD | | | | | | | | | | | | | | | | | | | | |
| CROSS-BASE | | | | | | | | | | | | | | | | | | | | |
| GRAVE-MARKER OR -COVER/ TOMB OR MEMORIAL | | | | | | | | | | | | | | | | | | | | |
| ARCHITECTURAL FEATURE | St | St | St | St | F | F | F | X | P | Ca Im | St | Ca | Ca | Ca Im | Ca Im | Ca | Ca | Bs | Ca | P E6 |
| FURNITURE | | | | | | | | | | | | | | | | | | | | |
| FRAGMENT | | | | | | | | | | | | | | | | | | | | F |
| INSCRIPTION | | | | | | | | | | | | | | | | | | | | |
| ARRANGEMENT OF ORNAMENT | | | | | | | | | P | | | | | | | | | | | |
| **DECORATIVE ELEMENT** | | | | | | | | | | | | | | | | | | | | |
| INTERLACE | | | | | | | | X | | | | | | | | | | | G | C |
| CABLE/CHAIN/TWIST/LINKED OR LOOPED PATTERNS | | | | | LT | L | L | | | | | | | | | | | | | |
| CURVILINEAR ORNAMENT | | | | | | | | | | | | | | | | | | X | | |
| BOSSES AND PELLETS | | | | | | | | | | | | | | | | | | | | |
| KEY/FRET PATTERN | | | | | | | | | | | | | | | | | | | | |
| STRAIGHT LINE PATTERN | | | | | | | | | | | X | | | | | | | | | |
| BALUSTER ORNAMENT | | | | | | | | | | | | | | | | | | | | |
| PLANT MOTIF | X | X | X | X | X | X | X | X | X | X | | X | | X | | X | X | | | |
| PLANT-SCROLL | | | | | X | | | | | X | | | X | | X | | | | | |
| INHABITED SCROLL | | | | | | | | | | | | | | | | | | | | |
| ANIMAL | | | | | | | S | | | | | | | | | | | | | |
| CHRIST-FIGURE/ CRUCIFIXION | | | | | | | | | | | | | | | | | | | | |
| SAINT | | | | | | | | | | | | | | | | | | | | |
| EVANGELIST'S SYMBOL | | | | | | | | | | | | | | | | | | | | |
| BIBLICAL SCENE | | | | | | | | | | | | | | | | | | | | |
| MYTHOLOGICAL OR SECULAR SCENE | | | | | | | | | | | | | | | | | | | | |
| HUMAN FIGURE | | | | | | | | | E | | | | | | | | | | O | |

| | | Southampton 1 | South Hayling 1 | South Leigh 1 | Stanbridge 1 | Stedham 1 | " 2 | " 3 | " 4 | " 5 | " 6 | " 7 | " 8 | " 9 | " 10 | " 11 | Steventon 1 | Steyning 1 | " 2 | Stoke D'Abernon 1 | Stratfield Mortimer 1 |
|---|---|---|---|---|---|---|---|---|---|---|---|---|---|---|---|---|---|---|---|---|---|
| **MONUMENT TYPE** | CROSS-SHAFT | ■ | | | ■ | | | | | | | | | | | | ■ | | | | |
| | CROSS-HEAD | | | R B6 | | | | | | | | | | | | | | | | | |
| | CROSS-BASE | | X | | | | | | | | | | | | | | | | | | |
| | GRAVE-MARKER OR -COVER/ TOMB OR MEMORIAL | | | | A1 | X | G1 | A1 B6 | X | A1 B6 | X | B6 | B6 | B6 | B6 | B6 | | B1 | X | | X |
| | ARCHITECTURAL FEATURE | | | | | | | | | | | | | | | | | | | Su | |
| | FURNITURE | | | | | | | | | | | | | | | | | | | | |
| | FRAGMENT | F | | | | | | | | | | | | | | | | | | | |
| | INSCRIPTION | | | | | | | | | | | | | | | | | | | | NR |
| | ARRANGEMENT OF ORNAMENT | P | | | | | | | | | | | | | | | P | | | | |
| **DECORATIVE ELEMENT** | INTERLACE | | PO | | | | | | | | | | | | | | O | | | | |
| | CABLE/CHAIN/TWIST/LINKED OR LOOPED PATTERNS | | | | | | | | | | | | | | | | | | | | |
| | CURVILINEAR ORNAMENT | | | | | | | | | | | | | | | | | | | | |
| | BOSSES AND PELLETS | | P | | | | | | | | | | | | | | | | | | |
| | KEY/FRET PATTERN | | | | | | | | | | | | | | | | | | | | |
| | STRAIGHT LINE PATTERN | | | | | X | | | X | | X | | | | | | | X | X | | |
| | BALUSTER ORNAMENT | | | | | | | | | | | | | | | | | | | | |
| | PLANT MOTIF | X | | | | | | | | | | | | | | | | | | | |
| | PLANT-SCROLL | | P | | | | | | | | | | | | | | | | | | |
| | INHABITED SCROLL | Bi Q | | | | | | | | | | | | | | | PR | | | | |
| | ANIMAL | C | | | | | | | | | | | | | | | | | | | |
| | CHRIST-FIGURE/ CRUCIFIXION | | | | | | | | | | | | | | | | | | | | |
| | SAINT | | | | | | | | | | | | | | | | | | | | |
| | EVANGELIST'S SYMBOL | X | | | | | | | | | | | | | | | | | | | |
| | BIBLICAL SCENE | | | | | | | | | | | | | | | | | | | | |
| | MYTHOLOGICAL OR SECULAR SCENE | | | | | | | | | | | | | | | | | | | | |
| | HUMAN FIGURE | | | | | | | | | | | | | | | | | | | | |

| | Tandridge 1 | Tangmere 1 | Titsey 1 | " 2 | " 3 | " 4 | " 5 | Walkern 1 | " 2 | Wantage 1 | Warnford 1 | West Mersea 1 | West Wittering 1 | Weyhill 1 | Wherwell 1 | Whitchurch 1 | White Notley 1 | Winchester Old Minster 1 | " 2 | " 3 |
|---|---|---|---|---|---|---|---|---|---|---|---|---|---|---|---|---|---|---|---|---|
| **MONUMENT TYPE** | | | | | | | | | | | | | | | | | | | | |
| CROSS-SHAFT | | | | | | | | | | R | | | | | ■ | | | | | |
| CROSS-HEAD | | | | | | | | | | | | | R B1 | | | | | | | |
| CROSS-BASE | | | | | | | | | | | | | | | | | | | | |
| GRAVE-MARKER OR -COVER/ TOMB OR MEMORIAL | B6 | | A1 | A1 | B6 | A1 | A1 | | | | | X | | B9 | | X | B/E 8 | X | B6 | X |
| ARCHITECTURAL FEATURE | | P | | | | | | X | Im | | Su | | X | | | | | | | |
| FURNITURE | | | | | | | | | | | | | | | | | | | | |
| FRAGMENT | | | | | | | | | | | | | | | X | | | | | X |
| INSCRIPTION | | | | | | | | | | | | | | | | | NR | NR | | |
| ARRANGEMENT OF ORNAMENT | | | | | | | | | | P | | P | | P | P | P | | P | P | |
| **DECORATIVE ELEMENT** | | | | | | | | | | | | | | | | | | | | |
| INTERLACE | | | | | | | | | | G | | G | | | G | | | | | |
| CABLE/CHAIN/TWIST/LINKED OR LOOPED PATTERNS | | | | | | | | | Ca | | | | | | | | | | | |
| CURVILINEAR ORNAMENT | | | | | | | | | | | | | | | | | | | | |
| BOSSES AND PELLETS | | | | | | | | | | | | | | | | | | | | |
| KEY/FRET PATTERN | | | | | | | | | | | | | | | | | | | | |
| STRAIGHT LINE PATTERN | | | | | | X | | | | | | | | X | | | | | | X |
| BALUSTER ORNAMENT | | | | | | | | | | | | | | | | | | | | |
| PLANT MOTIF | | | | | | | | | | | O | | | F | | | | | | |
| PLANT-SCROLL | | | | | | | | | | | | | | | | | X | | | |
| INHABITED SCROLL | | | | | | | | | | | | | | | | | | | | |
| ANIMAL | | | | | | | | | | | | | | | | | | | | |
| CHRIST-FIGURE/ CRUCIFIXION | | | | | | | | X | | | | | | | | C | | | C | |
| SAINT | | | | | | | | | | | | | | | | | | | | |
| EVANGELIST'S SYMBOL | | | | | | | | | | | | | | | | | | | | |
| BIBLICAL SCENE | | | | | | | | | | | | | | | | | | | | |
| MYTHOLOGICAL OR SECULAR SCENE | | X | | | | | | | | | | | | | | | | | | |
| HUMAN FIGURE | | | | | | | | | | | | | | | | | | | | |

| SITE AND NO. | 4 Winchester Old Minster | 5 " | 6 " | 7 " | 8 " | 9 " | 10 " | 11 " | 12 " | 13 " | 14 " | 15 " | 16 " | 17 " | 18 " | 19 " | 20 " | 21 " | 22 " | 23 " |
|---|---|---|---|---|---|---|---|---|---|---|---|---|---|---|---|---|---|---|---|---|
| **MONUMENT TYPE** | | | | | | | | | | | | | | | | | | | | |
| CROSS-SHAFT | | | | | | | | | | | | | | | | | | | | |
| CROSS-HEAD | | | | | | | | | | | | | | | | | | | | |
| CROSS-BASE | | | | | | | | | | | | | | | | | | | | |
| GRAVE-MARKER OR -COVER/ TOMB OR MEMORIAL | X | E9 | X | | | | | | | | | | | | | | | | | |
| ARCHITECTURAL FEATURE | X | | | Co | Co | Ba/Co | Ba/Co | Ba/Co | Ba/Co | Ba/Co | Ba/Co | Ba/Co | Ba/Co | Ba/Co | Bs | Bs | Ca/Bs | Co | Ca/Co | Ba/Co |
| FURNITURE | | | | | | | | | | | | | | | | | | | | |
| FRAGMENT | | X | | X | X | X | X | X | X | X | X | X | X | X | X | X | X | X | X | X |
| INSCRIPTION | | | NR | | | | | | | | | | | | | | | | | |
| ARRANGEMENT OF ORNAMENT | P | | | | | | | | | | | | | | | | | | | |
| **DECORATIVE ELEMENT** | | | | | | | | | | | | | | | | | | | | |
| INTERLACE | | | | | | | | | | | | | | | | | | | | |
| CABLE/CHAIN/TWIST/LINKED OR LOOPED PATTERNS | | | | | | | | | | | | | | | | | | | | |
| CURVILINEAR ORNAMENT | | X | | | | | | | | | | | | | | | | | | |
| BOSSES AND PELLETS | | | | | | | | | | | | | | | | | | | | |
| KEY/FRET PATTERN | | | | | | | | | | | | | | | | | | | | |
| STRAIGHT LINE PATTERN | | | X | X | X | X | X | X | X | X | X | X | X | X | X | X | | | | |
| BALUSTER ORNAMENT | | | | | | | | | | | | | | | | | | | | |
| PLANT MOTIF | | | | | | | | | | | | | | | | | | | | |
| PLANT-SCROLL | | | | | | | | | | | | | | | | | | | | |
| INHABITED SCROLL | | | | | | | | | | | | | | | | | | | | |
| ANIMAL | | | | | | | | | | | | | | | | | | | | |
| CHRIST-FIGURE/ CRUCIFIXION | | | | | | | | | | | | | | | | | | | | |
| SAINT | | | | | | | | | | | | | | | | | | | | |
| EVANGELIST'S SYMBOL | | | | | | | | | | | | | | | | | | | | |
| BIBLICAL SCENE | X | | | | | | | | | | | | | | | | | | | |
| MYTHOLOGICAL OR SECULAR SCENE | | | | | | | | | | | | | | | | | | | | |
| HUMAN FIGURE | | | | | | | | | | | | | | | | | | | | |

| | SITE AND NO. | 24 | 25 | 26 | 27 | 28 | 29 | 30 | 31 | 32 | 33 | 34 | 35 | 36 | 37 | 38 | 39 | 40 | 41 | 42 | 43 |
|---|---|---|---|---|---|---|---|---|---|---|---|---|---|---|---|---|---|---|---|---|---|
| | | Winchester Old Minster | " | " | " | " | " | " | " | " | " | " | " | " | " | " | " | " | " | " | " |
| **MONUMENT TYPE** | CROSS-SHAFT | | | | | | | | | | | | | | | | | | | | |
| | CROSS-HEAD | | | | | | | | | | | | | | | | | | | | |
| | CROSS-BASE | | | | | | | | | | | | | | | | | | | | |
| | GRAVE-MARKER OR -COVER/ TOMB OR MEMORIAL | | | | | | | | | | | | | | | | | | | | |
| | ARCHITECTURAL FEATURE | Ba/Co | X | X | St | St | X | X | X | X | X | X | X | F | F | X | X | X | X | O | O |
| | FURNITURE | | | | | | | | | | | | | | | | | | | | |
| | FRAGMENT | X | X | X | X | X | X | X | X | X | X | X | X | X | X | X | X | X | X | X | X |
| | INSCRIPTION | | | | | | | | | | | | | | | | | | | | |
| | ARRANGEMENT OF ORNAMENT | | | | | | | | | | | | | | | | | | | | |
| **DECORATIVE ELEMENT** | INTERLACE | | | | | | | | | | | | | | | | | | | | |
| | CABLE/CHAIN/TWIST/LINKED OR LOOPED PATTERNS | | | | | | | | | | | | | | | | | | Ca | Ca | Ca |
| | CURVILINEAR ORNAMENT | | | | | | | X | | | | | | | | | | | | | |
| | BOSSES AND PELLETS | | | | | | | | | | | | | | | | | | | | |
| | KEY/FRET PATTERN | | | | | | | | | | | | | | | | | | | | |
| | STRAIGHT LINE PATTERN | | X | X | | | | | X | X | | X | X | X | | | | | | | |
| | BALUSTER ORNAMENT | | | | | | | | | | | | | | X | X | X | X | X | | X |
| | PLANT MOTIF | | | | | | | | | | | | | | | | | | | | |
| | PLANT-SCROLL | | | | | | | | | | | | | | | | | | | | |
| | INHABITED SCROLL | | | | | | | | | | | | | | | | | | | | |
| | ANIMAL | | | | | | | | | | | | | | | | | | | | |
| | CHRIST-FIGURE/ CRUCIFIXION | | | | | | | | | | | | | | | | | | | | |
| | SAINT | | | | | | | | | | | | | | | | | | | | |
| | EVANGELIST'S SYMBOL | | | | | | | | | | | | | | | | | | | | |
| | BIBLICAL SCENE | | | | | | | | | | | | | | | | | | | | |
| | MYTHOLOGICAL OR SECULAR SCENE | | | | | | | | | | | | | | | | | | | | |
| | HUMAN FIGURE | | | | | | | | | | | | | | | | | | | | |

| | SITE AND NO. | 44 | 45 | 46 | 47 | 48 | 49 | 50 | 51 | 52 | 53 | 54 | 55 | 56 | 57 | 58 | 59 | 60 | 61 | 62 | 63 |
|---|---|---|---|---|---|---|---|---|---|---|---|---|---|---|---|---|---|---|---|---|---|
| | | Winchester Old Minster | " | " | " | " | " | " | " | " | " | " | " | " | " | " | " | " | " | " | " |
| **MONUMENT TYPE** | CROSS-SHAFT | | | | | | | | | | | | | | | | | | | | |
| | CROSS-HEAD | | | | | | | | | | | | | | | | | | | | |
| | CROSS-BASE | | | | | | | | | | | | | | | | | | | | |
| | GRAVE-MARKER OR -COVER/ TOMB OR MEMORIAL | | | | | | | | | | | | | | | | | | | | X |
| | ARCHITECTURAL FEATURE | F | X | X | F | F | F | X | X | X | X | X | Ba/Co | X | X | X | | | | F | |
| | FURNITURE | | | | | | | | | | | | | | | | | | | | |
| | FRAGMENT | X | X | X | | X | | X | X | X | X | X | X | X | X | X | X | X | X | X | X |
| | INSCRIPTION | | | | | | | | | | | | | | | | | | | | |
| | ARRANGEMENT OF ORNAMENT | P | | P | | | P | | | | P | | | P | P | P | P | | | | |
| **DECORATIVE ELEMENT** | INTERLACE | | | | | | | | | | | | | | | | X | | X | X | X |
| | CABLE/CHAIN/TWIST/LINKED OR LOOPED PATTERNS | T | T | T | T | | T | | Ca | Ca | | Ca | | Ca | Ca | Ca | | | | | |
| | CURVILINEAR ORNAMENT | | | | | | | | | | | | | | | | | | | | |
| | BOSSES AND PELLETS | | | | | | | | | | | | | | | | P | P | P | P | |
| | KEY/FRET PATTERN | | | | | | | | | | | | | | | | | | | | |
| | STRAIGHT LINE PATTERN | | | | | | | | | | X | | X | | | | | | | | |
| | BALUSTER ORNAMENT | X | | | X | X | X | | | | | | | | | | | | | | |
| | PLANT MOTIF | | | | | | | | | | | | | | | | | | | | |
| | PLANT-SCROLL | | | | | | | | | | | | | | | | | | | | |
| | INHABITED SCROLL | | | | | | | | | | | | | | | | | | | | |
| | ANIMAL | | | | | | | | | | | | | | | | | | | | |
| | CHRIST-FIGURE/ CRUCIFIXION | | | | | | | | | | | | | | | | | | | | |
| | SAINT | | | | | | | | | | | | | | | | | | | | |
| | EVANGELIST'S SYMBOL | | | | | | | | | | | | | | | | | | | | |
| | BIBLICAL SCENE | | | | | | | | | | | | | | | | | | | | |
| | MYTHOLOGICAL OR SECULAR SCENE | | | | | | | | | | | | | | | | | | | | |
| | HUMAN FIGURE | | | | | | | | | | | X | | | X | | | | | | |

| | SITE AND NO. | 64 | 65 | 66 | 67 | 68 | 69 | 70 | 71 | 72 | 73 | 74 | 75 | 76 | 77 | 78 | 79 | 80 | 81 | 82 | 83 |
|---|---|---|---|---|---|---|---|---|---|---|---|---|---|---|---|---|---|---|---|---|---|
| | | Winchester Old Minster | " | " | " | " | " | " | " | " | " | " | " | " | " | " | " | " | " | " | " |
| **MONUMENT TYPE** | CROSS-SHAFT | | | | | | | | | | | | | | | | | | | | |
| | CROSS-HEAD | | | | | | | | | | | | | | | | | | | | |
| | CROSS-BASE | | | | | | | | | | | | | | | | | | | | |
| | GRAVE-MARKER OR -COVER/ TOMB OR MEMORIAL | | | | | | | | | | | | | | | | | | | | |
| | ARCHITECTURAL FEATURE | F | | | X | | X | | | | | | | | | | | | | | |
| | FURNITURE | | | | | | | | | | | | | | | | | | | | |
| | FRAGMENT | X | X | X | X | X | X | X | X | X | X | X | X | X | X | X | X | X | X | X | X |
| | INSCRIPTION | | | | | | | | | | | | | | | | | | | | |
| | ARRANGEMENT OF ORNAMENT | | | | | | | | | | | | | | | | | | | | |
| **DECORATIVE ELEMENT** | INTERLACE | X | | X | | | | | | | | | | | | | | | | | |
| | CABLE/CHAIN/TWIST/LINKED OR LOOPED PATTERNS | | | | | | | | | | | | | | | | | | | | |
| | CURVILINEAR ORNAMENT | | | | | | | | | | | | X | X | | | | | | | X |
| | BOSSES AND PELLETS | P | | | | | | | | | | | | | | | | | | | |
| | KEY/FRET PATTERN | | | | | | | | | | | | | | | | | | | | |
| | STRAIGHT LINE PATTERN | | X | X | | | | | | | X | | | | | | | | | X | |
| | BALUSTER ORNAMENT | | | | | | | | | | | | | | | | | | | | |
| | PLANT MOTIF | | | | X | X | X | X | X | X | | | | | | | | | | | |
| | PLANT-SCROLL | | | | | | | | | | | | | | | | | | | | |
| | INHABITED SCROLL | | | | | | | | | | | | | | | | | | | | |
| | ANIMAL | P | | | | | | | | | Bi | | | | | | | | | | |
| | CHRIST-FIGURE/ CRUCIFIXION | | | | | | | | | | | | | | | | | | | | |
| | SAINT | | | | | | | | | | | | | | | | | | | | |
| | EVANGELIST'S SYMBOL | | | | | | | | | | | | | | | | | | | | |
| | BIBLICAL SCENE | | | | | | | | | | | | | | | | | | | | |
| | MYTHOLOGICAL OR SECULAR SCENE | | | | | | | | | | | | | | | | | | | | |
| | HUMAN FIGURE | | | | | | | | | | | | X | X | X | | X | X | X | | |

| | 84 | 85 | 86 | 87 | 88 | 89 | 90 | 91 | 92 | 93 | 94 | 95 | 96 | 1 | 2 | 3 | 4 | 5 | 6 | 7 |
|---|---|---|---|---|---|---|---|---|---|---|---|---|---|---|---|---|---|---|---|---|
| | Winchester Old Minster | " | " | " | " | " | " | " | " | " | " | " | " | Winchester New Minster | " | " | " | " | " | " |
| **MONUMENT TYPE** | | | | | | | | | | | | | | | | | | | | |
| CROSS-SHAFT | | | | | | | | | | | | | | | | | | | | |
| CROSS-HEAD | | | | | | | | | R | P | P | D E8/12 | | | | | | | | |
| CROSS-BASE | | | | | | | | | | | | | | | | | | | | |
| GRAVE-MARKER OR -COVER/ TOMB OR MEMORIAL | | | | | | | | | B8 | 8 | E8 | | | B9 | B6 | | | | | |
| ARCHITECTURAL FEATURE | | | | | F | | | F | | | | BsCa Co | | | | Ca | Ca | | | |
| FURNITURE | | | | | | | | | | | | | | | | | | | | |
| FRAGMENT | X | X | X | X | | X | X | | X | | X | | | X | X | X | X | X | X | X |
| INSCRIPTION | | | | | | | | | | | | | | | | | | | | |
| ARRANGEMENT OF ORNAMENT | | | | | | | | P | | | | | | | P | | | | P | P |
| **DECORATIVE ELEMENT** | | | | | | | | | | | | | | | | | | | | |
| INTERLACE | | | | | | | | | | | | | | | | | | | | |
| CABLE/CHAIN/TWIST/LINKED OR LOOPED PATTERNS | | | | | | Ca | Ca | T | | | | | | | | | | | T | T |
| CURVILINEAR ORNAMENT | | | | | | | | | | | | | | | | | | | | |
| BOSSES AND PELLETS | | | | | | | | | | | | | | | | | | | | |
| KEY/FRET PATTERN | | | | | | | | | | | | | | | | | | | | |
| STRAIGHT LINE PATTERN | | X | X | X | | X | | | | | | | X | | | | | | | |
| BALUSTER ORNAMENT | | | | | | | | X | | | | | | | | | | | | |
| PLANT MOTIF | | | | | | | | | | | F | | | | | | | | | |
| PLANT-SCROLL | | | | | | | | X | | | | | | | | | | | | |
| INHABITED SCROLL | | | | | | | | | | | | | | | | | | | | |
| ANIMAL | | | | | PQ | | | PQ | | | | | | | | | | | | |
| CHRIST-FIGURE/ CRUCIFIXION | | | | | | | | | | | | | | C | | | | | | |
| SAINT | | | | | | | | | | | | | | | | | | | | |
| EVANGELIST'S SYMBOL | | | | | | | | | | | | | | | | | | | | |
| BIBLICAL SCENE | | | | | | | | | | | | | | | | | | | | |
| MYTHOLOGICAL OR SECULAR SCENE | | | | | X | | | | | | | | | | | | | | | |
| HUMAN FIGURE | X | E/F | W | | W | | | | | | | | | | | | | | | |

| | Winchester St Maurice (1) | " (2) | Winchester St Michael (1) | Winchester St Pancras (1) | Winchester High Street (1) | Winchester Lower Brook Street (1) | Winchester Priors Barton (1) | Winchester Upper Brook Street (1) | Wing (1) |
|---|---|---|---|---|---|---|---|---|---|
| **MONUMENT TYPE** | | | | | | | | | |
| CROSS-SHAFT | | | | | R | | R | ■ | |
| CROSS-HEAD | | | | | | | | | |
| CROSS-BASE | | | | | | | | | |
| GRAVE-MARKER OR -COVER/ TOMB OR MEMORIAL | X | | | B6 | | | | | |
| ARCHITECTURAL FEATURE | | Su | Su | | | P | | | Ba |
| FURNITURE | | | | | | | | | |
| FRAGMENT | X | | | X | X | X | | X | |
| INSCRIPTION | R | | | | | NR | | | |
| ARRANGEMENT OF ORNAMENT | | | | | | | | P | |
| **DECORATIVE ELEMENT** | | | | | | | | | |
| INTERLACE | | | | | | | GO | X | |
| CABLE/CHAIN/TWIST/LINKED OR LOOPED PATTERNS | | | | | | | | | |
| CURVILINEAR ORNAMENT | | | | | | | | | |
| BOSSES AND PELLETS | | | | | | | | P | |
| KEY/FRET PATTERN | | | | | | | | | |
| STRAIGHT LINE PATTERN | | | | | | | | | |
| BALUSTER ORNAMENT | | | | | | | | | |
| PLANT MOTIF | | | X | | | | | | |
| PLANT-SCROLL | | | | | X | | X | | |
| INHABITED SCROLL | | | | | | | | | |
| ANIMAL | | | | | | | Q | R | |
| CHRIST-FIGURE/ CRUCIFIXION | | | | C | | | | | |
| SAINT | | | | | | | | | |
| EVANGELIST'S SYMBOL | | | | | | | | | |
| BIBLICAL SCENE | | | | | | | | | |
| MYTHOLOGICAL OR SECULAR SCENE | | | | | | | | | |
| HUMAN FIGURE | | | | | | | | | |

# BIBLIOGRAPHY

Abbreviations are made according to the Council for British Archaeology's Standard List of Abbreviated Titles of Current Series as at February, 1986. Titles not covered in this list are abbreviated according to the British Standard BS4148:1970, with some minor exceptions.

(——), **1834.** 'November 22, 1832.', *Archaeologia*, XXV, 604

(——), **1846.** 'St Martin's Church, Headbourne Worthy', *Proceedings at the Annual Meeting of the Arch. Inst. of Great Britain at Winchester, September MDCCCXLV*, 21

(——), **1850–3.** In *Proc. Roy. Ir. Acad.*, V, 351–4

(——), **1852.** *Morning Chronicle*, Sept. 18th, 1852

(——), **1854.** In *J. Brit. Archaeol. Ass.*, X, 99

(——), **1875a.** In *Archaeol. J.*, XXXII, 516

(——), **1875b.** In *Sussex Archaeol. Collect.*, XXVI, 276

(——), **1883.** In *The Antiquary*, VII, 82

(——), **1884.** In *J. Brit. Archaeol. Ass.*, XL, 118

(——), **1886.** 'Report for the year 1885', *Trans. Rep. North Oxford Archaeol. Soc.*, XX, 12–16

(——), **1887.** In *Sussex Archaeol. Collect.*, XXXV, xiii–xv

(——), **1890–3.** 'Early window at Boarhunt', *Pap. Proc. Hampshire Fld. Club*, II, 255–6

(——) **(ed. C. Plummer), 1896.** *Historia Abbatum Auctore Anonymo: Venerabilis Baedae Opera Historica*, 2 vols., I, 388–404 (Oxford)

(——), **1899.** 'Transactions . . . at the Annual Summer Meeting at Fairford . . . 1899', *Trans. Bristol Gloucestershire Archaeol. Soc.*, XXII, 22–72

(——), **1901.** *Bedfordshire Times and Independent,* August 2nd, 1901

(——), **1903.** *Catalogue of the Collection of London Antiquities in the Guildhall Museum* (London)

(——), **1903–4.** '[review of] *St. Aldhelm, his Life and Times* . . . by the Right Rev. G. F. Browne, . . .', *Wiltshire Archaeol. Natur. Hist. Mag.*, XXXIII, 177–9

(——), **1910.** 'Proceedings at the annual summer meeting at Oxford . . . 1910', *Trans. Bristol Gloucestershire Archaeol. Soc.*, XXXIII, 14–43

(——), **1911.** In *Proc. Dorset Nat. Hist. Ant. Field Club*, XXXII, lxi

(——), **1930.** *Burlington Fine Arts Club, Catalogue of an Exhibition of Art of the Dark Ages in Europe c.400–1000 AD* (London)

(——), **1937.** In *Sussex Archaeol. Collect.*, XLV, 168–9

(——), **1949.** *Herne Bay Press,* April 29th, 1949

(——), **1952.** In *Toc H Journal*, XXX, 88, pl.

(——), **1958.** *Orpington and Kentish Times,* August 22nd, 1958

(——), **1971.** In *Bull. Colchester Archaeological Group,* XIV, 37

Åberg, N., **1925.** *Förhistorisk Nordisk Ornamentik* (Uppsala)

Åberg, N., **1931.** 'Nordische Ornamentik in vorgeschichtlicher Zeit', *Mannus-Bibliothek*, XLVII, 1–118

Åberg, N., **1936.** *Vorgeschichtliche Kulturkreise in Europa. Bilderatlas mit erläuterndem Text* (Stockholm)

Åberg, N., **1941.** *Keltiska och Orientaliska Stilinflytelser i Vikingadtidens Nordiska Konst. Kungliga Vitterhets Historie og Antikvitets Akademiens Handlingar, 46:4* (Stockholm)

Abrard, R., **1925.** *Le Lutétien du Bassin de Paris* (Angers)

Adcock, G., **1978.** 'The theory of interlace and interlace types in Anglian sculpture' in Lang 1978, 33–45

Ælfric (ed. G. I. Needham), **1966.** *Lives of Three English Saints* (London)

Aldsworth, F. G., **1979.** '"The mound" at Church Norton, Selsey, and the site of St. Wilfrid's church', *Sussex Archaeol. Collect.*, CXVII, 103–8

Aldsworth, F. G., **1990.** 'Recent observations on the tower of Holy Trinity church, Bosham', ibid., CXXVIII, 55–72

Aldsworth, F. G., and Harris, P., **1988.** 'The tower and "Rhenish helm" spire of St Mary's church, Sompting', ibid., CXXVI, 105–44

Alexander, J. J. G., **1978.** *Insular Manuscripts 6th to the 9th Century.* (A Survey of Manuscripts Illuminated in the British Isles, I, London)

Alexander, J. J. G., **1987.** 'Sigmund or the king of the Garamantes?' in Stratford 1987, I, 1–6

Allen, J. R., **1882–3.** 'On the discovery of a sculptured stone at St. Madoes, with some notes on interlaced ornament', *Proc. Soc. Antiq. Scot.*, XVII, 211–71

Allen, J. R., **1885a.** 'On recent discoveries of pre-Norman sculptured stones', *J. Brit. Archaeol. Ass.*, XLI, 267–77

Allen, J. R., **1885b.** 'The crosses at Ilkley part III—conclusion', ibid., XLI, 333–58

**Allen, J. R., 1887.** *Early Christian Symbolism* (London)

**Allen, J. R., 1888.** 'On the antiquity of fonts in Great Britain', *J. Brit. Archaeol. Ass.*, XLIV, 164–73

**Allen, J. R., 1889.** *The Monumental History of the Early British Church* (London)

**Allen, J. R., 1893–4a.** 'Saxon doorway at Somerford Keynes, Wiltshire', *Illus. Archaeol.*, I, 46–9

**Allen, J. R., 1893–4b.** 'Notes on the ornamentation of the Early Christian monuments of Wiltshire', *Wiltshire Archaeol. Natur. Hist. Mag.*, XXVII, 50–65

**Allen, J. R., 1895.** 'The Early Christian monuments of Cheshire and Lancashire', *J. Architect. Archaeol. Hist. Soc. County City Chester North Wales*, V, 133–74

**Allen, J. R., and Anderson, J., 1903.** *The Early Christian Monuments of Scotland* (Edinburgh)

**Amos, E. G. J., and Wheeler, R. E. M., 1929.** 'The Saxon shore fortress at Dover', *Archaeol. J.*, LXXXVI, 47–58

**Andersen, C. B., 1986.** *Fire Romanske Sten fra Løvenholm* (privately printed)

**Anderson, A. H., 1914.** *Bexhill-on-Sea with Battle and Battle Abbey* (London)

**Anderson, F. W., 1990.** 'Provenance of building stone' in Biddle 1990a, 306–14

**Anderson, F. W., and Quirk, R. N., 1964.** 'Note on the Quarr stone' in Jope 1964, 115–17

**André, J. L., 1898.** 'Sompting church', *Sussex Archaeol. Collect.*, XLI, 7–24

**Andrews, H. C., 1934.** 'Walkern and its church', *Trans. East Hertfordshire Archaeol. Soc.*, IX, 96–101

**Anker, P., 1970.** *The Art of Scandinavia* (London)

**Arbman, H., 1961.** *The Vikings* (London)

**Arkell, W. J., 1947.** *Oxford Stone* (London)

**Arntz, H., and Zeiss, H., 1939.** *Die Einheimischen Runendenkmäler des Festlandes* (Leipzig)

**Ashpitel, A., 1846.** 'On the abbey church of Romsey', *Trans. Brit. Archaeol. Ass., Second Annual Congress, Winchester 1845* (London), 415–23

**Ashton, M., 1980.** 'The stratigraphy of the Lincolnshire Limestone Formation (Bajocian) in Lincolnshire and Rutland (Leicestershire)', *Proc. Geol. Assoc.*, XCI, 203–23

**Asser (ed. W. H. Stevenson), 1959.** *Asser's Life of Alfred* (2 ed., Oxford)

**Astley, H. J. D., 1904.** 'Scandinavian motifs in Anglo-Saxon and Norman ornamentation', *Sagabook*, IV, 133–70

**Astley, H. J. D., 1905.** 'The Saxon church at Bradford on Avon', *J. Brit. Archaeol. Ass.*, XI, 211–30

**Atkinson, T. D., 1938–40.** 'Fragments of architecture and sculpture at Wherwell church', *Proc. Hampshire Fld. Club Archaeol. Soc.*, XIV, 369–71

**Backhouse, J., 1981.** *The Lindisfarne Gospels* (Oxford)

**Backhouse, J., Turner, D. H., and Webster, L. (eds.), 1984.** *The Golden Age of Anglo-Saxon Art 966–1066* (London)

**Bæksted, A., 1935.** 'Vester Marie-stenen I og de danske runeligsten', *Danske Studier*, XII, 39–58

**Bæksted, A., 1943.** *Runerne Deres Historie og Brug* (Copenhagen)

**Bailey, R. N., 1977.** 'A cup-mount from Brougham, Cumbria', *Medieval Archaeol.*, XXI, 176–80

**Bailey, R. N., 1978.** 'The chronology of Viking-age sculpture in Northumbria' in Lang 1978, 173–203

**Bailey, R. N., 1980.** *Viking Age Sculpture in Northern England* (London)

**Bailey, R. N., and Cramp, R., 1988.** *Corpus of Anglo-Saxon Stone Sculpture, II, Cumberland, Westmorland, and Lancashire North-of-the-Sands* (Oxford)

**Baker, D., 1969.** 'Excavations at Elstow abbey, Bedfordshire, 1966–8, second interim report', *Bedfordshire Archaeol. J.*, IV, 27–41

**Baker, D., 1970.** *Excavations at Elstow Abbey 1965–70, A Progress Report* (Elstow)

**Baker, E. P., 1953.** 'St. Peter's church', *Archaeol. J.*, CX, 184–5

**Bakka, E., 1963.** 'Some English decorated metal objects found in Norwegian Viking graves', *Årbok for Universitetet i Bergen, humanistik serie*, I, 4–66

**Bannerman, W. B., 1909.** *The Parish Registers of Chipstead and Titsey, Surrey.* (Publ. Surrey Parish Register Soc., VII (London))

**Bassett, S. (ed.), 1989.** *The Origins of Anglo-Saxon Kingdoms* (Leicester)

**Bassett, S. (ed.), 1992.** *Death in Towns. Urban Responses to the Dying and the Dead, 100–1600* (Leicester)

**Bates, D. R., 1975.** 'The character and career of Odo, bishop of Bayeux (1049/50–97)', *Speculum*, I, 1–20

**Battiscombe, C. F. (ed.), 1956.** *The Relics of St. Cuthbert* (Oxford)

**Baylé, M., 1983.** 'Interlace patterns in Norman Romanesque sculpture: regional groups and their historical background' in R. A. Brown (ed.), *Anglo-Norman Studies, V, Proceedings of the Battle Conference 1982* (Woodbridge), 1–20

**Beckett, F., 1924.** *Danmarks Kunst* (Copenhagen)

**Beckwith, J. G., 1968.** 'Reculver, Ruthwell and Bewcastle' in Milojčić 1968, 17–19

**Beckwith, J. G., 1969.** *Early Medieval Art* (London)

**Beckwith, J. G., 1972.** *Ivory Carvings in Early Medieval England* (London)

**Bede (ed. C. Plummer), 1896.** *Historia Abbatum: Venerabilis Baedae Opera Historica*, 2 vols., I, 364–85

**Bede (eds. B. Colgrave and R. A. B. Mynors), 1969.** *Bede's Ecclesiastical History of the English People* (Oxford)

**Beresford, M. W., and Hurst, J. G., 1976.** 'Wharram Percy: a case study in microtopography' in P. H. Sawyer (ed.), *Medieval Settlement* (London), 114–44

**Berges, W., and Rieckenberg, H. J., 1983.** *Die älteren Hildesheimer Inschriften bis zum Tode Bischof Hezilos (+1079)* (Abhandlungen der Akademie der Wissenschaften in Göttingen (Göttingen))

**Biddle, M., 1964.** 'Excavations at Winchester 1962–3: second interim report', *Antiq. J.*, XLIV, 188–219

**Biddle, M., 1965.** 'Excavations at Winchester 1964: third interim report', ibid., XLV, 230–64

**Biddle, M., 1966a.** 'Excavations at Winchester 1965: fourth interim report', ibid., XLVI, 308–32

**Biddle, M., 1966b.** 'A late Saxon frieze sculpture from the Old Minster' in Biddle 1966a, 329–32

**Biddle, M., 1967a.** 'Excavations at Winchester 1966: fifth interim report', *Antiq. J.*, XLVII, 251–79

**Biddle, M., 1967b.** 'A late ninth-century wall painting from the site of New Minster' in Biddle 1967a, 277–9

**Biddle, M., 1967c.** 'Saxon Winchester' in Pevsner and Lloyd 1967, 659–61

**Biddle, M., 1968.** 'Excavations at Winchester 1967: sixth interim report', *Antiq. J.*, XLVIII, 250–84

**Biddle, M., 1969.** 'Excavations at Winchester 1968: seventh interim report', ibid., XLIX, 295–329

**Biddle, M., 1970.** 'Excavations at Winchester 1969: eighth interim report', ibid., I, 277–326

**Biddle, M., 1972.** 'Excavations at Winchester 1970: ninth interim report', ibid., LII, 93–131

**Biddle, M., 1975.** 'Felix urbs Wintonia: Winchester in the age of monastic reform' in Parsons 1975, 123–40

**Biddle, M., 1976.** *Winchester in the Early Middle Ages: an Edition and Discussion of the Winton Domesday* (Winchester Studies, I, Oxford)

**Biddle, M., 1981.** 'Capital at Winchester' in Roesdahl *et al.* 1981, 165–7

**Biddle, M., 1984.** 'Narrative frieze' in Backhouse *et al.* 1984, 133–5 (no. 140)

**Biddle, M., 1986.** 'Archaeology, architecture, and the cult of saints in Anglo-Saxon England' in Butler and Morris 1986, 1–31

**Biddle, M., 1990a.** *Object and Economy in Medieval Winchester* (Winchester Studies, VII (2), Oxford)

**Biddle, M., 1990b.** 'Changing patterns in the use of building stone' in Biddle 1990a, 315–18

**Biddle, M., forthcoming a.** *Venta Belgarum* (Winchester Studies, III (1), Oxford)

**Biddle, M., forthcoming b.** *The Brooks and Other Town Sites in Medieval Winchester* (Winchester Studies, V, Oxford)

**Biddle, M., and Keene, D. J., 1976.** 'Winchester in the eleventh and twelfth centuries' in Biddle 1976, 241–448

**Biddle, M., and Kjølbye-Biddle, B., 1969.** 'Metres, areas and robbing', *World Archaeology*, I (2), 208–19

**Biddle, M., and Kjølbye-Biddle, B., 1972.** *Winchester Saxon and Norman Art. An Exhibition of the Artistic Achievement of an Early Medieval Capital A.D. 900–1150* (Winchester)

**Biddle, M., and Kjølbye-Biddle, B., 1973.** *Winchester Saxon and Norman Art. An Exhibition of the Artistic Achievement of an Early Medieval Capital A.D. 900–1150 — a Revised Exhibition* (Winchester)

**Biddle, M., and Kjølbye-Biddle, B., 1985.** 'The Repton stone', *Anglo-Saxon England*, XIV, 233–92

**Biddle, M., and Kjølbye-Biddle, B., 1988.** 'An early medieval floor-tile from St Frideswide's minster', *Oxoniensia*, LIII, 259–63

**Biddle, M., and Kjølbye-Biddle, B., 1990a.** 'Painted wall plaster from the Old and New Minsters' in Cather *et al.* 1990, 41–4

**Biddle, M., and Kjølbye-Biddle, B., 1990b.** 'The dating of the New Minster wall painting' in Cather *et al.* 1990, 45–63

**Biddle, M., and Kjølbye-Biddle, B., forthcoming a.** *The Anglo-Saxon Minsters at Winchester* (Winchester Studies IV (1), Oxford)

**Biddle, M., and Kjølbye-Biddle, B., forthcoming b.** *Repton: Origin and Development* (Investigations at Repton, II)

**Biddle, M., and Quirk, R. N., 1962.** 'Excavations near Winchester cathedral, 1961', *Archaeol. J.*, CXIX, 150–94

**Binns, J. W., Norton, E. C., and Palliser, D. M., 1990.** 'The Latin inscription on the Coppergate helmet', *Antiquity*, LXV, 134–9

**Birch, W. de G., 1886.** 'Proceedings of the congress, Wednesday August 19th, 1885', *J. Brit. Archaeol. Ass.*, XLII, 100–106

**Bischoff, B., 1990.** *Latin Palaeography: Antiquity and the Middle Ages* (Cambridge)

**Blackburn, M., 1991.** 'Æthelred's coinage and the payment of tribute' in Scragg 1991, 156–69

**Blagg, T. F. C., 1981.** 'Some Roman architectural traditions in the early Saxon churches of Kent' in A. P. Detsicas (ed.), *Collectanea Historica: Essays in Memory of Stuart Rigold* (Maidstone), 51–3

**Blair, J. (ed.), 1988.** *Minsters and Parish Churches: the Local Church in Transition, 950–1200* (Oxford University Committee for Archaeology Monograph no. 17, Oxford)

**Blair, P. H., 1956.** *An Introduction to Anglo-Saxon England* (Cambridge)

**Blair, P. H., 1970.** *An Introduction to Anglo-Saxon England* (3 ed., Cambridge)

**Blake, E. O. (ed.), 1962.** *Liber Eliensis* (Camden Society, ser. 3, XCII, London)

**Blindheim, M., 1972.** *Sigurds saga i Middelalderens Billedkunst* (Universitetets Oldsaksamling, Oslo)

**Blondeau, A., Cavelier, C., Labourgigne, J., Mégnien, C., and Mégnien, F., 1980.** 'Éocene Moyen' in C. Mégnien (ed.), *Synthèse géologique du Bassin de Paris. Mémoires du Bureau de Récherches Géologiques et Minières, no. 101, vol. l* (Orléans), 367–77

**Bloxham, M. H., 1864.** 'Notes on places visited at the annual meeting, 14th August, 1863: the churches', *Sussex Archaeol. Collect.*, XVI, 233–46

**Bloxham, M. H., 1882.** *Companion to the Principles of Gothic Ecclesiastical Architecture* (3 vols., London)

**Bond, F., 1908.** *Fonts and Font Covers* (London)

**Bony, J., 1967.** 'Anglo-Saxon Architecture by H. M. and J. Taylor', *J. Soc. Architect. Historians*, XXVI, 74–7

**Bosworth, J., and Toller, T. N., 1898.** *An Anglo-Saxon Dictionary* (Oxford)

**Bott, A., 1978.** *A Guide to the Parish Church of St. Peter and St. Paul, Godalming* (Godalming)

**Bowen, M., and Page, R. I., 1967.** 'Saxon sundial in the parish church of All Saints, Orpington', *Archaeol. Cantiana*, LXXXII, 287–91

**Brand, F. J., 1936–40.** 'Pre-Conquest carving at Great Canfield church', *Trans. Essex Archaeol. Soc.*, XXII, 357–9

**Brandt, M., and Eggebrecht, A., 1993.** *Bernward von Hildesheim und das Zeitalter der Ottonen, Katalog der Austellung, Hildesheim 1993* (2 vols., Hildesheim and Mainz am Rhein)

**Brett-James, N. G., 1948.** 'The bombed buildings of London', *Trans. London Middlesex Archaeol. Soc.*, IX, 66–80

**Brix, H., 1932.** *Systematiske Beregninger i de danske Runeindskrifter* (Copenhagen)

**Brock, E. P., 1883.** 'Christianity in Britain in Roman times, with reference to recent discoveries at Canterbury', *Archaeol. Cantiana*, XV, 38–55

**Brøndsted, J., 1920.** 'Nordisk og fremmed ornamentik i vikingetiden, med særligt henblik paa stiludviklingen i England', *Årbøger for Nordisk Oldkyndighed og Historie*, X, 162–282

**Brøndsted, J., 1924.** *Early English Ornament* (London and Copenhagen)

**Brøndsted, J., 1965.** *The Vikings* (Harmondsworth)

**Brooke, C. N. L., 1975.** *London 800–1216. The Shaping of a City* (London)

**Brooks, N. P., 1978.** 'Arms, status and warfare in late-Saxon England' in Hill 1978, 81–103

**Brooks, N. P., 1984.** *The Early History of the Church of Canterbury* (Leicester)

**Brooks, N. P., and Walker, H. E., 1979.** 'The authority and interpretation of the Bayeux Tapestry' in R. A. Brown (ed.), *Proceedings of the Battle Conference 1978* (Ipswich), 1–34

**Brown, G. B., 1900a.** 'The statistics of Saxon churches, III, the criteria', *Builder*, LXXIX, 305–8

**Brown, G. B., 1900b.** 'The statistics of Saxon churches, IV, catalogue raisonné of examples', ibid., LXXIX, 335–8

**Brown, G. B., 1903–37.** *The Arts in Early England* (6 vols., London)

**Brown, G. B., 1925.** *The Arts in Early England, II, Anglo-Saxon Architecture* (2 ed., London)

**Brown, M. P., 1991.** *Anglo-Saxon Manuscripts* (London)

**Browne, G. F., 1884–8.** 'On various inscriptions and supposed inscriptions', *Proc. Cambridge Antiq. Soc.*, VI, 1–16

**Browne, G. F., 1885.** '"Scandinavian or "Danish" sculptured stones found in London; and their bearing on the supposed "Scandinavian" or "Danish" origin of other English sculptured stones', *Archaeol. J.*, XLII, 251–9

**Browne, G. F., 1886.** 'On inscriptions at Jarrow and Monkwearmouth', *Archaeol. Aeliana*, XI, 27–32

**Browne, G. F., 1899–1901.** 'Runic and ogham characters and inscriptions in the British Isles', *Not. Proc. Royal Inst. Great Britain*, XVI, 164–87

**Bruce-Mitford, R. L. S., 1969.** 'The art of the Codex Amiatinus', *J. Brit. Archaeol. Ass.*, XXXII, 1–25

**Bruce-Mitford, R. L. S., 1972.** *The Sutton Hoo Ship Burial. A Handbook* (London)

**Buckler, J. C., and Buckler, C. A., 1847.** *A History of the Architecture of the Abbey Church of St Alban, with Special Reference to the Norman Structure* (London)

**Budny, M. O., 1984.** 'British Library manuscript Royal 1.E.VI: the anatomy of an Anglo-Saxon bible fragment' (Unpublished Ph.D. thesis, University of London)

**Budny, M. O., and Graham-Campbell, J., 1981.** 'An eighth-century bronze ornament from Canterbury and related works', *Archaeol. Cantiana*, XCVII, 7–25

**Budny, M. O., and Tweddle, D., 1984.** 'The Maaseik embroideries', *Anglo-Saxon England*, XIII, 65–96

**Bugge, A., 1905.** *Vesterlandenes indflydelse paar Nordboernes og særlig Nordmændenes ydre kultur, levesæt og samfundsforhold i vikingetiden* (Videnskabs-Selskabets i Christiana Skriften, II, Historisk-filosofisk Klasse 1904, no. 1).

**Bugge, A., 1931.** 'The golden vanes of the Viking ships', *Acta Archaeologia*, II, 159–84

**Bugge, S., and Olsen, M., 1891–24.** *Norges indskrifter med de ældre Runer* (Christiania)

**Butler, J. E., 1851.** 'The antiquities of Stedham church', *Sussex Archaeol. Collect.*, IV, 19–21

**Butler, L. A. S., 1956.** 'Medieval gravestones of Cambridgeshire, Huntingdonshire and the Soke of Peterborough', *Proc. Cambridge Antiquarian Soc.*, L, 89–100

**Butler, L. A. S., and Morris, R. K. (eds.), 1986.** *The Anglo-Saxon Church: Papers on History, Architecture and Archaeology in Honour of Dr. H. M. Taylor* (Council for British Archaeology, Research Report, LX, London)

**Cabrol, F., and Leclercq, H., 1907–53.** *Dictionnaire D'Archéologie Chrétienne et de Liturgie* (30 vols., Paris)

**Cameron, C. L., 1901–2.** 'Mortimer in olden time', *Berkshire Buckinghamshire Oxfordshire Archaeol. J.*, VII, 71–3

**Campbell, A., 1959.** *Old English Grammar* (Oxford)

**Campbell, J., (ed.), 1982.** *The Anglo-Saxons* (Oxford)

**Capelle, T., 1968.** *Der Metalschmuck von Haithabu* (Neumunster)

**Carter, J., 1780–94.** *Specimens of Ancient Sculpture and Painting Now Remaining in the Kingdom* (London)

**Carter, O. B., 1845.** 'Headbourn [sic] Worthy church', *Weale's Quarterly Pap. Architect.*, III, 1–4

**Casson, S., 1932.** 'Byzantium and Anglo-Saxon sculpture—I', *Burlington Mag.*, LXI, 265–74

**Casson, S., 1933.** 'Byzantium and Anglo-Saxon sculpture—II', ibid., LXII, 26–36

**Cather, S., Park, D., and Williamson, P., 1990.** *Early Medieval Wall Painting and Painted Sculpture in England* (Brit. Archaeol. Rep., Brit. ser., CCXVI)

**Chadwick, H. M., 1894–9.** 'Studies in Old English', *Trans. Cambridge Philolog. Soc.*, IV, 87–265

**Charlton, E., 1855–7.** 'Runic inscriptions', *Proc. Soc. Antiq. Newcastle-upon-Tyne*, I, 66–8

**Charlton, E., 1859.** 'On an inscription in runic letters in Carlisle cathedral', *Archaeol. Aeliana*, III, 65–8

**Cherry, B., 1976.** 'Ecclesiastical architecture' in Wilson 1976, 151–200

**Chittenden, S. B., 1905–7.** 'Walkern church', *Trans. East Hertfordshire Archaeol. Soc.*, III, 295–6

**Clapham, A. W., 1911–13.** 'The Benedictine abbey of Barking: a sketch of its architectural history and an account of recent excavations on its site', *Trans. Essex Archaeol. Soc.*, XII, 69–87

**Clapham, A. W., 1927.** 'The carved stones at Breedon-on-the-Hill, Leicestershire and their position in the history of English art', *Archaeologia*, LXXVII, 219–40

**Clapham, A. W., 1929a.** 'The summer meeting at Canterbury, St. Mary-in-Castro', *Archaeol. J.*, LXXXVI, 255–7

**Clapham, A. W., 1929b.** 'The summer meeting at Canterbury, Reculver cross', ibid., LXXXVI, 266

**Clapham, A. W., 1929c.** 'The summer meeting at Canterbury, St. Martin's church', ibid., LXXXVI, 280

**Clapham, A. W., 1930.** *English Romanesque Architecture, Before the Conquest* (Oxford)

**Clapham, A. W., 1935a.** 'The summer meeting at Chichester, Sompting church', *Archaeol. J.*, XCII, 405–9

**Clapham, A. W., 1935b.** 'The summer meeting at Chichester, Corhampton church', ibid., XCII, 415

**Clapham, A. W., 1947.** 'Breamore church', ibid., CIV, 160

**Clapham, A. W., 1948.** 'The York Virgin and its date', ibid., CV, 6–13

**Clapham, A. W., 1951.** 'Some disputed examples of pre-Conquest sculpture', *Antiquity*, XXV, 191–5

**Clark, J., 1980.** *Saxon and Norman London* (London)

**Clayton, P. B., 1944.** 'Saxon discoveries in London', *NAFT Magazine*, XX, no. 2, 1–3

**Clayton, P. B., 1951.** 'Puzzle of the Saxon cross', *City Press* 14th Dec. 1951, 2

**Clayton, P. B., 1952.** 'Proceedings of the Society of Antiquaries, Thursday, 10th January 1952', *Antiq. J.*, XXXII, 128

**Clayton, P. B., 1960.** *Saxon Discoveries in London* (London)

**Clemoes, P., and Hughes, K. (eds.), 1971.** *England before the Conquest, Studies in Primary Sources Presented to Dorothy Whitelock* (Cambridge)

**Close, C., and Collingwood, W. G., 1922.** 'A cross base at Winchester', *Proc. Hampshire Fld. Club Archaeol. Soc.*, IX, 219–20

**Coatsworth, E., 1979.** 'The iconography of the Crucifixion in pre-Conquest sculpture in England' (Unpublished Ph.D. thesis, 2 vols., University of Durham)

**Coatsworth, E., 1988.** 'Late pre-Conquest sculptures with the Crucifixion south of the Humber' in B. Yorke (ed.), *Bishop Æthelwold: his Career and Influence* (Woodbridge), 161–93

**Cobb, G., 1977.** *London City Churches* (London)

**Cobbett, L., 1937.** 'Ornament in Hadstock church, Essex', *Proc. Cambridge Antiq. Soc.*, XXXVII, 43–6

**Cole, T. W., 1939.** 'Medieval church sundials', *Proc. Suffolk Inst. Archaeol.*, XXIII, 148–54

**Cole, T. W., 1945–7.** 'Church sundials', *J. Brit. Archaeol. Ass.*, X, 77–80

**Collingwood, W. G., 1908.** *Scandinavian Britain* (London)

**Collingwood, W. G., 1915.** 'Anglian and Anglo-Danish sculpture in the West Riding, with addenda to the North and East Ridings and York, and a general review of the Early Christian monuments of Yorkshire', *Yorkshire Archaeol. J.*, XXIII, 129–299

**Collingwood, W. G., 1927.** *Northumbrian Crosses of the Pre-Norman Age* (London)

**Conant, K. J., 1974.** *Carolingian and Romanesque Architecture* (Harmondsworth)

**Cotton, J. L., 1881–2.** 'St. Andrew's church, Sonning', *Trans. Berkshire Archaeol. Architect. Soc.*, I, 1–7

**Cottrill, F., 1931.** 'A study of Anglo-Saxon sculpture in central and southern England' (Unpublished M.A. thesis, University of London)

**Cottrill, F., 1935.** 'Some pre-Conquest stone carvings in Wessex', *Antiq. J.*, XV, 144–51

**Cottrill, F., 1947.** *Treasures of Winchester in the City Museum* (Winchester)

**Cox, J. C., 1935.** *Kent* (London)

**Cox, J. C., and Johnston, P. M., 1935.** *Surrey* (London)

**Cox, J. C., Johnston, P. M., and Piehler, H. A., 1938.** *Essex* (London)

**Cox, J. C., and Jowitt, R. L., 1949.** *Hampshire* (London)

**Cozens-Hardy, B., 1934.** 'Norfolk crosses', *Norfolk Archaeol.*, XXV, 297–336

**Cramp, R., 1965.** *Early Northumbrian Sculpture* (Jarrow)

**Cramp, R. J., 1970.** 'The position of the Otley crosses in English sculpture of the eighth to ninth centuries' in Milojčić 1970, 55–63

**Cramp, R. J., 1972.** 'Tradition and innovation in English stone sculpture of the tenth to eleventh centuries' in Milojčić 1972, 139–48

**Cramp, R. J., 1974.** 'Early Northumbrian sculpture at Hexham' in D. P. Kirby (ed.), *St Wilfrid at Hexham* (Newcastle upon Tyne), 115–40

**Cramp, R. J., 1975.** 'Anglo-Saxon sculpture of the reform period' in Parsons 1975, 184–99

**Cramp, R. J., 1977.** 'Schools of Mercian sculpture' in Dornier 1977, 191–233

**Cramp, R. J., 1978.** 'The Anglian tradition in the ninth century' in Lang 1978, 1–32

**Cramp, R. J., 1984.** *Corpus of Anglo-Saxon Stone Sculpture, I, County Durham and Northumberland* (2 parts, Oxford)

**Cramp, R. J., 1991.** *Grammar of Anglo-Saxon Ornament. A General Introduction to the Corpus of Anglo-Saxon Stone Sculpture* (Oxford)

**Cramp, R. J., 1993.** 'A reconsideration of the monastic site of Whitby' in R. M. Spearman and J. Higgitt (eds.), *The Age of Migrating Ideas: Early Medieval Art in Northern Britain and Ireland* (Edinburgh and Stroud), 64–73

**Crouch, F. A., 1910.** 'Details of Sompting church, Sussex', *Archit. Assoc. Sketch Bk.*, pl. 39

**Crowley, J., 1956.** 'Sundials in north Devon', *Rep. Trans. Devonshire Ass.*, LXXXIX, 175–91

**Cuming, H. S., 1873.** 'On sundials', *J. Brit. Archaeol. Ass.*, XIX, 279–88

**Cunliffe, B., 1973.** *The Making of the English* (London)

**Cutts, E., 1849.** *A Manual for the Study of the Sepulchral Slabs and Crosses of the Middle Ages* (London)

**Dalton, O. M., 1908.** 'A relief representing the crucifixion in the parish church of St Dunstan at Stepney', *Proc. Soc. Antiq. London*, XXII, 225–31

**Daniell, J., 1938.** 'Finds made during building works in the city of Oxford', *Oxoniensia*, III, 172–3

**Darby, H. C., 1977.** *Domesday England* (Cambridge)

**Dauzat, A., 1984.** *Dictionnaire étymologique des noms de famille et prénoms de France* (Paris)

**Davidson, H. R. E., 1967.** *Pagan Scandinavia* (London)

**Davies, D. S., 1926.** 'Pre-Conquest carved stones in Lincolnshire', *Archaeol. J.*, LXXXIII, 1–20

**Davis, F., 1930.** '*A History of Early Chinese Art*, reviewed by F. Davis', *Illus. London News*, CLXXVI, 218

**Day, G., 1904.** *Seaford and Newhaven with their Surroundings* (London)

**Deansley, M., 1961.** *The Pre-Conquest Church in England* (London)

**Deansley, M., 1963.** *The Pre-Conquest Church in England* (3 ed., London)

**Derolez, R., 1954.** *Runica Manuscripta* (Brugge)

**Deschamps, P., 1929.** 'Étude sur la paléographie des inscriptions lapidaires de la fin de l'époque mérovingienne aux dernières années du XIIᵉ siècle', *Bulletin Monumentale*, LXXXVIII, 5–86

**Descombes, F., 1985.** *Viennoise du Nord* (Recueil des inscriptions chrétiennes de la Gaul antérieures à la renaissance carolingienne, XV (Paris))

**Deshman, R., 1977.** 'The Leofric Missal and tenth-century English art', *Anglo-Saxon England*, VI, 145–73

**Dewald, E. T., 1915.** 'The iconography of the Ascension', *American Jnl. Archaeol.*, XIX, 277–319

**De Wald, E. T., 1933.** *The Illustrations of the Utrecht Psalter* (Princeton, London, and Leipzig)

**Dickins, B., 1932.** 'A system of transliteration for Old English runic inscriptions', *Leeds Studies in English and Kindred Languages*, I, 15–19

**Dickins, B., 1938.** 'The Sandwich runic inscription *ræhæbul*' in K. H. Schlottig (ed.), *Beiträge zur Runen-kunde und Nordischen Sprachwissenschaft* (Leipzig), 83–5

**Diehl, E. (ed.), 1925–67.** *Inscriptiones Latinae Christianae Veteres* (4 vols., Berlin (vol. 4, eds. J. Moreau and H. I. Marrou))

**Dines, H. G., Buchan, S., Holmes, S. C. A., and Bristow, C. R., 1969.** *Geology of the Country around Sevenoaks and Tonbridge* (Memoirs of the Geological Survey of Great Britain, London)

**Ditchfield, P. H., and Page, W. (eds.), 1906.** *The Victoria History of Berkshire,* I (The Victoria History of the Counties of England, London)

**Dodwell, C. R., 1954.** *The Canterbury School of Illumination 1066–1200* (Cambridge)

**Dodwell, C. R., 1971.** *Painting in Europe 800–1200* (Harmondsworth)

**Dodwell, C. R., 1982.** *Anglo-Saxon Art, a New Perspective* (Manchester)

**Done, W. E. P, 1958–62.** 'Saxon cross in West Wittering church', *Sussex Notes Queries*, XV, 228–9

**Done, W. E. P., 1965.** *The Parish of St. Peter and St. Paul West Wittering* (West Wittering)

**Dornier, A. (ed.), 1977.** *Mercian Studies* (Leicester)

**Doubleday, H. A., and Page, W. (eds.), 1903.** *The Victoria History of Hampshire and the Isle of Wight,* II (The Victoria History of the Counties of England, London)

**Dowker, G., 1878.** 'Reculver church', *Archaeol. Cantiana*, XII, 248–68

**Dryden, H., 1885.** 'Proceedings of the Association, Wednesday 18th November, 1885', *J. Brit. Archaeol. Ass.*, XLI, 418

**Drury, P. J., 1982.** 'Aspects of the origins and development of Colchester castle', *Archaeol. J.*, CXXXIX, 302–419

**Du Bourguet, P., 1972.** *Early Christian Art* (London)

**Duncombe, J., 1784.** *The History and Antiquities of the Two Parishes of Reculver and Herne in the County of Kent*

**Düwel, K., 1968.** *Runenkunde* (Stuttgart)

**Earle, J., and Plummer, C. (eds.), 1892–9.** *Two of the Saxon Chronicles Parallel . . .* (2 vols., Oxford)

**Earwaker, C., 1969.** *The Story of St. Peter's, Bexhill* (Gloucester)

**Eden, P., 1959.** 'Sompting: church of St Mary', *Archaeol. J.*, CXVI, 245–6

**Ekwall, E., 1930.** 'How long did the Scandinavian language survive in England?' in N. Bøgholm, A. Brusendorff and C. A. Bodelsen (eds.), *A Grammatical Miscellany Offered to Otto Jespersen on his Seventieth Birthday* (Copenhagen and London), 17–30

**Elliott, R. W. V., 1959.** *Runes, an Introduction* (Manchester)

**Elliott, R. W. V., 1989.** *Runes, an Introduction* (2 ed., Manchester and New York)

**Evison, V. I., 1960.** '*Runes, An Introduction* by Ralph W. V. Elliott', *Antiq. J.*, XL, 242–4

**Favreau, R., and Michaud, J., 1974.** *Corpus des inscriptions de la France médiévale, I.1, Poitou—Charentes, Ville de Poitiers* (Poitiers)

**Favreau, R., and Michaud, J., 1977.** *Corpus des inscriptions de la France médiévale, I.3, Poitou-Charentes, Charente, Charente-Maritime, Deux-Sèvres* (Poitiers)

**Favreau, R., and Michaud, J., 1978.** *Corpus des inscriptions de la France médiévale, 2, Limousin* (Poitiers)

**Favreau, R., Michaud, J., and Leplant, B., 1979.** *Corpus des inscriptions de la France médiévale, 5, Dordogne, Gironde* (Poitiers)

**Favreau, R., Michaud, J., and Laplant, B., 1982.** *Corpus des inscriptions de la France médiévale, 7, Ville de Toulouse* (Poitiers)

**Feilitzen, O. von, 1937.** *The Pre-Conquest Personal Names of Domesday Book* (Nomina Germanica, III (Uppsala))

**Fernie, E., 1983a.** 'The responds and the dating of St Botolph's, Hadstock', *J. Brit. Archaeol. Ass.*, CXXXVI, 62–73

**Fernie, E., 1983b.** *The Architecture of the Anglo-Saxons* (London)

**Figg, W., 1849.** 'On Bishopstone church', *Sussex Archaeol. Collect.*, II, 272–84

**Figg, W., 1854.** 'Proceedings at the meeting of the Archaeological Institute, December 2nd, 1853', *Archaeol. J.*, XI, 49–62

**Figg, W., 1856.** 'Catalogue of antiquities exhibited in the museum formed during the annual meeting of the Archaeological Institute, held at Chichester in July, 1853', *Sussex Archaeol. Collect.*, VIII, 281–344

**Finch, R. G. (ed.), 1965.** *Völsunga Saga: the Saga of the Völsungs* (London)

**Finny, W. E. St. L., 1926.** 'The Saxon church at Kingston', *Surrey Archaeol. Collect.*, XXXVII, 211–9

**Finny, W. E. St. L., 1943.** 'The church of the Saxon coronations at Kingston', ibid., XLVIII, 1–7

**Fisher, E. A., 1959.** *An Introduction to Anglo-Saxon Architecture and Sculpture* (London)

**Fisher, E. A., 1962.** *The Greater Anglo-Saxon Churches* (London)

**Fisher, E. A., 1969.** *Anglo-Saxon Towers* (Newton Abbot)

**Fisher, E. A., 1970.** *The Saxon Churches of Sussex* (Newton Abbot)

**Foote, P. G., and Wilson, D. M., 1970.** *The Viking Achievement* (London)

**Förster, M., 1906.** 'Zwei altenglische Steininschriften', *Englische Studien*, XXXVI, 446–9

**Fossard, D., 1947.** 'Les chapiteaux de marbre du VIIᵉ siècle en Gaule, style et évolution', *Cahiers Archéologiques*, II, 69–85

**Fox, C., 1920–1.** 'Anglo-Saxon monumental sculpture in the Cambridge district', *Proc. Cambridge Antiq. Soc.*, XVII, 15–45

**Fox, C., 1930–1.** 'Saxon grave slab: Balsham, Cambridgeshire', ibid., XXXII, 51

**Fox, G. E., 1896.** 'The Roman coast fortresses of Kent', *Archaeol. J.*, LIII, 352–75

**Freke, D., 1981.** 'Excavations in the parish church of St Thomas the Martyr, Pagham, 1976', *Sussex Archaeol. Collect.*, CXVIII, 245–56

**Freyhan, R., 1956.** 'The place of the stole and maniple in Anglo-Saxon art of the tenth century' in Battiscombe 1956, 409–32

**Fuglesang, S. H., 1978.** 'Stylistic groups in late Viking art' in Lang 1978, 205–23

**Fuglesang, S. H., 1980.** *Some Aspects of the Ringerike Style.* Mediaeval Scandinavia Supplements, I (Odense)

**Gameson, R., and Gameson, F., 1993.** 'The Anglo-Saxon inscription at St Mary's church, Breamore, Hampshire' in W. Filmer-Sankey (ed.), *Anglo-Saxon Studies in Archaeology and History*, VI, 1–10

**Gardner, S., 1915–16.** 'English gothic foliage sculpture', *Proc. Cambridge Antiq. Soc.*, XX, 67–72

**Gardner, A., 1951.** *English Medieval Sculpture* (Cambridge)

**Garmonsway, G. N. (trans.), 1967.** *The Anglo-Saxon Chronicle* (London)

**Gatch, M. McC., 1971.** *Loyalties and Traditions: Man and his World in Old English Literature* (New York)

**Gatty, M., 1872.** *The Book of Sundials* (London)

**Gatty, M., 1889.** *The Book of Sundials* (2 ed., London)

**Gatty, M., 1900.** *The Book of Sundials* (4 ed., London)

**Gauthier, N. (ed.), 1985.** *Première Belgique* (H. I. Marrou (ed.), *Recueil des inscriptions chrétiennes de la Gaule antérieures à la renaissance carolingienne*, XV, Paris)

**Gem, R. D. H., 1973.** 'The origins of the early Romanesque architecture of England' (Unpublished Ph.D. thesis, 3 vols., University of Cambridge)

**Gem, R. D. H., 1980.** 'The Romanesque rebuilding of Westminster abbey' in R. A. Brown (ed.), *Proceedings of the Battle Conference on Anglo-Norman Studies*, III (Woodbridge), 31–60

**Gem, R. D. H., 1983.** 'The early Romanesque tower of Sompting church, Sussex' in R. A. Brown (ed.), *Anglo-Norman Studies*, V, *Proceedings of the Battle Conference 1982* (Woodbridge), 121–8

**Gem, R. D. H., 1991.** 'Tenth-century architecture in England', *Settimane di Studio del Centro Italiano di Studi sull'Alto Medioevo*, XXXVIII, 803–36

**Gem, R. D. H., and Keen, L., 1981.** 'Late Anglo-Saxon finds from the site of St Edmund's abbey', *Proc. Suffolk Inst. Archaeol.*, XXXV, 1–30

**Gem, R. D. H, and Tudor-Craig, P., 1981.** 'A "Winchester school" wall-painting at Nether Wallop, Hampshire', *Anglo-Saxon England*, IX, 115–36

**Gering, H., 1910.** 'Neue Schrifter zur Runenkunde', *Zeitschrift für Deutsche Philologie*, XLII, 236–50

**Gervers, V., 1984.** 'An early Christian curtain in the Royal Ontario Museum' in idem (ed.), *Studies in Textile History in Memory of Harold B. Burnham* (Toronto), 56–81

**Gibson, A. C., 1858–9.** 'Runic inscriptions, Anglo-Saxon and Scandinavian', *Trans. Hist. Soc. Lancashire Cheshire*, XI, 111–32

**Gilbert, E. C., 1954.** 'Deerhurst priory church revisited', *Trans. Bristol Gloucestershire Archaeol. Soc.*, LXXIII, 73–114

**Gneuss, H., 1981.** 'A preliminary list of manuscripts written or owned in England up to 1100', *Anglo-Saxon England*, IX, 1–60

**Goddard, E. H., 1893–4.** 'Notes on pre-Norman sculptured stones in Wiltshire', *Wiltshire Archaeol. Natur. Hist. Mag.*, XXVII, 43–9

**Goddard, E. H., 1904.** 'Early gravestones recently found at Trowbridge, Wiltshire', *Reliquary Illus. Archaeol.*, X, 63–4

**Godfrey, W. H., 1930–1.** 'Sussex church plans, XV—St Botolph (next Bramber)', *Sussex Notes Queries*, III, 218–9

**Godfrey, W. H., 1948.** 'The parish church of St Andrew, Bishopstone', *Sussex Archaeol. Collect.*, LXXXVII, 164–83

**Godfrey, W. H., 1957.** *Guide to the Church of St. Andrew, Bishopstone* (Oxford)

**Goldschmidt, A., 1914–23.** *Die Elfenbeinskulpturen aus der Zeit der karolingischen und sächsischen Kaiser, VIII-XI Jahrhundert* (3 vols., Berlin)

**Grabar, A., 1969.** *Christian Iconography, a Study of its Origins* (London and Henley)

**Graham, R., 1944.** 'Sidelights on the rectors and parishioners of Reculver from the register of archbishop Winchelsey', *Archaeol. Cantiana*, LVII, 1–12

**Graham-Campbell, J., 1980a.** *The Viking World* (London)

**Graham-Campbell, J., 1980b.** *Viking Artefacts: a Select Catalogue* (London)

**Graham-Campbell, J., and Kydd, D., 1980.** *The Vikings* (London)

**Gray, N., 1948.** 'The palaeography of Latin inscriptions in the eighth, ninth, and tenth centuries in Italy', *Papers of the British School at Rome*, XVI, 38–167

**Gray, N., 1986.** *A History of Lettering: Creative Experiment and Letter Identity* (Oxford)

**Green, A. R., 1926.** *Sundials* (London)

**Green, A. R., 1928.** 'Anglo-Saxon sundials', *Antiq. J.*, VIII, 489–516

**Green, A. R., 1943.** 'Incised dials, scratch dials or mass clocks on the walls of Hampshire churches', *Proc. Hampshire Fld. Club Archaeol. Soc.*, XV, 269–73

**Green, A. R., n. d.** *The Saxon Church at Breamore* (Breamore)

**Green, A. R., and Green, P. M., 1951.** *Saxon Architecture and Sculpture in Hampshire* (Winchester)

**Green, G. W., and Donovan, D. T., 1969.** 'The Great Oolite of the Bath area', *Bull. Geol. Surv. Gt Br.*, No. 30, 1–63

**Greenwell, W., and Haverfield, F. J., 1899.** *A Catalogue of the Sculptured and Inscribed Stones in the Cathedral Library, Durham* (Durham)

**Grienberger, T. von, 1900.** 'Neue Beiträge zur Runenlehre', *Zeitschrift für Deutsche Philologie*, XXXII, 289–304

**Gutberlet, H., 1935.** *Die Himmelfahrt Christi in der bildenden Kunst von den Anfängen bis in das hohe Mittelalter* (Strasbourg)

**Haigh, D. H., 1846.** 'Church notes taken in the neighbourhood of Winchester', *Trans. Brit. Archaeol. Ass., Second Annual Congress, Winchester 1845* (London), 407–14

**Haigh, D. H., 1855–7.** 'On the inscribed cross at Bewcastle in Cumberland', *Proc. Soc. Antiq. Newcastle-upon-Tyne*, I, 104–6

**Haigh, D. H., 1857.** 'The Saxon cross at Bewcastle', *Archaeol. Aeliana*, I, 149–95

**Haigh, D. H., 1861.** *The Conquest of Britain by the Saxons* (London)

**Haigh, D. H., 1870.** 'The Runic monuments of Northumbria', *Reps. Proc. Geolog. Polytechnic Soc. West Riding Yorkshire*, V, 178–217

**Haigh, D. H., 1872.** 'Notes in illustration of the runic monuments of Kent', *Archaeol. Cantiana*, VIII, 164–270

**Haigh, D. H., 1877.** 'On runic inscriptions discovered at Thornhill', *Yorkshire Archaeol. J.*, IV, 418–55

**Haigh, D. H., 1879.** 'On Yorkshire dials', ibid., V, 134–222

**Hall, R. A., 1984.** *The Viking Dig* (London)

**Hallström, G., 1931.** 'Böra runstenar och hällristningar uppmålas?', *Fornvännen*, XXVI, 257–83

**Hare, M. J., 1972.** 'An Anglo-Saxon grave cover at Cardington church', *Bedfordshire Archaeol. J.*, VII, 83–5

**Hare, M., 1980.** 'The Anglo-Saxon church and sundial at Harrington', *Proc. Hants. Field Club Archaeol. Soc.*, XXXVI, 193–202

**Harris, J., 1885.** 'Saxon font at South Hayling church, Hampshire', *J. Brit. Archaeol. Ass.*, XLI, 43

**Harris, J., 1886.** 'Saxon font at South Hayling church, Hayling Island, Hampshire', ibid., XLII, 65–7

**Harrison, J. P., 1888.** 'Recent discoveries in Oxford cathedral', *Archaeol. J.*, XLV, 271–83

**Harrison, J. P., 1893a.** 'Proceedings at meetings of the RAI', ibid., L, 106

**Harrison, J. P., 1893b.** 'English architecture before the Conquest', *Archaeol. Oxoniensis*, I, 121–42

**Harrison, A. C., and Williams, D., 1979.** 'Excavations at Prior's Gate house, Rochester 1976–77', *Archaeol. Cantiana*, XCV, 19–36

**Hartland, E. S., 1918–19.** 'Proceedings of the autumnal meeting at Cirencester', *Trans. Bristol Gloucestershire Archaeol. Soc.*, XLI, 141–62

**Hastead, E., 1778–99.** *The History and Topographical Survey of the County of Kent* (Canterbury)

**Hawkes, S., 1986.** 'The early Saxon period' in G. Briggs, J. Cook, and T. Rowley (eds.), *The Archaeology of the Oxford Region* (Oxford), 64–105

**Hawkes, S. C., and Page, R. I., 1967.** 'Swords and runes in south-east England', *Antiq. J.*, XLVII, 1–26

**Heales, A., 1869.** 'Godalming church', *Surrey Archaeol. Collect.*, IV, 194–213

Hemp, W. J., 1925. 'Notes on Llangwm Uchaf church, Mon.', *Antiq. J.*, V, 433–5

Henry, F., 1964. *Croix Sculptées Irlandaises* (Dublin)

Heron-Allen, E., 1911. *Selsey Bill: Historical and Prehistoric* (London)

Heron-Allen, E., 1935. *The Parish Church of St Peter on Selsey Bill, Sussex* (Selsey)

Heslop, T. A., 1990. 'The production of *de luxe* manuscripts and the patronage of king Cnut and queen Emma', *Anglo-Saxon England*, XIX, 151–95

Higgitt, J. C., 1973. 'The Roman background to medieval England', *J. Brit. Archaeol. Ass.*, XXXVI, 1–15

Higgitt, J. C., 1979. 'The dedication inscription at Jarrow and its context', *Antiq. J.*, LIX, 343–74

Higgitt, J., 1982. 'The Pictish Latin inscription at Tarbat in Ross-shire', *Proc. Soc. Antiq. Scotland*, CXII, 300–21

Higgitt, J., 1983. 'The Thornton le Moors inscription', *J. Chester Archaeol. Soc.*, LXVI, 26–9

Higgitt, J., 1986. 'Words and crosses: the inscribed stone cross in early medieval Britain and Ireland' in idem (ed.), *Early Medieval Sculpture in Britain and Ireland* (Brit. Archaeol. Rep., Brit. ser., CLII), 125–52

Higgitt, J., 1990. 'The stone-cutter and the scriptorium: early medieval inscriptions in Britain and Ireland' in W. Koch (ed.), *Epigraphik 1988: Fachtagung für mittelalterliche und neuzeitliche Epigraphik, Graz, 10–14 Mai 1988* (Österreichische Akademie der Wissenschaften, philosophisch-historische Klasse, Denkschriften CCXIII (Vienna)), 149–62

Higgitt, J., 1994. 'The display script of the Book of Kells and the tradition of Insular decorative capitals' in F. O'Mahony (ed.), *The Book of Kells. Proceedings of a Conference at Trinity College Dublin, 6–9 September 1992* (Aldershot), 209–33

Hill, A. du B., 1897a. 'Annual meeting at Dorchester', *Archaeol. J.*, LIV, 408–9

Hill, A. du B., 1897b. 'The Royal Archaeological Institute at Dorchester', *Athenaeum*, no. 3642, 231–3

Hill, A. du B., 1898. 'A Saxon church at Breamore, Hampshire', *Archaeol. J.*, LV, 84–7

Hill, D. (ed.), 1978. *Ethelred the Unready: Papers from the Millenary Conference* (Brit. Archaeol. Rep., Brit. ser., LIX)

Hinde, H. (ed.), 1867. *Symeonis Dunelmensis Opera et Collectanea* (Surtees Soc., LI)

Hines, J., 1990. 'The runic inscriptions of early Anglo-Saxon England' in A. Bammesberger and A. Wollmann (eds.), *Britain 400–600: Language and History* (Heidelberg), 437–55

Hinton, D. A., 1974. *A Catalogue of the Anglo-Saxon Ornamental Metalwork 700–1100 in the Department of Antiquities, Ashmolean Museum* (Oxford)

Hinton, D. A., 1977. *Alfred's Kingdom: Wessex and the South 800–1500* (London)

Hobley, B., 1986. *Roman and Saxon London* (London)

Hodges, C. C., 1893. 'The pre-Conquest churches of Northumbria', *Reliquary*, VII, 1–18, 65–85, 140–56

Hogarth, A. C., 1973. 'Structural features in Anglo-Saxon graves', *Archaeol. J.*, CXXX, 104–19

Holder-Egger, O. (ed.), 1887. *Vita Willibaldi Episcopi Eichstatensis.* Monumenta Germaniae Historica, Scriptores, XV (Berlin), 86–106

Holländer, H., 1974. *Early Medieval Art* (London)

Holmqvist, W., 1951. 'Viking art in the eleventh century', *Acta Archaeologica*, XXII, 1–56

Home, G., 1904. *Oxted, Limpsfield and Edenbridge* (London)

Hooper, W., 1945. *Reigate: its Story Through the Ages* (Guildford)

Hope, W. H. St. J., 1902. 'Excavations at St Austin's abbey, Canterbury: (1) The chapel of St Pancras', *Archaeol. Cantiana*, XXV, 222–37

Hope, W. St. J., 1917. 'Recent discoveries in the abbey church of St Austin at Canterbury', *Archaeol. Cantiana*, XXXII, 1–26

Horsefield, T. W., 1835. *The History, Antiquities and Topography of the County of Sussex* (Lewes and London)

Hougen, B., 1940. 'Osebergfunnets billedvev', *Viking*, IV, 85–124

Hubert, J., Porcher, J., and Volbach, W. F., 1969. *Europe in the Dark Ages* (London)

Hubert, J., Porcher, J., and Volbach, W. F., 1970. *Carolingian Art* (London)

Hübner, A., 1876. *Inscriptiones Britanniae Christianae* (Berlin and London)

Hudd, A. E., 1887. 'On the Saxon baptismal font in Deerhurst priory church', *Trans. Bristol Gloucestershire Archaeol. Soc.*, XI, 84–104

Hughes, M., 1976. *The Small Towns of Hampshire* (Winchester)

Hunting, P., 1981. *Royal Westminster* (London)

Hussey, A., 1852. *Notes on the Churches in the Counties of Kent, Sussex and Surrey Mentioned in Domesday Book* (London)

Insley, J., 1991. 'The Scandinavian runic inscriptions of the older fuþark and Old English personal names' in A. Bammesberger (ed.), *Old English Runes and their Continental Background* (Heidelberg), 309–34

Irvine, J. T., 1877a. 'Notes on Britford church', *J. Brit. Archaeol. Ass.*, XXXIII, 215–9

Irvine, J. T., 1877b. 'Description of the Saxon church of Boarhunt in Hampshire', *J. Brit. Archaeol. Ass*, XXXIII, 367–80

Jackson, E. D. C., and Fletcher, E. G. M., 1962. 'The apse and nave at Wing, Buckinghamshire', *J. Brit. Archaeol. Ass.*, ser. 3, XXV, 1–20

Jacobs, N., 1977. 'Anglo-Danish relations, poetic archaism and the date of Beowulf', *Poetica*, VII, 23–43

Jacobsen, L., and Moltke, E., 1941–2. *Danmarks Runeindskrifter* (Copenhagen)

James, E., 1977. *The Merovingian Archaeology of South-West Gaul* (2 vols., Brit. Archaeol. Rep., supplementary ser., XXV)

Jansson, S. B. F., 1962. *The Runes of Sweden* (London)

Jenkins, F., 1975–6. 'Preliminary report on the

excavations on the church of St Pancras at Canterbury', *Canterbury Archaeol. 1975–6*, 4–5

**Jessep, H. L., 1913.** *Notes on pre-Conquest Church Architecture in Hampshire and Surrey* (Winchester)

**Jessep, H. L., 1914.** *Anglo-Saxon Church Architecture in Sussex* (Winchester)

**Jessup, R. F., 1930.** *The Archaeology of Kent* (London)

**Jessup, R. F., 1936.** 'Reculver', *Antiquity*, X, 179–94

**Jewell, R. H. I., 1986.** 'The Anglo-Saxon friezes at Breedon-on-the-Hill, Leicestershire', *Archaeologia*, CVIII, 67–94

**Johnston, P. M., 1900a.** 'Ford and its church', *Sussex Archaeol. Collect.*, XLIII, 105–57

**Johnston, P. M., 1900b.** 'Some curiosities and interesting features of Surrey ecclesiology', *Surrey Archaeol. Collect.*, XV, 51–79

**Johnston, P. M., 1904.** 'A pre-Conquest coffin slab from Arundel castle', *Sussex Archaeol. Collect.*, XLVII, 148–50

**Johnston, P. M., 1905.** 'A pre-Conquest grave-slab at Bexhill', ibid., XLVIII, 153–55

**Johnston, P. M., 1907.** 'Stoke D'Abernon church', *Surrey Archaeol. Collect.*, XX, 1–89

**Johnston, P. M., 1912.** 'Chithurst church', *Sussex Archaeol. Collect.*, XL, 97–107

**Johnston, P. M., 1913.** *A Schedule of the Antiquities of Surrey* (Guildford)

**Johnston, P. M., 1915.** 'Steyning church', *Sussex Archaeol. Collect.*, LVII, 149–61

**Johnston, P. M., 1921.** 'Cocking and its church', *Archaeol. J.*, LXXVIII, 174–204

**Johnston, P. M., 1926.** 'The parish church of All Saints Kingston-upon-Thames', *J. Brit. Archaeol. Ass.*, XXXII, 229–47

**Jones, G., 1973.** *A History of the Vikings* (London)

**Jope, E. M., 1964.** 'The Saxon building-stone industry in southern and midland England', *Medieval Archaeol.*, VIII, 91–118

**Jörg, C., 1984.** *Die Inschriften der Kantone Freiburg, Genf, Jura, Neuenburg und Waadt* (Corpus Inscriptionum Medii Aevi Helvetiae, II (Freiburg))

**Jukes-Browne, A. J., 1900.** *The Cretaceous Rocks of Britain, I: The Gault and Upper Greensand of England* (Memoirs of the Geological Survey of the United Kingdom, London)

**Kahn, D., 1992.** 'Anglo-Saxon and early Romanesque frieze sculpture in England' in eadem (ed.), *The Romanesque Frieze and its Spectator* (London), 61–74

**Kauffmann, C. M., 1975.** *Romanesque Manuscripts 1066–1190* (A Survey of Manuscripts Illuminated in the British Isles, III, London)

**Kemble, J. M., 1840.** 'On Anglo-Saxon runes', *Archaeologia*, XXVIII, 327–72

**Kemble, J. M., 1844.** 'Additional observations on the runic obelisk at Ruthwell, the poem of the Dream of the Holy Rood; and a Runic copper dish found at Chertsey', ibid., XXX, 31–46

**Kendrick, T. D., 1930.** *A History of the Vikings* (London)

**Kendrick, T. D., 1938.** *Anglo-Saxon Art to A.D. 900* (London)

**Kendrick, T. D., 1940.** 'Instances of Saxon survival in post-Conquest stone sculpture', *Proc. Cambridge Antiq. Soc.*, XXXIX, 78–84

**Kendrick, T. D., 1941.** 'The Viking taste in pre-Conquest England', *Antiquity*, XV, 125–41

**Kendrick, T. D., 1949.** *Late Saxon and Viking Art* (London)

**Kendrick, T. D., and Hawkes, C. F. C., 1932.** *Archaeology in England and Wales, 1914–31* (London)

**Kendrick, T. D., and Radford, C. A. R., 1943.** 'Recent discoveries at All Hallows, Barking', *Antiq. J.*, XXXIII, 14–18

**Kennedy, C. W., 1943.** *The Earliest English Poetry* (Oxford)

**Kent, W. R. G., 1947.** *The Lost Treasures of London* (London)

**Ker, N. R., 1957.** *Catalogue of Manuscripts Containing Anglo-Saxon* (Oxford)

**Keynes, S., and Lapidge, M. (ed. and trans.), 1983.** *Alfred the Great* (Harmondsworth)

**Keyser, C. E., 1904.** *A List of Norman Tympana and Lintels in the Churches of Great Britain* (London)

**King, H. W., 1851.** 'Proceedings of the Association, January 5th, 1851', *J. Brit. Archaeol. Ass.*, VII, 75–82

**King, L., 1942–5.** 'Quarterly meeting and excursion, Saturday, 8th July, 1939', *Trans. Essex Archaeol. Soc.*, XXIII, 229–32

**King, R. J., 1876.** 'Runes and rune stones', *Fraser's Mag.*, XIII, 747–57

**Kirby, D. P., 1978.** 'The church in Saxon Sussex' in P. Brandon (ed.), *The South Saxons* (London and Chichester)

**Kjølbye-Biddle, B., 1975.** 'A cathedral cemetery: problems in excavation and interpretation', *World Archaeology*, VII (1), 87–108

**Kjølbye-Biddle, B., 1986.** 'The 7th-century minster at Winchester interpreted' in Butler and Morris 1986, 196–209

**Kjølbye-Biddle, B., 1992.** 'Dispersal or concentration: the disposal of the Winchester dead over 2000 years' in Bassett 1992, 210–47

**Kjølbye-Biddle, B., and Page, R. I., 1975.** 'A Scandinavian rune-stone from Winchester', *Antiq. J.*, LV, 389–94

**Knocker, F., 1932.** *Illustrated Official Guide to Dover Corporation Museum* (Dover)

**Knowles, D., 1963.** *The Monastic Order in England: a History of its Development from the Times of St. Dunstan to the Fourth Lateran Council* (2 ed., Cambridge)

**Knowles, J. T., 1852.** 'Ancient stone found in St Paul's churchyard', *Illus. London News*, no. 576, 157

**Knowles, J. T., 1853.** 'Proceedings of the Society of Antiquaries of London, Thursday, January 13th, 1853', *Proc. Soc. Antiq. London*, II, 284–6

**Købke, P., 1879.** *Om Runerne i Norden* (Copenhagen)

**Kozodoy, R. L., 1976.** 'The Reculver cross' (Unpublished Ph. D. thesis, Columbia University)

**Kozodoy, R., 1986.** 'The Reculver cross', *Archaeologia*, CVIII, 67–94

**Krämer, K., 1974.** *Die frühchristlichen Grabinschriften Triers* (Trierer Grabungen und Forschungen, VIII (Mainz am Rhein))

**Krautheimer, R., 1975.** *Early Christian and Byzantine Architecture* (Harmondsworth)

**Laing, L., and Laing, J., 1979.** *Anglo-Saxon England* (London and Henley)

**Lamborn, A. E. G., 1935.** 'A note on a fragment of an Anglo-Saxon wheel cross found at Abingdon', *Berkshire Archaeol. J.*, XXXIX, 58–9

**Lamborn, A. E. G., 1937.** 'The Wantage crosses', ibid., LI, 122–4

**Lang, J. T., 1976.** 'Sigurd and Weland in pre-Conquest carving from northern England', *Yorkshire Archaeol. J.*, XLVIII, 83–94

**Lang, J. T. (ed.), 1978.** *Anglo-Saxon and Viking Age Sculpture and its Context* (Brit. Archaeol. Rep., Brit. ser., XLIX)

**Lang, J. T., 1984.** 'The hogback: a Viking colonial monument' in Hawkes, S. C., Campbell, J., and Brown, D. (eds.), *Anglo-Saxon Studies in Archaeology and History*, III (Oxford), 85–176

**Lang, J. T., 1991.** *Corpus of Anglo-Saxon Stone Sculpture*, III, *York and Eastern Yorkshire* (Oxford)

**Langdon, A. G., 1910.** 'Two early sculptured stones in St Stephen's church, Launceston', *Devon Cornwall Notes Queries*, VI, 81–3

**Langdon, A. G., and Allen, J. R., 1888.** 'Early Christian monuments of Cornwall', *J. Brit. Archaeol. Ass.*, XLIV, 301–15

**Langdon, A. G., and Allen, J. R., 1902.** 'The font at Dolton, Devon', *Reliquary Illus. Archaeol.*, VIII, 243–56

**Langley, B., and Langley, T., 1790.** *Gothic Architecture Improved by Rules and Proportions* (London)

**Lapidge, M., 1975.** 'Some remnants of Bede's lost Liber Epigrammatum', *English Historical Review*, XC, 798–820

**Lapidge, M., forthcoming.** *The Cult of St Swithun* (Winchester Studies, IV (2), Oxford)

**Larkby, J. R., 1902.** 'The churches of Hayling Island', *Reliquary Illus. Archaeol.*, VIII, 257–71

**Lasko, P., 1972.** *Ars Sacra 800–1200* (Harmondsworth)

**Le Blant, E. (ed.), 1856–65.** *Inscriptions chrétiennes de la Gaul antérieures au VIIIᵉ siècle* (2 vols., Paris)

**Le Blant, E., 1896.** 'Paléographie des inscriptions latines du IIIᵉ siècle à la fin du VIIᵉ', *Revue Archéologique*, troisième série, XXIX (1896), 177–97, 345–55; XXX (1897), 30–40, 171–84; XXXI (1897), 172–84

**Leeny, O. H., 1911.** 'The church of Bishopstone, Sussex', *Antiquary*, XLVII, 369–74

**Legge, W. H., 1901.** 'The villages and churches of the hundred of Willingdon, Sussex', *Reliquary Illus. Archaeol.*, VII, 145–57

**Legge, W. H., 1903.** 'The ancient church at Bishopstone', ibid., IX, 173–85

**Legge, W. H., 1905.** 'Fragmenta Antiquitatis in some Sussex churches', ibid., XI, 1–13

**Leland, J. (ed. L. Toulmin Smith), 1964.** *The Itinerary of John Leland* (2 ed., London)

**Lethaby, W. R., 1902.** *London Before the Conquest* (London)

**Leveson Gower, G., 1893.** 'Stone crosses from Titsey, Oxted and Tandridge', *Sussex Archaeol. Collect.*, XI, 30–7

**Levison, W., 1946.** *England and the Continent in the Eighth Century* (Oxford)

**Lewis, A. L., 1880.** 'A kitchen midden at Pevensey castle', *J. Archaeol. Ass.*, XXXVI, 445–6

**Lewis, B., 1877.** 'The antiquities of Scandinavia', *Archaeol. J.*, XXXIV, 242

**Light, A., and Dampney, I., 1980.** *A Short History of the Village of Breamore* (Breamore)

**Lind, E. H., 1905–15.** *Norsk-Isländska Dopnamn ock Fingerade Namn från Medeltiden* (Uppsala and Leipzig)

**Lindqvist, S., 1915.** *Den Helige Eskils Biskopsdöme* (Stockholm)

**Lindqvist, S., 1931.** 'Yngre Vikingastilar' in H. Shetelig (ed.), *Kunst. Nordisk Kultur*, XXVII (Oslo), 144–79

**Liveing, H. G. D., 1906.** *Records of Romsey Abbey* (Winchester)

**Livett, G. M., 1889.** 'Foundations of the Saxon cathedral church at Rochester', *Archaeol. Cantiana*, XVIII, 261–78

**Livett, G. M., 1932.** 'Sculptured stone from Reculver', *Kentish Gazette and Canterbury Press*, January 9th 1932, cols. 3–4

**Lobel, M. D. (ed.), 1957.** *The Victoria History of the County of Oxford*, V, *Bullingdon Hundred* (The Victoria History of the Counties of England, London)

**Longcroft, C. J., 1856.** *A Topographical Account of the Hundred of Bosmere* (London)

**Longhurst, M. H., 1926.** *English Ivories* (London)

**Lower, M. A., 1840.** 'Sundial at Bishopstone church, Sussex', *Gents. Mag.*, XIV, 496

**Lower, M. A., 1870.** *A Compendious History of Sussex* (London and Brighton)

**Loyn, H. R., 1977.** *The Vikings in Britain* (London)

**Loyn, H. R., 1991.** *Anglo-Saxon England and the Norman Conquest* (2 ed., London)

**Luard, H. R. (ed.), 1865.** *Annales Monastici*, II, *Annales Monasterii de Wintonia . . .* (London)

**Lynham, C., 1886.** 'A Brighton congress note', *J. Brit. Archaeol. Ass.*, XLII, 304–5

**Lynham, C., 1899.** 'Proceedings of the congress, Tuesday, July 19th, 1898', *J. Brit. Archaeol. Ass.*, V, 185

**Lysons, D., 1792–6.** *The Environs of London* (London)

**McCaul, J., 1870.** 'The sarcophagus of Valerius Amandinus', *Archaeol. J.*, XXVII, 110–18

**MacKay, T. F., 1963.** 'Anglo-Saxon architecture and sculpture in the Cotswold area', *Trans. Bristol Gloucestershire Archaeol. Soc.*, LXXXII, 66–94

**MacKenzie, W. M., 1937.** 'The dragonesque figure in Maeshowe, Orkney', *Proc. Soc. Antiq. Scot.*, LXXI, 157–73

**McKitterick, R. (ed.), 1990.** *The Uses of Literacy in Early Medieval Europe* (Cambridge)

**Macready, S., and Thompson, F. H. (ed.), 1986.** *Art and Patronage in the English Romanesque* (Society of Antiquaries of London, Occasional Paper, n. ser., VIII, London)

**Maillé (Marquise de), 1971.** *Les Cryptes de Jouarre* (Paris)

**Malcolm, J. P., 1793.** 'Curiosities in Stepney church', *Gents. Mag.*, LXIII, 713–4

**Malden, H. E. (ed.), 1905.** *The Victoria History of the County of Surrey,* II (The Victoria History of the Counties of England, London)

**Malden, H. E. (ed.), 1911.** *The Victoria History of the County of Surrey,* III (The Victoria History of the Counties of England, London)

**Mâle, E., 1928.** *L'Art religieux du XIIᵉ siècle en France* (Paris)

**Mantell, Lady, 1834.** 'Appendix', *Archaeologia*, XXV, 604

**March, H. C., 1912–13.** 'Scando-Gothic art in Wessex', *Dorset Natur. Hist. Antiq. Fld. Club*, XXXIV, 1–16

**Marquardt, H., 1961.** *Bibliographie der Runeninschriften nach Fundorten, I, die Runeninschriften der Britischen Inseln* (Göttingen)

**Marshall, J. G., 1900.** 'Lullington church, Somerset', *Archaeol. J.*, LVII, 166–9

**Marstrander, C. J. S., 1929.** 'De gotiske runeminnesmerker', *Norsk Tidsskrift for Sprogvidenskap*, III, 25–157

**Marucchi, O., 1912.** *Christian Epigraphy: an Elementary Treatise with a Collection of Ancient Christian Inscriptions mainly of Roman Origin* (Cambridge)

**Mason, C., 1907.** 'Romsey abbey', *Reliquary Illus. Archaeol.*, XIII, 253–64

**Mayr-Harting, H., 1972.** *The Coming of Christianity to Anglo-Saxon England* (London)

**Mee, A., 1936.** *The King's England, Kent* (London)

**Mee, A., 1937.** *The King's England, Sussex* (London)

**Mee, A., 1938.** *The King's England, Surrey* (London)

**Melville, R. V., and Freshney, E. C., 1982.** *British Regional Geology: The Hampshire Basin and Adjoining Areas* (London)

**Merrifield, R., 1975.** *The Archaeology of London* (London)

**Meyvaert, P., 1979.** 'Bede and the church paintings at Wearmouth-Jarrow', *Anglo-Saxon England*, VIII, 63–77

**Micklethwaite, J. T., 1896.** 'Something about Saxon church building', *Archaeol. J.*, LIII, 293–351

**Micklethwaite, J. T., 1898.** 'Some further notes on Saxon churches', ibid., LV , 340–9

**Milner, J., 1798–9.** *The History Civil and Ecclesiastical and Survey of Antiquities of Winchester* (2 vols., Winchester)

**Milojčić, V. (ed.), 1968.** *Kolloquium über spätantike und frühmittelalterliche Skulptur, I* (Mainz)

**Milojčić, V. (ed.), 1970.** *Kolloquium über spätantike und frühmittelalterliche Skulptur, II* (Mainz)

**Milojčić, V. (ed.), 1972.** *Kolloquium über spätantike und frühmittelalterliche Skulptur, III* (Mainz)

**Minns, E. H., 1942.** 'The art of the northern nomads', *Proc. Brit. Acad.*, XXVIII, 3–54

**Minns, G. W., 1899–1900.** 'On a Saxon sepulchral monument at Whitchurch', *Proc. Hampshire Fld. Club Archaeol. Soc.*, IV, 171–4

**Mitchell, J., 1990.** 'Literacy displayed: the use of inscriptions at the monastery of San Vincenzo al Volturno in the early ninth century' in McKitterick 1990, 186–225

**Moe, O. H., 1955.** 'Urnes and the British Isles: a study of western impulses in Nordic styles of the eleventh century', *Acta Archaeologica*, XXVI, 1–30

**Moltke, E., 1985.** *Runes and their Origin: Denmark and Elsewhere* (Copenhagen)

**Morlet, M.-T., 1968–85.** *Les noms de personne sur le territoire de l'ancienne Gaule du VIᵉ au XIIᵉ siècle* (3 vols., Paris)

**Moulden, J., and Tweddle, D., 1986.** *Anglo-Scandinavian Settlement South-West of the Ouse: The Archaeology of York,* VIII (1) (Council for British Archaeology, London)

**Munch, P., 1852.** 'En Nordisk Runsteen funden i London', *Illustreret Nyhedsblad*, I, 209–10

**Musset, L., 1974.** *Normandie Romane, La Haute-Normandie* (La Pierre-qui-Vire)

**Musset, L., and Mossé, F., 1965.** *Introduction à la Runologie* (Paris)

**Mütherich, F., and Gaehde, J., 1977.** *Carolingian Painting* (London)

**Nairn, I., and Pevsner, N., 1965.** *The Buildings of England. Sussex* (Harmondsworth)

**Nairn, I., 1971.** *The Buildings of England. Surrey* (Harmondsworth)

**Napier, A. S., 1903–6.** 'Contributions to Old English lexicography', *Trans. Philolog. Soc.*, XXV, 265–358

**Nash-Williams, V. E., 1950.** *The Early Christian Monuments of Wales* (Cardiff)

**Neale, J., 1877.** *The Abbey Church of St Alban, Hertfordshire* (London)

**Neckel, G. (ed.), 1927.** *Edda. Die Lieder des Codex Regius nebst verwandten Denkmälern* (Germanische Bibliothek, II (9), Heidelberg)

**Neckel, G., 1928.** 'Runische schmuckformen', *Buch und Schrift, Jahrbuch des deutschen Verein für Buchwesen und Schriften* II, 31–8

**Nevill, R., 1880.** 'Notes on the restoration of Godalming church', *Surrey Archaeol. Collect.*, VII, 277–87

**Newman, J., 1976.** *The Buildings of England. North East and East Kent* (Harmondsworth)

**Nisbett, N. C. H., 1891–3.** 'Notes on some examples of Saxon architecture in Hampshire', *Proc. Hampshire Fld. Club Archaeol. Soc.*, II, 309–16

**Nisbett, N. C. H., 1905–7.** 'Some notes on Warnford church', ibid., V, 37–46

**Nordenfalk, C., 1977.** *Celtic and Anglo-Saxon Painting* (London)

**Nylén, E., 1978.** *Bildstenar* (Visby)

**Oakeshott, W., 1945.** *The Artists of the Winchester Bible* (London)

**Oakeshott, W., 1967.** *The Mosaics of Rome from the Third to the Fourteenth Centuries* (London)

**Oddy, W. A., 1990.** 'The conservation of the Winchester Anglo-Saxon fragment' in Cather *et al.* 1990, 65–71

**Ogilvy, J. D. A., 1967.** *Books Known to the English, 597–1066* (Cambridge, Mass.)

**Ohlgren, T. H. (ed.), 1983.** 'Index to Iconographic Subjects in Anglo-Saxon Manuscripts *c.* 600 to 1100 AD' (unpublished manuscript draft, revised 1983)

**Ohlgren, T. H. (ed.), 1986.** *Insular and Anglo-Saxon Illuminated Manuscripts: An Iconographic Catalogue c. A.D. 625–1100* (New York and London)

**Okasha, E., 1967.** 'An Anglo-Saxon inscription from All Hallows, Barking-by-the-Tower, London', *Medieval Archaeol.*, XI, 249–51

**Okasha, E., 1968.** 'The non-runic scripts of Anglo-Saxon inscriptions', *Trans. Cambridge Bibliographical Soc.*, IV, 321–38

**Okasha, E., 1969.** 'Notes on some Anglo-Saxon architectural sculpture', *J. Brit. Archaeol. Ass.*, XXXII, 26–9

**Okasha, E., 1971.** *A Hand-List of Anglo-Saxon Non-Runic Inscriptions* (Cambridge)

**Okasha, E., 1983.** 'A supplement to *Hand-List of Anglo-Saxon Non-Runic Inscriptions*', *Anglo-Saxon England*, XI, 83–118

**Okasha, E., 1985.** 'The non-ogam inscriptions of Pictland', *Cambridge Medieval Celtic Studies*, IX, 43–69

**Okasha, E., 1992a.** 'A second supplement to *Hand-List of Anglo-Saxon Non-Runic Inscriptions*', *Anglo-Saxon England*, XXI, 37–85

**Okasha, E., 1992b.** 'The English language in the eleventh century: the evidence from inscriptions' in C. Hicks (ed.), *England in the Eleventh Century* (Harlaxton Medieval Studies, II (Stamford)), 333–45

**Okasha, E., 1993.** *Corpus of Early Christian Inscribed Stones of South-west Britain* (London and New York)

**O'Meadhra, U., 1987.** 'Irish, Insular, Saxon and Scandinavian elements in the motif pieces from Ireland', in M. Ryan (ed.), *Ireland and Insular Art A.D. 500–1200* (Dublin), 159–65

**Ørsnes, M., 1968.** 'Ole Klint-Jensen og David M. Wilson, Vikingetidens Kunst', *Mediaeval Scandinavia*, I, 204–13

**Owen, O. A., 1979.** 'A catalogue and re-evaluation of the Urnes style in England' (Unpublished M.A. thesis, University of Durham)

**Page, R. I., 1959.** 'Language and dating in Old English inscriptions', *Anglia, Zeitschrift für Englische Philologie*, LXXVII, 385–406

**Page, R. I., 1960.** '*Runes, an Introduction*, by R. W. V. Elliott', *Medieval Archaeol.*, IV, 168–70

**Page, R. I., 1964.** 'The inscriptions' in Wilson 1964, 67–90

**Page, R. I., 1967.** 'Note on the inscription' in Bowen and Page 1967, 289–91

**Page, R. I., 1969.** 'Runes and non-runes' in Pearsall and Waldron 1969, 28–54

**Page, R. I., 1971.** 'How long did the Scandinavian language survive in England? The epigraphical evidence' in Clemoes and Hughes 1971, 165–81

**Page, R. I., 1973.** *An Introduction to English Runes* (London)

**Page, R. I., 1985.** 'Runic links across the North Sea in the pre-Viking Age' in H. Bekker-Nielsen and H. F. Nielsen (eds.), *Beretning fra fjerde tværfaglige Vikingesymposium* (Forlaget Hikuin, Odense Universtet, Odense), 31–49

**Page, R. I., 1987.** *Runes* (London)

**Page, W. (ed.), 1905.** *The Victoria History of the County of Surrey*, II (The Victoria History of the Counties of England, London)

**Page, W. (ed.), 1907.** *The Victoria History of the County of Sussex*, II (The Victoria History of the Counties of England, London)

**Page, W. (ed.), 1908a.** *The Victoria History of Hampshire and the Isle of Wight*, III (The Victoria History of the Counties of England, London)

**Page, W. (ed.), 1908b.** *The Victoria History of Hertfordshire*, II (The Victoria History of the Counties of England, London)

**Page, W. (ed.), 1908c.** *The Victoria History of the County of Kent*, I (The Victoria History of the Counties of England, London)

**Page, W. (ed.), 1909.** *The Victoria History of London, including London within the Bars, Westminster, and Southwark*, I (The Victoria History of the Counties of England, London)

**Page, W. (ed.), 1911.** *The Victoria History of Hampshire and the Isle of Wight*, IV (The Victoria History of the Counties of England, London)

**Page, W. (ed.), 1912a.** *The Victoria History of Hampshire and the Isle of Wight*, V (The Victoria History of the Counties of England, London)

**Page, W. (ed.), 1912b.** *The Victoria History of the County of Bedford*, III (The Victoria History of the Counties of England, London)

**Page, W. (ed.), 1912c.** *The Victoria History of the County of Hertford*, III (The Victoria History of the Counties of England, London)

**Page, W. (ed.), 1914.** *The Victoria History of the County of Hertford*, IV (The Victoria History of the Counties of England, London)

**Page, W., 1915.** 'Some remarks on the churches of Domesday Surrey', *Archaeologia*, LXVI, 61–102

**Page, W. (ed.), 1925.** *The Victoria History of the County of Buckingham*, III (The Victoria History of the Counties of England, London)

**Page, W., and Ditchfield, P. H. (eds.), 1923.** *The Victoria History of the County of Berkshire*, III (The Victoria History of the Counties of England, London)

**Page, W., and Ditchfield, P. H. (eds.), 1924.** *The Victoria History of the County of Berkshire*, IV (The Victoria History of the Counties of England, London)

**Palmer, J. L., 1883.** *Notes on Runes. A Paper Read Before the Literary and Philosophical Society of Liverpool during its 73rd Session* (Liverpool)

**Parsons, D., 1994.** 'Sandwich: the oldest Scandinavian rune-stone in England?' in B. Ambrosiani and H. Clarke (eds.), *The Twelfth Viking Congress. Developments Around the Baltic and the North Sea in the Viking Age*, Birka Studies 3 (Stockholm), 310–20

**Parsons, D. W. (ed.), 1975.** *Tenth-Century Studies* (London and Chichester)

**Parsons, D. W., 1990a.** 'Review and prospect: the stone industry in Roman, Anglo-Saxon and medieval England' in Parsons 1990b, 1–15

**Parsons, D. W. (ed.), 1990b.** *Stone: Quarrying and Building in England AD 43–1525* (Chichester)

**Parsons, J., 1958.** 'Orpington Historical Records and Natural History Society, archaeological report 1957–8', *Archaeol. Cantiana*, LXXII, 209–11

**Pattison, I. R., 1973.** 'The Nunburnholme cross and Anglo-Danish sculpture in York', *Archaeologia*, CIV, 209–34

**Paues, A. C., 1911.** 'The name of the letter ȝ', *The Modern Language Review*, VI, 441–54

**Paulsen, P., 1992.** *Die Holzfunde aus dem Gräberfeld bei Oberflacht* (Forschungen und Berichte zur Vor- und Frühgeschichte in Baden-Württemberg, XLI (2), Stuttgart)

**Peake, H., 1931.** *The Archaeology of Berkshire* (London)

**Pearsall, D. A., and Waldron, R. A. (eds.), 1969.** *Medieval Literature and Civilisation* (London)

**Peers, C. R., 1901.** 'Saxon churches of the St Pancras type', *Archaeol. J.*, LVII, 402–34

**Peers, C. R., 1927a.** 'St Augustine's abbey church, Canterbury, before the Norman Conquest', *Archaeologia*, LXXVII, 201–18

**Peers, C. R., 1927b.** 'Reculver, its Saxon church and cross', ibid., LXXVII, 241–56

**Peers, C. R., 1929.** 'The earliest Christian churches in England', *Antiquity*, III, 65–74

**Penn, I. E., and Wyatt, R. J., 1979.** 'The stratigraphy and correlation of the Bathonian strata in the Bath-Frome area' in Penn, I. E., Merriman, R. J., and Wyatt, R. J., *The Bathonian Strata of the Bath-Frome Area* (Rep. Inst. Geol. Sci., No. 78/22), 22–88

**Pepys, W. L., and Godman, E., 1905.** *The Church of St. Dunstan Stepney* (Survey of the Memorials of Greater London, vi, London)

**Perkins, T., 1907.** *A Short Account of Romsey Abbey, a Description of the Fabric and Notes on the History of the Convent of SS. Mary and Ethelfleda* (London)

**Petrucci, A., 1980.** 'La scrittura fra ideologia e rappresentazione' in F. Zeri (ed.), *Grafica e Immagine*, Part I, *Scrittura, Miniatura, Disegno* (Storia dell'Arte Italiana, Parte terza, Situazioni, Momenti, Indagini (6 vols., Turin)), II, 5–123

**Pevsner, N., 1953.** *The Buildings of England. Hertfordshire* (Harmondsworth)

**Pevsner, N., 1954.** *The Buildings of England. Essex* (Harmondsworth)

**Pevsner, N., 1957.** *The Buildings of England. The Cities of London and Westminster* (Harmondsworth)

**Pevsner, N., 1966.** *The Buildings of England. Berkshire* (Harmondsworth)

**Pevsner, N., 1968.** *The Buildings of England. Bedfordshire and the County of Huntingdon and Peterborough* (Harmondsworth)

**Pevsner, N., 1972.** *Some Architectural Writers of the Nineteenth Century* (Oxford)

**Pevsner, N., and Cherry, B., 1977.** *The Buildings of England. Hertfordshire* (Harmondsworth)

**Pevsner, N., and Lloyd, D. W., 1967.** *The Buildings of England. Hampshire and the Isle of Wight* (Harmondsworth)

**Piggott, S., 1934–7.** 'A Saxon cross shaft fragment from Wantage', *Trans. Newbury Dist. Fld. Club*, VII, 149–50

**Ploss, E. E., 1966.** *Siegfried-Sigurd, der Drachenkämpfer: Untersuchungen zur germanisch-deutschen Heldensage* (Beihefte der Bonner Jahrbuch, XVII, Cologne)

**Plummer, C. (ed.), 1896.** *Venerabilis Baedae Opera Historica* (2 vols., Oxford)

**Plutzar, F., 1922–4.** 'Die Ornamentik der Runensteine', *Kungliga Vitterhets Historie och Antikvitets Akademiens Handlingar*, XXXIV, 5–105

**Pocknee, C. E., 1962.** *Cross and Crucifix in Christian Worship and Devotion* (London)

**Pomerol, C., 1973.** *Ère Cénozoïque* (Paris)

**Poole, A. L., 1958.** *Medieval England* (Oxford)

**Poole, H., 1870.** 'Some account of the discovery of the Roman coffin in the north green of Westminster abbey', *Archaeol. J.*, XXVII, 119–28

**Poole, H., 1948.** 'The Domesday Book churches of Sussex', *Sussex Archaeol. Collect.*, LXXXVII, 30–76

**Porter, A. K., 1923.** *Romanesque Sculpture of the Pilgrimage Roads* (Boston)

**Porter, A. K., 1928.** *Spanish Romanesque Sculpture* (Paris and Florence)

**Porteus, G. H., 1974.** *A Guide to Dartford Parish Church of the Holy Trinity* (Dartford)

**Prior, B. G. J., n. d.** *The Church of St. Peter on Selsey Bill* (Selsey)

**Prior, E. S., and Gardner, A., 1912.** *An Account of Medieval Figure Sculpture in England* (Cambridge)

**Puckle, J., 1864.** *The Church and Fortress of Dover Castle* (Oxford and London)

**Quirk, R. N., 1957.** 'Winchester cathedral in the tenth century', *Archaeol. J.*, CXIV, 28–68

**Quirk, R. N., 1961.** 'Winchester New Minster and its tenth-century tower', *J. Brit. Archaeol. Ass.*, ser. 3, XXIV, 16–54

**Radford, C. A. R., 1956.** 'The portable altar' in Battiscombe 1956, 326–35

**Radford, C. A. R., 1966a.** 'Corhampton church', *Archaeol. J.*, CXXIII, 188–9

**Radford, C. A. R., 1966b.** 'Breamore church', ibid., CXXIII, 203

**Radford, C. A. R., 1966c.** 'Romsey abbey', ibid., CXXIII, 218–20

**Radford, C. A. R., 1970.** 'The later pre-Conquest boroughs and their defences', *Medieval Archaeol.*, XIV, 83–103

**Radford, C. A. R., 1973.** 'Pre-Conquest minster churches', *Archaeol. J.*, CXXX, 120–40

**Rafn, C. C., 1845–9.** 'Remarks on a Danish runic stone from the eleventh century found in the central part of London', *Mémoires de la Société Royale des Antiquaires du Nord*, IV, 286–52

**Rafn, C. C., 1852.** 'Bemærkninger om en dansk Runesteen fra det Ellefte Aarhundrede funden midt i London', *Annaler for Oldkyndighed*, XII, 271–301

**Rafn, C. C., 1852–4.** 'Aarsmöde den 21de Marts 1853', *Antiquarisk Tidskrift*, IV, 9–10

**Rafn, C. C., 1854a.** *Remarks on a Danish Runic Stone from the Eleventh Century found in the Central Part of London* (Copenhagen)

**Rafn, C. C., 1854b.** *Bemærkninger om en dansk Runesteen fra det Ellefte Aarhundrede funden midt i London* (Copenhagen)

**Rafn, C. C., 1856.** *Inscription Runique du Pirée* (Copenhagen)

**Rahtz, P., 1971.** 'Excavations on Glastonbury Tor, Somerset 1964–6', *Archaeol. J.*, CXXVII, 1–81

**Raine, J. (ed.), 1879–94.** *The Historians of the Church of York and its Archbishops*. Rolls Ser., LXXI (3 vols., London)

**Ramm, H. G., 1976.** 'The church of St Mary Bishophill Senior, York: excavations, 1964', *Yorkshire Archaeol. J.*, XLVIII, 35–68

**Raw, B. C., 1990.** *Anglo-Saxon Crucifixion Iconography* (Cambridge)

**Ray, J. E., 1910.** 'The church of SS Peter and Paul, Bexhill', *Sussex Archaeol. Collect.*, LIII, 61–108

**Reed, H., 1935.** 'Saxon cross in the church of St Andrew, Colyton, Devon', *Rep. Trans. Devonshire Ass.*, LXVII, 285–9

**Reid, C., 1898.** *The Geology of the Country around Eastbourne (Explanation of Sheet 334)* (Memoirs of the Geological Survey of England and Wales, London)

**Rice, D. T., 1947.** *The Byzantine Element in Late Saxon Art* (London)

**Rice, D. T., 1952.** *English Art 871–1100* (Oxford)

**Rice, D. T., 1960.** 'Essai de classification de la sculpture Anglo-Saxonne des Xᵉ et XIᵉ siècles', *Cahiers de Civilisation Médiévale*, III, 195–207

**Rickert, M., 1954.** *Painting in Britain in the Middle Ages* (Harmondsworth)

**Rickman, T., 1817.** *An Attempt to Discriminate the Styles of English Architecture* (London)

**Rickman, T., 1836.** 'Further observations on the ecclesiastical architecture of France and England in a letter from Thomas Rickman to John Gage, esq. FRS, Director', *Archaeologia*, XXVI, 26–46

**Rickman, T., 1848.** *An Attempt to Discriminate the Styles of English Architecture* (5 ed., London).

**Rieckenberg, H. J., 1966.** 'Über die formel "Requiescat in Pace" in Grabinschriften', *Nachrichten der Akademie der Wissenschaften in Göttingen aus dem Jahre 1966, phil.-hist. Kl. 1966, no. 12* (Göttingen)

**Rigold, S. E., 1966.** 'Warnford church', *Archaeol. J.*, CXXIII, 189–90

**Rigold, S. E., 1977.** '*The Archaeology of Anglo-Saxon England* edited by David M. Wilson', *J. Brit. Archaeol. Ass.*, CXXX, 162–4

**Riley, H. T. (ed.), 1867–9.** *Gesta Abbatum Monasterii Sancti Albani*. Rolls Ser., XXVIII (3 vols., London)

**Rioult, M., 1962.** 'Sur l'âge du "Calcaire de Caen" et la stratigraphie du Bathonien de Normandie', *Bull. Soc. Linnéenne de Normandie*, 51–60

**Rivoira, G. T., 1933.** *Lombardic Architecture* (Oxford)

**Rix, M. M., 1960.** 'The Wolverhampton cross shaft', *Archaeol. J.*, CXVII, 71–81

**Robertson, A. J., 1956.** *Anglo-Saxon Charters* (2 ed., Cambridge)

**Robertson, S., 1895.** 'Preston church, next Faversham', *Archaeol. Cantiana*, XXI, 126–34

**Rodwell, W., 1976.** 'The archaeological investigation of Hadstock church, Essex', *Antiq. J.*, LVI, 55–71

**Rodwell, W., 1980.** *Wells Cathedral: Excavations and Discoveries* (Wells)

**Rodwell, W., 1981.** *The Archaeology of the English Church* (London)

**Rodwell, W., 1990.** 'Anglo-Saxon painted sculpture at Wells, Breamore, and Barton-upon-Humber' in Cather *et al.* 1990, 161–75

**Rodwell, W., and Rodwell, K., 1977.** *Historic Churches — A Wasting Asset* (Council for British Archaeology, Research Report, XIX, London)

**Rodwell, W., and Rouse, C. E., 1984.** 'The Anglo-Saxon rood and other features in the south porch of St Mary's church, Breamore, Hampshire', *Antiq. J.*, LXIV, 298–325

**Roesdahl, E. (ed.), et al., 1981.** *The Vikings in England and in their Danish Homeland* (London)

**Routh, T. E., 1937.** 'A corpus of the pre-Conquest carved stones of Derbyshire', *J. Derbyshire Archaeol. Natur. Hist. Soc.*, LVIII, 1–46

**Routledge, C. F., 1882.** 'St Martin's church, Canterbury', *Archaeol. Cantiana*, XIV, 108–12

**Routledge, C. F., 1897.** 'St Martin's church, Canterbury', ibid., XXII, 1–28

**Routledge, C. F., 1898.** *The Church of St Martin Canterbury* (London)

**Row, P. (ed.), 1914.** *Seaford, Newhaven and Lewes*. The Homelands Association Handbook, XXXIX (London)

**Royal Commission on Ancient and Historical Monuments and Constructions of Scotland, 1920.** *Inventory of Monuments and Constructions in the County of Dumfries* (Edinburgh)

**Royal Commission on Ancient and Historical Monuments in Wales, 1976.** *An Inventory of the Ancient Monuments in Glamorgan, Volume I: Pre-Norman, Part III, the Early Christian Period* (Cardiff)

**Royal Commission on Historical Monuments (England), 1911.** *An Inventory of the Historical Monuments in Hertfordshire, Volume I* (London)

**Royal Commission on Historical Monuments (England), 1912.** *An Inventory of the Historical Monuments in Buckinghamshire, Volume I* (London)

**Royal Commission on Historical Monuments (England), 1913.** *An Inventory of the Historical Monuments in Buckinghamshire, Volume II* (London)

**Royal Commission on Historical Monuments (England), 1916.** *An Inventory of the Historical Monuments in Essex, Volume I* (London)

**Royal Commission on Historical Monuments (England), 1921.** *An Inventory of the Historical Monuments in Essex, Volume II* (London)

**Royal Commission on Historical Monuments (England), 1923.** *An Inventory of the Historical Monuments in Essex, Volume IV* (London)

**Royal Commission on Historical Monuments (England), 1924.** *An Inventory of the Historical Monuments in London, Volume I* (London)

**Royal Commission on Historical Monuments (England), 1928.** *An Inventory of the Historical Monuments in London, Volume III* (London)

**Royal Commission on Historical Monuments (England), 1930.** *An Inventory of the Historical Monuments in London, Volume V* (London)

**Royal Commission on Historical Monuments (England), 1939.** *An Inventory of the Historical Monuments in the City of Oxford* (London)

**Rumble, A. R., forthcoming.** *Anglo-Saxon and Early Norman Charters Relating to Winchester* (Winchester Studies, IV (3), Oxford)

**Rydbeck, M., 1936.** *Skånes stenmästare före 1200* (Lund)

**St. Croix, W. de, 1875.** 'Notes and queries, ii: sundials', *Sussex Archaeol. Collect.*, XXVI, 274–5

**Salzman, L. F. (ed.), 1937.** *The Victoria History of the County of Sussex, IX, The Rape of Hastings* (The Victoria History of the Counties of England, London)

**Salzman, L. F. (ed.), 1939.** *The Victoria History of the County of Oxford, I* (The Victoria History of the Counties of England, London)

**Salzman, L. F. (ed.), 1953.** *The Victoria History of the County of Sussex, IV, The Rape of Chichester* (The Victoria History of the Counties of England, London)

**Samuels, M. L., 1952.** 'The study of Old English phonology', *Trans. Philological Soc.*, VIII, 15–47

**Sauer, J., 1964.** *Symbolik des Kirchengebäudes und seiner Ausstattung in der Auffassung des Mittelalters* (Münster)

**Sawyer, P. H., 1968.** *Anglo-Saxon Charters: An Annotated List and Bibliography* (London)

**Saxl, F., 1954.** *English Sculptures of the Twelfth Century* (London)

**Saxl, F., and Wittkower, R., 1948.** *British Art and the Mediterranean* (Oxford)

**Schapiro, M., 1943.** 'The image of the disappearing Christ, the Ascension in English art around the year 1000', *Gazette des Beaux Arts*, XXIII, 135–52

**Schiek, S., 1992.** *Das Gräberfeld der Merowingerzeit bei Oberflacht* (Forschungen und Berichte zur Vor- und Frühgeschichte in Baden-Württemberg, XLI (1), Stuttgart)

**Schofield, J., 1983.** 'Vikings in London' in *Vikings in the British Isles.* British Heritage (Harrisburg), 18–25

**Scott, G. G., 1862–3.** 'The church on the Castle Hill, Dover', *Archaeol. Cantiana*, V, 1–18

**Scragg, D. (ed.), 1991.** *The Battle of Maldon AD 991* (Oxford)

**Seaby, A. W., 1944.** 'Some Berkshire interlacings', *Antiquity*, XVIII, 88–94

**Seaby, W. A., and Woodfield, W., 1980.** 'Viking stirrups from England and their background', *Medieval Archaeol.*, XXIV, 87–122

**Searle, W. G., 1897.** *Onomasticon Anglosaxonicum* (Cambridge)

**Sellwood, B. W., and McKerrow, W. S., 1974.** 'Depositional environments in the lower part of the Great Oolite Group of Oxfordshire and north Gloucestershire', *Proc. Geol. Assoc.*, LXXXV, 189–210

**Service, A., 1982.** *The Buildings of Britain. Anglo-Saxon and Norman* (London)

**Sheerin, D. J., 1978.** 'The dedication of the Old Minster, Winchester, in 980', *Revue Bénédictine*, LXXXVIII, 261–72

**Sheppard, J. B., 1861.** 'Proceedings of the Society of Antiquaries, Thursday, April 11th, 1861', *Proc. Soc. Antiq. London*, I, 366–73

**Sherwood, J., and Pevsner, N. B. L., 1974.** *The Buildings of England. Oxfordshire* (Harmondsworth)

**Shetelig, H., 1909.** 'Urnesgruppen', *Foreningen til norske Fortidsmindesmærkers Bevaring Aarsberetningen*, LXV, 75–107

**Shetelig, H., 1911.** 'En Orientalisk Stilindflydelse paa Olav den Helliges Tid i Norge', *Kunst og Kultur*, I, 38–51

**Shetelig, H. (ed.), 1940–54.** *Viking Antiquities in Great Britain and Ireland* (6 vols., Oslo)

**Shetelig, H., 1948.** 'The Norse style of ornamentation in the Viking settlements', *Acta Archaeologica*, XIX, 69–113

**Shetelig, H., 1949.** *Classical Impulses in Scandinavian Art from the Migration Period to the Viking Age* (Oslo)

**Shetelig, H., and Falk, H., 1937.** *Scandinavian Archaeology* (Oxford)

Shore, T. W., 1898. 'The history and antiquities of Whitchurch', *Hampshire Notes Queries*, IX, 123–6

Shore, T. W., 1905. 'Anglo-Saxon London and its neighbourhood', *Trans. London Middlesex Archaeol. Soc.*, I, 366–91

Shore, T. W., 1906. *Origin of the Anglo-Saxon Race* (London)

Shortt, H. de S., 1976. *Old Sarum* (London)

Slessor, J. H., 1888. *Notes on the Church of St Swithin, Headbourne Worthy* (London and Winchester)

Smart, J. G. O., Bisson, G., and Worssam, B. C., 1966. *Geology of the Country around Canterbury and Folkestone* (Memoirs of the Geological Survey of Great Britain, London)

Smart, P. M. H., 1973. *Jevington Through the Ages* (Jevington)

Smith, C. R., 1848–80. *Collectanea Antiqua* (London)

Smith, C. R., 1850. *The Antiquities of Richborough, Reculver and Lympne, in Kent* (London)

Smith, C. R., 1854. *Catalogue of the Museum of London Antiquities, Collected by and the Property of Charles Roach Smith* (London)

Smith, C. R., 1871. 'Saxon sepulchral monument in the church of Whitchurch, Hants.', *The Builder*, XXIX, 884

Smith, G. W., 1905. 'Thursday, 29th June, 1905. Meeting', *Proc. Soc. Antiq. London*, XX, 354–6

Smith, L. T., 1964. *The Itinerary of John Leland* (London)

Smith, R. A., 1909–11. 'Thursday, 16th March 1911, Meeting', *Proc. Soc. Antiq. London*, XXIII, 397–402

Smith, R. A., 1913–14. 'Thursday, 22nd January 1914, Meeting', ibid., XXVI, 60–72

Smith, R. A., 1917. 'Roman roads and the distribution of Saxon churches in London', *Archaeologia*, LXVIII, 229–62

Smith, R. A., 1923. *British Museum, A Guide to the Anglo-Saxon and Foreign Teutonic Antiquities* (London)

Smith, R. A., 1925. 'Examples of Anglian art', *Archaeologia*, XXIV, 233–54

Smith, T. P., 1966. 'The Anglo-Saxon churches of Bedfordshire', *Bedfordshire Archaeol. J.*, III, 7–14

Smith, T. P., 1973. *The Anglo-Saxon Churches of Hertfordshire* (London and Chichester)

Solloway, J., 1910. *The Alien Benedictines of York* (Leeds)

Spence, C., 1841. *An Essay Descriptive of the Abbey Church, Romsey* (Romsey)

Sowan, P. W., 1976. 'Firestone and hearthstone mines in the Upper Greensand of east Surrey', *Proc. Geol. Assoc.*, LXXXVI, 571–91

Sperling, C. F. D., 1921–3. 'Discovery of portion of a pre-Norman stone coffin lid at Great Maplestead', *Trans. Essex Archaeol. Soc.*, XVI, 139–40

Stanley, A. P., 1870. 'Observations on the Roman sarcophagus lately discovered at Westminster', *Archaeol. J.*, XXVII, 103–9

Steer, F. W., 1976a. *Guide to the Parish Church of St Mary the Virgin Walberton* (Walberton)

Steer, F. W., 1976b. *Guide to the Church of St Andrew Steyning* (Steyning)

Stenton, F. M. (ed.), 1957. *The Bayeux Tapestry* (London)

Stenton, F. M., 1971. *Anglo-Saxon England* (3 ed., Oxford)

Stephens, G., 1866–1901. *The Old-northern Runic Monuments of Scandinavia and England* (4 vols., Copenhagen and London)

Stephens, G., 1884. *Handbook of the Old-northern Runic Monuments of Scandinavia and England* (London and Copenhagen)

Stephens, G., 1894. *The Runes, Whence Came They?* (London and Copenhagen)

Stocker, D. (with Everson, P.), 1990. 'Rubbish recycled: a study of the re-use of stone in Lincolnshire' in Parsons 1990b, 83–101

Stoll, R. R., 1967. *Architecture and Sculpture in Early Britain* (London)

Stone, L., 1955. *Sculpture in Britain: The Middle Ages* (Harmondsworth)

Stratford, N. (ed.), 1987. *Romanesque and Gothic: Essays for George Zarnecki* (2 vols., Woodbridge)

Strecker, K. (ed.), 1939. *Die lateinischen Dichter des deutschen Mittelalters* (Monumenta Germaniae Historica, Poetae Latini Medii Aevi, v (2) (Berlin))

Styan, K. E., 1902. *A Short History of Sepulchral Cross Slabs* (London)

Sumbler, M. G., 1984. 'The stratigraphy of the Bathonian White Limestone and Forest Marble formations of Oxfordshire', *Proc. Geol. Assoc.*, XCV, 51–64

Swanton, M. J., 1973. 'A pre-Conquest sculptural fragment from Rochester cathedral', *Archaeol. Cantiana*, LXXXVIII, 201–3

Sweet, H., 1885. *The Oldest English Texts* (London)

Syers, Canon, 1899. 'Barnack church', *J. Brit. Archaeol. Ass.*, LV, 13–28

Talbot, J. G., 1860. 'The columns of Reculver church', *Archaeol. Cantiana*, III, 135–6

Tatham, F. H., 1892–7. 'The restoration of Wing church', *Rec. Buckinghamshire*, VII, 153

Tatton-Brown, T. W., 1990. 'Building stone in Canterbury, c.1070–1525' in Parsons 1990b, 70–82

Tatton-Brown, T. W., 1991. 'The buildings and topography of St Augustine's abbey, Canterbury', *J. Brit. Archaeol. Ass.*, CXLIV, 61–91

Tavenor-Perry, J., 1909. 'Saxon architecture' in P. D. Mundy (ed.), *Memorials of Old Sussex* (London), 54–71

Taylor, H. M., 1962a. 'The pre-Conquest churches of Wessex', *Wiltshire Archaeol. Natur. Hist. Mag.*, LVIII, 156–70

Taylor, H. M., 1962b. *Our Anglo-Saxon Heritage* (Keele)

Taylor, H. M., 1968. 'Reculver reconsidered', *Archaeol. J.*, CXXV, 291–6

Taylor, H. M., 1969. 'Reculver church', ibid., CXXVI, 225–7

Taylor, H. M., 1973. 'The position of the altar in early Anglo-Saxon churches', *Antiq. J.*, LIII, 52–8

Taylor, H. M., 1975. 'Tenth-century church building in England and on the continent' in Parsons 1975, 141–68

Taylor, H. M., 1978. *Anglo-Saxon Architecture*, III (Cambridge)

Taylor, H. M., and Taylor, J., 1965–78. *Anglo-Saxon Architecture* (3 vols., Cambridge)

Taylor, I., 1879. *Greeks and Goths* (London)

Taylor, J., and Taylor, H. M., 1961. 'Problems of the dating of pre-Conquest churches', *North Staffordshire J. Fld. Studies*, I, 58–76

Taylor, J., and Taylor, H. M., 1966. 'Architectural sculpture in pre-Norman England', *J. Brit. Archaeol. Ass.*, XXIX, 3–51

Temple, E., 1976. *Anglo-Saxon Manuscripts 900–1066*. (A Survey of Manuscripts Illuminated in the British Isles, II, London)

Thomas, C., 1971. *The Early Christian Archaeology of North Britain* (Oxford)

Thompson, A. H., 1924. 'The summer meeting at Winchester: Romsey abbey', *Archaeol. J.*, LXXXVI, 336–7

Thompson, F. H. (ed.), 1983. *Studies in Medieval Sculpture* (Society of Antiquaries of London, Occasional Paper, n. ser., III, London)

Thorsen, G., 1864–80. *De Danske Runemindesmærker* (Copenhagen)

Thurrell, R. G., Worssam, B. C., and Edmonds, E. A., 1968. *Geology of the Country around Haslemere* (Memoirs of the Geological Survey of Great Britain, London)

Toynbee, J. M. C., and Ward-Perkins, J. B., 1950. 'Peopled scrolls: a Hellenistic motif in imperial art', *Pap. Brit. Sch. Rome*, XVIII, 2–43

Turner, D. H., 1971. *Romanesque Illuminated Manuscripts* (London)

Turner, E., 1870. 'Steyning and West Grinstead churches, and the ancient castle of Knepp', *Sussex Archaeol. Collect.*, XXII, 1–21

Tweddle, D., 1978. 'A fragment of pre-Conquest sculpture from Balsham, Cambridgeshire', *Proc. Cambridge Antiq. Soc.*, LXVIII, 17–20

Tweddle, D., 1982. 'Discussion', *Interim*, VIII (2), 26–9

Tweddle, D., 1983a. 'The Coppergate helmet', *Fornvännen*, LXXVIII, 105–11

Tweddle, D., 1983b. 'Anglo-Saxon sculpture in south-east England before c. 950' in Thompson 1983, 18–40

Tweddle, D., 1984. *The Coppergate Helmet* (York)

Tweddle, D., 1986a. *Finds from Parliament Street and Other Sites in the City Centre. The Archaeology of York*, XVII (4) (Council for British Archaeology, London)

Tweddle, D., 1986b. 'The pre-Conquest sculpture of south-east England' (unpublished Ph. D. thesis, University of London)

Tweddle, D., 1987. 'The sculpture' in Wenham *et al.* 1987, 118–22

Tweddle, D., 1990. 'Paint on pre-Conquest sculpture in south-east England' in Cather *et al.* 1990, 145–59

Twining, L., 1852. *Symbols and Emblems of Early Medieval Art* (London)

Vieillard-Troiekouroff, M., 1962. 'Les sculptures et objects préromans retrouvés dans les fouilles de 1860 et de 1886 à Saint-Martin de Tours', *Cahiers Archéologiques*, XIII, 85–118

Vince, A., 1990. *Anglo-Saxon London* (London)

Vulliamy, C. E., 1930. *The Archaeology of Middlesex and London* (London)

Wallace-Hadrill, J. M., 1988. *Bede's Ecclesiastical History of the English People, A Historical Commentary* (Oxford)

Waller, J. G., 1884. 'The church of Great Canfield and the painting of the Virgin and Child', *Trans. Essex Archaeol. Soc.*, II, 377–88

Wamers, E., 1985. *Insularer Metallschmuck in wikingerzeitlichen Gräbern Nordeuropas* (Neumünster)

Warner, G. F., and Wilson, H. A. (ed.), 1910. *The Benedictional of St Æthelwold, Bishop of Winchester 963–984, Reproduced in facsimile from the Manuscript in the Library of the Duke of Devonshire at Chatsworth* (Roxburghe Club, Oxford)

Warren, F. E., 1883. *The Leofric Missal* (Oxford)

Way, A., 1868. 'Ancient sun-dials', *Archaeol. J.*, XXV, 207–23

Webb, J. F., 1965. *Lives of the Saints* (Harmondsworth)

Webster, L., and Backhouse, J. (eds.), 1991. *The Making of England: Anglo-Saxon Art and Culture AD 600–900* (London)

Weitzmann, K., 1977. *Late Antique and Early Christian Book Illumination* (London)

Wellesz, E., 1960. *The Vienna Genesis* (London)

Wenham, L. P., Hall, R. A., Briden, C. M., and Stocker, D. A., 1987. *St Mary Bishophill Junior and St Mary Castlegate: The Archaeology of York*, VIII (2) (Council for British Archaeology, London)

Werner, J., 1964. 'Frankish royal tombs in the cathedrals of Cologne and St Denis', *Antiquity*, XXXVIII, 201–16

West, J. K., 1983. 'A carved slab fragment from St Oswald's priory, Gloucester' in Thompson 1983, 41–53

Westwood, J. O., 1846. 'Archaeological intelligence: Saxon or early Norman period', *Archaeol. J.*, III, 355–7

Westwood, J. O., 1853. 'Antiquities and works of art exhibited', *ibid.*, X, 82–3

Westwood, J. O., 1885–7. 'Thursday, December 16th, 1886. Meeting', *Proc. Soc. Antiq. London*, XI, 224–6

Westwood, J. O., 1886–93. 'On an Anglo- or Dano-Saxon memorial preserved in Stratfield Mortimer church, Berkshire', *Proc. Oxford Hist. Soc.*, V, 293–5

Westwood, J. O., 1890. 'Meetings, Michaelmas term, 1890, Nov. 18th . . .', *Proc. Excursions Oxford Architect. Hist. Soc.*, XXXVI, 292–8

Wheeler, R. E. M., 1927. *London Museum Catalogues: No. 1, London and the Vikings* (London)

Wheeler, R. E. M., 1935. *London Museum Catalogues: No. 6, London and the Saxons* (London)

**White, H. J. O., 1912.** *The Geology of the Country around Winchester and Stockbridge.* Mem. Geological Surv. England and Wales (London)

**Whitley, H. M., 1919.** 'Primitive sundials on West Sussex churches', *Sussex Archaeol. Collect.*, LX, 126–40

**Whitelock, D., 1972.** 'The pre-Viking church in East Anglia', *Anglo-Saxon England*, I, 1–22

**Wilkinson, J., 1972.** 'The tomb of Christ: an outline of its structural history', *Levant*, IV, 83–97

**William (of Malmesbury, ed. N. E. S. A. Hamilton), 1870.** *Willelmi Malmesbiriensis Monachi de Gestis Pontificum Anglorum.* Rolls Ser., LII (London)

**Wilson, D. M., 1960.** *The Anglo-Saxons* (London)

**Wilson, D. M., 1964.** *Anglo-Saxon Ornamental Metalwork 700–1100 in the British Museum. Catalogue of Antiquities of the Later Saxon Period,* I (London)

**Wilson, D. M., 1970.** *The Vikings and Their Origins* (London)

**Wilson, D. M., 1974.** 'Men de ligger i London', *Skalk*, V, 3–8

**Wilson, D. M. (ed.), 1976.** *The Archaeology of Anglo-Saxon England* (London)

**Wilson, D. M. (ed.), 1980.** *The Northern World* (London)

**Wilson, D. M., 1981.** 'Bronze mount from the castle bailey' in P. Crummy (ed.), *Aspects of Anglo-Saxon and Norman Colchester. Colchester Archaeological Report, 1.* (Council for British Archaeology Research Report, XXXIX, London), 78

**Wilson, D. M., 1984.** *Anglo-Saxon Art from the Seventh Century to the Norman Conquest* (London)

**Wilson, D. M., 1985.** *The Bayeux Tapestry* (London)

**Wilson, D. M., and Foote, P. G., 1970.** *The Viking Achievement* (London)

**Wilson, D. M., and Hurst, D. G., 1961.** 'Medieval Britain in 1960: pre-Conquest', *Medieval Archaeol.*, V, 309–39

**Wilson, D. M., and Hurst, D. G., 1967.** 'Medieval Britain in 1966: pre-Conquest', ibid., XI, 262–319

**Wilson, D. M., and Hurst, D. G., 1969.** 'Medieval Britain in 1968', ibid., XIII, 230–87

**Wilson, D. M., and Klindt-Jensen, O., 1966.** *Viking Art* (London)

**Wimmer, L. F. A., 1893–1908.** *De Danske Runemindesmærker* (Copenhagen)

**Woerden, I. S. van, 1961.** 'The iconography of the sacrifice of Abraham', *Vigilae Christianae*, XV, 214–55

**Wormald, F., 1944.** 'The survival of Anglo-Saxon illumination after the Norman conquest', *Proc. British Academy*, XXX, 127–45

**Wormald, F., 1957.** 'The inscriptions with a translation' in Stenton 1957, 177–80

**Wormald, F., 1959.** *The Benedictional of St Ethelwold, with an Introduction and Notes* (London)

**Wormald, F., 1967.** 'Anniversary address', *Antiq. J.*, XLVII, 159–65

**Worsaae, J. J. A., 1873.** *De Danskes Kultur i Vikingetiden* (Copenhagen)

**Worssam, B. C., forthcoming.** 'Provenance of building stone' in Biddle forthcoming a

**Worssam, B. C., and Bisson, G., 1961.** 'The geology of the country between Sherborne, Gloucestershire, and Burford, Oxfordshire', *Bull. Geol. Surv. Gt Br.*, XVII, 75–115

**Worssam, B. C., and Tatton-Brown, T. W., 1990.** 'The stone of the Reculver columns and the Reculver cross' in Parsons 1990b, 51–69

**Wright, T., 1844.** 'Anglo-Saxon architecture illustrated from illuminated manuscripts', *Archaeol. J.*, I, 24–35

**Wright, T., 1845.** *The Archaeological Album: or, Museum of National Antiquities* (London)

**Wyatt, J., 1868.** 'Bedford after the Saxon period', *Ass. Architect. Soc. Rep.*, IX, 255–82

**Yarborough, J. C., 1898–1903.** 'An account of some recent discoveries in Romsey abbey', *Proc. Hampshire Fld. Club Archaeol. Soc.*, IV, 227–233

**Zarnecki, G., 1951a.** 'Regional schools of English sculpture in the twelfth century' (Unpublished Ph.D. thesis, University of London)

**Zarnecki, G., 1951b.** *English Romanesque Sculpture 1066–1140* (London)

**Zarnecki, G., 1953.** 'The Chichester reliefs', *Archaeol. J.*, CX, 106–19

**Zarnecki, G., 1955.** 'The Winchester acanthus in Romanesque sculpture', *Wallraf-Richartz Jahrbuch*, XVII, 211–5

**Zarnecki, G., 1966.** '1066 and architectural sculpture', *Proc. Brit. Acad.*, LII, 87–104

**Zarnecki, G., 1984.** 'The so-called Sigmund relief' in Zarnecki et al. 1984, 150–1

**Zarnecki, G., 1986a.** 'An invasion delineated' [review of Wilson 1985], *Times Literary Supplement*, 21 March 1986, 301

**Zarnecki, G., 1986b.** 'Sculpture in stone from the English Romanesque art exhibition' in Macready and Thompson 1986, 7–27

**Zarnecki, G., Holt, J., and Holland, T. (eds.), 1984.** *English Romanesque Art 1066–1200* (London)

**Zinner, E., 1939.** *Die Ältesten Räderuhren und Modernen Sonnenuhren, Forschungen über den Ursprung der Modernen Wissenschaft* (Bamberg)

**Zinner, E., 1964.** *Alte Sonnenuhren an Europäischen Gebäuden* (Wiesbaden)

# PHOTOGRAPHIC
# ACKNOWLEGEMENTS
## and Copyright

The greater part of the photographs have been taken by the following individuals: P. M. J. Crook (Ills. 376, 381-96, 447, 482-6, 488-9, 490–592, 594–666, 673–8, 691–4, 710-22); S. I. Hill (Ills. 1–3, 20–8, 29, 31, 36–49, 50–3, 59–60, 62–8, 77–8, 84–94, 98–100, 111, 116–17, 120, 123, 126, 128–40, 162–95, 208, 210, 213–15, 220–8, 229–34, 273–8, 235–9, 241–5, 249–53, 255, 273–8, 280–3, 285–92, 296–317, 359–70, 374, 400–5, 407–12, 413–17, 420, 423–4, 429, 432, 434–8, 442–6, 448–50, 454, 456, 461–3, 470–2, 474–7, 479, 667, 669–71, 680–90, 695–709); Ills. 4–5, 8–9, 57–8, 61, 95–7, 101–4, 141–2, 146, 151–61, 217–19, 228, 256–9, 263–4, 279, 284, 318–19, 320, 325–6, 329, 331, 335, 338, 340–3, 345–6, 350–1, 354, 356–8, 371–2, 375, 397–9, 406, 418–19, 421–2, 431, 439–41, 457–60, 464–9, 473, 478, 481, 672, and 679, were taken by D. Tweddle. In addition, the following illustrations have kindly been supplied by the individuals specified, who have allowed them to be reproduced here: M. Barnes (668); E. Donadio (109); J. Higgitt (7, 150, 324, 333, 433, 487); R. I. Page (105–7); D. Parsons (76); D. Wright (32).

The following institutions have supplied the photographs listed after their names, and granted permission for them to be reproduced: Bedfordshire Photographic Service (Bedfordshire County Council), copyright D. Baker (265–7, 268–72); the British Museum, London (Ills. 54–6, 147–9, 321–3, 327–8, 330, 332, 334, 336–7, 339, 344, 347–9, 353, and Pl. 1); Canterbury Archaeological Trust (Ills. 10-19); The Conway Library, Courtauld Institute of Art, London (Ills. 6, 108, 110, 112–15, 118–19); the Historic Buildings and Monuments Commission for England (Ill. 30); the Royal Commission on the Historical Monuments of England, (Ills. 196–207, 209, 211–12, 293–5, 425–8, 430, 451–2, 453, 455, 480, the copyright in Ill. 453 being held by B. T. Batsford Ltd., and that in Ill. 455 by the Hampshire Field Club); Saffron Walden Museum (Ill. 373).

## NOTE ON REDUCTIONS

Wherever possible, the photographs have been reduced so that the stones are shown at one eighth of their actual size. This scale is not indicated in the captions. Views of details of larger stones, and small ones (normally those with dimensions not greater than 20 cm (8 in)), are shown at one quarter or one half of their acutal size, and are marked (1:4) or (1:2) in the captions. Stones which are either too large to be reproduced at one eighth of actual size, or the dimensions of which are unobtainable, have not been reduced according to any fixed scale, and are therefore marked in the captions as not to scale (nts).

ILLUSTRATIONS 1–255

# KENT, SURREY, AND SUSSEX

**Illustrations 1–5**

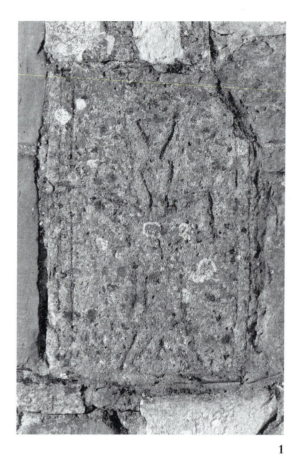

1

2

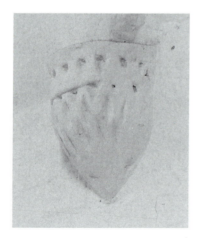

3

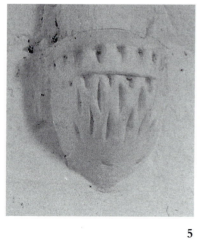

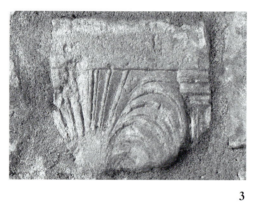

4

5

**1** Arundel 1A   **2** Betchworth 1   **3** Bosham 1   **4** Botolphs 1a
**5** Botolphs 1a

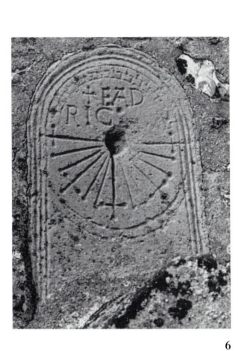

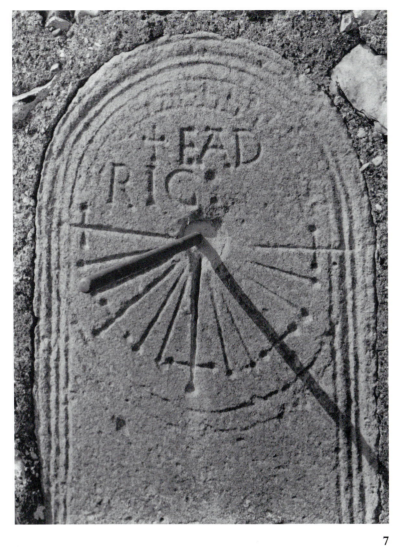

6

7

8

9

**6** Bishopstone 1 **7** Bishopstone 1 (1:4) **8** Botolphs 1b
**9** Botolphs 1b

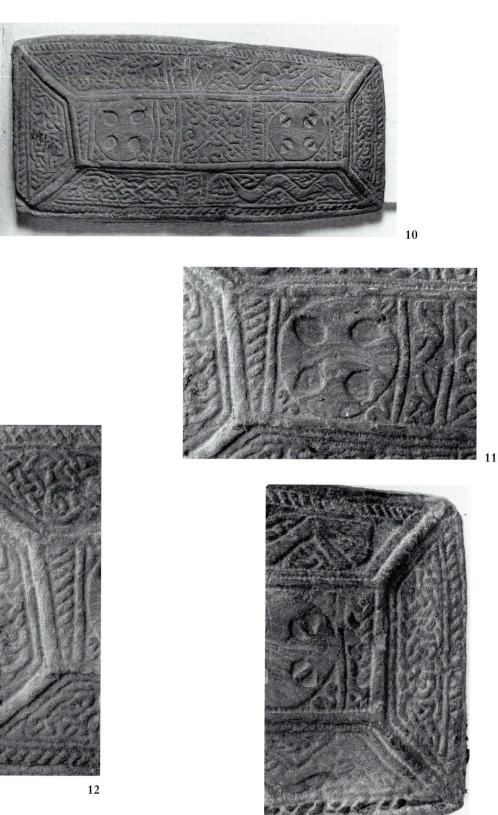

**10** Bexhill 1A  **11** Bexhill 1Axi, xiii, xv (1:4)  **12** Bexhill 1Ai,
xv (1:4)  **13** Bexhill 1Aiv–v (1:4)

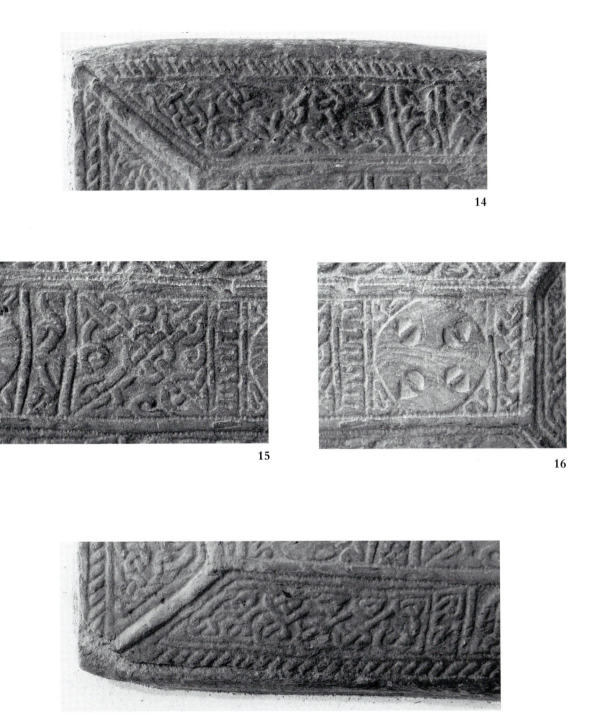

14

15

16

17

14 Bexhill 1Aii–iii (1:4)   15 Bexhill 1Avi, xiii–xiv (1:4)
16 Bexhill 1Av, xii, xiv (1:4)   17 Bexhill 1Avii–viii (1:4)

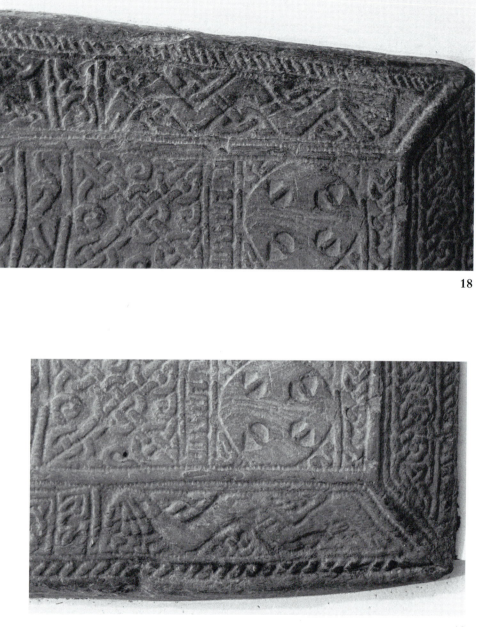

18

19

18 Bexhill 1Aiii, ix (1:4)  19 Bexhill 1Avii, x (1:4)

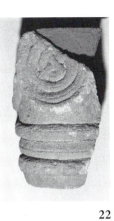

20

21

22

23

24

**20** Canterbury St Augustine 1A/B  **21** Canterbury St Augustine 1A  **22** Canterbury St Augustine 1B  **23** Canterbury St Augustine 1E  **24** Canterbury St Augustine 2A

25

26

25 Canterbury St Augustine 2A (1:4)  26 Canterbury St
Augustine 2A (1:4)

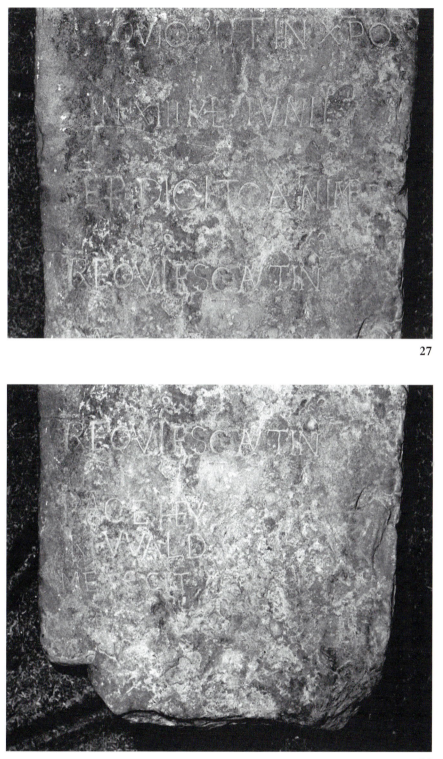

27

28

27 Canterbury St Augustine 2A (1:4)  28 Canterbury St
Augustine 2A (1:4)

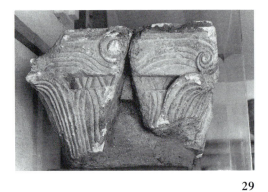

29

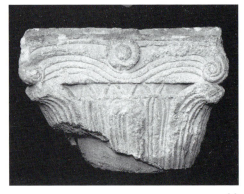

30

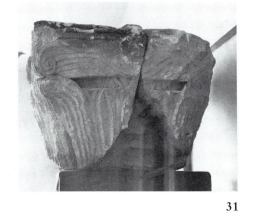

31

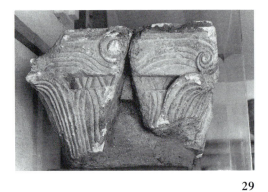

32

29 Canterbury St Augustine 3D  30 Canterbury St Augustine
3A  31 Canterbury St Augustine 3B  32 Canterbury St
Augustine 3A (1:4)

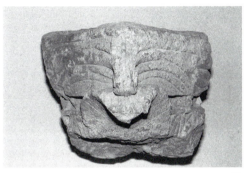

33

34

35

36

37

**33** Canterbury St Augustine 4A/B **34** Canterbury St Augustine 4E **35** Canterbury St Augustine 4B **36** Canterbury St Augustine 4A **37** Canterbury St Augustine 4F (nts)

38

39

40

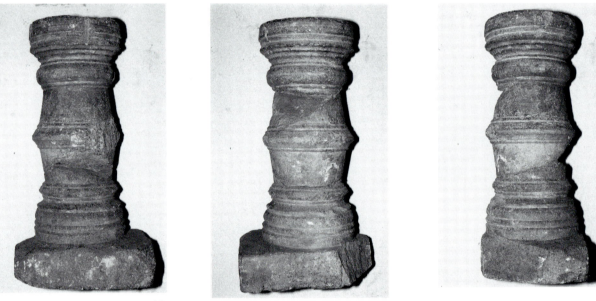

41

42

43

44

45

**38** Canterbury St Augustine 5A   **39** Canterbury St Augustine 5A/B   **40** Canterbury St Augustine 5B   **41** Canterbury St Augustine 6A   **42** Canterbury St Augustine 6C   **43** Canterbury St Augustine 6D   **44** Canterbury St Augustine 6F   **45** Canterbury St Augustine 6E

46

47

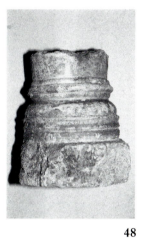

48

49

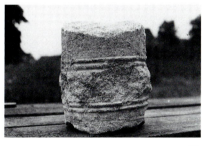

50

51

52

53

46 Canterbury St Augustine 7A  47 Canterbury St Augustine 7B  48 Canterbury St Augustine 7D  49 Canterbury St Augustine 7F  50 Canterbury St Augustine 8A  51 Canterbury St Augustine 9C  52 Canterbury St Augustine 9B  53 Canterbury St Augustine 9A

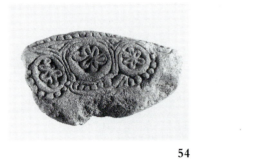
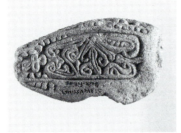

54

55

56

57

58

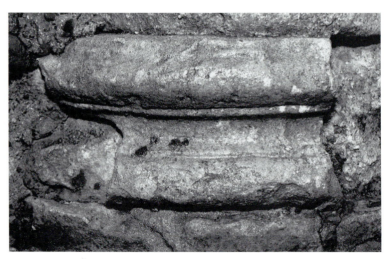

59

54 Canterbury St Augustine 10A (1:2)  55 Canterbury St
Augustine 10C (1:2)  56 Canterbury St Augustine 10E (1:2)
57 Canterbury St Martin 1 (1:4)  58 Canterbury St Augustine
11A (1:4)  59 Canterbury St Pancras 1 (detail, 1:4)

**Illustration 60**

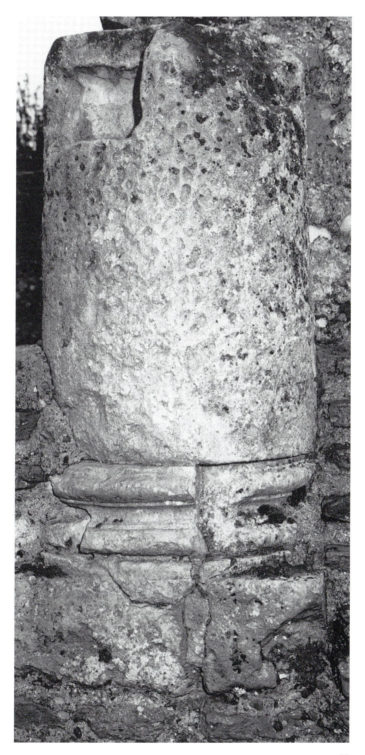

60

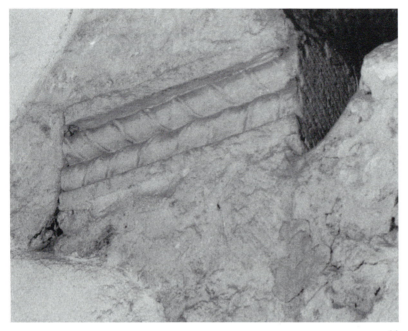

61

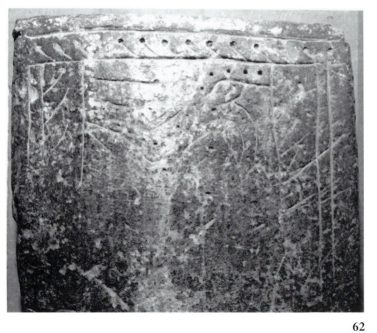

62

63

**61** Dartford 1 (nts)  **62** Dover St Mary in Castro 1A (1:4)
**63** Dover St Mary in Castro 1A

64

65

66

68

67

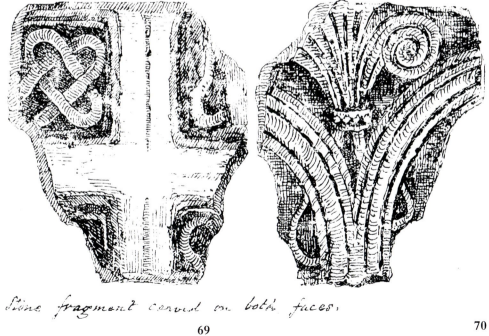

*Stone fragment carved on both faces.*

69

70

64 Dover St Mary in Castro 2E  65 Dover St Mary in Castro 2A  66 Dover St Mary in Castro 2D  67 Dover St Mary in Castro 2C  68 Dover St Mary in Castro 1A (detail, 1:4)

69 Dover St Mary in Castro 4A (after Puckle 1864)  70 Dover St Mary in Castro 4C (after Puckle 1864)

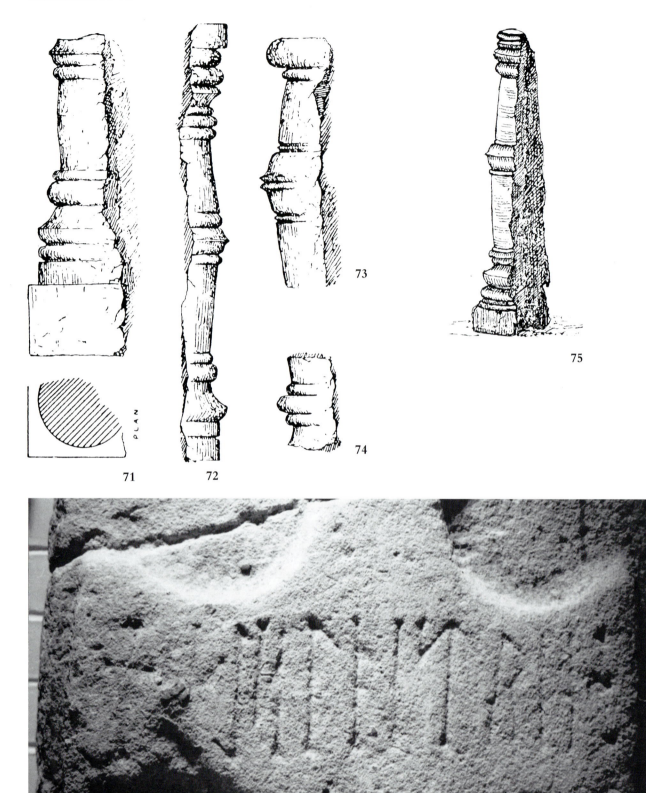

71 Dover St Mary in Castro 3a (after Brown 1925, nts) 72 Dover St Mary in Castro 3c (after Brown 1925, nts) 73 Dover St Mary in Castro 3b (after Brown 1925, nts) 74 Dover St Mary in Castro 3d (after Brown 1925, nts) 75 Dover St Mary in Castro 3c? (after Puckle 1864) 76 Dover St Peter 1A (detail of Ill. 77, turned through 180 degrees, 1:4)

Illustration 77

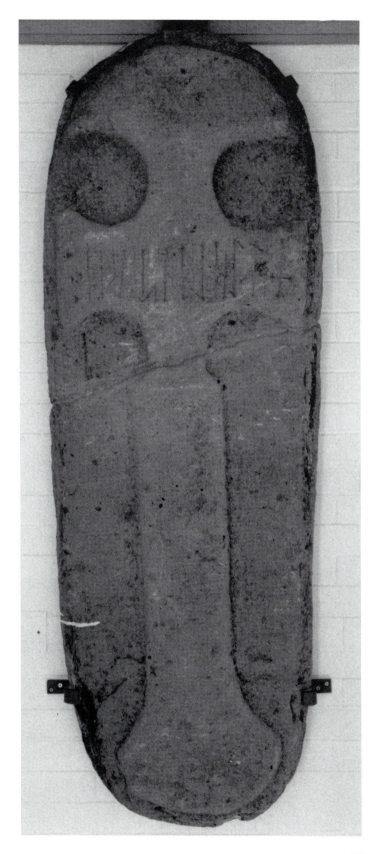

**77** Dover St Peter 1A (nts)

78

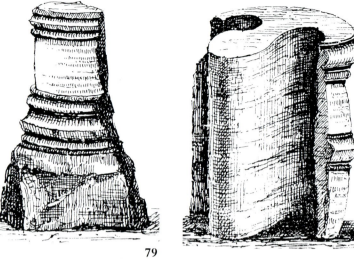

79

80

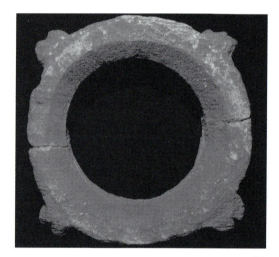

81

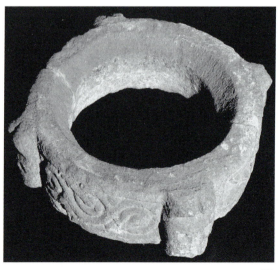

82

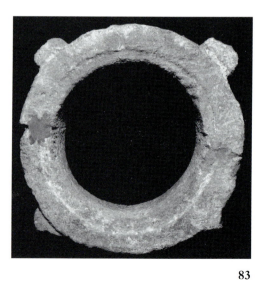

83

**78** Ford 1 **79** Dover St Mary in Castro 3a (after Puckle 1864, nts) **80** Dover St Mary in Castro 3b (after Puckle 1864, nts) **81** Godalming 1E **82** Godalming 1A/E **83** Godalming 1F

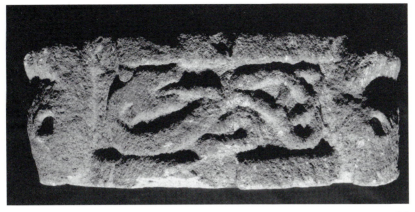

84

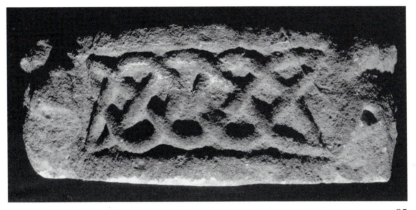

85

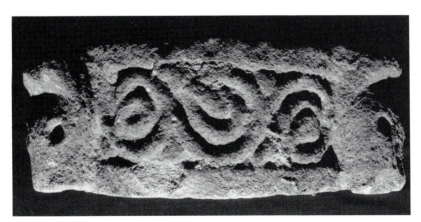

86

**84** Godalming 1Aii (1:4)  **85** Godalming 1Ai (1:4)
**86** Godalming 1Aiii (1:4)

87

88

89

90

91

87 Godalming 1A (1:4)  88 Godalming 1A (1:4)
89 Godalming 1A (1:4)  90 Godalming 1A (1:4)
91 Godalming 1Aiv (1:4)

92

93

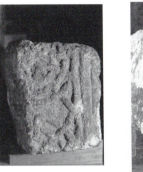

95

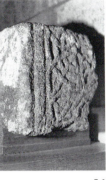

96

94

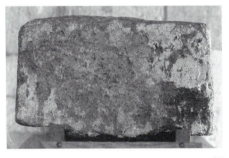

97

98

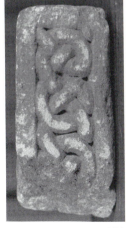

99

100

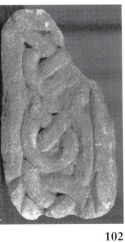

101

102

103

104

**92** Godalming 2A  **93** Godalming 2A  **94** Godalming 2F  **95** Kingston upon Thames 1D  **96** Kingston upon Thames 1B  **97** Kingston upon Thames 1A  **98** Pagham 1E  **99** Pagham 1A

**100** Pagham 1C  **101** Preston-by-Faversham 1A (1:4) **102** Preston-by-Faversham 1B (1:4)  **103** Preston-by-Faversham 1C (1:4)  **104** Preston-by-Faversham 1D (1:4)

Illustration 105

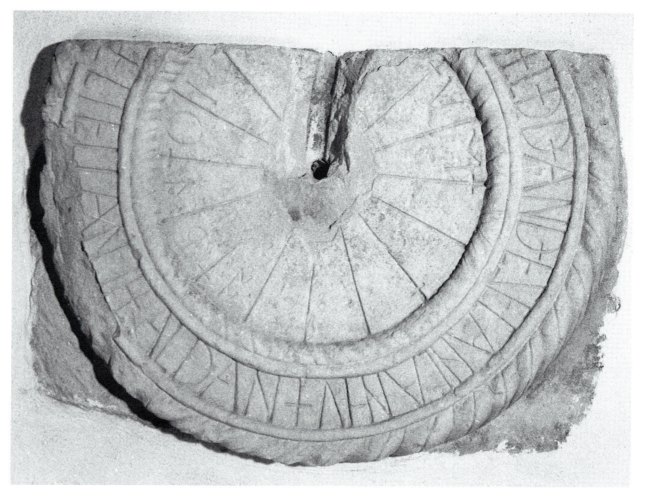

**105** Orpington 1 (1:4)

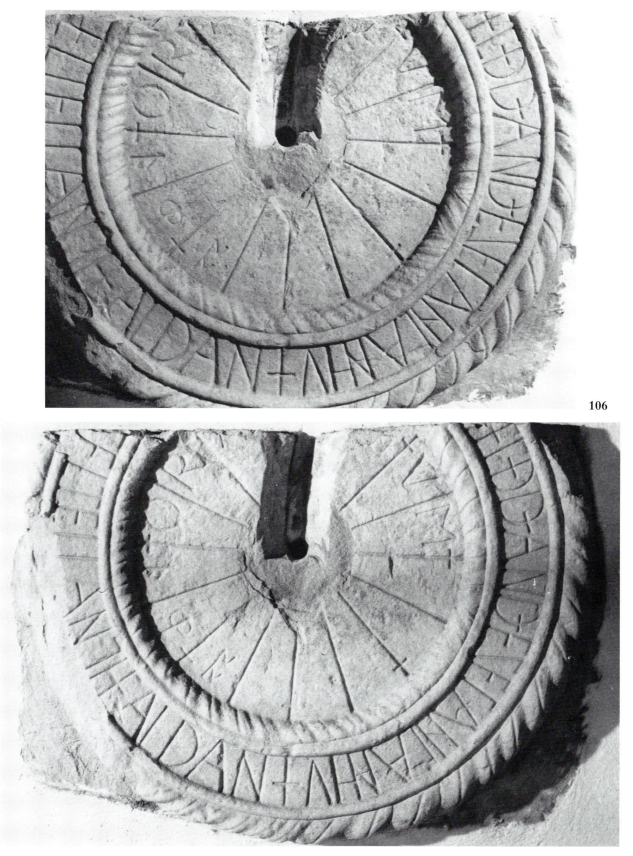

**106** Orpington 1 (1:4)  **107** Orpington 1 (1:4)

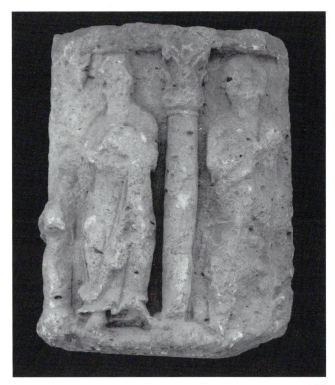

108

109

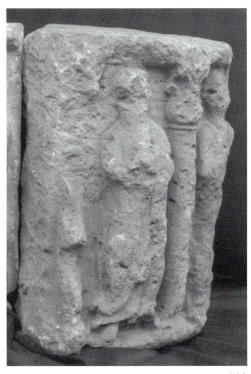

110

**108** Canterbury Old Dover Road 1A (1:4) **109** Canterbury Old Dover Road 1A/F (1:4) **110** Canterbury Old Dover Road 1A (1:4)

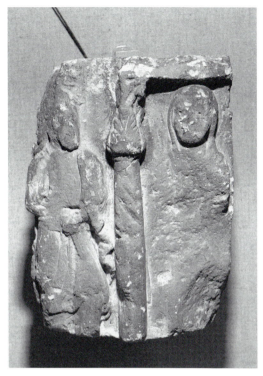

111

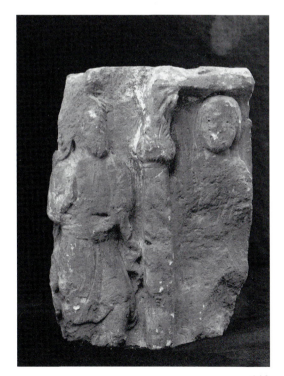

112

**111** Reculver 1d (1:4)  **112** Reculver 1d (1:4)

113

114

113 Reculver 1a (1:4)  114 Reculver 1a (1:4)

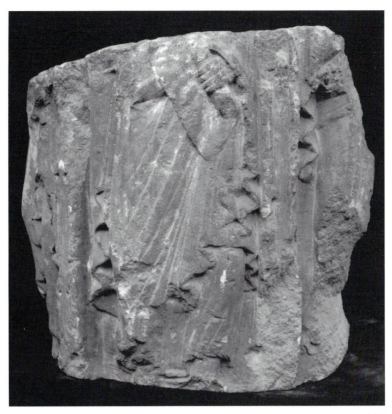

115

116

**115** Reculver 1a (1:4)  **116** Reculver 1b (1:4)

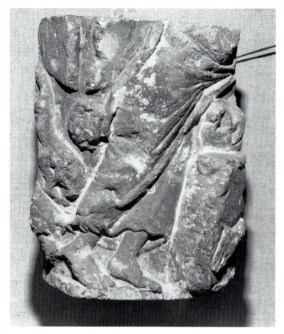

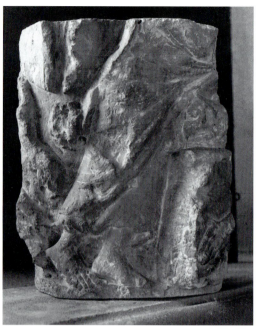

117                                           118

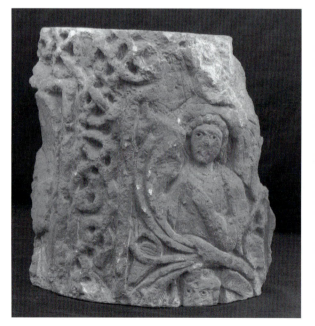

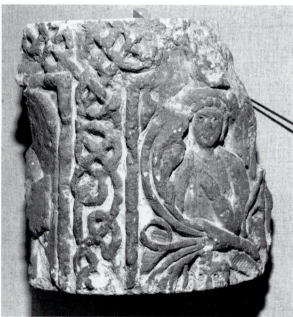

119                                           120

117 Reculver 1c (1:4)  118 Reculver 1c (1:4)  119 Reculver 1e
(1:4)  120 Reculver 1e (1:4)

121

122

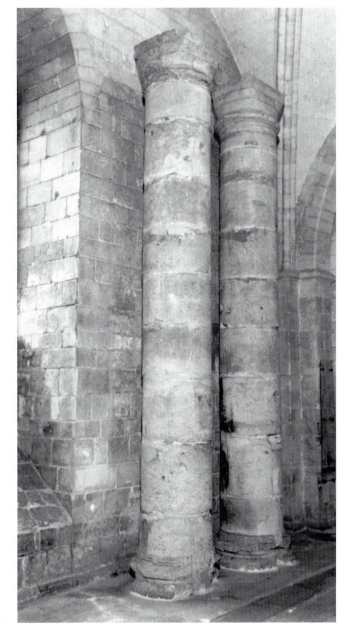

123

121 Reculver 3A (after Peers 1927, nts)  122 Reculver 2 (after
Peers 1927, nts)  123 Reculver 4a–b (nts)

**Illustration 124**

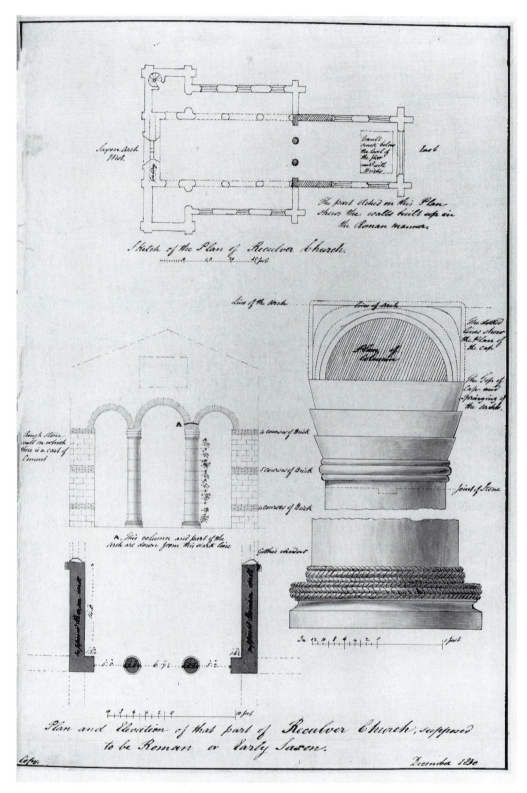

**124** Reculver 4a–b (by Gandy, nts)

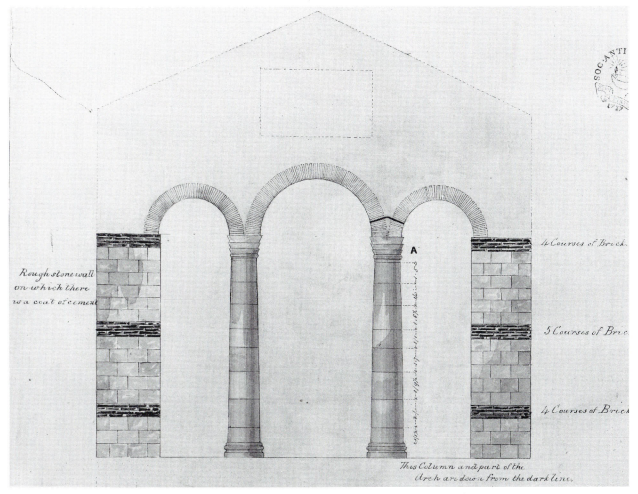

Rough stone wall
on which there
is a coat of cement

4 Courses of Brick.

5 Courses of Brick.

4 Courses of Brick.

A

This Column and part of the
Arch are down from the dark line.

125

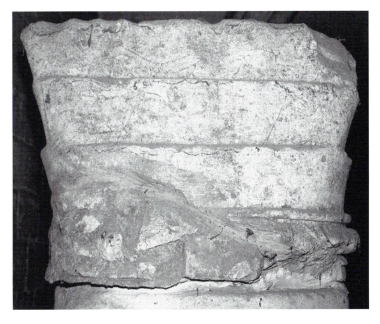

126

125 Reculver 4a–b (by Gandy, nts)  126 Reculver 4a

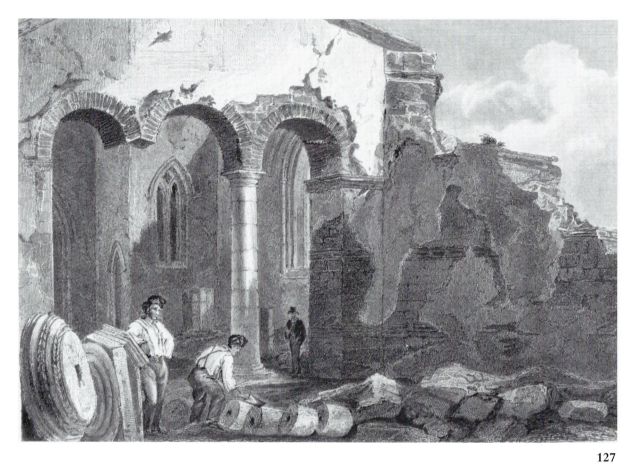
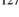

127

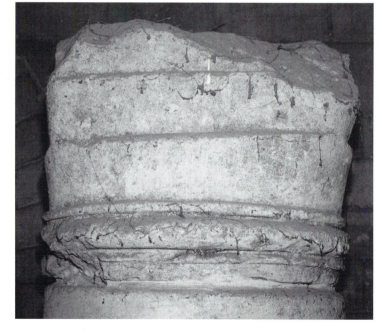

128

**127** Reculver 4a–b (by Baynes (engraved Adlard), nts)
**128** Reculver 4a

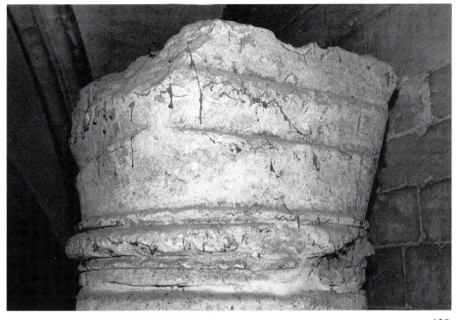

129

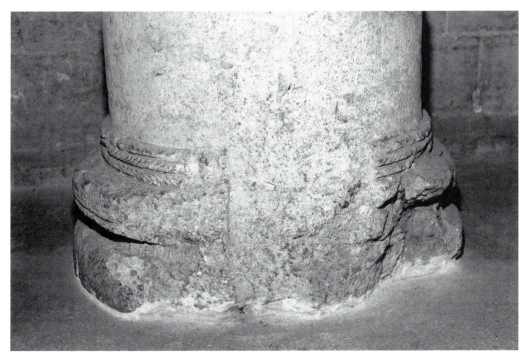

130

129 Reculver 4a  130 Reculver 4a

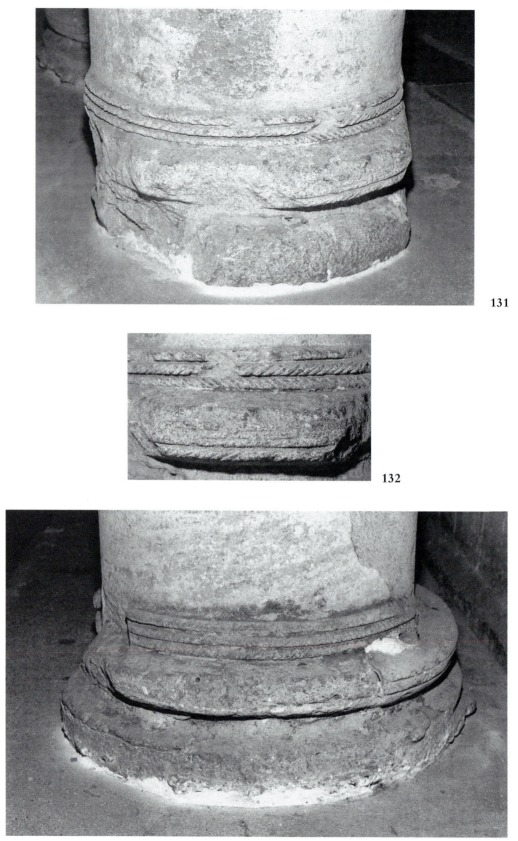

131 Reculver 4a  132 Reculver 4a (1:4)  133 Reculver 4a

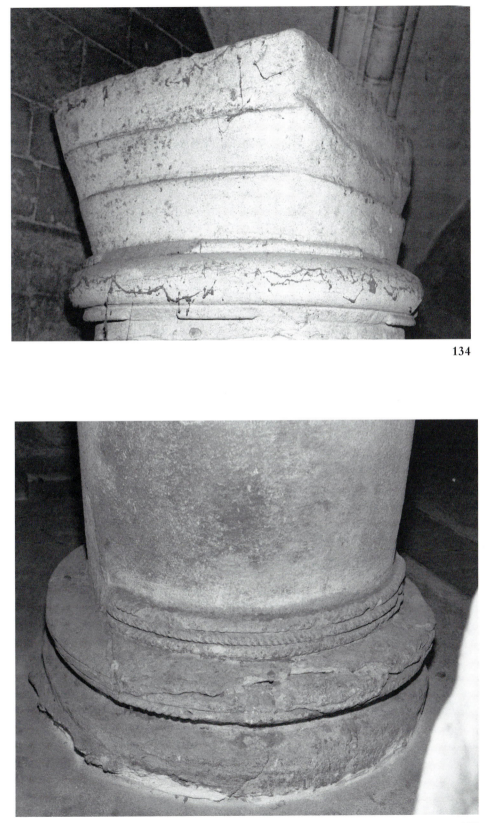

134

135

**134** Reculver 4b (nts)  **135** Reculver 4b

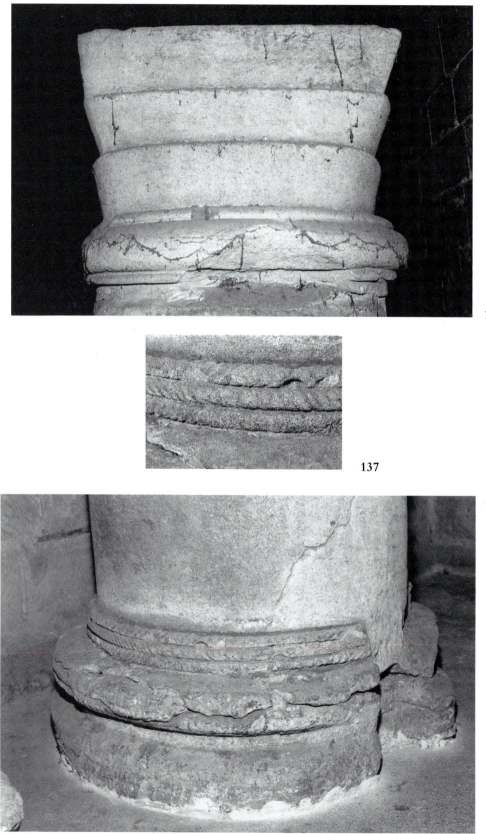

136

137

138

**136** Reculver 4b  **137** Reculver 4b (1:4)  **138** Reculver 4b

139

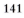

141

140

142

144

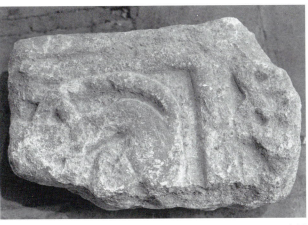

146

143            145

139 Reigate 1D (1:4)  140 Reigate 1A (1:4)  141 Rochester 1A
(1:4)  142 Rochester 1C (1:4)  143 Rochester 2A (after Livett
1889, 1:4)  144 Rochester 2B (after Livett 1889, 1:4)
145 Rochester 2C (after Livett 1889, 1:4)  146 Rochester 4A

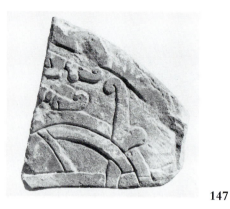

147

148

149

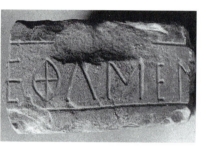

150

151

152

153

**147** Rochester 3A (1:4) **148** Rochester 3C (1:4)
**149** Rochester 3E (1:4) **150** Rochester 3E (1:4) **151**
Sandwich 2C **152** Sandwich 2D **153** Sandwich 2B

154

155

156

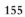

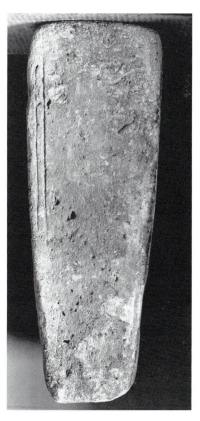

157

**154** Sandwich 2A  **155** Sandwich 1D (1:4)  **156** Sandwich 1A
(1:4)  **157** Sandwich 1B (1:4)

**Illustrations 158–166**

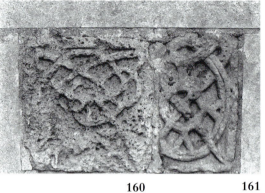

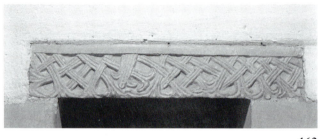

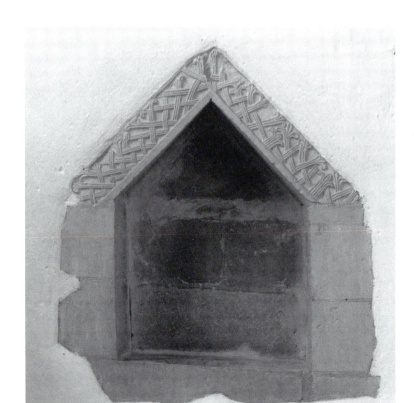

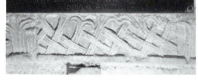

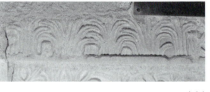

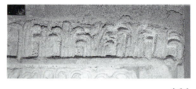

158 Selsey 4  159 Selsey 3  160 Selsey 2  161 Selsey 1  162
Sompting 1  163 Sompting 7  164 Sompting 8  165 Sompting
2–3 (nts)  166 Sompting 6

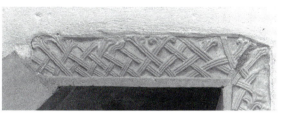

167

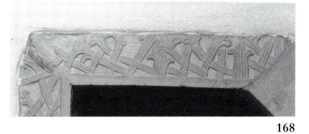

168

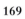

169

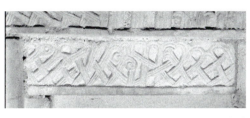

170

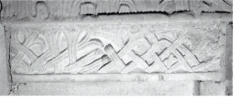

171

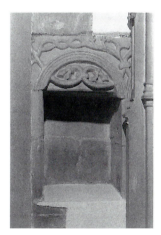

172

173

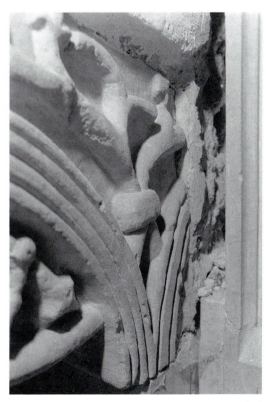

174

167 Sompting 2  168 Sompting 3  169 Sompting 4–8 (nts)
170 Sompting 4  171 Sompting 5  172 Sompting 9A (nts)  173
Sompting 9A  174 Sompting 9A (nts)

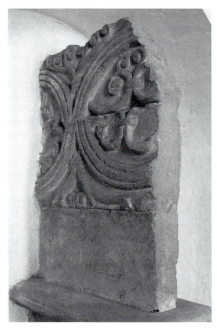

175

176

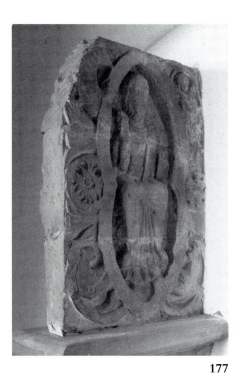

177

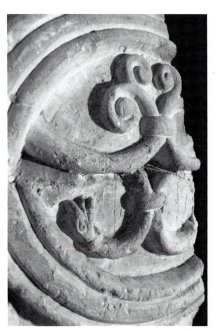

178

180

179

**175** Sompting 10–11A/B **176** Sompting 10–11B
**177** Sompting 10–11B/C **178** Sompting 10–11A (nts)
**179** Sompting 11A (nts) **180** Sompting 10–11A (1:4)

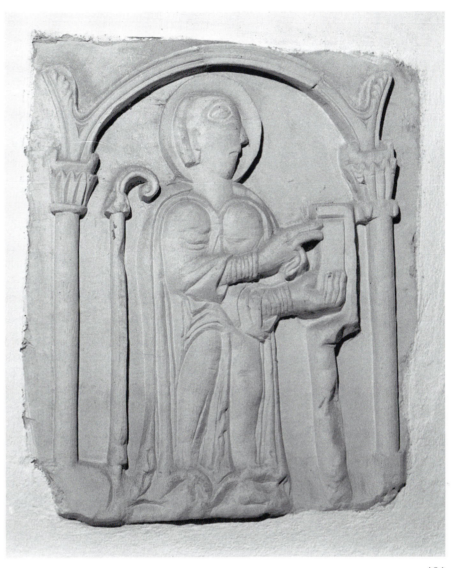

181

182

181 Sompting 13 (1:4)  182 Sompting 12 (1:4)

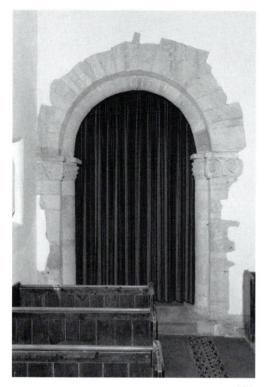

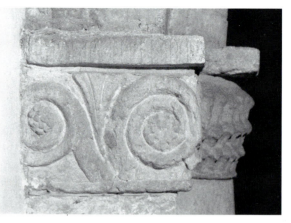

184

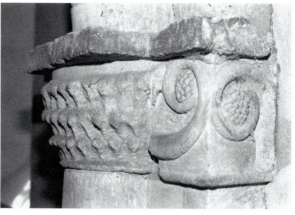

185

183

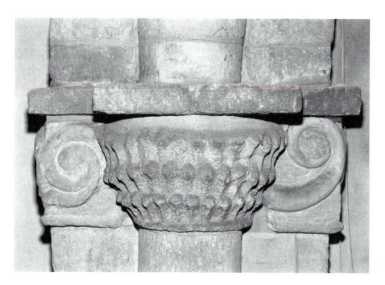

187

186

**183** Sompting 14a–bC (nts)  **184** Sompting 14aC  **185** Sompting 14aA/B  **186** Sompting 14aB  **187** Sompting 14aA

188

189

190

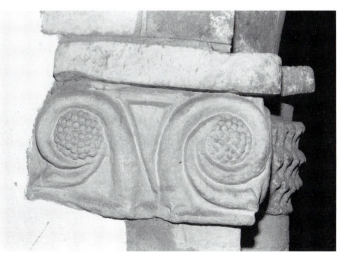

191

**188** Sompting 14bC  **189** Sompting 14bA/B  **190** Sompting
14bB  **191** Sompting 14bA

192

193

194

192 Sompting 15 (nts)  193 Sompting 15 (south, nts)
194 Sompting 15 (west, nts)

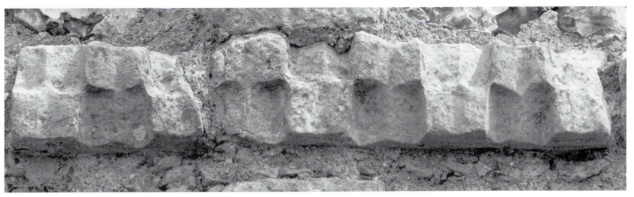

195

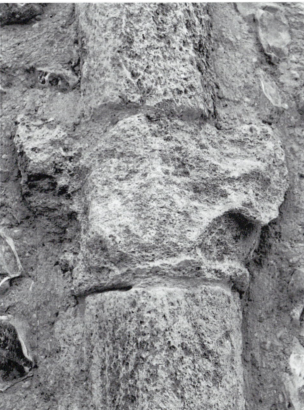

196

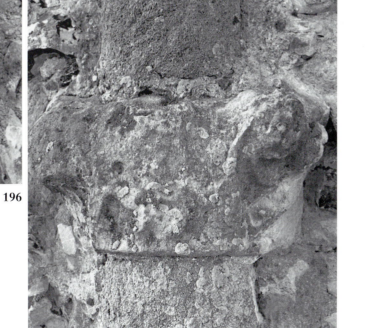

197

**195** Sompting 15 (south, nts)  **196** Sompting 16 (nts)
**197** Sompting 17 (nts)

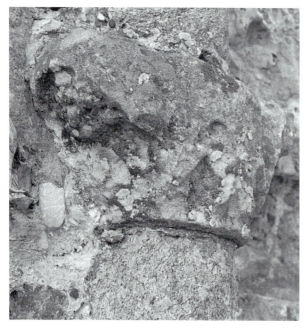

198

199

200

201

**198** Sompting 17 (nts)  **199** Sompting 17 (nts)  **200** Sompting
18 (nts)  **201** Sompting 18 (nts)

202

203

204

**202** Sompting 19 (nts)  **203** Sompting 19 (nts)  **204** Sompting 19 (nts)

205

206

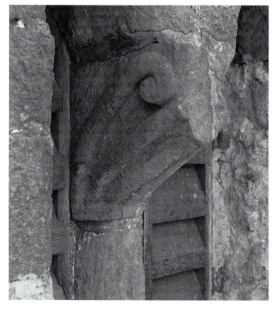

207

**205** Sompting 20 (nts)  **206** Sompting 20 (nts)  **207** Sompting 20 (nts)

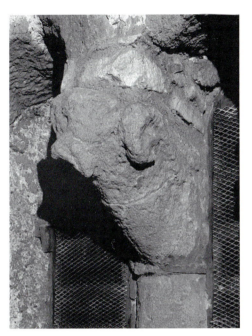

208

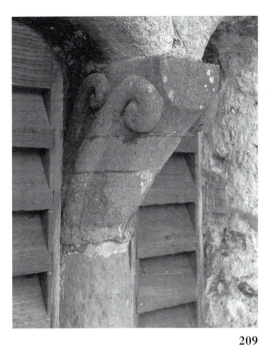

209

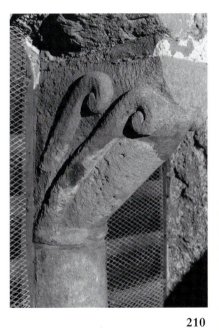

210

212

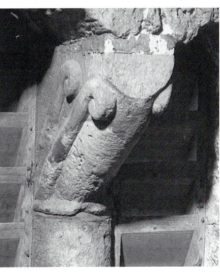

211

208 Sompting 20 (nts)   209 Sompting 21 (nts)   210 Sompting
21 (nts)   211 Sompting 21 (nts)   212 Sompting 21 (nts)

213

214

215

216

217

218

**213** Sompting 22a–b (nts) **214** Sompting 23 (nts) **215**
Sompting 23 (nts) **216** Stoke D'Abernon 1 (after Johnson
1900b) **217** West Wittering 1A **218** West Wittering 1C

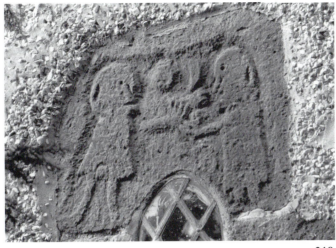

219

220

221

**219** Tangmere 1A  **220** Chithurst 1A (nts)  **221** Chithurst 2A

222

223

224

**222** Chithurst 3A  **223** Chithurst 4A  **224** Chithurst 5A

225

226

227

225 Chithurst 6A  226 Chithurst 7A  227 Chithurst 8A

228

229          230

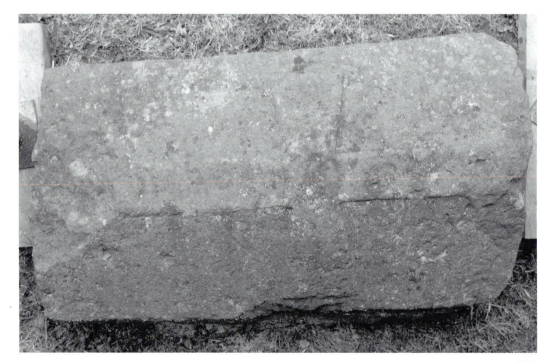

231

228 Cocking 1A   229 Jevington 2a (nts)   230 Jevington 2b
(nts)   231 Tandridge 1A

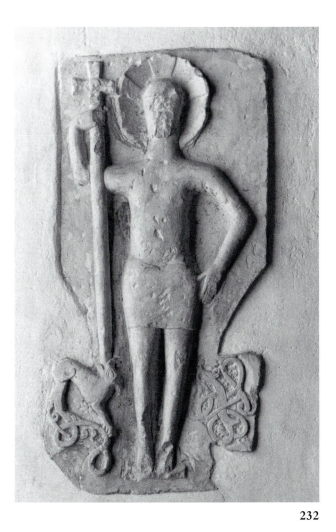

232

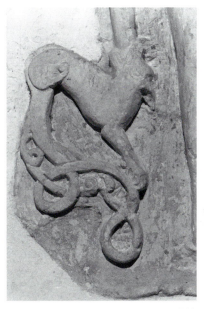

233

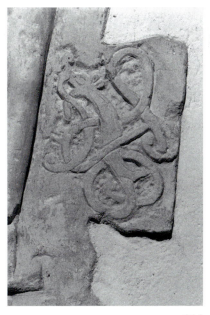

234

**232** Jevington 1  **233** Jevington 1 (1:4)  **234** Jevington 1 (1:4)

235                                    236

**235** Oxted 1A (nts)  **236** Oxted 2A (nts)

237

238

237 Stedham 1A  238 Stedham 3A (nts)

239

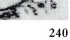

240

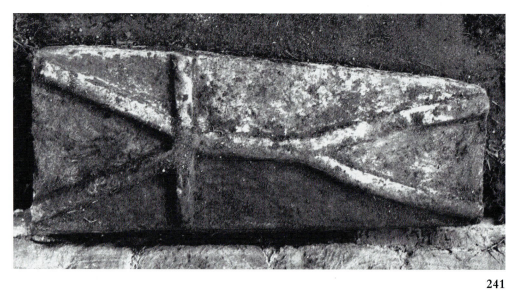

241

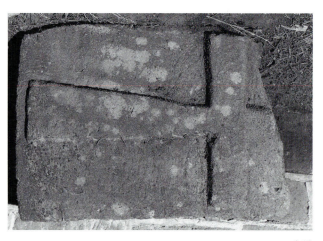

242

243

**239** Stedham 2A   **240** Stedham 8A (after Butler 1851, nts)
**241** Stedham 4A   **242** Stedham 5A   **243** Stedham 7A

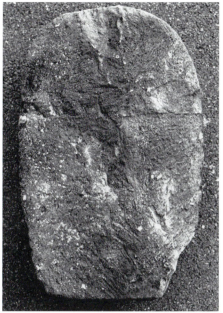

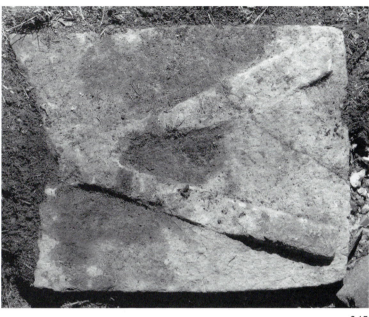

244

245

246

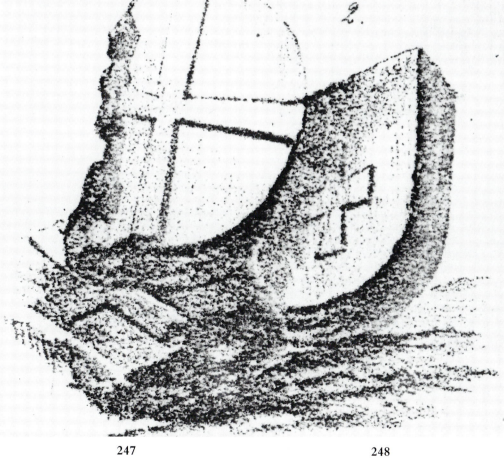

247

248

244 Stedham 7C  245 Stedham 6A  246 Stedham 10A (after
Butler 1851, nts)  247 Stedham 9A (after Butler 1851, nts)
248 Stedham 11A/B/E (after Butler 1851, nts)

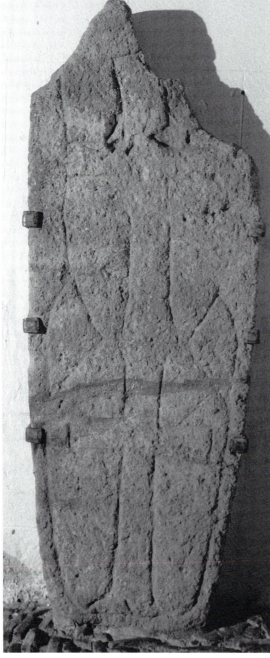

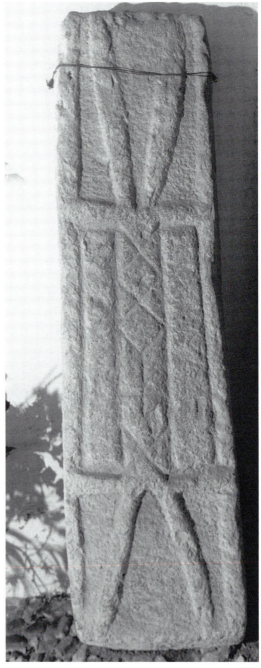

249

250

249 Steyning 1A (nts)  250 Steyning 2A (nts)

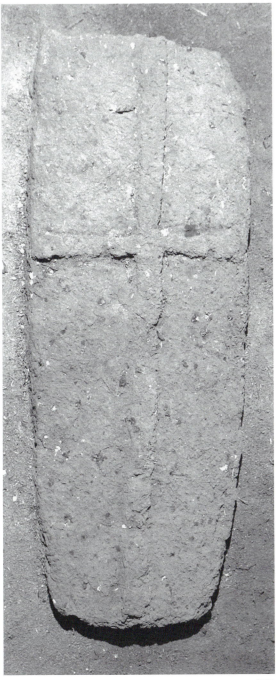

251

252

**251** Titsey 2A  **252** Titsey 1A (nts)

253

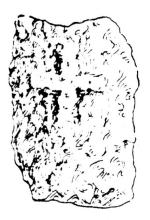

254

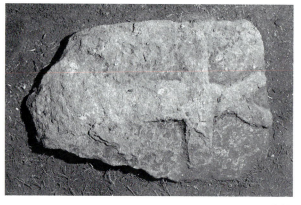

255

**253** Titsey 3A  **254** Titsey 5A (after Gower 1893)  **255** Titsey 4A

ILLUSTRATIONS 256–412

# NORTH OF THE THAMES

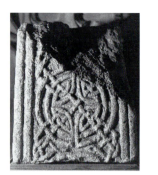
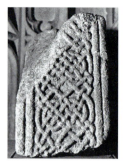
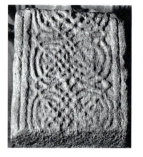
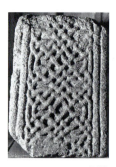

256      257      258      259

260      262      261

263

256 Barking 1A    257 Barking 1B    258 Barking 1C
259 Barking 1D   260 Barking 2A (1:4)   261 Barking 2B (1:4)
262 Barking 2F (1:4)   263 Great Canfield 1A/B/C (nts)

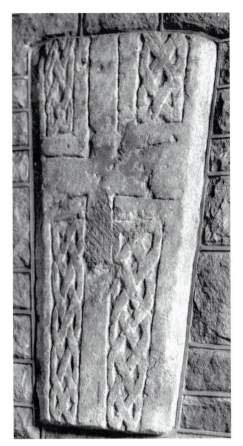

264

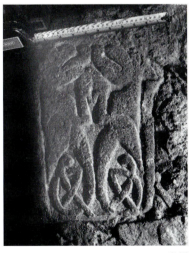

265

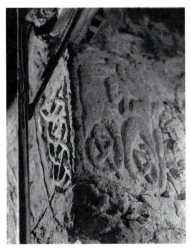

266

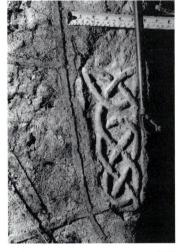

267

264 Cardington 1A  265 Bedford 1A  266 Bedford 1D/A (nts)
267 Bedford 1D

268

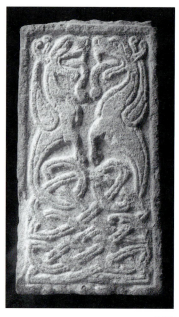

269

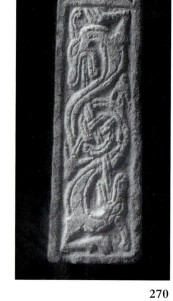
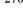

270

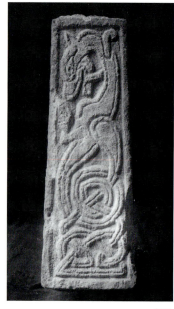

271

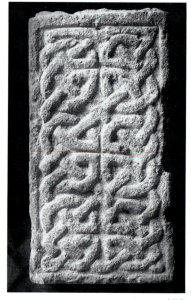

272

**268** Elstow 1E  **269** Elstow 1A  **270** Elstow 1B  **271** Elstow 1D
**272** Elstow 1C

273

274

275

276

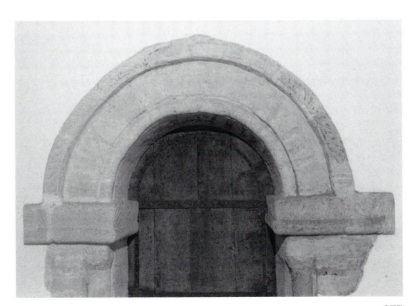

277

**273** Great Maplestead 1E  **274** Great Maplestead 1A  **275** Great
Maplestead 1B  **276** Great Maplestead 1D  **277** Hadstock
1a–eA (nts)

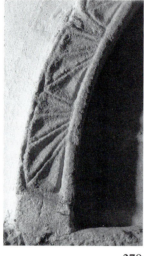

278

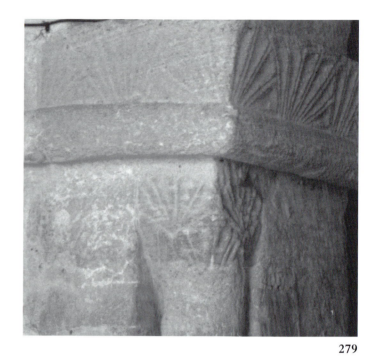

279

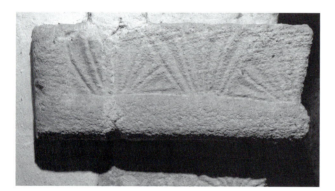

280

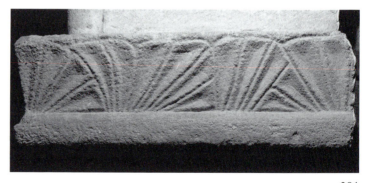

281

**278** Hadstock 1eA **279** Hadstock 1aA/B, 1cA/B
**280** Hadstock 1cA **281** Hadstock 1cB

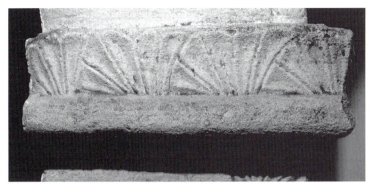

282

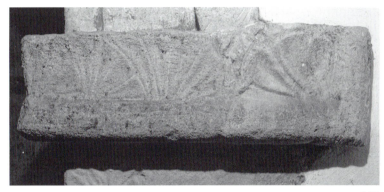

283

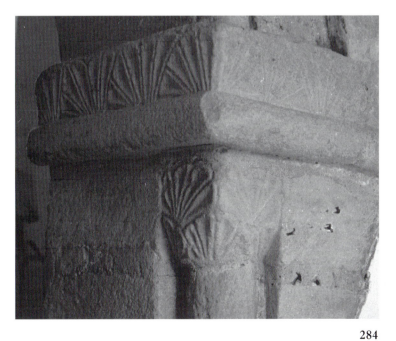

284

**282** Hadstock 1dB  **283** Hadstock 1dA  **284** Hadstock 1bB/A,
1dB/A

Illustration 285

**285** Hadstock 2aA, 2cA, 2eA, 2fA (nts)

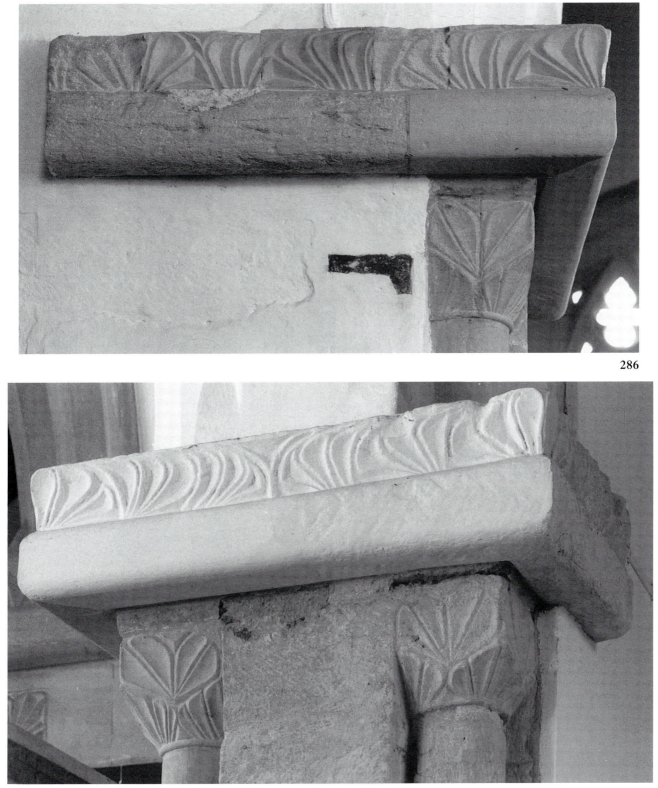

286

287

286 Hadstock 2aA, 2eA  287 Hadstock 2aA, 2bB/C, 2eB/C (nts)

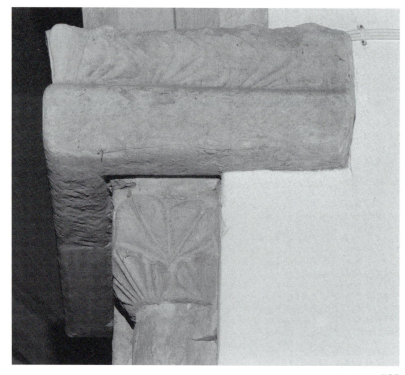

288

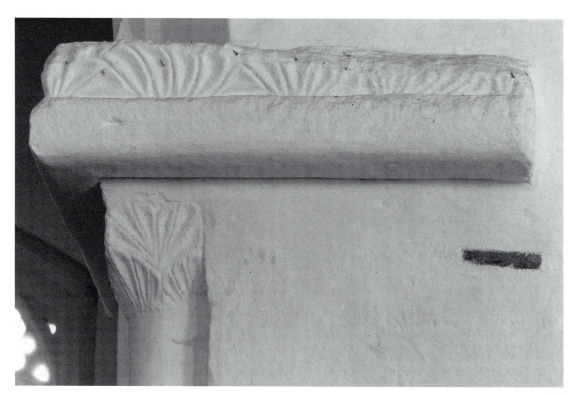

289

**288** Hadstock 2bC, 2eC  **289** Hadstock 2cA, 2fA

**Illustration 290–291**

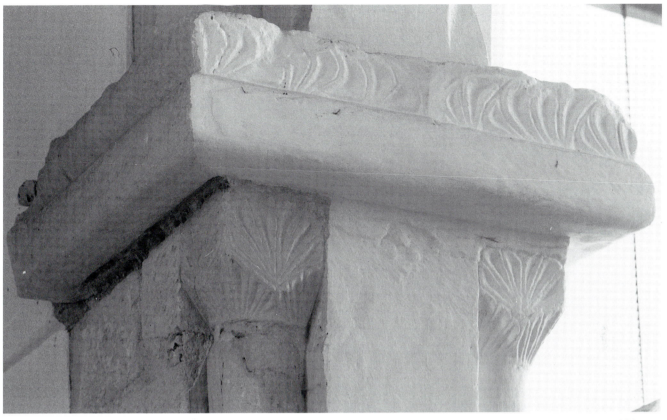

290

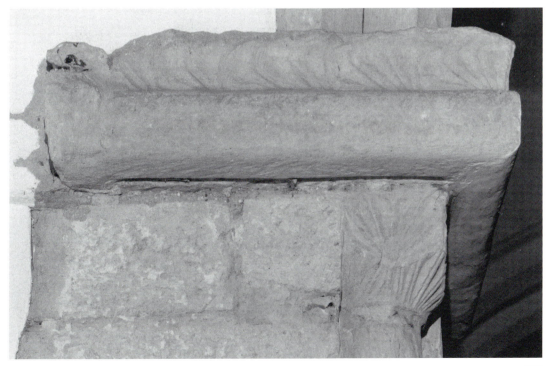

291

**290** Hadstock 2cB, 2dC/B, 2fC/B (nts)  **291** Hadstock 2dC, 2fC

Illustration 292

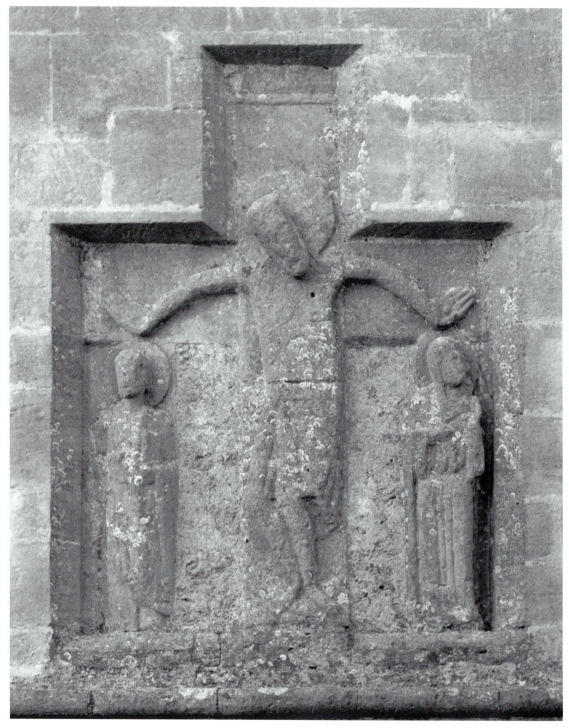

292

Illustration 293

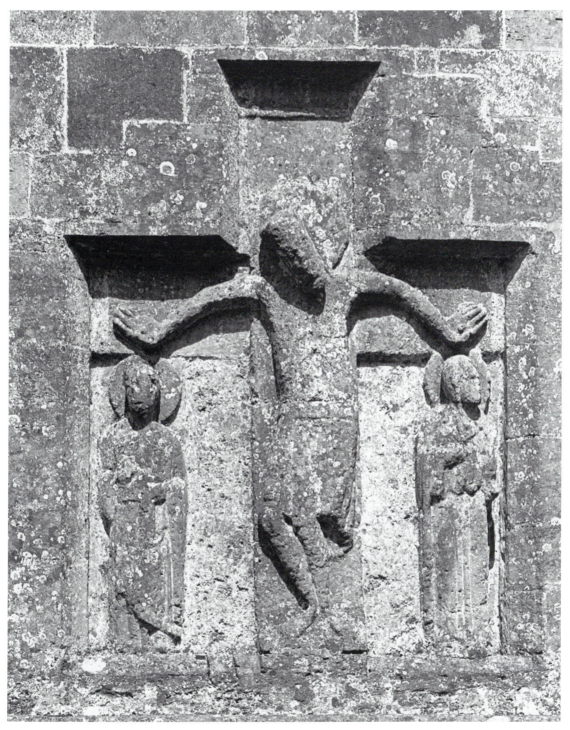

293

Illustration 294

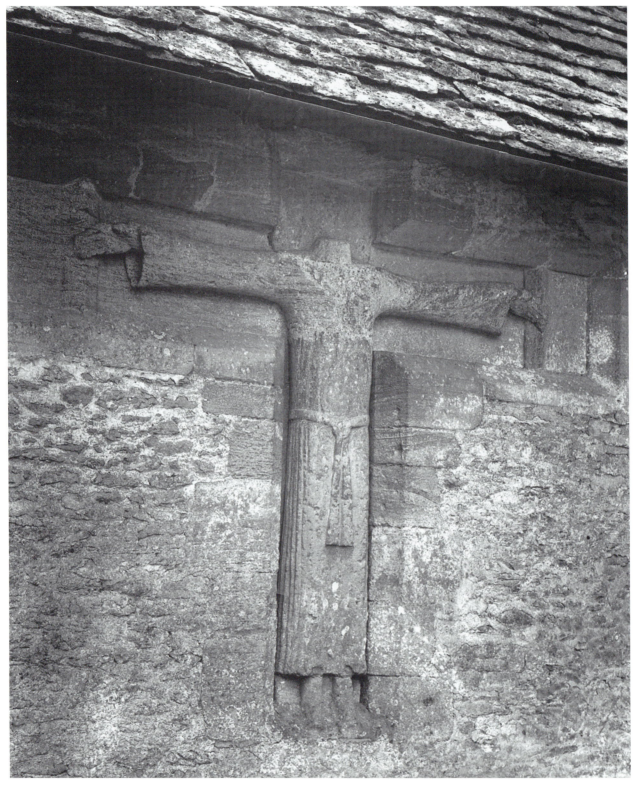

294

294 Langford 2 (nts)

Illustration 295

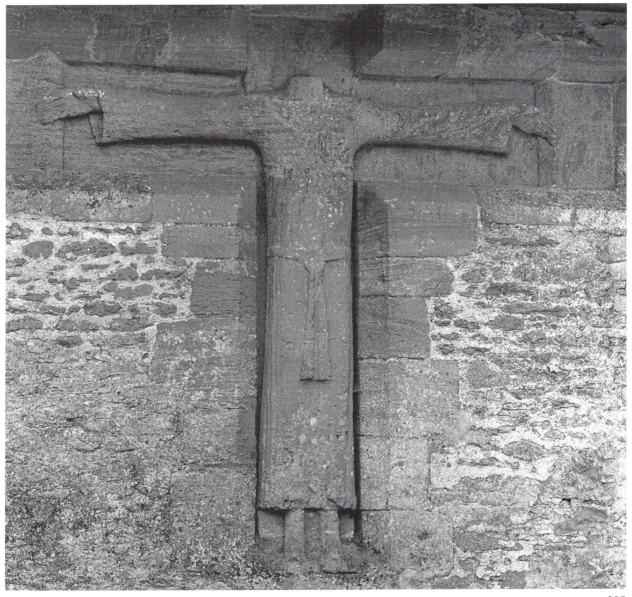

295

Illustration 296

296

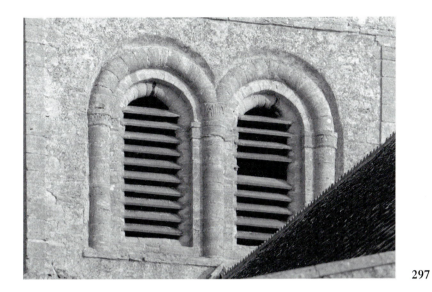

297

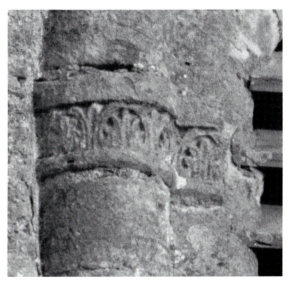

298

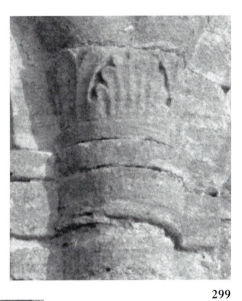

299

300

**297** Langford 4a (nts)  **298** Langford 4a (nts)  **299** Langford 4a
(nts)  **300** Langford 4a (nts)

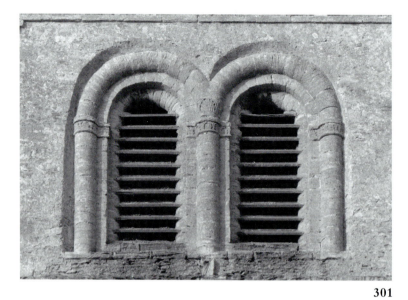

301

302

303

304

**301** Langford 4b (nts) **302** Langford 4b (nts) **303** Langford 4b (nts) **304** Langford 4b (nts)

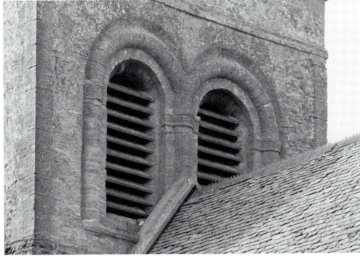

305

306

307

308

**305** Langford 4c (nts)  **306** Langford 4c (nts)  **307** Langford 4c (nts)  **308** Langford 4c (nts)

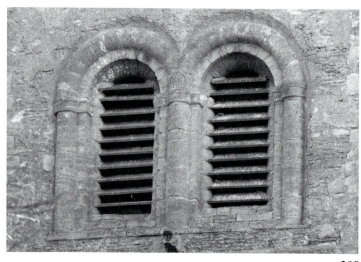

309

310

311

312

**309** Langford 4d (nts)  **310** Langford 4d (nts)  **311** Langford 4d (nts)  **312** Langford 4d (nts)

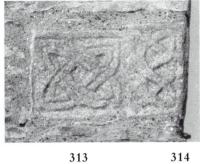

313 314

315

316

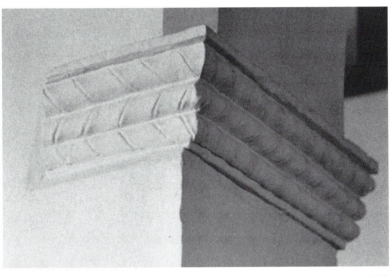

317

318

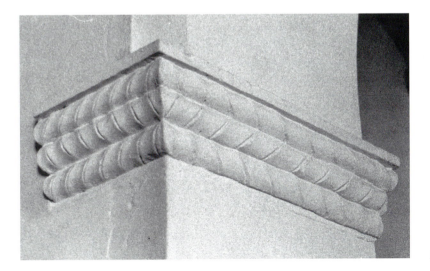

319

**313** Lavendon 1A (nts)  **314** Lavendon 2A (nts)  **315** Lavendon 2A/B (nts)  **316** Lewknor 1  **317** Lewknor 2  **318** Little Munden 1a (nts)  **319** Little Munden 1b (nts)

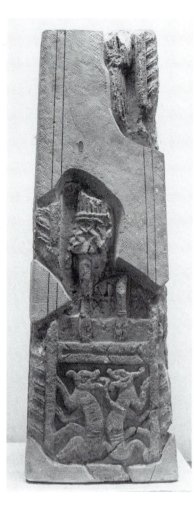

322

321

320

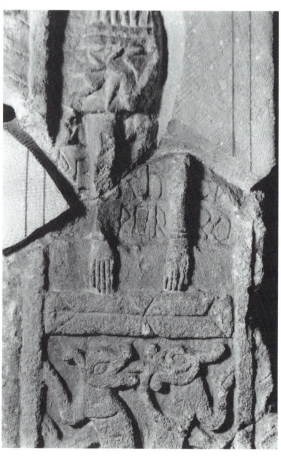

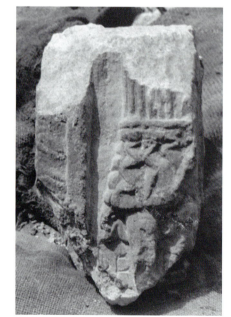

323

324

320 London All Hallows 1a–bA  321 London All Hallows 1bA
(1:4)  322 London All Hallows 1aiiiA (1:4)  323 London All
Hallows 1aiiA (1:4)  324 London All Hallows 1ai–iiA (1:4)

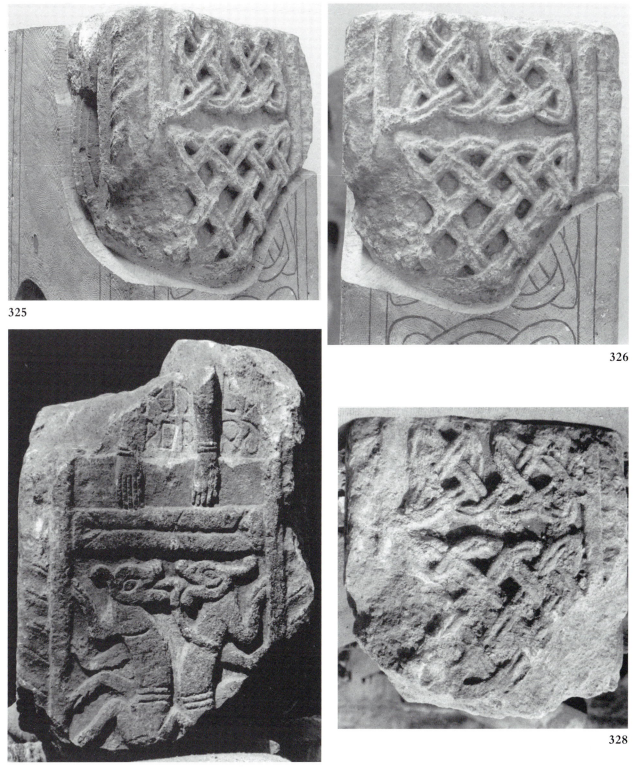

325

326

327

328

325 London All Hallows 1bA/B (nts)  326 London All Hallows 1bB (1:4)  327 London All Hallows 1aiA (1:4) 328 London All Hallows 1bB (1:4)

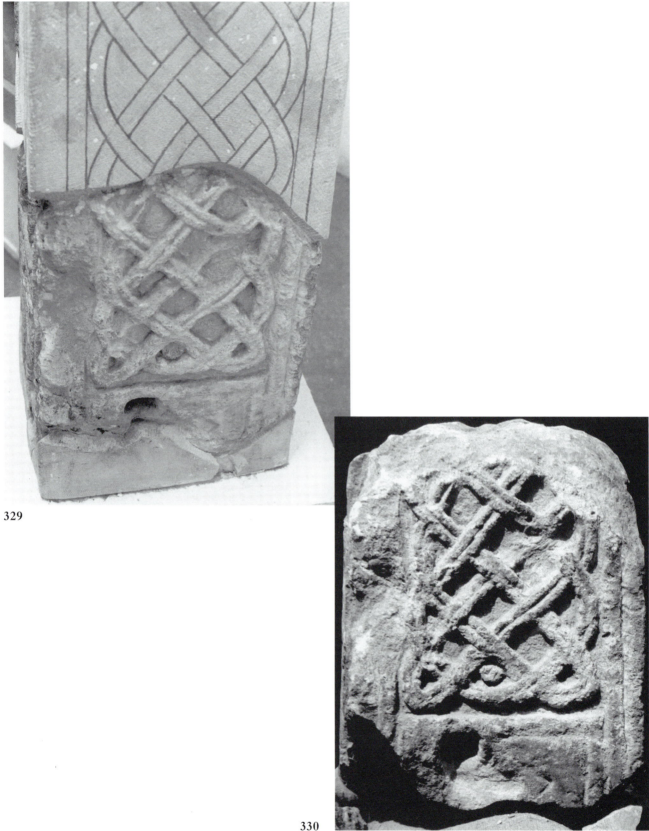

329

330

**329** London All Hallows 1aiA (nts)  **330** London All Hallows 1aiB (1:4)

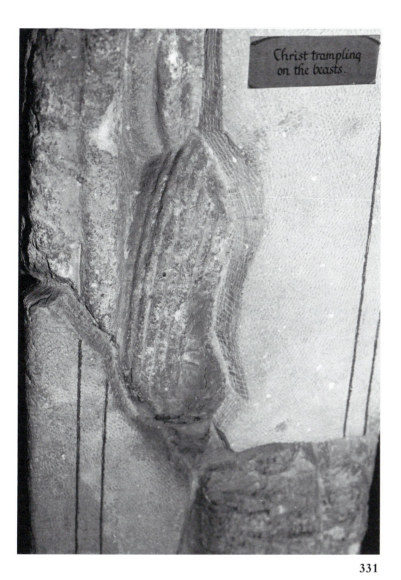

Christ trampling on the beasts.

332

331

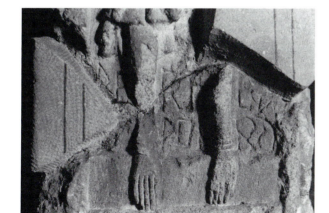

333

334

331 London All Hallows 1bC (nts)  332 London All Hallows
1bC (1:4)  333 London All Hallows 1ai–iiA (1:4)  334 London
All Hallows 1aiiC (1:4)

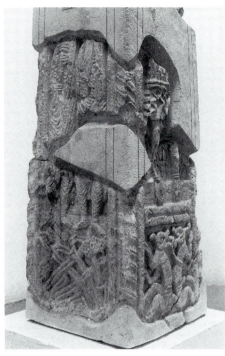

335

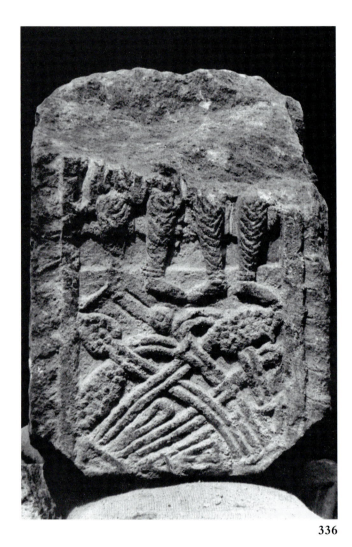

336

**335** London All Hallows 1aD/A (nts)  **336** London All
Hallows 1aiD (1:4)

337

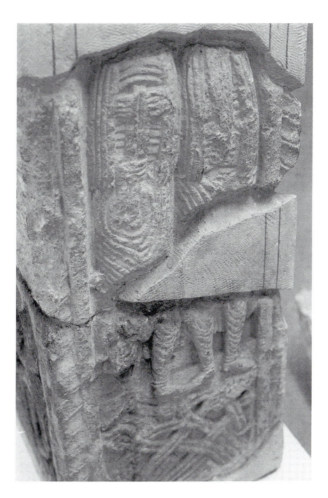

338

337 London All Hallows 1aiiD (1:4)  338 London All Hallows
1aD (nts)

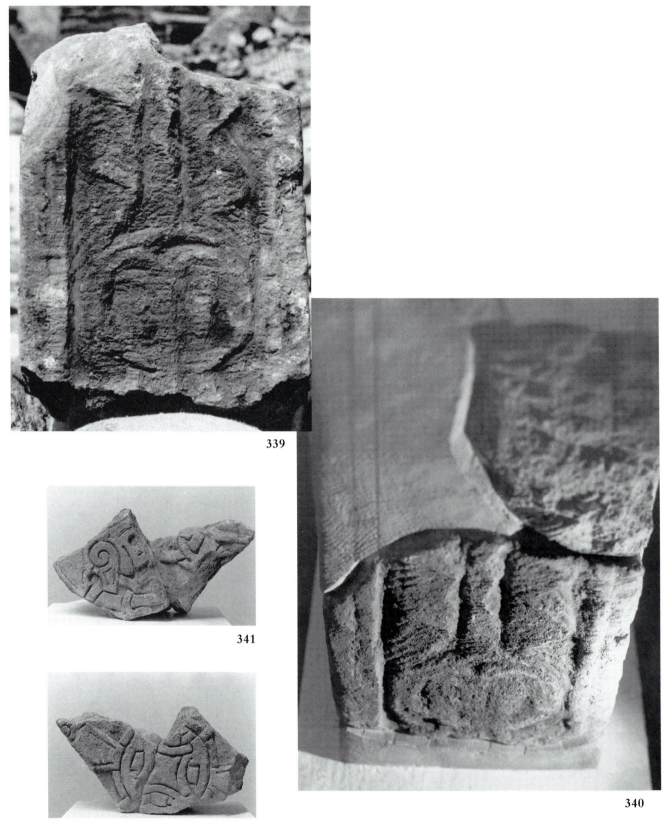

339

341

342

340

**339** London All Hallows 1aiC (1:4)  **340** London All Hallows
1aC (nts)  **341** London All Hallows 3A  **342** London All
Hallows 3C

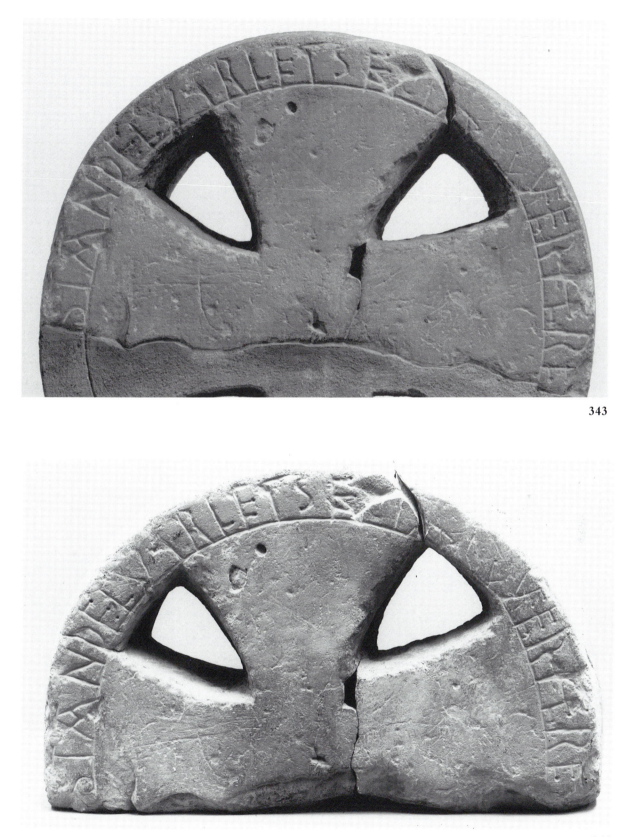

343

344

**343** London All Hallows 2A (nts)  **344** London All Hallows 2A
(nts)

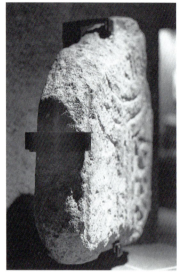

345

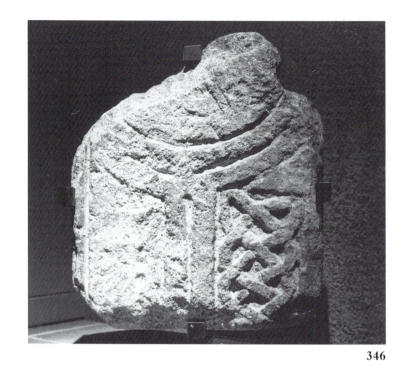

346

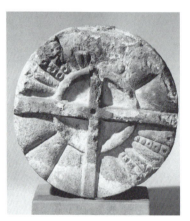

347          348

349

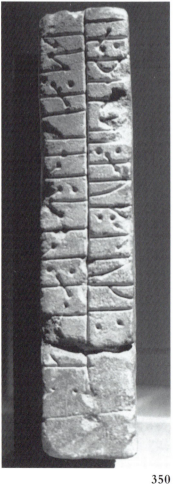

350

**345** London St Benet Fink 1D/A  **346** London St Benet Fink
1A  **347** London St John Walbrook 1A  **348** London St John
Walbrook 1C  **349** London St John Walbrook 1B  **350** London
St Paul's 1D (1:4)

**Illustration 351**

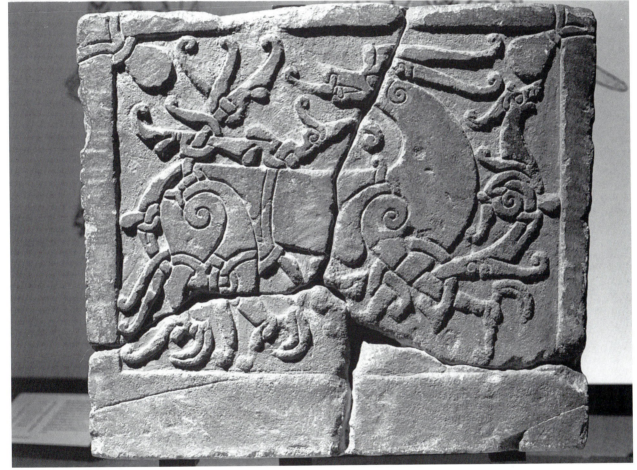

**351** London St Paul's 1A (1:4)

Illustration 352

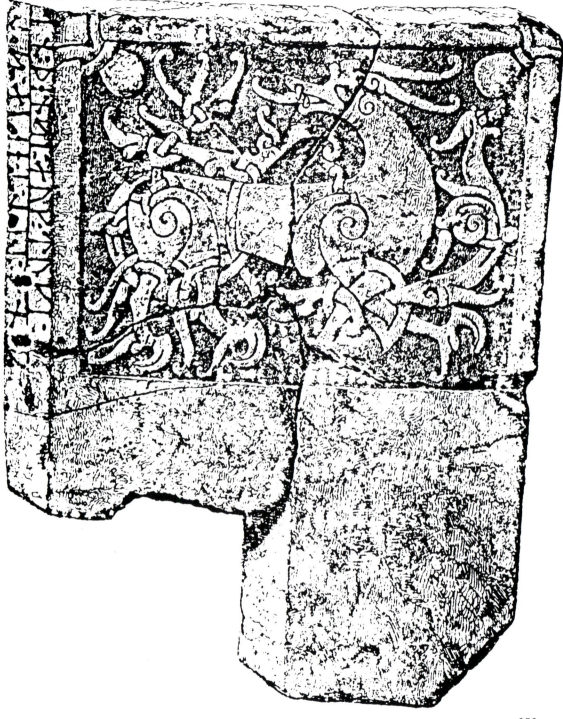

352

**352** London St Paul's 1A/D (after Beckett 1924, 1:4)

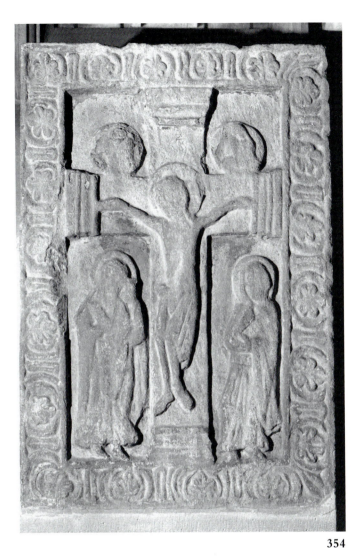

354

353

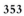

**353** London City 1a–bA  **354** London Stepney 1

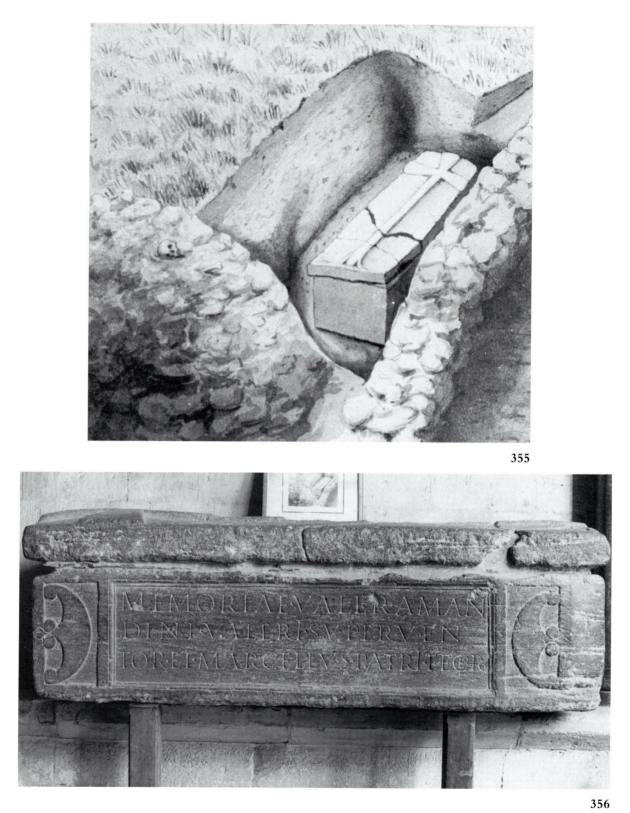

355

356

355 London Westminster Abbey 1A/C/D (watercolour, artist
unknown, nts)  356 London Westminster Abbey 1B

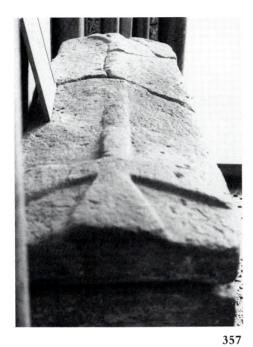

357

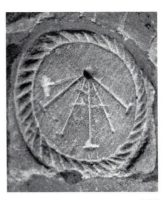

358

359

360

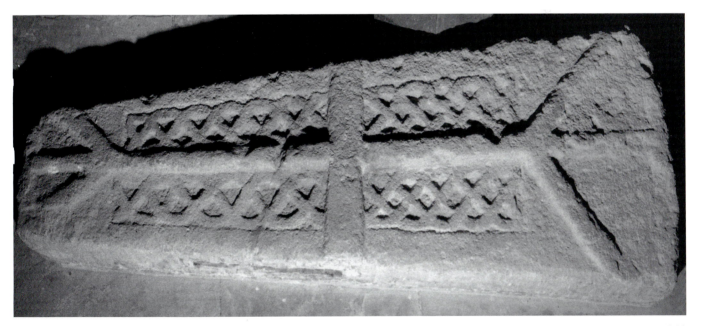

361

**357** London Westminster Abbey 1A/E  **358** Marsh Baldon 1
**359** Oxford St Aldate's 1E  **360** Oxford St Aldate's 1A  **361**
Milton Bryan 1A (nts)

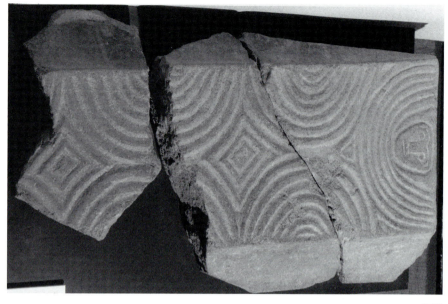

362

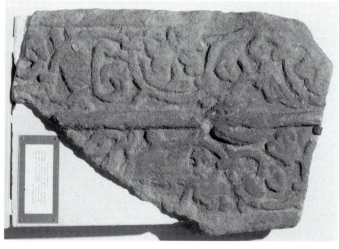

363

362 Oxford Cathedral 1A   363 Oxford New Examination
Schools 1A

364

365

364 Oxford St Michael 1a (nts)  365 Oxford St Michael 1b (nts)

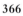

**366**

**367**

**366** Oxford St Michael 1g (nts)  **367** Oxford St Michael 1c (nts)

368

369

370

368 Oxford St Michael 1f (nts)   369 Oxford St Michael 1e
(nts)   370 Oxford St Michael 1d (nts)

371

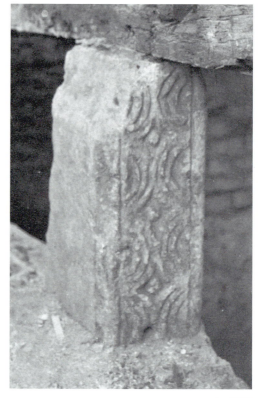

373

372

374

375

**371** Saffron Walden 1A  **372** Saffron Walden 2A  **373** Saffron Walden 2D/A  **374** West Mersea 1A  **375** White Notley 1A

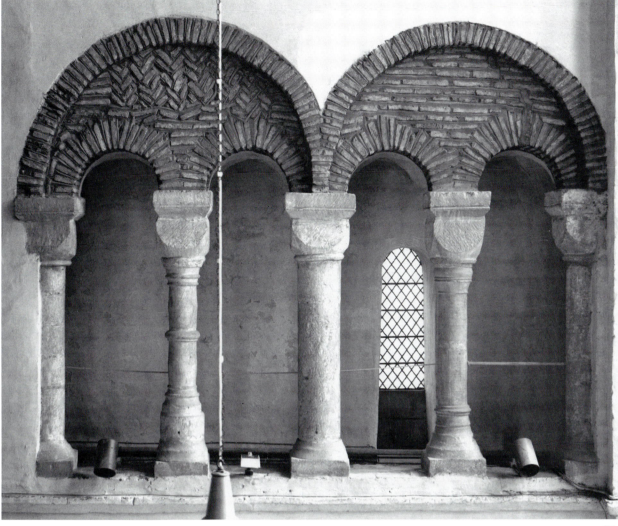

376

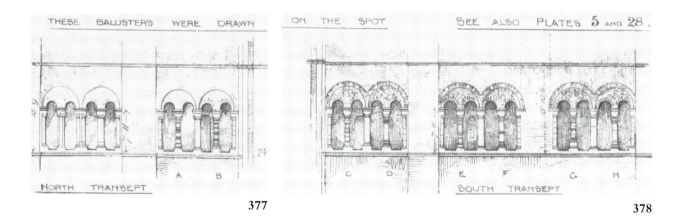

377                                                                    378

**376** St Albans 1m–p (nts)   **377** St Albans 1a–d (after Neale
1877, pl. 32, elevation of north transept, nts)   **378** St Albans
1e–p (after Neale 1877, pl. 32, elevation of south transept, nts)

**Illustration 379**

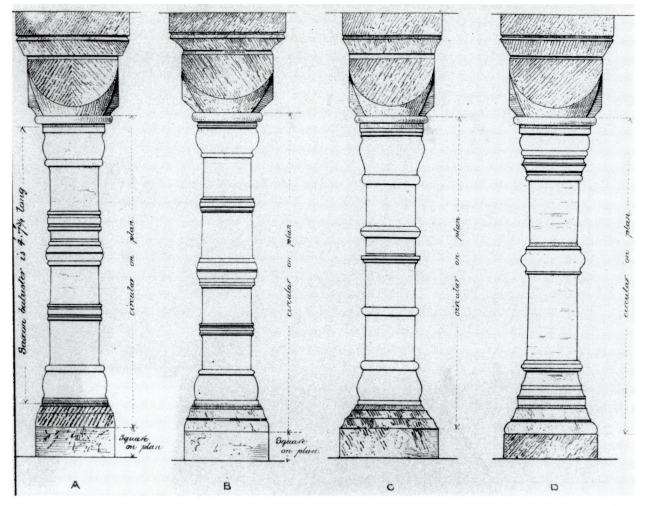

**379** St Albans 1a–h (after Neale 1877, pl. 32, A–D, nts)

**Illustration 380**

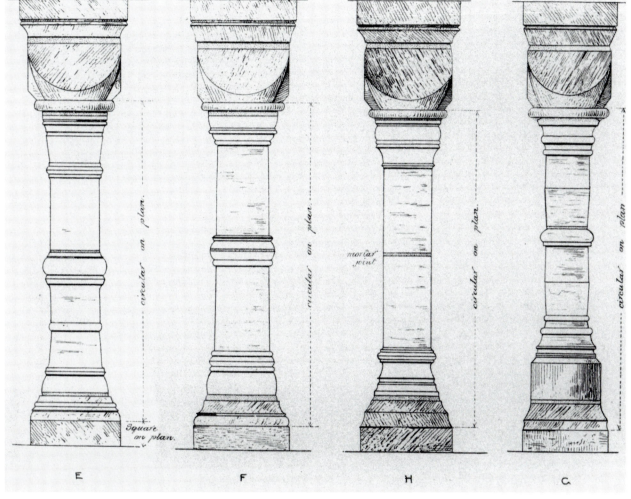

**380** St Albans 1i–p (after Neale 1877, pl. 32, E–H (order of G and H reversed), nts)

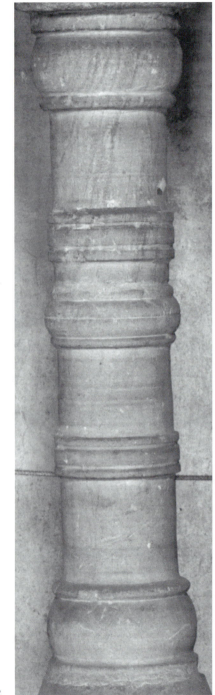

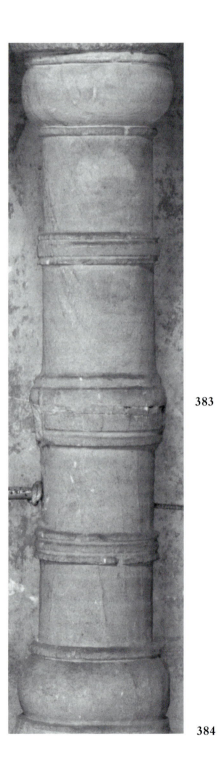

381 St Albans 1a  382 St Albans 1b  383 St Albans 1c  384 St Albans 1d

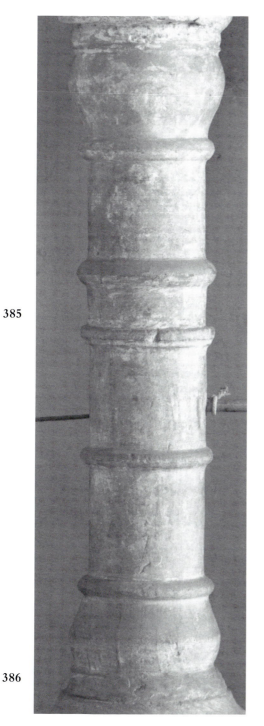

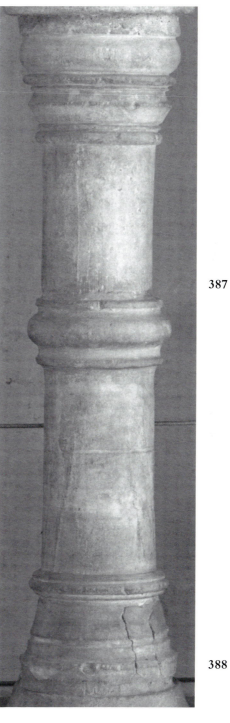

385

386

387

388

385 St Albans 1e  386 St Albans 1f  387 St Albans 1g  388 St Albans 1h

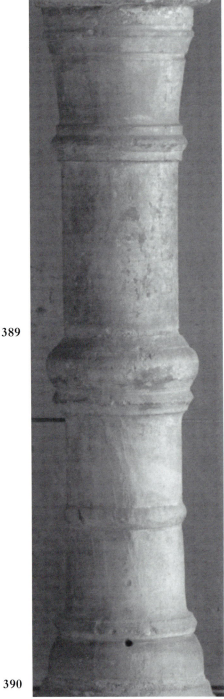

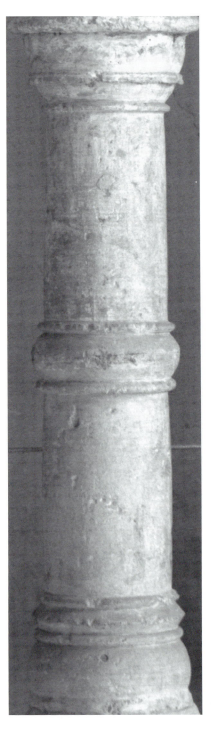

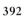

389

390

391

392

389 St Albans 1i  390 St Albans 1j  391 St Albans 1k  392 St Albans 1l

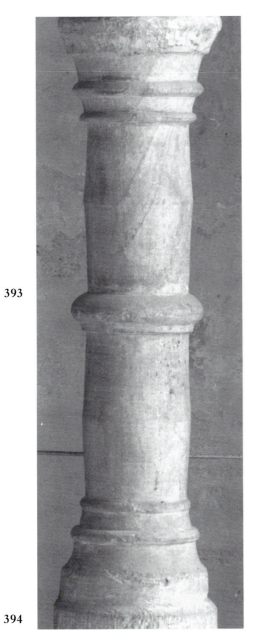

393

394

395

396

393 St Albans 1m  394 St Albans 1n  395 St Albans 1o  396 St Albans 1p

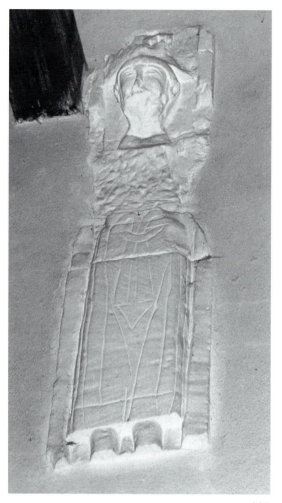

397

398

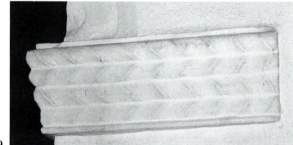

399

**397** Walkern 1 (nts)  **398** Walkern 2A  **399** Walkern 2B

400

401

402

403

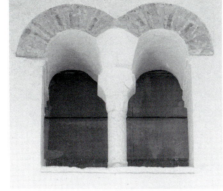

404

407

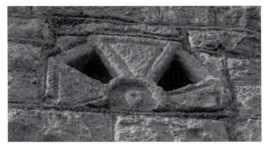

405

406

408

**400** North Leigh 1a (nts)  **401** North Leigh 1b (nts)  **402** North Leigh 1c (nts)  **403** North Leigh 1d (nts)  **404** Oxford St Michael 2A  **405** Oxford St Michael 2B  **406** South Leigh 1A (nts)  **407** Wing 1 (nts)  **408** Wing 1 (nts)

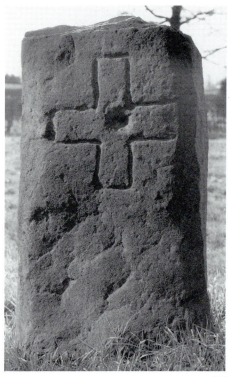

409

410

411

412

**409** Stanbridge 1aA  **410** Stanbridge 1aB  **411** Stanbridge 1b?A
**412** Stanbridge 1b?B

ILLUSTRATIONS 413–722

# HAMPSHIRE AND BERKSHIRE

413

414

416

417

415

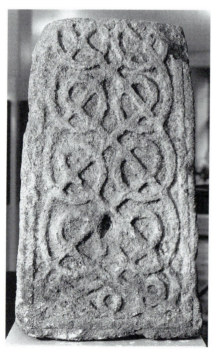

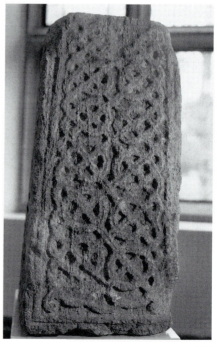

418

419

**413** Abingdon 1A  **414** Abingdon 1C  **415** Bishops Waltham
1E  **416** Abingdon 1B/E  **417** Abingdon 1F  **418** Bishops
Waltham 1A  **419** Bishops Waltham 1B

420

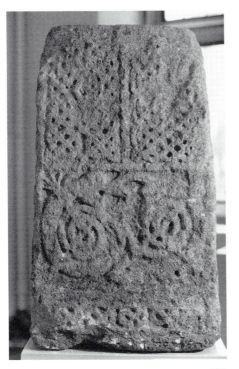

421

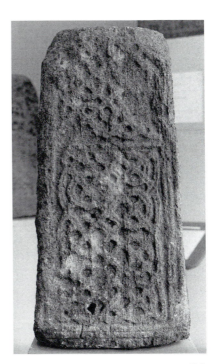

422

**420** Boarhunt 1 (nts)   **421** Bishops Waltham 1C   **422** Bishops Waltham 1D

423

424

**423** Boarhunt 1  **424** Boarhunt 1 (1:4)

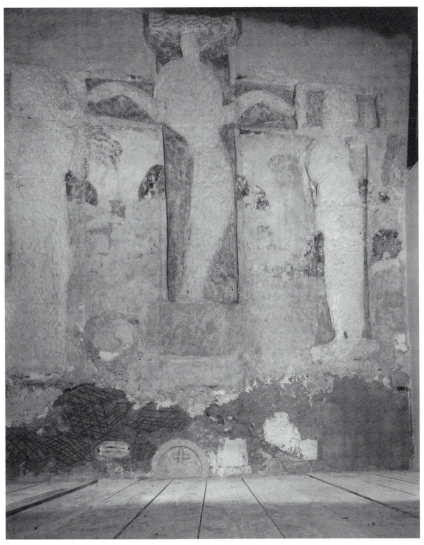

425

426

**425** Breamore 1 (nts)  **426** Breamore 1 (nts)

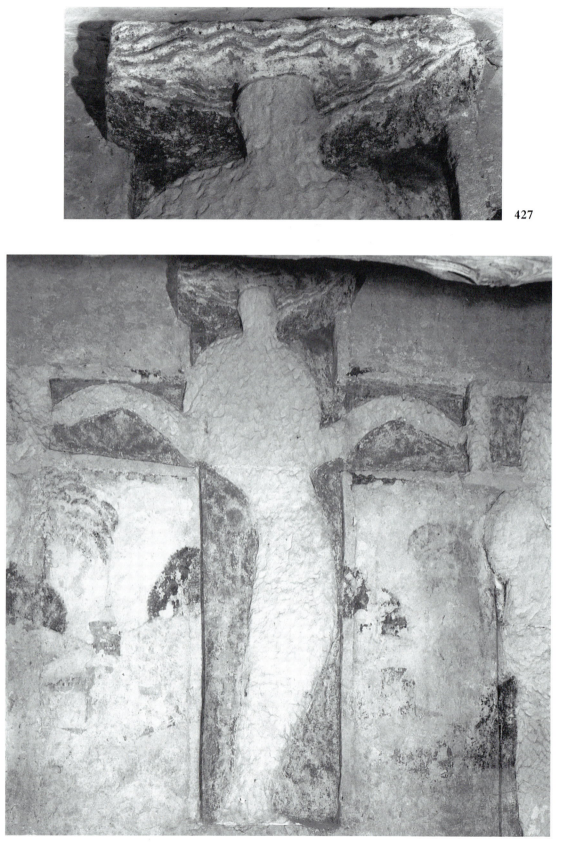

**427** Breamore 1 (nts)  **428** Breamore 1 (nts)

**Illustration 429**

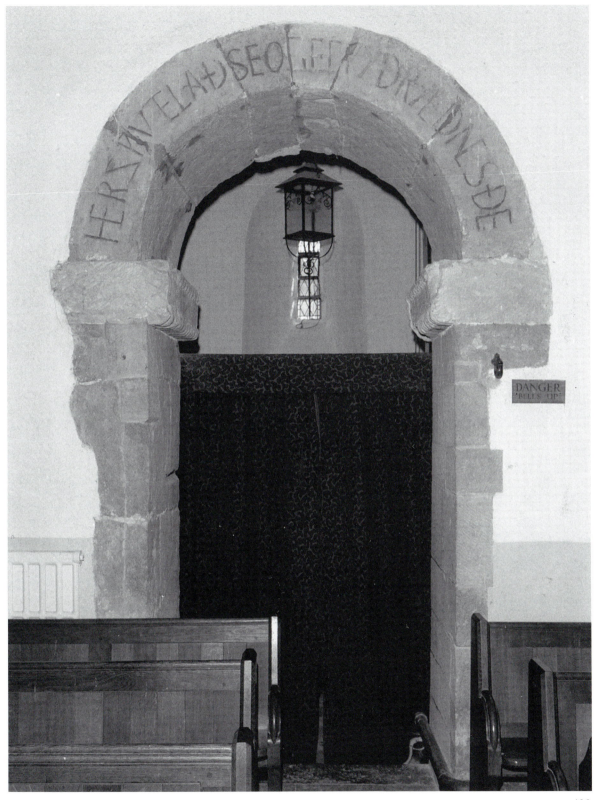

**429** Breamore 2a–cA (nts)

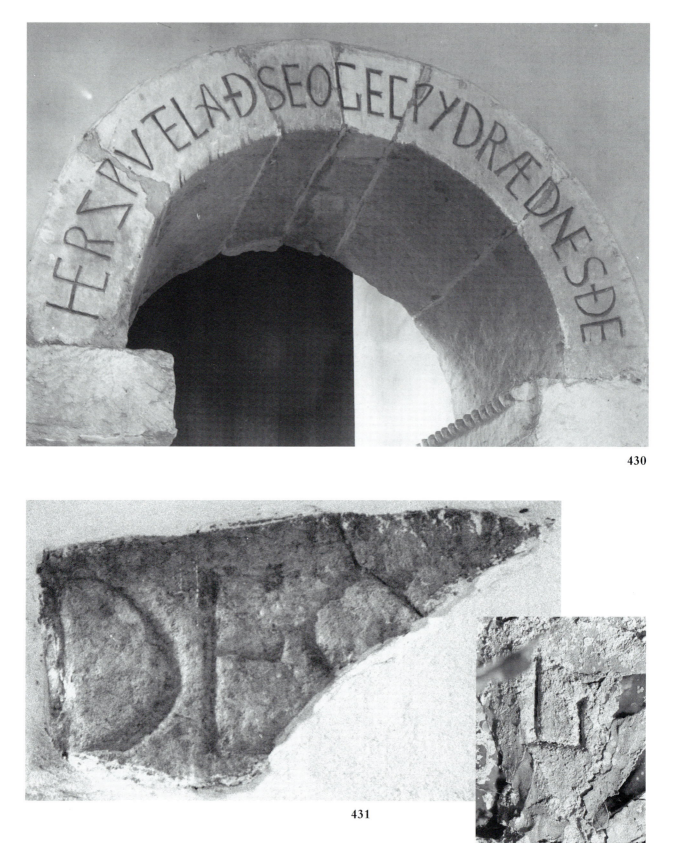

430

431

432

**430** Breamore 2a–cA (nts)  **431** Breamore 3 (nts)
**432** Breamore 4 (1:4)

Illustration 433

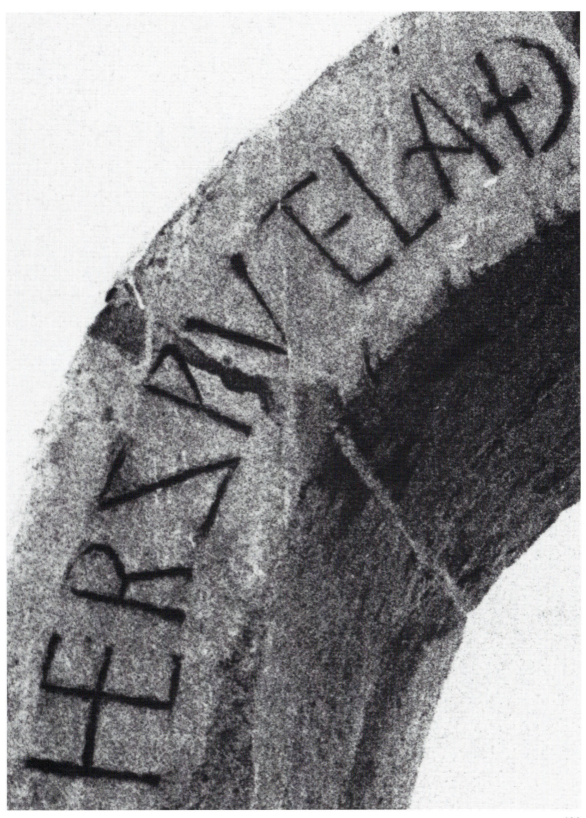

**433** Breamore 2cA (1:4)

434

435

436

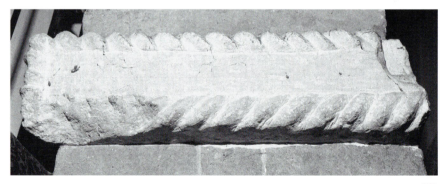

437

**434** Breamore 2aB  **435** Breamore 2aC  **436** Breamore 2bC
**437** Breamore 2bB

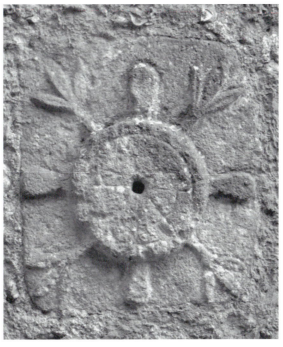

438

439

440

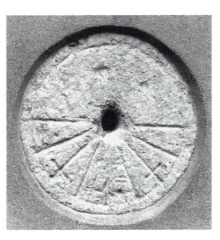

441

**438** Corhampton 1   **439** Corhampton 3   **440** Corhampton 2
**441** Hannington 1

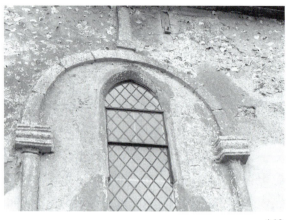

**442**

**443**

**444**

**442** Corhampton 4a–bA (nts)   **443** Corhampton 4a–dA (nts)
**444** Corhampton 4cA

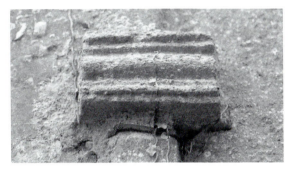

445

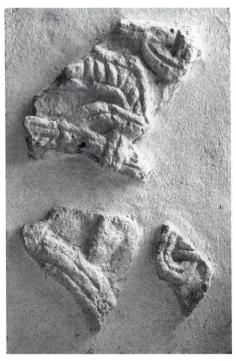

447

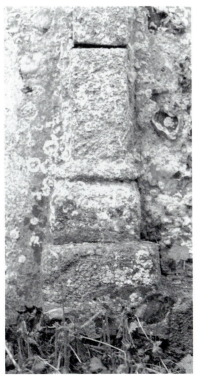

446

445 Corhampton 4aA  446 Corhampton 4dA
447 Little Somborne 1a–c (1:4)

Illustration 448

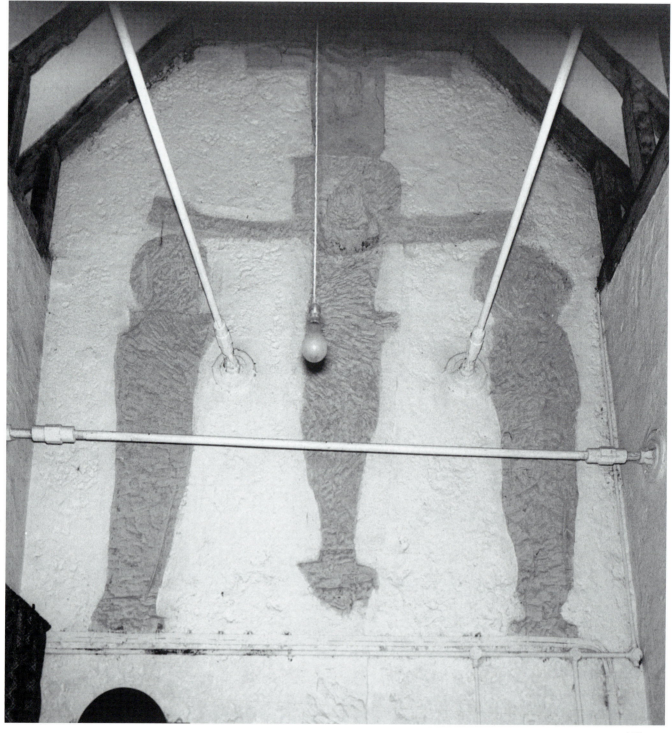

**448** Headbourne Worthy 1 (nts)

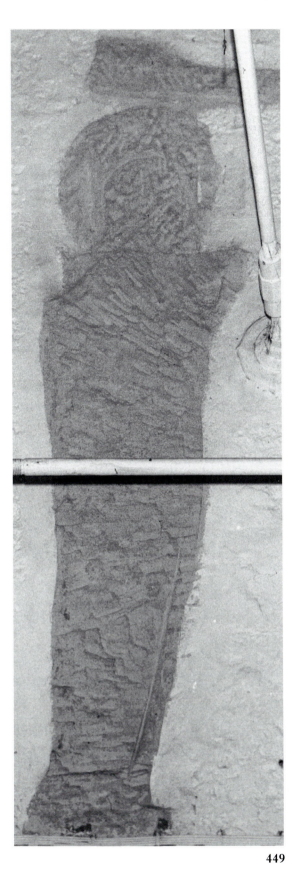

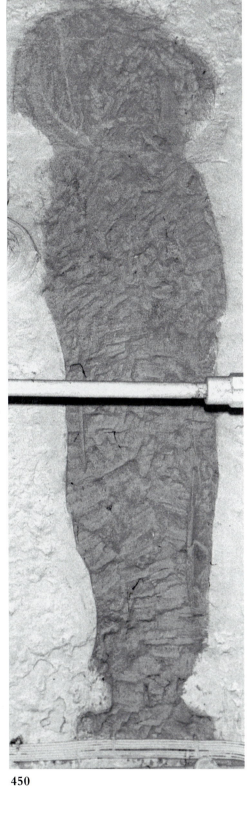

449

450

449 Headbourne Worthy 1 (nts)  450 Headbourne Worthy 1 (nts)

Illustration 451

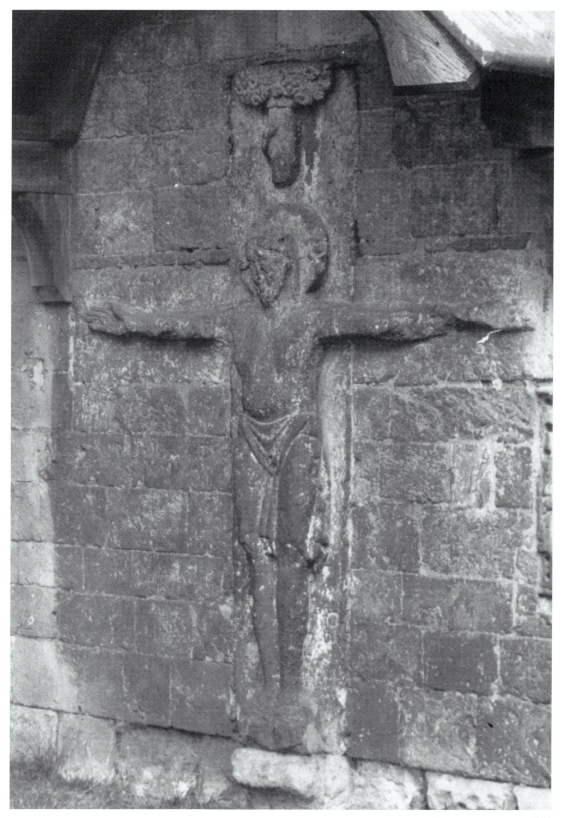

**451** Romsey 1 (nts)

Illustration 452

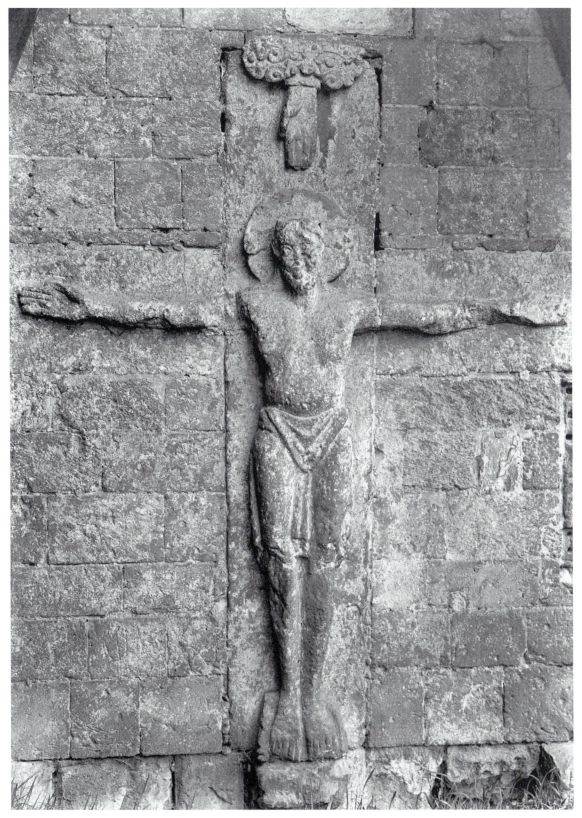

**452** Romsey 1 (nts)

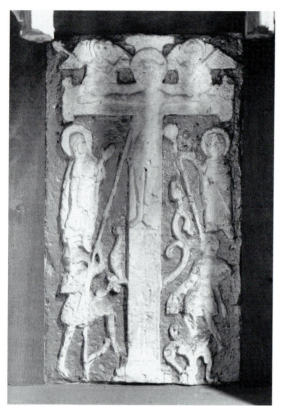

453

454

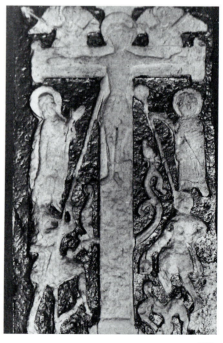

455

**453** Romsey 2   **454** Sonning 1   **455** Romsey 2

456

457

458

**456** Romsey 1 (detail, 1:4)  **457** Southampton 1bB (1:4)
**458** Southampton 1bA (1:4)

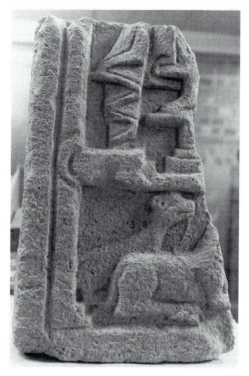

**459**

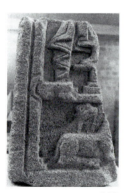

**460**

**461**

**462**

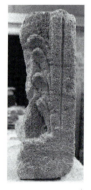

**463**

**464**

**459** Southampton 1aA (1:4)  **460** Southampton 1aA  **461**
Southampton 1aB  **462** Southampton 1aC  **463** Southampton
1aD  **464** Southampton 1aF

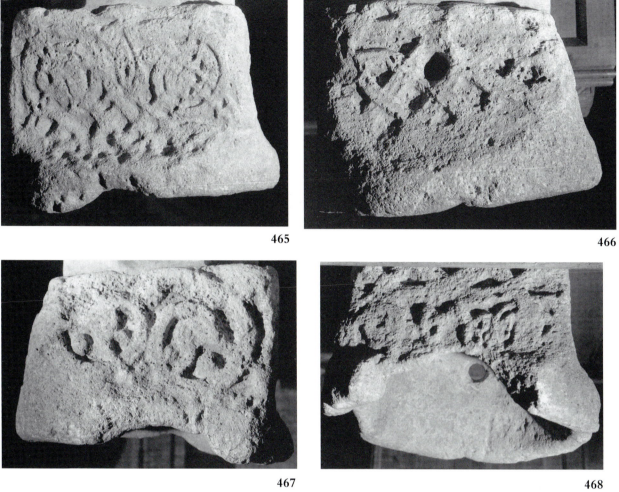

465

466

467

468

469

465 South Hayling 1A   466 South Hayling 1B   467 South
Hayling 1C   468 South Hayling 1D   469 South Hayling 1B/C

470

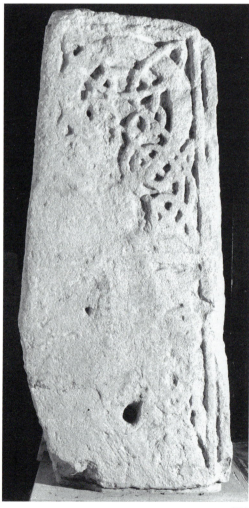

471

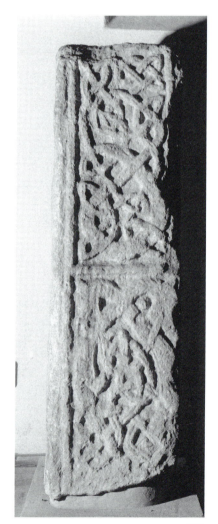

472

**470** Steventon 1E  **471** Steventon 1A  **472** Steventon 1B

474

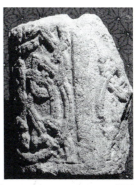

475

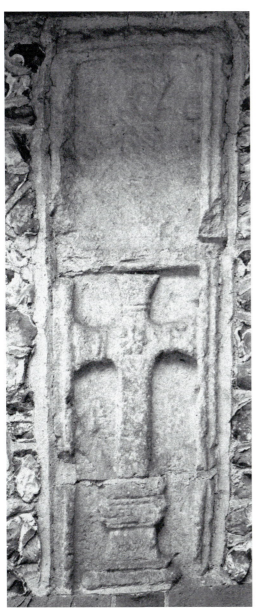

473

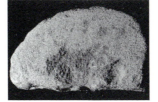

476

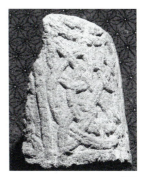

477

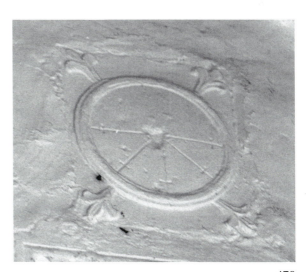

478

473 Weyhill 1A  474 Wantage 1A  475 Wantage 1A/B
476 Wantage 1F  477 Wantage 1D/A  478 Warnford 1 (nts)

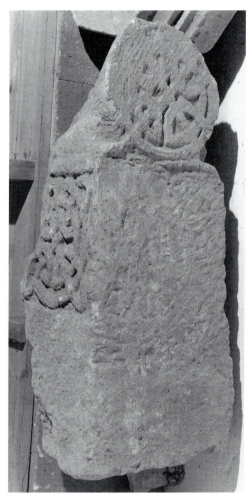

479

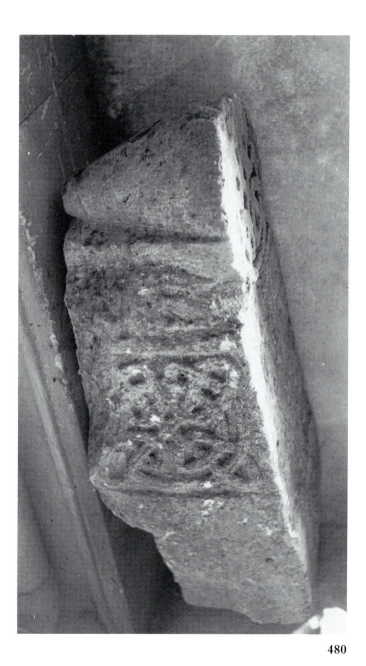

480

**479** Wherwell 1D/A (nts)  **480** Wherwell 1D (nts)

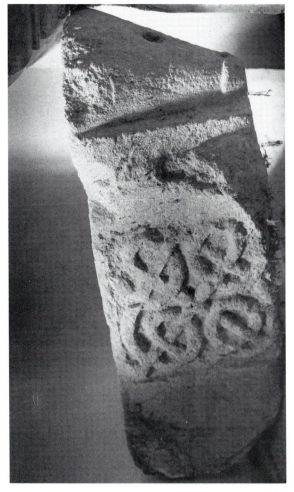

481

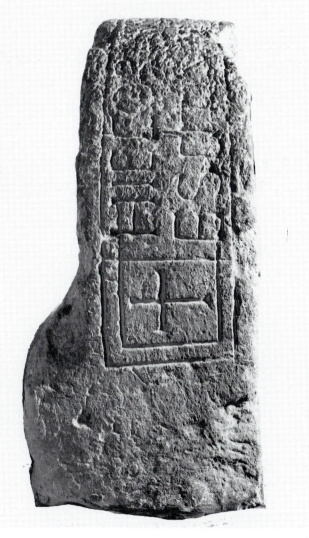

482

481 Wherwell 1B (nts)  482 Whitchurch 1D/E (1:4)

Illustration 483

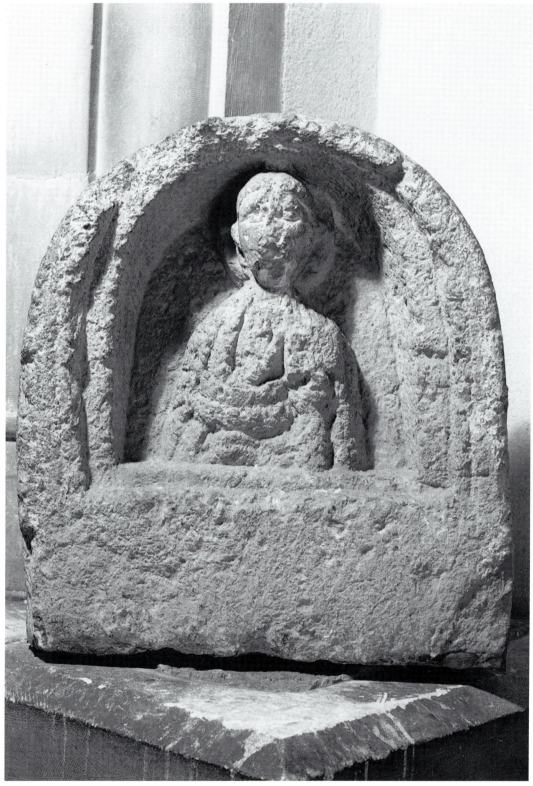

483

**483** Whitchurch 1A (1:4)

Illustration 484

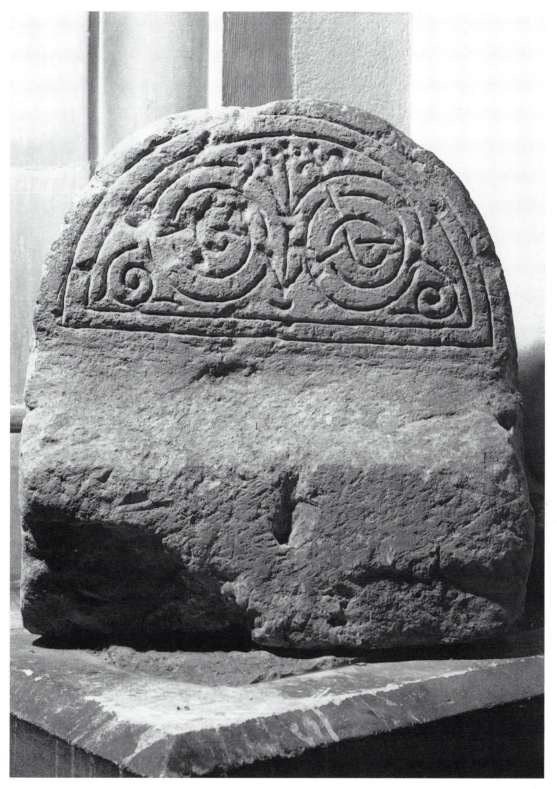

**484** Whitchurch 1C (1:4)

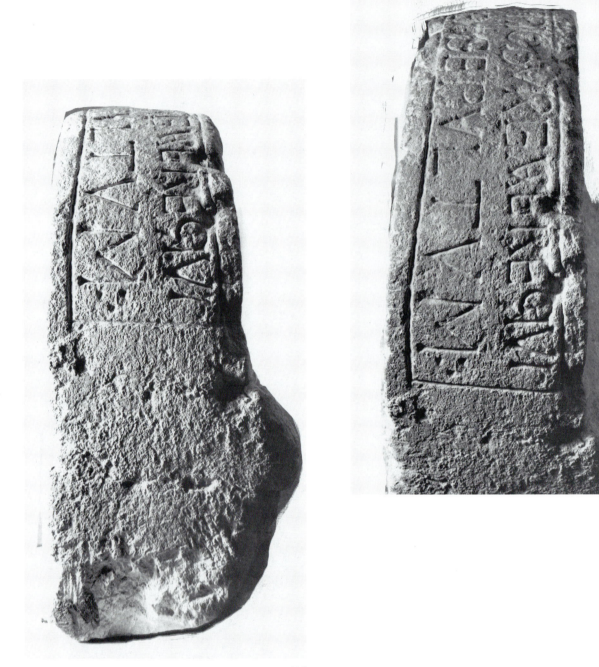

485

486

485 Whitchurch 1B/E (1:4)  486 Whitchurch 1E (1:4)

487

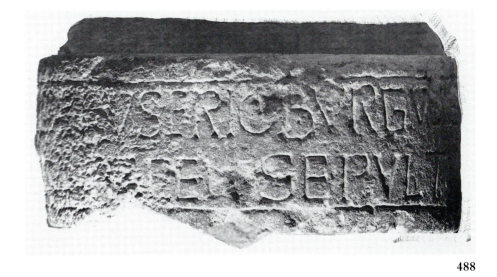

488

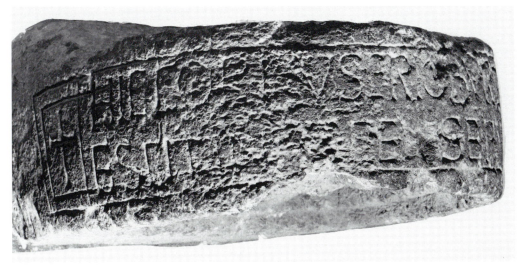

489

487 Whitchurch 1E (1:4)  488 Whitchurch 1E (1:4)
489 Whitchurch 1E (1:4)

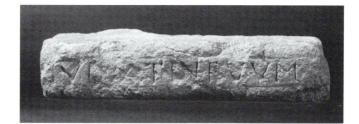

490

491

492

493

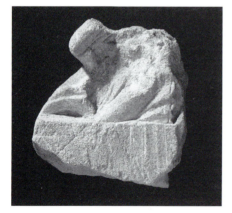

494

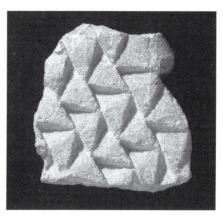

495

496

**490** Winchester Old Minster 1A (1:4)  **491** Winchester Old
Minster 1F (1:4)  **492** Winchester Old Minster 1B (1:4)
**493** Winchester Old Minster 1D (1:4)  **494** Winchester Old
Minster 3A (1:4)  **495** Winchester Old Minster 3C (1:4)
**496** Winchester Old Minster 3D (1:4)

497

498

500

499

501

**497** Winchester Old Minster 2C **498** Winchester Old Minster
2A **499** Winchester Old Minster 2B **500** Winchester Old
Minster 2E **501** Winchester Old Minster 5A

502

505

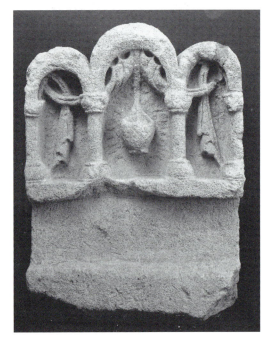

503

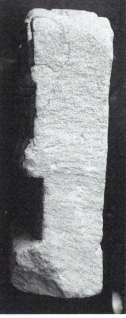

506

507

504

502 Winchester Old Minster 4E  503 Winchester Old Minster
4A  504 Winchester Old Minster 4F  505 Winchester Old
Minster 4C  506 Winchester Old Minster 4B  507 Winchester
Old Minster 4D

Illustration 508

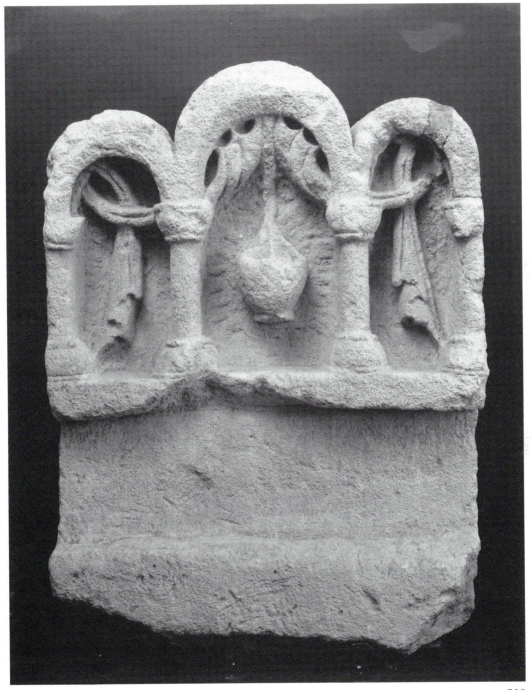

508

**508** Winchester Old Minster 4A (1:4)

510

509

509 Winchester Old Minster 6A  510 Winchester Old Minster 6E

511

512

513

511 Winchester Old Minster 6A (1:4)   512 Winchester Old
Minster 6A (1:4)   513 Winchester Old Minster 6A (1:4)

514

515

516

517

518

519

520

521

**514** Winchester Old Minster 16 (nts)  **515** Winchester Old Minster 17 (nts)  **516** Winchester Old Minster 18 (nts)  **517** Winchester Old Minster 19 (nts)  **518** Winchester Old Minster 20E  **519** Winchester Old Minster 20A  **520** Winchester Old Minster 20F  **521** Winchester Old Minster 6B

522

526

527

528

529

530

523

532

531

524

534

533

525

535

522 Winchester Old Minster 7F  523 Winchester Old Minster 7A  524 Winchester Old Minster 8A  525 Winchester Old Minster 8F  526 Winchester Old Minster 21  527 Winchester Old Minster 12 (1:4)  528 Winchester Old Minster 13 (1:4)  529 Winchester Old Minster 14 (1:4)  530 Winchester Old Minster 15 (1:4)  531 Winchester Old Minster 9b (1:4)  532 Winchester Old Minster 9a (1:4)  533 Winchester Old Minster 10A (1:4)  534 Winchester Old Minster 10F (1:4)  535 Winchester Old Minster 11 (1:4)

536

538

537

539

540

542

543

544

541

545　　　　　546　　　　　547　　　　　548

**536** Winchester Old Minster 22A **537** Winchester Old Minster 22F **538** Winchester Old Minster 23 **539** Winchester Old Minster 29 **540** Winchester Old Minster 28 **541** Winchester Old Minster 27 **542** Winchester Old Minster 24A **543** Winchester Old Minster 24F **544** Winchester Old Minster 25E (1:4) **545** Winchester Old Minster 25A (1:4) **546** Winchester Old Minster 25D (1:4) **547** Winchester Old Minster 26B (1:4) **548** Winchester Old Minster 26A (1:4)

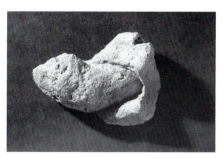

**549**

**550**

**551**

**552**

**553**

**554**

**556**

**555**

**557**

**558**

**559**

549 Winchester Old Minster 30A (1:4)   550 Winchester Old Minster 30E (1:4)   551 Winchester Old Minster 30F (1:4) 552 Winchester Old Minster 32A (1:4)   553 Winchester Old Minster 32F (1:4)   554 Winchester Old Minster 36 (1:4) 555 Winchester Old Minster 31 (1:4)   556 Winchester Old Minster 33A   557 Winchester Old Minster 33F 558 Winchester Old Minster 35 (1:4)   559 Winchester Old Minster 34 (1:4)

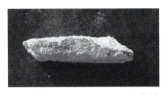

**560**

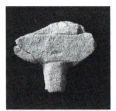

**563**

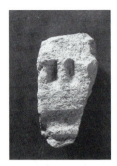

**564**

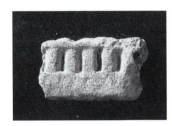

**561**

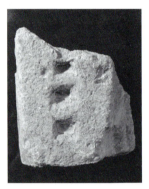

**565**

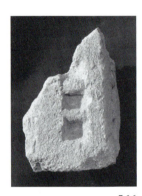

**566**

**562**

**567**

**568**

**569**

**560** Winchester Old Minster 37E (1:4)  **561** Winchester Old Minster 37A (1:4)  **562** Winchester Old Minster 41 (1:4) **563** Winchester Old Minster 38 (1:4)  **564** Winchester Old Minster 39 (1:4)  **565** Winchester Old Minster 40A (1:4)  **566** Winchester Old Minster 40D (1:4)  **567** Winchester Old Minster 40F (1:4)  **568** Winchester Old Minster 42D (1:4) **569** Winchester Old Minster 42A (1:4)

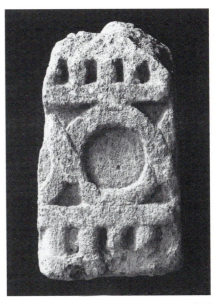

570

572

571

573

576

574

577

575

578

**570** Winchester Old Minster 44A (1:4)  **571** Winchester Old Minster 44F (1:4)  **572** Winchester Old Minster 45 (1:4)  **573** Winchester Old Minster 46 (1:4)  **574** Winchester Old Minster 43A  **575** Winchester Old Minster 43B/E  **576** Winchester Old Minster 47A (1:4)  **577** Winchester Old Minster 47F (1:4)  **578** Winchester Old Minster 47B (1:4)

579

584

586

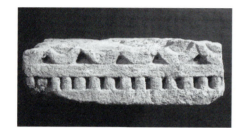

580

585

587

581

588

582

583

589

**579** Winchester Old Minster 48 (1:4) **580** Winchester Old Minster 49A **581** Winchester Old Minster 49F **582** Winchester Old Minster 55 (1:4) **583** Winchester Old Minster 54 (1:4) **584** Winchester Old Minster 52 (1:4) **585** Winchester Old Minster 51 (1:4) **586** Winchester Old Minster 50A (1:4) **587** Winchester Old Minster 50F (1:4) **588** Winchester Old Minster 53A (1:4) **589** Winchester Old Minster 53F (1:4)

590

591

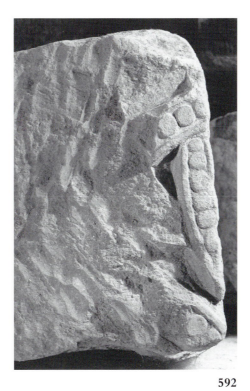

592

593

594

595

596

597

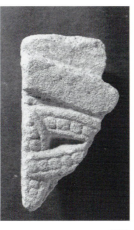

598

599

**590** Winchester Old Minster 58 (1:4)  **591** Winchester Old Minster 57 (1:4)  **592** Winchester Old Minster 62  **593** Winchester Old Minster 61 (1:2)  **594** Winchester Old Minster 60A (1:4)  **595** Winchester Old Minster 60F (1:4)

**596** Winchester Old Minster 56 (1:4)  **597** Winchester Old Minster 59D (1:4)  **598** Winchester Old Minster 59A (1:4)  **599** Winchester Old Minster 63 (1:4)

600

602

601

603

604

605

606

**600** Winchester Old Minster 64D  **601** Winchester Old Minster 64A  **602** Winchester Old Minster 64E  **603** Winchester Old Minster 65A (1:4)  **604** Winchester Old Minster 65F (1:4)  **605** Winchester Old Minster 66 (1:4)  **606** Winchester Old Minster 67 (1:4)

607

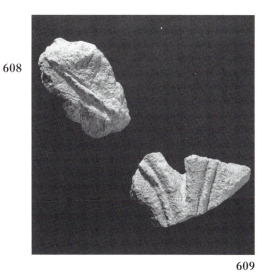

608

609

610

611

612

613

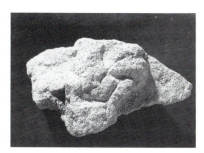

614

615

616

**607** Winchester Old Minster 69A (1:4)  **608** Winchester Old Minster 68A (1:4)  **609** Winchester Old Minster 69A (1:4)  **610** Winchester Old Minster 68A (1:4)  **611** Winchester Old Minster 70A (1:4)  **612** Winchester Old Minster 70B (1:4)

**613** Winchester Old Minster 70C (1:4)  **614** Winchester Old Minster 72 (1:4)  **615** Winchester Old Minster 71  **616** Winchester Old Minster 70F (1:4)

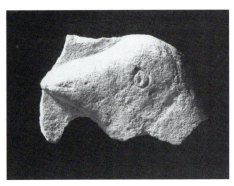

623

617

618

624

619

620

625

621

622

**617** Winchester Old Minster 74A (1:2)   **618** Winchester Old Minster 75D/A (1:4)   **619** Winchester Old Minster 75A (1:4)   **620** Winchester Old Minster 79 (1:4)   **621** Winchester Old Minster 78 (1:4)   **622** Winchester Old Minster 77 (1:4)   **623** Winchester Old Minster 73A (1:2)   **624** Winchester Old Minster 73F (1:2)   **625** Winchester Old Minster 76 (1:4)

626

627

630

631

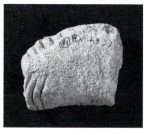

628

632

633

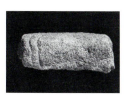

629

636

634

635

637

638

626 Winchester Old Minster 80D (1:4)   627 Winchester Old Minster 80A (1:4)   628 Winchester Old Minster 83A (1:4)   629 Winchester Old Minster 83F (1:4)   630 Winchester Old Minster 81D (1:4)   631 Winchester Old Minster 81A (1:4)   632 Winchester Old Minster 82D (1:4)   633 Winchester Old Minster 82A (1:4)   634 Winchester Old Minster 82F (1:4)   635 Winchester Old Minster 84D (1:4)   636 Winchester Old Minster 84A (1:4)   637 Winchester Old Minster 84F (1:4)   638 Winchester Old Minster 84B (1:4)

**639**

**640**

**641**

**642**

**643**

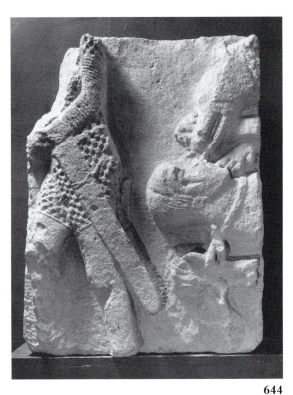

**644**

**645**

**639** Winchester Old Minster 87 (1:4)  **640** Winchester Old Minster 86 (1:4)  **641** Winchester Old Minster 85 (1:2)  **642** Winchester Old Minster 88E  **643** Winchester Old Minster 88F  **644** Winchester Old Minster 88A  **645** Winchester Old Minster 88B

Illustration 646

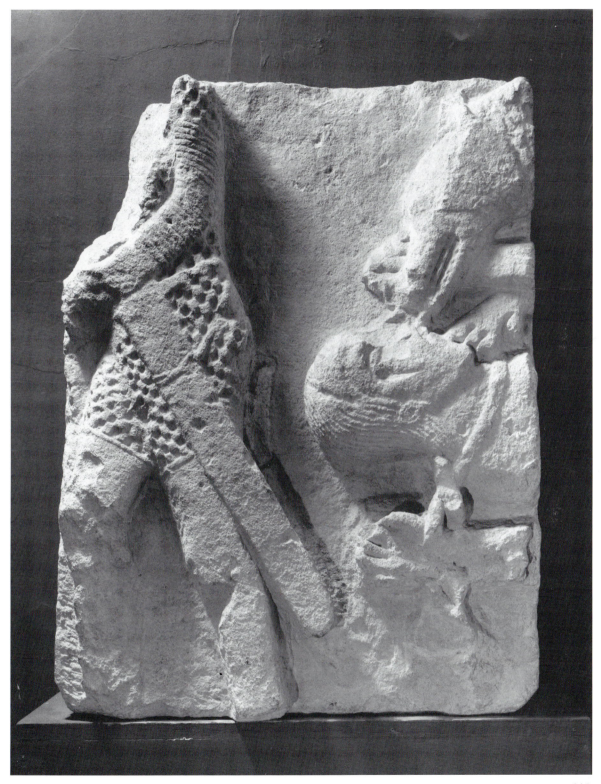

**646** Winchester Old Minster 88A (1:4)

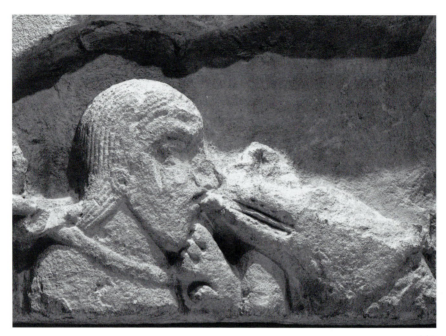

647

648

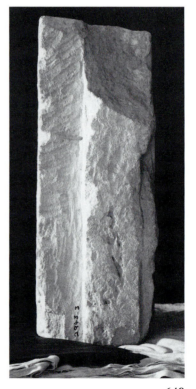

649

**647** Winchester Old Minster 88A (detail, 1:4)  **648** Winchester
Old Minster 88C  **649** Winchester Old Minster 88D

650

651

**650** Winchester Old Minster 91E (1:4)  **651** Winchester Old
Minster 91A (1:4)

Illustrations 652–660

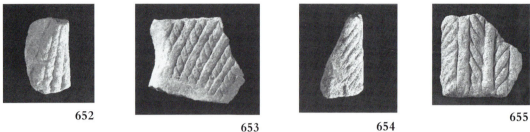

652

653

654

655

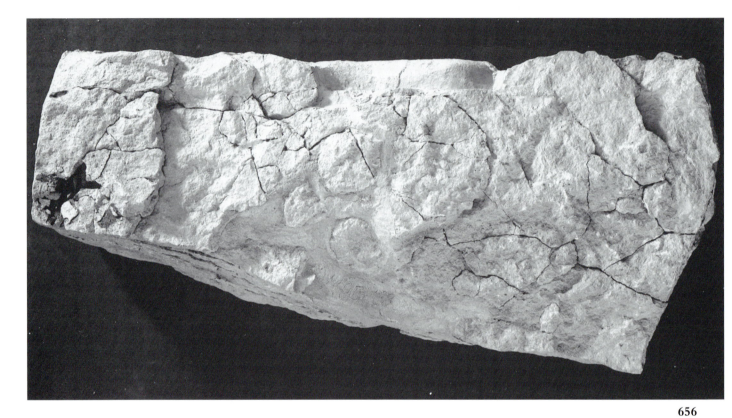

656

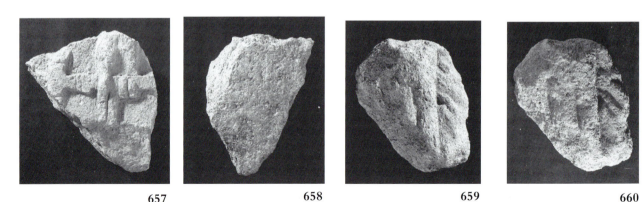

657

658

659

660

652 Winchester Old Minster 90 (1:4)  653 Winchester Old
Minster 89 (1:4)  654 Winchester New Minster 6D (1:4)
655 Winchester New Minster 6A (1:4)  656 Winchester Old
Minster 91F (1:4)  657 Winchester New Minster 1A
658 Winchester New Minster 1C  659 Winchester New
Minster 7A (1:4)  660 Winchester New Minster 7A (1:4)

661

662

663

664

665

666

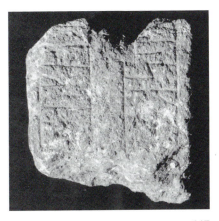

667

668

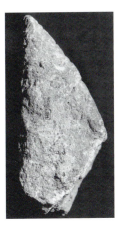

669

670

661 Winchester New Minster 2A    662 Winchester
New Minster 2B    663 Winchester New Minster 2C
664 Winchester New Minster 3    665 Winchester New Minster
5 (1:4)    666 Winchester New Minster 4    667 Winchester St

Maurice 1A (1:4)    668 Winchester St Maurice 1A (1:4)
669 Winchester St Maurice 1C (1:4)    670 Winchester St
Maurice 1B (1:4)

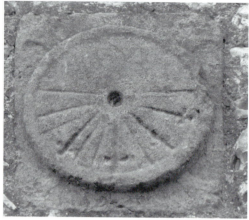

671

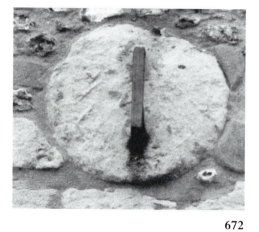

672

673

674

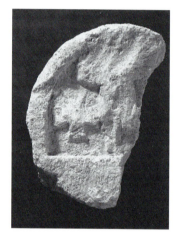

675

676

677

678

**671** Winchester St Michael 1 **672** Winchester St Maurice 2 (nts) **673** Winchester St Pancras 1C **674** Winchester St Pancras 1D **675** Winchester St Pancras 1A **676** Winchester Lower Brook Street 1C (1:4) **677** Winchester Lower Brook Street 1D (1:4) **678** Winchester Lower Brook Street 1A (1:4)

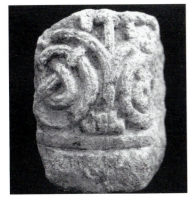

679

680

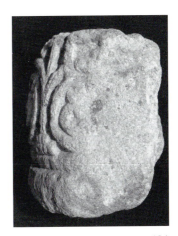

681

682

683

684

685

679 Winchester High Street 1A (1:4)  680 Winchester High Street 1E (1:4)  681 Winchester High Street 1A (1:4)  682 Winchester High Street 1F (1:4)  683 Winchester Upper Brook Street 1A  684 Headbourne Worthy 3C  685 Headbourne Worthy 3A

686

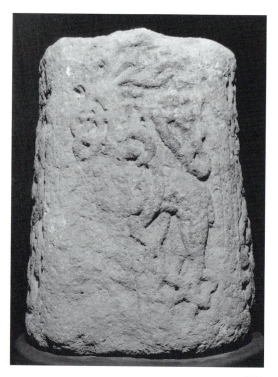

687

688

689

686 Winchester Priors Barton 1E  687 Winchester Priors
Barton 1A  688 Winchester Priors Barton 1B  689 Winchester
Priors Barton 1C

691

690

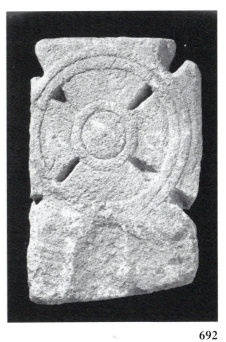

692

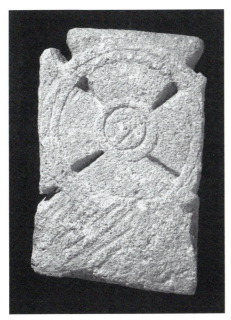

693

694

**690** Winchester Priors Barton 1D  **691** Winchester Old Minster 92E  **692** Winchester Old Minster 92A  **693** Winchester Old Minster 92C  **694** Winchester Old Minster 92B

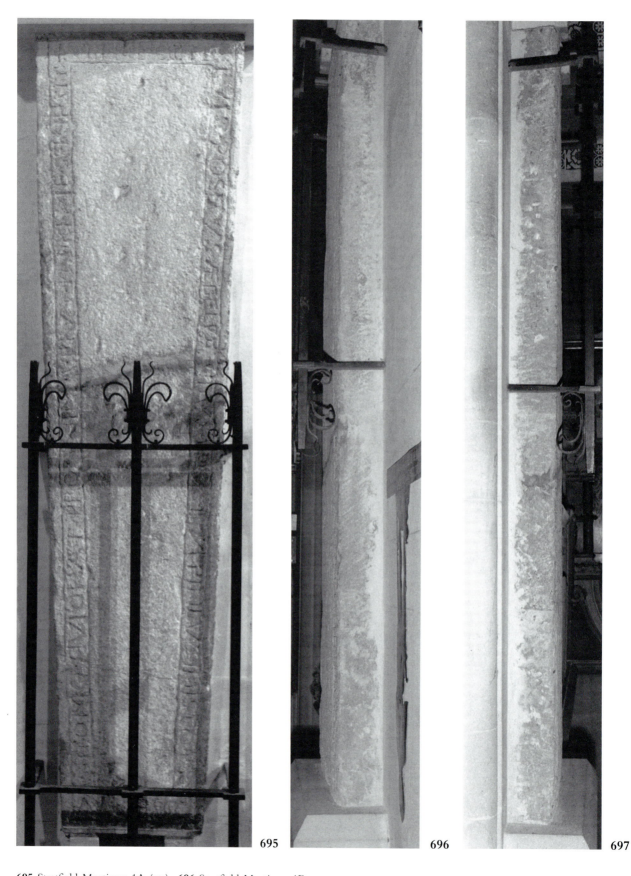

695    696    697

**695** Stratfield Mortimer 1A (nts)   **696** Stratfield Mortimer 1B
(nts)   **697** Stratfield Mortimer 1D (nts)

698

699

700

701

702

698 Stratfield Mortimer 1A (1:4)  699 Stratfield Mortimer 1A
(1:4)  700 Stratfield Mortimer 1A (1:4)  701 Stratfield
Mortimer 1A (1:4) 702 Stratfield Mortimer 1A (1:4)

703

704

705

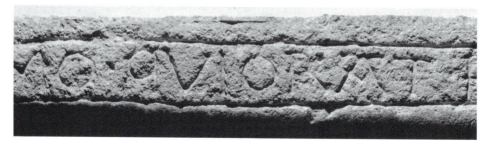

706

**703** Stratfield Mortimer 1A (1:4)  **704** Stratfield Mortimer 1A (1:4)  **705** Stratfield Mortimer 1A (1:4)  **706** Stratfield Mortimer 1A (1:4)

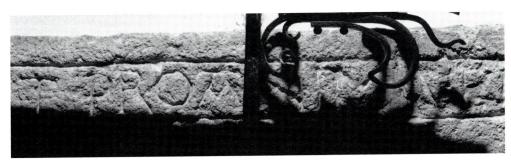

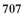

707

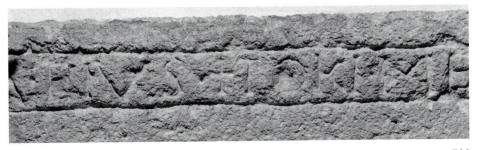

708

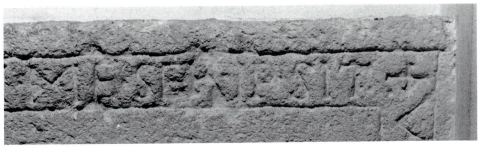

709

**707** Stratfield Mortimer 1A (1:4)  **708** Stratfield Mortimer 1A
(1:4)  **709** Stratfield Mortimer 1A (1:4)

710

711

712

713

714

715

716

**710** Winchester Old Minster 93C (1:4)   **711** Winchester Old Minster 93D (1:4)   **712** Winchester Old Minster 93A (1:4)   **713** Winchester Old Minster 94aD   **714** Winchester Old Minster 94aA   **715** Winchester Old Minster 94bD   **716** Winchester Old Minster 94bA

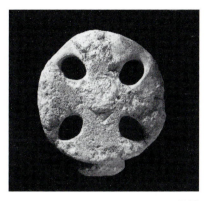
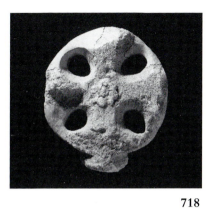

717

718

719

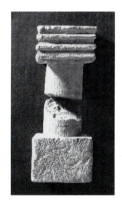

720

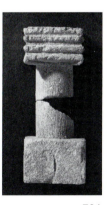

721

722

**717** Winchester Old Minster 95C   **718** Winchester Old Minster 95A   **719** Winchester Old Minster 96E   **720** Winchester Old Minster 96B   **721** Winchester Old Minster 96A   **722** Winchester Old Minster 96 (underside of capital)

# INDEX

1. Indexing of the Introduction and the Catalogue entries is complete, including the figures. The illustrations are not indexed, but are listed at the beginning of each entry in the Catalogue. In the index the catalogue entry for each sculptured stone is given first, followed by any other references. The Form and Motif Table should also be consulted.

2. Sites in England, Scotland and Wales are followed, first, by the counties which applied to them before the reorganization of 1974, and then, if appropriate, by their post-1974 counties (in parentheses).